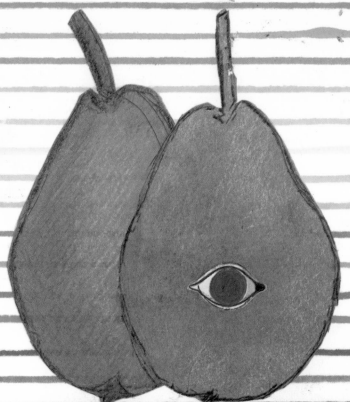

Deux poires dont une touchée.

Tel

'éCHO

Collage

Herta Wescher

COLLAGE

Translated by Robert E. Wolf

Harry N. Abrams, Inc., New York

Endpapers: E. L. T. Mesens. *What is Needed to Make a Collage? (Que faut-il pour faire un collage).*
1963. Reproduced in *Quadrum*, no. 16, 1964. Collection Joseph Derweduwen, Brussels

Standard Book Number: 8109-0184-6
Library of Congress Catalogue Card Number: 79-161620
Copyright 1968 in Germany by Verlag M. DuMont Schauberg, Cologne
Printed and bound in West Germany

Contents

Publisher's Note

The present book is one of what was ultimately to have been a two-volume work on collage—its immediate precursors, its Cubist and post-Cubist flowering in the early part of this century, and its reappearance as a major creative mode in recent years.

At the end of this monumental first volume, which deals with the "classical age" of collage, roughly prior to World War II, Herta Wescher gives us a glimpse of the revival of collage during the 1950s and 60s—a taste of things to come.

For art lovers it is a matter of deep regret that work on the second volume was terminated by Dr. Wescher's death in 1971.

I The Forerunners

Crafts, Folk Art, and Amateur Art from the Middle Ages to the End of the Nineteenth Century

Pictures assembled from assorted materials have an ancient ancestry, and the earliest examples known are also among the most refined. It seems to have been in the twelfth century that Japanese calligraphers began to copy poems on sheets pasted up from a number of irregularly shaped pieces of delicately tinted papers. The composition that resulted was then sprinkled over with flower patterns or tiny birds and stars made from gold and silver paper, and when the torn or cut edges of the papers were brushed with ink, their wavy contours represented mountains, rivers, or clouds. From such papers the calligrapher chose the one most appropriate to the spirit of a particular poem, which he then wrote out in an elegant hand. Among the most famous of such manuscripts is the *Iseshu*, from the beginning of the twelfth century, a collection of thirty-one-syllabled *waka* poems by the tenth-century poetess Ise (colorplate 1).

The tradition of these text-collages—the earliest forerunners of modern tableaux-poèmes—has lived on in Japan, where New Year's greetings from one family to another are still often written on pasted papers.

In time new arts based on cutting grew up in the East. In the thirteenth century the masters of leatherwork in Persia began to excel in cutting leather for precious bookbindings. That new art had its most brilliant period in the fifteenth and early sixteenth centuries, after which it was eclipsed by paper cutting, with paper cutters, calligraphers, and bookbinders collaborating to turn out sumptuous volumes. From Persia the specialty of cutting out delicate flowers spread to Turkey, and in Bursa, where the Persian art of the book first took hold, the paper cutter Fakhri became celebrated for the lovely leaves, blossoms, stems, and roots he contrived with his scissors. About the middle of the sixteenth century craftsmen in nearby Constantinople achieved fame for their cutouts of flowers, true works of art.

Western Europeans were cutting paper and parchment for artistic purposes by 1600, as evidenced in the genealogical registers, where, added to the entries of coats of arms and heraldic devices in the oldest volumes, are painted or pasted pictures. Among the handsomest works of this sort are two pictures in the 1612 family register of the Nuremberg patrician Hans Eberhard Pfaudt, with filigree-like scissor cutouts of deer and bird hunts glued to black silk backgrounds. In later examples cloth sometimes forms the picture itself, as in another Nuremberg album, with entries running from 1739 to 1744, which includes a vase with a bouquet made from scraps of silk pasted on parchment. As the eighteenth century went on, the decoration of such family albums was carried out for the most part by artistically inclined ladies whose taste was not

The Book of Thirty-six Poets, Kyoto National Museum, 1953
I am indebted to Mr. L. Alcopley of New York for information about Japanese collages.

In his chronicle of the Turks, published in Frankfort on the Main in 1595, Nikolaus Hanolt tells how, for the circumcision festival of 1582, ten masters of the paper cutters' guild presented to Sultan Murad III a gift on which they had collaborated, "a truly lovely pleasure garden and a castle with flowers ingeniously cut out of papers of many different colors."

Much of the information on this and the next page is drawn from A. Spamer, *Das kleine Andachtsbild vom 14. bis zum 20. Jahrhundert*, Munich, 1936.

7

always fastidious. Many of them commemorated themselves for their posterity with cutout silhouettes and pasted pictures.

It was about the middle of the seventeenth century that the upper classes in Holland took up the fashion for cutout silhouettes, and certain women artists gained considerable reputation in this field. The first handbook to teach this art was published there in 1686.

Artists working in paper or cloth came into contact at a very early date with pictures made of other materials, most notably the Mexican feather-work brought home to Europe in the sixteenth century by the Spanish conquerors. For the curio collection in his castle at Ambras, Archduke Ferdinand of Tirol in 1524 was presented by Emperor Charles V with feather robes and a shield on which red, blue, and green feathers had been glued. Other shields covered with hummingbird or parakeet feathers are mentioned in early sources. A feather mosaic picture, brought back from Mexico by the Jesuits, was in the collection of the Augsburg patrician Philip Hainhofer in 1611.

Such objects were imitated in Austria with peacock feathers, and the practice has not died out: peasants' rooms in the Ohře River region of northern Czechoslovakia are still decorated with feather pictures, though reduced to the makeshift plumage of barnyard fowl.

In the cabinets of rare and curious objects assembled by wealthy men in the seventeenth century could be found art works of the most outlandish materials, such as mosaic pictures made of beetles or corn kernels, ancestors of the reliefs made nowadays by Pierre Bettencourt from coffee beans, eggshells, fruit stones, and the like. The art collection of the palace in Dresden acquired in 1658 a picture "setting forth the story of a queen along with her tiring women, soldiers, and a ship, all in colored straw; in black frames decorated with birds and flowers likewise of straw."

Very skillful hands are required for the butterfly-wing collages, first mentioned in Europe in the eighteenth century. Famous among these was a *Joseph and Potiphar* composed entirely of butterfly wings that was made in the workshop of a southern German convent and often copied. There are reports too of a *David as a Harper* in which David's garment was completely fashioned from wings of the brimstone butterfly.

In the course of the centuries Russian icons became true and proper collages of various materials. Quite early, the old Byzantine masters took to adorning the Virgin's crown and the hems of the saints' robes with gems and pearls. Halos of fine gold leaf, incised or in filigree, surrounded the heads, and thin metal mountings with floral arabesques covered the borders of the picture, which were also often further decorated with precious stones. Out of these elaborate mountings there developed in seventeenth-century Russia a special type of icon casing made of finely worked sheets of metal concealing everything in the picture except the face and hands. As the old ecclesiastical and monastic art merged into folk art, these *oklads* became richer and more variegated. Brocades, embroidery in silk and pearls, ribbons, and bright trappings embellished pictures of the Virgin, and many were set into shrine-like housings over which equally precious hangings were drawn.

The popular saints' pictures, crèches, and reliquary shrines of the Baroque churches in Central Europe were fitted out gaily and colorfully with glistening finery. Among the treasures of religious folk art in the R. Kriss Collection of the Bayerisches Nationalmuseum of Munich there is a reliquary panel

At the beginning of our century it was still the custom at country weddings in Normandy for the peasant women to give the bride a picture made of feathers glued together, each woman contributing a feather from her hat. Feather decorations of more sophisticated taste are made in Paris by the *plumassiers*, last exponents of a craft now becoming extinct.

Dresden palace inventory of 1741

About the middle of the seventeenth century, prisoners in English jails fabricated portraits of straw, which were later imitated by artists of some repute.

In southern Germany and Switzer-
land, during the late Rococo period
and the early nineteenth century,
small art objects were made of
colored waxes and sometimes also
trimmed with cloth. Thus, in a small
box one finds a wax Madonna
wrapped in gold brocade and bedded
in glistening paper stars, and in a
group of figures from Appenzell
there is a lovely little doll laid out
on lace-trimmed cushions.

Jan Tschichold has illustrated a
little volume of German love poems
from the Baroque and Rococo
periods, *Schönste liebe mich*,
Heidelberg, 1957, with enchanting
old lace pictures from southern
Germany, Austria, and Alsace.

The Victoria and Albert Museum
in London has a collection of fine
valentines.

from Salzburg with two thorns of Christ's crown surrounded by brocaded
stars, and nails from the True Cross are laid out in a box covered with bright
spangles. However, for assemblages of truly diverse materials we must look
at the weather charms (plate 2), dating from as early as the sixteenth century
and still being made in the nineteenth: round or monstrance-shaped shallow
containers filled with the most singular amulets, saints' pictures, Benedictine
crosses, and medals, but also with seeds and stones believed to be efficacious
against bad weather and illness. With their separate components each framed
in fine gold wire, they occasionally make highly artistic compositions. On a
Breverl (a small breviary) of the eighteenth century, there is a three-dimen-
sional collage of relics and pilgrimage mementos on a sheet of paper pasted
with naive illustrations of saints besought for protection and good fortune.

Typical examples of paper collage are the small devotional pictures made
to be carried in prayer books that became widespread in the seventeenth and
early eighteenth centuries in southern Germany and neighboring regions.
The nuns who made them lavished loving care on the finest details, cutting
delicate lace out of thin parchment and then pasting it around minutely de-
tailed paintings of saints. For backgrounds they used colored paper or, upon
occasion, silks. (In time such pictures came to be mass-produced by opportun-
istic publishers, for sale especially at pilgrimage places.)

Rather similar were the pictures made from bits of cloth glued together,
with flowers and ornamental foliage cut out of snippets of fine silks and
placed around painted miniatures. Sometimes, the painted saints themselves
wear garments of patterned or painted cloth and are glued to silk or gauze.
Their halos may be made of gold wire and metal paillettes, or tiny paper stars
may be scattered over the brocades.

Such religious lace work pictures were paralleled in the middle of the eigh-
teenth century by secular examples in which the festive decoration framed
symbols of love or naive verses, and these were addressed by sentimental
swains to their sweethearts.

With time, these developed into the valentines exchanged in English-
speaking countries on February 14th, the feast of the patron saint of lovers.
They first appeared in mid-eighteenth century, and the earliest cards were
hand-painted and decorated with sentimental or humorous pictures, engrav-
ings, or lithographs. The first lace-paper greetings came from Litchfield in
1826, and specialized publishing houses soon sprang up elsewhere in England
to produce them. Before 1850 Joseph Mansell, a small stationer in London,
was dealing in valentines wholesale. His specialty was to emboss cameos,
medallions, and friezes with the antique gods and cupids within the delicate
paper lace, itself painstakingly gilded or hand-colored. Between 1840 and
1860 the London publishers vied with each other in embellishing their prod-
ucts ever more elegantly, the firm of Dobbs outstripping all others in the
variety of its series. As background there was always delicate net lace stamped
out of paper and often framed by gold lace, and sometimes the borders were
further decorated with medallions of spun glass or gold filigree. Among
Dobbs's finest pieces is the *Barometer of Love*, which appeared about 1845
(plate 5). The barometer is surrounded by delicately colored flowers and
leaves, all pasted by hand. Its indicator is poised between "Fair Weather"
("Never to be separated") and "Sunny" ("Within the sunshine of your smile"),
and the degrees of the thermometer run from "esteem," "friendship," and

"love" up to "rapture," "unity," and "bliss." In the 1850s the publisher John Windsor brought out a valentine with the bust of the young Queen Victoria printed in relief, and other houses decorated their cards with feathers, locks of hair, or tiny cloth-dressed dolls.

Valentines made their way from England to the United States about the middle of the nineteenth century. The best-known firm, Esther Howland, imported its lace materials and paper flowers from England but enriched its compositions with colored papers of its own fabrication.

Ruth Webb Lee, *A History of Valentines*, London, 1953

The French have their own version of valentines, the postcards sent on Saint Catherine's Day. New designs are to be found each year in the small stationers' shops, but they always include a bonnet made of cloth, lace, and ribbons pasted together to resemble those worn by the Parisian midinettes in their processions on their patron saint's day (plate 4).

From the middle of the nineteenth century on, postage stamps provided a new material for collage, and people all over the world specialized in gluing them together into artistic compositions. At the international collage exhibition organized by the Contemporary Arts Museum in Houston in 1958, there was a picture of a classical vase made entirely from postage stamps with portraits of American presidents, and each of its flowers was a separate small collage of stamps (plate 6). In another and somewhat later European example, a romantic landscape with churches and trees is conjured up out of French postage stamps, and this type of collage was generally glued to a piece of curved glass to make a paperweight (Collection E. L. T. Mesens, London).

Collage International : From Picasso to the Present, Contemporary Arts Museum, Houston, Tex., 1958

As popular taste deteriorated, about the turn of the century there began to appear ashtrays adorned with cigar bands, and industry contributed large-scale versions in the form of so-called smoking tables with this sort of collage under glass. Similarly, glass trays with collages of exotic butterflies were produced commercially, the more luxurious types having, in addition, punched-out black silhouettes. Boxes and caskets decorated with shells or even dried starfish, originally a cottage industry of fishermen, began to be manufactured extensively as ornaments for middle-class homes.

There are still connoisseurs of this type of collage. Some ten years ago the illustrated papers published photographs of a house in Volendam, Netherlands, whose walls and ceilings had been papered by the painter Nico Molenaar with decorative collages composed exclusively of the cigar bands he had been collecting through half his lifetime.

Quite apart from such commercial products, however, was an original work of 1896 by Max Hamm, a merchant in Krefeld, Germany: a casket covered all over with buttons, hooks, braid, corset stays, ladies' garters, and the like. In 1958, during a discussion in the Krefeld Rotary Club in connection with the current Dada exhibition in Düsseldorf, the painter Georg Muche rightly hailed the creator of this box as an *Ur-Dada*, the grandfather of them all, as it were.

In the first half of the nineteenth century, during the period known variously as Biedermeier, Empire, or Early Victorian, better-class homes were decorated with other priceless treasures, such as the pictures by specialized "hair artists," who formed lovely flowers or ornaments out of locks and braids of hair (plate 3). Elaborately decorated "memory chests" preserved bridal wreath and veil surrounded by bowknots and dried flowers with beautifully penned inscriptions of the names and dates to be commemorated. Other such sentimental assemblages have found a place in museums and collections, and the finest of these may well be a round picture, *Souvenirs de Sainte-Hélène*, donated in 1896 to the Musée Carnavalet in Paris by Baron Larrey (plate 1). Roots and twigs from Napoleon's grave, a fragment of rotted wood from the window ledge on which the Emperor used to lean to

look out, playing cards found in the room he died in, and other carefully identified memorabilia are combined into a composition worthy of a Schwitters.

The days are long gone when globe-trotting relatives brought *Greetings from Nazareth*, little volumes with flowers and grasses from the Holy Land glued together to form nosegays and wreaths and bound in sweet-smelling cedarwood, delights that spurred young girls to paste together their own art works of pressed flowers and leaves. Such childish efforts were even more encouraged by the albums whose pages could be filled with the embossed scrapbook pictures obtainable in sheets and whose posies of roses, anchors, hearts, angels, and hands clasped in eternal faith were printed in splendid colors of an irresistible appeal.

Modern pedagogues turn a jaundiced eye on such ready-made album pictures and the related decalcomanias transferred by dampening or rubbing or blowing, claiming that they do not stimulate youngsters to develop their own imaginations. The pedagogic methods introduced in Germany as early as 1840 by Friedrich Froebel's kindergartens, and further developed particularly by Maria Montessori, consign the raw material of art directly to the hands of the children. Now, often enough, the raw material is colored paper from which the youngsters can themselves cut out whatever forms they wish and create collages whose originality, it must be said, is often no less than that shown by many recognized adult artists.

Sometimes, though, paste-up pictures were taken up by grownups and used for the higgledy-piggledy, gaudy collages with which they decorated not just album pages but whole folding screens (known to antique dealers as "cut, or découpage, screens"). These date well back into the nineteenth century, and with changing tastes the choice of materials also changed. The earlier examples were made up of prints, fashion plates, and graceful verses framed in garlands and floral borders, whereas with the turn of the century one finds photos, postcards with views of distant places, vaudeville programs, and the like, lending these large-scale collages a somewhat less aesthetic but certainly much livelier note.

The folding screens have a parallel in a specific category of trompe-l'oeil pictures in which an accumulation of printed matter, engravings, and other documents is so faithfully imitated that one can easily mistake the painted representations for collages. They are sometimes known as *quodlibets*, a name more usually applied to fantasias from various musical compositions but also, according to Petri's *Handbuch der Fremdwörter* (Gera, 1899), referring to "all kinds of paintings," in short, to a medley of images. Painters specializing in such pictures are found in many countries. In an exhibition of trompe-l'oeil painting at the Arthur Jeffress Gallery in London in 1957 there was a German example signed and dated "A. G. Schumann 1797," with a reichstaler banknote, playing cards, a map of Saxony, a Leipzig newspaper (which tells us where the picture came from), and a half-charred letter dedicating the "present quodlibet" to a connoisseur of such paintings. The paper items are carefully and distinctly arranged, and mingled with them appear a pencil, a quill pen, and a pair of eyeglasses, three-dimensional elements used in such works to intensify the illusion of spatial depth. Table tops of veined wood with gnarls and bird's-eyes are found also in such other "still lifes" of this sort as the *Kladderadatsch (Kit and Caboodle)* by Theodor Flügel, 1882 (Louis Pappas

The educational method of Maria Montessori, who founded her first school in 1907 in Italy, was adopted generally by German kindergartens in 1919, and today, in children's homes and preschools throughout the world, the youngsters not only paint but also cut and paste and carry out all sorts of manual activities.

In the rooms she inhabited in 1781–84 in the small palace of Tiefurt in Weimar, Luise von Göchhausen, maid of honor in permanent attendance on Duchess Anna Amalie, decorated the walls of a chamber in collage with pictures, prints, and cutout silhouettes.

Collection, San Francisco), in which a torn cover from the German political-satirical magazine *Kladderadatsch*, a Rembrandt portrait, a small image of a saint, and an envelope addressed to a hairdresser are combined in a spirit not too remote from that of Dada.

In the nineteenth-century versions of such pictures, as a rule the components are arranged more loosely and arbitrarily, and newspaper cuttings and commercial handbills join the sentimental and picturesque illustrations. G. Kutsmich Leonov, in his *Moscow Souvenirs* of 1891 (likewise exhibited by Jeffress in London), arrays a great number of mementos: visiting cards, photos of statues and portraits, brochures, newspapers, and a volume of piano music whose title, *Collection of Potpourris*, could serve for the entire picture. In other examples cutout illustrations are assembled in a humorous manner—grotesque heads stuck on the figures, and the like—with an effect that is Surrealist before the fact.

There is an American subspecies of these pictures, the "letter-holders," which depict horizontal or crosswise strips fixed on a wall or door and holding letters and printed matter. Goldborough Bruff's watercolor of 1845, *Associated Prints*, was followed in 1881 by William M. Harnett's *Old Souvenirs*, with its tattered insurance policy and portrait of a young girl. However, the most productive and imaginative exponent of this genre was JOHN HABERLE (1856–1933), who, along with the usual odds and ends of papers, also shows all sorts of objects hanging on the walls and whose trompe-l'oeil painting thereby anticipates the present-day tableaux-objets (plate 7). His last work in this vein, *A Bachelor's Drawer*, was painted between 1890 and 1894 and has paper money, photos, illustrations from comic papers, and advertising throwaways all nailed in picturesque disorder over a door panel, together with a comb, a pipe, cigarettes, a pocket knife, and so on, the whole very much like a bona-fide Pop assemblage.

Although the painters of these pseudo-collages are for the most part known by name and properly appreciated, along with the many anonymous practitioners of authentic paper-cutting and pasting in the nineteenth century, there are a few artists distinguished in their own right, and their work was shown in the exhibition of *Malende Dichter—Dichtende Maler (Painting Poets—Versifying Painters)* in Saint Gall, Switzerland, in 1957. Among the exhibits was an 1801 sheet by the Romantic painter PHILIPP OTTO RUNGE (1777–1810), *Lehrstunde der Nachtigall und Amor (Lesson of the Nightingale and Cupid)* (Kunsthalle, Hamburg), in which a pen drawing is combined with a poetic text and the white cutout silhouette of a cupid to make a genuine collage laid out against a dark background.

VICTOR HUGO (1802–1885), whose qualities as a draftsman are becoming more and more admired, occasionally worked also with scissors. During his years of exile on the island of Jersey, which dragged on from 1852 to 1855, he cut shapes from blackened paper, which he then affixed to other sheets and worked over with his brush to make romantic landscapes. At times he utilized these cutout shapes as stencils, laying them over light backgrounds and rubbing them with soft pencil, so that within the pencil hatching there remained negative shapes which he painted with India ink.

HANS CHRISTIAN ANDERSEN (1805–1875) not only wrote fairy tales but also distinguished himself with paper and scissors. For his relatives' children he combined cutouts, collages, and sketches to make a *Picture Book for Agnes*,

Wolfgang Born, *Still-Life Painting in America*, New York, 1947

Retrospective exhibition of Haberle, New Britain Museum of American Art, New Britain, Conn., 1962

A. Frankenstein, "Haberle or the Illusion of the Real," *Magazine of Art*, October, 1948

Victor Hugo's passion for experimentation extended also to other fields of graphic art. For example, he laid net lace over paper, brushed over it with India ink, and used the resulting delicate stencil designs as the pictorial basis for a new composition. Once he formed in this way a head in double view, fullface and in profile, an anticipation of Picasso's simultaneous portraits (Musée Victor Hugo, Paris, catalogue no. 162). To obtain especially black tones he mixed ink and India ink with coffee or,

according to some accounts, also with cigar ash, blackberry juice, and burnt onions. He also made ink-blot pictures by pouring ink on a piece of paper folded one or more times. In this sort of pictorial play he appears to have been preceded by the Swabian poet Andreas Justinus Kerner, who in 1857, in the foreword to his *Hades-Bilder, klecksographisch entstanden und in Versen erläutert (Hades Pictures, originating in ink blots and explained in poems)*, stated that for the previous seven years he had been sharing this procedure with his friends from near and far.

Victor Hugo, Dessinateur, notes and captions by R. Cornaille and G. Herscher, Paris, 1964
G. Herscher, "Papiers découpés de Victor Hugo," *L'Oeil*, no. 10, November, 1963

Mary, and Charlotte. Charles Dickens's son, Sir Henry Dickens, recalled that Andersen had a truly marvelous dexterity in cutting out with an ordinary pair of scissors charming little figures of sprites, elves, gnomes, fairies, and animals of every sort that seemed to leap from the pages of his books.

His most astonishing work was a four-leaf folding screen, of the type mentioned above, that he made toward the end of his life, in 1873–74 (plate 9). He covered it with every imaginable kind of reproduction, reflecting whatever had caught his fancy on his travels or at home: landscapes, seas and rivers with steamships and sailboats, monuments and friezes in the classical taste of his time, stage sets, drawings with tiny genre scenes, and much more. The hugely diversified background is packed with people gathered for solemn occasions or in parades and with cutout portrait heads of historical personalities, including many of the famous contemporaries Andersen was so proud to know personally. All these heterogeneous elements are assembled in astounding optical combinations from which grow compositions of real spatial depth, and they make of this screen an amazing ancestral creation of Surrealism.

As for collages of rather more "normal" type, there is an entire series by CARL SPITZWEG (1808–1885), who had been a pharmacist before becoming a painter and who, in the course of his eccentric existence, took a lively interest in the secrets of the culinary art. At home and traveling he noted down all sorts of recipes and for his niece Lina Spitzweg he illustrated a collection of them with collages. For these he used woodcuts snipped from the comic paper *Fliegende Blätter* plus old steel engravings, rounding them out by adding his own drawing and by painting in watercolor those parts he wished to emphasize. His choice of components for his pictures was based on the name of the dish, which he chopped up and twisted around in order to transform wordplay into pictorial play. To illustrate *Ross-bif* (roast beef) he pasted together half a horse and half an ox (*Ross* being somewhat high-flown German for "horse," or "steed"), and to depict *Suhr-Fleisch* (marinated meat) he had recourse to a rebus: a clock *(Uhr)* preceded by a capital letter S. For *Löffel-Bisquits* (spoon bisquits) he glued two real crackers to a watercolored background and labeled it: "Photograph from nature."

Die Leibgerichte des weiland Apothekers und Malerpoeten Carl Spitzweg, von ihm eigenhändig aufgeschrieben und illustriert, Munich, 1962

Among the most pleasing of these sheets are the illustrations for cherry and strawberry marmalades (colorplate 2), on which pictures of the fruit in containers are pasted on light and dark marbled *(marmorierten)* papers, which in Spitzweg's dialect are called "*Marmelpapiere*," leading him very nicely to the verbal association with marmalade. These pastime collages are not dated, but internal evidence suggests the period between 1850 and 1875.

The pictorial efforts of the Berlin poet CHRISTIAN MORGENSTERN (1871–1914) bring us closer to modern times. Along with witty ink-blot pictures and drawings in an ornamental Art Nouveau style, in the 1890s he turned his hand to collages. They were very much a product of the Galgenberg-Bund (Gallows Mountain Association) founded by him, for which he also penned his first *Galgenlieder (Gallows Songs)*. Among the earliest sheets is an illustration for his verses:

Information from a letter from Frau M. Morgenstern and from the introduction by M. Bauer to *Christian Morgenstern, Leben und Werk*, 4th ed., Munich, 1948. *Die Schallmühle*, published in 1928 by the Piper-Verlag, is illustrated with two collages, *Dragon over the Iceberg* and *Two Climbers*, the latter identified as Palmström and Korff, the chief characters in the *Galgen-lieder*.
According to Bruno Cassirer, Morgenstern also made wire

> Auf dem schwarzen Schifflein schlank
> Wächst das Bäumlein "Liebestrank."
> (On the black and slender little ship
> Grows the treelet "Philter of Love.")

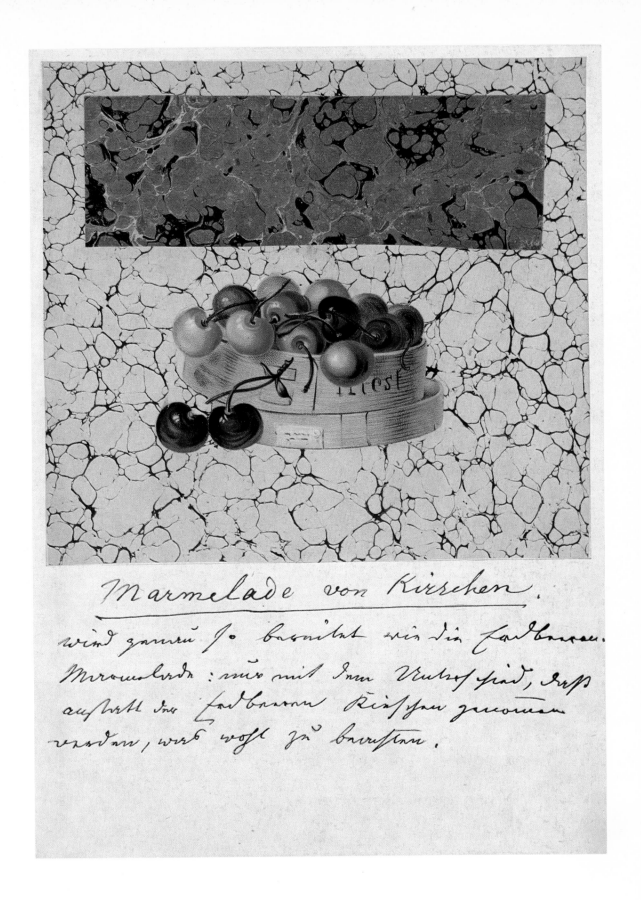

Colorplate 2. Carl Spitzweg. *Cherry Marmalade*. Second half of nineteenth century

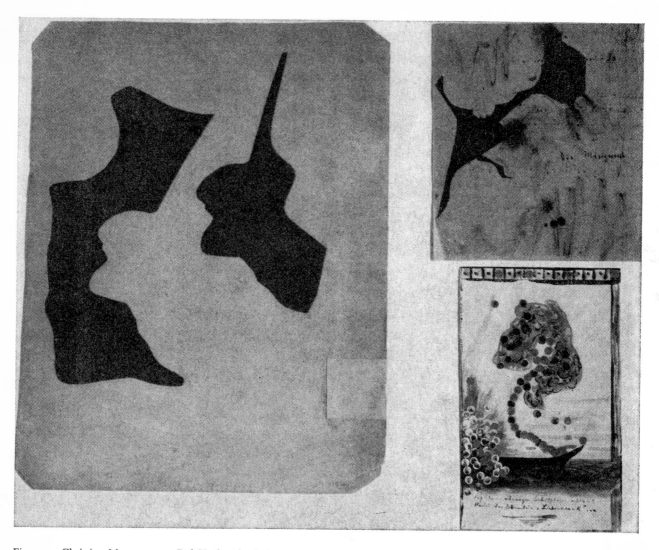

Figure 1. Christian Morgenstern. *Red Head with Shadows* (left), *Envy* (upper right), and illustration for the poem *Auf dem schwarzen Schifflein . . .* (lower right). Late nineteenth–early twentieth century. Collage, with (lower right) India ink

sculptures of hairpins and small statues from his detachable stiff shirtcuffs, which, after soaking, yielded a malleable mass that hardened when dry.
O. Stelzer, *Die Vorgeschichte der abstrakten Kunst*, Munich, 1964, p. 103

This is an India-ink drawing in which bright-colored dots are pasted on the tree in the boat and on the bushes on the bank (figure 1).

About 1903 Morgenstern began to execute real compositions in collage. Guided only by his own spontaneous intuition, he cut out large simple shapes of plain or patterned colored paper and joined them as fantastic creatures and monsters for whom he invented ironic titles such as *Professor Parakeet—Member of the Ethical Society* or *The Aggrieved Dachshund*. In the collage *Iceberg in Moonlight* a rather horrifying flying dragon blocks out the sky; in *Seasickness* the creature laid low by nausea looks like nothing so much as a bluebell falling out of a bowl. The *Red Head with Shadows* (figure 1) consists of two shapes cut from the same piece of paper and juxtaposed as a positive and a negative (an idea used later by Matisse in his découpages), and the *Woman with Three Faces* has three profiles pasted one above the other but at different intervals.

Efraim Frisch, who collaborated on the magazine Morgenstern edited for the Reinhardt Theater in Berlin, says of him: "Tricks with ink blots, colored silhouettes, figures assembled out of the weirdest components, all were turned out by his hand like jovial child's play and made striking illustrations for our wide-ranging talks. It was always the shortest path to expression that he

16

sought by these means, which unveiled the deeper meaning behind every game." Nevertheless, once the *Galgenlieder* were finally published in book form in 1905, Morgenstern gave up dabbling in collage.

It was in the 1890s that collage was used for the first time in posters. The English painters William Nicholson (father of Ben Nicholson) and his brother-in-law James Pryde were the first to discover how apt the technique was for advertisements. Pioneers in a field in which, since their time, collage has been more and more employed, they opened an advertising agency in London for which they chose the name Beggarstaff Brothers, after a brand name they found on an old nose bag.

James Thorpe, "The Posters of the Beggarstaff Brothers," *Alphabet and Image*, no. 4, April, 1947

The first exhibition of their posters was held in 1894 in the Royal Aquarium in Westminster. Figures and objects, formerly sketched in charcoal on sheets of colored paper, were now cut out in large, clear shapes and arranged more clearly and saliently on a surface. Colors were restricted to two or three striking tones which would stand out against a light background. Text material and signatures were incorporated into the composition as typographical elements (figure 2).

The Beggarstaffs designed this sort of poster for both industry and the theater *(A Trip to China Town, Cinderella, Don Quixote)*. Their style had much in common with the buoyant contours and the broad layout of surface areas found in the drawings of Aubrey Beardsley, as well as in the lithographs and woodcuts produced in the same years by Bonnard and Vallotton. Even compared with the masterly posters of Toulouse-Lautrec, whose *Aristide Bruant* of 1892 could have served them as an example, the Beggarstaffs hold their own with their highly effective, simplified style directly influenced by their use of collage. Ben Nicholson tells that in his youth he was very much impressed by these compositions.

The idea of using posters themselves as collage material, something much in fashion since the discovery of *affiches lacérées*, likewise seems to have been realized at least once about the turn of the century. The Swiss-German Symbolist painter Arnold Böcklin (1827–1901), during the last years of his life, which were spent in Fiesole, is said to have been asked to decorate a restaurant in Florence, whereupon, aided by his students, he papered all the walls with posters. The restaurant is said to exist still and to be frequently repapered with fresh posters. The story was told to Max Bill in Zurich by the painter Giuseppe Scartazzini, who heard it from friends in Italy.

Finally, photomontage too, whose development overlaps that of collage in many particulars, has a history going back more than a century. Its inventor is thought to have been the Swedish photographer O. G. REJLANDER (1813–1875), who opened a photographic studio in London in 1855 and in 1857 (some say 1856) contrived a colossal allegorical photographic picture, *The Two Paths of Life*, using thirty different separate shots of figures and backgrounds. He was followed in 1858 by H. P. ROBINSON (1830–1901) with a photomontage from five negatives, *Fading Away*, in a romantic sentimental style intended to emulate academic painting of the time and dubbed by Robinson himself "art photography." The pictorial effect was achieved by retouching the prints in a painterly manner and by concealing the joins between photographs by brushing over them. A preparatory stage for a photomontage of about 1860 by Robinson's son Ralph, a country scene with women and children, has a cutout photograph pasted on the drawing, showing that such works did derive directly from collages all of whose components were mounted and then photographed.

In its earliest phase journalistic photography likewise turned to montage for aid in recording actual events. In a primitive example, the shooting of hostages under the authority of the Paris Commune on May 24, 1871, in the courtyard of La Roquette prison, the portrait heads of the Communards supervising the execution and those of the hostages, for the most part ecclesiastical dignitaries, were pasted on the bodies of stock figures set up on a kind of stage in front of the prison wall. To make it appear as if the ranks of

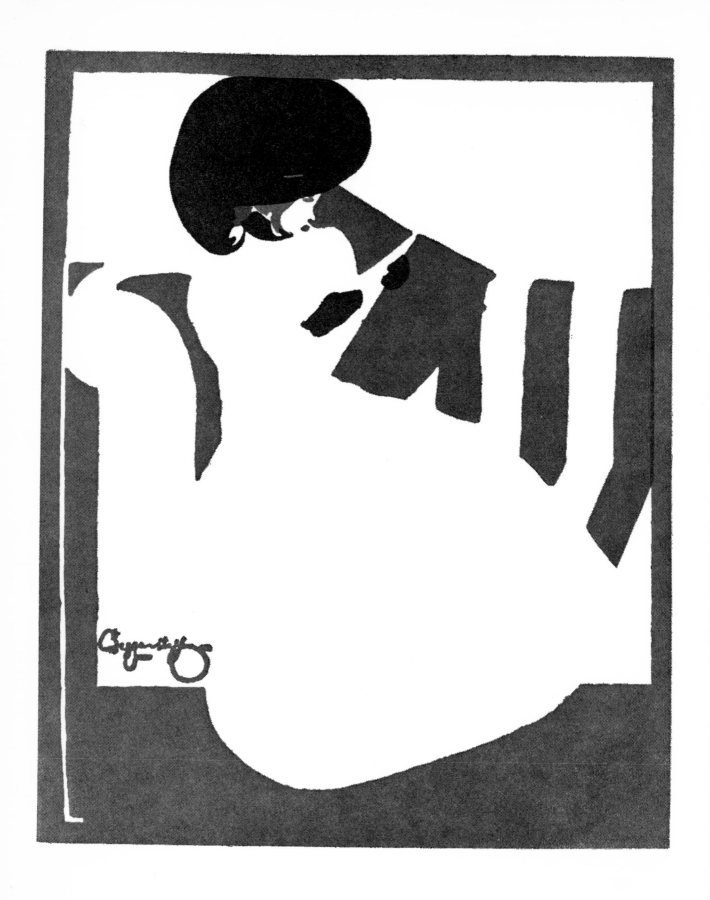

Figure 2. The Beggarstaff Brothers (William Nicholson and James Pryde). Sketch for a theatrical poster for Sir Henry Irving. c. 1894/95. Collage

the execution platoon were densely packed, a single photographic detail was copied many times.

About the turn of the century montage began to be used for commercial publicity and for picture postcards. The health resort at Leukerbad (Loèche-les-Bains) in the Swiss Valais attracted patients by an amusing view of the thermal baths shown in montage with every phase of the treatment. A greeting card from the resort at Norderney was assembled from a number of picturesque snapshots to portray the halcyon delights of sea bathing in pre–World War I costumes and poses (plate 8).

Photo studios were set up in resorts, complete with panoramas and accessories before which tourists could pose for their portraits. At Königswinter on the Rhine one could find a large photographic blowup of the Drachenfels, the nearby rock said to resemble a dragon, and in front of it was a wooden donkey on which children sat to be photographed. Hovering over the Prater in Vienna there was a fantasy airplane in which, in 1913, Kafka, Albert Ehrenstein, and other friends had themselves photographed. Such montages are related to the regulation soldier pictures with a recruit standing at attention in front of the barracks, on which families and fiancées pasted a snapshot head of their absent loved one, a primitive sort of photomontage which, nevertheless, was to give Raoul Hausmann the idea for his Dadaist productions.

In summary, it is certain that collage, montage, and assemblages of various materials had innumerable predecessors in past centuries, but only an insignificant number of these can be related in any way to what is done today. As products of craftsmen, folk artists, and amateurs, the forerunners all remained on the sidelines of the major artistic development and had no influence on it. Not until the twentieth century, when creative artists took to working with it, did collage become a new and valid means of expression, one which has left its mark indelibly on the art of today.

In the possession of the Jewish and National Library, Jerusalem, and shown at the exhibition *Expressionismus 1910–1923*, Schiller-Nationalmuseum, Marbach, 1960

II Cubism

The Creators of Cubist Papiers Collés in France and Their Successors

An India-ink drawing of 1908 by Picasso, *The Dream* (Collection Justin K. Thannhauser, New York), has come to notice recently. Because it has a drawing pasted in its center, it has been hailed as the earliest-known collage, which it certainly is not, since the drawing was quite obviously added later. The outlines of the outstretched hand of a reclining woman on the left and those of a tree on the right are not consistent with the flowing contours of the original drawing, which belongs to the period of the *Demoiselles d'Avignon*.

Both are reproduced in Robert Rosenblum, *Cubism and Twentieth-Century Art*, New York, rev. ed., 1966, pls. IX and 30 respectively.

Le Portugais (Kunstmuseum, Basel), *Le Quotidien*, *Le Pyrogène*

L'Homme à la pipe, 1911

The first time that some component was ever glued into a Cubist painting was early in 1912, when PABLO PICASSO (b. 1881) inserted a piece of oilcloth into a still life (plate 10). The design on the oilcloth was an imitation of chair caning, and Picasso painted wooden strips around it to enhance the illusion of a piece of furniture. Behind it, their planes overlapping in typical Cubist fashion, a painted glass, pipe, newspaper, lemon, and other objects are so crammed together that what strikes the eye is the large and otherwise empty insert of oilcloth, without which the small oval picture, painted in subdued, mat colors and framed with twisted cord, would have little particular significance.

Other remarkable optical illusions appear in pictures by GEORGES BRAQUE (1882–1963) as early as 1909 or 1910, when Cubist painting reached the high point of the Analytical phase, in which the artist's interest focused on opening out the ostensibly closed surface. Toward that end the constituent forms were depicted in different views simultaneously, and the result was compositions of a many-sided, unreal pictorial space. In two still lifes of this sort done in 1910, *Violin and Pitcher* (Kunstmuseum, Basel) and *Violin and Palette* (Solomon R. Guggenheim Museum, New York), Braque painted on the upper margin nails which appear to stand out three-dimensionally against the picture plane, and a painted nail with painted string occurs in the *Man with Guitar* of 1911 (Museum of Modern Art, New York). These "real" elements are evidence that the Cubists already had in mind the idea of incorporating into their pictures objects from daily life in a new form.

From 1910 on, Braque's abstract pictorial vocabulary included also printed characters and numbers, and in 1911 these began to be utilized more decisively and methodically. Soon Picasso too was using them. For the most part they appeared as fragments of words from newspaper headlines or posters, set into seemingly arbitrary places in the pictures.

As for his aim in all this, Braque explained later that in this period, when the object depicted was being broken down, that is, deformed in order to be integrated into the pictorial space, the letters signified forms resistant to any kind of deformation and therefore, by reason of their two-dimensional flatness, outside the spatial construction. The fact is, these letters, especially when stenciled, are seen close up, as if in a foreground plane, behind which the pictorial space extends into the depths of the composition. Be that as it may, Braque recognized that he adopted them also for other than formal purposes when he said further that he put them in his pictures in order to come ever closer to reality. Furthermore, Daniel-Henry Kahnweiler, an inti-

mate participant in the day-to-day development of Cubism, viewed the introduction of printed letters as a decisive step in a new direction. In his book on the "road to Cubism," whose first essays were written in 1914–15, he said that once again lyrical painting had discovered a new world of beauty which lay dormant, unremarked, in the wall posters, shop windows, and business signs that play such a great role in our contemporary visual impressions. This statement applies equally well to the path that was to lead from such printed letters to the papiers collés (the pasted papers) of the Cubists.

Daniel-Henry *(Kahnweiler)*, *Der Weg zum Kubismus*, Munich, 1920 (English translation, New York, 1949)

The interpretation of these printed characters has disturbed many critics and historians. Christian Zervos, friend of both Braque and Picasso, insists that at first their only function in the composition was to substitute for certain desired shades of black, but that, in addition, they gave rise to poetic associations which mere spots of color cannot evoke. This became evident when Braque and Picasso replaced meaningless word fragments with entire words replete with suggestions: Braque inscribed the name "Bach" in his musical still lifes; and in a whole series of pictures Picasso introduced the words "ma jolie" from the refrain of a song heard on everyone's lips at the time; later he even wrote out a declaration of love, "J'aime Eva." On the other hand, if such invocations or appeals to sentiment were introduced to alleviate the tight formal organization of those pictures, the very banality of the words is such as to admit the sounds of daily life into otherwise thoroughly abstract compositions. That, however, was a task soon to be taken over by collage.

However, before true papiers collés appeared, a change of style within Cubism itself created the formal preconditions necessary for that new medium. By the close of 1911 Analytical Cubism had attained such complexity in the overlapping and intersection of pictorial segments that it could be pushed no farther. The next step, almost inevitably, had to be clarification and simplification. In place of articulation of deep space, it was now the picture plane itself that was organized: the object depicted no longer evolved out of the depths of the picure in easily perceived areas. Such areas afforded the opportunity of using color once again, something the Cubists had neglected so long as their main interest centered on the problem of form. Now they attempted to infuse their colors with new, substantial qualities, to transform the paint, as Braque put it, into matter in its own right. Toward that end, Braque mixed sand, sawdust, or metal filings into his pigment and thereby discovered how strongly color values are dependent on the physical properties of their medium.

At the same time Picasso too was seeking new textural values in different materials: mixtures of sand and other unconventional substances. The exchange of ideas between the two friends during this time was such that questions of priority can no longer be settled and are, in fact, quite futile. In their search for new solutions Braque and Picasso made no fuss over which of them was first to light on whatever it might be. It would seem, though, that it was Braque who most often took the initiative in technical experimentation during the summer of 1912, which they spent together in Sorgues. Certainly he was the first to introduce imitations of wood graining and veined marble into painting. For this he could draw on knowledge acquired during the apprenticeship as a practical decorator that he served on the insistence of his father, a building contractor much appreciated in Le Havre and Paris. Mock wood and marble walls were all the rage at the time, and,

André Salmon tells an amusing story (in *Cahiers d'Art*, 1939) about a discussion in Picasso's circle at that time, as to whether the artist had a right to use such combs. The consensus was that it was not legitimate for him simply to ape the house painter's tricks of the trade but that, by imitation of the imitation, he must fit the process into his own means of artistic expression. A patron of the arts who happened to be present thereupon hailed a taxi, went off and bought one of those steel combs, and brought it back to Picasso, who beamed with childlike joy at the sight of the new plaything. When his benefactor turned up the next morning in Picasso's studio, he found waiting for him a painstakingly executed portrait (*Le Sapeur?*) with hair and beard waved by the steel comb.

to keep the patterns as regular as possible, the house painters used the small steel combs that Braque and Picasso eventually adopted to convey the optical illusion of wallpaper in their paintings.

The next and logically inevitable step was to paste bits of such wallpaper itself directly on a canvas. It was Braque who happened upon such wall coverings in a shop in Avignon and recognized how handy they would be in shortcutting what was otherwise a tedious process of painting, and he thereupon introduced pieces into a drawing. The whole business was so natural and logical that the simple facts suffice to dispel all the myths about the "birth of collage" within the history of Cubism.

The *Still Life with Fruit Bowl and Glass* of September, 1912 (plate 14), generally accepted now as the first papier collé, is a variant of a composition Braque had already painted in oil. In the painting (Collection Riccardo Jucker, Milan) the textures are brought out by use of sand and painted wood grain, whereas in the collage they are rendered by pieces of colored wallpaper which contrast with the black-and-white values of the charcoal drawing. The play of two-dimensional surfaces against three-dimensional depths resulting from the use of both pasted paper and charcoal drawing gives rise to a spatial ambiguity within which the false wood grain of the wallpaper, with its suggestion of wall paneling or table drawers, takes on a remarkably realistic significance.

The wallpapers Braque bought helped him pass the time of Picasso's absence (Picasso had to spend the first weeks of September in Paris), and by the time his colleague returned he was able to surprise him with this new pictorial means, which Picasso then and there adopted for himself. From that moment on, the possibilities of collage gave no rest to those two passionate experimenters. For the next two years papiers collés were to be almost as important in their work as oil paintings.

At the outset Braque employed his pasted papers exclusively in combination with drawing, usually charcoal on a white ground, and only rarely with oil colors. A few large pieces of paper, a single scrap of wood-patterned wallpaper, a strip of wallpaper border, plus one or two bits of solid-colored, dull-toned paper sufficed as the basic components of his compositions, which he then drew over and around in thin lines of charcoal. For the most part the geometrical rectangles were carefully cut out with scissors, but occasionally, as in the 1913 *Still Life with Mandolin, Violin, and Newspaper (Le Petit Éclaireur)* (private collection, France), the shapes were merely torn out roughly and thereby given a new variety of animation.

Mostly the subjects were musical instruments, the violins, guitars, and mandolins that also turn up so often in Braque's oil paintings from 1910–13 on (plate 15). Braque explained this partiality by the fact that he had always been surrounded by musical instruments and that their volumes could fit in so harmoniously in the still lifes that preoccupied him at the time. As a third reason he alleged that if you touched them you could wake these instruments to life. Indeed, they do seem to take on some miraculous existence in such abstract collages as the *Aria de Bach* (Collection Mme. Marie Cuttoli, Paris) or the *Guitar* (Museum of Modern Art, New York), whose compositions are constructed by the simplest means of lines, surfaces, and colors. Sometimes half the instrument is rendered in clear outlines; sometimes there are no more than a few details, the fingerboard with the pegbox and strings or the

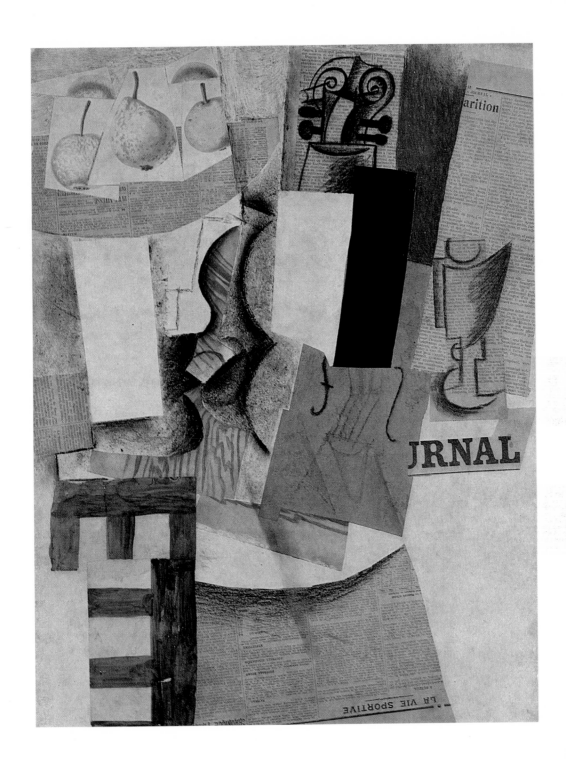

Colorplate 3. Pablo Picasso. *Still Life with Violin and Fruit.* 1913

"La Peinture et nous," the artist's observations as noted by Dora Vallier, in *Cahiers d'Art*, 1954

strings themselves drawn taut across the soundboard. Only later did the allusions become more concrete, as in the *Mandolin* of 1914, in which the ribbing of the corrugated cardboard gives the impression of strings actually raised above the soundboard.

Braque discovered that pasted papers were an invaluable aid in laying out color. They made it possible, he said, to separate color completely from form and to allow both elements to emerge in their own right.

Because the rectangular cutout inserts in Braque's earliest papiers collés made for rigorously horizontal and vertical compositions, as a next step he frequently framed them in an oval, a form that, as he later explained, first disclosed to him the real meaning of vertical and horizontal. Framed in an oval, the objects in the picture become pressed more densely together, and the pasted papers thereby take their place neatly and inconspicuously within the transparent strata of planes and surfaces.

In the course of 1913–14 both color and textural values became richer (colorplate 3). To the dull-surfaced, wood-patterned wallpapers Braque added papers of livelier green, bluish green, and blue tones, and the painted playing cards and checkerboard patterns are accompanied by such elements as revenue stamps from packages of tobacco. In place of neutral pieces of newsprint, now at times Braque chose advertising illustrations, for example one for the latest fashions in furs, and when he finally went so far as to insert into a musical still life (plate 11) a program from the Tivoli Cinéma with the exciting announcement of the forthcoming drama *Statue d'Epouvante (Statue of Terror)*, he introduced an "appeal from without" that strikes one as an alarming intrusion into the tranquillity of his picture.

It is no accident that that particular collage has remained in the possession of Picasso, whose influence can certainly be seen in it. With his always lively imagination, Picasso expanded the expressive possibilities of collage in many different ways, and the reflective art of Braque could not always keep pace with the great leaps forward of his more temperamental colleague. The number of collages turned out by Picasso in those years far exceeds those of Braque. Daring improvisations, thoroughly thought-out compositions, and hastily dashed-off studies came tumbling out one after the other.

In a series of works from the autumn of 1912 and the winter of 1912–13, Picasso too took to combining collage with charcoal drawings, mostly of abstract heads or figures. Along with a few solid-colored or patterned papers he used chiefly newspaper, which he cut out with great precision into the simplest forms. Combined with the linear outlines of the drawing, these printed structures make up distinct flat areas of print, though their texts never take on any sort of significance in or for themselves.

The undated collage *Bouteille de vieux marc* (Collection Dr. Henri Laugier, Paris), whose provenance is given as Céret, spring of 1912, by Christian Zervos (*Pablo Picasso*, vol. IIa, no. 339) and, following him, by innumerable other cataloguers, is certainly of later date, probably not before 1913. Pieces of the same wallpaper are found in another collage, *Guitar and Coffee Cup* (Collection Berggruen, Paris), which Douglas Cooper dated 1913 in the catalogue of the Picasso exhibition, Musée Cantini, Marseilles, 1959, no. 22.

However, another quality, implicitly representational, made itself felt when Picasso introduced a flower-patterned wallpaper instead of newspaper into an abstract picture of a woman. Still lifes too were soon filled with bright or dark wallpaper, with rosebuds and garlands, thereby lending a strangely poetic mood to those sober spatial constructions. Guitars and violins find a melancholy resonance when imbedded in old sheets of music and scraps of used paper, and in a *Still Life with Violin and Fruit* (colorplate 4) the colorful pears and apples, cut out of a picture book, radiate a cheerful summery atmosphere. On a few of these early collages the added papers are not pasted but simply affixed by pins. The pins, though, have rusted, the pieces

of newspaper gone yellow, and the scraps of faded wallpapers breathe an air of a vanished past.

In the course of 1913 the building up of layer upon layer in space was abandoned in favor of a clear, frontal display of the elements making up the picture, resulting in simple, reposeful still lifes in which all components—bodies of instruments, sheets of music, flowered wallpaper, and so on—were set out with equal importance. For the most part, however, Picasso's main aim in his collages continued to be the discovery of novel and startling ideas. At times he concealed this aim in a kind of behind-the-scenes game of hide-and-seek; at times he brought off highly naturalistic effects. Thus he gave his *Student with Pipe* (formerly Collection Tristan Tzara, Paris) a three-dimensional cap of crumpled paper, and on another occasion he glued a realistic-looking paper chicken onto a plate. In the *"Purgativo,"* or *Still Life with Lacerba* (plate 16), a bent fork and a murderous-looking knife lie alongside the plate, and the background is covered with clippings from the Italian magazine *Lacerba*, with which Picasso had connections by way of Ardengo Soffici, who, while in Paris, steered a course midway between Cubists and Futurists.

In time Picasso came to enrich his repertory of real components with the most motley objects, introducing into his collages visiting cards, labels from bottles, matchbox covers, cigarette or pipe-tobacco packages, bits of cloth, and printed matter, without abandoning his characteristic abstract transposition of whatever materials came to hand. He was the first to exploit the special expressive power that inheres in ordinary worn-out materials after they have passed through countless hands, and he utilized them in such a way that a medium can no longer be considered as "worthy" or "unworthy" of an artist but only as serviceable to any artist who can translate his emotion into it.

From 1912 on, Braque and Picasso also experimented with three-dimensional figures. Braque made sculpture of folded paper, while Picasso devised constructions in paper, sheet metal, wood, and other material, combining collage and relief to produce musical instruments (plates 12, 13) rigged up at first out of cardboard and paper but later also of wood, wire, sheet metal, and twine. In one case an old tin can was made to serve as the soundhole of an imaginary instrument, and wires were pulled across it in lieu of catgut. Once something that can be called a mandolin was sawed out of wood and then screwed and nailed to a panel to make a three-dimensional picture. In such fantastically imaginative creations as *Glass of Absinthe* of 1914 (Philadelphia Museum of Art, A. E. Gallatin Collection), in painted bronze with a scoop holding a lump of sugar balanced on the goblet, Picasso anticipated the Dadaistic "object."

In the history of collage 1913 was the year of the basic discoveries; in 1914 the artists showed more forethought and more system in their use of paper as a raw material, focusing rather more on the relations between textures and tones of color. Polka-dot patterns such as had become all the rage in textiles and wallpapers invaded the papiers collés; contours and outlines dissolved in the hand-painted or printed polka dots as well as in the soft hatching of the drawing technique. Stimulated by collages, the painters did oils containing virtual show cards of pointillistic designs. A typical example is Picasso's *Portrait of a Young Girl* (Collection Georges Salles, Paris), painted in Avignon

Picasso remembers from his boyhood that his father, who taught drawing in his home town of Màlaga, pinned together the sketches of his compositions in the same way before painting them. Joseph Pulitzer, Jr., who acquired the pinned collage *Guitar on a Table* (plate 13) from the A. Lefèvre Collection, had a restorer at the Fogg Museum treat the pins to prevent further rusting.

A collage in the Peggy Guggenheim Collection, Venice, likewise has cuttings from the January 1, 1914, issue of *Lacerba*.
The catchword "PURGATIVO" was also used by the Florentine painter Ottone Rosai in a collage.

Six copies were cast from the wax model, of which one is in the Philadelphia Museum of Art, A. E. Gallatin Collection. Reproduced in Rosenblum, pl. 202

in 1914, which owes its rococo charm to the bright and graceful patterns of dots and the floral ornaments spreading over the figure and filling the space. Such decorative elements infused both paintings and collages with an aesthetic note, thereby relieving their compositions of something of their formalistic rigor.

JUAN GRIS (1887–1927), who soon became the third musketeer, went to Paris from Spain in 1906 and was Picasso's neighbor in the Montmartre studio building known as the "Bateau-Lavoir." Up to 1910 he worked exclusively as caricaturist for such magazines as *L'Assiette au Beurre*, *Le Charivari*, and *Le Cri de Paris*. Under the influence of Picasso and his friends, in 1911 he produced his first oil painting in his own personal version of the Analytical Cubist style, in which objects were not broken up in planes but, instead, in segment sof forms resulting from the interplay of light and shadows in space. It was with the Cubist group formed in 1911 in Jacques Villon's studio in Puteaux, including, besides the Duchamp brothers, Albert Gleizes, Roger de La Fresnaye, Fernand Léger, Francis Picabia, and Frank Kupka, that Gris exhibited in the spring of 1912 in the *Salon des Indépendants* and again in October in the second *Salon de la Section d'Or*. Picasso and Braque no longer took part in these and other public exhibitions after 1907, when Kahnweiler opened his gallery in the Rue Vignon and bound them to an exclusive contract. At the close of 1912 Kahnweiler concluded a similar agreement with Juan Gris and was to remain thenceforth his best patron and friend.

The Watch is reproduced in Rosenblum, pl. XIX.

At the *Salon de la Section d'Or*, Juan Gris showed his first two pictures to contain collage elements, *The Washstand* (Collection Vicomtesse de Noailles, Paris) and *The Watch* (Collection Hans Gether, Basel). Their pictorial construction shows how the style was shifting to Synthetic Cubism, in that the backgrounds are rendered in purely frontal view, whereas the objects on the tables are seen as if from above. Juan Gris himself explained this compositional principle by saying that the only possible form of painting for him was "a kind of flat and colored architecture," and that the pictorial subject could arise only out of this architecture, which inevitably entailed incorporation of elements taken from reality. There are striking naturalistic details in these pictures, such as the hangings at the upper margin, and the comb and curling iron in one, the watch chain in the other. The pasted elements in *The Watch*—three clippings from a brownish printed page—are gone over with white paint and scarcely make much effect. Much more important are the pieces of a broken mirror in *The Washstand*, which are used to simulate actual reflections, so that details such as the faucet and the pattern on the washbowl are repeated in the upper and lower halves of the picture. Juan Gris utilized a mirror once again in *The Marble Pier Table* of 1914 (plate 19) and in that connection explained: "A painted surface can be translated onto a canvas, a volume can be interpreted on it. For a mirror though—a changing surface that reflects the viewer himself—one can only glue on just such a piece of looking glass."

The first Futurist exhibition in Paris had taken place in the Galerie Bernheim-Jeune in February of 1912.

About 1912–13, perhaps under Futurist influence, the rigorous horizontal-vertical arrangements of Juan Gris's compositions wavered. In *The Smoker*, known as both drawing and oil painting (Collection Mr. and Mrs. Armand P. Bartos, New York), and the collage *Le Torero* (reproduced in *Art d'Aujourd'hui*, no. 3, 1952), the forms fan out so that the eyes, ears, and nose

The first of these is reproduced in Rosenblum, pl. 71. The latter was shown in the exhibition *30 ans de la Galerie Max Kaganovitch*, Paris, 1966.

Brenner was the American sculptor and art dealer representing Kahnweiler in New York.
Daniel-Henry Kahnweiler, *Juan Gris, sa vie, son oeuvre, ses écrits*, Paris, 1946, vol. III, p. 274 (revised English translation, New York, 1947)

Guitar on Chair of September, 1913; *Still Life with Pears* of October, 1913; and *The Chair*, presumably from the beginning of 1914. The *Still Life with Pears* is reproduced in Michel Seuphor, *Abstract Painting*, New York, 1962, pl. 6.

circle and spin about, and the cut-up posters in *Le Torero* intensify even more the impression of dispersal or dismemberment.

Soon after, though, equilibrium was re-established. The compositions became articulated in vertical strips which appear to be so staggered in space that objects can be pushed between them at varying distances from the foreground. Furthermore, because Gris often tipped the whole thing on its side, diagonals intervene as an active element in the system of coordinates. In one of his most impressive collage pictures of this period, the *Still Life with Book* (plate 20), pages of the open book are interposed obliquely between the verticals, and the poetry inherent in the image is further emphasized by the delicate shades of blue and pink and the faded pattern of the wallpaper.

In two still lifes from the same time, the *Violin and Engraving* dated April, 1913 (Museum of Modern Art, New York), and *The Guitar* (plate 18), Gris glued in reproductions of old paintings, as if he wished to use traditional illusionistic painting as a foil to bring out the qualities of his Cubist compositions based on nothing more than line, plane surface, and color. That the choice of such traditional pictures was a matter of indifference to him is indicated in a letter to Kahnweiler dated September 17, 1913, in which he wrote with reference to the *Violin and Engraving*: "If Mr. Brenner acquires the picture, he is free to replace the print by another one, even by his own portrait if he wishes. That can make it better or worse, in the same way as the frame one picks out for a picture. It cannot harm the basic quality of the picture."

Toward the end of summer, 1913, Juan Gris and Picasso met in Céret, near the Spanish border. The discussions they had there about artistic problems led Gris to clarify his compositions and to simplify them. At the same time he turned to intensely glowing colors and large, ornamental curving patterns. A direct influence from Picasso, the oilcloth with caning (plate 10) now turns up again in three works by Gris. Whereas in the *Still Life with Pears* of October, 1913 (Collection Mr. and Mrs. Burton G. Tremaine, Meriden, Conn.), folded newspapers are painted and drawn in, a collage of about the same time has a figure seated at a table holding a real copy of *Le Matin* in his hand.

Unlike Picasso and Braque, Juan Gris always combined collage with oil painting or gouache, and their color lends his work in that medium a pictorial character comparable with painting. In 1914 he shifted completely to this technique, producing innumerable still lifes with the same objects—chiefly bottles and fruit bowls, glasses and cups, newspapers and pipes, and sometimes also musical instruments and music. Each time the textures and color tones give off a different, unique note. Hard chessboard patterns alternate with soft marble veinings, the usual wood-grained papers with flower garlands, carnations, and roses of old wallpapers (plate 21); and, alongside ordinary commercial wrapping papers, with their matter-of-fact printed labels, one's eye is caught by bottle labels with their colorful pictorial decoration (plate 17).

Juan Gris pushed the interplay of plane surfaces and space to ever more mysterious and subtle solutions. He superimposed transparent layers, modeled some objects with soft crosshatching, delineated others only by whisper-thin light outlines against a dark background. As if he himself were his own onlooker, Gris allowed the various components of his pictures to come to-

gether by themselves, as if of their own will, and then controlled and modified their interrelationships until the definitive composition took shape. "To work after a preconceived pictorial idea," he said, "is no different from copying a model." He insisted that he never had the representation of an object in mind in advance but always began with the abstract elements of form and color, allowing them to suggest to him whatever objects might be needed. Giving himself over to the intuition which arises out of the creative process itself, he did not, nevertheless, let the reins of the formal conception slip from his hand. Counter to Braque's famous dictum, "*J'aime la règle qui corrige l'émotion*" ("I love the rule that rectifies emotion"), Juan Gris set its inversion: "*J'aime l'émotion qui corrige la règle*" ("I love the emotion that rectifies the rule"). Nowhere did he so completely give himself over to his feelings as in his collages, on which he conferred a highly personal magic, interlocking reality and unreality like meshed gears (colorplate 5).

When Gris returned from Collioure to Paris at the end of October, 1914, after the outbreak of the war, he gave up working in collage. In a letter of November 13 he wrote that since his return he had used only oils. Once during the following year he had occasion to use the medium again, when he was busy with the illustrations for Pierre Reverdy's prose poems. There exists a sketch in collage for the first sheet, *Au soleil du plafond*, which bears a dedication from both Gris and Reverdy to the latter's wife, Henriette.

For Picasso and Braque, too, the great days of Cubist papiers collés ended with the outbreak of the war. At that time also their collaboration came to an end, and thenceforth each was to go his own way. Whatever they did afterward in collage no longer had the same vitality as their earlier efforts.

Braque, who suffered a severe wound in the Ardennes in May of 1915, was not well enough to begin to paint again until 1917. As a start he returned to the rigorous surface compositions of Synthetic Cubism and in a few cases again glued pieces of paper into his still lifes. In *Musical Forms (Guitar and Clarinet)* in the Philadelphia Museum of Art (Louise and Walter Arensberg Collection) the old materials—white and colored papers, wood-grained wallpaper, corrugated cardboard, wrapping paper—are once again clearly in evidence. In the second half of 1918 the hard, geometric contours become rounder and more flowing, and dark coloring tends to swallow up the objects. One of the most important pictures from this period, *The Table*, has on its reverse side a collage still life in which newspaper clippings and marbled papers are laid into the oil painting, and in the upper part there is something like a picture within a picture, a separate collage with musical instruments standing out against a white background, under which a pasted label bears the signature and date, "Braque 18."

Sketches in collage exist also for various still lifes with fruit bowls, among which is one in the shape of an upright rectangle (Collection Paul Heim, Brussels) with scraps of colored polka-dot papers intercalated in the two-dimensional ornamentation of the drawing. Another, in horizontal format with marbled papers (Hanover Gallery, London), has light-colored objects standing out against a darker background, as in the oil paintings of the same time.

Among the great number of variations on the theme of still life on a small table in Picasso's drawings, oils, and watercolors from 1919 on, at least two were sketched in collage. Both were versions of *Guitar on a Small Table* and

The collage was long thought to date from 1913, but Douglas Cooper quite credibly allocates it to abaut the end of the war. Reproduced in Rosenblum, pl. 65

Examples: *Still Life with Guitar and Grapes* (Musée d'Art Moderne de la Ville de Paris), 1918–19; and *Still Life with Guitar on a Table* (Collection Joseph Pulitzer, Jr., Saint Louis), 1919

Catalogue of the exhibition *Hommage à Pablo Picasso*, Petit Palais, Paris, 1966–67, vol. II: *Dessins, Sculptures, Céramiques*, nos. 62 and 77

Rosenblum, pl. 117. About the same time Severini, in portraits of Paul Fort and Marinetti, glued the titles of their books

Rosenblum, pl. 122

Reproduced in *Cahiers d'Art*, 1937, p. 233

Jean Lafranchis, *Marcoussis, sa vie, son oeuvre*, Paris, 1961

Modigliani too, in a few of the portraits of Beatrice Hastings, with whom he lived from 1914 to 1916, pasted on pieces of newspaper, apparently under the influence of the

done in 1920, one of them (known through a photograph of the Galerie Leiris, Paris) pasted together from solid-colored papers, the other attached to the cover of an album of poetry with a sewing needle. Both of these, however, are at best colored sketches for other compositions. The collage character is much more obvious in one of those called *Still Life Before a Window*, of 1924, in which the window is trimmed with cutout reproductions of draped lace curtains from the advertising folder of a textile firm.

Though they could be seen only in Paris, in Kahnweiler's gallery, the papiers collés of Picasso, Braque, and Gris obviously excited lively interest in Cubist circles there and abroad, influencing the painting of the many Cubist adherents and inducing them to try collage, though most of them soon gave it up.

ALBERT GLEIZES (1881–1953), who had come to Cubism as early as 1909 and who, in 1912, together with Metzinger, had published *Du "Cubisme,"* the first theoretical essay on the new style, in 1913 painted a portrait of the publisher Figuière (Musée des Beaux-Arts, Lyons) surrounded by the books and magazines of his publishing house, the whole arranged in collage fashion. As for LOUIS MARCOUSSIS (1883–1941), who became acquainted with Braque and Picasso in 1910 through the friend and champion of the Cubists, the poet Guillaume Apollinaire, and who subsequently followed their lead, his *Still Life with Chessboard* (Musée National d'Art Moderne, Paris), from about the end of 1912, contains all those elements which had become standard in the papiers collés of Braque and Picasso—playing cards, a letter, a tobacco package, and the caned chair seat—and even the letters "GIL" happen to be the very first ones that Braque ever painted, in his *Safety-Match Holder* of 1910 (Collection Dutilleul, Paris). In two pictures of 1914, *Still Life with Scaferlati Tobacco* (plate 33) and *Still Life with Page of a Calendar*, both of which anticipate the procedures of Synthetic Cubism, Marcoussis glued real paper elements: in the first picture whisky labels and a page from the catalogue of the Librairie Hachette; in the second, a small title shield on the spine of a book. However, the actual printing on the package of tobacco and the calendar page (for January 24, 1914), from which in both cases the pictures derive their names, is painted with a letter stencil; and the interpolated pieces of printed matter disappear in the warm tonality of Marcoussis's palette. Marcoussis enclosed his compositions in irregular octagons, and the strips of gilded cardboard that frame his still life *Le Pyrogène "Byrrh"* (Collection Romanet, Paris), itself closely connected with the *Still Life with Page of a Calendar*, were quite certainly added later in order to give the picture a normal format.

ROGER DE LA FRESNAYE (1885–1925) belonged to the Cubist group in Puteaux, and we know one example of collage by him (plate 30), a gouache sketch of 1913 into which light-colored papers are set to convey pure tonal values. This intimate study is characteristic of La Fresnaye's painting of those years, with its concentration on light and color.

Another of the painters of the Galerie Kahnweiler was ANDRÉ DERAIN (1880–1954), whose reputation shot up because of a collage. In the original version of the *Portrait du Chevalier X* of 1914 (The Hermitage, Leningrad) the sitter holds in his hand a real newspaper attached to the canvas by thumbtacks. Probably the idea goes back to a conversation Derain had with Braque and Picasso during a summer together in Avignon, when they argued about

whether one should paint, or simply paste on *in natura*, a newspaper being read by a figure in a picture. Although Derain first opted for the latter solution, he later replaced the folded newspaper with a painted one.

As far back as 1905 the Hungarian painter ALFRED RETH (1884–1966) had set up his first studio in Montparnasse, and he struck out very early in Cubist paths. Without giving his personal allegiance to one group or another, it was with the Cubists that he exhibited in the *Salons des Indépendants* from 1911 to 1913. In 1910 he was already making nonfigurative sketches with only lines and curves, and these were succeeded in 1912 by composition studies of planes in space. He showed these sketches in an exhibition at the gallery of Der Sturm in Berlin in February, 1913, and, in an essay published by the magazine of that German group, he explained that what counted for him in painting was the relationships between the forms, relationships he determined by certain specific numerical ratios: "The problem was to find the absolute universality of the form and yet at the same time, by the particular arrangement of the relationships, to make the form in each and every individual instance appear as if it were unique and personal."

In 1912 Reth painted a few still lifes with the clear arrangement of planes characteristic of Synthetic Cubism. One of them, the *Still Life at a Window* (Musée National d'Art Moderne, Paris), has a whitish paper pasted over a rectangle next to a lamp, interposing a smooth surface between areas dotted and textured with the brush and, at the same time, constituting the brightest light value within a pictorial space built up of lighted and shadowed forms.

He did a full-fledged collage in 1916 (plate 27), an abstract composition of stripes and circles incorporating a great many clippings from newspapers, which, except for the title *Le Petit* (from *Le Petit Parisien*), are noticeable only as graphic textures within the gloomy brown colors of the paint.

Most people seem to have forgotten that the Mexican painter DIEGO RIVERA (1886–1957) also participated in the Cubist movement in Paris, having come into contact with its exponents during his second sojourn in Europe in 1911 and 1912 and exhibited with them in 1912 and 1913 in the *Salon d'Automne*. There are two collages by him in European collections, both with pieces of a large-patterned, pseudo-Renaissance-style wallpaper. In the first, *Anise Bottle and Stringed Instrument* (Billedgalleri, Bergen, Norway), which is dated 1913, influences can be discerned from the pictures Juan Gris was doing at the same time, most notably in the composition, which is divided into two, one half organized vertically, the other diagonally. In the second collage, *Still Life with Carafe* dated 1914 (plate 22), which contains among other things a telegram addressed to the painter himself, Rivera evokes remarkable effects of transparency by a piece of newspaper pasted under the drinking glass and by a piece of wallpaper "inside" the carafe, as if seen through it, both of these, like the ornamental wood grain of the table, recalling Juan Gris. What is highly personal, however, is the marked contrast between the soft, drawn-in elements and the hard, sharp character of the pasted shapes. Cubist influence is still present in his *Synthetic Portrait* of 1915, as well as in the *Still Life with Sponge and Toothbrush* of the following year, though the modulated color of the latter no longer has much in common with the harsh contrasts between different materials that characterize his collages.

Cubists, an influence also discernible in the rectangular fields of color in the backgrounds of those pictures. Nevertheless, in the portrait in the Barnes Foundation, Merion, Pa., the paper elements were so painted over as to be scarcely noticeable.

After war and illness had interrupted Reth's work, he began again in 1920 with a large collage, a seated female nude drawn with Expressionistic vehemence, to which were glued pieces of painted paper. Toward the end of the 1920s he did street scenes influenced by De Chirico's Metaphysical painting, among them a scene in Les Halles of Paris, with inserts of paper and cloth. After producing a series of constructions in wood and metal called *Forms in Space*, in the 1940s he began to mix sand, gravel, coal dust, powdered eggshells, and so on into his paint, and up to his death he used these textures for nonfigurative compositions in "material harmonies" or "rhythm-harmonies of matter and color." W. George, *Alfred Reth, ce méconnu*, Galerie de l'Institut, Paris, 1959; catalogue of the Reth exhibition, Gimpel Fils Gallery, London, 1959; Seuphor, *Abstract Painting*

The same bottle label, "*Anis del Mono*," was used by Gris in a collage now in the H. and N. Rothschild Collection, New York (plate 17).

Shown in the exhibition *Cinquante ans de Collages*, Musée, Saint-Étienne and Pavillon Marsan, Paris, 1964

In the years before World War I there were already a number of Russian artists active in Paris who, in one way or another, were connected with Cubism and used it to a greater or lesser extent as a point of departure.

Not at all well known is the painter PAUL KOTLAREWSKY (1883–1950), who went to Paris in 1913. Like others among his countrymen, he worked in the atelier of Henri Le Fauconnier, under whose influence he painted a few strongly colored Cubist pictures, among them a still life with a bowl of apples, in which, alongside a painted Russian newspaper, pieces of wallpaper and paper lace are pasted in. The picture can be dated by comparison with the 1913 portrait *Fräulein Bönig*, of a German acquaintance of the painter, which originally had a Russian newspaper pasted on it. Unfortunately his pictures, which have remained in the possession of his widow, are so poorly preserved that one can only guess at their indubitably good original quality.

At the outbreak of the war Kotlarewsky returned to Russia, and it was not until 1925, when he was again in Paris, that he resumed his work. In that year he turned out a *Still Life with a Lamp* (Collection Charchoune, Vanves, near Paris), a Cubistic pencil drawing into which once again he pasted a piece of newspaper. However, in his subsequent work he abandoned Cubism completely until 1935, when once again he used collage additions in a self-portrait; the drawing is pasted on wallpaper, his suit is improvised of felt, he wears a cardboard collar, and he once had a patterned cloth necktie.

The painter SERGE FÉRAT (1881–1958), whose real name was Sergey Yastrebzov, was linked to the Cubists mostly through his friendship with Apollinaire. With his sister, Helene von Oettingen, he took over in the fall of 1913 the magazine *Soirées de Paris*, which had been founded by Billy. Under his and Apollinaire's direction the magazine played an important role in the literary and artistic milieu of Paris right up to the outbreak of the war. The "evenings" organized by the magazine were regularly attended by Picasso and Léger as well as the Italians Soffici and Gino Severini, and, significantly, Férat's painting was alternately influenced by the Cubists and the Futurists.

In certain works of 1914 he introduced collage accessories. Along with the usual paraphernalia of glass, bottle, playing cards, pipe, and so on, assembled into a closed Cubist composition, the *Still Life with Ace of Clubs* has a cut-up page from a catalogue pasted on the foot of the glass, a sheet of music is pasted behind it, and athwart them is a bottle label with large letters.

Fragments of music, newspapers, and a torn page from a magazine with the reproduction of a clockface are intercalated between fragmented musical instruments on a more remarkable picture (plate 34), within whose hard forms and lines they stand out as delicate graphic elements. The title, *Still Life with Lacerba*, of this Futuristic-dynamic composition refers once again to the Italian magazine *Lacerba*, which published the collage in its issue of July 15, 1914, Férat being a close friend of Soffici, the editor.

For the performance of Apollinaire's *Les Mamelles de Tirésias* in 1917, Férat constructed the settings and costumes in collage, gluing brightly colored papers to newspaper. These aroused a protest from certain of the Cubist painters, from which Picasso, however, held aloof.

Included in the catalogue of the exhibition cited above

Catalogue of the exhibition *Albert Gleizes et Tempête dans les Salons de 1910–1914*, Musée, Grenoble, 1963, no. 14

Colorplate 5. Juan Gris. *The Table.* 1914 ▷

Sonia Delaunay, "Collages de Sonia et de Robert Delaunay," *XXième Siècle*, no. 6, January, 1956, pp. 19 ff.

Their friendship with Blaise Cendrars led Sonia Delaunay, in 1913, to propose for his *La Prose du Transsibérien* a "simultaneous illustration" in color rhythms which would accompany the text on a straight strip of paper six and one-half feet long and would make its effect on the reader or viewer simultaneously with the text. The book ranks among the most important predecessors of present-day tableaux-poèmes.

More detailed information about the book collages can be found in the catalogue of the exhibition *Retrospective Sonia Delaunay*, Musée National d'Art Moderne, Paris, 1967–68. The original collages for *Der Sturm* are now in the same museum (Donation Delaunay).

Sonia Delaunay is scarcely likely to have known the collage book covers being made in the same years in Russia, in the circle of the Futurist poets Khlebnikov, Kruchenykh, and others, which are discussed in Chapter V.

SONIA DELAUNAY-TERK (b. 1885 in the Ukraine) settled in Paris as early as 1905. With Robert Delaunay, whom she married in 1910, she opened up new and highly personal paths based on the study of color and light. The forms she used virtually came into existence by themselves in the course of her day-to-day practical work. After the birth of their son in 1911, she made for his cradle a blanket of varicolored cloth scraps such as she had seen in Russian peasant homes. Such compositions based on primitive squares and triangles seemed to her and Delaunay very much in line with contemporary Cubist art, and she set about modernizing their home with lampshades and cushions in patchwork colors. Soon she went on to cover the books of their library with collages (plate 25), cutting out small, simple formal elements from whatever paper or cloth she had at hand. For the compositions, she took her inspiration from the spirit of each particular book, so that sometimes they were more spontaneous, sometimes more carefully thought out. Among the first of these was the original edition of Blaise Cendrars's poem *Les Pâques*, whose leather binding she decorated both outside and inside with collages during January of 1913. While for the outer covers she gave free rein to her fancy in assembling the forms, the endpapers were covered uniformly with paper squares in shades of yellow, gray, green, rose, and violet to make two-dimensional surface compositions which anticipated those of the painters of the Dutch De Stijl group, as well as the collages by Hans (Jean) Arp and his wife, Sophie Taeuber, a few years later.

In her subsequent work this formal rigor relaxed somewhat. The geometrical elements were less tightly linked and penetrated the pictorial space at acute angles; the static character was little by little transformed into movement; the forms became rounded and spread over the surfaces, one alongside the other, in broad curves; and the cutout shapes overlapped and tended to cover the background more and more densely. This development can be followed in the three issues of the magazine *Der Sturm* that Sonia Delaunay brought out, one on the heels of the other, between April and August of 1913. The Delaunays were great friends of Herwarth Walden, who had founded *Der Sturm* in 1910 and, two years later, a gallery of the same name in Berlin. In January, 1913, he arranged a special show for Robert and invited both to participate in the first German "Salon d'Automne," the *Erste Deutsche Herbstsalon*, which opened in September of that year. Sonia Delaunay exhibited there a number of her book covers, along with pictures and crafts objects.

The collage reproduced in the last volume of *Der Sturm*, with its patterned papers and tulle on a silver ground, exemplifies the richness of tonal and textural values that animate these abstract book coverings. The color scales are of an incomparable audacity and vary from one book to another. On a volume of Rimbaud a sickly green, brick red, and violet stand out against the pale pink of the background, while in other examples gold and silver tinfoil glisten among delicately patterned papers. A large volume of Canudo was decorated by a luxurious collage of cloth combining dull gray and rose-red velvet, dark violet and iridescent green silk, blue wool, and ribbons of green ribbed rep.

Besides book covers, in 1913 Sonia Delaunay also did a free collage in colored papers whose circling forms appear to make a stylized figure (colorplate 6). No sort of figurative representation appears in another example,

Prisme solaire simultané (Simultaneous Solar Prism), dated 1914 (Musée National d'Art Moderne, Paris), in which the mat-surfaced colored papers are pasted on whitish gray wrapping paper and worked over with chalk and watercolors. Out of the ascending diagonal movement arises a color melody rare enough in the banal materials used for collages. Both of these collages belong among the studies of "simultaneous color contrast" which intensively preoccupied the Delaunays from 1913 on. For Sonia, who was especially interested in the breaking down of colors under electric light, those contrasts were given their definitive form in 1914, in a large oil painting, *Electric Prisms* (Musée National d'Art Moderne, Paris).

Seuphor, pl. 8

In 1914 she also designed a series of *affiches simultanées*, posters in which the text material is integrated into the color composition. Two of these were executed in collage, one for the apéritif Dubonnet, the other for Zenith watches; the latter incorporates a line of poetry by Cendrars which is broken down typographically and leaps out from amid the colored papers.

Reproduced in the exhibition catalogue *Schrift und Bild*, Baden-Baden, Staatliche Kunsthalle, 1963, p. 81. The originals are now in the Musée National d'Art Moderne, Paris (Donation Delaunay).

At the same time Sonia launched a new and *dernier cri* style in women's fashions with her *robes simultanées*. These found their way even into Robert's more or less abstract pictures. To two of his circular compositions, whose colored forms and rhythms originally illustrated only "sun" and "moon," in 1914 he added a figure, that of Sonia herself in one of her "simultaneous dresses." He also conceived a collage, *Drame politique*, in a related manner when the news broke that the wife of the French finance minister Caillaux had shot Calmette, the director of *Le Figaro*. The two figures, cut out of the *Petit Journal* of March 29, 1914, were outfitted by Robert with paper trimmings, the man with a black suit and reddened face, the woman with a brownish red jacket and black muff, and he set them into a disk which, when rotated, spun them to the surface.

G. Vriesen and M. Imdahl, *Robert Delaunay—Licht und Farbe*, Cologne, 1967

The clothes that Sonia and Robert wore to gatherings of their friends aroused such admiration that Cendrars, Soupault, and Tzara all wrote poems about them.

Despite all these efforts, in the course of the same year, 1914, the Delaunays gave up collage because it no longer corresponded to the goals they were by then pursuing in their paintings. However, during the war years that she and her husband spent in Spain and Portugal, when her earlier works in colorful scraps of cloth came into her hands again, she executed yet another collage, a portrait of the dancer Nijinsky, whom she came to know in Madrid through Diaghilev and for whose ballet *Cléopâtre* she designed the costumes and Robert the scenery in 1917.

Michel Seuphor, *L'Art abstrait, ses origines, ses premiers maîtres*, rev. ed., Paris, 1950, p. 44, and Mina Journot in the same book, pp. 289–291

The fashion booth assembled entirely out of collages that Sonia Delaunay devised for the Bal Bullier in 1923 will be discussed later.

In an exhibition of Cubist painters held in 1963 by the Kaplan Gallery in London, along with paintings by EMMANUEL GONDOUIN (1883–1934), there was also a collage by him which the catalogue dated 1918–20. This *Abstract Composition* of geometric shapes in gradated colors glued to adjoin or overlap one another occupies a special place within Gondouin's production. He became friendly with Gleizes in 1916 in Calvaire and later, in Paris, saw much of the Delaunays, who esteemed him highly as a painter. In fact, the abstract collages of Sonia's book covers may well have been the inspiration for this collage.

ALEXANDER ARCHIPENKO (1887–1964) can be credited with revolutionary advances that range well beyond the narrow field of collage to introduce many new kinds of materials into art. By his participation in the *Armory Show* in New York and the first German *Herbstsalon* in Berlin in 1913, he occupied a place in the prewar international art movement matched, among

the Russians, only by that of Marc Chagall. After studying in his native Kiev and in Moscow, he went to Paris in 1908 and about 1910 allied himself with the Cubists, exhibiting with them in 1911 and 1912 in the *Salon des Indépendants*, in 1912 in the *Salon d'Automne* and in the second *Salon de la Section d'Or*.

Archipenko introduced the geometric forms of the Cubists into sculpture, broke open closed volumes, and allowed the circumambient space to penetrate into his statues through the openings thereby created. He united figures in audacious movements into dancing groups and, in his *Boxing Match* of 1913 (Solomon R. Guggenheim Museum, New York), combined volumes and flat planes in sharp-angled dovetailings.

Rosenblum, pl. 203

Certain studies for his sculptural works were executed in collage because, as he explained, he found these spontaneous, sketchlike first drafts ideal for clarifying his compositions. In the *Woman in an Armchair*, signed and dated "Archipenko, Paris 13" (plate 23), he broke down the body and the chair into their basic formal elements, using colored papers which spread across the dark surfaces in harmonious curves. On a gouache-heightened drawing of a couple dancing (Nationalmuseum, Stockholm), white papers accentuate the contrast of light and dark that clearly brings out the rhythmic movement; the drawing was given to Nell and Herwarth Walden after the exhibition in Der Sturm in September, 1913. Another collage drawing (Gemeentemuseum, The Hague; formerly Paul Citroen Collection) has a figure cutting diagonally across the space and belongs among the preliminary studies for the *Médrano* of 1914 (Solomon R. Guggenheim Museum, New York). It is one of the first reliefs incorporating various materials, the figure of the circus juggler being made of painted tin, glass, wood, and oilcloth.

Quoted in Erich Wiese, *Archipenko* (Collection "Junge Kunst"), Leipzig, 1923

The artist explained the origin of this work thus: "When in 1912 I utilized various materials in sculpture for the first time, it was because certain plastic forms, which cried out for realization within my conception, could not be realized with the materials theretofore used for sculpture. And quite naturally I was obliged to find new techniques for these new materials. On the basis of my experience I can say that it is the new formal style that calls for different kinds of material and not, vice versa, the new materials that create new styles. Their use is the product, not the goal."

In his "sculpto-paintings," as Archipenko called his new reliefs, his aim was to render simultaneously the form and the color of objects, those being for him the two essential and mutually complementary elements. In so doing, basically he was translating the principle of Synthetic Cubism into three-dimensional compositions. Arguing that colored sculpture had a history going back to the ancient Egyptians, he maintained that his only merit had been to discover new kinds of forms. However, equally new were the combinations of materials he used, predominantly wood, glass, and metal, and the effects of reflection he contrived to draw from them. In 1914 he constructed a head of glass, metal, and painted wood in four superimposed layers, and behind it he placed a concave mirror whose reflections multiplied the play of forms. Highly polished metal serves the same purpose in his relief *In Front of the Mirror*, of 1915 (plate 29), to which, in the lower part alongside a small-patterned shelf paper, the artist glued a photograph of himself in lieu of a signature. A related composition of two years later, *Woman and Interior* (Tel Aviv Museum), has papers with varicolored polka dots and

checkerboard patterns pasted on it; and such reminiscences of the Cubists' papiers collés are even more marked in a still life in circular format done in 1916 in Nice, on which sandpaper, cotton lace, and the characteristic imitated woven cane are interposed between the wooden forms. Papers painted with spots of color and wood graining also were used on the reliefs in wood and papier mâché that Archipenko produced in 1919–20 as three-dimensional still lifes.

In the last years before his death Archipenko again made genuine paper collages, abstract compositions with the same ornamental stylization that characterized the sculpture of his later period.

Assemblages from unusual old materials were made in Paris before the war by WLADIMIR BARANOFF-ROSSINÉ (1888–1942), a sculptor who left his native town of Kherson in the Ukraine quite early and, after sojourns in Germany and Holland, settled down in 1910 in Paris, where he soon became friendly with Arp and the Delaunays. The year of his arrival he exhibited at the *Salon des Indépendants* his *Symphonie no. 1*, a nonrepresentational composition of intertwined ribbon shapes "inspired by nature," according to his own statement. Following this, he began painting Cubistic pictures on figurative subjects, although his *Symphonie no. 2*, exhibited at the 1914 *Salon des Indépendants*, was a polychrome sculpture described by a critic as "paradoxical assemblages of zinc painted up in motley and gaudy colors, gutter pipes serving as support for strange pepper mills, small discs in blue, cream, or Turkey red run through with unexpected coil springs and steel rods." It seems that, with the outbreak of the war, the artist consigned this piece to the Seine and took himself off to Scandinavia. In 1917, after the February Revolution, he returned to Russia, and a year later he gathered some pupils and opened a painting atelier in Petrograd, taking part in exhibitions there and in Moscow. By 1925 he was back in Paris. A spectral figure made in 1926–27 from planks, coils, and other hardware and titled *Dynamic Sculpture* appears to have been by and large a replica of the drowned prewar piece. The Cubist reminiscences still visible there are entirely absent from a *Polytechnical Sculpture* of 1933, in which a massive core of plaques and round forms is surrounded by energetic curves of metal bands and wires.

Among Rossiné's boldest inventions was the "color-clavier," which projected changing color combinations on a screen under control of a keyboard. He presented it in "optophonic demonstrations" at the Meyerhold Theater in Moscow in 1923 and at the Paris Opéra in 1925.

Another and better-known sculptor, HENRI LAURENS (1885–1954), likewise made use of collage, for the first time in 1915 in connection with experiments in the use of various metals for reliefs and sculptures. These constructions of wood and sheet iron he painted so that reflections of light from their glossy metal and smooth wood would not introduce confusion into the purely formal conception. To his collages he also applied the Cubist principle of representing the spatial dimensions by means of relations between planes. On his first sheets the figures are broken down into circular and planar forms and are loosely linked at different orientations within the pictorial space; as in the wooden reliefs, the surfaces are enlivened by ornamental patterns. The *Young Girl*, signed and dated "Laurens 1915," presents

Helsey, in the *Journal*, March 2, 1914

L. Degand, "Rossiné," *Art d'Aujourd'hui*, 1954, no. 1, and exhibition catalogue *Wladimir Baranoff-Rossiné*, Paris, Galerie Jean Chauvelin, 1970

Exhibition catalogue *Henri Laurens, Sculptures and Drawings*, London, Marlborough Gallery, 1957

Figure 3. Henri Laurens. *Woman with Fan.* 1915. Collage

a figure seated in profile and is fitted out with a twisted turban, a fan decorated with flowers, and a striped dress, below which emerge the crossed legs. In the *Woman with Fan* (figure 3) the body is entirely split up into circles, cones, and cylinders, a starry headdress soars like a comet into the air, and above the tubes representing arms are three colored fans. The picture bears a friendly dedication to the art dealer Léonce Rosenberg, with whom Laurens concluded a contract in 1915. Delicate shades of pink surround the figure in the *Dancer*, later retitled *Josephine Baker* (colorplate 7), a jointed doll resembling an artist's manikin with ball-and-socket joints, stretching out long legs like sharp-pointed wedges.

Similarly, in the heads and portraits of the following year, whose compositions are more closed, Laurens often introduces a poetic or humorous note in drawn or pasted details. A garland of skittish ringlets is drawn in white over a black ground in a *Head of a Woman* dated 1916, whose superimposed light-green, brownish, and black papers suggest that it may have been a study for some three-dimensional construction. Another female sitter (formerly Collection A. Lefèvre, Paris), with her profile in corrugated cardboard, wears a delicate chain around her neck; and perky little hats lend a feminine charm to the portraits of Josette Gris, the painter's wife.

In still lifes, eventually the chief theme of Laurens's collages, there is considerable influence from Braque, with whom he had become friendly during the war years. For all that Laurens might borrow Braque's typical subjects, a sculptor's way of thinking is reflected in his clearer disposition of the formal elements, which, moreover, are restricted to a few indispensable pieces. In his first still life, the *Green Glass* of 1915 (formerly Collection A. Lefèvre, Paris), a greenish blue paper behind the glass and a brick-red strip on the lower margin create an effect of color that Laurens was to tone down in his subsequent work. For the most part he used ordinary wrapping paper in dull brown, blue, or black, to which on occasion were added only a few isolated livelier tones.

In Laurens's various works labeled *Still Life with Bottle* from 1916–17, half the bottle is usually cut out of paper, black as a rule, the other half completed in drawing, and the label-cum-title "Beaune" is written on a slant by hand. On a collage of 1916 (Berggruen catalogue) the bottle stands out in green against a speckled paper; on another, from 1917 (Collection Riccardo Jucker, Milan), the tablecloth has a pattern of dots. One exceptional still life of that year, in which the objects are surrounded by painted areas, has a shred of a railroad ticket and a slip of paper with numbers pasted on, real elements which seem alien in this abstract composition.

Nevertheless, they have a counterpart in a *Still Life with Music*, of 1917 (Berggruen catalogue), which includes a newspaper cutting, though in this case it is better integrated into the composition because the charcoal drawing extends over it. Titles such as *Musique* may appear truncated, as here, or spelled out in large letters (plate 24), or the name "Mozart" may be placed next to a flute to evoke musical associations in much the same way as Braque and Picasso had done. In the horizontal formats of the guitar subjects of 1918, the technical means are restricted to planes and lines; whereas plate 24, with its guitar and sheet of music—one of the finest examples of Laurens's particular collage style, with its large shapes which are at the same time trenchant and concise—suggests spatial relationships only by vague white

Laurens, *Papiers collés*, Paris, Berggruen & Cie., 1955. Reproduced in *XXième Siècle*, January, 1950, special number: *Les Papiers collés du Cubisme à nos jours*

Rosenblum, pl. 205, reproduces the *Bottle of Beaune* of 1917 (Collection Christian Zervos, Paris).

lines on a black ground between the pasted shapes of the instrument and the rounded tablecloth. Objects are raised above their background by delicate shadowing, and in a *Still Life with Fruit Bowl* he makes the bowl appear round by resorting to gentle reflections of light. Often, despite their figurative basis, his compositions take on fully abstract forms, as in a *Head* built up of rectangles and trapezoids (Berggruen catalogue) and a *Lute and Clarinet* framed by sharp-angled bottles. In the *Mandolin* (Berggruen catalogue) and the *Seated Woman* (formerly Collection G. David Thompson, Pittsburgh), both from 1918, the clear disposition of the elements parallels the three-dimensional sculptural conceptions with which Laurens was concerned at the time. In 1920 he executed similar subjects in stone sculpture and in 1922 a *Fruit Bowl with Grapes*, basically borrowed from Braque, in a painted terracotta relief.

From 1918 on he produced no more collages, properly speaking. In the 1940s, however, he occasionally again pasted on his drawings pieces of paper in mat brownish tones which give the effect of shadows behind figures. They preserve the basic shapes of the human body, and around them are drawn a head and limbs with fine lines, so that the permanent, unchanging form is also caught in the gesture of an instant.

That FERNAND LÉGER (1881–1955) took to working in collage during the war years was due as much to accident as to design, since, with no other materials at hand in September, 1915, on the Argonne front, he resorted to pasting papers on lids of ammunition boxes to make two pictures. During this time he drew a great deal: views of villages, scenes in the front lines, soldiers in their quarters, and the like. On the two box-top pictures, *Horses in Village Quarters* (plate 36), dated and signed "Le Neufour, sept. 15, F. Léger," and *Artillery Horses* (formerly Svensk-Franska Konstgalleriet, Stockholm, present location unknown), to make a few patches of color within the black charcoal drawing he added a couple of pieces of brown and black paper to cover walls and roofs of houses. Léger later explained that the military environment and his war experiences contributed decisively to detaching him from the abstract atmosphere in which he and his painting had existed in the prewar years and to bringing him back to a reality rooted in the earth on which he stood. Between the "pictures with mechanical elements" of 1919 he illustrated Blaise Cendrars's *La Fin du monde* with pages composed entirely of letters and a few geometric elements. These are true "letter collages" and belong among the many by which the painters of the first generation of our century anticipated the output of the present.

In Paris it was mainly foreign artists who continued to paint and to design collages during the war years. Gino Severini made perhaps the chief contribution to the further development of the new medium with a series of collages from 1917, in which the clear organization of planes typical of the Cubists supersedes his previous Futurist tendencies (to be discussed in Chapter III).

A number of Cubist collages of a very personal stamp were produced by the Belgian painter MARTHE DONAS (1885–1967), who in an early period signed her pictures "Tour-Donas" or, upon occasion, "Tour-d'Onansky." She went to Paris in 1917 from Ireland, attended André Lhote's academy, and for a few months worked in the atelier of Archipenko, under whose

This exists in a second version with the instruments on a table.

L. Aragon, *Les Collages*, Paris, 1965, reproduces a collage done by Léger in 1933, *Le petit cheval n'y comprend rien*, in which pictures of a horse and two chorus girls are pasted into an abstract drawing.

Pictures by her, under the name of Tour-d'Onansky, were published in the Dutch magazine *De Stijl* in 1919.

Colorplate 6. Sonia Delaunay-Terk. *Electric Prisms*. 1913 ▷

influence she assembled colorfully painted wooden reliefs in his style of "sculpto-painting." Parallel with these, from 1917 on she created collages in the most diverse materials, from coarse canvas to the most delicate tulle, and including, among other elements, wallpaper and sandpaper. In compositions built upon large planes arranged in strata either vertically or diagonally, a few linear outlines here and there may make a particular shape more precise or brushstrokes may obliterate the pattern of a paper and add a new one. The materials lose all realistic significance in an unreal sphere of space and light. In a *Still Life with Bottle and Cup* from 1917 (colorplate 8) the objects virtually dissolve in the veil-like weaves of the cloths. Figures in portraits of women, such as the *Woman Looking at a Vase* (plate 38), present themselves in costumes trimmed with lace, and the air of solemnity that surrounds them is in no wise disturbed by accessories such as the metal hemisphere of an electric bell.

In Paris Marthe Donas joined the circle of painters of the Section d'Or and exhibited with them in 1920 in the Galerie La Boëtie. That same year her relief pictures were shown at Der Sturm in Berlin, where she found in Herwarth Walden an enthusiastic supporter of her art. She settled in Brussels in 1921, but six years later, in 1927, she renounced all artistic activity for a full twenty years. Beginning in 1954 she painted nonobjective compositions in subtle color harmonies.

From time to time collages also occupied LÉOPOLD SURVAGE (1879–1969), originally named Leopoldy Sturtsvasgh and of Finnish-Danish extraction, who studied in Moscow but then, in 1908, settled in Paris, where he became associated with the Cubists, exhibiting with them in the 1911 and 1912 *Salons des Indépendants* but nevertheless remaining always an outsider in their ranks. In 1912–13 he composed his astonishing *Color-Rhythms*, strips of pictures made up of abstract color sketches which are considered to be forerunners of animated cartoons and "*dessins animés.*"

In 1916–17 Survage produced a few watercolors with collage additions (plate 32) in the style of the landscapes and city views that he painted in Nice in 1915–17. The compositions consist of flat segments of images in which exteriors and interiors interpenetrate. Through doors and windows appears the shadow image of a man wearing a hat, a character who for years haunted Survage's pictorial world. A tall goblet recalls the Cubist still lifes. The painted wallpaper that Survage had often included in his pictures ever since the *Still Life with Cup* of 1913 is here replaced by cutout pieces, whose delicate designs in the midst of this airy architecture represent impenetrable walls. His collages strike one as sketches for stage scenery, a field to which his colorful and decorative style was, in fact, especially well suited.

Survage once said, concerning the origins of his pictures, that "displayed outside of natural space, the object creates its own space, so to speak, and we take advantage of the fact that it associates to itself other objects that participate in its rhythm."

MARIE LAURENCIN (1885–1956), through her friendship with Apollinaire, had links with the Cubists, though they had little influence on her painting. Her enchanting little collage of 1917, *The Captive* (plate 35), is related in style to her painting of the same year, *The Cage*. The brightly colored birds seen by the girl through her barred window are cutout color reproductions, and it is likely that Laurencin, who otherwise had nothing to do with collage,

Herwarth Walden, *Einblick in Kunst*, 3rd–5th printings, Berlin, Verlag Der Sturm, 1924, with black-and-white photographs and one colorplate. Marthe Donas also took part in the international art exhibition organized in Düsseldorf in 1922 by the Junge Rheinland group.

Retrospective exhibition, *Survage*, Paris, Musée Galliera, 1966

A collage dated 1916 and two dated 1917 were included in the international collage exhibition at the Rose Fried Gallery, New York, in 1956, and one from 1917 was shown at the Galerie de l'Institut in Paris in 1957.

In 1922 he created the costumes and scenery for Stravinsky's *Mavra* for the Ballets Diaghilev.

was motivated toward it in this instance only because she happened to come upon these attractive prints.

A certain number of truly original collages were done about 1920 by GEORGES VALMIER (1885–1937) in his second Cubist phase. As early as 1910 he had painted Cubist works distinguished by the bright coloration that was to remain his hallmark. After the interruption of the war his compositions changed. Forms came to be broken down into small segments that cover the pictorial field in colorful profusion. Frequently figurative details are drawn in on the collage fragments—windows, treetops, a church spire, little ships, and waves—and these combine to create unreal landscapes. Abstract ornaments such as dots, circles, spirals, and zigzag lines often play over the geometrically tessellated surfaces (plate 28). At times, the bright bits of paper interpolated into the black-and-white drawings are tuned to the warm resonance of brownish violet, mat green, and silver; at others they make a happy harmony of light green and rose. Slowly Valmier managed to bring a certain order into the chaos of shapes, and on a collage presumably of 1921 (Collection Jean Pollac, Galerie Ariel, Paris) an oval framing gathers the diverse forms into an abstract still life. In explanation of his motifs Valmier made the point that he was not concerned with bringing out the illusion of visible things but rather with inducing a synthesis of the real by a freer invention.

Valmier exhibited his collages in 1921 in the Galerie L'Effort Moderne of Léonce Rosenberg, who put him under contract. He continued in this medium for a few years more, but his later compositions tend toward trite flower patterns and decorative stylizations best explained as the result of his extensive activity in designing scenery and costumes for the theater.

It was precisely at the time in the 1920s when Cubism had been overtaken by other artistic orientations and pushed into the background that it exerted its greatest power of attraction on foreign artists newly arrived in Paris. By reason of his acquaintance with his fellow countrymen Picasso and Juan Gris, the Spaniard ISMAEL DE LA SERNA (1900–1969), who settled in Paris in 1921, became one of its converts. He painted innumerable still lifes with such standard paraphernalia as bottles, playing cards, and fruit bowls, often too with musical instruments, a reflection of his personal interests. After his first show in the Galerie Paul Guillaume, Tériade wrote about the "musical relationships" that sound through his compositions.

He was a school friend of Garcia Lorca and illustrated the poet's first book.

Cahiers d'Art, 1927

La Serna's pictures have an individual approach to color based on the union of white, black, and blue, enriched here and there by isolated areas of green or violet. When printed matter such as newspaper headlines or tickets appears in his still lifes, it is usually not in collage but written in with the brush, and between such areas he often pasted pieces of wallpaper or patterned papers. In a *Still Life with Violin* dated "21" (plate 31) the marbled papers are scarcely noticeable in the midst of powerful brush textures, the wood graining of the instrument, and the musical notes written either black on white or white on black; and with their grayish blue and beige red shadings the pages are perceived only as areas of color.

La Serna turned out a great number of such collages but in later years no longer recalled their exact dates. A *Still Life with Guitar* (property of the heirs of the artist), to which he later assigned the date of 1930, is given a poetic savor

René Barotte, *Ismael de la Serna, ce constructeur silencieux*, New York, Hammer Galleries, n. d.

Kochar (b. 1899), another Armenian, moved to Paris in 1923 and two years later invented his "painting-in-space." He painted on sheets of wood, glass, and copper and then assembled his components into three-dimensional constructions in much the same way as Picasso has in his recent sculptures in painted sheet metal.

Tutundjian told of other inventions by Russian artists of his acquaintance in Paris in the 1920s, among them the boxes decorated by Polisadiev with scrap iron and other bits of rubbish, which were certainly forerunners of today's Pop assemblages.

by the pieces of old-fashioned wallpaper in black, red, gold, and beige and by a yellow starflower pasted around the soundhole of the instrument, while the musical notes and tablecloth are painted in a sketchy *tachiste* manner. Tiny blue and yellow squares cover the costume on a more recent *Harlequin with Mandolin*, and the collar and cuffs are decorated with pastry-shop paper lace, but the pasted newspaper clippings and wood-grained paper mark a return to the original elements of papiers collés.

In his later years La Serna utilized collage for more up-to-date subjects, as in the *Orly Airport*, with an airplane pasted against a bluish-white flowered wallpaper. His essential subject, however, remained the still life, in which he continued to grapple with the problem of the relationships between form and color.

LÉON TUTUNDJIAN (1905–1969) went from his Turkish-Armenian homeland to Paris in 1924 by way of Athens, where he learned the art of ceramics by which he was later to support himself, and Italy. He attended the Académie Rossi in Paris and had his first contact with modern art when the Russian painter Evrand Kochar showed him a publication of the Ballets Diaghilev. Soon after this he also saw Cubist paintings, and, at a show in the Galerie Paul Rosenberg in 1926, along with other works by Picasso, he saw collages incorporating sandpaper and other materials. He was particularly struck by a picture on whose frame Picasso had glued an ordinary glass bead. It was the geometry of the compositions that fascinated him as much as the unexpected materials used. After trying his hand at small Cubist pictures, he started a series of collages in which he turned to account both sources of inspiration and developed therefrom a personal style.

Tutundjian began by pasting a few rectangular pieces of paper on India-ink drawings of straight lines and curves, using ordinary drawing and wrapping paper in unglazed neutral tones. Soon, though, he was superimposing his papers in layers, and between the carefully cutout shapes he inserted roughly torn pieces whose accidental contours he stressed with a series of parallel outlines. From these elements he laid out abstract still lifes on imaginary tabletops. As time went on, he added to his repertory of images elements such as engravings of old paintings, picture postcards, anatomical diagrams, illustrations and text pages from a history of the French Revolution, a sheet with the Declaration of the Rights of Man, and a map of Napoleon's campaigns with portraits of the emperor and his generals (plate 26). These black-and-white reproductions constitute graphic focuses within his geometric compositions, supplying a representational content which, for Tutundjian himself, had a metaphysical significance. The subtle interplay of representational and nonrepresentational elements lends a special character to these last and more refined offshoots of the Cubist papiers collés.

From collages Tutundjian switched in 1926 to watercolors, in which he attempted to imitate certain transparent effects of glazing, familiar to him from his ceramics, that occur in firing when the undercoats of enamel break through the outer coats and create unpredictable cracklings and colored speckles on the surfaces. In an analogous procedure, he let various mixtures of paint flow over one another on the paper and then, with the pen, defined and completed the resulting accidental shapes. The watercolors were followed about 1930 by reliefs of an entirely different and rigorous character, among them disks against which elementary concave or convex forms stand out.

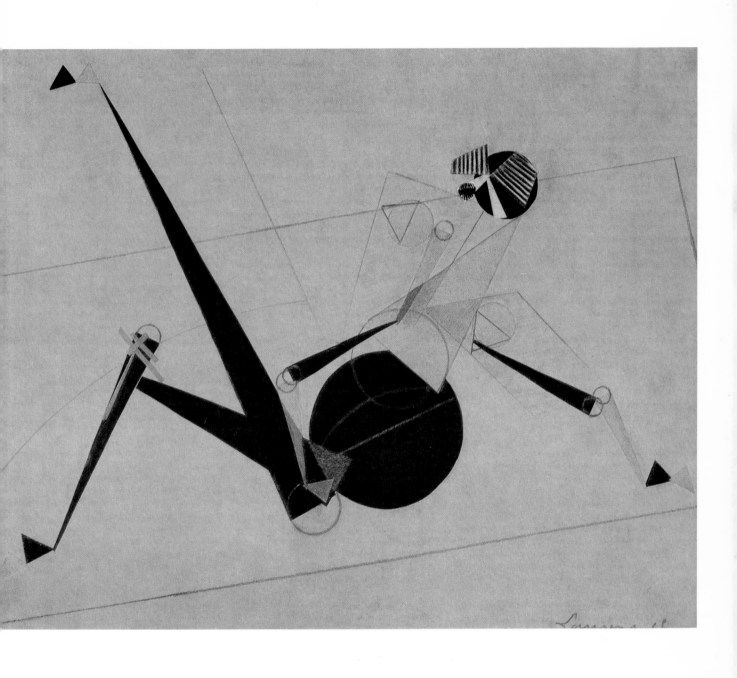

Colorplate 7. Henri Laurens. *Josephine Baker*. 1915

There was an exhibition of Tutundjian's work in 1929 in the Galerie Vanouin in Paris. The following year, together with Theo van Doesburg, Jean Hélion, and Otto Carlsund, he formed the Art Concret group, which signaled its public début by issuing a manifesto. At its foundation in 1931 he joined the Abstraction-Création group but soon left it to explore the ways of Surrealism in his paintings and drawings. Tutundjian himself said that in his experiments with color materials—his "deformations of matter," as he put it—he was supported by DAVID KAKABADZE (b. c. 1890), with whom he became acquainted about 1925.

Little specific information is to be had about this Russian-Georgian artist, who was much discussed because of his audacious undertakings. He is said to have studied natural sciences in Moscow, along with art, and even taught them. He arrived in Paris in 1920 and in the following year took part in the *Salon des Indépendants*. At about that time he was using watercolors for abstract Cubist compositions based on flower motifs and on shapes resembling sails. Subsequently, however, he constructed relief pictures and sculpture out of unusual new materials. André Salmon, in his *Art russe moderne*, Paris, 1928, reproduces two of these material reliefs. On one, dated 1924, painted wooden elements, buttons, and a curved metal shape are nailed on a colored shaded ground in a genuine Dadaist accumulation of materials but laid out in a very objective arrangement. On the other, from 1925, metal rods are bent to make a curved ornament enclosing colored surfaces (plate 37). Related to this in style is the *Speared Fish* (Yale University Art Gallery, Collection Société Anonyme, New Haven, Conn.), a painted wooden sculpture into which he set two glass eyes.

Tutundjian observed firsthand how Kakabadze covered sheets of plywood with cotton batting, over which he spread fine textiles, by preference pure silk, previously dipped into a solution of size. Using an atomizer, he sprayed paint over these "arrangements" and pulled wire through them so that, when dry, they became reliefs resembling topographical maps.

In 1926 Kakabadze returned to Georgia, where during the following years he did stage designs for the Mardshanishvili Theater in Tiflis.

Czechs and a Romanian

Outside France, Cubism had its strongest response in Prague, where the modern art movement set in very early. The first association of forward-looking artists, the Osna (Group of the Eight), came before the public in exhibitions as early as 1907 and 1908, in the second of which LINKA PROCHÁZKOVA, the wife of the painter Antonín Procházka, also took part, the first woman there to join the artistic avant-garde. A 1913 collage of hers is known, a sketchy Cubistic still life with a piece of printing in Czech pasted on it. Other than this we know only that in the 1920s she painted in the Neo-Plasticist style, but there is no mention of her in further exhibitions.

In 1911 the painters Filla, Beneš, Čapek, Procházka, Šima, and others joined with the sculptor Otto Gutfreund and a few architects to form the Skupina výtvarných umělců (Group of Visual Artists). They followed with interest the modern developments in France, and the collector Vincenc

In the Woks publication, *Die bildenden Künste in der USSR*, 1934, it is said that during his sojourn in Paris he was concerned with painting procedures and often replaced paints with metals, mirrors, colored glass, and other materials.

During a sojourn in the United States, Kakabadze invented "relief-cinematography," involving the simultaneous use of three action cameras. He published a brochure on the subject but could not find anyone willing to help him to exploit the procedure commercially.

Kramář, who acquired a number of important works by Picasso, Braque, and Derain between 1910 and 1913, called their attention to the Cubists. The group organized an exhibition in 1913 to which they invited those three artists, plus Juan Gris and Soffici. Some Czech artists also had direct personal contact with the Cubists during sojourns in Paris.

During 1909 and 1910 OTTO GUTFREUND (1889–1927) had rounded out his studies by working with Bourdelle in Paris. Upon returning to Prague, in 1911 he began to produce Cubist-influenced sculptures of planes in space which are among the most important examples of modern sculpture. At first the baroquely modeled and highly animated forms were more related to the Futurist works of Boccioni, but, like the latter's *Development of a Bottle in Space* of 1912, Gutfreund's slightly later *Female Bust* shows influences from Synthetic Cubism in the more rigid and more frontal disposition of the elements. In the sketches for these sculptures, isolated watercolor areas are set into the geometric line drawing, recalling Picasso's early papiers collés.

Back in Paris in 1914, Gutfreund made a genuine collage on which a still life with bottle, glass, and spoon is drawn over an underlying composition of cutout French newspapers (plate 39). At the outbreak of the war he enlisted in the Foreign Legion but was nevertheless interned in a concentration camp in southern France from 1915 to 1918. There, in 1917, he produced the *Seated Woman*, a completely abstract sculpture nailed together out of old wooden planks.

EMIL FILLA (1882–1953), who occupied the leading place among the painters of the group, had already come under the influence of Edvard Munch and the German Expressionists; upon his first visit to Paris in 1907 he came to know the French Fauves also, but finally in 1911 he discovered his true affinity in the Cubists, whose development he proceeded to follow with a certain time lag between one phase and the next. After a second visit to Paris, in 1914 he did a *Still Life with Cards* which reflects the impression left on him by Analytical Cubist pictures, those of Braque in particular, though its painted sheets of music and maps point rather to the collages of the following period. During the war years, which Filla spent in Holland, first in Rotterdam and then in Amsterdam, he used light brush stippling in his still lifes to imitate the wallpapers and trimmings of papiers collés and smothered the representational elements in porous textures of granular impasto. In his drawings he varied the geometric surfaces with printed material, and on a watercolor drawing of a still life he pasted the label from a bottle of Vichy water. Along with these, in 1915, he created true collages of small format which bear his individual stamp in the somewhat muted diversity of materials and colors. In one (plate 42), pages of music from a French psalmbook, together with a playing card, are pasted between patterns speckled with color which cover the background as if with a diffuse layer of light, and glistening gold and silver intermingle with dull brown, blue, and green tones.

After the war Filla returned to Prague, where he remained faithful to Cubism. His *Woman in Front of a Carpet*, of 1921, expressed once again his old partiality for decorative surfaces in the carpet painted in heavy impasto and the checkerboard pattern of the flooring. Later Filla took to mixing sand into his oil paints and even upon occasion bits of cork, as in the *Glass and Pear* of 1929.

ANTONÍN PROCHÁZKA (1892–1942), whose painting developed along parallel lines with that of Filla, likewise went over as early as 1916 to piling up a

The portrait of *Viki* should be compared with Boccioni's bronze head *Antigrazioso (La Madre)* (Galleria d'Arte Moderna, Rome).

Reproduced in the periodical *Výtvarné Uměni*, 1966, no. 4

The catalogue of the exhibition *Otto Gutfreund*, Städtische Kunstgalerie, Bochum, December, 1969–January, 1970, includes an obviously related work, no. 82, *Still Life with Bottle*, a drawing with India ink and black chalk on newspaper and brown paper, collage, 40.5 × 22.8 cms. (roughly 16 × 9″), belonging to the Regional Gallery, Ostrava, Czechoslovakia.

Catalogue of the Gutfreund exhibition, Grosvenor Gallery, London, June, 1966. Gutfreund's most important works are in the Národní Galerie, Prague.

There was an exhibition of Munch in 1905 in Prague.

They were acquired by Paul Citroen, Wassenaar, Netherlands.

thick impasto around the objects in his still lifes so as to give them virtually relief contours. The face—in simultaneous different views—in the portrait *Young Girl with Wreath of Flowers*, 1921, is crowned by ringlets of the thickness of a relief, and the pigments are mixed not only with sand but also shreds of cloth. A sketchlike still life with teapot, fruit bowl, and flask, of about 1923–24 (plate 43), has on the flask a cutout label with a prominent printed text. The background is covered with a zigzag pattern representing a curtain which hangs behind the objects and forces them to be viewed in the immediate foreground, without spatial depth.

Seen side by side in Paris, in 1966, the treasures of French Cubists belonging to Czech collections and the works of Czech artists from the same period demonstrated plainly how well the latter held their own in comparison.

Exhibition *Picasso, Braque et leurs contemporains tchèques 1906–1930*, Paris, Musée National d'Art Moderne, 1966. The catalogue has a historical introduction by Dr. Miroslav Lamač. He made available the photographs of collages in Czechoslovak collections.

It was for decorative purposes, rather than with any really artistic aim, that the Romanian painter JEANNE COPPEL (b. 1896) made her first collages in 1917. Since it was wartime and the shops in her town of Galati had nothing she considered acceptable as Christmas gifts, for her friends she cut and pasted bright-colored tissue papers into small pictures appropriate to the holiday and in accord with her own taste, which had run to abstraction ever since she had visited the first German *Herbstsalon* in 1913 and seen pictures by Kandinsky, Chagall, Delaunay, and the Cubists. With time, her collage compositions became richer and more interesting. She still has two from 1919, one of large stars with intersecting rays, the other with oval shapes that float like Japanese lanterns in a theaterlike space enclosed by checkerboard-patterned floor and zigzag side flats. In such pictures she had in mind circuses and the performances of the prewar Ballets Russes she had seen, whose colorful folkloristic settings had especially appealed to her.

For an indication of her later style, see below, p. 306.

Jeanne Coppel settled in Paris in 1919 and has since become a French citizen. It was not until 1947 that she resumed the nonfigurative style of her earlier years, but eventually she played an essential role in the development of lyrical abstract collage within the School of Paris.

Scandinavians

In Denmark during 1917 and 1918 VILHELM LUNDSTRØM (1893–1950) was responsible for a number of astonishing collages in a variety of materials. These occupy a special place between Cubism and Dada, consisting, as they do, of relief pictures made from sawed-up pieces of wooden boxes, sheets of plywood, and other worthless materials whose use, it is said, was suggested to him by an exhibition, *Treasures from the Trenches*, held in Copenhagen during the war. Lundstrøm titled his pictures *Bud 1*, *Bud 2*, and so on, *bud* being a word which can mean "morsel" but also "commandment" and which he used for whole series of his work, simply adding to it the serial number.

Many are also titled *Opus I*, *Opus II*, etc.

He nailed pieces of wood in simple geometric forms or loosely distributed over a background and then painted the entire composition with flat colors, for the most part hastily brushed on. To one of the earliest compositions of 1917 (formerly Collection F. C. Boldsen) he added a piece of curtain lace, which stands out as a light and delicate patch among the dark wooden ele-

Colorplate 8. Marthe Donas. *Still Life with Bottle and Cup.* 1917 ▷

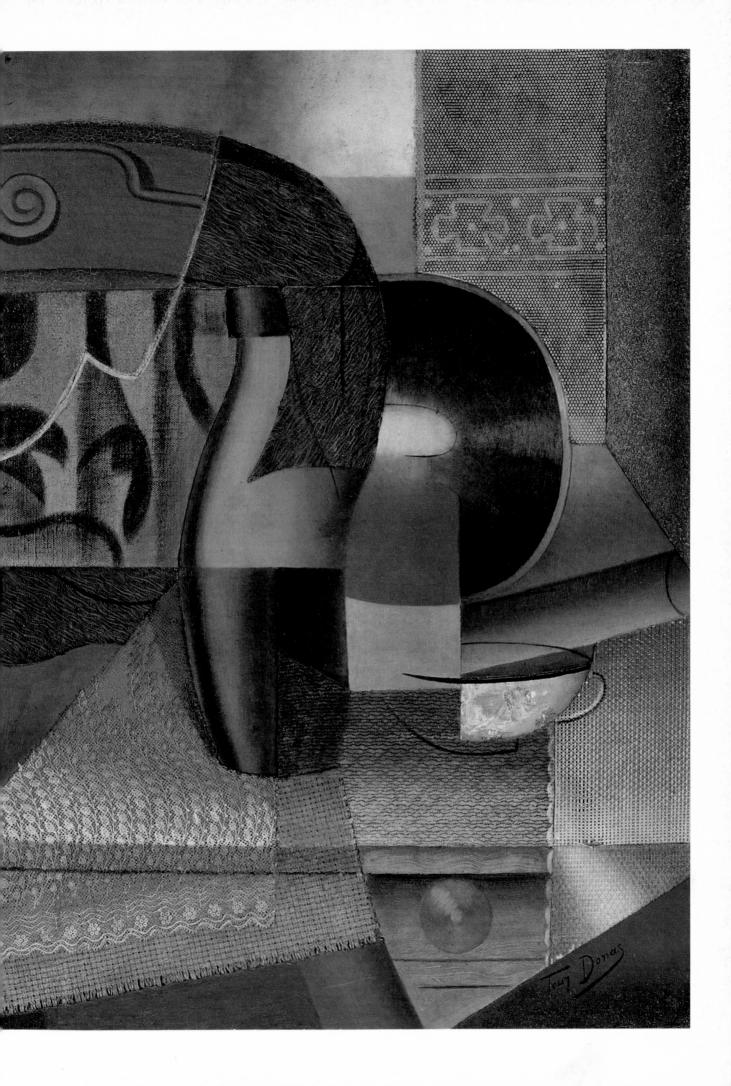

ments. The *Lattice Picture* of the same year (plate 41) consists of a roll of sheet iron towering above pieces of wood and cardboard which project from the picture surface, a composition that recalls Vladimir Tatlin's *Counter-Reliefs* of 1914–15, though Lundstrøm certainly never saw them. On a relief of 1918 (Collection Erling Koefoed, Copenhagen) part of the surface is covered with newspapers dipped into paint and corrugated, and thick masses of pigment are piled up on the round arches which contrast with straight and angular shapes.

Usually Lundstrøm's reliefs are spoken of as "Cubistic compositions," but they are closer in spirit to such works of the Zurich Dadaists as Marcel Janco's reliefs composed, from 1917 on, of painted plaster of Paris, wood, and other materials, or those that Arp nailed together a little later out of discarded pieces of wood. With the *2 det Bud (The Second Commandment)* (colorplate 9), on which old wooden planks marked with signs and numbers are mounted one above the other in all directions and enclosed within an oval, Lundstrøm anticipated the "Merz-constructions" of Kurt Schwitters. This strangely intimate picture, whose internal composition of grayish white and bluish shadowings protrudes from a greenish-gray toned ground, emanates the same strange poetry that Schwitters infused into his assemblages of odds and ends.

Lundstrøm showed a number of these works for the first time in 1918 in Copenhagen at the autumn exhibition of the Artists' League, and a few also in the following year at an exhibition of the Four Group, which he founded with A. Salto, Svend Johansen, and K. Larsen. While the magazine *Klingen*, published by that group, energetically defended Lundstrøm's works, the public sarcastically dismissed them as "packing-case painting," a name which still clings to them.

After 1919 Lundstrøm did no more of this sort of work. From 1923 to 1932 he lived in Cagnes in southern France, where he painted nudes and landscapes in partly Cubist, partly Expressionist style. He returned to Copenhagen in 1940, became professor at the Royal Academy of Arts, and died in 1950.

It may have been this "packing-case painting" that inspired a relief in 1920 by the Swede GÖSTA ADRIAN-NILSSON (b. 1884), who as an artist used the pseudonym GAN. The relief is made up of lentils, matches, corks cut into disks, and strips of cardboard. As in Lundstrøm's work, the materials and ground are covered with oil paint, and, like the *2 det Bud*, the composition is enclosed in a medallion form, here surrounded by a length of twine. The execution shows great care as to both form and color. The whitish tonality of the inner field contrasts with a gray-shaded ground, and the red star on a cork in the center is echoed by reds in the borders around areas of lentils. There is no doubt that the geometric surface composition reflects the influence of the Cubist still lifes that GAN saw in Paris in 1920.

GAN spent the years 1912–14 in Germany, where he was influenced by the works of the Blaue Reiter group and the Italian Futurists that he saw at Der Sturm in Berlin. He himself participated in 1915 and 1917 in exhibitions of Der Sturm and joined the painters of that gallery also in the international exhibition of 1922 in Düsseldorf.

From 1920 to 1925, years GAN spent in Paris, his subject matter of sports and machines points to the influence of Delaunay but even more of Léger. The latter's illustrations for *La Fin du Monde* may have been the stimulus for

Information from a letter from Poul Fad, Curator of the Royal Museum of Art, Copenhagen

Reproduced in the exhibition catalogue, *L'Art suédois*, Paris, Galerie Denise René, 1953

Léger's atelier was especially frequented by the young Scandinavian artists.

a series of collages with word and letter elements that GAN did about 1921. In his *Lettre recommandée* (plate 40) postage stamps, postmarks, addresses, and a diagrammatic illustration of a uniform from a catalogue are spread across a schematic composition of tinted planes outlined in color. In another collage, *Sailors*, strips of text from the same catalogue describing uniforms for the British navy are broken up into shreds of words and isolated letters and rear up in almost threatening fashion against the viewer. A third one, *The Boxer and His Phantom*, has in the foreground the cutout portrait of a boxer outlined by his painted shadow, and behind him rises the large and disquieting shape of the ghost. In his manner of drawing, as well as in the way of filling surfaces with tiny dots, one senses reminiscences of Cubism, which continued in GAN's oil paintings also.

Under the influence of Archipenko GAN also did "sculpto-paintings" in Paris, among them, in 1928, a collage relief titled *Contact* (Collection Lambert Werner, Stockholm), an abstract machine construction of wooden elements painted white, gray, and black and glued on a blue-gray ground. It was this sort of work that GAN submitted to the *International Exhibition of Post-Cubist Art* in Stockholm in 1930. At about that time he was a member of the Halmstad Group, which took its name from the port city frequented by these artists, and championed the Cubist and Neo-Plasticist tendencies that had a second blooming in Sweden about 1930. Soon thereafter, however, he went over to Surrealism.

In the course of his many-sided activities GAN has also turned out designs for theatrical scenery, tapestries, silverware, and pewter and, in addition, has worked as a journalist and writer.

51

III Futurism

Founders—Florence—The Second Generation—Turin

M. T. Drudi Gambillo and T. Fiori, eds., *Archivi del Futurismo*, vol. I, Rome, 1958, list an oil painting with collage by Russolo, *Il Vino* (Collection Cesare Tosi, Milan).

Manifesto tecnico della scultura futurista, April, 1912. For the major documents of the movement and for reproductions of art works see Marianne W. Martin, *Futurist Art and Theory 1909–1915*, Oxford, 1968; also Joshua C. Taylor, *Futurism*, The Museum of Modern Art, New York, 1961.

While everyone today concedes the importance of papiers collés in the history of Cubism, and thereby in the subsequent development of modern art as a whole, much less well known is the role played by collage in Futurism. Few realize how many adherents the new medium found in that movement too, and yet Boccioni, Balla, Severini, Carrà, and Russolo, the artists who signed the *First Manifesto of Futurist Painting*, all practiced cutting and pasting, and some of them produced truly fundamental works with that technique. What is more, in the heyday of Futurism that followed Italy's entry into World War I a great many other artists followed their lead. If those works have so far scarcely been appreciated at their true worth in the books and exhibitions of the Futurists, it is perhaps because the Italians are aware that, in this case at least, the Futurists were not innovators but, instead, only followers of the French Cubists.

Be that as it may, as early as 1912 UMBERTO BOCCIONI (1882–1916) raised the cry for the introduction of new and up-to-date materials into art. In a *Technical Manifesto of Futurist Sculpture* he called on the sculptors to make an end to the traditional "noble art" of marble and bronze statues and to seek their means of expression among the countless materials used in everyday life. "A sculptural composition must not be made throughout from a single material," he wrote, "but rather twenty different kinds can be combined in a single work in order to heighten its power of expression. To mention only a few: glass, wood, cardboard, cement, horsehair, leather, cloth, mirror, electric light, etc." Concerning the use of newer means he says in another place: "With the aid of transparent bottles, glass disks, sheets of metal, illumination from within and without, we can bring to expression the planes, movements, tones and half-tones of a new reality."

Boccioni drew up this manifesto immediately following the Futurist exhibition of February, 1912, in the Galerie Bernheim-Jeune in Paris. He and his coterie went to Paris to attend the opening, and Severini, who introduced them to his friends among the Parisian artists, maintains quite rightly that the ideas promulgated in Boccioni's pronunciamento grew out of the joint discussions between the young Italian and French artists. During that same visit Boccioni also met Archipenko, for whom the problems of new materials were very much a concern at the time and so, no doubt, were discussed by the two artists.

Boccioni treated a related theme in an oil painting, *Testa + Luce + Ambiente*, dated 1912/13 (Civica Galleria d'Arte Moderna, Milan, but now missing from there).

In two sculptures, *Head + House + Light* and *Fusion of a Head and a Window* (plate 44), both destroyed, Boccioni translated the proposals of his *Technical Manifesto* into practice; or, more properly, as he explained in an article in the

magazine *Lacerba* of July 1, 1913, they became the point of departure for his manifesto. Though in his essay *Pittura, scultura futuriste—Dinamismo plastico* of 1914, in which both works are reproduced, Boccioni gives 1911 as the year of their origin, the fact is that they were not done until after his Parisian sojourn of February, 1912. In both, figurative and abstract formal elements or, as Boccioni himself calls them, "elements of concrete reality and atmospheric blocks," are united. In the first an old iron grate, in the second a piece of window frame, a sheet of glass, and, even more disconcerting, a real crown of hair are mounted together with a plaster head, ingredients of everyday existence such as had not previously been admitted into art.

Both works were included in an exhibit of Boccioni's sculpture held from June 20 to July 16 of 1913 in the Galerie La Boëtie in Paris. A few drawings of 1914 show an attempt to unite horse, rider, and houses into a single form, probably as preliminary studies for sculpture, though there survives only the construction *Plastic Dimension: Horse + Rider + Houses* in the Peggy Guggenheim Collection, Venice, made of wood, cardboard, and metal.

As early as a visit Boccioni made to Paris in November of 1911, he saw pictures by Braque and Picasso and certainly had them in mind in *The Farewells* (private collection, New York), one of three pictures of *States of Mind*, for he introduced a large four-figure number such as was common in Cubist pictures. After his second sojourn in Paris, on the occasion of the show in the Galerie Bernheim-Jeune, Cubist influences appeared even more clearly. The *Development of a Bottle in Space*, of 1912 (silvered bronze casting, Museum of Modern Art, New York), is basically the translation of a typical Cubist subject into a three-dimensional construction.

Other casts are in the Civica Galleria d'Arte Moderna, Milan; the Gianni Mattioli collection, Milan; and the Museu de Arte Moderna, São Paulo, Brazil.

At the same time pasted papers began to appear in his oil paintings. In a pen drawing shaded with tempera, *Still Life with Seltzer Siphon* (Yale University Art Gallery, Collection Société Anonyme, New Haven, Conn.), there is a piece of newspaper and the title page of the *Initial Futurist Manifesto* with the half-hidden name of its author, Filippo Tommaso Marinetti. Similarly, newspaper cuttings form the basis for two tempera sketches, *scomposizioni* (de-compositions) of a male and of a female head closely related in style to the *Antigrazioso (Anti-Graceful)* portrait that Boccioni exhibited May 18–June 15, 1913, at the Futurist show in Rotterdam. In the sketches he used paper exclusively for the disposition of the planes but so covered them with paint that often they are scarcely visible. This is especially true in the preliminary study (Collection Mr. and Mrs. Harry Lewis Winston, Birmingham, Mich.) for *The Drinker* of 1914, on which the pasted papers disappear entirely under the paint. In a related composition, *Under the Pergola at Naples* (plate 45), the interpolated collage, a page from a book of poetry illustrated with a landscape, is more conspicuous, being placed at the right on the edge of the table.

It was preceded by the sculpture *Antigrazioso (La Madre)* (Galleria d'Arte Moderna, Rome).

On the other hand, clippings with news from the front for January 1, 1915, pasted in *The Cavalry Charge* (Collection Riccardo Jucker, Milan) possess the value of more direct topical allusions. In this, the most important collage by Boccioni that we know, the Futurist dynamism, which had been temporarily held in check under Cubist influence, breaks through fully once again, though nothing of the sort can be found in the pictures of August, 1916, the last he painted before his death.

The contrast between engraving and painting recalls Juan Gris's *Still Life with Violin and Engraving* of 1913 (Museum of Modern Art, New York).

A not inconsiderable role was played in Boccioni's development by his riendship with GINO SEVERINI (1883–1966). Boccioni was eighteen, Severini

seventeen in 1900, when they met in Rome and together frequented the atelier of Balla, who about that time was acquainting his students with the problems of Impressionism. Boccioni made study trips into France and Russia in the following years and in 1908 moved to Milan, which soon thereafter became the center of the Futurist movement. Severini settled in Paris in 1906 and subsequently made only brief visits to Italy.

Severini soon gained access to those artistic and literary circles responsible for the decisive impulses of the first years of the twentieth century. As a painter he was impressed by the Neo-Impressionists and the Fauves, and his profound admiration for Seurat proved to be the point of departure for his own Divisionist painting. In 1909 he occupied a studio near the Place Pigalle in the street where Suzanne Valadon, her son Utrillo, and Braque all lived. Through Braque Severini became acquainted with the other Montmartre Cubists and was able to observe their development firsthand. After the Futurists had invited him to join them in signing their manifestos of Futurist painting in 1910, he did his best to persuade the Italians to come to an understanding with the Cubist avant-garde, and it was to a great extent due to him that the Futurist exhibition in the Galerie Bernheim-Jeune did take place. On that occasion he took the Italian artists to visit the studios of Picasso, Braque, Dufy, Brancusi, and others very much in the news; and together with Soffici, who was likewise at home in Cubist circles, he made possible the personal contacts between the two groups that gave rise to such a lively exchange of ideas and opinions in the prewar years.

Vol. I, Rome, Paris, Milan, 1946

Among the pictures Severini showed at Bernheim-Jeune was a *Memories of Travels* (whereabouts unknown) of 1910, on which the most unlikely images are thrown together seemingly at random—the Eiffel Tower, Sacré-Coeur, the Palazzo Comunale of Pienza, a train and a bus, the bust of a woman, and the head of the artist's father—to make a painted "montage" that was Dadaist before the fact. In his autobiography, *Tutta la vita di un pittore*, 1946, he recounts that Picasso saw this painting in his studio and was very much impressed by it.

Letter to R. Carrieri published in the latter's *Futurismo*, Milan, 1961

Severini also became interested very early in the Cubists' collages. Apollinaire told him about Picasso's use of oilcloth, and he saw Braque's earliest papiers collés with their wood-grained wallpaper. During a visit to Italy in the fall of 1912, he told Boccioni about these, and the latter passed the information on to Carrà.

Severini tells too about a conversation with Apollinaire that took place toward the end of 1912 somewhere in Montmartre. Apollinaire mentioned the early Italian masters who inserted real objects into their altarpieces in order to make their representation more dynamic through the contrast between extraneous materials and painting, citing as examples a Saint Peter (in the Brera in Milan) who holds a real key, and other saints' images in which the halos are decorated with real pearls and precious stones. It was from this that Severini got the idea of gluing sequins into his pictures to give them more relief.

Probably he meant the triptych of 1486 by Crivelli, in which the border of the pectoral, the upper part of the cross, and the key are all modeled in plaster.

From 1912 on, sequins appear in a great many of Severini's oils and pastels of dancers, male as well as female, in which the contours of the figures become more and more broken down into abstract formal rhythms. The sequin-studded *Blue Dancer* (Collection Gianni Mattioli, Milan) gives the impression of a festive radiance, and other compositions that Severini set into old round

Colorplate 9. Vilhelm Lundstrøm. *The Second Commandment*. 1918 ▷

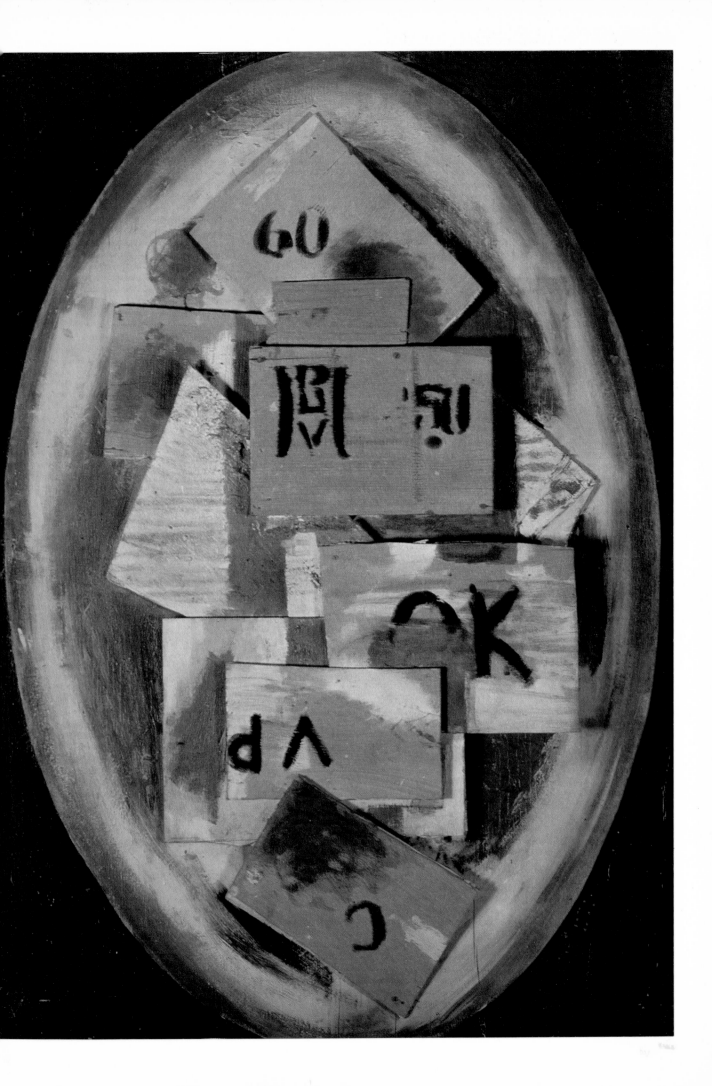

or oval frames possess an intimate charm. One such round picture, dated Paris, August, 1913 (plate 47), is dedicated to Madame Rachilde, the writer and wife of Gustave Kahn, editor of the *Mercure de France*, at whose famous "Tuesday evenings" Severini was a regular guest and in which Marinetti also participated when he was in Paris.

Sequins are found also in the larger pictures inspired by Severini's visits to the dance halls and cabarets of Montmartre; these, in true Futurist manner, are composed of movement, color, and light. In the *Dynamic Hieroglyphic of the Bal Tabarin* (Museum of Modern Art, New York) fragmented faces and figures emerge from the whirlpool of abstract forms in which gleam ornaments of varicolored sequins. As Severini told Carrà in a letter, by introducing such words as "VALSE" and "POLKA" in large capital letters he aimed to inject noise and sound into painting and to impose on the viewer acoustical effects along with the visual ones. Among the most important of such works, according to Severini himself, was The *"Pan Pan" at the Monico* of 1913 (Collection Mr. and Mrs. Samuel H. Maslon, Wayzata, Minn.), in which he used sequins of various colors in order, as he says, "to produce pictorial zones where reality is not described but rather expressed in a transcendental manner."

In 1913 Severini began to introduce other sorts of materials into his portraits. During the summer of that year he painted one of Marinetti (plate 48) and glued on it half a carnival false mustache and a piece of velvet in the guise of a jacket lapel, as well as cutout titles and excerpts from his sitter's most important works, the *Manifeste du Futurisme* and *Imagination sans fil*. The titles, broken up and distributed across the surface, seem to leap out at the viewer, whereas the printed texts tend to amalgamate into the pointillistic painting.

The documents on the collage portrait with which Severini honored his father-in-law, Paul Fort (Musée National d'Art Moderne, Paris), are less disguised and more profuse. Title pages and excerpts from the magazine *Vers et Prose*, edited by Fort, as well as from others of his publications, are spread out around the sitter, who is portrayed in simultaneous frontal view and profile and has been provided with eyeglasses, mustache, and black cloth.

Along with these Severini composed collages in a more restrained Cubist style: still lifes (colorplate 10) in which colored papers, printed matter including title pages from *Lacerba*, corrugated cardboard, playing cards, and the like are used. The outlines of the glasses, bottles, and fruits are drawn either light on dark or black on white, with light hatching to round out the shapes. Two such still lifes were dedicated to his parents and contain specific allusions to them (Collection Peppino Palazzoli, Galleria Blu, Milan). In that for his father (plate 49), "Usher for the Royal Prefecture of Pienza," as the dedication reads, he incorporated a bulletin of judicial decrees. In his mother's she is hailed as *"Grande Sarta Cortonese"* (Great Dressmaker of Cortona), and included are a fashion illustration and an advertisement for sewing machines. Corrugated cardboard, a green paper overlapping the fashion plate, a blue one under a partly drawn pair of scissors, and a pink tissue paper under a real tape measure lend the picture a note of gaiety. Severini made these collages as gifts for his parents in September of 1913 presumably, while honeymooning with his young bride in Pienza, but, as he told it later, the old couple could not make much out of them.

During the war, Severini continued with his Cubist still-life collages in

According to the *Archivi del Futurismo*, it was painted in Pienza during the summer of 1912 and exhibited in Rotterdam in 1913.

In the essay, "L'Art plastique et néo-futuriste," written in Rome in 1913–14, Severini formulated his ideas concerning the bases of modern painting. It is reprinted in Michel Seuphor, *Dictionary of Abstract Painting*, New York, Paris Book Center, 1957.

Exhibited at Der Sturm in Berlin in 1913

Paris, and about 1917 they took on a somewhat decorative character, with bright-colored patterns and dottings. In connection with the mathematical studies by which he computed the proportions of lines and surfaces, he also designed a few purely geometric compositions. It was probably not before 1916 that he portrayed the Dadaist poet Arthur Cravan and pasted in the title page of the first number of Cravan's magazine *Maintenant,* whose date of April, 1912, has led to the misdating of this painting.

Even before Severini, the Florentine painter ARDENGO SOFFICI (1879–1964) had put down roots in Paris. By 1900 he had settled there, and between 1907 and the outbreak of the war he returned each year for protracted visits. After having at first adhered to the Impressionists, he soon found his true models in the Cubists, with whom he maintained friendly relations. As champion of the Cubists, he contributed to the Florentine magazine *La Voce* attacks on the Futurists, whose works he pronounced provincial and secondhand; but after Severini had reconciled him with the Milan avant-garde, he allied himself with the Italian movement. The definitive change appears in pictures such as the *Ballo di pederasti* of 1913 (destroyed), in which fragments of shapes and words whirl around and through each other, as in Severini's Montmartre pictures.

In January of 1913 Soffici joined with Giovanni Papini to found the magazine *Lacerba,* which remained to its last number, that of May, 1915, the most important mouthpiece for Futurism and at the same time carried on a running battle against the Cubists. There were all-out polemics between Apollinaire and Boccioni as to which of the two movements was the pioneer, which the imitator. Boccioni's accusation against Cubism was that its static disintegration of surfaces left the object itself lifeless, whereas Futurism made visible the effective lines of force in an object and thereby expressed its dynamic vitality. Apollinaire finally, in September of 1913, put an end to the controversy with an article, "*L'Antitradizione Futurista*" ("Futurist Antitradition"), in which he pleaded for an alliance between the adherents of the avant-garde in both countries.

At the beginning of 1914 a difference of opinion involving collage arose within the ranks of *Lacerba* itself. In an article, "*Il cerchio si chiude*" ("The Circle Closes"), Papini inveighed against the return to naturalistic tendencies, which he found in the fact that artists were using real objects in their works without transforming them lyrically or rationally, as art should do. As examples he cited Picasso's constructions and Boccioni's sculptures in wood, sheet metal, iron, glass, and so forth, as well as Severini's portrait of Marinetti with the false mustache and scrap-velvet lapel. Soffici concurred in these accusations to the extent of writing in his diary about the "frivolity" of Severini's sequins. On the other hand, he defended the introduction of papers, newspapers, posters, cloth, and the like into painting and sculpture, using Picasso's argument that the artist was justified in adopting them if he subjected them to a mental process of transformation. Real objects employed as artistic materials, it was claimed, have a chromatic, rather than an illustrative, function and are to be incorporated harmoniously into the pictorial whole for their compositional and formal values.

About 1914 Soffici himself inserted collage elements into a large number of still lifes, toning down the Futurist dynamism and diverting the expansive

The dating of Severini's collages is not always certain, because later he duplicated a number of his earlier works.

57

force into the composition itself, to the compression within space of the objects depicted and to the intensity of the colors broadly brushed in a thick impasto. Between fruits, bottles, and bowls he interspersed a variety of newspaper cuttings, tickets, and labels which diffuse a strange unrest among these stable objects (plate 50). Inscriptions and titles push their way into the foreground, demanding to be taken literally, so to speak. Typographical elements completely dominate the field in a collage with tempera (Collection Cesare Tosi, Milan) reproduced in *Lacerba* for February 14, 1915, and in an oil painting *Tipografia* (formerly Collection Frua de Angeli, Milan), though in the latter the letters are painted.

This concern with the optical effects of words and print, which appears also in the work of other Futurist painters, is connected with the new forms of poetry that Marinetti launched in his manifesto of May 11, 1913, *L'Immaginazione senza fili e le parole in libertà (Wireless Imagination and Free Words)*. As early as 1912 he composed his verses dedicated to the Battle of Adrianople in

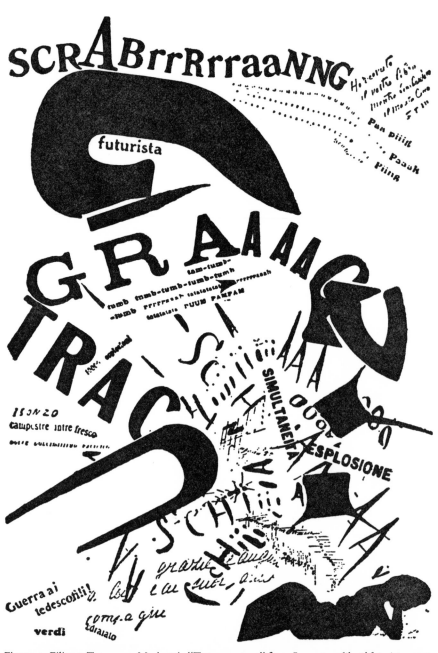

Figure 4. Filippo Tommaso Marinetti. "Typomontage" from *Les mots en liberté futuristes*. 1919

the Balkan Wars, in newer and freer typography, and he published them in 1914 under the title *Zang Tumb Tumb*. Subsequent poems were set in geometric shapes, an example of which, "The Dunes," accompanied by an essay, "The Geometrical and Mechanical Splendor of Free Words," appeared in *Lacerba* for January 1, 1914. Marinetti went on to smash customary syntax and to liberate typography from all conventions and restraints. During the war he made "typomontages" of words, numbers, and onomatopoeic equivalents for loud (or rude) noises, which he distributed at random over surfaces and interlaced with abstract shapes and lines, the whole in an attempt to reproduce the hallucinatory experiences of soldiers in the front lines. These poems appeared in book form in 1919, together with theoretical writings about Futurist poetry and typography, under the title *Les mots en liberté futuristes* (figure 4), published in French in the hope of guaranteeing a wider distribution for what the author considered an epoch-making revelation.

Poets and artists of the Futurist circle followed Marinetti's lead in great numbers. *Lacerba* published the "Words in Freedom" of the young Ferrarese poet Francesco Cangiullo, among which were certain typographical poems he called "*Divagazione medianica*" ("Mediumistic Digressions") which were juxtaposed with abstract pictorial compositions by Carrà. In 1915 Soffici laid out the magazine *BIF & ZF + 18* in "lyrical typography."

Included in *Lacerba* for July 1, 1914, was a "composition in words and shapes" by Severini, *Danza serpentina (Snake Dance)* (figure 5), a lettered drawing on which the indications for shades of color and for concepts such as "warmth, fragrance, profundity, and silence" are written out in curves and areas intersecting in a centrifugal movement, and the whole accompanied by the suggested rattling noise of "Ttattatta." During the war he drew a similar sheet in color, with lines of words composed of military designations (catalogue, Rose Fried Gallery, New York), and an oil painting simulating montage (Galleria Bergamini, Milan), in which, between the words "*antihumanisme*" and "*effort maximum*," are interposed mathematical formulas with computations of curves plus the chemical formulas for poison gases.

Before CARLO CARRÀ (1881–1966) got caught up in the tumult that swept over the Futurists about the time of the outbreak of the war, he too had carried on a flirtation with Cubism. Parisian impressions, acquired during the exhibition in the Galerie Bernheim-Jeune, left their traces in his paintings, and in pictures such as *The Galleria in Milan*, 1912 (Collection Gianni Mattioli, Milan), influences of Braque's Analytical Cubist pictures are plain to see. Nevertheless, in the abstract compositions of 1913 (especially the India-ink drawings) that bear titles such as *Centrifugal Forces* or *Form-Dynamism*, once again Futurist tendencies emerge, and in a few still-life collages of 1914 they mingle with Cubist traits. A clear spatial disposition like that found in Synthetic Cubism marks the *Candlestick* (private collection, United States), in which large pieces of newspaper and painted wallpaper surround the main subject. This is also true of the *Still Life with Siphon* (colorplate 11), which was reproduced in *Lacerba* for July 1, 1914, as *Circular Synthesis of Objects*. Its glowing blue, green, and red colors succeed in muting the aggressiveness of the real materials of the collage, which include the artist's visiting card (in imitation of Picasso) and, among other printed matter, an announcement of a performance of "noise-music" by Luigi Russolo and Ugo Piatti. (Another

Carlo Belloli, "Pioniere der Grafik in Italien, 1905–1937," *Neue Grafik*, Olten, no. 3, 1958

He himself later altered the title to *Danseuse = mer*. In his autobiography Severini tells how Apollinaire, having received that issue of *Lacerba*, wrote to him to say that Severini's brilliant idea reminded him of the seventeenth-century poems arranged in pictorial shapes, and this is supposed to be the origin of Apollinaire's *Calligrammes*.

Exhibition catalogue, *Italien 1905–1925*, Frankfort, Kunstverein, 1964, pl. 69.

A complete catalogue is available: M. Carrà, *Carrà: Tutta l'opera pittorica*, Milan, 1967–69.

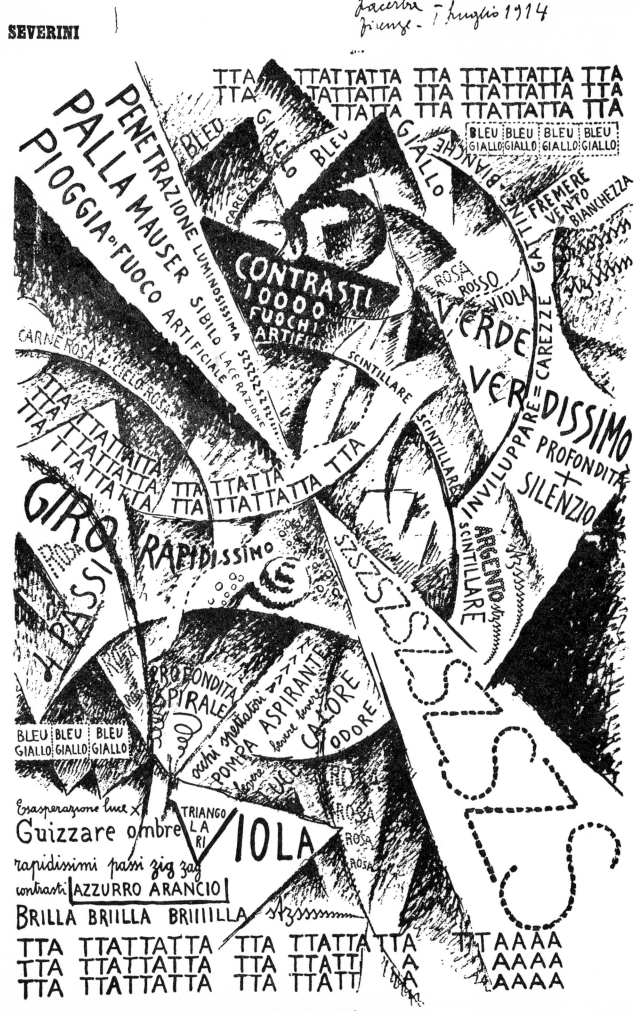

still-life collage also alludes to a concert by Russolo using "electrical instruments.")

There is somewhat more Futurist dynamic in a *Flask* (private collection, New York) whose collage elements are a colorful jumble of newspaper fragments, brand labels, sheet music, tickets, and so forth, covering the background in thick layers. On a *Still Life with Glass* (catalogue number 7/14; formerly Collection Diaghilev) the printed papers surge centrifugally into space; and on another, which is also called *Noises of the Night Café* (formerly Collection Marinetti, now lost), all formal structures are literally swamped under the "*parole in libertà.*"

The high point of this tendency was the *Manifestazione Interventista* of the summer of 1914 (plate 51). It is not unrelated to Severini's *Danza serpentina*, and, in fact, when Carrà saw that work, he wrote to Severini that he himself was currently busy with a similar idea, a "poetic picture" whose color harmony would be intensified by colored papers: "I have suppressed all representation of human figures in order to render the plastic abstraction of a civic riot." The resultant collage was published by *Lacerba* in its issue of August 1, 1914, with the title *Festa patriottica—dipinto parolibero (Patriotic Celebration—Free-Word Painting)*. It is a composition of explosive dynamism. From its circling center, rays shoot out into space in all directions in the form of narrow strips of printed paper covered by paint in reddish and bluish shadings. Words, slogans, titles, series of letters all absurdly ripped out of their contexts make up a genuine "sound-poem" whose patriotic aims are manifested in the thickly brushed and prolonged acclamations, "Long live the King" and "Long live the Army."

The warlike spirit imbues another collage also, *Pursuit* (plate 46), in which Carrà returned to a subject already exploited for a drawing with watercolor (Collection Riccardo Jucker, Milan) and an oil painting *Spazialità di un fantino (Spatiality of a Jockey)* shown in February, 1914, in the Galleria Sprovieri in Rome (present whereabouts unknown). The body of the horse in *Pursuit* is cut out of marbled paper from a school exercise book, irrelevant newspaper clippings fill the background, but the name of Joffre, painted in scattered large letters, links the picture with the current events of the war.

In the course of 1914–15 Carrà did a series of "free-word" drawings of the war, which appeared in book form in 1915 in Milan under the title *Guerrapittura (War Painting)* and which, like Marinetti's wartime *Parole in libertà*, rendered visions of happenings at the front. Carrà, however, reproduced these more thoughtfully, with geometric shapes and surfaces lending stability to the contours and suggestions of figures, objects, and landscapes. The drawings are crammed with names, slogans, phonetic renderings of noises, and in a few of them there are also documentary collage elements, such as a news item, a postage stamp, a photograph. Concerning his *Joffre Drives a Wedge on the Marne Between Two German Cubes* (Collection Mr. and Mrs. Harry Lewis Winston, Birmingham, Mich.), Carrà says in his text that the picture came to him in a dream during the night of January 20, 1915; therefore the date "914" on the original of the drawing can only have been added later.

These drawings mark the end of Carrà's Futurist period. In 1915 there was yet another still-life collage with a bottle in marbled paper and a glass cut out of newspaper pasted on a speckled ground (Collection A. Mazzotta, Milan), and this constitutes the transition to a number of pictures in "naive" style,

Russolo published his manifesto *L'Arte dei rumori (The Art of Noises)* on March 11, 1913; and on August 11, 1913, Carrà brought out his own *La pittura dei suoni, rumori e odori (The Painting of Sounds, Noises, and Smells)*.

M. T. Drudi Gambillo and T. Fiori, *Archivi del Futurismo*, vol. I, Rome, 1958, vol. II, Rome, 1962

The title *Manifestazione Interventista* must be a later label, for when the issue of August 1 of *Lacerba* went to press, the declaration of war had not yet been made public, and the Futurists were still holding tumultuous demonstrations (*manifestazioni*) calling for Italy's intervention in the war.

There is also an old woodcut illustration of which there is a counterpart in the collage of the *Festa patriottica*. Since Joffre's name became famous because of the Battle of the Marne in September, 1914, the collage can scarcely have originated before then.

A *Composition with Female Figure* (Pushkin Museum, Moscow) has paint plus collage, but its female head on a pedestal in empty space seems so metaphysical that neither of the dates proposed, 1914 and 1915, seems credible.

G. Castelfranco, in the exhibition catalogue *Futurismo*, Rome, Palazzo Barberini, 1959

Letter of March 2, 1954, to the author

The painter Antonio Marasco, on a visit to Balla's home in 1923, saw there a collage over a glass door, but in that case it depicted a stylized landscape.

among which the *Droshky* of 1916 (Collection C. Frua, Milan) once again includes pasted components. Once Carrà made the acquaintance of De Chirico in January, 1917, he threw in his lot with Metaphysical painting.

The key point of this general development is that pasted papers and interpolated words and letters brought into Futurist painting a topical, realistic, day-to-day aspect unparalleled in the French papiers collés. In the latter, the newsprint, labels, and titles allow only a vague suggestion of everyday reality to enter the abstract world of forms, whereas in Futurist pictures they are assigned an active propagandistic role and go along with the patriotic war mood. To justify this direction the Futurists explained that the ideals of revolt and heroism for which they had campaigned from the outset found in the war concrete goals to which concrete means of representation were entirely appropriate.

Among the Futurist painters subscribing to the first manifesto in 1910, the oldest was GIACOMO BALLA (1871–1958), who, along with Russolo, was the only one to remain untouched by Cubist influences and who, as early as 1912, was turning out nonfigurative compositions. In that year he designed frescoes in geometric patterns for the apartment of the violinist Löwenstein in Düsseldorf, and he used the same approach in several versions of a painting titled *Compenetrazione iridescente (Iridescent Interpenetration)*. A year later he gave his abstract compositions a Futurist twist by bringing out in them rhythmic currents of movement. His main theme became the *velocità astratta* (abstract speed) which an Italian art critic has designated as a fundamental principle of abstract art. Balla embodied this speed in innumerable permutations, among which there is also a relief in colored papers and tin foil. As for his initiation into collage, he said, at the end of 1913 he conceived the idea that simple and easily handled means such as colored papers could be used to obtain more pronounced effects of color and relief in abstract conceptions. During the ensuing years he made a number of collages exclusively of colored papers: both abstract subjects such as *Lines of Speed* or *Forces and Volumes* and landscapes which are ornamentally stylized or, in the case of the *Geometric Landscape* of 1915 (plate 54), articulated into mathematical planes. Most of these are in small format, except for the *Bridge of Speed*, a theme used also for an oil painting.

Balla too was swept along in 1914–15 by the Futurist enthusiasm for the war, which he expressed in such pictures as *The Flag on the Altar of Its Country* (Collection Benedetta Marinetti, Rome) and *The Perils of War*. These have a bold coloration which Balla considered to be "the privilege of the Italian genius." A sketch for a picture of this sort was prepared in collage and on the reverse is inscribed "Dimostrazione patriottica, 1914" (colorplate 12). Against the background of geometric surfaces in brick red and shades of blue, green, and yellow, "dynamic forces" spread out in powerful curves and loops opposed, in the foreground, by converging black silhouettes. The same elements of form and color are found in a collage of large format, *Collage for Marinetti* (plate 52), once owned by Benedetta Marinetti, which, alongside the signature "Balla Futurista," bears the date 1915, apparently applicable likewise to the *Dimostrazione patriottica, 1914*. The dimensions of the Marinetti composition ($62^5/_8$ x $27^5/_8$") suggest that this may be the collage which, as Signora Benedetta Marinetti recalls, Balla made during a visit to the ailing Marinetti to cover a cabinet mirror whose light reflections bothered the patient.

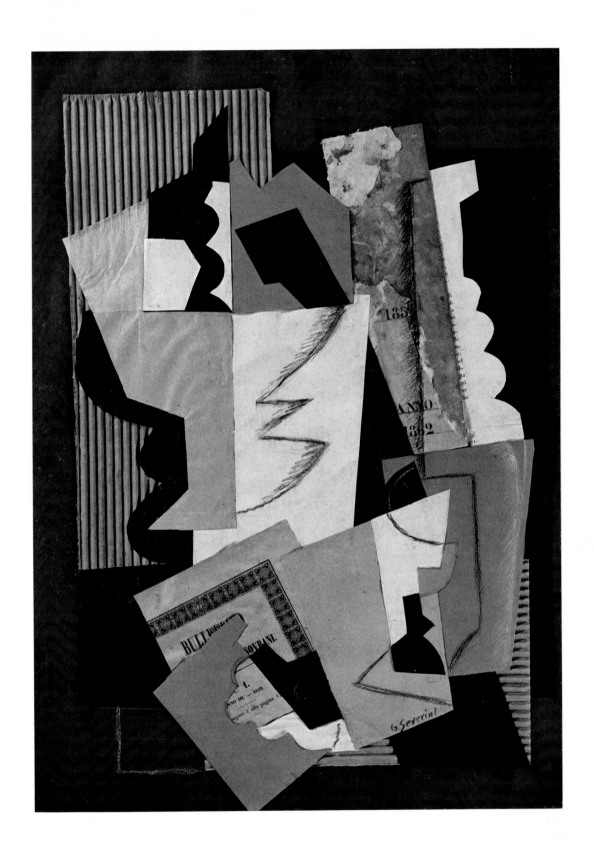

Colorplate 10. Gino Severini. *Still Life with Fruit Bowl.* c. 1913

During the following years Balla continued to use collage for working out ideas for decorations, as in a *Decorative Motif for a Floor* (signed "Balla Futurista, Via Oslavia 39"), or for practical objects such as a jardiniere. As time went on, his painting became dominated by an ornamental character.

Among Balla's most eager disciples was ENRICO PRAMPOLINI (1894–1956), who, after visiting Balla's studio, promptly withdrew from the Accademia delle Belle Arti in Rome, where he had enrolled in 1912, and entered the Futurist group. In August of 1913 Prampolini published in the *Gazzetta di Ferrara* the first of his innumerable manifestos, a call for the "chromophony of colors, sounds, and smells", in which he followed the lead of Carrà. As early as 1912 Prampolini was painting his first figurative subjects in Futurist movement, which two years later gave way to abstract representations of dynamics of form, lines of force, and the like. Two collages are known from this early period. The first, *Spatial Rhythms*, dated "13" (plate 53), suggests acquaintance with the Cubist papiers collés, since pasted in it are a newspaper clipping and the title page of an edition of Dante with a romantic illustration, and over these there is bold drawing in which a head takes shape. The sharp distinction between foreground and background and the summarily sketched figure reappear in the oil painting *Figure + Window* of 1914 (private collection, Rome). In the second collage, *Chromophony—Lines of Force, or Mechanical Rhythms*, dated 1914 (Collection Lorenzelli, Bergamo), the spread-out pages of a book disappear behind a system of lines and curves. Prampolini submitted fourteen works to the *Mostra Libera Futurista*, the *First Free International Exhibition of Futurist Art*, held from April 13 to May 25, 1914, in the Galleria Sprovieri in Rome. Along with abstractions "still determined by the object being depicted," he showed also *Béguinage* (colorplate 13), a still life of scraps of lace, tinsel, velvet, straw, wire netting, and a feather on a wooden panel with splashes of red paint. This assemblage of scraps, put together with poetic feeling, was entirely unconventional in Italy at the time.

Not only the Futurist painters but also the poets Marinetti and Cangiullo showed pictures and sculpture in the Galleria Sprovieri. According to Prampolini, among the works of Cangiullo were two "object sculptures," early ancestors of Dada. One, the *Poeta in corso* (*Poet in Progress*), consisted of brushes, frames, and boxes all stuck together and hanging by a wire from the ceiling. The other, *Filosofo modelato a schiaffi* (*Philosopher Modeled by Slaps in the Face*), was made mostly of paper and books; a grater stood for the brain of the individual portrayed, and tampons of cotton protruded from his ears.

Prampolini himself continued to maintain a lively interest in new materials and their potentials for artistic purposes. For the first number of the magazine *Noi*, which he founded with B. Sanminiatelli, he wrote an article dealing with the various materials and objects the Cubists had introduced into their pictures. In his view, these real elements convey lyrical emotions to the inner, psychic content, and only through them do geometric constructions take on their real meaning. Since then, he says, a newer way has been opened: "We have come to the point where the conventional components of pictures are replaced by real elements, which we take in their authentic material nature; then, as is well known, we eliminate their usual utilitarian character and, quite literally, give new life to the fragments of objects, insofar as we arrange them according to their effectiveness in plastic-architectonic terms." As

The title, date, and signature appear to be added later but can be taken as trustworthy.

A picture made of cork inner soles and tufts of wire (Galleria Lorenzelli, Bergamo) is reproduced in the catalogue of the *Dada 1916–1966* exhibition (Civico Padiglione d'Arte Contemporanea, Milan, 1966) and dated 1914. In style, however, it appears to be one of the "multimedia pictures" of the early 1930s.

Delaunay certainly had a work of this sort in mind when he complained of the foreigners who meddled in French art and who, with Picasso and Boccioni at their head, introduced newspaper, nails, and fragments of glass into their catastrophic imitations; and he cited as an example an Italian who was said to have put *mortadella*, hair, and heteroclite objects into a frame (*Du Cubisme à l'art abstrait*, Paris, 1957, p. 123).

examples he cites cuttings from newspapers, scraps and fragments of objects, illustrations, numbers and printed letters, canvas, cardboard, sand.

True to his convictions, Prampolini continued to seek out new materials and combinations of materials and soon began to produce relief pictures, which he called "interviews with matter" and which he later developed more methodically into his system of *"arte polimaterica"* (multimedia art).

Like Prampolini, FORTUNATO DEPERO (1892–1960), who joined Balla in Rome in 1914, took up the cudgels for new materials and artistic genres. On Balla's proposal he was officially taken into the Futurist group in 1915, during which year he and Balla together put out a manifesto, *Ricostruzione futurista dell'Universo (Futurist Reconstruction of the Universe)*. The list of utilizable materials that Boccioni had already compiled in 1912 in his *Technical Manifesto of Futurist Sculpture* is here considerably expanded to include all sorts of cloth, metals, shiny substances, and transparent chemical fluids. With the help of these, artists were to create mechanical, electrotechnical, musical, and noise-producing works, as well as "plastic complexes" which would revolve around vertical, horizontal, and diagonal axes—in short, "kinetic sculpture" such as has become again in our days a focus of artistic interest. Finally, says the manifesto, art should make use of water, fire, and smoke. In line with all this, Balla himself produced a *Portrait of the Marchesa Casati* in wood and cardboard, with mechanical devices to set the eyes and heart in movement (destroyed).

Depero's inventive spirit extended to all fields of applied art. In 1916, at an exhibition in the Sala di Corso Re Umberto in Rome, he showed *Tavole parolibere murali*, "free-word" collages in large printed letters filling entire wall surfaces in geometric arrangements. These were forerunners of the "typographical architecture" Depero devised for the Book Pavilion of the *International Exhibition of the Decorative Arts* held in Monza in 1927. He also busied himself with Futurist toys intended to stimulate and entertain children and adults alike. Above all, however, his name is linked to the mechanical marionettes he devised for Anton Giulio Bragaglia's Teatro dei Piccoli and the costumes and scenery he designed for the Diaghilev Ballet in Rome in 1917–18, for which upon occasion he used collage.

The catalogue of the Société Anonyme Collection, Yale University Art Gallery, lists "*New Marionette for Plastic Ballet*, collage of colored papers on cardboard, $20\frac{1}{4} \times 16$ in., purchased: the artist, New York, 1929."

According to Mikhail Larionov, she had previously been married to the Russian ambassador in Rome, V. B. Kvotchinsky, who before the war owned an important collection of modern Russian art.

The Czech painter ROUGENA ZATKOVA (1880–1924), Marinetti's sister-in-law (she was married to the brother of Benedetta, Marinetti's wife), likewise was in contact with Balla. The Russian painter Mikhail Larionov received as a gift from her a collage (plate 55) which, according to his information, was done about 1913 and which, in materials and use of color, shows the unmistakable influence of Balla. It is an abstract composition, full of movement, using metallic foil in gold, silver, and green, along with plastic film and tissue paper in shades of yellow, rose, orange, and green.

Information about this artist is scanty and anything but precise, but what is known seems most often to have to do with collage. Benedetta Marinetti owns a Bible which her sister-in-law illustrated with collages at an early date. There was an oil painting by Zatkova in the exhibition at the Galleria Sprovieri, and her connection with the Futurists is attested by her presence at a soiree organized by Marinetti in his salon in Milan on the eve of Italy's entry into the war. As entertainment for the occasion, Luigi Russolo and Francesco

Francesco Cangiullo, *Le serate futuriste*, Naples, 1930

Balilla executed their noise music, and among the guests were Stravinsky and Diaghilev with friends of theirs from Switzerland. Zatkova met both of them soon again in the home of Larionov and Natalia Gontcharova in Lausanne, where she had moved for reasons of health. Gontcharova recalls that about that time an exhibition of Zatkova's still-life collages caused a stir, but it has not been possible to track down exactly when and where this took place.

Between 1917 and 1920 Zatkova made a number of very unusual painted metal reliefs, among them one of 1918, *The Monster of the War* (Collection Benedetta Marinetti, Rome), in which narrow and broad bands of metal were riveted together in curves and vaultings and shaded with color, a technique in which Zatkova obviously did her most personal work. When Marinetti went to Prague in January, 1922, and gave a lecture sponsored by the magazine *Veraicon*, he was welcomed by Zatkova in the name of the Czech Futurists. A portrait of Marinetti (Collection Benedetta Marinetti, Rome), painted in somewhat Expressionistic manner, was reproduced in the Czech magazine *Pásmo*, no. 10, 1925, and Prampolini published works by her in the second series of *Noi* in 1922–24.

Because the later work of MARIO SIRONI (1885–1961) was so different in style, one tends to overlook that in his youth he too was part of the Futurist group in Rome. There he became acquainted with Balla, Boccioni, and Severini as early as 1905–1906 and followed in their footsteps about 1912, though at first he held aloof from the Futurists' exhibitions. Boccioni introduced him to Marinetti in Milan in 1914 and shortly before the outbreak of the war took him with him to Paris. In 1915 Sironi was adopted into the Milan Futurist group. When Italy entered the war, he signed up, together with Marinetti, Boccioni, and Russolo, in the "Volunteer Bicyclist Battalion," which thereafter became famous.

While one can find reminiscences of Boccioni in Sironi's *Self-Portrait* of 1913 (Civica Galleria d'Arte Moderna, Milan), his early abstract compositions are unequivocally modeled after those of Balla. Two of them, the earliest ones with collage additions (Collection A. Mazzotta, Milan), were certainly not done before the similar works by Balla and should probably be dated 1914. In one case Sironi used colored papers and metal foil in the same way as Balla, though, unlike him, he went over them with brush textures. In the other he glued a railway ticket with the notation "Rapido" between textural matter written out by hand.

From 1915 on Sironi often had recourse to collage, and in it he worked out a very personal style of expression. The exact chronology of those works is difficult to establish, since only a few are dated and even then the dates are often subject to question. A *Dancing Girl* (Collection Gioffrè, Rome) is dated January, 1915; *The Bicyclist* (formerly Collection Margherita Sarfatti, Rome), 1916; and very close to the latter is *The Motorcyclist* (Collection Mr. and Mrs. Harry Lewis Winston, Birmingham, Mich.), in which a piece of newspaper from 1916 is pasted. However, within the vigorous painting of *The Bicyclist* the collage elements scarcely stand out. Also to be dated relatively early are the *Harlequin* (Collection A. Mazzotta, Milan) and the *Leaping Horse* (Collection Eric Estorick, London), both including various colored papers whose contours, in the *Harlequin*, belly out like festoons to enhance the decorative quality.

Included in the exhibition *40 Futuristi* organized by C. Belloli at the Galleria Toninelli, Milan, 1962. See Belloli, "Regesti del futurismo plastico" in the catalogue of that exhibition, which also includes a photograph of the metal relief.

In the catalogue of the Venice *Biennale* of 1962 and in that of the exhibition *Italien 1905–1925*, Frankfort, Kunstverein, 1964, the first collage is dated 1912 and the second, mentioned only in the Frankfort catalogue, about 1912–14.

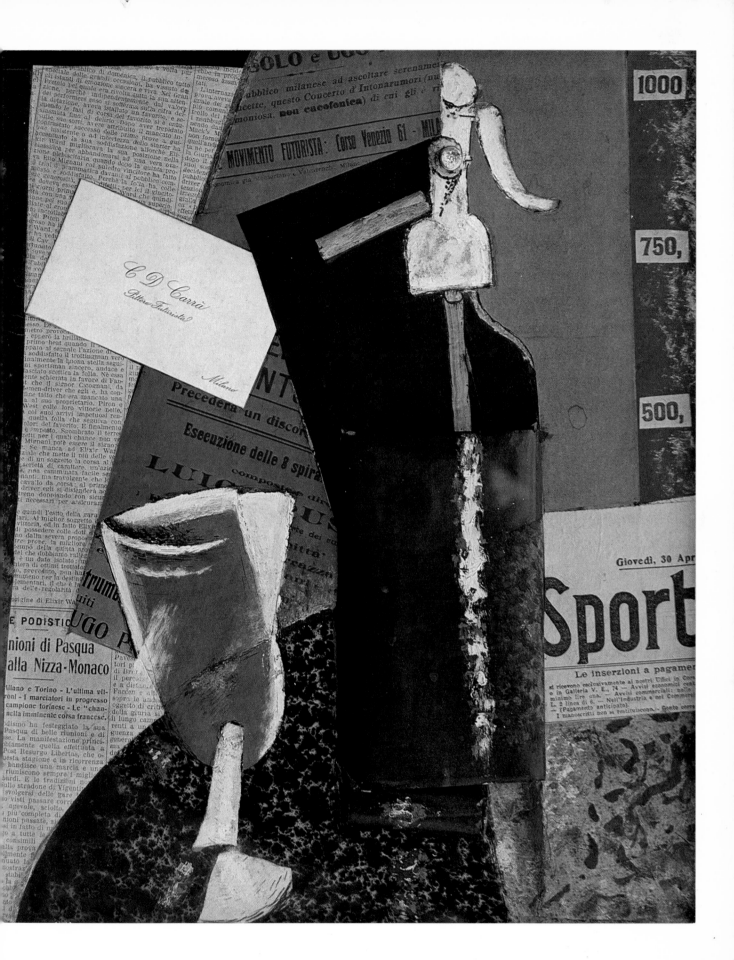

Colorplate 11. Carlo Carrà. *Still Life with Siphon*. 1914

With the 1915 *Composition with Propeller* (Collection Gianni Mattioli, Milan), in which a pasted page of printing makes a conspicuous triangle in the foreground, appear new pictorial subjects in which Sironi intermingled machine and engineering parts with abstract color-shapes, thereby throwing into question the real nature of the real objects. *The Atelier of Miracles* (Collection Emilio Jesi, Milan), a tempera painting, shows what mysterious effects Sironi could achieve. There is something weirdly fantastic too about a collage sketch, *L'Apocalisse Cartacea (The Paper Apocalypse)* (Collection Eric Estorick, London), on which, as on an illuminated stage, stands a statue made of folded paper, like those that children make, representing a horseman of the Apocalypse with a penholder for a lance. A dateline of November 17, 1917, on one of the pasted pieces of newspaper gives a basis for dating the picture. On another collage connected with mechanical subjects, *The Airplane* (Galleria Blu, Milan), the large, geometric shapes of paper are organized into a lucid composition.

Pieces of the same Spanish newspaper used in the *Composition with Propeller* occur in two other collages, *The Ballerina* (colorplate 14) and *The Fisherman's Wife* (private collection, Milan). This would seem to indicate that at the time Sironi did them, probably the end of 1916 and in 1917, he was already from time to time abandoning the agitated Futurist treatment of form in favor of the more tranquil metaphysical approach that was to dominate his painting after the war. In *The Ballerina* a rigid manikin like those of Giorgio de Chirico is transformed into a fidgety jointed doll performing her tightrope dance in a twilight of darkly glowing colors damped down by the mat-gray tones of the newspaper cuttings. The Futurist dynamism, however, was brought to a full stop in *The Fisherman's Wife* (plate 56). A strange melancholy exudes from this image of a woman in a stiff newspaper dress standing on the shore, while behind her a small steamship belching thick smoke sails out of the harbor. In like manner the collage of *The Wanderer*, from about 1917–18 (Collection Emilio Jesi, Milan), with its large figure striding in front of night-lighted houses, holds something of the romantic atmosphere that was more and more to pervade Sironi's subsequent pictures.

Over and beyond the genuine collage pictures there exist a number of sketches which Sironi enlivened by the occasional use of pasted elements. A *Dancer* (Collection Cesare Tosi, Milan) wears a tutu and short jacket of lace and a checked apron; a *Seated Woman* (same collection) is decorated with a polka-dotted blouse, and a piece of wallpaper serves as label for a bottle alongside her. When newspaper cuttings are used, it is chiefly as graphic differentiations. Thus, in the *Still Life with Siphon* (Tate Gallery, London) they cover an unreal house front in the background of the open window. In another collage of somewhat later date they are used to clothe a male figure (Collection Eric Estorick, London). Paper trimmings are found also in the oil and tempera paintings of 1917–19, such as one in the *Yellow Truck* series, the *Suburban Café* (Galleria La Tartaruga, Rome, 1958), and the *Suburban Cathedral*. Finally, pale papers are used as architectural side flats in the *Mystery* of about 1923 (Collection Paoletti, Milan), the last known example of a collage by Sironi.

By that time he had broken completely with Futurism. At the close of 1922 he joined the Seven Painters group in Milan, which met in the Galleria Pesaro and aimed at a return to academic painting. In 1926 he also became a member

of the "900" movement (the year 1900 in Futurist formulation), which called for a national art of the good old school and won for itself the good will of the Fascist government.

Florence

In Florence Futurism gained ground as a result of the exhibition *Pittura Futurista di Lacerba* organized by Soffici, which took place from November, 1913, to January, 1914, in the Galleria Ferrante Gonnelli. It aroused lively interest among the younger artists, providing for many among them a first contact with Futurism which would lead to further repercussions. Among these was ANTONIO MARASCO (b. 1896), at that time still a student at the Accademia in Florence. In January of 1914 Marasco accompanied Marinetti to Russia, where the collector Ivan Morosov is said to have bought one of Marasco's pictures. Initially influenced by Cézanne and the Cubists, Marasco's work was given a dynamic impulse by Futurism, and the example of Boccioni especially is evident in such pictures of 1917 as *Caletta a Capri* and *Drinker* (Collection the artist, Rome).

For the collages he did in Florence, however, Marasco followed the Cubist orientation, with surface compositions varied by lively brush textures. In the earliest *Still Life with Bottle and Glass*, which is dated 1914, as a nod to Futurism he introduced the catalogue cover of the Brussels exhibition of May–June, 1912, along with picturesque illustrations from a coffee advertisement, a horseman with mustache binder, and so forth. In the *Still Life with Carafe* (plate 59) the large-lettered names "Braque" and "Boccioni" represent the decisive models that he had in mind; the newspaper photograph of a baby, which appears as if reflected in the carafe, makes a rather embarrassing effect within this context. In a third collage, *Jo e il Bar* (Collection Melvin Ury, San Francisco), a head in profile is formed within the transparent planes between which, as in Soffici's pictures, are interposed innumerable pieces of printed matter and labels.

The three collages are so similar in style that they are thought to have been finished within a short period.

Marasco had his first private show in 1918 in Florence. After the war he traveled in Switzerland, the Baltic countries, and Germany, where he came under the influence of the painting of Oskar Schlemmer and Willi Baumeister. On the strength of that experience he undertook the abstract geometric pictures with which he participated in the various exhibitions of the "second wave" of Futurism.

As for OTTONE ROSAI (1895–1957), as late as 1913, in his first sho win Florence, he exhibited landscapes he called *Fuochi (Fires)*, whose color and formal treatment were still marked by a diffuse Neo-Impressionism. About 1913–14 he took the decisive turn to Futurism. Numerous pictures of that period, among them the *Still Life with Bottle + Zang Tumb Tumb* (Collection Riccardo Jucker, Milan), the *Dynamism of Bar San Marco* (Collection Gianni Mattioli, Milan), and *De-composition of a Street* (Collection Gianni Mattioli, Milan), were executed in oil as well as in collage; and the collages seem to have been usually later than the paintings. The scraps of paper distributed across the pictorial surface in angles and curves transmute the more static underlying compositions into energetic movement. At the same time the interpolated words

In the *Still Life*, a volume of poems by Marinetti, with fragments of its title *Zang Tumb Tumb*, is painted; and the date of its publication, 1912, has been erroneously connected with the date of the picture. The collage version is lost or destroyed.

and texts lend to the representations an air of modernity in line with Futurist principles. In the collage version of the *Dynamism of Bar San Marco* (plate 57), newspaper reports and advertising posters tumble down, smothering beneath them the drinker and his table. In the *De-composition of a Street* publicity slogans cover the house fronts, which in the painted version remain bare, and in the foreground scraps of newspaper whirl around the wagon wheels. In the center there is a small strip with the name of *Lacerba*, which, in its issue of April 1, 1914, published another collage by Rosai with the title *Latrina* and appropriate printed matter, which includes, among other things, an advertisement for a cure for skin diseases. A *Still Life with Bottle and Glass* of 1914 (Collection P. Rosai, Trieste) is crowded with cutout and piled-up pieces of paper and printed matter.

Such excesses are no longer found in *The Carpenter's Bench*, likewise from 1914 (Collection Emilio Jesi, Milan), a very impressive still life, in which the various pieces of printed matter and labels lose all their aggressiveness in the mysterious half-light of the colors. The flask and the slow-freight label *("piccola velocità")* are enough to assure us of Soffici's influence. The landscapes and still lifes of the following year are even calmer and simpler. A *Still Life with Fruit Bowl* of 1916 (Collection Gianni Mattioli, Milan), on which an inconspicuous newspaper marks the parts of the bowl that are in shade, is entirely in the spirit of Cézanne. The *Typist* of 1918 (Collection A. Mazzotta, Milan)—listed in the *Archivi del Futurismo* as *Soldato dattilografo (Soldier Typist)*—includes collage one last time, two tiny typewriter keys glued on. By that time Rosai had long forgotten his flirtation with Futurism, which later he recalled only with the greatest reluctance.

On the entire group of Florentine Futurists—which during the war was comprised of Rosai, Primo Conti, Achille Lega, Neri Nannetti, Emilio Notte, and Lucio Venna—the influence of Soffici was such as to make formal discipline and careful application of paint dominate, and to curb the Futurist explosive *brio*. Most of these artists occasionally introduced collage elements into their pictures, but usually only for their documentary value. Thus NERI NANNETTI (b. 1890), in his *Portrait of the Writer Rivosecchi* of 1916, followed the example of Severini and introduced two pages from books by the sitter. In his *Portrait of the Artist's Mother*, dated 1917 (colorplate 15), ACHILLE LEGA (1899–1934) glued in a fragment of the title page of the magazine *L'Italia Futurista*, founded by Bruno Corra and Emilio Settimelli in Florence in 1916, in which Futurism was hailed as a nationalistic movement. On the other hand, a collage by EMILIO NOTTE (b. 1891), *The Piazza* of 1919 (Galleria Civica d'Arte Moderna, Brescia), has scarcely anything to do with Futurism. It depicts an animated piazza in traditional Expressionistic style, with a few scraps of paper pasted on houses in the foreground; printed matter makes "real" posters on the front of one house; the roof of another is covered with red paper.

Collage played a greater part in the work of PRIMO CONTI (b. 1900). Precocious, he published poems and musical compositions as a youth and as early as 1914 exhibited painting in an exhibition in Florence. The impressions made on him by the *Lacerba* exhibition finally crystallized about 1917 into a Futurist style of a personal stamp, in which figurative subject matter was split into simultaneous color and form complexes. Pieces of newspaper are glued into

Reproduced in Joshua C. Taylor, *Futurism*, The Museum of Modern Art, New York, 1961, p. 105

A. Parronchi, "Preistoria di Rosai," *Paragone*, no. 25, 1952

The Galleria La Medusa in Rome disinterred these rather forgotten pictures for an exhibition *Dopo Boccioni* in 1961, for which there is a well-prepared catalogue.

In 1917, together with Venna, Notte issued the manifesto *Fondamento Lineare Geometrico*, in accord with which his pictures from this time are geometric linear constructions.

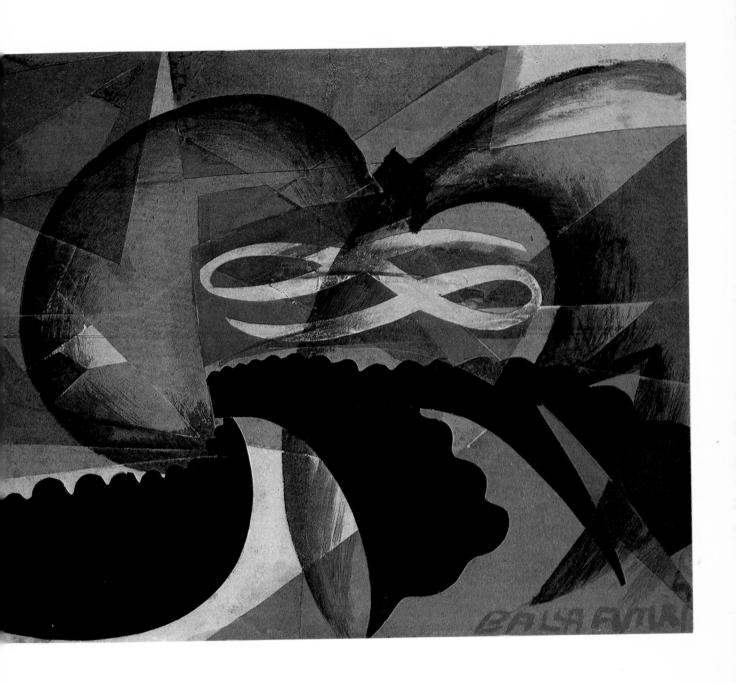

Colorplate 12. Giacomo Balla. *Patriotic Demonstration.* 1915

a number of his pictures of that time: *Simultaneity of Environment* (plate 58), *Juggler* (Collection of the artist in 1958), *Doll—Synthesis of Modern Night* (Collection Giuliano Gori, Prato, Italy), and *Refugees at the Railroad Station* (Collection of the artist in 1958), among others. The paint is applied in a thick impasto of glowing red, blue, and dull whitish gray and yellowish tones, enveloping the figurative elements in an unreal atmosphere where forms emerge and withdraw. Alongside the modeled bodies and objects, the newspaper cuttings and marbled papers are used to set up graphic surface values, as with the Cubists, and the numerals have the effect of suddenly arresting the eye. At the same time, these elements too belong among the fragments of the shattered world seen in these pictures.

Two of the collages, *Village Street* and *Doll—Synthesis of Modern Night*, are dated 1918; the others originated a year before or after that. There were no more of them, once Conti turned away from Futurism in 1920.

At Pistoia, in Tuscany, from 1916 to his early death, MARIO NANNINI (1895–1918) evolved a personal style under the impact of Futurism, though he held aloof from its public demonstrations and exhibitions. He coupled the Futurist way of rendering the environment by a multiplicity of simultaneous optical impressions with a splitting up of surfaces more suggestive of Cubism. His definitive work was preceded by a rather sentimental still life with candlesticks and vases of flowers titled *Ave Maria* (private collection, Modena, in 1958), in which are pasted a death announcement from a newspaper and a small common holy picture with the Madonna in the clouds. In the works that followed, collage played an ever greater role, and occasionally Nannini drove segmentation so far that the contours of figures became transformed entirely into dynamic lines of force. Between the planes set at acute angles to one another, large letters and numbers crop up, cover the faces, metamorphose into flowers and fruits; and in the midst of it all there are newspaper headlines alluding to the day-to-day happenings of the artist's provincial home town. In a still life, *La Nazione* (Galleria Civica di Arte Moderna, Brescia), the typographical elements pile up to such an extent that one recognizes the objects only because of the color associated with them. The portrait *Aunt Esther* (private collection, Modena, in 1958), representing the confidante of his difficult early years, is full of newspaper items and numbers which create an environment of everyday, banal reality around her. Other collages have scraps of cloth—a bit of brownish red brocade in *Two and Stroll* (plate 60); a piece of white net lace embroidered with flowers in *Roses*. These elements suffice for the artist to bring into his dramatic pictorial construction a gently poetic note, also caught by the color harmonies.

The Florentine painters Rosai, Lega, Conti, Nannetti, and Notte all took part in the *Grande Esposizione Nazionale Futurista* that Marinetti organized in the Palazzo del Cova in Milan in 1919. But this was to be the last time. Already they were venturing into other paths that were to lead them away from Futurism, as well as from each other.

To the Florentine Futurists must be added the Argentinian EMILIO PETTORUTI (b. 1895), who was associated with the Futurist movement in Florence from 1913 to 1916 but without joining in their public activities. When he went there in 1913, he became a habitué of the Caffè delle Giubbe Rosse, where Soffici and Papini presided over discussions with their adherents concerning the artistic problems of the day. At the *Lacerba* exhibition he also encountered

Village Street was exhibited by the Galleria Michaud, Florence, at the *Mostra Mercato Nazionale d'Arte Contemporanea*, Florence, Palazzo Strozzi, 1964.

Most of these pictures are in the collection of Dr. Vittorio Frascione, Florence.

A. Parronchi, "Il Futurista incognito Mario Nannini," *Paragone*, no. 85, 1957

Marinetti, Boccioni, and the other Futurists and remained in contact with them thereafter. However, he was seeking his own way, one which took him into the museums, where he plunged into the study of the old Italian masters and of Etruscan art. It was there that he discovered the principles of order and measure which have continued to dominate his painting up to the present.

In December, 1914, at the *First Tuscan Winter Exhibition*, he showed two black-and-white drawings of abstract rhythms, early examples of a series of representations of dynamic forces and harmonious movements related to the abstract pictures of Balla. He held his first exhibition in Florence in 1916 in the Galleria Ferrante Gonnelli, showing collages along with paintings and drawings. During those years Pettoruti had been intensively concerned with collage. One of the earliest of his pictures, *City-Country* of 1914, in which a piece of newspaper and picture postcards are pasted, reveals Futurist influences in the circular arrangement of the architecture. However, in the *Bunch of Grapes*, of the same year, there are Cubist reminiscences in the static disposition of the surface elements, and these were to dominate in his later works, which contain the typical paraphernalia of the French papiers collés: the Seltzer siphon, the goblet, and the cluster-of-grapes motif of Braque. On the other hand, the link of the Futurists, to Soffici in particular, is confirmed by excerpts from the magazines *Lacerba* and *La Voce*; and the *Siphon* of 1915 (Collection E. Pettoruti, Paris) includes also a postcard showing the Duomo of Florence.

Reproduced in the exhibition catalogue *Cinquante ans de collages*, Saint-Étienne, 1964

Pettoruti's special, unique qualities reside particularly in the delicate accord of tonal and textural values, of subtle coloring in which bright green and glowing red contrast with mat brown and dark blue, and glistening silver paper sparkles amid the monotone of newsprint. He made use of scraps of wallpaper with old gold patterns, and the introduction of clear plastic film made possible delicate, transparent effects which lent an air of unreality to his extremely precise pictorial constructions.

Besides the title page of the October 1, 1914, *Lacerba*, there is also a page from Soffici's article, "Per la guerra—il trionfo della merda" ("For War—the Triumph of Shit"), which made a particular impression on Pettoruti.

From October, 1916, to June, 1917, Pettoruti was in Rome, where he became acquainted not only with Balla and Prampolini but also with Giorgio de Chirico. Collages such as *The Folded Curtain* and *My Window in Florence* (colorplate 16), dating from 1917 presumably after his return to Florence, reveal influences of De Chirico in the alternation of illuminated and shadowed pictorial surfaces as well as in the abrupt foreshortening in depth.

Pettoruti moved in August of 1917 to Milan, where he was occupied not only with painting but also with mosaics and stained-glass windows. After a stay in Paris, where he came into contact with Severini too, he returned to Argentina in 1924 and remained there until 1951. Since 1953 he has been living in Paris and devoting himself entirely to nonobjective painting.

Catalogue, *Pettoruti, Cinquante ans de peinture*, Paris, Galerie Charpentier, 1965

The Second Generation

The second phase of Futurism set in after World War I and at first had its center once again in Rome, in the circle of Balla. It was Prampolini and Depero who, in their subsequent work, made a major contribution to bridging the gap between the first and second generations.

At that time geometric tendencies came to the fore in Prampolini's painting. Out of interpenetrating planes differentiated by color, he constructed

73

Fedele Azari, "Il Teatro Aereo Futurista," *Roma futurista*, January, 1920, reprinted in Luigi Scrivo, *Sintesi del futurismo, storia e documenti*, Rome, 1968. For the Futurist theater in general, see Mario Verdone, *Teatro del Tempo Futurista*, Rome, 1969.

Pannaggi designed collage costume for Marinetti's *I Prigionieri di Baia* in 1925 and for *L'Angoscia delle Macchine* by Ruggero Vasari, which Marinetti presented in 1927 in Bragaglia's Teatro degli Independenti in Rome (photographs of costumes and sets, with an excerpt of the Futurist incidental music, in Verdone, *Teatro del Tempo Futurista*). In the same year, Depero showed his *Ballo meccanico* in Russia.

Both in the Study Collection, Museum of Modern Art, New York; one reproduced in *Pannaggi*, Oslo, 1962, a brochure put out by the artist himself; the other in John Lynch, *How to Make Collages*, London, n.d. Pannaggi was one of the earliest Futurists to exhibit in the United States. Since the end of World War II he has been living in Oslo.

still lifes and architectural forms in space, and to some of these he added colored papers. In *Landscape: White Houses and Brown Door* (Yale University Art Gallery, Collection Société Anonyme, New Haven, Conn.), of somewhat later date, the papers arching outward further emphasize the decorative character that, in general, dominates all Futurist painting of this period.

Two new personalities soon entered Balla's atelier, IVO PANNAGGI (b. 1901) and VINICIO PALADINI (b. 1902), both of whom were studying architecture as well as painting and, like the entire group, were interested in new forms in all fields of art. A manifesto for "Futurist Decorative Art," issued by Prampolini in 1919, was followed in 1920–21 by manifestos for "Futurist Aerial Theater," "Futurist Dance," "Futurist Furniture," and "Futurist Scenography." All these cultural undertakings received the active support of the avant-garde photographer Bragaglia, whose home had been the Futurists' meetingplace even before the war. In October, 1918, he opened a gallery called the Casa d'Arte Bragaglia with a show of Balla and in January, 1921, exhibited the first Futurist pictures by Pannaggi. It was at the Circolo delle Cronache d'Attualità, which he also organized, that, in June, 1922, the *Mechanical-Futurist Ballet* by Pannaggi and Paladini was performed by two Russian dancers accompanied by "polyphonic noise-rhythms" from the racing motors of two motorcycles in a room above the stage. For one dancer Paladini designed a costume of a "human phantom"; the other was dressed by Pannaggi in a "mechanical costume." These were made of cardboard and varicolored papers and cloths covering the bodies in stiff sheaths and tubes, somewhat related to the Dadaistic costumes and masks made by Marcel Janco for the Cabaret Voltaire in Zurich. For this occasion Pannaggi also made a poster in which a photo of the dancer in costume is combined with a montage of printed matter and illustrations (plate 63).

In subsequent years he did other photomontages, such as the *Self-Portrait* of 1925, in which a snapshot of the artist in an athletic pose is set into an advertisement for locomotives. He designed various advertising posters for German patrons during sojourns in that country, where he was well known after 1923, when his works were exhibited at Der Sturm.

Along with these he executed more typical examples of the form as "post collages," which were assembled from photographic and typographic elements and even incorporated the address of the receiver, the post office courteously cooperating in applying the regulation cancellations to the applied postage stamps. Pannaggi sent a first collage letter to Marinetti in 1920; two others were addressed in 1926 to Katherine Dreier in New York, who had invited him to an exhibition at the Société Anonyme. On one of these, together with the address of cutout printed letters, a menu appears, surrounded on fibrous wrapping paper by the announcement of a cure for aching feet, transportation tickets, newspaper illustrations, and the portrait of the artist mounted in an automobile tire. The horizontal–vertical organization of planes reveals influence from the Bauhaus, with which Prampolini had been connected since 1922.

Further photomontages were done by Pannaggi and Paladini about 1927 in the course of their experiments with photography and cinema. Paladini mounted a surrealist film, *Luna Park traumatico*, in 1927 and in 1929 published an article in *L'Italia letteraria* on the significance of abstract photomontage. In those same years BRUNO MUNARI (b. 1907) was using photomontage for

book covers, some with football players rather like Baumeister's photodrawings of athletes.

Paladini was among the active champions of "Rational Architecture," who aspired to do away with the traditional classicistic styles of building. That group was founded in 1926 by certain Roman architects and held two exhibitions, one in 1929, the other two years later. For the second of these, P. M. BARDI (b. 1900) put out a gigantic montage *Tavola degli orrori (Panel of Horrors)* (plate 61) with a text fulminating against "culturalistic" architecture, whose romantic-eclectic buildings blocked the development of a truly modern architecture, and with reproductions of monuments and elaborate buildings of all times and styles jumbled together with portrait photos, caricature drawings, and scraps of printing—the whole intended to put before the eyes of the public the wrong track being pursued by official Italian building policy. The montage was published in the daily newspapers and unleashed a heated discussion on the directions and aims of architecture.

Large-scale photomontages and wall decorations were in demand for the *Exposition of the Fascist Revolution* held in the Palazzo Venezia in Rome to celebrate the tenth anniversary of the March on Rome. Responsibility for the decorations was assigned to forty architects, painters, and sculptors, among them Sironi and Prampolini. In response to Mussolini's appeal to artists to abandon all the decorative styles of the past and to create instead "something contemporary, audacious, suitable to Fascism," the usual materials for exposition displays, mainly cardboard, were replaced by glass, marble, wood, and steel in order to provide worthy frameworks for the enormous montages with their floods of documents, newspaper clippings, photos, proclamations, letters, banners, black shirts, weapons, and other trophies. A wall collage (plate 62) by GIUSEPPE TERRAGNI (1904–1943), a member of the League of Rational Architects, was built around the heart-stirring theme of "How the Blazing Words of Mussolini Appeal to the Italian People with the Force of Turbines and Convert Them to Fascism" and gives some idea of what effect of "grand style" the Italians were able to achieve with photomontage. They continued to be masters in this medium, as they proved again in their national pavilion at the Brussels World Fair of 1935.

Turin

While neither constructions using various materials nor the photomontages that played such a role in Rome in the second phase of Futurism coincide more than marginally with collage, genuine collage found new adepts among the artists of the Futurist group founded in Turin in 1924 by FILLIA (pseudonym of Luigi Colombo). Their works reveal no common style but instead derive from the most diverse sources and tendencies, and at the most it was the newly awakened interest in the use of unconventional materials that linked them.

The earliest and most unusual collages were done by FARFA (real name, Tommasini) (1881–1964), who in the 1920s participated in all the manifestations of the Turin Futurists but nevertheless remained a lone wolf whose inborn irony was incompatible with the Futurists' hyperdramatic approach to life. In Trieste, his native city, he participated in the first "Futurist evening" in January, 1910, and made the firsthand acquaintance of Mussolini

The *Tavola degli orrori* had a forerunner in a montage that El Lissitzky devoted to architecture at the *First Agricultural Exposition of the Soviet Union*, Moscow, 1923. Reproduced in *Kunstwerk* in 1935, it may already have been known in Italy. Paladini was born of Italian parents in Moscow and maintained a lively interest in the modern art of the Soviet Union. After the Russian pavilion at the Venice *Biennale* of 1924 showed modern art, Paladini published, in the next year, an essay on art in Soviet Russia (Rome, Collection Bilancia). Of the works exhibited by Pannaggi at the Venice *Biennale* of 1926, Prampolini wrote that "using architectonic elements, he constructed abstract volumes after the manner of Malevich and Lissitzky." The photomontages of both Italians may have been inspired by Russian examples.

The portrait was shown by the
Galleria Schwarz, at the
Dada 1916–1966 exhibition, Milan,
Civico Padiglione d'Arte Contemporanea, 1966.

in 1919, in Turin, where he settled after the war. His first postwar pictures, such as the *Arcicorde Paganini* of 1919 (Galleria Schwarz, Milan), have a linear, ornamental character that recalls the *Jugendstil* and the French *musicalistes*. At the *Grande Mostra Nazionale Futurista* held in the Palazzo Madama at Turin in 1923 Farfa showed twenty-five pictures, among them his first collages, which were made exclusively of colored papers and designated by their author as "paper-paintings," *cartopitture*. His *Geographical Portrait of Marinetti* dates from 1923 and consists of a map of Italy composed of varicolored strips of paper pasted together to assume the aspect of a heaven-storming Titan. A year later his compositions were fully abstract, like the *Mani a riflessi variopinti (Hands with Varicolored Reflections)*, two five-fingered bundles of rays that intersect on a dark background. In other pictures a single simple object is repeated rhythmically with an effect rather like that of poster art, as in the collage of the *Cavalcata delle campane (The Cavalcade of the Bells)*, of 1928, in which bells of different sizes swing into the pictorial space from either margin.

Along with these, however, Farfa fabricated collages with extremely fantastic subjects, in which he gave full rein to his caustic flippancy. These bear highly evocative titles such as *Eve Presents the Apple to the Serpent*, *The Cedar Tree in Love*, or *The Scandalmonger*, applied to pictures full of subtle allusions and double meanings. Among the most curious is the *Soubrette* of 1927 (plate 66), with its grotesque monster, something like a female minotaur, descending a staircase while a gentleman scampers away on all fours as if blinded by a spiral-shaped sun. At the exhibition of *Dada 1916–1966*, held in Milan in 1966 in which Farfa was included with good reason, he showed sculpture of 1929 in wood and sheet metal.

Farfa exhibited with the Turin Futurists at the Venice *Biennale* in 1926 and again in 1928 at Turin, but repeated conflicts with Fillia led him in 1929 to move to Savona, where he opened a ceramic workshop. Some of his designs for vessels and decorations in this "Futurist pottery" were executed in collage.

In Savona Farfa continued to carry
on a many-sided artistic activity
including, besides ceramics, musical
compositions, opera librettos,
recipes for Marinetti's Futurist
cook book, and, notably, the poetry
in which he developed his own
individual Dadaistic style of
language. In 1934 Marinetti wrote
the foreword for his Futurist poem
Junges Italien: ..., Milan, 1933.

Exhibition catalogues: *Farfa il
futurista*, with texts by Asger Jorn
and Enrico Baj, Milan, Galleria Blu,
1958; two shows at the Galleria
Schwarz, Milan, 1961 and 1962;
Farfa il futurista patafisico, Brescia,
Galleria d'arte Cavalletto, 1967.
E. Jaguer published pictures and
poems by Farfa in his review
Phases, no. 7, 1961, and no. 8, 1963.

In his last years Farfa returned to collages and other works in various materials. His autobiographical notes mention a *Metal Dance* in which he used metals in place of colors. However, among his most amusing inventions belong the DAM-DOM collages made of pieces from a domino set and coins; among these the pair in *Executioner and Girl Student* perform daring dances, and the "inmates" of the *Asylum Dwellers* shuffle round and round in a closed circle.

Certain collages by the Bulgarian-born NICOLAY DIULGHEROFF (b. 1901), who joined the Turin Futurists in 1926, represent a quite different trend. Diulgheroff had attended the School of Applied Arts in Vienna and the New School for Art in Dresden and had traveled about in Germany. His portraits of 1924 recall prototypes in German Expressionist graphic art, but his purely geometric pictures of the following period reveal influences from the Bauhaus group, with whom he had also come into contact. In Turin, under Futurist influence, his abstract compositions took on dynamic movement which, in a collage, *Composizione-spazio-forza*, of about 1927 or 1928 (plate 65), was then toned down and clarified. Checkerboard patterns and playing cards interspersed among the intersecting colored forms recall the Cubist papiers collés, which Diulgheroff could have seen on visits to Paris. In a related com-

Colorplate 13. Enrico Prampolini. *Béguinage.* 1914

He exhibited in Paris in the *Salon des Indépendants* of 1928.

position of 1918, *Transparencies*, the "spherical volumes" are made entirely of pasted paper.

Beginning in 1927, Diulgheroff took part as painter and architect in the Futurist exhibitions in Turin. He painted symbolic portraits such as those of Marinetti and of Mussolini, made of chromatically shaded planar segments, and subsequently he took to the new manner of Futurist painting known as "*aeropittura.*" He still lives in Turin, where he works primarily as an architect.

PIPPO ORIANI (b. 1909), the youngest of the Turin group, entered into contact with Fillia in 1927. In the following year, at only nineteen, he exhibited with the Futurist group in the *International Exhibition* in Turin, where he made friends with Diulgheroff and Mino Rosso. He was often in Paris between 1929 and 1933, and there he came under the spell of the Cubists. He painted still lifes in 1929 in the spirit of Braque, whom he admired, pasting into them the characteristic paper elements of the old days: wood-grained paper to represent table tops and instruments, corrugated cardboard, labels, and pieces of printed matter, among them pages from the theater magazine *Comoedia*, on which he collaborated. He also utilized fine cloths and tissue papers, in whose transparency the forms drew together like shadows. In other examples, such as *Objects* (Collection Carli, Turin), a collage of 1929 with guitar, wine bottle, and fruit bowl in front of a window ledge, the clear disposition of the objects suggests that there may also have been influence from Severini, with whom Oriani was in personal contact. In a "painted collage," the *Residues of Romanticism* of 1930 (lost), which had playing cards, a letter with the black shadow of a hand on it, and a revolver, all set between broad planes warped by perspective, the reminiscences were more probably of Juan Gris, by whom Fillia too was influenced in those years.

The Cubist tendencies lost ground in the *Portrait of the Surveyor*, from about 1930 (now lost), a technological-mechanical pictorial construction in which Oriani followed the lead of the painting of Léger and Le Corbusier. The schematic profile head of the surveyor stood out in an equally stylized landscape, into which survey lines and numbers were introduced; and below it were pasted two cutout illustrations of modern skyscrapers, introducing a feeling of spatial dimension.

These collages were preliminary studies for an oil painting of 1935, *Analogia–paesaggio–figura* (*Analogy–Landscape–Figure*).

Along with such pictures Oriani also produced a number of collages of a more facile genre. On the first of these, the *Woman Bathing* of 1929 (plate 64), the landscape is placed behind the figure in a naive simultaneous representation, like pictures within a picture, and around them there is a boxlike stage with festooned proscenium flounce. The other examples likewise suggest theater scenes, *Trois masques au Bal des 4 Arts, L'Arlequin du Bobino, Petits rats,* all done in 1930 with typical Parisian subjects. With bright colors, variegated polka dots, painted or pasted decorations on the costumes, he managed to express all the gaiety of the vaudeville world of the Parisian *Variétés.*

About 1930 Oriani turned to cosmic landscapes in the manner of Prampolini, whose influence was then being felt by all the Turin artists. In the series *Conquista siderale (Stellar Conquest)* Oriani added to his pigment both colored and tarred papers, gauze, and other materials in order to obtain effects of relief.

Relief pictures of various materials were also composed in 1932–33 by the sculptor MINO ROSSO (1904–1963), who, like Oriani, was affiliated with the

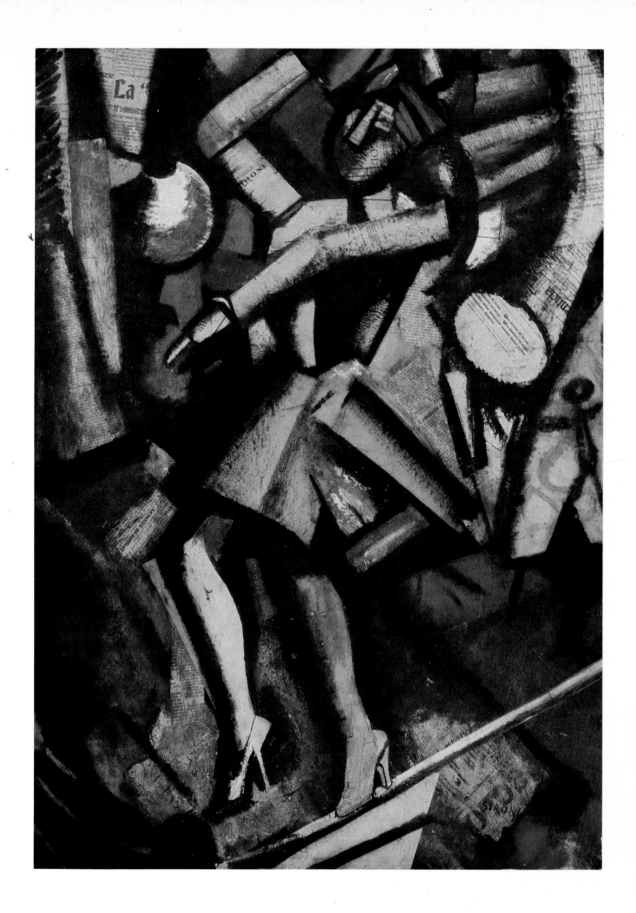

Colorplate 14. Mario Sironi. *The Ballerina*. 1916–17

He published an essay "Dalla pittura murale alla composizione polimaterico" ("From Mural Painting to Multimedia Composition"), *Natura*, 1936, and a small volume titled *Arte polimaterica.*

E. Crispolti, *Il secondo Futurismo: Torino 1923–38*, Turin, 1961; and the exhibition catalogue *Aspetti del Secondo Futurismo torinese*, Turin, Galleria Civica d'Arte Moderna, 1962

Turin Futurist group in 1927. His *Abstract Portraits*, the most successful of which is that of Marinetti (Collection Elio Benoldi, Turin), assembled in 1933 out of wooden shapes and wire, go back to the example of Archipenko, who also exerted a decisive influence on Rosso's sculpture.

During those same years Prampolini was intent upon three-dimensional mural conceptions, which he carried out in one new combination of materials after another. Out of wood, metal, glass, linoleum, and slabs of mosaic he formed "plastic organisms" which stretched across public wall surfaces. He also championed collaboration among architects, artists, and craftsmen, and in Rome in 1936, together with Oriani and Rosso, he executed a model of this sort, *Comunicazione*, a symbolic representation of cosmic spatial links.

The boldest juxtapositions of new materials are to be found, however, in Prampolini's easel pictures of the 1930s, in which industrial products, components taken from nature, and real objects are combined. Alongside a piece of cork and a curtain ring tied together with string, pops up a sea horse; hazelnuts and birch bark combine with varicolored buttons, sheet metal, and lead pipe to make a "living forest." Later Prampolini also combined montage with painting, so that subtle shadowings and textures made the real objects appear less crude. In one of the latest examples in this vein, from about 1940 (Collection Mr. and Mrs. Harry Lewis Winston, Birmingham, Mich.), withered leaves, a feather, colored glass, and cotton wadding express once more something of the poetry contained in his very early work, the *Béguinage* (colorplate 13).

IV The German Expressionist Period

In Germany up to the end of World War I collage played only an insignificant role. The few artists concerned with it proceeded from very different bases and only in part can be grouped under the general heading of Expressionists. It was HILLA VON REBAY (1890–1967) who devoted herself most intensively to collage, and she cannot be identified with any particular tendency.

A native of Strasbourg, she spent her study years partly in Germany, partly in France, and began to frequent the academies of art in Düsseldorf and Paris at a very early age. She participated in the *Salon des Indépendants* in 1913, and in 1914 and 1915 in the Berlin and Munich exhibitions of the Freie Sezession. She herself declared that she became involved with collage at the latest in 1913 and entirely on her own, without knowing anything about the Cubist or Futurist efforts in that medium. Her first efforts were representational pictures with elegant ladies, scenes characterized by amused irony or romantic elegy such as the graceful *Conte champêtre*. What fascinated her especially in this sort of work was the precision of lines and shapes she could achieve with fine scissors, and she discovered the importance of the white background which takes on the appearance of space between the cutout shapes.

She showed a number of those collages in Paris in 1916, in an exhibition at the Galerie Bernheim-Jeune organized by the critic Félix Fénéon.

At an exhibition in Switzerland in the late autumn of 1915 she made the acquaintance of Arp, who presented her with one of his abstract collages. Thereupon, in 1916, she turned to nonfigurative art and became even more its partisan during the following year, when she went to Der Sturm at Arp's invitation and there met the painter Rudolf Bauer, for whom she had profound admiration, and also first saw abstract paintings by Kandinsky. Influences of both those artists appear in her collages, notably in the *Zurückweichend (Receding)* of 1918.

In the catalogue of the 1949 retrospective exhibition at the Museum of Non-Objective Painting in New York, the earliest date given for a collage is 1915. *Receding* is reproduced in that catalogue. The museum, which was founded in 1937 by the Solomon R. Guggenheim Foundation, was the forerunner of the Solomon R. Guggenheim Museum. The baroness Rebay served as director and curator from 1937 to 1952.

There are anticipations of a good many of today's artists in the large body of collages in which Hilla von Rebay continued to work out her ideas and to express a personal emotional content. Her compositions often revolve around some musical subject which determines their "sonority" and rhythms. She worked with a great number of formal elements cut out of plain-colored or delicately patterned papers, arranging them in constantly new combinations. For all that she tended to follow the impulse of the moment, she kept firmly in mind the composition as she had conceived it, and her forms and colors were laid out with the sureness of an experienced artist.

The earliest collages to come out of German art circles properly speaking were the small pasted pictures created in Munich between 1909 and 1911 by Kandinsky's companion, GABRIELE MÜNTER (1877–1962). To some extent

these derive from the folk art in which the painters who later came to be known as the Blaue Reiter group saw a still vital source of new artistic ideas. In their naive style, her collages, scarcely more than postcard-size, are related to the underglass paintings with which she and Kandinsky were experimenting at about the same time. The Virgin as the Mother of Mercy, in black robe and enclosed in a rose-dotted green mandorla (plate 68), may very well have been inspired by a Bavarian votive image. Other compositions, however, are marked by the Expressionist tendencies that had their impact on all the Munich painters about 1910. Mountain tops, trees, and haystacks are set into her landscapes in the form of cutout colored silhouettes and fill the pictorial space with their rhythmic progression. A geometric order is imposed on the *Flowerpots Before a Window*, for example, by means of the divisions of the pane of glass. Cheerful color lends a certain charm to these collages, which, after all, show no aspiration to any lofty artistic goal.

When NELL WALDEN (b. 1887), who married Herwarth Walden in 1912, visited Kandinsky and Gabriele Münter in Murnau in 1914, she saw the old and new underglass paintings that were their current source of inspiration. From 1915 on she adopted this technique, painting religious subjects and landscapes in a style that was both folk and Expressionist, though she soon moved on to abstract compositions based only on sheer delight in color. About 1920-21 she occasionally underlaid such pictures with collages of gold and silver papers, a folk technique which lent a mysterious, luminous power to the red, violet, and blue tones of the painting.

Along with these Nell Walden painted oils and temperas that she exhibited annually from 1917 to 1921 in Der Sturm. In 1924 she used tempera and collage for an abstract composition of black centers from which colored beams radiate (plate 67). With the arrival of Nazism, she returned to her Swedish homeland and then, in 1933, moved to Switzerland, where she wrote poetry and continued to paint landscapes shimmering in their light colors. Into these she sometimes pasted torn pieces of paper. A few years ago she began a new collage procedure in her *Sgraffiti*, incising a white network of lines on black backgrounds and then filling certain parts with cutout pastel drawings to obtain highly colorful effects.

Other than these, only a few artists in Germany pasted papers into their oil paintings. At Der Sturm in December, 1916, the Munich painter MARIA UHDEN (1892–1918) exhibited a tempera painting *Town by Water*, in which the village, church, and fishermen in their boat are reflected in the water in such a way that the upper part of the picture is repeated inverted in the lower part, with only slight displacements. Gold and silver papers introduce a festive note in the painting, in which a few red accents gleam out of the mat gray and brown tones.

In similar fashion PAUL BUSCH (b. 1889) pasted papers into a watercolor of 1918, *The Stairs*, in order to enliven the play of space and planes which receives its rhythmic emphasis from the stairs rising between the houses in all directions. Busch studied in Berlin before the war, took part in exhibitions at Der Sturm in 1921 and 1922, and in the latter year designed decorations and costumes in glowing colors for the ball held by Der Sturm. His costume figurines, which look like artists' manikins with ball-and-socket joints, were pre-

Her collages can be seen in the Städtische Galerie, Lenbach Haus, Munich.

Herwarth Walden's first wife, the poetess Else Lasker-Schüler, used collage in the illustrations of her books. In *Der Malik*, of 1919, and *Theben*, of 1923, various colored shiny papers are pasted into the drawings to give them an air of Oriental fairy tale. Copies in the possession of Dr. W. Feilchenfeldt, Zurich, and Dr. Hans Bolliger, Lucerne

Executed as a mosaic now in the Ermler Museum, Berlin

Afterwards Maria Uhden explained that the pictures by Chagall she saw in Munich in 1914 opened for her the world of the miraculous and fantastic, from which thereafter she drew the subjects for her woodcuts and paintings. In 1918 she exhibited a second time at Der Sturm, together with her husband, the painter G. Schrimpf. When she died that year, Herwarth Walden wrote a warmly appreciative obituary.

Reproduced in the exhibition catalogue, *Der Sturm*, Berlin, November, 1961

Colorplate 15. Achille Lega. *Portrait of the Artist's Mother.* 1917

ceded by the watercolor collage drawing of *The Dancer* in 1921 (plate 68a), in which isolated pieces of paper are pasted on the figure and give texture to the background. Since 1920 Busch has been living in Cottbus, in East Germany, where he has been active as a teacher of arts and crafts.

The Russian painter LASAR SEGALL (1891–1957), born in Vilna, sometimes used collage as a means of enriching the surface textures. He settled in Dresden in 1910, and there he followed the Expressionist paths of the Brücke group, embodying social themes in the etchings, lithographs, and paintings with which he made his reputation in the postwar years. About 1920 he became interested in collage. In his *Accordion Player Before the Door* the instruments and window panes are covered with crumpled tin foil, which brings a shimmer of light into the otherwise bleak picture. For the *Woman Before a Mirror*, of about 1922, a glistening paper on the mirror stresses the contrast between bright and dark surfaces; this picture offers evidence that, at that time, Segall was already going over to *Neue Sachlichkeit* (New Objectivity), the trend which would eventually supersede Expressionist emotionalism in his painting. During the following years he painted occasional nonobjective compositions of rectangles, circles, and chromatic strips of color, into which gold papers are pasted. Segall emigrated in 1925 to Brazil and exhibited regularly in São Paulo until his death.

V Russian Collage
 and Related Mediums

A thoroughgoing survey of what was done in the field of collage in the Russia of the first quarter of this century can as yet scarcely be undertaken in the West. From time to time, however, there do occur gaps in the iron curtain, and then we manage to exchange some information. We learn, for instance, that in recent years the Russians have begun at least to acknowledge the historical significance of the "bourgeois" avant-garde movements, for so long placed under a ban of silence in which they could not even be discussed. However, since we cannot track down the works themselves on their home grounds, our documentation concerning them can be at best only incomplete and fortuitous. Contemporary publications, catalogues, and magazines have become very rare, and statements in more recent publications often do not stand up to rechecking. As a result one is forced to rely on the accounts of the surviving *émigré* artists who took part in the various phases of the development of modern art in Russia. Unfortunately, in most cases, their memories have become cloudy with time; their statements are often contradictory and may be slanted to display in the best light their own role or that of the movement they championed and to draw a veil over that of others, or even to call their contributions into question. All this makes it very difficult to determine just what was the real state of things. This is not to deny that such accounts cast light on the picture of artistic development from various angles and that they round out the evidence already on hand. Since these sources all agree that collage was practiced extensively in Russia and at a very early date, it has seemed worth while to compile what is known in this field, provisional and fragmentary as the information may be, in the hope that it may serve as a basis for further exploration.

Poets and Artists

Apparently collage was born in Russia about 1912 with the publications of the circles of young poets to which David Burliuk, Velimir Khlebnikov, Alexei Kruchenykh, and Vladimir Mayakovsky belonged. To reduce costs, their slender volumes were often issued as loose pages clipped together and printed on cheap colored or wrapping paper, and at times even almanacs

Researchers in linguistics have pointed out the relationship of his "sound poems" to the hymns composed of brute sounds that certain sixteenth-century religious sects used to express, while in mystical trance, all stages of joy, sorrow, and ecstasy.
Velimir Khlebnikov, *Ka, textes choisis*, ed. B. Goriély, Paris, 1960

Marinetti e i Futuristi, I: *Prefascisti*, Anno VII, 1929

C. Belloli, "Regesti del futurismo plastico," in the exhibition catalogue *40 Futuristi*, Milan, 1962; and *Il contributo russo alle avanguardie plastiche*, Milan-Rome, Galleria del Levante, 1964

In a letter to M. A. Ossorguine in 1913, Marinetti wrote: "My book *Le Futurisme* (Paris, 1911), as my publisher Sansot has just told me, has sold better in Russia than in any other part of the world."

were printed outright on wallpaper. The artist friends of the poets illustrated the text pages and sometimes also decorated the jackets with collages of bright-colored papers in the hope of catching the browser's eye. Concerning the close collaboration between poets and painters, El Lissitzky wrote in an article published in the *Gutenberg-Jahrbuch* for 1926–27: "With us in Russia, the new movement that began in 1908 established close links between painters and poets from its first day, and there was scarcely a book of poems issued to which some painter had not contributed his efforts. The poems were written out with a lithographer's crayon, and drawings were added to them. Or they were incised into woodblocks. The poets themselves set type for entire pages. So it was that the poets Khlebnikov, Kruchenykh, Mayakovsky, Aseyev worked together with the painters Rosanova, Gontcharova, Malevich, Popova, Burliuk. It was not a matter of individual numbered de luxe copies but of cheap unbound little booklets that today, in spite of their being products of cultured citydwellers, we must consider as a kind of folk art."

VELIMIR (VICTOR) KHLEBNIKOV (1885–1922), the intellectual leader of this group, published his first poems in a new free form of language as early as February, 1909, in a magazine whose title can be translated as *Studio of the Impressionists*, edited by N. Kulbin, a military doctor, painter, and collector all in one, who played an active role in the literary and artistic movement. To renew the poetic language, Khlebnikov went back to primitive linguistic sources, to Old Slavic idioms and the verbal constructions in use among the folk, and attempted to infuse new life into these. The word could be created anew, he claimed, if one split, twisted, distorted it, or even resorted to notation of mere sounds. Besides the "Zaum language" (*Za-um* meaning something like "over and beyond the rational") that he developed out of such elements, he invented a "star language" composed of signs, letters, ciphers, and hieroglyphs having symbolic meaning.

The incipient literary revolution took a Futurist turn when Marinetti visited Russia in November, 1910, and recited his own poems and those of his friends during his lecture evenings in Moscow and Saint Petersburg. The Saint Petersburg correspondent of the Trieste newspaper *Il Piccolo* sent back word that Marinetti had become the man most in view in Russia and had excited the highest enthusiasm at the Stray Dog, a night spot in Saint Petersburg where poets and artists met for their discussions. During that visit Marinetti was the guest of Kulbin and met Khlebnikov there.

While Marinetti was still there, the founding manifesto of Futurism of February 11, 1910, appeared in Russian, and the subsequent artistic manifestos were translated during the same year. The Russians followed the Italian development with the greatest interest, and "Futurism" became the catchword for all artistic and literary manifestations and exhibitions.

In their demands for poetic freedom the Russians went beyond even the Futurists. In a manifesto titled *Slap in the Face of Public Taste* that Burliuk, Kruchenykh, Mayakovsky, and Khlebnikov issued in Moscow in December, 1912, they declared all existing literature to be over and done with, and demanded for the poet the right "to enrich his vocabulary with arbitrary and derived words (word innovations)." The play on words, new interpretations, and distortions in meaning exploited by the "Zaum poets" anticipated the Dadaist poetry of Arp, and their "sound poems" those of Hugo Ball.

However, in their free treatment of the page and of typography they were the followers rather of the Futurists' "*parole in libertà.*" Such factors afford some idea of the publications to whose decoration collage made its contribution.

Unfortunately, there are only a few copies of these known or surviving. For a booklet *Mirskontsa (The World Backward)*, with poems and prose texts by Kruchenykh and Khlebnikov, which came out in August or September of 1912, Natalia Gontcharova made a collage jacket with a green clover leaf on yellow-brown wrapping paper and with the title pasted on a lighter colored paper. The texts were all handwritten by Gontcharova, Mikhail Larionov, Rogovin, and Vladimir Tatlin and illustrated with drawings. The booklet, of which 200 copies were issued with original collages by Gontcharova, was listed in a publisher's spring catalogue of 1913 at a price of seventy kopecks and was already out of print about that time.

Before the Revolution ALEXEI KRUCHENYKH (b. 1886) published some twenty such small volumes, several of them in two different editions and most of them handwritten and illustrated by himself or his artist friends. On the cover of the first edition of his *Porosyata (The Piglets)*, issued in Saint Petersburg in 1913, was pasted a reproduction of Kasimir Malevich's *Portrait of a Peasant Woman* on greenish paper; at that time the picture (now in the Stedelijk Museum, Amsterdam) hung in the studio of Ivan Puni in Saint Petersburg, and Puni's widow has preserved a copy of the booklet. For forty kopecks one could buy in February, 1914, Kruchenykh's *Postoyannaya (The Continuous Poem)*, a folio of loose sheets in various colors on which the "Zaum" text, handwritten or printed, was distributed in free typographical arrangement over the pages and frequently illustrated by abstract lithographs, some by Kruchenykh himself, others by his companion OLGA ROSANOVA (1886–1918), who also helped decorate his other books. For his *Zaumanaya-gniga* (roughly translated, *A Zaum Book*) in 1915 she designed a collage wrapper with a red heart and over it a white bud, and inside on the second page there was pasted a geometric composition of cutout pink papers.

In 1916 twelve full pages of her collages made up a book titled *Vselenskaya Voiná (The Universal War)* with the subtitle *Colored Pastings*, which, in the publisher's identification on the reverse of the title page, were even more precisely designated as "colored découpages." These were compositions of abstract two-dimensional shapes in various colors (colorplate 17), sometimes merely juxtaposed, at other times overlapping and interpenetrating. For these images Kruchenykh composed brief poetic texts referring to the "universal war" which, according to his prophecies, is scheduled for 1985. In a foreword he explains that the collages are products of the same spirit of free, nonrepresentational conception as the "Zaum language," of which he proclaims himself the founder: "Zaum verse reaches out its hand to Zaum painting, whose first examples have been created by Rosanova, while other painters such as Malevich and Puni paint in the same style but call it by the meaningless name 'Suprematism.' I rejoice over the victory of this painting which puts up the backs of the narrow-minded people and Italian journalists."

In 1919 appeared another improvised small folio, *Zaumchata* (roughly *Zaum's Children*) (plate 81). The text of the poem was written by hand with

This earliest example of a pasted book jacket known to us dates from the same time as Sonia Delaunay's book covers. Prof. V. Markov states that there is a copy of *Mirskontsa* in the library of the University of Michigan, and another was in the possession of Gontcharova herself.
The pages by Larionov and Gontcharova are reproduced in Camilla Gray, *The Great Experiment: Russian Art 1863–1922*, London, 1962, pl. 223, 224.

This and subsequent information from H. von Riesen, editor of *Kasimir Malewitsch, Suprematismus— Die gegenstandslose Welt*, Cologne, 1962; and from Prof. V. Markov, Department of Slavic Languages, University of California at Los Angeles, author of *Russian Futurism: A History*, University of California Press, 1968

Described by C. Belloli in *Il contributo russo*

Purely abstract pictures of white, gray, and black planar forms were shown for the first time by Rosanova in May, 1915, at the *Exhibition of Left-Wing Movements* in Petrograd.

Copy in possession of L. Kassák, Budapest

brush and red ink on newspaper folded in book form and was illustrated by
VARVARA STEPANOVA (1894–1958), Alexandr Rodchenko's wife, with Supre-
matist compositions cut out of colored papers.

From 1911 to 1914 Ilya Zdanevich (b. 1904), who called himself ILIAZD,
was associated with the group of poets around Kruchenykh, Mayakovsky,
and the others, and took part in their manifestations and discussions in
Moscow. In 1917 he returned to his native Tiflis, where he gathered the
literary-minded youth around him. He founded a publishing house called
41 Grad (41 Degrees Centigrade), which brought out some Zaum poems
illustrated with collages. For a booklet with poems and collages printed in
1917 and titled *1918*, Iliazd recalls that the illustrations were created by his
brother K. Zdanevich and by Kruchenykh. In 1919, when he published a
volume of his plays dedicated to the actress Sofie Georgievnie Melnikova,
he himself provided collages for the play *Donkey for Rent*, with abstract
figures of the three principal characters interlaced with printed letters and
other typographical elements. However, the collages were included in only
twenty copies.

Iliazd moved to Paris in 1921 and there joined the Dadaists. He lectured
on modern Russian literature at the Café Caméléon in Montparnasse and in
the atelier of Madame Olénine d'Arnsheim in Passy. He was also among
the organizers of the famous Dada evening of July 6, 1923, at the Théâtre
Michel, which climaxed with the performance of Tristan Tzara's *Le Cœur
à Gaz* and included Iliazd reading one of his own Zaum poems. At about
the same time he published a dramatic poem, *Ledentu le Phare*, whose text
was spread across the pages in constantly changing, geometrically organized
and grouped letters and numbers. The binding of all 300 copies was deco-
rated with an original collage by N. Granovsky (who had also designed the
scenery for *Le Cœur à Gaz*), a rigorously geometric composition in silver
and gold paper on a mat-brown ground (plate 73), logically evolved from
the earlier Russian book jackets, which had generally been pasted together
in an improvised fashion.

The theater scenery and costumes executed in collage during World
War I by NATALIA (NATHALIE) GONTCHAROVA (1881–1962) and ALEXANDR
SAKHAROV (1886–1963) have little to do with the artistic development of
painting as such. In the case of Gontcharova they were a product of her
collaboration with Diaghilev, for whom she designed the first costumes and
decorations for *Le Coq d'Or* in a style of Eastern color and sumptuousness.
During the war, in 1915, Larionov and Gontcharova met with Diaghilev
again, this time in Lausanne, where they were joined by Stravinsky. It was
there that Gontcharova once again utilized collage for the settings and
costumes of *Liturgie* (plate 83), a choreographic mystery presenting the life
and Passion of Christ in seven scenes. Eight full-length, frontally posed
Biblical figures were to make up a back wall for the stage, a kind of living
backdrop for the other masked dancers. To correspond to the dancers'
austere gestures and movements, the costumes were conceived in hard
materials such as leather, wood, and metal, and the curtain was to be in
hammered metal, like the old icon covers. Gontcharova preserved a few
collage sketches for the robes of the cherubim, which show clearly how
much her ideas owed to Byzantine icons. Gold and silver papers suggest the
shimmering luster of old religious images, and the hems of the robes are

trimmed with disks to resemble the real jewels with which such pictures were studded.

Rehearsals for *Liturgie* took place in Lausanne during 1915, but it never came to performance. However, Gontcharova's sketches were often shown to friends in Rome, where she and Larionov accompanied Diaghilev in 1916. There too in 1917, in the Casa di Bragaglia, she exhibited her work. In later years she made many costume figurines and masks from brightly colored scraps of paper pasted together, and these, unlike the solemn, stylized personages of the religious mystery, possess all the delight in vivid color that typefies Russian folk art.

Alexandr Sakharov began his studies first as a painter in Paris and continued them even after he moved to Munich in 1905 to study ballet. There he became acquainted with Alexei von Jawlensky, who, in 1909, painted two portraits of him, *The White Feather* and *The Red Lips*. In the same year Sakharov joined the Neue Künstler Vereinigung, the artists' association founded by Vassily Kandinsky and Jawlensky. At their exhibitions he showed dressed wax dolls as costume sketches; these, as he later explained, should be considered forerunners of the collages which, in time, came to seem to him more serviceable for costume designs because they permitted greater precision. His first collages were executed during the war years, which he spent in Lausanne with his wife and partner Clothilde von Derp. Probably these were influenced by Gontcharova's collages for *Liturgie*, which he certainly must have seen there. Among his earliest efforts was a collage sketch for a stage curtain for Debussy's *Le Martyre de Saint-Sébastien*, showing the saint decked out in all sorts of colored and glistening papers (now in the possession of Dr. Clemens Weiler, Wiesbaden).

In 1917 Jawlensky and Sakharov went with their wives to Zurich, where on one occasion, documented by the entry for April 28, 1917, in Hugo Ball's *Flucht aus der Zeit*, they visited the Cabaret Voltaire. Jawlensky also introduced Sakharov to Ferruccio Busoni, for whose opera *Turandot*, which had its world première there that year, Sakharov produced a number of exceptionally fine collages. Using bright scraps of paper, metal foil, and patterned brocades, he assembled settings of an Oriental fairy-tale splendor; and for the Princess he designed a stylized garment of delicate gauze veil (plate 82). Three sketches for *Turandot*, a Saint Agnes in wax, and sketches for "fantastic Baroque costumes" were exhibited with a few other works in 1919 at the Kunsthaus in Zurich.

After a sojourn in the United States, Sakharov went to Paris in 1921, where he continued to make collages, among them the designs from which the Parisian *haute couture* completed for him and Clothilde von Derp the luxurious costumes that, as he insisted in his essay *L'Art et l'esprit de la danse*, had the greatest importance for the style of their dances. He worked out each and every detail of cutting, patterning, and combination of color with extraordinary care. A collage of the costumes for a "Fantastic Pavane" gives an idea of the refined tones of color in the embroidered and paillette-studded cloth which flowed around the dancers' bodies. Sakharov planned many other stage designs in collage, always well matched to the character of the projected ballet—whether it was a charming setting in the style of the *commedia dell'arte*, with a temporary platform set up on a village river bank and distant city lights in the background, or, as in the case of a ballet after

According to Gontcharova, Sakharov showed collages in an exhibition of works by Russian *émigrés* in Lausanne, probably in 1916, to which pictures were also submitted by Jawlensky, who, at the time, was living in Saint-Prex, near Geneva.

89

a story by Alexandr Kuprin that he designed in 1930, sets in which something of the spirit of the old Russian legends lives again.

Collage per se

Along with such more or less utilitarian works, Russians devoted themselves also to collage pictures true and proper, that is, easel paintings containing pasted paper elements. The first recorded work of this sort, apart from folk art, was shown by ARISTARKH LENTULOV (1882–1943) in February, 1913, in Moscow, at the second exhibition of the artists' association Karo-Bube, which he, with Larionov and Gontcharova, had founded in 1910. Although only the vaguest idea of that picture comes through from the yellowed newspaper photograph that survives, the critics have left vivid descriptions of it. In an article titled "Ink Squirter," published in the *Moskovsky Listok*, Arkady Irissov virtually foams with rage: "Imagine a huge canvas which is not only smeared all over with all sorts of different colors but, even more, is all pasted over with shreds and tatters of wrapping paper, corrugated cardboard, and metal foil. In the upper part of the picture one can make out a few meaningful brushstrokes representing a broken cross. The picture is called *Moscow* and sprang from Lentulov's brush. A young man quite without fear: he did not hold back from printing in the catalogue not only his address but, what is worse, his telephone number."

In the newspaper *Russkoe Slovo (The Russian Word)* a critic signing himself V.B. compares the pictures in the Karo-Bube exhibition with the drawings by mentally ill persons shown by Dr. Karpov at a psychiatric congress in Moscow, from which, in the critic's opinion, they in no way differ. He especially attacks Lentulov, whose works occupied the largest space in the exhibition: "Just picture to yourself in its full dimensions a canvas over two yards long with the title *Moscow*, in which the old capital is represented in the guise of brightly colored little scraps of paper like those used at Easter time to color Easter eggs. Over these shreds of paper, furthermore, are pasted the paper wrappers from the very cheapest bonbons. In the same way he also put together 'non-naturalistic' studies, among which one cannot possibly distinguish which is meant to represent a *Dacha in Kislovodsk* and which an *Electrical Garden with Fountains*." Besides Lentulov's *Moscow* ·collage the newspaper also reproduced Kasimir Malevich's *The Woman in the Tram*, and the editor commented: "In view of the fact that we are publishing the 'works' of the Karo-Bube, the Editor's Office considers it its duty to assure the readers that what is involved is not a mystification but authentic photographs of pictures taken by our staff photographer."

At first glance it is clear that Lentulov's collage pictures had nothing in common with the contemporary Cubist papiers collés. Rather, the dynamic, rhythmically articulated composition reveals tendencies toward Italian Futurism, by which the Rayonist painting of Larionov and Gontcharova was likewise influenced. In any case, the real prototypes of Lentulov's collage are the colorful decorations of folk art, such as the Easter eggs to which the exasperated critic alluded. The best characterization of their style comes from the critic A. Grishchenko, reviewing the pictures Lentulov showed in February, 1914, at the third exhibition of the Karo-Bube: "One

Information and translation of these citations from H. von Riesen and from Peter Lufft, Brunswick

There is an unmistakable relationship between the Futurist pictures painted by Boccioni, Carrà, and Russolo in 1910–11 and the Rayonist paintings. Further, the numeral that Larionov introduced into his *Portrait of Tatlin* (Collection Michel Seuphor, Paris) is much more an imitation of that in Boccioni's *The Farewells* than of any Cubist prototype.

90

can also consider it as Impressionism in a Russian version. The pasted silver and gold tinsel underscores even more the effect of jovial lightheartedness" (from the newspaper *Nov* for February 7, 1914).

At that same exhibition of the Karo-Bube in 1914, collages were also shown by Piotr Konchalovsky, Vassily Rozhdestvensky, and Alexandra Exter. What Grishchenko wrote about Konchalovsky's style of painting is so illuminating that it is worth quoting in full: "I said at the outset that one had to regard the pictures in this exhibition from the standpoint of decorative painting. And, in fact, whether P. Konchalovsky paints mountains in southern France or a nude or the port at Cassis, one recognizes throughout the characteristics of this kind of painting: the same treatment (use of paint, way of painting); over the entire picture surface everything is given exactly the same value, the sky throughout is painted in the same blue color, as if ultramarine had been poured out on it. . . . And it is simply not in line with the real nature of this painter to paste on labels and scraps of wallpaper and newspaper. He understands that method of Picasso's in a curiously crude and realistic way. Picasso takes as his point of departure the endeavor to achieve a spatial effect in a picture by the use of diversified materials and treatments, but here a newspaper cutting remains always no more than a newspaper cutting."

Within the group of artists of the Karo-Bube, PIOTR KONCHALOVSKY (1876–1956) and Lentulov, along with ROBERT FALK (1886–1958), ILYA MASHKOV (1884–1944), and others, made up the so-called "Cézannists," who saw in Cézanne the great renewer of art and who accepted Cubism also, because it was in line with Cézanne's principles. After the Revolution, both Konchalovsky and Lentulov taught for a time at the Moscow *Vkhutemas*, the "advanced artistic-technical workshops," and Lentulov also worked as stage designer for Alexandr Tairov's chamber theater. Konchalovsky's portraits, still lifes, and landscapes are not uninteresting from the standpoint of color and were later given official approval. An article in a publication on the visual arts in the USSR put out in 1934 by the VOKS (Association for Cultural Ties Between the Soviet Union and Foreign Countries) states that he began his artistic career with Cubism and "even went so far as to attempt to introduce concrete materials into painting."

Although not a single one of the collages by Konchalovsky and Rozhdestvensky is known to this writer, one by ALEXANDRA EXTER (1884–1949) was reproduced in the monograph devoted to her by I. Tugendhold and published in Moscow in 1922. This *Still Life* of 1913 (plate 75), with bottle, glass, and apple on an oval table, has, in the manner of the French Cubists, large painted letters and pasted commercial labels with French and German texts. Grishchenko, who stated that she too "glued in golden snippets," said of her handling of composition that she brought color and form into representation simultaneously, but separated in different parts of the picture. What he is describing is, of course, the basic principle of Synthetic Cubism, the undoubted prototype of this still life.

Alexandra Exter grew up in Kiev, where in 1918–19 she was head of an art school. In the prewar years she traveled extensively in France and Italy. As both her friends and her enemies attest, she was always eager to seize upon the latest innovation and to make it promptly her own, with the result that her painting reflects one influence after another. From the works

Oddly enough, in the German edition of Tugendhold's book almost all the pictures are dated differently. This still life is given as 1915, whereas the date of 1913 found in the Russian edition would appear to be entirely plausible within the artist's own development.

of the Analytical Cubists she took over briefly the gray-toned local coloring but very soon switched to richer and more intense color harmonies. Her city pictures of 1914–16 reveal influences from Delaunay but also from the Futurists she had encountered in Italy. In 1914 she participated in the *First Free International Exhibition of Futurist Art* at the Galleria Sprovieri in Rome, where she became acquainted with Balla and Boccioni.

Gray, *The Great Experiment*, pls. 139, 140

The channels of communication between Russia and the West were open in both directions, and every phase of the French development was immediately known in Moscow. Since the beginning of the century Ivan Morosov and Sergey Shchukin had been building up their collections there, acquiring the best examples of French painting, from the Impressionists up to the Fauves and Cubists. Shchukin became the most important foreign client of Kahnweiler, who said of him: "Whenever I got together a considerable number of pictures by Picasso, I telegraphed to Shchukin and he came immediately from Moscow." He bought certain Picassos of key importance from the years of 1908–09, including the *Woman with Fan* and the *Queen Isabeau*, as well as still lifes of 1912–13 related to the papiers collés, among them the *Pernod Bottle with Glass*, with its typical painted lettering and bottle labels, and the oval composition of the *Musical Instruments*, with its wallpaper and sheet of music.

The Cubists of the Section d'Or group also became known early in Russia. Gleizes, Le Fauconnier, and Lhote contributed to the Karo-Bube exhibitions, and the book *Du Cubisme*, which Gleizes and Metzinger published in 1912, appeared the following year in Russian translation. On the other hand, innumerable Russian artists made study trips to Paris and Italy.

The painter LIUBOV POPOVA (1889–1924) visited Marinetti in Milan in 1910 to bring him greetings from Kulbin. She and NADEZHDA UDALTSOVA (1886–1961) spent the winter of 1912–13 in Paris working with Le Fauconnier and Metzinger. Both women developed a Cubist style of distinctive character but bearing the indelible stamp of French influences. Following the example of Braque, in her *At the Piano* of 1914 (Yale University Art Gallery, Collection Société Anonyme, New Haven, Conn.) Udaltsova wrote the name of Bach in large letters above the music. In her oval composition of 1914, *Violin* (Tretyakov Gallery, Moscow), Popova imitated the standard elements of the Cubist papiers collés, such as playing cards, sheets of music, and wallpaper. For her *Italian Still Life* (plate 95), however, she pasted in real clippings from *Le Figaro*, and at the same time the first letters of the title *Lacerba* indicate her links with the Futurists.

Gray, pl. 144

Gray, pl. 142

Contacts and controversies with Futurism took on renewed animation when Marinetti visited Moscow for a second time in January of 1914 to give lectures at the invitation of the art critic Genrikh Tasteven. This time, however, he ran into the open enmity of the painters around Larionov, who, in the meantime, had organized the Donkey's Tail group. Their development having taken directions quite independent of their Italian predecessors, they felt themselves to be the true and only Futurists. Larionov proposed welcoming the "traitor to Futurism" with rotten eggs, whereas Tasteven much preferred to offer him roses.

Georgy Yakulov, Rodchenko, and the latter's wife, Olga Rosanova, took the occasion to beg Marinetti to make their works known in the West, and Rosanova was soon thereafter invited to participate in the exhibition at the

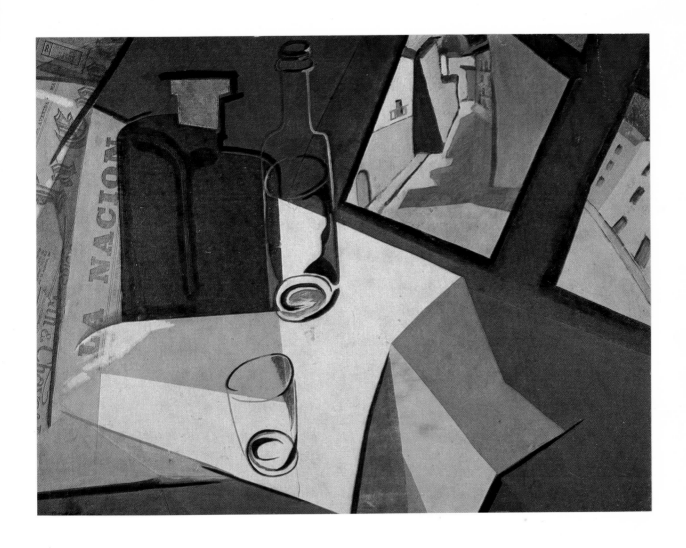

Colorplate 16. Emilio Pettoruti. *My Window in Florence.* 1917

Gray, pl. 141

Galleria Sprovieri. In her *Geography*, from the end of 1914 (present whereabouts unknown), the Futurist influences are apparent. As if activated by the rotation of a clockwork mechanism that appears within the abstract composition of planes, the names of countries—France, England, Holland, Belgium, America—swirl about the pictorial surface, seeming almost to be inspired by such collages of Carrà as his *Patriotic Celebration*. In general, however, one can say that the collages of this Russian artist derive from Cubist examples, although upon occasion Futurist tendencies predominate in her painting.

Malevich, Tatlin, and Their Circle

Among them, *The Woodcutter* (Stedelijk Museum, Amsterdam), *Woman with Buckets* (Museum of Modern Art, New York), and *Morning in the Country after the Rain* (Solomon R. Guggenheim Museum, New York), reproduced in Gray, pls. 90, 91, 92

In *Art d'Aujourd'hui*, no. 15, December, 1957. The *Knife-Grinder* is reproduced in Gray, *frontispiece*.

What KASIMIR MALEVICH (1878–1935) adopted in his painting from Cubism and Futurism was mixed with his own specifically Russian traits, and it was the latter that produced a few truly astonishing collages in 1913 and 1914. Though the cylindrical and conical shapes in certain pictures on peasant themes (1911 and 1912) seem much like those of Léger, their style was defined by Malevich himself, in the catalogue for the autumn exhibition of the League of Youth in Saint Petersburg in 1913, as "Zaum realistic," meaning that color and form elements had been incorporated into them in the spirit of "Zaum," according to the artist's own free will (figure 6). He showed these works along with others he called "Cubistic-Futuristic" at the exhibition of the Target group arranged by Larionov in March and April of 1913 in Moscow. Larionov reported that in the latest of the works submitted, *Scissors Grinder* (Yale University Art Gallery, Collection Société Anonyme, New Haven, Conn.) and the *Dynamic Decomposition*, Malevich expressed a new Futuristic approach to the representation of continuous phases of movement and of mechanical functions.

The *Guardsman* is reproduced in Gray, pl. 93.

In two pictures, *The Guardsman* and *Woman in the Tram* (both Stedelijk Museum, Amsterdam), that Malevich had already shown in February of the same year in the Karo-Bube exhibition, there is no mistaking the derivation from the Analytical Cubism of Braque and Picasso, as is true also of still others such as *Musical Instrument* and *Writing Desk in Room*. The striking pictorial motifs within the abstract composition of planes in the *Woman in the Tram* are augmented in the preparatory drawing, where wheels, a man's head with a bowler hat, the bust of a woman, a card from a lotto game, an arm with a hand are all inserted into a spatial construction with lattice and stairs. In the oil painting certain of these details were replaced by more Cubistic elements, such as a cluster of grapes and a bottle, as in a more conventional still life. Nevertheless, even though the original concept is thereby weakened, the "realistic" components retain a challenging character not to be found in the similar Cubist paintings and collages.

M. Lamač, "Malewitsch und sein Kreis," *Výtvarné Uměni*, no. 8/9, 1967

These realistic elements demonstrate the theory of "alogical" linkage between objects of totally different nature with which Malevich had been concerned since 1911. On the back of the picture *Violin and Cow* Malevich noted: "Logic was always a hindrance to new subconscious currents. To liberate us from this prejudice, the approach of 'alogicality' was created. The alogical collusion of two forms, the violin and the cow, illustrates the moment of struggle between logic, the natural law, bourgeois sense and

Cited in Gray, p. 308 (n. 5 to chap. V)

Figure 6. Kasimir Malevich. *Tailor* (left) and *What Impudence!* (right). 1913/14. Zaum pencil drawings

prejudice." One cannot help but recall in this context the poet Lautréamont's "fortuitous encounter of an umbrella and a sewing machine on an operating table," which was to become the credo of the Surrealists, but at the time under consideration here, the idea was also basic to the program of the "Zaum" poets, with whom Malevich was in close contact.

The most bizarre potpourri of heterogeneous folk-style bric-a-brac can be found in his 1914 *An Englishman in Moscow* (Stedelijk Museum, Amsterdam): small church and huge fish, small ladder and oversize saber, and wooden spoon are all distributed between bright patches of color to round out the bisected portrait of the Englishman, and, in addition, there are meaningless inscriptions such as "Partial Eclipse" and "Riding Club." Malevich also drew sketches for compositions to be made up entirely of handwritten titles such as *Street Massacre* and *Sneak Thievery of a Coin Purse in the Street Car.*

Gray, pl. 97

There are possibly accidental stylistic relationships between the *Englishman in Moscow* and paintings and drawings done by Juan Gris in 1912–13; Malevich's *Still Life with Mona Lisa* of 1913 (plate 70) is certainly a counterpart to Juan Gris's collage still life with engravings of the same year (for example, the *Violin and Engraving* in The Museum of Modern Art, New York). Both artists deliberately counterposed their new conceptual forms to an example of obsolete traditional art. Malevich did so with even greater emphasis, in that he used a torn reproduction of the *Mona Lisa* and then made a very conspicuous X on it—quite literally crossing it out—and alongside it painted a large, blank rectangle which can now be recognized as one of the earliest forerunners of his later nonobjective Suprematist style. Besides, he pasted in strips of decorative paper, inserted below the Mona Lisa a fragmentary advertisement announcing "Dwelling in Moscow now available," and repeated the inscription "Partial Eclipse." And all this six

The portrait in frontal pose with top hat and protruding left eye and the building with the cupola go back to Juan Gris's *Man in Café* of 1912, and fragmented words are used in the same way in his *Torero.*

Compare Habasque, "Documents inédits sur les débuts du Suprématisme," *Aujourd'hui,* no. 4, 1955.

Gray, pl. 99

M. Lamač, "Gegenstände sind ausgekühlte Gedanken," in the Frankfort student newspaper *Diskus*, July, 1967

Gray, pl. 100

On a photograph of the *Soldier* that Prof. Hildebrand obtained from Lissitzky, the title written on the back is *The War Tailor*, which may mean that Malevich later altered it (information from E. Steneberg, Frankfort).

R. Stanislawski, of Warsaw, advises by letter that in 1916, at the exhibition *Magazin (Store)* organized by Tatlin, Malevich showed a picture incorporating a thermometer and a wooden spoon. If this is not merely a confusion with the painted spoon in the *Englishman in Moscow*, the collage in question here may also originally have included a spoon. In the catalogue of the *Vladimir Tatlin* exhibition, Moderna Museet, Stockholm, 1968, Troels Andersen writes: "In a couple of 'alogical' pictures from 1914 Malevich uses a wooden spoon and a thermometer as elements of collage. He later removed the wooden spoon and simply painted it on the canvas." The fact is, the Russian wooden spoon became a symbol of the native Futurists: Malevich and his friend Morgunov strolled about Moscow in 1914 with spoons in their lapels, and Burliuk attended Marinetti's lecture of February 13, 1914, similarly adorned.

years before the time of Dada, when Marcel Duchamp would commit blasphemy against the *Mona Lisa* by endowing her with a mustache.

Malevich's first "square" is found on a stage curtain for *Victory over the Sun*, a Futurist opera with text by Kruchenykh and music by M. V. Matyushin which spurns all the rules of art. For the first performance in December, 1913, at the Luna Park Theater in Saint Petersburg, a prologue written by Khlebnikov was recited by Kruchenykh in front of one of the stage curtains by Malevich, which was thereupon ripped open. Malevich provided both settings and costumes, for the latter using wire, corrugated cardboard, and pasteboard to turn the actors into robots, much as the Dadaists were to be rigged out a few years later for their turns at the Cabaret Voltaire.

Even though scarcely anyone continues to doubt that his famous *Black Square on White Ground* (Russian National Museum, Leningrad) was painted as early as 1913, it does represent the culmination of a transition from Synthetic Cubism to completely nonrepresentational painting which took place slowly and in several stages. In that changeover, two collages of 1914, *Woman Beside an Advertisement Pillar* and *Soldier of the First Division*, played a key role. The composition of the *Woman Beside an Advertisement Pillar* (colorplate 18) is divided into blank rectangular fields in glowing colors and others on which there is an accumulation of fragmentary elements, most of them pasted on. Among the latter are a numeral, printed strips of words, embroidery patterns, bits of lace, and fragments of illustrations. With the *Soldier of the First Division* (plate 69) the contrast between the blank and filled surfaces is moderated by the fact that the figurative elements are spread out over the surface much more clearly. Along with collage words such as "Thursday," "President Vasnyetsov," "Snuffbox," and a numeral and a postage stamp, Malevich also mounted a thermometer, creating a disconcerting effect of matter-of-factness on the viewer. The composition, which also includes a blank square pure and simple set in a prominent position, is characteristic of the specific "alogical" style which makes his collages bona fide forerunners of Dada.

Along with Malevich, whose Suprematism pointed a new way for painting, in the prewar years in Russia VLADIMIR E. TATLIN (1885–1953) played the decisive role in winning acceptance for the use of previously unexploited materials in sculpture. He began his studies in Moscow in 1909 as a painter, at first following the ideas of Cézanne but at the same time influenced also by the old Russian icons. He became friendly with Larionov, who in 1912 invited him to exhibit with the Donkey's Tail group. According to Larionov, Tatlin held aloof from all discussions about art, though they were the order of the day for all the other artists. He delved into his own problems in isolation, always seeking the simplest and clearest solutions, and he himself stressed later that he never belonged to any group or movement whatsoever.

In 1913, in the company of Ukrainian musician friends, he traveled to an exhibition of Russian folk art in Berlin, where he managed to pick up a bit of needed money by passing himself off as a blind folk singer. His funds, in fact, stretched far enough to afford him a stay of a few weeks in Paris, where he desired above all to visit Picasso in his studio. He recounted later that what really excited him there was not Picasso's painting but, instead, a still life made of wire, cardboard, and wood, apparently one of the *Musical Instruments* that the artist had concocted. In a lightning-stroke revelation, it

dawned on Tatlin just what could be done with the most worthless everyday materials if exploited in the right way for artistic purposes.

Upon his return Tatlin promptly set about composing reliefs, using any and every sort of material he could lay hands on: wood, metal, paper, glass, plaster, and so forth, but also metal filings and slivers of glass which served for decorating surfaces. These were much the same materials being used by Archipenko, whom Tatlin could have met in Paris, but nothing of that sculptor's objective, experimental spirit can be found in Tatlin's works, and, for his part, what counted was the expressive value inherent in or associated with his materials.

These new works, which he called "painting-reliefs," were launched by *The Bottle* (plate 96), which no longer exists but for which a photograph and a detailed description have been furnished by Camilla Gray. Three elements are disposed on a diagonal across the background: at the upper left, on a thin sheet of metal, is painted the bottle, its swelling belly formed by a piece of metal held on with wire mesh; glued at the lower right a swatch of wallpaper with a coffered pattern gives an illusion of three-dimensional space; in the middle a broad roll of metal presents the fact, not the mere illusion, of three-dimensionality. Tatlin too, in his first true reliefs, made use of old materials that carried with them something of their original character. Thus, under pieces of wood he might glue a piece of old wallpaper, or on a heavy upright board he might nail a battered tin can with its label half ripped off and attach to the whole a broken pane of glass. For all that Tatlin, unlike Picasso, ruled out figurative subject matter, his works seem to convey some sort of mysterious message. As time went on his compositions grew simpler, and he utilized his various materials in more sober fashion. He employed metal and wood in precise flat and round forms, juxtaposed transparent and compact substances, and placed his planes at angles to the background so as to project the entire composition out into space. In 1915 he began to make "counter-reliefs" out of wire stretched across the corners of rooms, and these took on the appearance of fantastic flying machines with wings raked against the wind and with struts and looped supports: symbols of the age of technique, but more menacing than auspicious.

Tatlin showed his first reliefs in the winter of 1913–14 in the Moscow studio he shared with Alexandr Vessnin, and then again at the *Tramway V* exhibition in Petrograd, which opened in February, 1915, and at which Malevich showed his *Englishman in Moscow*, the *Woman Beside an Advertisement Pillar*, and other works of 1912–14. Shchukin is said to have acquired there, for 3,000 rubles, a work by Tatlin which, as the press ironically described it, consisted of "a little plank with two other little planks nailed one above the other." One of the critics remarked in this connection: "That is not true. I can testify that the artist asked of me only twenty-five rubles, and the Shchukin collection could have acquired something more interesting. As far as I was concerned, I only inquired about the price because at the moment firewood is so very expensive in Petrograd."

At the *0.10* exhibition organized by Ivan Puni and his wife in Petrograd in December, 1915, a separate room was set aside for Tatlin's works, since he was also showing for the first time five of his counter-reliefs. On that occasion there was issued an illustrated folder containing autobiographical data about Tatlin, one of the most important documents for the dating of

Likewise for financial reasons, he had already earned his living in Odessa as a boxer and at least once had taken a terrific beating.

Personal communication from Pavel Mansurov, who a few years later became a close friend of Tatlin

According to Larionov, it was these geometric formal elements that inspired Malevich's Suprematist style.

Gray, pls. 126–128

Tatlin never lost his passion for airplanes. In the last years of his life, spent in the monastery of Novo-Devich, where the state housed penniless artists, he was occupied with the construction of a glider plane which he named "Letatlin."

his early works. Since, in another room, Malevich was first exhibiting a large number of his Suprematist pictures, both artists became involved in rather stormy controversies.

The *Tramway V* exhibition—named after the tram line serving the most remote district of Petrograd—was organized by IVAN PUNI (1894–1956), who as an *émigré* to France subsequently changed his name to Jean Pougny, and his wife, XENIA (ZHENIA) BOGOSLAVSKAYA. To it both of them contributed collages which clearly derive from examples they had seen firsthand in France. Puni's first visit to Paris took place in 1910, and in 1913–14 both of them stayed there for some time. Puni's *Still Life with Cup and Spoon*, dated 1914, is a typical, Cubistic, two-dimensional composition of the early Synthetic period, but the Russian newspaper clippings alongside the patterned wallpaper are evidence that this collage was done after Puni had returned to Petrograd upon the outbreak of the war. More Russian in effect is another collage *Chair and Shoe* (plate 72), with a fashionable high-button shoe in the midst of pieces of wallpaper and newspaper densely and turbulently piled up in layers one above the other and surrounded by pointillistic brush textures. A more intimate and feminine world is mirrored in Bogoslavskaya's *Dressing Table* (plate 71), a collage crammed with reminiscences of Paris. Amid bits of delicate cloth, wallpaper, and one of the typical Cubist wood-grained papers are pasted illustrations from a Paris fashion magazine, the lid from a box of French powder, and half a lipstick. The amusing composition shows the charm with which the artist was able to relax the rigorous organization of her surface planes.

Elsewhere Puni incorporated into his painting certain elements and practices of collage. In the *Hairdresser*, with the portrait of the artist in the background, there are numerals, letters, imitated wood grains, and a simulated newspaper page with incomprehensible "Zaumatic" text all inserted among partly abstract, partly representational forms. The influence of Malevich's "alogical" painting is even more obvious in *Window Cleaning*. As in a page from a picture album, without logical or spatial relationship one to the other, the most diverse objects—an armchair, a single table leg, a lamp, a key, a parasol, and so on—are spread out against house fronts stretching high or slantwise, while a tiny charwoman standing on her head bends over the arm of an easy chair and two yoghurt pots illustrate the fragmentary slogan: "Eat Lactobacilli."

At the same *Tramway V* exhibition Puni also showed a construction of 1914, the *Cardplayer*, a Cubistic composition in which can be detected influences from Picasso's constructed musical instruments as well as from Tatlin's reliefs. Puni later told how the interest aroused in France about 1913–14 in the artistic utilization of iron, cardboard, paper, wood, and so on had an immediate effect in Russia during the same years and, in fact, led to a kind of fetishism for real materials. He himself felt an intimate relationship to everyday, worthless objects. In a discussion that took place on the occasion of the *0.10* exhibition he declared, "The buttons on my jacket are more beautiful than the masterworks of the old painters.... Crude iron is more beautiful than precious metals."

In the course of these manifestations Puni officially proclaimed his allegiance to Suprematism, and from 1915 on a number of his reliefs from wood, metal, and cardboard were based on Suprematist drawings. With

Gray, pl. 138

98

their generally muted black, gray, and silvery tones and the effects of light and shade that he conjured out of vaulted forms or even transparent disks, these constructions possess a subtle, unstable equilibrium. Two objects are more provocative in effect: the *White Globe*, which rises three-dimensionally in a metal box divided into different colors, and the *Plate on Table* (Collection Xenia Bogoslavskaya, Paris), a china plate which, one day during his wife's absence, Puni mounted in the walnut top of their dining table, obliging the household to make do with the remaining half of the table.

Gray, pl. 136

In contact with Khlebnikov and his friends, Puni too created letter pictures, among them one from 1916 which consists of nothing more than its title, *Baths* (figure 7). A later work, *Flight of the Forms* of 1919 (Russian National Museum, Leningrad), has letters arbitrarily dispersed among bright circles and stripes and looks like nothing so much as a painted collage.

However, Puni returned to making real collages in Berlin in 1921, when he had to decorate the rooms of Der Sturm for a show of his paintings and drawings. Simple geometric shapes and patterns cut out of brightly colored paper along with large letters and numerals appeared under and between the pictures—some figurative, others completely nonrepresentational—and spread across the windows and ceilings. On a wall with a door was pasted a large figurative composition with an acrobat plunging down from the heights with a ball and hoop. For a dance held by the Sturm group Puni devised similar decorations and costumes.

In Berlin Bogoslavskaya also still worked in collage on occasion. One example, a still life with freer and more agitated forms than she had previously used, includes a bottle whose label is a clipping from a German newspaper. In 1923 the Punis emigrated to Paris, where two years later his painting turned toward an Impressionist orientation.

While the *0.10* exhibition in Petrograd was announced as "the last Futurist exhibition" (to which the critics retorted that that was one promise they hoped would be kept), in Moscow the controversies over Tatlin's "constructions" raged on and led to demonstrations and counterdemonstrations. Larionov used to tell with amusement how, in 1915, at the very moment that Tatlin's "counter-reliefs" were becoming known, the Futurist group held an exhibition of works satirizing those creations. There was, among others, a *Self-Portrait* by Vladimir Mayakovsky with dirty gloves and a ventilating fan, upon which Larionov jammed a bowler hat that thereupon was promptly whirled around and around.

MIKHAIL (MICHAEL) LARIONOV (1881–1946) had already constructed a "Dadaistic" work of various materials as far back as 1912: *The Smoker* (plate 77), a three-dimensional replica of the painting *Manya*, of which two versions are known, one in oil, the other in watercolor. The relief is composed of two parts. In the upper section a small plank is nailed on with a plaster of Paris head of the smoker in profile, a straw pipe, and a swab of cotton wool. The female figure in the lower part of the relief is dressed in a spiral roll of paper fastened to her posterior by large nails, and a nail also serves as an eye. A 1915 Larionov relief preserved only in the form of a photograph (plate 78) had pieces of cardboard and sheet metal nailed to a painted ground and tied with string.

The head of the smoker returns in the oil painting, and the contours of the female figure conform to those in the watercolor. Gray, pls. 73, 74

Figure 7.
Ivan Puni. *Baths.*
1916

Gray, pl. 177

Reproduced in Belloli, *Il contributo russo*, p. 60; *Das Kunstblatt*, 1922, p. 496; and *Entgegnung*, 1924, p. 32

In his book *Neue Kunst in Russland 1914–1919*, Munich, 1920

At the *Magazin (Store)* exhibition organized by Tatlin in 1916 as a protest against the last, and in the eyes of the avant-garde completely reactionary, exhibition of the Karo-Bube group, new Constructivist artists joined those already known. IVAN KLYUN (KLYUNKOV), who belonged to Malevich's circle of friends, showed there a relief with wooden disks and parts of a telegraph apparatus. A year later, LEV BRUNI, one of Tatlin's supporters, made a construction no longer extant of cloth, glass, and metal elements attached by cord to a wooden armature. SAVYALOV likewise was so influenced by Tatlin that one of his reliefs of 1916–17, in iron and painted wooden parts, was reviewed by the critics at the Russian exhibition in Berlin in 1922 under the impression that it was by his master.

At the beginning of 1917 Tatlin collaborated with GEORGY YAKULOV (1884–1928) and Alexandr Rodchenko on decorations (plate 76) for the Café Pittoresque in Moscow, the meeting place of the literary and artistic avant-garde, counterpart of the Stray Dog in Petrograd. Constructions of tin, glass, and ornamental painted plywood in angular and intersecting planes filled the corners of the hall, covered the platform, and hung down from the glass cupola. Konstantin Umansky described the effect as follows: "Are they aircraft, dynamo machines, dreadnoughts? The viewer senses an unflagging dynamism in these half-mechanical, half-decorative structures, whose constructions suggest the ritual mystery of modern machines and excite in him a strange unrest."

To what an extent general opinion saw in Tatlin the real founding father of modern constructions in unconventional materials can be deduced from two post-World War I publications in which the diametrically opposite viewpoints of an opponent and of a supporter are expressed. In the volume devoted to Russia published in Vienna in 1921 in the Gegenwartskunst series, under the heading "Machine Art" Fritz Karpfen says: "To the Russian sphere belongs also that very newest type of representation which has now become the fashion in every part of the world. This involves total rejection of all traditional materials such as paint, charcoal, etc., and their replacement by everyday utility tools, pieces of broken glass, shreds of newspaper, box lids, gas pipes, stones, brass fittings, and so on. These lovely things hauled out of garbage bins are slapped onto wooden surfaces, nailed fast, and provided with a harmless, innocent-looking caption. . . . But that one should not simply and flatly relegate this activity to the realm of outright swindle is shown by the fact that it is practiced by artists like Archipenko, Picasso, etc. . . . This new conception of art in Russia is under the intellectual leadership of Tatlin and is referred to as Tatlinistic machine art."

That author obviously held Tatlin responsible also for all the excesses of Dada and ridiculed him, whereas Umansky, in the book already mentioned, rose to the defense of this art with all emotional stops out: "A triumph of the intellectual and the material, the negation of the right of the spirit to isolated autonomy, a quintessence of contemporary reality, of sovereign technique, of victorious materialism—it is thus that we must define the counter-reliefs which have relegated within quotation marks all such sacrosanct words as Art, Painting, Picture." Umansky's interpretation climaxes in a real apotheosis: "Art is dead, long live art: the art of the machine with its constructions, its logic, its rhythm, its components, its materials, its metaphysical spirit—the art of the counter-relief!"

The Revolutionary Years

With the Revolution, artists saw themselves faced with new tasks: the decoration of streets and public squares for revolutionary celebrations, posters and wall newspapers for the proletarian clubs and propaganda posts of the Red Army. The style of this "agit-prop" art was determined by the Rosta, the Russian wire service, which put its news in the form of large sheets of pictures with commentary. These were displayed in the windows of the warehouses (empty by then), nailed up on the walls of factories and in military canteens, pasted on the propaganda trains carrying books and films to all sectors of the front. For political gatherings it was often necessary to assemble overnight the propaganda material to be displayed, and so there came into use immense wall montages with revolutionary slogans and news in huge headlines, the whole studded with visual documents. Gustave Klutsis, one of the active participants in this renewal of Russian poster art, subsequently asserted that these determined the entire later course of photomontage.

Among the artists who worked for the Rosta, the outstanding contribution, along with that of the painter Vladimir Lebedev, came from the poet

Catalogue of the *Photomontage* exhibition, Berlin, 1931

101

In the poem "Mandate to the Army of the Arts," December, 1918

Mayakovsky moved from Petrograd to Moscow in 1919 and in subsequent years designed posters for the reviving Soviet industry.

Biographical notice in the catalogue of the *Chagall* exhibition, Paris, Musée des Arts Décoratifs, 1959

Gray, pls. 164–167

Most of the originals can no longer be found, but there were prints and reproductions of a number of them in Russian magazines of the time.

A drawing of 1914, *Dancer and Cat*, is reproduced in the catalogue by Belloli mentioned above.

Vladimir Mayakovsky, who used his vivid caricatures to make highly effective display windows. Overcome with enthusiasm, he hailed the exit of art from the academies and museums and proclaimed: "The streets are our brush, our palette the public squares."

All artists of rank and name made themselves available to the revolutionary committees for the decorations for public celebrations. Named commissar for visual arts for the district of Vitebsk in September, 1918, Marc Chagall promptly appealed to all local master painters and their apprentices to design posters in large format as decorations for the city on the occasion of the anniversary celebrations in October. However, the motley-colored cows and the horses galloping up to the heavens which thereafter made a fine show on all the walls found only divided approval from the Communist authorities.

On the other hand, in Petrograd for that same first anniversary of the October Revolution, Natan Altman designed decorations for the square in front of the Winter Palace, using the style of modern nonobjective art. A Suprematist construction of large, flat and concave, colored surfaces surrounded the Alexander Column, and bright-colored, two-dimensional compositions enlivened the front of the palace, on which hung gigantic panels with the portraits of the glorious leaders of the peasants and workers. For the Uritzky Square, Xenia Bogoslavskaya turned out vividly colored geometric decorations. Notwithstanding all this abstract art, the young Pavel Mansurov painted patriotic scenes and subjects on wall-high posters covering the front of the Hôtel d'Angleterre.

In Moscow, for the same celebrations, it was YURY ANNENKOV (b. 1889) who was charged with decorating Red Square and the platform from which Lenin was to speak. Two years later, for the May Day celebration in Petrograd, he was commissioned to design decorations and costumes for the historical pageant *The Taking of the Winter Palace*, the most colossal mass spectacle of all time, staged by Nicolai Evreinov. Eight thousand participants, including professional performers from the theater, ballet, and circus, along with sailors and Red Army soldiers, filled the square on which Annenkov had erected enormous painted screens towering up to the third story of the Winter Palace. He had begun as early as 1917 to concern himself with new conceptions in theater design, and in a manifesto titled "Theater to the End," published in 1921 in the magazine *The House of Art*, he advocated a total theater, built up from abstract-dynamic constructions in a variety of materials which would be brought to life by color and light projections. For the 1922 production of Georg Kaiser's *Gas* at the Great Dramatic Theater in Petrograd he designed kinetic décors and mechanical costumes which are among the very earliest of this genre.

However, as Annenkov recalls it, he had also begun to deal with collage as far back as 1915 and continued to do so into the twenties. The stimulus for this may have come in Paris, where he had been in 1912 and 1913 and where he had participated in the 1913 *Salon des Indépendants*. Also in 1912 he saw the Futurist exhibition at the Galerie Bernheim-Jeune, and Cubist and Futurist influences jostle each other in his paintings and drawings of those years. Upon his return to Saint Petersburg he joined the Cubist-Futurist painters.

Colorplate 17. Olga Rosanova. *Combat of Mars and Scorpio*, from *The Universal War*. 1916

Before the Revolution Annenkov designed his own bookplate in collage (figure 8). It included a scrap of newspaper with news of the war—in the orthography of czarist times—which lies on a table pen-drawn in exaggerated perspective foreshortening, as well as other pen drawings of anecdotal details, a mouse and a fly on the newspaper, a shoe and an open book on the floor. A pen drawing titled *Citizen* and dated 1917 turned up in 1964 in a Leningrad State Academy of Art exhibition of drawings and watercolors from the end of the eighteenth century to the beginning of the twentieth century in private collections. The catalogue listed it as a collage and, as Annenkov remembers, it was an illustration for a book, which would explain the figurative subject of a man at a table. On the photograph one can scarcely distinguish the pasted pieces of newspaper from the painted ones. However, some idea of the original can be gleaned from a later collage (Galerie Y. Lambert, Paris), dated 1923 but remarkably enough designated as Saint Petersburg, not Petrograd. This too has a piece of newspaper crumpled in such a way as to force the columns of text out of line, and above and below the newspaper are drawn an egg and a box of matches which seem to project as three-dimensional objects.

The magazine *The House of Art* published in 1921 a collage by Annenkov with a view of London drawn in Cubist fashion and, in large letters, the title *Rolls Royce* (figure 9). In the original, an English advertising handbill and a printed reproduction of a lady's high-laced boot were pasted in along with paper lace whose Gothic filigree suggested a cathedral. Another collage, in a book titled *Red Protectorate* that appeared in Moscow in 1924, was a full-page reproduction of a poster which, as Annenkov recalls, was executed in 1922 and had a portrait of Lenin above books, machine parts, a grotesque face, and statistical data referring to the liquidation of illiteracy. Two dark figures seen from the rear in the foreground, plus a curtain on one side, made this odd assemblage appear as if on a lighted stage. In the reproductions of these collages, whose sketches Annenkov executed in black and white in order to facilitate the preparation of the printing plate, the pasted elements served only for graphic animation, but their precise forms and texts contrasted with the vague suggestions of the drawing.

The artist himself has preserved a noteworthy construction dated, questionably, 1919. On this, between rectangles in cardboard and wooden molding are mounted a marbled paper, a twist of wire, and a framed view of the Cathedral of Amiens, which, according to the inscription, the artist had visited in 1912. Even more disconcerting in their effect are the objects added to the 1922 portrait of Alexander Tikhonov (plate 74), director of the World Literature publishing house: an electrical push button and a sentimental framed color print, entirely Dadaistic elements, though not intended to have any provocative association or aim. Annenkov explains that the buzzer is there simply because, in fact, there happened to be one on the wall behind his sitter; and the saccharine oleograph was particularly welcome to him because, by contrast, it made so much more effective the emphatic brush strokes of his own technique. He characterizes his method as "relief painting," a Cubistic disruption of surfaces and planes to which, by skillful manipulation of light and shade, he contrives to lend an effect of relief.

Annenkov made a name for himself in Russia with his portraits. A selection of portrait drawings of well-known personalities was issued in book

Annenkov tells us that in Petrograd he also produced three-dimensional metal constructions which he exhibited in the Institute of the INKHUK.

form in Moscow in 1922, and an over-life-size oil portrait of Lenin was eventually used for a postage stamp. Along with the portrait of Tikhonov he exhibited a similarly huge portrait of Trotsky at the Venice *Biennale* of 1924, in the section of the Russian pavilion specifically set aside for the most recent trends in art.

Annenkov himself went to Venice for the opening of the *Biennale* and chose not to return to Russia. Since then he has lived in Paris, where, after a long period of figurative painting, he has again been concerned with abstractions into which he incorporates occasional plastic elements in order to emphasize a third dimension within painting.

Other painters likewise were familiar with Western painting and during the revolutionary years experimented with collage and material constructions. Among them were DAVID SHTERENBERG (1881–1948) and Natan Altman, both of whom had lived in Paris before the war.

About 1919 Shterenberg designed book and magazine covers evoking certain reminiscences of the Cubists' papiers collés. On the collage he devised as cover for the first issue of the magazine *Izo (Pictorial Art)*, published in Petrograd in 1919 (plate 87), the title is painted in large letters, but in the center of the collage itself there is a scrap of delicate lace on dark paper, a lyrical survivor of the old days that is literally drowned out by the revolutionary catchwords on the pasted strips of newspaper.

In his painting Shterenberg sought to introduce new textural values by pressing objects and cloth into the painted ground and then going over the impressions with appropriate colors. Reporting on the artistic situation in Russia for *Kunstblatt* in 1922, on the occasion of the Russian exhibition in

Figure 8. Yury Annenkov. *Bookplate*. 1917. Pen drawing and collage

Both held official positions in the Soviet Union. Lunacharsky, the head of the Ministry for Culture, appointed Shterenberg and Altman as chairmen, respectively, of the Moscow and the Petrograd sections of the IZO, the Art Department of the Commissariat for People's Education.

A.H. Barr, Jr., catalogue of the exhibition *Cubism and Abstract Art*, New York, Museum of Modern Art, 1936

Figure 9. Yury Annenkov. *Rolls Royce*. 1921. Drawing and collage

Berlin, Shterenberg wrote about himself: "In my easel painting I was the first to build up surfaces by contrasts in treatment, insofar as I painstakingly represented objects through the materials appropriate to them." Knowing these pictures only from reproductions, it is scarcely possible to distinguish the imprints of objects, of lace doilies for instance, from materials actually glued into the compositions, nor can one say whether certain inscriptions and labels were done in trompe-l'oeil painting or by collage.

B. Arvatov, *Natan Altman*, Moscow, 1924

NATAN ALTMAN (b. 1899), who lived in Petrograd, changed about 1918 from his initial Cubist style to wholly nonrepresentational painting, working out his own way for himself. Upon occasion he thickened his oil paints with plaster of Paris and resorted to lacquer, vegetable oils, sawdust, coal, and so on in order to vary his surface textures. A picture of 1920, in which he utilized oils, size, stucco, and sawdust, bears the revealing title of *Collection of Materials*. In the picture *Petrocommune* of 1921–22 wood and paper are introduced, and large painted typographical letters complement the geometric areas.

Reproduced in Hans Arp and El Lissitzky, *Die Kunstismen 1914–1924*, Zurich, 1925

Altman moved in 1921 to Moscow, where, in the following year, there was the first showing of his abstractions. There he took on every kind of practical task, designing posters, book covers, and postage stamps, all requiring good typographical disposition of titles and texts. He spent some time in Berlin from 1922 on, and it was there, it seems, that he used collage in his sketch for a poster advertising Garbaty cigarettes (plate 85), a rigorously horizontal and vertical composition into which he introduced the cigarette package with its illustrated wrapper, revenue stamps, and three real cigarettes.

Along with these, Altman also did black-and-white sketches of an entirely different, virtually tachiste character, which he sprayed with lacquer and to which, on one occasion, he even glued a piece of tree bark.

Reproduced in the Czech magazine *Pásmo*, 1924

ISSACHAR RYBAK (1894–c. 1965) was one of the Russian Jewish painters of Kiev who, during the revolutionary years, sought to instill new impulses into traditional Jewish art, and he was obviously influenced by the Cubist-Futurist painting of Alexandra Exter. He moved to Moscow in 1919 and in 1922 emigrated to Berlin. *Albatros*, the Berlin Yiddish-language magazine for new poetry and graphic art edited by Uri Zvi Grünberg, reproduced in 1923 a *Still Life with Alphabet* by Rybak (plate 86), in which there is no mistaking his Cubist models. Certain segments of the surface are covered with a thickened, granular impasto of pigment; others are pasted over with varicolored papers, wallpaper borders, and lace. A religious image with Hebrew inscription and a broad strip with the letters of the Hebrew alphabet reflect the traditional importance ascribed to writing in Jewish pictorial representations.

E. Steneberg, *Russische Kunst in Berlin 1919–1932*, Berlin, 1969

According to the Polish painter Henryk Berlewi, who composed the typographical title page for this number of *Albatros* and who was in contact with Rybak and other Russian Jewish emigrants in Berlin, this and other pictures were shown by Rybak at exhibitions of the Berlin November group, in which he himself participated in 1922–23.

As for MARC CHAGALL (b. 1887), reminiscences of his early years in Paris crop up in his *Cubistic Landscape* of 1919, in which the suggestions of wallpaper and wood graining allude to the typical components of papiers collés, while the view of the white building of the Vitebsk Academy, interpolated between the circular and surface forms, recalls Malevich's "alogical" compositions.

F. Meyer, *Chagall*, New York, n.d., states that, although dated 1918, the picture was probably painted the following year.

Chagall invited Malevich to that Academy, and their discussions led Cha-

gall to come to terms artistically with Suprematism. In the *Painter at His Easel*, one of the sketches for murals for the school atelier, the painter is seen working at a composition of pyramids and spheres. Geometric forms are found also in certain stage designs, such as those for Sholem Aleichem's *Agent* and Gogol's *The Inspector General*, on which Chagall apparently had begun to work in Vitebsk before moving to Moscow in May of 1920. It was there that he did the collage (plate 88) that is almost unique in his career, a composition in the Suprematist spirit (erroneously dated 1920) with clear spatial arrangement of the pictorial elements. It includes cutouts from solid-colored, marbled, and patterned papers, an envelope, and the invitation to an exhibition of his murals for the Jewish theater in Moscow that took place in June of 1921.

Recently Chagall again used collage in one of his sketches for the ceiling painting of the Paris Opéra, a color sketch in which colored swatches of cloth mark the areas of color planned. See J. Lassaigne, *Le Plafond de l'Opéra de Paris par Marc Chagall*, Paris, 1965.

Also in Vitebsk by 1917 was EL LISSITZKY (1890–1941), who before World War I had studied architecture and mechanical engineering at the Technische Hochschule in Darmstadt and had taken his architect's diploma in 1915 in Moscow. At first in Vitebsk he worked on illustrations for Jewish children's books, and for the Passover song *Chad Gaya (The Kid)* he did hand-colored woodcuts with their images framed by Hebrew inscriptions. These words fulfill the same double function—textual and pictorial—as those in Chagall's paintings from the same time, for example the *Cemetery Gate* of 1917 (Collection Mme. Ida Meyer-Chagall, Basel); and they led Lissitzky to recognize the special expressive possibilities of typography. Subsequently he made a major contribution to its revitalization and use as a factor in publicity presentation.

Gray, pl. 162

In 1919 Chagall appointed Lissitzky as teacher of architecture and graphic arts at the Vitebsk Academy, and it was Lissitzky who persuaded him to invite Malevich there also. Lissitzky was deeply impressed by Malevich's Suprematist works, and they were the point of departure for his own "Proun" constructions, which he characterized as a "transfer station between painting and architecture."

Lissitzky began his first "Proun" pictures immediately after the *Tenth State Exhibition*, which was held in Moscow at the beginning of 1919 and revealed nonrepresentational painting to be at its apogee. Malevich exhibited there his *White Square on White Ground* (Museum of Modern Art, New York), the climax of his Suprematist style, and Rodchenko, who defined himself as a "nonobjectivist," countered with his *Black on Black* (whereabouts unknown), an abstract composition made up of segments of circles. As for Lissitzky's "Proun" pictures, they ushered in a new phase of Constructivism in which collage too was to find a fundamentally new utilization.

Respectively, Gray, pls. 172 and 173

Lissitzky's chief concern was how to utilize mathematical-geometric means of representation to make spatial constructions of unlimited extension visible upon a plane surface. In this the material itself played an essential role. As Lissitzky put it in an article published in Moscow in 1920: "The configurations with which the Proun undertakes its assault against space are based on the material used and not on aesthetics. That material, in the first phases, is color. It is considered, in its state of energy, as the purest state of matter. From the rich mines of color we have extracted that vein which is most free from all subjective properties. In its fullest realization Suprematism liberated itself from the individualism of orange, green, blue, and the rest, and arrived ultimately at black and white. With these we beheld the purity of the force

Catalogues *El Lissitzky*, Hanover, Kestner Gesellschaft; Eindhoven, Stedelijk van Abbemuseum; Bremen, Kunsthalle, 1965–1966

of energy. The power of opposition or agreement of two grades of black, white, or gray gives us the basis for comparison of the agreement or contrast between two technical materials, such as, for example, aluminum and granite, or concrete and iron.... Color becomes a barometer of the material and results in a thoroughly new way of working with materials. In this way the Proun creates new material through a new form."

Lissitzky executed "Proun" pictures in the most diverse techniques, in pencil or chalk drawings, oil or tempera paintings, with colored papers, sandpaper, plaster of Paris, or lacquer to differentiate the textural values and, by means of shading, to allow certain volumes to stand out in relief (plate 91). He introduced isolated papers of pronounced colors into black-and-white drawings, using them to cover surface fields interpolated into the linear projections. To a collage in an open circular form (Collection Mr. and Mrs. Harry Lewis Winston, Birmingham, Mich.) he added a tiny, glowing red triangle, which becomes the spatial center. Silver paper is often used to produce a metallic middle tone amid black, gray, and white, while in other instances the paper is of an especially intense black, which sets it entirely apart from both the paint and the pencil work.

Lissitzky became head of an architectural workshop at the Vkhutemas in 1921. He helped organize the *First Russian Art Exhibition*, which opened in October of 1922 at the Van Diemen Gallery in Berlin, and moved in the next year to Amsterdam. His sketches for the cover design of the catalogue were carried out in collage.

T. Andersen, in the catalogue of the *Tatlin* exhibition, Stockholm, Moderna Museet, 1968, states that, at an exhibition of the INKHUK in Petrograd in 1922, Tatlin too presented a monochromatic picture, in pink.

At the Berlin exhibition interest was aroused especially by Rodchenko's monochromatic pictures, which had already been shown at the $5 \times 5 = 25$ exhibition in Moscow in 1921 and which anticipated the controversial works of Yves Klein, more than forty years after. Paul Westheim wrote about them in *Kunstblatt:* "Rodchenko spreads a small rectangle—symmetrical, uniform, craftsmanlike—with a brilliant crimson. A task such as is imposed in our applied-arts schools on apprentices in house painting and lacquering as the test for promotion to master. What is important is to be perfectly clear as to the treatment values of such surfaces. A mat color area is placed against a shining one, a smooth one against one that is roughened. Investigation is made into the distinction of a painted black from a pasted black paper surface." The last sentences obviously refer to Lissitzky's pictures.

Prints in the Stedelijk Museum, Amsterdam

After a first portfolio of "Proun" pictures appeared in Moscow in 1921, the Kestner Gesellschaft in Hanover brought out a second one in 1923, comprising six lithographs, most of them colored, after works dating between 1919 and 1923. Certain of these lithographs also include collage elements: in one a black disk, in another a vertical strip of reddish paper. Probably Lissitzky again used collage for the original sketches of the costume designs for *Sieg über die Sonne (Victory over the Sun)*, which appeared as a second portfolio of the Kestner Society. The color values of these prints are especially well calculated, and the delicate yellow and red surface shapes that stand out against the shaded gray tones may very well have been designed in the preliminary studies with pasted papers.

Horst Richter, *El Lissitzky: Sieg über die Sonne*, Cologne, Verlag Galerie Christoph Czwiklitzer, 1958

During 1920–21 Lissitzky had been occupied in Moscow with the plan to present the opera *Podeda nad Solntsem (Victory over the Sun)* on a text by Kruchenykh, the same work that had been performed in Saint Petersburg in 1913 with scenery by Malevich. Lissitzky visualized his production as a

"plastic conception of an electromechanical spectacle," calling for an open stage on scaffolding. In the center the "creator of the spectacle" was to operate switchboards which would set into motion the various parts of the stage framework along with the "acting bodies" set into them, that is, the entirely abstract human figures, and at the same time synchronize the changing light effects and noise music. For the lithographs of his costume designs, Lissitzky wrote in a foreword: "The colors of the individual sheets are to be considered, as in my Proun works, material-equivalent. That means: in performance the red, yellow, or black parts of the costumes will not be painted in to match but, instead, executed in a corresponding material, as for instance burnished copper, dull iron, and so forth."

In his abstract, two-dimensional compositions Lissitzky followed the Suprematist style of Malevich, but his special interest in materials constituted a bond with Tatlin, who also was a teacher at the Vkhutemas. Tatlin's counter-reliefs led naturally to the conception of the walls in the "Proun room" that Lissitzky executed for the *Great Berlin Art Exhibition* of 1923. There too the corners of the room were cut across by elementary shapes in wood, and coloring was restricted to the contrast between natural wood and certain parts painted black, white, or red.

Lissitzky also paid homage to Tatlin in a collage (plate 92) showing Tatlin with compasses and yardstick alongside Lissitzky's own diagrammatic plan of a model for the Monument to the Third International. Pasted horizontally across the top of the picture there is half of a cutout head of Lilya Brik, who was Mayakovsky's friend. The figure of Tatlin was drawn after a photograph in which he was seen at work on the construction of the model, together with his pupils S. Tolstaya, T. Shapiro, and I. Meyerson.

In the Vkhutemas young artists who sought their models in engineering and industry gathered around Tatlin and Rodchenko. For art works they preferred impersonal materials such as metal, glass, and concrete, and they also adopted the engineers' mechanical methods of assemblage and montage. At an exhibition of the Obmokhu, the League of Young Artists, held in May, 1920, most of the works shown were metal constructions in line with the prevailing "spirit of the machine" of those years.

Another contribution to the great upswing of art in Russia in the first years of the Revolution was made by the brothers ANTON PEVSNER (1886–1962) and NAUM GABO (b. 1890), who returned to Moscow from abroad in 1917. Pevsner was called in to teach painting at the Vkhutemas, and Gabo as a free-lance artist collaborated closely with that workshop. To Gabo came especially students interested in sculpture, since he was seeking new solutions through the use of new materials.

In Oslo in 1916 Gabo had executed a bust and a head in Cubist style, in which the form was not broken down into segments of planes but rather into mathematically precise segments of space. The choice of materials for the female head (Museum of Modern Art, New York), metal and celluloid, appears to have been influenced by the work of Archipenko, which Gabo had probably seen in 1913, when he visited his brother Anton in Paris.

In 1920 Gabo and Pevsner issued their *Realistic Manifesto*, which proclaimed that the factors of space and time should also be brought to expression in artistic concepts. Gabo constructed a *Kinetic Sculpture* in 1920, a steel blade set swinging by electrical impulse so as to produce a virtual volume. This

The model, at which Tatlin worked in Moscow during 1919 and 1920, is one of the most audacious unexecuted architectural projects of our time. Two cylinders and a pyramid of glass were to revolve around each other at different speeds within a metal spiral rising into space. In the interior were to be halls for meetings, concerts, and exhibitions. The height of the monument was to be over 1,300 feet. A reconstruction was made for the Stockholm *Tatlin* exhibition and was also shown at the Venice *Biennale*, 1970. Gray, pl. 168

Gabo changed his name to distinguish himself from his brother.

"Russia and Constructivism: An Interview with Naum Gabo," *The World of Abstract Art*, New York, 1957

was one of the very first "mobile" art works of our century, along with Rodchenko's suspended sphere (present whereabouts unknown). At the same time Gabo was continuing his experiments with new materials. For two abstract reliefs in 1920–21 he utilized transparent plastics, which made it possible to incorporate space and light directly into the composition, and in a three-dimensional construction of 1921 he introduced tubes containing colored fluids in order to reflect and to break up light. Later in his sculpture he combined aluminum with other metals and adopted a wide range of the newest synthetics.

Pevsner too experimented with new materials. Shortly before he left Russia in 1923, he created a composition of abstract forms incised into a layer of wax and then given texture by painting (Museum of Modern Art, New York). In his new home in Paris he repeated this wax technique upon occasion and went on to construct three-dimensional heads and torsos of metals such as brass and zinc in combination with celluloid.

Whereas in Moscow under the NEP (the New Economic Policy instituted in 1921), abstract nonrepresentational art fell into disgrace, in Petrograd the Institute of Artistic Culture, commonly known from its initials as the INKHUK, was opened just a year later, in 1922, to concern itself in particular with the analysis and utilization of techniques and materials. Malevich was appointed director, and the faculty included Tatlin, Pavel Filonov, Mansurov, the composer Matyushin, and the art critic Nikolai Punin. Mansurov, who had been in association with the Commissar for Education, Anatoly Lunacharsky, in Petrograd became the head of the "Experimental Section."

At the first art exhibition organized by the IZO (an acronym for that department) from April to June of 1919 in the Petrograd Winter Palace, PAVEL MANSUROV (b. 1896) showed nonfigurative pictures of a highly personal stamp: small wooden panels into whose gray-toned primings a few straight lines, curves, and angles were introduced. Soon thereafter he began to make multilayered compositions of a variety of materials. By means of metal rods he mounted drawings at a certain distance above sheets of wood, or he glued a drawing on a piece of frayed canvas mounted on a board, or he slipped a loose-weave wire net between the painted wood and the picture ground in order to show the contrast between the treatments of paint and of the basic material. Much more astonishing are the collage reliefs of the following year, conceived to serve as visual education material at exhibitions directed toward the country population, because these incorporate elements from nature, twigs and pieces of roots, affixed to plywood or cardboard. On one of them, over the metal chassis of an old typewriter hangs a piece of weather-beaten tree bark, with a gleaming dried butterfly. On another (plate 89), a butterfly with outspread wings was mounted on a crumpled piece of wrapping paper painted with white highlights that are echoed by similar white patches on the wooden plank making up the base of the relief. At an exhibition of the Petrograd Institute in 1923, these collages were hung alongside Mansurov's early abstractions as examples of the new treatment values he was now discovering in nature.

Mansurov himself says that in the course of his investigations into the phenomena of mimicry he became aware of the way animals are protected by their colors, which blend into their environment. On the basis of this

Alexei Pevsner, in *A Biographical Sketch of My Brothers Naum Gabo and Antoine Pevsner*, Amsterdam, 1964, states that he himself procured the material for this picture, a disk of cork set into a board, and therefore knows the date, which is usually given erroneously as 1913. See M. Seuphor, *Le Style et le Cri*, Paris, 1965, p. 59.

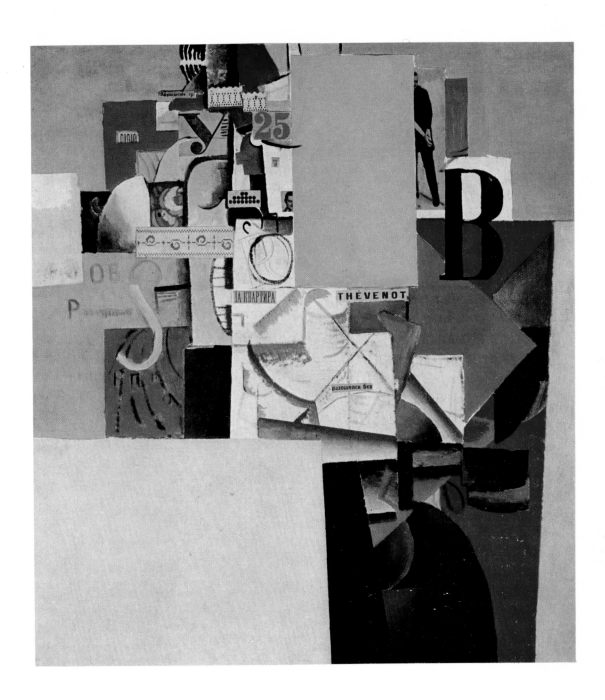

Colorplate 18. Kasimir Malevich. *Woman Beside an Advertisement Pillar.* 1914

phenomenon he took to pasting white feathers into drawings on a white ground, and for one collage (plate 90) he deliberately chose a butterfly whose light color shadings matched the silvery tones of the birchbark he was using. In the courses Mansurov taught at the INKHUK, he pointed out the organic sources from which artistic forms develop, and in the exhibitions of his students' workshop he demonstrated by means of photographs the relationships that exist between topographical features and primitive buildings, between vegetable forms and the implements used by less developed populations. To point out the prototypes from which peasant textile art draws its motifs, he prepared a three-dimensional composition in which a branch with pine cones, a hemp rope, an ear of corn, and a country-style straw shoe were mounted in a splint basket—an "assemblage" in the manner of today, in which, for all that the aim was purely practical, there remains much that is poetic.

Within the context of his courses on the theory of form at the INKHUK Malevich plunged deeply into the study of elementary forms and colors, their specific expressive values and functions within a picture. He illustrated his essay, *Introduction to the Theory of Additive Elements in Painting*, which he finished in 1925, with collage panels made of colored papers demonstrating the formal and chromatic developmental series. The explanatory texts are not only in Russian but also in part in German, in consideration of the projected German edition of his writings published in 1927 by the Bauhaus with the title *Die gegenstandslose Welt*. According to information from Mansurov, these collages were intended only as study material and were not executed by Malevich himself but by Matyushin, who headed the "Organic Section" at the INKHUK and worked on comparative studies of optical and acoustical perceptions.

English translation, *The Non-Objective World*, Chicago, 1960

Innovations in Theatrical Design, Graphic Arts, and Photomontage

The energetic discussions concerning the meaning and purpose of art that went on in the Moscow ateliers at the start of the 1920s split the artists into two camps. Kandinsky had been teaching since 1917 at the Moscow Academy and at the Vkhutemas, and as museum organizer he played an important role in the commissions of the Ministry of Culture. He, Malevich, Gabo, and Pevsner advocated an independent creative art, while Tatlin, Exter, Popova, Rodchenko, Stepanova, and others argued that the justification for art in the new society depended upon its fulfilling practical needs. The latter group called especially for the application of modern conceptions to the theater, book production, and propaganda activities, fields in which the Russians were at their height at the time and in which collage and montage were finding new forms and applications.

Alexandra Exter had designed settings in 1916 for the chamber theater directed by Tairov in Moscow, using Suprematist elements such as cubes, cones, cylinders, and stairs. In the following year she made a model for a stage setting of a city with houses, bridges, staircases, open squares, smokestacks, and electric advertising signs. For this she utilized plaster of Paris, sheet metal, and other practical materials and glued pieces of newspaper and shreds of posters over the boxlike rectangular and round forms, much

Reproduction and description of this unexecuted design in the monograph by Tugendhold

as in her early Cubist-Futurist pictures. For *Romeo and Juliet*, which was performed at the Tairov Theater in 1921 with her settings and costumes, she achieved striking effects of light and space by mounting vertical planes of glass, mirror, and metal between the palace facades, staircases, and bridges.

There is a certain relationship between Exter's work and the stage designs that MICHEL ANDREENKO (b. 1894) executed in collage in the 1920s. A former student at the czarist Academy in Saint Petersburg, in 1918 he turned to abstract Cubist painting, which, in the subsequent years, grew closer to Constructivism in his simplification of forms. His earliest contact with the theater was before 1918, as a collaborator on the preparation of décors in the Saint Petersburg Theater. During the revolutionary years of 1918 and 1919 he remained in Odessa, where he designed the settings, costumes, and masks for a comedy by Plautus. At the various stages of his emigration he continued to work for the theater, first for plays and ballets at the Royal Opera in Bucharest, then at the Národní Theater in Prague and at the Deutsche Theater in Berlin. In 1923 he settled in Paris, and there he began to execute his designs in collage, a technique with which he had not been acquainted in Russia.

His stage settings consist of severe, simple architectural forms differentiated by brush textures and pasted papers. For the latter he makes his own marbled and flocked speckled papers and also uses sandpaper, whose granular surface he covers with silvery lacquer. His color scales are subtly harmonized, for the most part in mat grayish blue chords with light reddish, violet, and green shadings, enlivened at times by applied silver and gold papers. For the presentation of Tristan Tzara's *Mouchoir de nuages* at the Théâtre de la Cigale in Paris in 1924, he used collage for a model of the setting composed of arches of bridges and columns, to which the dark, open background lent a feeling of spatial depth; and out of the grayish pepper-and-salt and textured surfaces gleamed narrow red and green strips of paper. Andreenko also did décors for the Théâtre l'Arc-en-Ciel directed by the Russian actress Komissarshevskaya, who had worked with V. E. Meyerhold. Into his design for an ornamental stage curtain (plate 84) he pasted bright-colored confectioner's paper, and, in another design, he enveloped a Cubistic stage set in fluted, rough-napped, and speckled papers. During those years he occasionally incorporated into his oil paintings other materials such as delicate net lace, wire, or a scrap of Russian embroidery, which brought a lyrical note into his abstract compositions. After a long period of figurative painting, in recent years Andreenko has returned to nonrepresentational painting, in whose nuances of color he no longer uses collage elements.

Other students of Exter in Kiev were the film directors S. Yutkevich and G. Kosinev, who, together with L. Trauberg, founded in Petrograd the theater group Feks (from the initials of "Factory for Eccentric Stage Performers"). The collages of all sorts of colorful papers jumbled together that they showed in 1922 at the *Exhibition of Left-Wing Movements* in Petrograd were very much in the spirit of that group. Circus and "eccentric stage performers" were pasted together with cutout slogans from advertising posters and annual market displays, as a protest on the part of Yutkevich and Kosinev against the Suprematist and monochrome pictures which made up the bulk of the exhibition. Equally aggressive in their raillery were

Both are in the collection of Eckhard Neumann, Frankfort on the Main.

Concerning Exter's school in Kiev, see Ilya Ehrenburg, *People and Life, Memoirs of 1891–1917*, London, 1961.

Le Cinéma soviétique par ceux qui l'ont fait, Paris, 1966

Huntley Carter, *The New Theatre and Cinema of Soviet Russia*, London, 1924; and N. Gourfinkel, *Théâtre russe contemporain*, Paris, 1931. Gray, pl. 186

Gray, pl. 189

At the end of the first performance, February 23, 1923, the motorcycles and harvester machines used in the play roared through the auditorium, and the soldier-actors dispersed themselves among the public, who joined in their songs.

This was a children's book whose English title would be *The Story of Two Squares*. All ten of its pages are reproduced in Gray, pl. 225.

These are forerunners of Baumeister's photo-drawings of athletes, 1927.

B. Aranson, *Zeitgemässe jüdische Graphik in Russland*, Berlin, 1924

F. Roh and J. Tschichold used it as the title page for their book *Foto-Auge* in 1929.

the three parodies staged by Yutkevich and Eisenstein in the theater workshop of the Vkhutemas, which made fun of the Cubistic décors created by ALEXANDR VESNIN (1883–1959) for Claudel's *L'Annonce faite à Marie* at the Tairov Theater. For their purposes they invented portable scenery in cardboard pasted over with bright-colored shiny papers, having in mind something like Picasso's costumes for the Diaghilev ballet *Parade*, of 1917. Vesnin himself conformed to Constructivist tendencies in 1923 in his setting for Chesterton's *The Man Who Was Thursday*, a bare framework of laths to which were added posters and electric signs.

V. E. Meyerhold, appointed in 1921 to head the State Higher Directorial Workshops, out of which were to develop in time the State Higher Theater Workshops, welcomed every kind of modern theatrical experiment in his own theater. A sensation was made there in 1922 by Stepanova's décors for *The Death of Tarelkin*, with their elastic seats which rebounded in the air when the actors stood up, and likewise by the mechanical constructions in wood and iron that Popova designed for *The Magnanimous Cuckold*. In 1923, for Sergey Tretyakov's *The World Upside Down*, a revolutionary drama after Sergey Gorodetsky's *The Night*, Popova did a stage design that was essentially a collage blown up to huge dimensions. Immense photographs exalted the advance of the Red Army and its commander Trotsky, the electrification of the countryside, and the new means of transportation. Banners proclaimed: "The World Upside Down" and "We Are Building a New World."

Collage also found a special field in the publishing houses, as up-to-the-minute decoration for books and magazines, and there the most important contribution was that of El Lissitzky. His first attempt at an optical amalgamation of illustrations and a text conceived in terms of typography was made in Berlin in 1922. There, in the same year, he collaborated with Ilya Ehrenburg on a trilingual magazine *Veshch/Objet/Gegenstand (Object)* whose aim was to acquaint Russian and Western European artists with each other's work. The magazine was distinguished by lively page layouts with illustrations and texts disposed in columns in different type faces and sizes. For the jacket of Ehrenburg's *Six Stories with Happy Endings*, also published in Berlin in 1922, Lissitzky designed something much like the title pages of the magazine they both worked on. He also prepared collages for these stories, though they were not used in the book and some at least were done after its publication. Among them are the collage of *Tatlin at Work* mentioned earlier (plate 92) and two in a related technique with cutout reproductions of photos of sportsmen, a gymnast and a football player, pasted on a drawn "Proun" construction (plate 79). Rather different in style is a collage titled *The Ship's Chart* (plate 93), with a black handprint on a diagram of drawn lines to which are added Hebrew characters and printed matter, as well as the title page of a prospectus issued by the Hamburg-America Line.

In 1924 in Hanover and during a medical cure in Locarno, Switzerland, Lissitzky undertook new photographic experiments. His *Self-Portrait* (plate 94) shows a double exposure of his head and a hand holding compasses mounted within an abstract drawing, and the *Simultaneous Portraits* of Kurt Schwitters and Hans Arp has several photographic images superimposed. That of Arp, in which the ear of the rather blurred rear view appears on the cheek of the sharper frontal view, was used in 1928 for the jacket of Ilya

Selvinsky's *Jottings of a Poet*, whose Dadaist spirit is quite in line with this portrait. For posters for the Pelikan factory in Hanover Lissitzky used photograms and photos with distorted perspective whose blurred contours made the clear printed title stand out so much the more forcefully. In 1924 he transformed a sketch that he and his students had constructed in 1920 for the speaker's platform in Vitebsk into a photomontage by inserting a portrait of Lenin.

He collaborated with Schwitters in putting out the *Nasci-Heft* of the magazine *Merz*, 1924, no. 8/9.

In 1925 *Das Kunstblatt* published another sort of photomontage prepared by Lissitzky to illustrate his article *"SSSR's Architektur."* It shows the plan of the *First Agricultural Exposition* of the Soviet Union, of 1923, surrounded by buildings in the would-be historical styles which Lissitzky, as architect, condemned. The text comments: "This is not Dada. These are no excavations from the Forum Romanum. This is the architecture of the First Agricultural Exposition of 1923, turned out by degenerated students of Palladio and impotent architects."

Lissitzky returned to Moscow in June of 1925, and beginning with the following year his chief task was to organize the very important Russian expositions both at home and abroad. His greatest success was the Russian pavilion at the *International Press Exposition* in Cologne in 1930, for which he utilized every means of script, typography, and photography. The chief feature was a gigantic photomontage, roughly seventy-five by thirteen feet, with scenes from life in the Soviet Union stressing the importance of books and writing. The photographic frieze, on which S. SYENKIN collaborated, was also reproduced as a folding catalogue. In his autobiography Lissitzky states that this became the model for all the over-life-size photomontages which were the distinguishing feature of the subsequent expositions. The way the material was put together had much in common with the documentary films of D. Vertov, with whom Lissitzky was in close contact.

Reproduced in the catalogue of the *Lissitzky* exhibition, Eindhoven, 1966, and in Gray, pl. 217

He used photomontage also for the cover of the catalogue of the Japanese film festival held in Moscow in 1929 and for posters such as that for the Dresden *Hygiene Exposition* of 1930. Among his most impressive posters is that for the Russian exhibition in the Zurich Kunstgewerbemuseum in 1929, with the heads of a young man and a girl superimposed so as to blend into one. Documentary photomontages appeared in the 1930s in the magazine *The Soviet Union Builds*, in the special numbers on the Red Army and the Dnieprostroi power plant among others, and in albums such as *The Soviet Union Builds Socialism*, and *The Industry of Socialism*.

Sophie Lissitzky-Küppers, *El Lissitzky*, Dresden, 1967

N. Natan Chardshiev, in the catalogue of the exhibition devoted to the art of the book, Moscow, 1962

In the entrance hall of the Dresden *Hygiene Exposition*, which Lissitzky decorated with large pictorial compositions, he also showed the work of the Russian photographer S. FRIEDLAND, whose photomontage *The Mercenary Press* (plate 101) is a typically impressive example. Over a photograph of French newspapers lying crisscrossed is superimposed a woman's head with the eyes blacked out by India ink. It would appear to date from 1927, when Lissitzky was carrying out this type of photographic experimentation.

See the exhibition catalogue, *Die Fotomontage*, Ingolstadt, 1969. In Paris, A. M. Cassandre did a poster design in 1930 for a literary periodical in which, in similar fashion, a transparent head is superimposed on an open book. Reproduced in A. M. Cassandre, *Peintre d'affiches*, Paris, 1948

Even before the Revolution, L. KULESHEV (1899–1970) began to exploit cinematographic montage, a field closely interrelated with photomontage. As early as 1917 he based his first film, *The Plan of the Engineer Prigh*, on the principles of montage, having discovered the extraordinary possibilities of bringing the most diverse subjects, whether landscapes, persons, or objects, into new relationships. As model for this he had American films, those of

Le Cinéma soviétique..., Paris, 1966

In the catalogue of the *Film und Foto* exhibition, Stuttgart, 1929

D. W. Griffith in particular. One of his earliest undertakings was to combine photographs of the face, head, coiffure, hands, legs, and feet of a number of female models into the image of a single woman. In 1920 he was appointed to teach at the newly organized State Cinema School and turned out a propaganda film, *On the Red Front*, in which the documentary strips he had photographed during the civil war in Poland were mounted into a narrative played by actors, thereby incorporating actual events photographed first-hand. In his Moscow laboratory, Eisenstein and Pudovkin worked along with him as students. As N. Kaufmann, D. Vertov's brother and cameraman, put it in an article about the Soviet cinema, it was Kuleshev who "organized the inarticulate material, who worked with syllables and not merely with words."

However, the real pioneer of montage films was DZIGA VERTOV (1896–1954), who organized the group Kino-Eye in Moscow in 1922, and whose *Kino-Pravda (Cinema Truth)* films were mounted entirely out of contemporary photographic documents set in dynamic, rhythmically organized sequences. He expounded his views in a magazine of the same name, *Kino-Pravda*, which appeared from 1922 to 1924. For the most part Vertov prepared his own scenarios for his innumerable films glorifying the deeds and conquests of the Soviet Union and portraying the lives of its citizens.

ALEXANDR RODCHENKO (1891–1956) assisted Vertov in 1922 in one of his earliest films and learned the technique of montage from him. Subsequently he also profited by contact with Kuleshev, for whose film *The Death Ray*, of 1925, he executed the décors. However, before he himself took to photomontage, he began in 1922 with graphic works. He took over the job of typographic layout for the magazine *Kino-Fot* and published in it collages composed entirely of strips of text and newspaper clippings. On one of them, diagonally across the middle is pasted the title *The Press and the Revolution* in new-style characters (figure 10), and around it are grouped advertisements in the old czarist spelling for new methods in the treatment of deafness and stuttering, "flower glycerine soap," and subscriptions for a children's illustrated magazine.

Most of the photographs were taken by Wassermann.

Lissitzky's collage with Tatlin and the portrait of Lilya Brik appears to be later than this book.

In such works there are reminiscences of the typographical collages of the Berlin Dadaists, but the illustrations that Rodchenko did in 1923 for Mayakovsky's volume of poems *Pro Eto (Of This)* are more clearly influenced by the photomontages of Raoul Hausmann, Hannah Höch, George Grosz, and John Heartfield. The Russians became acquainted with the Dada montages during the Russian exhibition in Berlin in 1922, and Hausmann tells in his *Courrier Dada* how Lissitzky, on a visit to his studio, said, "This is still unknown among us." It is said that Rodchenko went to Berlin for the exhibition, and Mayakovsky also was there at about that time.

The style of the elegiac love poems that Mayakovsky addressed to Lilya Brik is matched by Rodchenko's photomontage illustrations, in which, in like manner, real and fantastic elements interpenetrate directly. Lilya Brik's portrait decorates the title page, and a great many photographs of her and Mayakovsky are incorporated into the illustrations, which echo the poet's desires and anxieties. They show Lilya in the intimacy of her home, or Mayakovsky as the image of what he felt when separated from her—a caveman or a polar bear—or on the telephone, whose lines, together with the telephone number in huge figures, stretch across the entire expanse of

the city. Other illustrations depict the struggle between past and future which dominated all relationships during the post–revolutionary years. In a collage, *Another Cup of Tea?* (plate 99), Rodchenko lavished his irony on the philistine habits and attitudes of the old bourgeoisie, juxtaposing to them pictures of the civil war and the revolutionary youth. On another, *I Hold the Balance of Power* (plate 100), from the very top of a church steeple the poet dominates the crowd below, and the new age announces itself in gigantic skyscrapers and a fantastic flying machine.

Rodchenko's collage illustrations became known abroad also. The Czech artist and critic Karl Teige mentioned them in an article on the new art in the Soviet Union that he published in 1925 in the magazine *Host*, declaring that, by composing pictures entirely from photographs, Rodchenko had invented a new type of painting. In this connection he spoke also of Rodchenko's pupil LYUBA KOSINTSEVA, the wife of Ilya Ehrenburg, "who likewise bows down before the machine and employs photographs as a means of expression." Kosintseva had attended Exter's art school in Kiev before moving to Moscow, where she gravitated to Rodchenko's orbit. Influences of his early nonobjective drawings were reflected in a collage that *Host* published in its following issue, an abstract composition of rectangles and circles into which she pasted a newspaper cutting and a portrait photo (plate 80).

From 1923 on, Rodchenko utilized photomontage consistently for title pages of magazines and for book covers, photographs being an ideal medium for revolutionary propaganda. Concerning his use of photographs instead of painted or drawn representations, he explained: "The point of this changeover is that, in place of optical impressions rendered in drawing, here one reproduces accurately recorded facts. Fidelity to fact and documentary truth give the depiction a power to stir the viewer such as is simply not possible for painterly and graphic techniques."

For the magazine *Lef (Left)*, which Mayakovsky founded in 1923, Rodchenko composed title pages with cutout photos, at first somewhat Dadaist in style, gaudy and slashed through with lines of text. In his later work for the new series of *Lef*, which appeared from 1928 on, and for *Daesh (You Give)* and various other periodicals, his compositions became simplified in Constructivist fashion, with a few photos and terse titles organized so as to be more clearly taken in at a glance. Rodchenko also did photomontages in 1924 for the volume *Mess-Yende* by the poetess Marietta Shaginyan and in 1925–26 took over the page layout and montage jackets for various publications by Mayakovsky, including *Paris, Syphilis, Conversation with an Inspector Concerning the Art of Poetry*, and the ode *To Yessenin*, written in 1926 after that poet's suicide. Along with these he designed innumerable propaganda posters for the state and the party, as well as for films by Vertov and Eisenstein, including the latter's *Potemkin*.

Varvara Stepanova collaborated in her husband's work for the publishing houses and contributed a collage of newspaper clippings to his *To Yessenin*. She helped him with *Lef* and the various other periodicals devoted to questions of propaganda, press, film, and so forth, took care of layouts, and did illustrations which exploited photomontage. The magazine *The Book and the Revolution* published one of these, which consisted of a portrait of M. Borisoglebsky surrounded by photos presumably related to the works

C.L. Friaux, *Majakovski par lui-même*, Paris, 1961

Louis Aragon reproduced one of these illustrations in 1930 in his *La Peinture au défi*.

Kosintseva accompanied Ehrenburg to Berlin, where, in 1922, she exhibited with Kurt Schwitters at Der Sturm and afterward, with Lissitzky, at the Kestner Gesellschaft in Hanover.

Gray, pls. 232, 233

Figure 10. Alexandr Rodchenko. *The Press and the Revolution.* 1922. Collage with advertising clips

Stepanova's daughter, Barbara
Alexandra Rodchenko, continues
her mother's work. At an exhibition
organized in Moscow in 1966 by the
Committee of Graphic Book
Artists, along with watercolors she
showed albums of photographs,
photographic covers for books and
periodicals, and photograms.
The invitation had a reproduction of
her *Caricature of a Self-Portrait*,
a photogram with the head of the
artist in profile in the midst of
scissors, brushes, and graphic
structures.

In the catalogue of the *Photomontage*
exhibition, Berlin, 1931

Gray, pl. 218

of that author and bearing titles such as *Swamp*, *Katya in Paper*, and *Holy Dust*.

Stepanova and Rodchenko collaborated in 1930 on photo illustrations for Tretyakov's *Animals Themselves* and published photomontages in the magazine *Beyond the Borders*. Both also worked on the magazine *The Soviet Union Builds*, which published a number of extensive pictorial reportages by Rodchenko. He eventually produced photographic albums of the republics of Uzbekistan and Kazan, the Red Army, Soviet aviation, and the like, and Stepanova did photomontage jackets for *The First Cavalry* and the *Results of the First Five Year Plan*.

Among the artists who specialized entirely in book and advertising art, GUSTAVE KLUTSIS (1895–1944) was among the most gifted and most successful. He became a pupil of Malevich in 1918 at the Free Artistic Workshops in Moscow and adhered to the Suprematist movement. A collage of 1919, *The Dynamic City*, whose buildings rise up from a Suprematist ground plan, shows relations with Lissitzky's early "Proun" constructions. He used photomontage in 1923 for a very modern poster on the theme of *Sport* (plate 97), built up in layers on a geometric ground composition with the title in very large block letters, over which, in the center, lies a circular disk with superimposed photographs of gymnasts on the side horse and parallel bars, cut out so that the athletes appear to be soaring in the air. Klutsis continued to exploit this kind of mathematical division of the pictorial field. For a poster of 1926 for *Hygiene*, behind a laughing man under the shower is a dark trapeze shape traversed by the symmetrical streams of water. About 1928 he created covers for books and magazines, using the diagonally disposed elements of words and pictures which became characteristic of the style of Russian montage. S. Syenkin did rather similar posters, but the photos are graphically linked by solid lines and by strips of text (plate 98). Among Klutsis's most effective posters is the *Fulfillment of the Plan*, of 1930, with photos of peasants and workers in the foreground, their upraised hands ascending on a diagonal to a single gigantic hand towering against the sky. Concerning the special expressive potentialities of such montages, Klutsis stated: "Photomontage organizes the material according to the principle of maximum contrast, unexpected arrangement, difference in dimensions, by which means it yields a maximum of creative energy."

The STENBERG brothers, VLADIMIR (b. 1899) and GEORGY (1900–1933), adherents of the group of Moscow Constructivists, had recourse to other specific photographic procedures for their cinema posters. On the poster for *Woman Bandit*, of 1927, a dark portrait of a woman is blotted out by a superimposed bright hand, through whose fingers peer large piercing eyes. Here the brilliant invention of Lissitzky's *Self-Portrait* is heightened dramatically to attain new expressive force. For the poster for Vertov's film *The Eleventh* of 1928, Klutsis's disk of concentric rings is transformed into a spiral leading into the depths; within its center one sees a building construction, while portrait heads appear before the viewer on radial strips with perspective diminution.

In the exhibition of photomontage organized by César Domela (Nieuwenhuis) in 1931 at the old Berlin Kunstgewerbemuseum, fourteen artists of the Soviet Union took part, an indication of the extent to which montage had implanted itself in Russian publicity art. Soon afterward, however, the

Colorplate 19. Man Ray. *Shadows,* from the album *Revolving Doors.* 1926

medium obviously lost the approval of the official powers-that-be in art. P. Kaufmann asserted in 1934, in an article titled "Poster and Caricature in the Soviet Union," that "the new tasks, the further sharpening of the message in posters, and the deepening of meaning in their pictorial content, go beyond the possibilities of pure photomontage." He names Dolgurov and Lyubimov as young poster artists who, on these grounds, had developed a combination of photomontage and graphic techniques. Unfortunately the present writer has no direct acquaintance with their work, nor with that of Klinch, of whom it is said that his caricatures were strongly influenced by "the great European master of photomontage, John Heartfield."

Professing himself a pupil of Heartfield, A. SHITOMIRSKY (b. 1907) is today the most widely recognized artist in Russia to use photomontage. Even before World War II he was working as draftsman and picture editor for Moscow periodicals and composing photomontages. He was well aware of the effectiveness of the technique for propaganda purposes and turned to it, when war broke out, as an aid in producing leaflets and posters in record time under difficult circumstances. Shitomirsky's political photomontages appeared among others in the *Front Illustrated Paper*, founded in 1941 (plate 102).

In his first efforts, rousing war photos and amateur shots of the happier days of peacetime were juxtaposed in what was still a rather primitive manner. As time went on, however, they increased in both aggressive sharpness and visual impact. Shitomirsky took special pleasure in satirizing the leaders of the Nazi regime, portraying an ape-snouted Goebbels who sneers his macabre war pronouncements into a microphone, or narrating the decline of the Führer, whose figure, from his initial emotion-laden, heroic poses, shrivels more and more, as events go against him, into something pitiable. With texts partly in German, such montages were also addressed to the German troops and prisoners in Russia.

Since the war, Shitomirsky has continued to create satirical photomontages which are occasionally published in the magazine *Soviet Union*.

VI Dada

Proto-Dada: Marcel Duchamp and Friends—Dada from Zurich to Berlin, Hanover, Cologne, Paris—Dada Followers in Italy, the United States, Czechoslovakia

In the course of World War I the revolt against an art subservient to academic rules and concepts of beauty exploded openly in a movement that, with deliberate irreverence, christened itself "Dada." The fact is, though, the mutiny had been under way for years. Long before the proponents of Dada finally opened fire, Boccioni had already set a window frame and a tuft of hair into a piece of sculpture, Picasso had combined cardboard, wood, and wire to make what purported to be musical instruments, Malevich had nailed a thermometer into a collage, and a good many others had done their bit toward revaluating the traditional means of artistic expression.

Chief of them all, the most resolute front-line fighter in the anti-art campaign, and the one who led it to victory, was quite certainly MARCEL DUCHAMP (1887–1968). Duchamp had struck out on his own independent path as early as 1911 and 1912 with paintings such as the *Nude Descending a Staircase*, which raised a furore at the Armory Show, the first extensive international exhibition of avant-garde art, held in February of 1913 in an armory in New York. Breaking away from the Cubism to which he had originally adhered as a member of the group of Puteaux, Duchamp shattered the static fixity of Cubist art and replaced it with a continuous movement expressive of the succession of one phase after another. His painting differed from analogous Futurist efforts in its more abstract rendering and breaking down of forms and in the use of light and shade as means of suggesting spatial depth. With other pictures of 1912—*The King and Queen Surrounded by Swift Nudes* and *The Bride Stripped Bare by Her Bachelors*—Duchamp also achieved the metamorphosis of the human figure into a kind of fantastic mechanical apparatus, a mode which was adopted by Francis Picabia and was to have its influence on the young Max Ernst.

Duchamp already had a lively interest in mechanical forms in 1911, when he painted a *Coffee Mill* (Collection Maria Martins, Rio de Janeiro). It was at that time that his brother, Jacques Villon, proposed to the Cubist circle meeting regularly in his studio in Puteaux that they paint pictures for his kitchen. While working on his *Coffee Mill*, Duchamp discovered that his attention was more and more diverted from the object itself to the mechanical functioning of the grinder, and in his picture he marked the rotary motion of the apparatus by an arrow. He found himself caught up in the irresistible fascination of mechanical things, and in 1913 this led to the *Chocolate Grinder No. 1* and the *Water Mill Within Glider (in Neighboring Metals)*, studies related to his magnum opus, *The Bride Stripped Bare by Her*

Arturo Schwarz, *The Complete Works of Marcel Duchamp*, New York, n.d., contains full photographic documentation.
Except as indicated, the Duchamp works are in the Louise and Walter Arensberg Collection of the Philadelphia Museum of Art. The *Large Glass* is in the same museum as a bequest from Katherine S. Dreier.

Bachelors Even, generally referred to as the *Large Glass*, on which he worked for more than a decade. In that work his rather special mentality, a blend of irony, rationalism, and sagacity, is expressed most emphatically. For it he turned out sketches, prepared detailed study sheets, made mathematical calculations, put together separate sections as individual pieces. By executing his picture on glass he aimed to divorce the image from a background and to set it free in space. In order to give it as objective a form as possible, uninfluenced by the "handwriting" of the artist himself, he constructed the contours out of lead wire and glued them to the glass with varnish and paint. Similarly, in the *Chocolate Grinder No. II* of 1914 the outlines are in thread glued to the canvas with the same adhesives but also sewed directly to it at points of intersection. These, it is obvious, are techniques that go beyond the usual collage procedures.

Nevertheless, Duchamp's boldest leap forward was the introduction of his "ready-mades." The earliest one dates from 1913 and consists of a bicycle wheel with its fork inserted into a kitchen stool in such a way as to leave it free to revolve. Then, in 1914, he bought from a warehouse an iron bottle rack, which he signed and thus converted into a work of art, that is, displaced into an aesthetic context (original lost). As he himself stated, his choice of objects was determined not by taste, either good or bad, but only by pure chance. However, what he found he titled in a manner which promptly changed the entire significance of the object and aimed to disconcert the viewer. Upon settling in New York in June, 1915, he acquired a snow shovel and inscribed it *In Advance of a Broken Arm*. The famous urinal was rebaptized *Fountain* and signed "R. Mutt 1917."

Duchamp also assembled "improved ready-mades," in which he "corrected" the "found object" by minor alterations and additions. Thus in 1914 he fabricated a collage in which, on a cheap color print of a winter landscape, he pasted tiny dots of red and yellow paper and called the result *Pharmacy*. In New York he found an advertising sign of an enamel-paint company and gave a personal twist to the name by converting it into *Apolinère Enameled*, then signing and dating it "[from] MARCEL DUCHAMP 1916/1917."

Duchamp's protest against Cubism's incipient hardening of the arteries was soon joined by FRANCIS PICABIA (1879–1953). Pictures from as early as 1912, such as *Dances at the Spring* (Philadelphia Museum of Art, Louise and Walter Arensberg Collection) and *Procession in Seville* (private collection, Paris), show that Picabia, like Duchamp, was subjecting Cubistically decomposed forms to a dynamic movement which was to become increasingly intense in subsequent works and to lead to ever more abstract compositions. In 1913 he began to pin bizarre titles on his works, such as *Udnie* (Musée National d'Art Moderne, Paris), an anagrammatic distortion of an actual word, or *Edtaonisl* (Art Institute of Chicago), a mere arbitrary jumble of letters, a practice later to become typical of Dada. Concerning the role he assigned to titles, Picabia explained that in his work the subjective expression is the title; the painting itself is the object. Nevertheless, that object is to some extent also subjective, since it is the pantomime or semblance of the title, and to a certain extent affords the means of comprehending its potential — the very heart of man.

There is a replica of the lost original in the Museum of Modern Art, New York, Sidney and Harriet Janis Collection.

Various replicas have been made.

These, along with many other works discussed in this and the next chapter, are reproduced in William S. Rubin, *Dada and Surrealist Art*, New York, n.d. See pls. 25, 26, 28, and III.

In the periodical *291*, no. 12

Picabia went to New York in 1913 for the opening of the Armory Show, where his pictures aroused much excitement. He and his wife, Gabrielle, made friends there with the photographer Alfred Stieglitz, who had converted a part of his studio into a gallery to show the modern trends in art and to provide a discussion center for his circle of friends. Invited by Stieglitz to show in his gallery, Picabia set to work on a series of "mechanical drawings," of which some were published in Stieglitz's magazine *291*, so called after his house number on Fifth Avenue (figure 11). Picabia proved to have struck an inexhaustible vein in those drawings and continued to experiment with them for a number of years, complete with startling titles and texts.

After a brief period of military service cut short by illness, Picabia rejoined Duchamp in New York in 1915. During that year he produced a few machine compositions in oil. In one of them, *Très rare tableau sur la terre (Very Rare Picture upon the Earth)* (Collection Peggy Guggenheim, Venice), he lent volume to the forms by means of wooden half-cylinders glued to cardboard and reinforced the color effects by using gilt and silver paint. Similar gold and silver tonalities are found in drawings and watercolors from this period, as well as in the oil painting on panel, *L'Enfant carburateur* (Solomon R. Guggenheim Museum, New York), in which, next to the "*sphère de la migraine*" (the sphere of migraine), Picabia wrote the Dadaist motto, "*Détruire le futur*" (Destroy the future).

In 1914 JEAN CROTTI (1878–1958) moved from Paris to New York, where he came under the double influence of Duchamp and Picabia. In Duchamp's atelier in 1915 he produced a *Portrait to Measure* of that artist, a "sculpture in space" that caught the ironic spirit of his sitter (plate 104). The profile and contours of the head were modeled in lead and silver wire, a luxurious crop of horsehair sprouted from a paper headband, and from beneath it two porcelain eyeballs protruded. Similar dolls' eyes were used in a constructed picture, the *Clown*, of 1916 (Musée National d'Art Moderne, Paris), in which, according to the artist, they represent the circus visitors who gawk at the clown while he juggles bright blue and red balls, painted as colored disks. A long-drawn-out spiral spring serves as spinal column, and the clown's legs are made of straight lengths of wire.

Less Dadaist is a relief of 1916, *The Mechanical Powers of Love in Action*, which is not unrelated to Picabia's *Very Rare Picture*. However, unlike Picabia's frontal disposition of the forms, the elements here are so staggered in depth as to suggest a spacious architecture. Mingled with the intense red, blue, green, deep black, and shining white is the metallic gleam of longitudinally bisected copper and nickel tubes, much like Picabia's wooden half-cylinders. Similarly, the title is a conglomerate of metal letters mounted in the picture. The painting is executed on the back of a pane of glass, which is screwed slightly above a piece of cardboard, a technique quite certainly suggested to Crotti by Duchamp's studies for the *Large Glass*. The same influence is seen in the relief *In Two Directions*, in which the lines of lead wire are glued to the glass ground of the picture.

The only American among the group of European artists around Duchamp was MAN RAY (b. 1890), whose passion for discovery and invention merits a special place among the pioneers of modern art. From the beginning of his

The fantastic machines of his drawings were transformed into portraits of Stieglitz, Vauxcelles, Tzara, and others, and a separate series comprising "feminine" machines, which eventually gave rise to the volume *Poèmes et dessins de la fille née sans mère*, published in Lausanne in 1918.

Rubin, colorplate IV

Reproduced in Michel Sanouillet, *Il Movimento Dada*, Milan, Fabbri, 1969, colorplate LIX

Sanouillet, colorplate XXXIII

Figure 11. Francis Picabia. *Portrait of Alfred Stieglitz*, from the magazine *291*, 1916. "Mechanical drawing"

Text in the catalogue of the Société Anonyme Collection, Yale University Art Gallery, New Haven, Conn., 1950

It was shown at the *Man Ray* exhibition, Los Angeles County Museum of Art, 1966.

In 1916 Ivan Puni (Chapter V) followed him with pictures consisting of nothing more than the Russian word for "baths" (figure 7).

Rubin, colorplate V

It was issued by the Paris publishing house Au Sans Pareil. The title comes from the fact that Man Ray attached these sheets to a hinged rack so they could be viewed each in turn like the panels of a revolving door.

career he tried one experiment after another with the most varied techniques and materials. He once proclaimed as his ideal to paint as much as possible unlike other painters and even unlike himself, so that each succeeding work, or series of works, would be totally different from earlier works.

Like Sonia Delaunay-Terk in 1911, Man Ray realized his first abstract composition with the aid of cloth swatches from a tailor's sample book. He combined these into a wall hanging in which the variously patterned rectangular patches were so arranged that the light and dark areas formed a figurative geometric image (Collection Mr. and Mrs. Man Ray, Paris). Three years later he painted a small oil consisting only of the name and date *Man Ray 1914* in large isolated characters. The numerals and letters that the Cubists scattered about in their pictures were here converted into a kind of official statement, conferring on the artist's name a specifically Dada character that goes beyond the roughly contemporary letter pictures of Malevich and the Futurists.

His first collage element is found in a watercolor titled *Chinese Theater*, signed and dated 1914 (Collection J. Petithory, Paris), a kind of still life centering on a Chinese porcelain figure dressed in a shimmering gold paper. Collage plays no more essential role in *Interior* (Philadelphia Museum of Art), in which a Cubist drawing is pasted in the middle, like a picture on a wall, along with a clock with chain and counterweight, a passing nod to the mechanical interests of the Duchamp circle. The collage *Theatr* of the following year (Moderna Museet, Stockholm) is a "corrected ready-made" in the spirit of Duchamp, a piece of newspaper with cinema and theater advertisements which Man Ray garnished with cutout pink and red letters and numerals and, beneath the vertically pasted title *Theatr*, a large question mark.

During 1916 Man Ray worked quite often with colored papers. He cut out shapes for the sketch of a picture called *Rope Dancer*, but when he put them together he was not satisfied with the result. Then, however, he noticed, scattered on the floor, the discarded scraps he was about to throw away and utilized them to make a new composition which he subsequently executed in paint, *The Rope Dancer Accompanies Herself with Her Shadows* (Museum of Modern Art, New York).

In the same year Man Ray began a series of truly unique collages that were published ten years later as a portfolio with the title *Revolving Doors*. Figurative themes such as *Legend*, *Dragonfly*, *Young Girl*, and *Shadows* (colorplate 19) are reduced to totally abstract formulas in these collages. Precise shapes cut out of papers in luminous colors are juxtaposed or linked together and completed by line drawings and, in some cases, also by bright silk threads. Where two colored surfaces overlap, the color that would normally result from the mixture of those two colors is provided by a paper in that particular hue, so as to give the illusion of transparent layers. The rather uncompromising character of these pictures has been explained by Man Ray on the basis that what matters to him is to render his chosen pictorial objects, not in an attractive aesthetic manner, but rather in a definitive form that would imprint itself on the viewer's mind. Nevertheless, within such formal discipline there is more than a hint of the spirit of Dada, mostly in the latent humor of the subjects.

For his works of 1916 and 1917, Man Ray had recourse to other materials as well as pasted papers. In 1916 he fabricated a *Self-Portrait* which has his

P · B · T
THE BLIND MAN
33 WEST 67th STREET, NEW YORK

Figure 12. Marcel Duchamp.
Cover for the magazine *The Blind
Man*, New York, 1917

Figure 13. Francis Picabia. Cover
for the magazine *391*, no. 8,
New York, 1919. Drawing

signature in the middle in the form of a print of his hand dipped in paint, and over and below this two doorbells and a doorbell button are mounted on a ground brushed with black and aluminum paint. For *In Volute* (Collection Roland Penrose, London) a shape was cut from a sheet of perforated metal, and a twist of colored silk threads surrounded by a nailed-on frame acts as a picture within the picture, an anticipation of "Informal" conceptions within a cool surface composition. In *Boardwalk* (Collection Mlle. Gloria de Herrera, Paris) wires drawn taut between furniture knobs form a kind of propeller above the chessboard pattern of the background, and alongside it is glued a piece of coarse cloth. According to Hans Richter, the chessboard, which was among the lifelong bonds of friendship of the inveterate chess players Marcel Duchamp and Man Ray, represents the "club badge" of the New York Dada group.

That group manifested itself as such after Dada had undergone its official christening in Zurich. With the backing of the collector and broad-minded patron Walter Arensberg and the enthusiastic support of Henri-Pierre Roché (author of the novel *Jules et Jim*), Duchamp and Man Ray brought out in 1917 a magazine, *The Blind Man*, which ran to all of two numbers (figure 12). Picabia, who meanwhile had been in Barcelona, where he founded the magazine *391* as an extension of Stieglitz's New York *291*, returned to New York and issued there three more numbers of his publication (figure 13). Both periodicals published ready-mades by Duchamp (there was a bumper crop of them that year), and it was these that constituted the core of authentic Dada production, from whose spirit Duchamp and Man Ray tended to stray in their other works.

It is difficult to categorize a 1918 work by Duchamp in which real and unreal components intermingle in perplexing fashion and to which he gave the highly suggestive title *Tu m'* (Yale University Art Gallery, Collection Société Anonyme, New Haven, Conn.). At the lower left is a linear construction developed from the "standard stoppages" that Duchamp

The original was destroyed, but in 1965 Man Ray made a replica and, more recently, an "edition" under Plexiglas. It is reproduced in Man Ray's book *Self Portrait*, Boston, 1963.

Rubin, pl. 40

It was not until 1921, and in Paris, that Duchamp and Man Ray brought out one more special number, *New York Dada*.

125

conceived in 1913–14—units of measure derived by dropping a meter-long cord to the floor three times in succession from a height of one meter, noting each time the resultant mass. In the middle there is a false tear in the canvas painted in trompe-l'oeil but held together—so to speak—by real safety pins. Fastened to it also is a real bottle brush with its long handle projecting diametrically out of the picture. Beneath a huge, shadowy, merely suggested corkscrew is a hand, also painted in trompe-l'oeil, which is signed "A. Klang." The hand points to sketchy abstract lines that contrast with the rectangles in the other half of the picture, which are carefully gradated according to perspective. It would seem that Duchamp brought together in this picture all the essential factors of his previous works for one last time, before giving up painting entirely.

Man Ray continued to try his hand at innumerable new experiments. In 1919 there were the "aerographs," in which he placed objects on a light background, sprayed them with an atomizer, and then shaded in color the resulting hazy outlines. He approached "mobile" sculpture in the form of a cutout lampshade which, attached at one end, revolved spirally around a rod. In 1920, under the title *The Enigma of Isidore Ducasse*, he displayed a package wrapped and tied so that its contours suggested that it contained a human body, whereas, in fact, packed inside was a sewing machine. This was an early sign of the advancing Surrealist wave, which Man Ray was to meet in Paris.

Man Ray found the lampshade in a rubbish heap and decided to contribute this "sculpture" to the inauguration of the Société Anonyme. However, on opening day only the base could be found, for, while cleaning the exhibition room, the janitor had innocently thrown out the shade along with other trash. Thereupon Man Ray cut a new spiral out of sheet metal and streaked it with white to make the first of some dozen replicas needed for other exhibitions over the years.

Zurich

> We have raised our voice
> against civilization and the
> war it unleashed
> against the calcification of the arts
> against the art acrobatics
> against the perfumed luxury art
> against the Cubist formalism
> against the art object, portable market goods
> against snobism and tittle-tattle
> against beauty and its perfection.
> In order to make a new beginning, first everything had to be destroyed, most of all the picture in its gold frame, the "black sheep" always ready for any prostitution, object of retail trade.

The preceding quotation expresses the way the Dada program is still thought of in the recollections of Marcel Janco, who, together with Hans Arp, Hugo Ball, and Tristan Tzara, belonged to the Zurich group of founding fathers, soon joined also by Richard Huelsenbeck. With the tumultuous scenes staged in promoting its program of demolition, the Zurich Dada era has entered legend, and art history, as an explosion of furious protest which stopped at nothing and—in equal measure—arrived at nothing. In summing up everything that Dada opposed, even so active a Dada partisan as Janco seems to have forgotten just what the movement was *for*, the new artistic ideas that were taking shape at the time. Even though the new ideas were brought to realization only as a by-product of the notorious activity of the Dadaists, they have real importance in the general development of art, and their contribution to the history of collage in particular cannot be ignored.

It all began well before the founding of Dada. In November of 1915 the

Galerie Tanner in Zurich presented an exhibition of modern wall hangings, embroideries, paintings, and drawings by Hans Arp, Otto van Rees, and the latter's wife, A.C. van Rees-Dutilh. For the catalogue Arp wrote a foreword in which, in rather emotional terms, he declared his allegiance to abstract art. The works, he said, were constructions of lines, planes, forms, and colors, intended to approach the inexpressible, to move beyond the human to the eternal, to renounce the self-centered human character. They embodied a hatred for traditional pictures, for painting, for making a likeness, which is mere imitation, spectacle, tightrope dancing, even though some tightrope acrobats display various degrees of excellence. Art, he maintained, is truth, and universal truth must supplant the particular.

Included in the exhibition were draperies in wool and silk embroidery executed by Van Rees's wife after designs by Arp and Otto Freundlich, as well as her own compositions. Along with recent and earlier oil paintings, Van Rees showed a collage, *Adya*, of paper and cloth (plate 106); and his design for the exhibition poster was also in collage.

Dutch in origin, OTTO VAN REES (1884–1957) had met Otto Freundlich in Paris, where he went to study in 1904. Before the war he had secured entree to the circles around Picasso, Braque, Kees van Dongen, Chagall, and others, and felt himself especially drawn to the Cubists. He exhibited in the *Salon des Indépendants* of 1911 and 1912, and Clovis Sagot, the first art dealer to acquire Cubist works, took him into his gallery. Among the lessons Van Rees learned from the Cubists was the technique of collage, which, as he said later, he adopted "in order to achieve greater and, above all, more direct decorative effects." At the outbreak of the war Van Rees was inducted into the Dutch army, but it is said that he was declared *non compos mentis* when, at an exhibition in March, 1915, he showed a collage of a dancer. Excused from military service, he went to Switzerland, where he met Arp. Together they executed wall paintings in the entrance hall of the Pestalozzi School in Zurich, but their abstract compositions so shocked the public that they had to be painted over.

It was probably Arp's influence that led Van Rees to abstraction, a change first manifested in 1915 in a collage of newspaper clippings and a scratch pad with numerals and letters pasted between angular and round forms cut from solid-colored papers. Even more geometrically simplified is the composition of a collage done in December of the same year for the cover of a sketchbook, making use of a brick-red and a silver paper (Collection M. Arp-Hagenbach, Basel). In his *Still Life with Pipe* of 1916 (Collection H. Corray, Agnuzzo, Switzerland), an oil painting with collage that was on display in the Cabaret Voltaire, the impression of spatial depth is achieved by placing dark surfaces next to bright ones, so that the geometric shapes acquire volume through what appear to be shadows.

HANS (JEAN) ARP (1887–1966) and the Van Rees couple had another exhibition together in December, 1916, at the Galerie Corray, which had been opened in March of that year. A review in the *Zürcher Zeitung* of January 28, 1917, praised the tapestries of Frau van Rees for their "outstanding taste for the colorfully decorative" and commended an embroidered hanging by Arp as being "of marked beauty of color." Mentioned also were pictures in which Arp used strips of paper and fragments of wallpaper, and it was remarked that, in these, naturally one had to disregard all concrete content.

It was reproduced in the catalogue of the Galerie Tanner exhibition.

Many of the works mentioned in the following pages are reproduced in Herbert Read, *The Art of Jean Arp*, New York, n.d.

In the foreword to the catalogue of
his collage exhibition, Galerie
H. Berggruen, Paris, 1955

Hans Richter, *Dada: Kunst und
Antikunst*, Cologne, 1964, p. 23
(translated as *Dada: Art and Anti-Art*,
New York, 1965)

Arp had been in Paris in 1914, and there he had made friends with
Amedeo Modigliani, Apollinaire, and Delaunay and been introduced to
Picasso by Max Jacob, thus coming into contact with Cubist ideas from all
angles. He wrote later that at that early date, when he had his studio in the Rue
du Mont-Cenis, he produced a first series of collages (plate 110), in which
the art dealer Léonce Rosenberg showed interest. Arp described them as
"static, symmetrical constructions, archways of emotion-laden vegetation,
gates into the realm of dream," put together from plain-colored papers in
black, orange, gold, and blue. In 1915 he was commissioned by the theoso-
phist René Schwaller to do wall decorations, which he executed in similar
fashion, using colored papers cut into large curved shapes.

In summer of 1915 Arp extricated himself from a precarious situation by
moving from Paris to Switzerland (he held a German passport, though by
birth he was Alsatian). In Zurich he continued with collage, using papers of
all kinds, printed cloths, wallpapers with flower or wickerwork patterns,
strips from tobacco packages, commercial labels, the paper lace from pastries,
and so on, all from the Cubist repertory but assembled by Arp into totally
abstract compositions. At first he superimposed form segments in the
manner of Analytical Cubism, but soon he spread them across the surface in
arrangements based on simple juxtaposition. Straight-line contours were
joined by round and arched shapes of similar precision, making up forms
with that "well-defined indefinability" that he now envisaged as the ideal
of a new art (plate 111).

Marcel Janco recounts in his reminiscences how Arp turned out one new
surprising picture after another, using chiefly paper: "It was wonderful the
way the forms organized themselves naturally, without his having to do
violence to his material.... He told us that art grew out of him in the same way
as the nails of his body, and we believed him to be sincere in this." For Arp,
artistic conception was already at that time a game to be played with forms
and colors, a game in which he allowed chance to have its part even though
he kept his eventual composition firmly in mind. Paper and scissors fulfilled
his desire to remain anonymous, to confer on the work of art that impersonal,
objective validity which liberates it from the "egomania of oil painting."

"Creative Dada," in Willy Verkauf,
ed., *Dada: Monograph of a Movement*,
New York, 1957, pp. 26–49

Along with those collages, Arp also made reliefs from pieces of wood,
which sometimes he simply nailed, unworked, to box lids, though more
often he sawed them into shapes and then painted them. With these he cre-
ated compositions in which natural objects seemed to take form, and he
sometimes added to them, afterward, evocative titles such as *Forest*, *Plant
Hammer*, and *Terrestrial Forms*.

Respectively, Collection Roland
Penrose, London; Collection
François Arp, Paris; and Collection
Fernand Graindorge, Liège

Dada found a home in Zurich in February of 1916, when Hugo Ball
opened his Cabaret Voltaire in the Spiegelgasse. At the first Dada evening,
which took place on July 14, 1916, in the Zunfthaus "Zur Waag," a seven-
teenth-century guild hall, Janco and Arp were listed on the program as offer-
ing "explanations of their own works," and in the case of Arp it was specif-
ically stated that these were "paper pictures." Besides those featured attrac-
tions there were also "*Negergesänge*" (American jazz) and masked dances,
Hugo Ball recited his "poems without words," Huelsenbeck and Tzara
presented "simultaneous poems," and noise concertos and noise poems were
performed. Obviously the main appeal was to the ear, with experiments in
words and sounds predominating.

"Simultaneous poems" had already
been invented in Paris by Henri
Martin Barzun and Fernand Divoire.

commemorative volume *Unsern täglichen Traum… (Our Daily Dream…)* he tells how Sophie, at that time teacher of embroidery and weaving at the Zurich school of applied arts, carried on a heroic struggle against the wreaths of flowers "that hordes of young girls from every canton incessantly embroidered on cushion covers" and in favor of the square as symbol of a new artistic orientation of mathematical precision and clarity. The limpid repose of her horizontal and vertical compositions led him eventually to renounce the "Baroque-diagonal dynamics" of his own conceptions.

Arp's "Baroque" tendency goes back to Expressionist influences acquired in 1911 and 1912, when he was in contact with the Blaue Reiter group, and it was still present in some of his woodcuts for Tzara's *Vingt-cinq poèmes*, published in Zurich in 1916, and for various other Zurich Dada publications. In his collages, however, the decisive turn can be made out as early as 1916. In these, somewhat irregular geometric forms are distributed across the surface "according to the laws of chance" (colorplate 20), and it is the non-schematized, rather random disposition of the elements that gives these early nonobjective compositions their inner vitality.

During 1918 and 1919, Arp and Sophie Taeuber, working both independently and jointly, produced collages of squares and oblongs, of which an occasional rectangle is subdivided geometrically and thereby made to stand out. The shapes were cut with a mechanical paper cutter in order to avoid even the slightest imprecision in their contours. The colors were restricted to gray and blue on black and white with, between them, glistening silver and gold papers.

Sophie Taeuber made her personal contribution to the Dada soirees with expressive dances in the style of the Laban School, wearing costumes and masks designed for her by Arp. She herself painted masks and Dada heads with patches of color and ornaments, and in 1918, for Carlo Gozzi's *King Stag*, she devised astonishing marionettes out of spools loosely tied together and fitted out, according to the role assumed, with feathers, beads, or rags and tatters.

The most impressive masks for the Dada activities were fabricated by Marcel Janco out of cardboard, which he painted—by preference blood-red—and glued and pinned together. Hugo Ball's journal entry for May 24, 1916, describes the subjective effect—the "motor-like power"—they exercised on those who wore them: "The masks not only immediately aroused the desire for a costume, they also dictated a very specifically emotive type of gesture, one that indeed came close to lunacy…. What fascinates us all about the masks is that they do not embody human but, instead, over-life-size characters and passions. The horror of these times, the paralyzing background of things, is made visible."

MARCEL JANCO (b. 1895) went to Zurich from his native Romania in 1915 to study architecture at the Technische Hochschule. There his compatriot Tristan Tzara introduced him into the Dada group, to which he was soon making a scintillating contribution through his many activities. He drew portraits of the Dadaists, designed posters for the exhibitions, executed colored woodcuts for Tzara's first book, *La première aventure céleste de Monsieur Antipyrine*, which was published in 1916, and others in black and white for other Dada publications. He also painted oils such as the *Zurich Ball* (Collection Mr. and Mrs. Henry Marcus, Chicago), which is not unrelated to

Zurich, Verlag Die Arche, 1955

A woven *Composition of Triangles, Rectangles, and Circles* of 1916 is reproduced in Sanouillet, colorplate XIV.

For a de luxe edition of the magazine *Dada* edited by Tzara (no. 4–5, *Anthologie Dada*, May 15, 1919), Arp designed a collage title page in which he glued one of those woodcuts to a clipping from the newspaper *Tribune de Genève*. The woodcut was also afterward incorporated among the illustrations for Tzara's *Cinéma calendrier du cœur abstrait*, Paris, 1920.

Some have been preserved in the Kunstgewerbemuseum, Zurich.

Rubin, pl. 54. The examples seen in the Dada exhibitions of 1966 at the Kunsthaus in Zurich and the Musée National d'Art Moderne in Paris no longer conveyed anything of this horrific impression.

Sanouillet, colorplate I

Severini's Futurist pictures on similar themes. In the same spirit as the masks, he made three-dimensional objects of wire, feathers, horsehair, and other odds and ends, in which insignificant and spectacular elements were combined. In one such work, *Universe*, a geometric housing of soldered wires is jammed over a hemisphere on which has been set a glass eye—an attempt, Janco explains, "to bring entirely diverse materials together in mystical, poetical relationships."

Janco's most substantial works, however, are the reliefs in wood and plaster he began to make in 1917. These are compositions of elementary forms clearly arranged in planes, and they were intended to be incorporated into interiors just as they are, without frames, as architectonic components of a room. Some are in white on white, others colorfully painted, and in one relief of 1917 pieces of mirror are inserted between the fields of color.

Into oil paintings with analogous compositions Janco also introduced real components, for example, an oval bit of silk in a picture of 1916–17, where it is surrounded by areas textured with brush stippling. For the *Dada Armor* (Collection H. Stoffel, Herrbrugg), on which the key word "Dada" appears once vertically and once horizontally but in mirror writing, Janco used corrugated cardboard and crumpled papers to evoke a certain effect of relief. In his *Écriture (Writing)* of 1920, torn pieces of paper and scraps of tattered canvas surround the dancing letters. Shreds of burlap, which emphasize the desperately dramatic character of these works, are found also in *Fetish-Miracle* and *Red Dream*, on the latter of which, in addition, a hieroglyph of twine stands out against an isolated brighter ground surface. Finally, *Le Poilu* of 1924 (plate 108) is a veritable omnium-gatherum of Dadaist materials: gold foil, scraps of linen, horsehair, a mother-of-pearl button, blades of straw, plaster of Paris, and pieces of newspaper, the latter introducing a somewhat lighter note into the dark and heavy range of colors. As in other instances, the composition is set on a medallion shape which raises the material assemblage above the picture surface. Among the printed clippings there are fragments from volume IX (1924), no. 6–7, of the magazine *Ma*, edited in Budapest by Lajos Kassák, so that apparently the picture was done in Bucharest, where Janco returned in 1922 after a stay in Paris, having lost patience with the Dada and Surrealist demonstrations and debates. Like Kassák with *Ma* in Hungary, Janco carried on the fight for new art in Romania with the magazine *Contimporanul* and has continued to do so in Israel, where, for some years now, he has headed the artists' kibbutz El H'od near Tel Aviv.

HANS RICHTER (b. 1888), who went to Zurich from Berlin in September, 1916, tells us that, like Janco, he glued glass and scraps of cloth into reliefs and pictures, but unfortunately none survives. As a birthday gift in 1917 to the Austrian writer Walter Serner, he made a relief, *Justitia minor*, of various materials. In it, a rubber doll that Richter had picked up in the street held in its hand, like a sword, a small strip of metal, from which dangled a silver Christmas tree ball tied to a long cord.

Nonetheless, Richter was another of those Dadaists, like Janco and Arp, who envisaged a new art of a constructive spirit behind all the wanton destruction. In an exchange of ideas with the Swede VIKING EGGELING (1880–1925), whom he had met in Zurich in 1918 through Tzara, Richter began during the next year to draw pure lines and planes arranged in sequences,

Soleil, Matin clair of 1918 is reproduced in M. Seuphor, *Abstract Painting*, New York, n.d., pl. 105, and there is a *White on White* relief of 1917 in Rubin, pl. 53.

Figure 15. Christian Schad. Woodcut. 1917

M. Seuphor, *Marcel Janco*, Amriswil, 1963; exhibition catalogues: *Marcel Janco*, Paris, Galerie Denise René, 1963; and *Marcel Janco: Dada documents et témoignages, 1916–1958*, Tel Aviv Museum, 1959

Serner is identified by Arp as "adventurer, author of detective novels, society dancer, skin specialist, and gentleman housebreaker" (*Unsern täglichen Traum...*, p. 93). Together with Tzara and Otto Flake he edited the magazine *Der Zeltweg* in 1919.

Rubin, pls. 64 and 65, juxtaposes examples by both men.

which, like Eggeling's continuous strips of pictures, were to lead to the first abstract films.

CHRISTIAN SCHAD (b. 1894) had contacts with the Dada group in Zurich through his friend Serner, and on a visit there in 1918 he took with him the results of photographic experiments he had carried out in Geneva. Tzara gave the punning name "Schadographs" (plate 109) to these compositions produced, without camera or lens, by arranging objects on photosensitive paper which was thereupon exposed to light, a procedure soon to be taken up also by Man Ray and Moholy-Nagy. Schad combined shapes cut or torn from paper with transparent webs, lace, wire netting, or bird feathers. He distributed rings and twine among them and sometimes added printed matter, which would be reproduced in negative in the final copy. The result is a kind of nonmaterial collage in black and white, full of movement and mysterious metamorphoses. One of his "Schadographs," *Arp and Val Serner in the Royal Crocodarium of London*, was published in *DADAphone*, the seventh and last number of the periodical *Dada*, which Tzara issued in March, 1920, in Paris.

After a brief period at the Munich Academy, Schad went his own way as an artist and, at a very early date, published woodcuts in the political papers *Die Aktion* and *Weisse Blätter*. He returned to Switzerland in 1915 and in the same year exhibited at the Salon Wolfberg in Zurich. At the close of 1916 he moved to Geneva but remained in touch with the Zurich Dadaists, publishing graphic works in their periodicals (figure 15). Among his oil paintings a few portraits are of special interest, for example the *Marietta* of 1917, whose prismatic de-composition of planes strewn with seemingly random scraps of words makes one think of Futurist prototypes such as those of Severini, while another portrait, *E. Epstein*, 1918, has pasted on it a thin gold-printed paper from a cigarette package.

During 1919 and 1920 Schad produced, in the manner of Arp, reliefs of thin planks, which he sawed into shapes, painted with Ripolin, and glued together. In one such picture, *Érotisme* (Collection the artist, Keilberg, Germany), he introduced typical Dada elements: a small watch face, a piece of curtain lace, upholstery buttons, a length of gold cord running across a spool. He showed this work at the Dada exhibition in the Galerie Néri, Geneva, in 1920, contemporaneously with the Grand Dada Ball organized by Serner, an exhibition which included also Arp, Picabia, Georges Ribemont-Dessaignes, and Gustave Buchet. One of the Geneva critics harangued in sarcastic vein about the "many unforgettable works" by Schad, in particular the *Indian Trepanation*, which he described as "a complicated mélange of yellow, red, and blue wood, cigarette paper, old buttons harmoniously distributed over holes and humps, toothed wheels, cord, and other elements. A work of genius (in a certain sense)."

In the summer of 1920 Schad went to Italy, became friendly with Prampolini in Rome, and associated with Giulio Evola, who was attempting to launch Dada in Italy. However, for Schad, Dada had had its day, and in his painting he soon turned to the Neo-Realist tendencies of the Valori Plastici group.

Last but scarcely least, in the fall of 1918 new impulses reached the Zurich Dada movement from Lausanne by way of Picabia, who represented the link with New York, Barcelona, and Paris. His long-standing passion for

The process of obtaining images by placing objects on a photosensitive surface and exposing it to light antedates photography itself. Thomas Wedgwood, son of the English potter, undertook experiments of this sort about 1800, placing leaves and insect wings on leather impregnated with silver nitrate, but never succeeded in permanently fixing these "photograms." At a session of the Royal Institution in London in January, 1839, Michael Faraday presented images of flowers, leaves, and lace along with figures from a glass painting and a view of Venice that William Fox Talbot had captured on photosensitive paper, anticipating his camera exposures. In blueprints produced by potassium ferricyanide between 1843 and 1853, the botanist Anna Atkins prepared albums of all varieties of English underwater plants and gave them to the British Museum. H. and A. Gernsheim, in their *History of Photography*, London, 1955, reproduce the "cyanotype" of an unknown photographer from 1845, which used various peacock feathers, another of the authentic forerunners of the photogram of our century. A "Schadograph" of 1918 is reproduced in Rubin, pl. 49.

Sanouillet, colorplate VI

The reliefs remained in the gallery for years unnoticed and only recently came to light again, in surprisingly good condition thanks to their Ripolin paint.

F. Gutrel, "Salon Néri, Exposition Dada," in *La Feuille*, February 5, 1920

Exhibition catalogue *Schad*, Milan, Galleria Schwarz, 1970

Meanwhile, Tzara had entered into relations also with Birot and Reverdy, the latter the editor of the periodical *Nord-Sud*, another organ of Dadaist tendencies.

M. Seuphor, "Dadakoll," in *XXe Siècle*, no. 6, January, 1956

Figure 16. Francis Picabia. Title page, *Dada*, no. 4–5, 1919. "Mechanical drawing"

Figure 17. Hans (Jean) Arp. Title page, *Der Zeltweg*, Zurich, 1919. Woodcut

the mechanical led him, abetted by his wife, Gabrielle, and by Arp, to dismantle an old alarm clock and use the parts as models for the title page of *Dada*, no. 4–5, of 1919 (figure 16). Picabia continued to work at his mechanistic drawings, but into their cogs and wheels he now inserted words, sometimes conveying factual information, sometimes mere fragments of Dada poems. He also helped to enliven the typography of the various Dada publications, conceiving them more or less in terms of his own magazine *391* and the French periodical *Sic*, which had been edited by Pierre-Albert Birot since 1916. Yet the third issue of *Dada* left all these models well behind. Type faces of every sort and size were thrown together, words distributed across pages in all directions, color pages interspersed with black-and-white. The reader had to turn page after page around in circles in order to decipher the sense, or nonsense, of what was printed on them.

The Zurich Dadaists' audacious experiments with words and language touch on the closely related field of collage. Tzara set down these directions for the making of a Dadaist poem: "Take a newspaper; take a pair of scissors. From the newspaper choose an article of the same length as you would like your poem to have. Cut out the article. Then carefully cut out every word of that article and put the words into a paper bag. Shake them up gently. Take out the slips of paper one by one and lay them out in sequence. Copy them just as they are. The poem will resemble you. And you will stand as a writer of unsurpassable originality and fascinating sensibility, though not understood by the general public."

At the Dada soirees "static poems" also were presented: on the stage were placed chairs to which were fixed placards bearing certain words, and each time the curtain fell, their arrangement and sequence were changed.

For all that, it was only Arp who produced true Dada poems. He broke up words, regrouped the fragments, put series of words together on the basis of free association, interpolated commonplaces which acquired new meaning by their unexpected juxtapositions, and thereby produced what, in essence, are word collages created according to the laws of chance.

Arp's first poems of this sort appeared in 1919 in *Der Zeltweg*, the last Zurich Dada publication (figure 17). His first volume, *Die Wolkenpumpe (The Cloud Pump)*, was published in Germany in 1920, while Arp was visiting Max Ernst in Cologne and organizing a local Dada branch there.

Echoes of the Zurich Dada style can be found in the early works of KURT SELIGMANN (1901–1962) of Basel. Influences from Arp turn up in his sculptures, such as the *Two Heads* of 1925, and in the reliefs in various materials that he did in 1928 and 1929. Arp's *Trousse de naufragé (Kit for Shipwrecked Persons)*, of 1920–21 (formerly Collection Tristan Tzara, Paris), has its sequel, though rather more Constructivist in style, in Seligmann's *The Sailor*, which has a head nailed together from small boards, contains a concealed sailboat, and is enclosed by a leather strap. Seligmann designed his compositions with clear, simple forms, and in his *Annual Fair* of 1928 (plate 138) the various materials—targets, quoits, and metal bands—are distributed neatly across the slab of wood decorated with stars. In Seligmann's hands the material, however old, seemed fresh and clean, and when he combined carefully sawed out and perforated pieces of wood to make a jumping jack (plate 133), his craftsmanly precision lent its own special character to Dadaist humor.

After a period of study in Florence, Seligmann moved to Paris in 1929 and there devoted himself to painting, in which he was soon exploring the Surrealist paths.

Berlin

> We live for uncertainty, we want neither sense nor values that flatter the bourgeoisie. We want "non-values" and "non-sense."
>
> Raoul Hausmann

When Richard Huelsenbeck made his way back to Berlin from Zurich in January of 1917, the third winter of war lay heavily on Germany, and the homecomer was struck by an atmosphere he could not even have imagined in Switzerland: "While people in Zurich went on living as if in a spa, where with twitching nostrils one chased women and yearned for the evening, with its boating, Japanese lanterns, and music by Verdi, in Berlin no one knew whether he would have a hot lunch tomorrow. Fear settled into people's bones; they began to suspect that the big undertaking of Hindenburg & Co. was going to turn out disastrously."

Nonetheless, the triple pressure—military, political, economic—had in no way put a halt to cultural life in the capital. Quite the contrary, for it had brought into being an intellectual resistance movement firmly opposed to all flag-waving chauvinism and to the suppression of artistic freedom that inevitably ensues from it. The new art and literature, foreign as well as domestic, were still on display in Herwarth Walden's gallery, Der Sturm, and published in his review of the same name. Even more decisively, Franz Pfemfert's *Die Aktion*, a weekly for politics, literature, and art, was taking up the cudgels for any nonconformist trend. From 1916 on, Franz Jung and Richard Oehring published their magazine *Die freie Straße (The Open Road)*, among whose collaborators was Raoul Hausmann, who, in 1918, took over the editorship and used it as a forum for the first Dada texts and illustrations. Also in 1916 Wieland Herzfelde incorporated the monthly *Neue Jugend (New Youth)* into his publishing house, which soon took the name of Malik-Verlag, after the title of a novel by Else Lasker-Schüler. His group of collaborators, among them George Grosz and Herzfelde's brother John Heartfield, took an unequivocally left-wing political line.

Thus, when Huelsenbeck appeared on the scene, Berlin intellectual life was already in full ferment. However, his arrival and the fame of the exploits in Zurich sufficed to induce the revolutionary artists of Berlin to add the battle cry "Dada" to their banners. Hausmann, Jung, Grosz, and Heartfield made contact with Huelsenbeck, and in April of 1918 they founded the Club Dada (figure 18). At its first soiree, held on April 12, 1918, in the quarters of the Neue Sezession, Huelsenbeck read aloud a Dada manifesto signed by the Zurich founding fathers and their newly acquired Berlin partisans and containing the bold assertion: "With Dadaism a new reality wins new rights." The Club Dada organized matinees and soirees which were easily a match for those of the Cabaret Voltaire in spirit of provocation.

Especially conspicuous on those occasions was RAOUL HAUSMANN (b. 1886). At every opportunity he was ready to recite his abstract poems, which he dubbed *"Seelen-Automobile"* (Soul Automobiles). They consisted of brute sounds, the equivalents of single letters, an idea at which he had arrived

"Pamphlet gegen die Weimaierische Lebensauffassung" ("Pamphlet Against the Weimar Conception of Life"), published in *Der Einzige*, April 20, 1919

In *En avant Dada*, Hanover, 1920

Figure 18. Back cover of program, *Club Dada*, Berlin, 1918

When Hausmann went off on a Dada tour with Schwitters in 1921 to Dresden and Prague, his recitation of his phonetic poem *fmsbw* made such an impression on Schwitters that it eventually led to his *Ursonate (Primordial Sonata)*.

without knowing anything of Hugo Ball's noise poems. He also published these "phonetic poems" in the form of posters on bright pink, green, yellow, and white paper.

The Dada manifesto called also for the use of new materials in art, and the Berliners were, in fact, familiar with not only the Cubist and Futurist prototypes but also the collages that Arp and Van Rees were currently producing in Zurich. In a manifesto titled *Synthetische Cino der Malerei* Hausmann proclaimed that "the doll a child throws away, a brightly colored scrap of cloth, are more essential expressions than those of all the jackasses who wish to transplant themselves for all eternity in oil paints into an endless number of front parlors." He went on: "Cubistic Orphism, Futurism, which have the power to bring their mediums—paint on canvas, then cardboard, artificial hair, wood, paper—into true interpenetrating relationships, become, in the long run, inhibited by their own scientific objectivity. *L'Art Dada* will offer them a fabulous rejuvenation, an impulse toward the true experience of all relationships.... In Dada you will recognize your true state: wonderful constellations in real materials, wire, glass, cardboard, cloth, organically matching your own consummate, inherent unsoundness, your own shoddiness."

Works in this spirit were shown by the Dadaists at an exhibition held in April of 1919 in the Galerie J.B. Neumann, to which Hausmann, Hannah Höch, Grosz, Heartfield, and Jefim Golyschev all contributed. Hausmann later said of it: "J. Golyschev and I showed mechanistic drawings, woodcuts, cardboard sculptures (Hausmann), and compositions of heteroclite materials such as tin cans, glass, hair, paper lace (Golyschev)."

In his *Courrier Dada*, Paris, 1958

Walter Mehring, *Berlin-Dada*, Zurich, 1959, pl. 14, but erroneously attributed there to Hannah Höch

One of those long-vanished, wonderful art works by Golyschev was recognized by Hausmann in a photograph in Walter Mehring's book of reminiscences. It consisted of a frame of old lead and rods garnished with spiral springs, colored papers on skewers, and down feathers. H. von Riesen recalls seeing works by Golyschev about 1920 or 1921 at the great Berlin art exhibition held in the Lehrte suburban railway station, among them an "object" made of a herring skeleton and a dried-up slice of bread laid on brown wrapping paper with a dark spot nearby resembling nothing so much as a squashed bedbug.

JEFIM GOLYSCHEV (b. 1897) himself says that, among the Dada members, he was esteemed as an "animal specialist," because he took special pleasure in incorporating into his work every kind of animal, dead or alive, whole or in parts. Thus he made "feather cutouts" by painting and then clipping the wings of live sparrows. Another object consisted of an egg lying on a bed of cotton batting lighted by electric bulbs all around it and topped by a lampshade making a halo above it. A caption announced that the egg would hatch in nine days, an event for which the ever-curious public, who appear to have turned out in great numbers for the show, waited in vain.

Golyschev also tells about composing collages of woodcuts by Gustave Doré and color prints of paintings, into which he incorporated all sorts of allusions to happenings of the day: ration cards, certificates from the unemployment-relief offices, discharge papers for wounded soldiers who were, in fact, dead, and so on. Recently he has reconstructed two collages of 1919. One combines two color reproductions, one by Albert Marquet, the other by Braque, to make a new view of a city with a harbor. The other collage

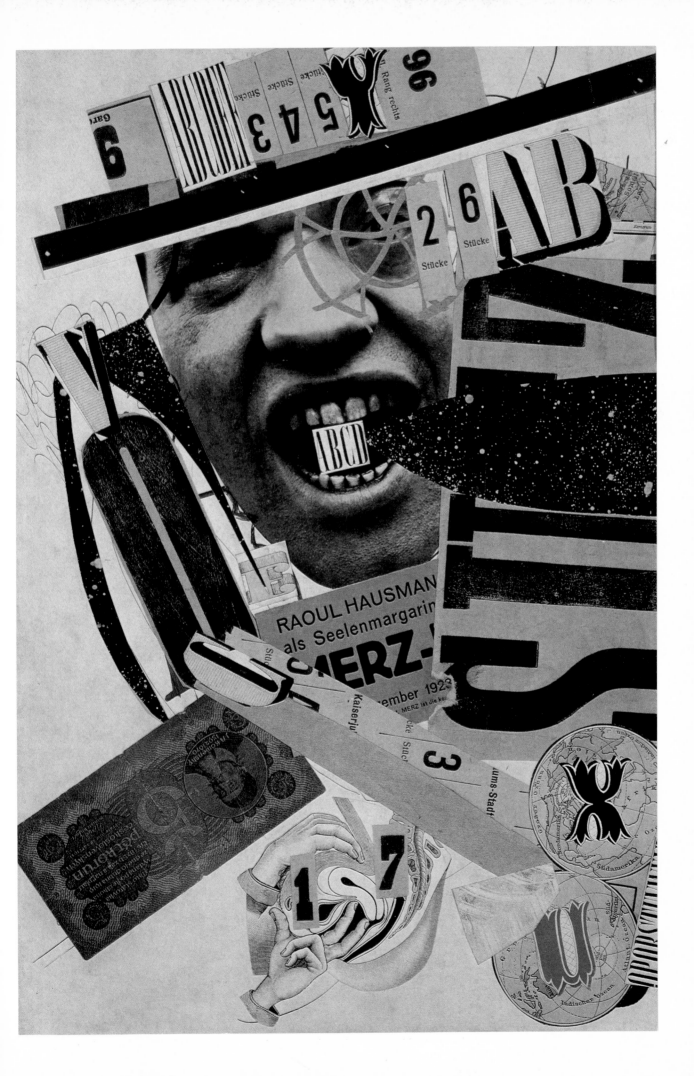

Behne reproduced four drawings in different styles, of which at least one conforms to the "mechanistic drawings" mentioned by Hausmann.

Golyschev also has his place in music history. In Berlin, during the years before World War I, he studied both music and painting, and in 1914 composed a quartet and a string trio in twelve-tone technique based on the principle of the "duration complex." During the Dada show in the J. B. Neumann Gallery in April, 1919, he presented an *Anti-Symphony* in which the orchestra members played on kitchen utensils. Concerning Golyschev's many-sided activities, Behne comments: "He invented new musical instruments, wrote poems, made children's toys, sculptures, and craft objects." In his more recent pictures Golyschev sets down cosmic visions within whose turbulent world of forms appear ghostlike figures and weird faces that often recall those by James Ensor.

Exhibition catalogue, *Golyscheff*, Milan, Galleria Schwarz, 1970

Mehring, *Berlin-Dada*

Reproduced in Hausmann, *Courrier Dada*, and in Georges Hugnet, *L'Aventure Dada*, Paris, 1957

(plate 112), based on a landscape by André Derain, is transformed in various ways and has had added to it in the recent reconstruction, among other things, a package of Omo soap powder pouring into a washing machine, cutout photos of Chagall and Picasso in person, and details from a painting by Paul Delvaux.

In the 1919 article that Adolf Behne devoted to Golyschev in *Cicerone* are described collages of another sort, for which Golyschev utilized "sentimental little things" that remind one of Klee: figures pasted together from bright-colored slips of paper, varicolored bookbinding papers, within whose free patterns a few lines are drawn. From these grew enchanting atmospheric images: tiny pasted drawings on long colorful strips.

Although Golyschev joined Hausmann and Huelsenbeck in 1919 in signing the *Manifesto of the Dadaistic Revolutionary Central Council*, it was not long before he broke away from the movement. He took part in 1919 and 1920 in the November Group shows and in 1922 in the international exhibition organized by the Junge Rheinland group in Düsseldorf, after which, for decades, he simply disappeared from the art world. It was not until 1965 that he returned to public attention, with an exhibition in São Paulo, Brazil.

According to Hausmann himself, it was in the summer of 1918 that he took up collage, using scraps of newspapers and posters. Shortly thereafter, during a stay on the Baltic island of Usedom, he got the idea of photomontage, since in every house he visited he saw the same picture of a soldier, always a grenadier, posed in front of barracks but each time with a different head, each family having added the cutout face from a photo of its absent son or husband. Confronted with these, he was struck by the artistic potential in cutting out and grouping existing photographs.

As early as 1918, for his *Synthetische Cino der Malerei*, he made title vignettes in both techniques, one a collage of shiny cigar bands pasted fanwise on a piece of violet necktie silk, the other a circularly framed photomontage presenting two cutout eyes at the side of an open mouth. The manifesto was prepared for the *Dadaistic World Atlas*, known as the *Dadaco*, a vast anthology of Dada documents. Planned by the Munich publisher Kurt Wolff, the entire project collapsed because, according to Mehring, the material grew and grew until it became such an enormous "*Cliché-Foliante des Universal-Kitsches*" (folio volume of all the clichés of universal *kitsch*) that the printing cost became literally prohibitive. Only a few amusing samples have survived, among them a collage by Hausmann entitled *Dada Cordial*, with colored illustrations and texts packed with political allusions such as: "The Dada Club has instituted a bureau for newly independent states. States founded in every size as per tariff."

In 1919 Hausmann founded the review *Der Dada*, which lasted for four issues. For the cover of the second number he prepared a collage of colored papers and Dadaist printed matter interlocked and superimposed in typically Cubist fashion. The magazine also published a photomontage in which, over Hausmann's head in profile, was superimposed a full-front portrait of "Oberdada" Johannes Baader smoking a pipe that emitted a rose. In another photomontage of the two friends, this one from 1920, their profile heads are superimposed horizontally.

In 1919 Hausmann also produced three notable collage portraits: *Portrait*

of an Old Woman, by which was meant Dr. Salomon Friedländer, alias My-nona; *Portrait of a Poet*, namely Paul Gurk; and *Portrait of a Porter*, which contains the name "Dr. Max Ruest" but actually refers to Anselm Ruest. The heads are pasted together from pieces of newspaper with mangled texts and from fragments of Hausmann's own woodcuts, and the face of Dr. Ruest has eyes made up of two portrait photos.

Respectively, Collection Vordem-berge-Gildewart, Stuttgart; Kunstarchiv Arntz, Haag, Ober-Bayern, Germany; and lost, surviving only as a photograph

More freely composed is another collage, *The Art Critic*, a figure in three-quarter profile pasted on a brick-red "phonetic poster," with a gigantic head grossly enlarged about the eyes and mouth with blue papers to give it a menacing militaristic aspect. Although the figure's suit is rubber-stamped "Portrait constructed by George Grosz 1920," the real author identifies him-self on a small label as "Raoul Hausmann, President of the Sun, the Moon, and the small Earth (inner surface), Dadasoph Dadaraoul, Director of the Dada Circus." Hausmann also conferred on himself the title "Algernon-Syndeticon" in tribute to the brand of glue he used.

Collection Vordemberge-Gildewart, Stuttgart

Hausmann's goal was to create "static films" in which, by analogy with the Dadaist "simultaneous poems," arbitrary and heterogeneous elements would be brought into optical unity. Some idea of what he had in mind can be gleaned from the montage *Dada siegt (Dada Triumphs)* (plate 113), in which a room is furnished with the most bizarre assortment of things. Beneath a map of the world there is an easel holding a framed view of Saint Wenceslas Square in Prague. In front of this stands Hausmann in person, accompanied by male fashion models wearing clothes he had designed. Scattered around are a typewriter, an adding machine, meat grinders, an elegant woman's shoe, and a soccer ball. One senses in the composition in-fluences of De Chirico, who exhibited in Berlin in 1919 and who also had an impact on George Grosz.

Along with his collages and montages, Hausmann also created sculptural assemblages. As a first effort he decorated a drawing board with the rods from an umbrella stand, installed above this a blue faience plate, and strewed razor blades over the entire work. At the Berlin November Group exhibi-tion in 1919 he presented his notorious *Mechanical Head* (Collection the artist, Limoges), a wooden head such as was standard equipment in every art school at the time, on which he mounted a centimeter ruler, a slide rule, the works of a watch, and other utilitarian objects serving to project the various functions of the brain onto the exterior of the head.

Sanouillet, colorplate XLVI

In similar fashion, on the montage *Tatlin at Home* of 1920 (Collection Hannah Höch, Berlin) an enormous machine construction grows out of the head of the "subject." In these compositions Hausmann aimed at striking effects through skillful distribution of protruding components. Also, by a few differentiated patches of color he was able to enliven the black and white of his graphic materials. Among Hausmann's most effective montages is *ABCD* (colorplate 21), in which his own head with wide-open mouth is pasted in the center and overlapped by strips of paper with various pictures, printed letters, and numerals. Following a Dada matinee with Schwitters in Hanover on December 30, 1923, Hausmann added to this montage a Czech bank note and a fragment of the program layout devised by Lissitzky.

Sanouillet, colorplate XLII
Tatlin was celebrated among the Berlin Dadaists, and at their Dada Fair they put up a poster announcing "Art is dead! Long live the new machine art of Tatlin!" According to Mehring, for the magazine the Herzfelde brothers finally baptized *Die Pleite (The Wash-Out)*, the title originally proposed was *Tatlin*.

Very little has survived of the work of the "Oberdada" JOHANNES BAADER (1876–1955), Hausmann's most faithful confederate in all his Dada outrages.

Ten years older than Hausmann, Baader already had behind him a conventional activity as architect when the two of them met in Berlin. Among other things, he had designed for Karl Hagenbeck in Hamburg a zoological garden without cages, a project which was later to give rise to the proposal to lay out a similar section in the Jardin d'Acclimatation in Paris, in which would be set aside unfenced tracts to house (as it were) all the German and French practitioners of Dada.

An extraordinary mixed bag of ideas of religious salvation and an unscrupulous contempt for all bourgeois morals predestined Baader to a Dada activity marked by provocative and scandalous public stunts. In November, 1918, in the Cathedral in Berlin, when the court chaplain posed the rhetorical question, "What does Christ mean to us?" Baader blared out his reply: "Christ doesn't mean a bloody thing to me!" During a session of the Weimar National Assembly in June of 1919, Baader threw down from the visitors' gallery leaflets entitled "The Green Corpse," which, among other delights, announced that the Constitutional Assembly would be blown to smithereens and that Oderdada Baader would thereupon be acclaimed President of the World. (Compare figure 19.)

Baader's portrait is preserved in two of his own typographical collages of 1919, which very much suggest familiarity with Futurist prototypes. In one, reproduced in the second number of *Der Dada*, the bearded face is surrounded by dancing numerals and letters and bread-and-food ration cards. In the other, dedicated to Hannah Höch, it is pasted in along with strips of text bearing Christian sayings overlaid by meaningless Dada printed matter. At the Berlin Dada Fair held in June, 1920, this collage was presented as *Gutenberggedenkblatt (Commemorative Page for Gutenberg)*, and the catalogue annotation reads: "With the same pleasure as a cottage dweller tends his garden, Baader makes a page that emphasizes the great diversity of printed matter and its possibilities for content." Baader pokes similar fun at himself in a collage of 1920 titled *The Author of the Book "Fourteen Letters of Christ" in His Home* (Museum of Modern Art, New York, Abby Aldrich Rockefeller Fund), which has a uniformed puppet-like figure with glued-on head standing in a cluttered room. On its back wall illustrated magazines, printed matter, and drawings make up a collage within a collage.

Baader was the prime mover in that masterwork of Dadaist collage art, *Das Handbuch des Oberdada (The Handbook of the Oberdada)*, known in abbreviation as the *Hado*, which unfortunately has survived only in the legendary tales of his friends. Hausmann says that the work began as something like a diary made up of hundreds of news clippings, to which each day Baader added new documents, splashes of color, printed letters and numerals, and even representational figures. Baader was also in the habit of ripping posters off walls and advertising pillars and then, at home, carefully classifying them, which makes him the ancestor of Raymond Hains, Jacques de la Villéglé, and other present-day creators of *affiches lacérées*.

In the catalogue of the Dada Fair, at which eight pages of the *Hado* were on display, Baader stated that he completed the first edition on June 26, 1919, the second on June 28, 1920. Interested customers were instructed to apply to the American writer Ben Hecht, who, employed at the time as correspondent of the *Chicago Daily News*, gained notoriety in Berlin as a jazz musican and, in the starvation years that followed the war, played the

Rubin, pl. 73
Among the components is a cut-up woodcut by Hausmann made to illustrate his essay *Material der Malerei, Plastik, Architektur* of 1918.

Rubin, pl. 72
The reference is to one of Baader's writings consisting of prophetic pronouncements.

Figure 19. Leaflet, Berlin, 1919

host so generously with all his Dada friends that they bestowed on him the title of Honorary Dada. From Weimar Baader wrote to the Dada Club in Berlin-Steglitz to inform them that "on one occasion the book was offered to Mr. Hecht himself for $50,000 (he joked about how everything in Berlin was so cheap . . .). He saw the book, laughed at it, but now has sent me a telegram saying that he is ready to pay $32,586 for it. We replied yesterday evening by Dada-postcard: Agree to telegram. Please deposit $32,586 in our bank account, whereupon negotiations can begin. As confidential agent for the transaction I have appointed the successor of Ptolemy and Copernicus, Johannes Schlaf. Weimar, Lassen-Strasse 31, The President of the World." However, the deal fell through. Baader is said to have finally buried the book in the ground somewhere in the vicinity of his home in the Lichterfelde-Ost suburb of Berlin.

Lost also was a gigantic three-dimensional montage that Baader showed at the Dada Fair with the title: *Drama God-Dada: Germany's Greatness and Decline Through the Agency of Master Hagendorf, or The Fantastic Life Story of the OBERDADA. Monumental Dada-Architecture in 5 Stories, 3 Gardens, 1 Tunnel, 2 Elevators, and 1 Cylinder to Crown It*. Like Schwitters in his Merz constructions, Baader erected here a commemorative monument to his times, using only rubbish, but he foisted on it a grandiloquent commentary of what purported to be cosmic significance.

With the end of Dada, Baader disappeared from the Berlin artistic circles. After World War II he was seen from time to time in Hamburg and, according to Hausmann, died on January 15, 1955, in a Bavarian home for the aged.

Together with Raoul Hausmann, HANNAH HÖCH (b. 1889) experienced firsthand the military defeat in World War I and the ensuing revolution, and it was he who drew her into the whirl of Dada and infected her with his delight in pulling one invention after another out of the hat. Collage and montage fitted in so naturally with her innate imagination that she immediately made them her own and, throughout the years that followed, turned to them over and over again.

Her first montages, in 1919, took her immediately out of the somewhat romantic world of her study years and plunged her into the uproar of the moment. Like her comrades-in-Dada, she too held the mirror up to the dubious society that mushroomed in the postwar years, though it was rather a distorting mirror, in which the image of the time was disintegrated. Phantom-like, pale, or garish figures of high society drift into the real world of engineering and industry. Enthroned in the midst of rubber tires and machine pistons is *The Lovely Maiden*, whose enlightened brain is symbolized by an electric bulb; another lady dances on a phonograph surrounded by prospectuses for up-to-date household appliances (Collection Mr. and Mrs. Morton G. Neumann, Chicago). Often Hannah Höch stuck gigantic heads on normal bodies, and she invented her own kind of "simultaneous portrait" in a likeness of the writer Gerhart Hauptmann, whose face she divided down the middle, inserting between the two halves the face of a young girl. Her gibes take on more earnest form in only a few montages, among them *High Finance*, in which the portrait heads of the industrial magnates Ford and Kirdorf are set on the bodies of itinerant musicians striding across industrial

Also known as *The Double Face of the Overlord*

and urban installations. At the Dada Fair she displayed works of aggressive high spirits, such as the montage *Cut with the Kitchen Knife Through the Last Weimar Beerbelly Cultural Epoch* (plate 115), in which the imperial powers-that-were—Kaiser Wilhelm II, Hindenburg, the Crown Prince—are dressed as chorus girls, while the new powers-that-be—Ebert, Schacht, and their consorts—whirl through the air, along with acrobats and sports stars, in the midst of locomotives and wheels. In the background of an old photograph showing Hausmann and Hannah Höch in front of their works at the Dada Fair, one catches a glimpse of a picture which includes wheels and wires to give a three-dimensional aspect to the collage.

Reflecting her more personal taste, Hannah Höch also made grotesque dolls equipped with all sorts of bright-colored odds and ends, as well as more feminine collages, in which she turned to account the most varied objects of her household. She cut up needlework albums and dressmaking patterns along with old stellar charts, pasting the bits together to make weird flowers and figures, which she then tinted lightly with watercolors. From festoons, net lace, and delicate tulles she made airy, transparent images, often utilizing also bright scraps of coarser cloth and pasting amid them a crocheted doily. Besides these, she also composed nonrepresentational collages of varicolored papers in geometric shapes.

Sanouillet, colorplate XLIV

Among her authentic Dada documents there is a large collage from 1922, grouping portraits of all the Berlin Dada adherents, but there is also a small one, *Meine Haussprüche (My Household Maxims)* (Galerie Nierendorf, Berlin), which has a quotation from Goethe along with autographs and comments from all her Berlin friends—Hausmann, Huelsenbeck, Baader, Arp, Sophie Taeuber, Schwitters, Serner, Friedländer—written out in a colorful page of an album containing photos and picture postcards, wallpapers and lace, beetles and astronomical charts, all set in rectangular fields with a photo of a Romanesque crucifix in the center. When Schwitters arrived in Berlin shortly after the Dada Fair, he became a great friend of Hannah Höch, and in her collage *Souvenirs*, of 1923, his name appears alongside those of Arp and Sophie Taeuber. Something of the special poetry that was Hannah Höch's link with Schwitters can be made out in the *Homage to Arp*, a collage on a bluish green background covered with delicate grasses and tiny leaves; six seals over these combine to make a stellar constellation, along with cutout postmarks of various dates in December of 1923—by which time Dada had almost disappeared from public notice.

Besides the group around Hausmann, the duo GEORGE GROSZ (1893–1959) and JOHN HEARTFIELD (Helmut Herzfelde, 1891–1968) made up another wing of the Berlin Dada movement. Between the two groups raged, and rages still, an interminable battle over the paternity of photomontage, a dispute as ferocious as that, still not settled today, among the Zurich Dadaists as to the original coiner of the name "Dada." To put Hausmann once and for all out of the running, George Grosz wrote a letter on the subject to Franz Roh, asserting: "In 1915 Heartfield and I had already made interesting experiments with photo-pasting-montage. At that time we founded the Grosz-Heartfield Combine (at Südende in 1915). I concocted the word *Montör* for H., who went about always in the same old blue suit and whose activity in our partnership recalled engineering assembly ['montieren'] more

The argument is futile, for the technique had been invented a full half-century earlier; furthermore, it really makes little difference whether one utilizes printed reproductions or actual photographs in collages. Grosz's letter was published in F. Roh and J. Tschichold, *Foto-Auge*, Stuttgart, 1929; in the French edition the crucial date 1915 is twice printed erroneously as 1925.

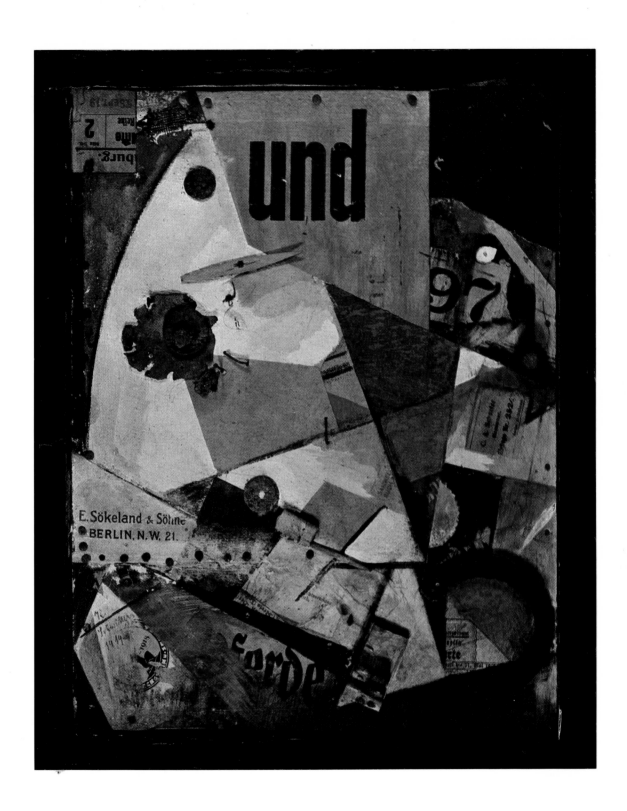

Colorplate 22. Kurt Schwitters. *The And Picture (Das Und-Bild)*. 1919

In the *Blätter der Piscatorbühne*, 1928;
reprinted in Konrad Farmer,
"John Heartfields Fotomontagen,"
in *Graphik* (Zurich), 1946, no. 13,
and in Wieland Herzfelde,
John Heartfield, Dresden, 1962, p. 18

Bode Uhse, in the exhibition
catalogue *John Heartfield und seine
Photomontagen*, Berlin, Akademie der
Künste, 1957

A Little Yes and a Big No, New York,
Dial Press, 1946, p. 147

Figure 20. George Grosz.
Title page, *Der Blutige Ernst*,
Berlin, 1919. Drawing

than anything else." Nevertheless, that date can be challenged, because up to 1916 George Grosz was a soldier in the field and not until that year, with a provisional discharge, did he return to Berlin and to his studio in the Südende district. Another statement by Grosz seems rather more factual: "When John Heartfield and I, in my Südende studio, invented photomontage early one May morning about five o'clock in 1916, neither of us suspected its great potentialities nor the thorny but very successful path that this discovery was destined to take. As so often happens in life, we stumbled on a gold mine without knowing it."

Actually Grosz and Heartfield began to work with collage about 1916 in the form of postcards that they sent to their friends in the army, pasting up photographs from the illustrated papers in such a way that their opinion of the war situation was made perfectly clear without offering the censors any possibility of interfering. Thus, on one occasion Heartfield, himself inducted into the Guards, pasted a photo of a front-line trench next to one of a Berlin society soiree, and it was from this kind of play with images that eventually he developed a specific artistic means of expression.

As described in his autobiography, Grosz's studio in the Stephanstrasse in Berlin was itself much like a Dadaist collage: "Part of the wall decoration consisted of empty wine flasks. Their labels, portraying ancient castles, Mount Vesuvius, or luscious grapes, were either in vivid colors or in black and white, which gave the effect of etchings. A gas lamp hung from the center of the ceiling. That too was decorated by a large black spider suspended by a thread. The slightest breeze would make the spider sway and its wire legs quiver realistically. The walls, ceiling and furniture were further decorated with cigar bands, bits of broken mirror and stars made of tinsel."

The advertising posters covering the house fronts and city streets in Grosz's drawings in 1915–16 suggest the collages he was to make later, and they are also scattered about in such oil paintings as *Metropolis*, 1916–17 (Museum of Modern Art, New York), and *To Oskar Panizza*, 1917–18 (Staatsgalerie, Stuttgart), in which kaleidoscopic shattered fragments of images derive from Futurist influences. During the Dada years the text elements became more numerous and more prominent. On a title page for the magazine *Der Blutige Ernst*, published by Carl Einstein and Grosz in 1919, there is a drawing by Grosz, *Arbeiten und nicht verzweifeln! (Work and Do Not Despair!)* (figure 20), its background entirely covered by what look like real, cutout newspaper advertisements and comprising, to all intents and purposes, a genuine collage composition.

In another number of that magazine, Grosz illustrated the caption "The Most Mysterious and Inexplicable Ever Displayed" with grotesque portrait figures taken from photos, drawings, and texts and mounted together. Other periodicals also—in 1919 they seemed literally to spring from the ground—resorted to photomontage, beginning with the title page of the one and only number of an illustrated semimonthly magazine, *Jedermann sein eigener Fussball (Every Man His Own Football)*, February, 1919, published by the Malik-Verlag. Under the caption "Prize Competition! Which Is the Prettiest?" photographs of members of the Weimar National Assembly were combined into a fan, and above it, beside the title, appeared the editor, Wieland Herzfelde, in an enormous soccer ball. In an interview, Hannah

Höch has identified as among the earliest Berlin photomontages one by Grosz, *The Dadaists Mount a Pudding*, in which photographic heads of the Dada proponents were mounted "in side-splitting fashion" on various bodies.

The Malik-Verlag brought out in 1917 the first *Kleine Grosz-Mappe (Small Grosz Portfolio)*, with lithographs of his satirical drawings. In 1922 another portfolio, *Mit Pinsel und Schere (With Brush and Scissors)*, containing seven "materializations," reproductions after colored originals of 1919 to 1922, shows clearly the road the artist had traveled from drawing to collage and montage. Into broad and initially empty pictorial spaces that reflect the influence of De Chirico's Metaphysical painting, Grosz was soon pasting scraps of text and illustrations of houses, people, and machines; later he also used bank notes, paper lace, and other odds and ends. On one of these collages (plate 118), Kaiser Wilhelm II, with huge military decorations pinned all over his hunting costume, appears behind a war casualty, who no less ostentatiously sports his many medals across his chest. On the best-known of them, *Daum Marries Her Pedantic Automation*, which dates from May, 1920, there is one of Grosz's typical whore figures—whose bodies, according to the comment in the Dada Fair catalogue, needed airing—accompanied by her partner, "who devotes himself to other sober, pedantic, bookkeeping tasks," as symbolized by the numerals and mechanical gear-work pasted on him. The later montages were stamped by Grosz with his name and the qualification of "Constructor" or "Constructed," plus the date.

Within the cooperative activity of the Malik-Verlag, Grosz came to collaborate closely with John Heartfield, whose chief concern was modernizing typography and layout for the press's publications. For the magazine *Neue Jugend* in 1917 he composed amusing pages in which old-fashioned printers' vignettes of phonographs, passenger balloons, sailboats, skulls and crossbones, and so on were combined with titles in large and small characters and distributed across the surface in a kind of collage technique (figure 21). Similar vignettes are also found, along with other illustrations, in a collage drawing by Grosz from 1919, *The Culprit Remains Unidentified*. For their montages, Grosz and Heartfield often cut up American magazines sent to Grosz by his brother-in-law in San Francisco. From these Heartfield took views of American cities, which he combined with cutout drawings by Grosz and fragments of printed matter to make dynamic images of great metropolises, such as the *Universal City Twelve O'Clock Noon* reproduced on the catalogue of the Dada Fair. A related composition was used for the cover of Huelsenbeck's *Dada siegt*; and yet another, *Das Pneu umreist die Welt (The Tire Circumnavigates the World)*, which includes a photograph of Hausmann reciting, appeared on a special issue, no. 3, of *Der Dada*. As editors of that issue, the three Dada stars signed themselves with the jumbled names Groszfield, Hearthaus, and Georgemann.

The magazine contained highly elaborate montage portraits of the Dadaist Arp, the "Pipi-Dada" Walter Mehring, the "Music-Dada" Reiss, and others. The style Grosz devised for his *Portrait of the Engineer Heartfield* was applied also to one of Wieland Herzfelde, photographed in profile and surrounded by pictures of a house and landscape, a palm and a violin,

Edouard Roditi, "Hannah Höch und die Berliner Dadaisten," *Der Monat*, November, 1959; also as "Interview with Hannah Höch on the Berlin Dadaist Group," *Arts* (New York), December, 1959

A few of the originals are in the possession of the Galerie Nierendorf, Berlin.

Rubin, pl. 91

Because one of these sheets was dedicated by Grosz to "Photo-Monteur R. Hausmann," the dedicatee takes this as confirmation that Grosz acknowledged him to be the father of photomontage.

Figure 21. John Heartfield
Page from *Neue Jugend*,
Berlin, 1917

machines and printed matter. This collage was used in 1920 for the dust
jacket of *Tragigrotesken der Nacht: Träume von Wieland Herzfelde.*

The "Grosz-Heartfield Combine" signed a number of works with their
double name, among them a montage *Dada-merika* (plate 114), in which,
over two-dimensional elements such as newspaper clippings, star maps,
illustrations, tram tickets, and a tachometer, are mounted three-dimensional
objects such as a centimeter ruler, a kitchen knife, tufts of hair, and coins—
all assembled into a clear and well-thought-out composition. The joint
signature was also used on two "corrected masterpieces," *Picasso amélioré*
(dedicated to Dr. Carl Einstein) and *Henri Rousseau—Self-Portrait.* On the
former, over a reproduction of a Picasso drawing from 1912–13, are pasted
a picture of a German officer, a cut up portrait with eyeglasses mounted on
it, a view of a city, as well as strips with the title *Vollendete Kunst (Perfect
Art)* and the names "Grosz" and "Noske." In the latter, the Douanier him-
self wears the head of Raoul Hausmann, and the landscape has been replaced
by a city view with a conspicuous advertisement for Leibniz-Cakes.

To the International Dada Fair which opened in June, 1920, in the gallery
of Dr. Otto Burchard, the organizers Hausmann, Grosz, and Heartfield
invited every artist or nonartist who, in some way or other, could be
considered as connected with the Dada movement. Side by side with
drawings, paintings, and montages by such guests of honor as Arp, Max
Ernst, and Picabia, hung other works which were the living evidence of the
motto: "The Dadaists count it their glory to champion amateurism."
Wieland Herzfelde expounded the artistic goals of the movement in the text
of the catalogue: "The Dadaists recognize as their only program the duty to
make the events of the here-and-now, of this time and this place, the subject
of their pictures, for which reason they do not view as the fountainhead of
their production the *Thousand and One Nights* or *Glimpses of Indochina* but,
instead, the illustrated newspaper and the lead article. Collages and montages

On the back is a dedication to
Paul Citroen dated September 14,
1919, and signed by Grosz alone.

The Rousseau was reproduced in the
catalogue of the Dada Fair, of
which a double-page spread can be
seen in Rubin, pl. D-82.

are the predestined medium for the realization of this program. The Dadaists say: 'If by reason of time, love, and struggle, hordes of individuals before us were impelled to paint a flower, a hat, a shadow, then we need only take up our scissors and cut out of paintings and photographic representations all the required objects; when they are of modest dimensions, we do not even need pictures of them but, instead, can take the objects themselves—for example, pocket knives, ashtrays, and the like—real things to be found in painted form in the museums of old art but, for all that, merely painted.'"

Such were the reasons for the prominent place taken by collage and montage in the Dada Fair. However, so many of them were thrown together in haste and not conceived as art works of enduring value that, quite understandably, most of the exhibits did not survive. Nowadays one can only depend on the thorough catalogue for some idea of the many works that have since disappeared.

Grosz's brother-in-law OTTO SCHMALHAUSEN (b. 1890), known as "Dada-Oz," was singled out as one of the first Dadaists, "who, in Antwerp, even before the war, when no one yet thought of Dada, constructed 'Dada works' in connection with his activity in organizing publicity and soon found imitators in the countries of the Entente." One of his works, *Beethoven's Death Mask*, attracted much attention at the Fair and was used on the cover of Huelsenbeck's *Dada-Almanach*. Based on a white plaster replica of Beethoven's death mask, it was described in the catalogue as follows: "After having passed through the hands of the Belgian Dadaist, it gazes at us with utterly lifeless grief out of true blue eyes; the mustache swirls around unmanageably; the old codger's hair hangs down in disorder over his brow." An announcement of the "Institute for Oz-Dada-Works," which Schmalhausen founded in 1920, offers to prepare Dada photo portraits but also promises, among other things, "practical instruction in Dada pasting."

Rubin, pl. 84, but without mention of Schmalhausen

Among the "corrected masterworks" were the *Improved Statues of Antiquity* by RUDOLF SCHLICHTER (1890–1955), plaster casts of Greek sculpture with Dada-style, incongruous heads. Schlichter and Heartfield also collaborated on the *Prussian Archangel*, a life-size doll of a German soldier in field gray with a pig's head under his military cap. It was hung from the ceiling at the Fair and stirred up considerable public indignation. Of the collages that Schlichter turned out from time to time in the Dada period, along with satirical watercolors in the style of Grosz, only one, *Phenomenon-Works*, is still known, thanks to its reproduction in Willrich's notorious book attacking avant-garde art as "non-Aryan" and "decadent." It shows a gathering of grotesquely assembled figures pasted over with illustrations of all sorts, as well as with real materials such as gloves, watches, and buttons.

Wolfgang Willrich, *Säuberung des Kunsttempels: Eine Kampfschrift zur Gesundung deutscher Kunst im Geiste nordischer Art*, Munich and Berlin, J.F. Lehmann Verlag, 1937, where it is said to have been shown in an exhibition, *Humor in der Kunst*, held in 1928 at the Berlin Sezession

The music critic H.H. STUCKENSCHMIDT, known as "Music-Dada II," has described some pieces he himself displayed at the Fair. *The Crisis in Production* was the title given to a strip of crepe toilet paper about a yard long, on which were glued pieces of newspaper, a button, a postage stamp, a ten-pfennig voucher, and other worthless items. In the center, as eye-catcher, was a photo of Kaiser Wilhelm II with his sons marching in officers' uniforms. The catalogue commented: "Here you see at its most glaring the sad state of German textiles."

In the postwar years Stuckenschmidt lived in Magdeburg, where, together with Herbert B. Fredersdorf, he once organized a tumultuous Dada soiree. He eventually occupied the august chair of Professor of Music History at the Berlin Technische Hochschule and became—as he has remained—a major influence in the development of avant-garde music throughout the world.

As the youngest Dada adherent, the fourteen-year-old HANS CITROEN (b. 1905) received special acclaim at the Fair, and among his collages *Wilson's*

Fourteen Points was particularly applauded. The catalogue gives an interesting analysis of another of his collages, *The Net:* "An assemblage of the most diverse odds and ends such as fill the brain of a young person who, unburdened by problems, has an accepting, acquisitive, virtually heedless conception of the world. Meanwhile, however, concepts that play a great role in the consciousness are not as yet brought to realization, and for that reason are represented here in the manner in which one becomes acquainted with them, for example, in the form of newspaper headlines."

Among the most inflammatory exhibits at the Dada Fair were two pictures by OTTO DIX (1891–1969), *Butcher Shop* and *45% Unemployed,* which pilloried the postwar situation with mordant irony. With their vehement Expressionist painting, their effect was even more powerful and more accusatory than Grosz's drawings and watercolors, and they introduced a lurid note into the antics of the exhibition. More in line with the general atmosphere of the Fair would have been a Dix work of 1919, *The Sailor Fritz Müller from Pieschen* (Galerie Klihm, Munich), which includes collage elements. It is set up something like a page from a folk-art picture book, on which, out of the surging sea, rise images of the unfulfilled desires of the seafarer, the remote continents where adventure may await him. On the sailor's cap is glued an anchor, the pupil of his eye consists of a metal button, and alongside his head is a scrap of the town plan of Pieschen, a suburb of Dresden. The surface of the picture is embellished with glittering metal filings, and buttons stud the frame. Dix made use of this same style of popular illustration in 1920 for his *Suleika the Tattooed Wonder* and in 1921 for the *Farewell to Hamburg,* in which various details—the ship, shells, starfish, the pairs of lovers, and so on—are isolated in typical collage style.

In certain of Dix's pictures of macabre social criticism dating from 1920, which remain his essential achievement for those years, real materials are incorporated to underscore the violence of the content. In *Barricade,* which he later destroyed, the riflemen, sailors, burghers, and workers squat on a barricade built from the debris of bourgeois culture. Piled up on it—glued or painted—are a Crucifix, the *Venus* of Milo, a religious wall motto, the journal *Neue metaphysische Rundschau,* a margarine label, and pages from a hymnal. In three other pictures showing war cripples, gruesome to the point of being grotesque, newspapers and other printed matter are pasted in among the realistic painted objects. In another example the legless war casualties, with their stitched-up faces and artificial limbs, sit playing cards at a table on which there is a real bank note, and Dresden newspapers hang on the wall (Collection Mrs. F. Klook, Constance, Germany). *The Match Vendor* (Staatsgalerie, Stuttgart) has genuine devalued bank notes pasted alongside painted boxes of matches among the peddler's wares, and in the gutter lies a scrap of real newspaper. The most fantastic jumble of heterogeneous elements appears in *Prague Street* (plate 117), with its nerve-shattering human derelicts in front of vivid shop windows. A legless man wearing the Iron Cross rolls on a dolly with wheels of pasted tin foil across a handbill headlined "*Juden raus!*" (Jews get out!). Behind his head is an election poster for the German Socialist Party. In a hairdresser's display window in the background stand busts topped with actual wigs of real hair, and in the window of an orthopedic supply shop Dix has painted his own portrait beside female figures and advertising matter in collage.

Sanouillet, colorplate **XXXIX**

Exhibition catalogue *L'Art en Europe autour de 1918*, Strasbourg, 1968, pl. 66

This series marked an end to Dix's horror pictures in Expressionist style. Soon thereafter he went over to the Neue Sachlichkeit movement, and his biting keenness of observation was later to pale away into a somewhat antiquated kind of romanticism.

PAUL CITROEN (b. 1896) had taught his younger brother Hans, mentioned above, the knack of cutting and pasting but did not himself take part in the Dada Fair, although he was in contact with the Berlin Dadaist circles. He began to experiment with collage in Amsterdam shortly after the end of the war, striking out in an original direction: pictures of great metropolises put together in a tightly woven mosaic of cutout photos and postcards. His first *City* dates from 1919, a complex of a hundred thousand windows, with facades and stairs, one surmounting another, in dizzying compression, and with paved plazas to which the eye plunges from giddy heights. During the same year he also produced another, *New York*, with a boxing bout in the foreground and the looming fantastic city behind. The theme of the great city became a veritable obsession for the artist and underwent its most magnificent variations in the *Metropolis* pictures of 1923 (plate 120). Here the skyscrapers reach up and up, gigantic spans of bridges spring from an endless sea of houses, electric signs create such optical confusion that one no longer distinguishes distance from proximity. What is astonishing in these compositions is that the innumerable fragments of which they are composed truly coalesce into a completely defined and yet unreal unity. Today, now that the photos and postcards Citroen used have faded, it is difficult to see how colorful these collages were originally.

Published in *Berliner Illustrirten*, no. 24

One has been preserved in the Print Room of the University of Leiden, Netherlands, and is reproduced in Rubin, pl. 74.

The *Metropolis* pictures were done in Weimar, where Citroen lived from 1922 to 1925 as a student at the Bauhaus. Although they were received there with enthusiasm, Citroen soon discontinued them. He used collage again, but in an entirely different manner, in a drawing, the *Piazza della Signoria, Florence*, 1924–25. Pasted photos or other reproductions of Florentine palaces, art treasures, the statues of the Cathedral, and the bronze doors of the Baptistery introduce volume and space as exceptional factors within the graphic sphere of contour drawings and speckled color.

L. Moholy-Nagy, *Malerei, Photographie, Film*, Munich, 1925 (facsimile edition, Mainz and Berlin, 1967), reproduces several examples.

Citroen says that his big-city pictures were inspired by the photographs of ERWIN BLUMENFELD, who was experimenting with collage in 1919 in Amsterdam and, on one occasion at least, adopted photomontage, using two photographs of houses. Citroen owns an amusing collage by him, *Mystik*, signed and dated "Erwin T. 21." Over musical notes, a sentimental oleograph, and cutout words, some in Hebrew letters, are pasted photographs, sometimes cut out and assembled grotesquely. A bit of silver paper, a bright little flag, and two dark violet strips introduce delicate coloring into a very successful composition.

Blumenfeld, who like Heartfield Americanized his name, signed himself "Bloomfield" in a letter from the Berlin Dadaists to Charlie Chaplin in 1920, and he signed a postcard to Tzara "Dada-Chaplinist."

Blumenfeld later moved to New York, where he undertook other interesting experiments in photomontage, utilizing superimposed shots under varied lighting.

On his well-known poster, *Make-Up*, designed for Helena Rubinstein about 1960, the facial contours were entirely rubbed out in order to render the makeup more conspicuous; then he superimposed a strand of real hair and made a second color photo from the whole.

Collages were produced by various members of the group known as Rih (named after Old Shatterhand's horse in the Western novels of the German writer Karl May), which was organized by Schlichter in Karlsruhe during the Dada period, together with Werner Scholz, Vladimir Zabotin, and Oskar Fischer. Of their work Beringer wrote: "The new artistic attitude

burst apart the traditional frontiers of art and brought into existence a changeling of repulsive concepts and forms who set to work with surface varnishes, textile patterns, newspaper cuttings, matchboxes to display a wealth of material, life, and possibilities. Whereupon there was a stop to all 'conventional' form—including that which conveys meaningful information."

The Russian painter VLADIMIR ZABOTIN (1884–1967), who settled in Karlsruhe after studying at the Academy there, liked to pin up in his studio small collages in the format of a child's school notebook and often made gifts of them to his friends. He exhibited some in 1919 at the November Group exhibition, in which he participated as a member of the Rih. During the 1920s Zabotin made study trips to Yugoslavia, France, and the Volhynian region of the Ukraine. Everything he had ever done was confiscated by the Nazi authorities in 1934, and, after emigrating to Italy five years later, he was eventually once again hounded down by the Nazis and interned. After a stay in New York, he returned to Germany in 1954 and died in Karlsruhe in 1967.

In 1923 Der Sturm also showed collages by PAUL FUHRMANN, who belonged to the League of Revolutionary Artists of Germany. Willrich's *Säuberung des Kunsttempels* ... (see page 147) reproduced one of them, apparently a typical Dada product, complete with strips of inflammatory text pasted across cutout illustrations.

The influence of the rage for collage unleashed by the Berlin Dadaists on the Bauhaus will be discussed later, within that context. However, many of the pertinent works never passed beyond a circle of friends to reach the public, particularly those intended for a particular occasion and thereafter lost. Even among amateurs there were truly gifted artists in the medium. For example, a collage of assorted materials was made by Professor Hans Hildebrandt presumably about January 21, 1921, to judge by the date on a menu that it incorporates, along with advertisements for entertainments, sheets of paper dolls, coins, a painted wooden heart, an angel's head, and so on, all pasted together with brightly colored papers (in possession of Frau Lily Hildebrandt, Stuttgart).

Of the old Berlin group, only Hannah Höch remained faithful to collage, once the Dada days were over, discovering in it ever new possibilities. Her abstract compositions of fine embroidery canvas and other woven fabrics were succeeded about 1925 by figurative work. In one cheerful collage (plate 116) a baroque angel with a doll's head soars above a city made up of tall square posts on which rest single buildings or, like lone survivors from the Flood, isolated examples of flora, fauna, and humankind. About 1928 she executed a new series of montages, *The Ethnographical Museum*, in which photographic reproductions of exotic sculpture are cut up and combined with portraits to produce twisted, one-eyed faces with gigantic mouths and wooden skulls adorned with feathers. In one case an *Indian Dancing Girl* includes a headdress of knives and spoons printed on paper. After 1930 her compositions again took on bizarre references; *The Flight*, for instance, shows a winged face with stern eyes pursuing a crippled creature of ill omen, and the protagonists of the *Strong Men* are exposed to menacing attacks.

For Hannah Höch the fundamental significance of the collage medium lies in its potentialities for unexpected juxtapositions, arbitrary reversals of

In his book *Badische Malerei 1917–1920*, published in 1922

Information from E. Steneberg, Frankfort

This book, a lamentable document of Nazi cultural policy, has at least the merit of calling to our attention certain otherwise forgotten works of art.

H. Hildebrandt, professor at the Technische Hochschule, Stuttgart, was one of the most enthusiastic proponents of modern art and was in personal contact with artists of all tendencies. His *Die Kunst des 19. und 20. Jahrhunderts*, Potsdam, Athenaion-Verlag, 1924, was the first comprehensive study of the general development.

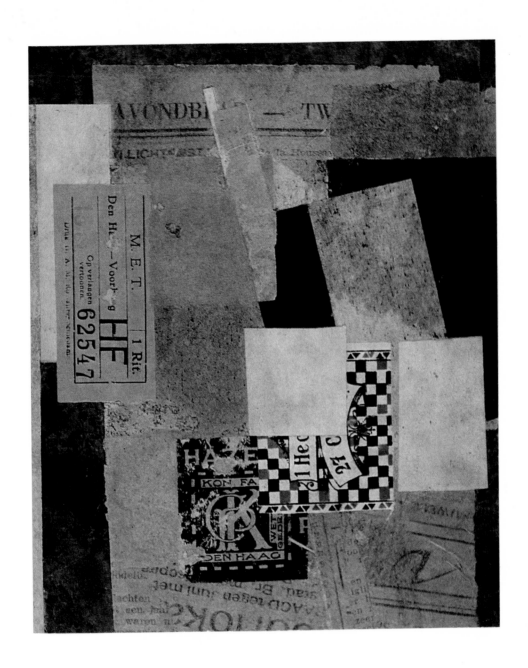

Colorplate 23. Kurt Schwitters. *Mz 600, Leiden.* 1923

spatial relationships, transformations, and mystifications. Here is her goal as she set it down for the catalogue of an exhibition in The Hague in 1929: "I should like to wipe out the solid borders that we human beings in our self-confidence tend to draw around everything within our reach. . . . I wish to demonstrate that little is also big and big is also little, and that the only thing that changes is the standpoint from which we judge, so that all our human laws and principles lose their validity."

During the 1960s Hannah Höch has once again worked intensively with collage, exploiting a virtually inexhaustible repertory of themes. After a series of abstract compositions with an animated play of colors and forms, she embarked on new series in which strange plant forms or dreamlike landscapes and cities take shape. Upon occasion, in her most recent works, the old Dadaist fantasy still breaks through.

Schwitters

> This morning I visited the place where the streetcleaners dump the rubbish. My God, it was beautiful!
> Tomorrow they are bringing a couple of interesting pieces from that muck heap, among other things broken street lanterns, for me to admire or, if you wish, to use as models. The things are rusted and bent. One of the garbage men brings them to me. It would make a fine subject for a fairy tale by Andersen, that mass of garbage cans, baskets, pots, serving bowls, metal pitchers, wires, lanterns, pipes, stovepipes that people have thrown away. I really believe that I shall dream about it tonight, and in winter I shall have much to do with it in my work.
> If you ever come to The Hague, it would be a pleasure for me to take you to this place, and to a few other places that are a real paradise for the artist, however unsightly they may be.
> From a letter from Van Gogh to Von Rappard, The Hague, 1882

Art had a long time to wait before Van Gogh had a successor who, like him, discovered the treasures of the world in rubbish. However, in time that successor also took a giant step beyond him, in that the things Van Gogh sought to bring to life with crayon and brush were simply taken as they were, put into pictures, and allowed to speak in and for themselves. In so doing, KURT SCHWITTERS (1887–1948) has become for us so much the central figure of Dada that we tend to think of him as head of the movement, whereas it was only with difficulty that he ever came to terms with the established Berlin Dada circle, and with most of them he was perpetually at drawn daggers.

In 1918 Schwitters left Hanover to visit Berlin, with the aim of joining the Club Dada. As luck would have it, at the Café des Westens he happened on Raoul Hausmann, and the way he introduced himself ("I am a painter, I nail my pictures.") struck a sympathetic chord in Hausmann and laid the basis for a long friendship. Nevertheless, when Hausmann passed on Schwitters's application to the "President," Huelsenbeck turned thumbs down, saying that the Club could not simply take in anyone who happened along. Even after Schwitters had made a name for himself on his own, with a show at Der Sturm in 1919 and an article about him published by Christoph Spengemann in *Cicerone*, the committee in charge of the 1920 Dada Fair did not find him worthy of participating in their exhibition. Yet the title of a

For a comprehensive and virtually fully illustrated treatment of Schwitters and his work see Werner Schmalenbach, *Schwitters*, New York, n.d.

work by Rudolf Schlichter, *Der Tod der Anna Blume*, proves that Schwitters's poems at least were not ignored. Schwitters himself maintained a thoroughly critical attitude toward the Dada group. In the "creed" he set down in December, 1920, for the Munich magazine *Der Ararat*, he drew a line of demarcation between the "hard-core" Dadaists—Arp, Picabia, Ribemont-Dessaignes, Archipenko, with whom Schwitters was linked in close artistic friendship—and what he called the "Huelsendadaists" (a pun on "Huelsenbeck" and "*Huelsen*," husks, outer rinds), who had separated themselves from the real group. Huelsenbeck's political pronouncements, such as that in *En avant Dada* proclaiming that "Dada is a German Bolshevik affair," were distasteful to Schwitters, whose character did not at all incline to radicalism and who preferred to carry on his fight on something other than a political plane. He agreed expressly with Tzara's maxim, "Dada is the distinctive sign of abstraction."

Although today the real elements Schwitters introduced into his pictures seem a factor of key importance, he himself never thought of his art as other than abstract, and it was on that grounds that he took up the cudgels in its defense. For him, abstraction was the only "new and objective art of the time," the ultimate logical phase of the artistic development of our century.

In his youth Schwitters had traversed the various phases of that development and, from one to the next, each time had drawn his own reasoned conclusions. At the Dresden Academy he learned to make accurate copies of objects and, in so doing, came to realize that, in essence, painting is a matter of harmonizing elements one with the other in form and color. There followed a period of Impressionistic landscapes, in which at first he sought to reproduce his personal impressions of nature but then discovered that it was precisely the impersonal, the objective, factors of a picture that determined its entire expressiveness. In 1917 and 1918 he painted mountain landscapes in broad all-embracing contours, and in these he was influenced by the Expressionist painters of the Dresden group, Die Brücke. The next step led to formal abstractions of Cubistic character, when it became clear to him that "every effort to imitate nature's forms proves to be detrimental to the force of logical consistency in the elaboration of an expression." Inducted into the army, from March of 1917 to June of 1919 he worked as an engineering draftsman at the Wülfel ironworks, an occupation which led him to new discoveries: "There I acquired my love for the wheel and recognized that machines are abstractions of the human spirit."

Schwitters's interest in collage grew logically out of his intuition that creating artistic form is synonymous with the artistic devaluation of the constituent elements as things in themselves, a phenomenon that has nothing to do with the material utilized: "Since the material does not matter, I take whatever material I like if the picture requires it. Because I balance different kinds of material against one another, I have an advantage over oil painting, for in addition to evaluating color against color, line against line, form against form, and so on, I also evaluate material against material—wood against burlap, for example.... Every artist should be permitted to put together a picture out of nothing more than, say, blotting paper, as long as he knows how to give it form."

In 1919 Schwitters composed a series of pictures consisting primarily of bits and pieces pasted together, scraps of newspaper, paper lace, corrugated

Schwitters's first volume of poems, *Anna Blume*, was published in 1919 by the Verlag Paul Steegemann in Hanover, in the series *Die Silbergäule*.

"The separation was carried through with loud caterwauling, singing of the *Marseillaise*, and distribution of prods with the elbows, a tactic that Huelsenbeck still makes use of today." From "Merz," *Der Ararat*, 1921

From this period dates his *Still Life with Chalice* of 1909, which he later converted into a collage by adding Dadaistic accessories and sent as a postcard to a friend. Reproduced in Sanouillet, p. 96

Text in the *Sturm-Bilderbuch*, IV

In the periodical *Merz*, 1923

The word "Merz" was cut out of an advertisement of the Commerz- und Privat-Bank and thenceforth applied as a generic title to all of Schwitters's works.

In *Zweemann*, I, 1919, translated in W. Schmalenbach, p. 94

It was destroyed in a bombing raid in 1943.

cardboard, tin foil, and so forth. For the most part they were smeared over with paint, and thus those materials were not very conspicuous within the colorful broken-up planes of form. In the same year, however, he also began the first series of true "Merz pictures" in large format: *Das Arbeiterbild (The Worker Picture)* (Moderna Museet, Stockholm); *Das Undbild (The And Picture)* (colorplate 22); *Franz Müllers Drahtfrühling (Franz Müller's Wire Springtime)*; *Das grosse Ich-Bild (The Large I Picture)* (Marlborough-Gerson Gallery, New York); and others, whose basic components—all sorts of rubbish including wood and wire, dented wheels, broken hoops—are nailed together. The titles (for example, *Und, Ich*, and the like) appear for the most part on slips of paper pasted on the picture along with numerals, tickets, and other items of waste paper. In explanation of these works Schwitters wrote: "Merz painting makes use not just of paint, canvas, brush, and palette, but of all materials perceptible to the eye and of all requisite instruments. At the same time it is unimportant whether or not the material used was already formed for some purpose or other. A perambulator wheel, wire netting, string, and cotton wool are factors having equal rights with paint. The artist creates through choice, distribution, and dissociation of the materials. This dissociation of the materials may follow from their distribution over the picture surface. It can be reinforced by dividing, distorting, overlapping, covering over, or painting over. In Merz painting the box top, playing card, newspaper clipping become surfaces; string, brushstroke, and pencil stroke become line; wire netting becomes overpainting; pasted waxed paper becomes varnish; cotton wool becomes plasticity" (plate 121).

In point of fact, however absurd the materials he utilized, Schwitters always integrated them into well-balanced compositions, in which straight lines and angles, rectangles and circles make up firm scaffoldings. In many pictures the wire netting, twine, metal disks, and other bits and pieces he scavenged fit very well into his geometric conceptions. In others, for example the *Playing Card Harmonica*, such materials set up a kind of action and introduce a certain unrest into the orderly organization at which the artist aimed. In that work, Schwitters inserted his own neatly inscribed visiting card, together with harmless playing cards, into a pictorial ground of old scraps of cloth, boards, and odds and ends of metal. Portraits crop up among the objects in other collages: the painted head of a girl in the *Construction for Noble Ladies*, a profile in *Merz Picture IA, The Alienist*, which also includes a two-pfennig piece and a cigarette.

It was likewise about 1919 that Schwitters began to try his hand at Merz statues such as the *Gallows of Desire* (plate 124), with its wagon wheel from which a noose dangles and the cardboard wall concealing the victim. A year later he constructed his first Merz building, something resembling the tiny church in a child's construction set, though in its open hall the cogwheels of a machine grind away. This was an innocent predecessor to what came to be known as the *K.d.e.E.*, the *Kathedrale des erotischen Elends (Cathedral of Erotic Misery)*, the monster Merz building which, for ten years beginning in 1923, Schwitters constructed out of scraps and pieces of everyday rubbish and which in time stretched through two stories of his house in Hanover and down into the cellar. Hidden within an architectonic scaffolding of Cubist forms that tended to impose their character on the over-all impression were grottoes full of unholy relics to which Schwitters constantly

added, gluing, painting, and grouping them according to subject in categories such as "Nibelungen Hoard," "Goethe Grotto," "Ruhr Region," "Art Exhibition," "Sexual Murder Den." These literary allusions likewise played a part in the structural conception.

Equally productive as poet and painter, Schwitters hunted ceaselessly in the domain of words for elements that could be made to coalesce. He broke down the barriers between his dual talents, interlarding his pictures with words and giving visual and rhythmic shapes to his poems. His persistent dream was of a *Gesamtkunstwerk*, a union of all the arts, of a theatrical spectacle in which an all-pervading "Merz spirit" would triumph in setting, text, and music. In 1921, he set down a recipe for a real orgy of materials: "Take a dentist's drill, a meat-grinder, a car-track scraper, take buses and pleasure cars, bicycles, tandems and their tires, also war-time ersatz tires and deform them. Take lights and deform them as brutally as you can. Make locomotives crash into one another, on curtains and portières make threads of spider webs dance with window frames and break whimpering glass. Explode steam boilers to make railroad mist. Take petticoats and other kindred articles, shoes and false hair, also ice skates and throw them into place where they belong, and always at the right time. For all I care, take man-traps, automatic pistols, infernal machines, the torpedo, and the funnel, all of course in an artistically deformed state. Inner tubes are highly recommended. Take in short everything from the hairnet of the high-class lady to the propeller of the *S. S. Leviathan*, always bearing in mind the dimensions required by the work."

"Merz," in *Der Ararat* (Munich), no. 2, 1921. Translated in W. Schmalenbach, pp. 189–90

Whatever extremes Schwitters may have gone to in planning and executing his fantasy buildings and scenery, the core of his work consists of collages plain and simple, the "paper-scraps pictures" out of which he put together the great picture book of his daily life. For them he doggedly collected materials every day and hour and place. At first he scarcely bothered about picking and choosing. Anything that fell into his hands he cut up and tore up—printed matter, wrapping paper, cloth, sheets of paper smeared with color—and then in an outpouring of dynamic energy he pasted them over and under one another. In time, however, he came to select his materials more thoughtfully and to arrange them with greater care. To his junk he took to adding more delicate items such as fine tissue paper, scraps of lace, wallpapers with charming patterns, things that exhaled a homely poetry. In 1919 he also used rubber stamps (figure 22), hammering at us the same banal words over and over—PRINTED MATTER, AUTHOR'S COPY, THE SECRETARY'S OFFICE—and in between them he drew and wrote in an awkward childish hand and also pasted strips of postage stamps. About 1921 he began cutting out of catalogues and magazines all sorts of illustrations, fashion plates, and reproductions of old art works, and by combining these with advertisements announcing sensational happenings, tickets of admission promising cut-price entertainments, labels extolling the qualities of dubious wares, he devised picturesque images not unrelated to the montages of the Berlin Dadaists.

Soon, however, Schwitters plunged back into his own intimate world, once again bringing to the surface those unimportant bits and pieces that document his own daily existence. The used tickets he picked up tell of places he could reach by tram or local train; postmarked letters and cards

tell of more distant places. Still, as always, in the midst of the abstract forms, there are mysterious numerals and words ripped out of any imaginable context and seeming to wait for an echo. "There is never a deliberate goal," wrote Schwitters in *Der Sturm* in 1927, "other than the consistency of the conception in itself. The material is definite, has rules, dictates directions to the artist, but this the goal does not do. It is this consistency that governs and guides the creation."

His themes arise from the way the materials blend together, from the formal and color values they contain. Many of these collages have a naive colorfulness, but the bold combinations of red, blue, violet, orange, and yellow are most often toned down by the patina typical of all used and worn-out things. At times only a bit of silver or gold mingles with the brownish gray tones of old paper and the faded black of printer's ink on the pasted snippets. The small format of these collages, often no more than that of a postcard, makes them seem like pages from some album that chance and time have detached and scattered about. The poetic resonance becomes even more pronounced when the compositions are installed in old-fashioned oval frames (plate 122) or in an old hand mirror.

Consistent as Schwitters's production was, only a few specific phases of development stand out somewhat more distinctly. An obvious turning point occurred about 1922, when, through Theo van Doesburg, Schwitters became acquainted with the Stijl movement. His earlier compositions, with their splintered forms generally moving diagonally across the picture, were

Figure 22. Kurt Schwitters. *The Critic.* 1921. Drawing, with rubber stamps from *Der Sturm* and *Quirlsanze*

156

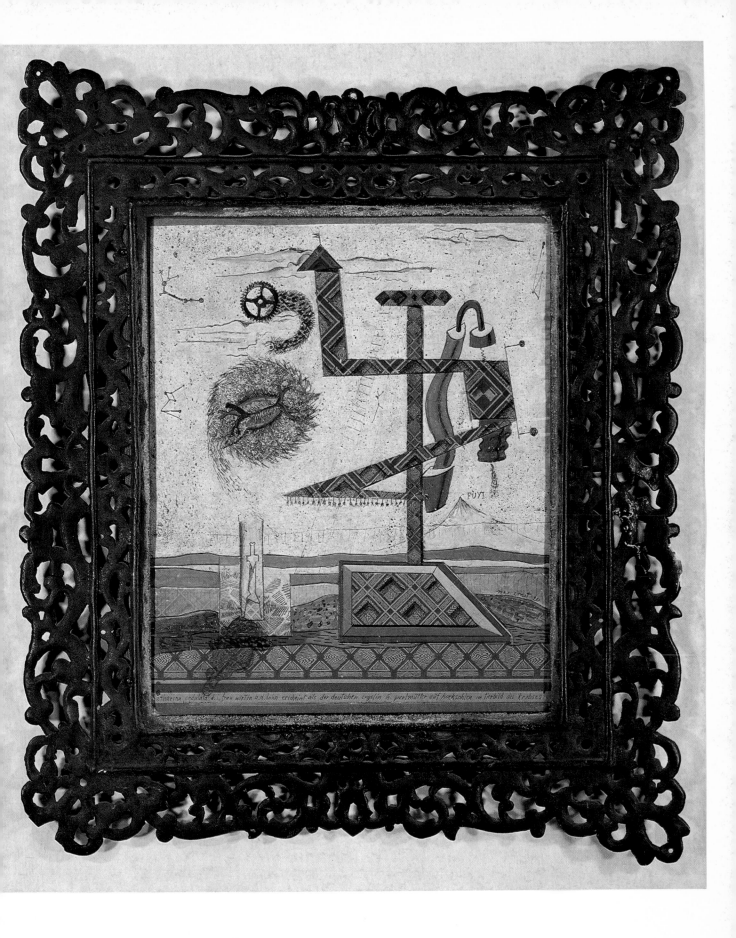

Colorplate 24. Max Ernst. *Undulating Catherine (Katharina ondulata)*. 1920

In the magazine *Merz*, which Schwitters published from 1923 on, there was an oscillation between Dadaist and nonfigurative tendencies, and to them in particular two special numbers were devoted, no. 6 (October, 1923), *Imitatoren watch step*, and no. 8 (April–July, 1924), *Nasci*, both of them edited by Schwitters and Lissitzky in collaboration.

superseded then by a clear organization of planes dominated by verticals and horizontals. In works consisting only of abstract geometric shapes, for instance, *Moscow* or *Mz 380: Schlotheim*, both from 1922, Schwitters was as remote as he could be from the spirit of Dada. When Lissitzky arrived in Hanover, the influence of Russian Constructivism was added to that of Dutch Neo-Plasticism. In 1924 Schwitters produced abstract reliefs of wood and cardboard such as *Relief with Cross and Sphere*, based on a rigorous system of coordinates, and the *Peacock Wheel* (Yale University Art Gallery, Collection Société Anonyme, New Haven, Conn.), a colorful circular composition recalling the work of Delaunay. Working with Lissitzky, Schwitters too began to promote the use of modern typography in advertising art, and his Merz-Werbezentrale (Merz Advertising Agency) took on special jobs for the Pelikan works in Hanover. He also joined the Ring of New Publicity Designers, formed in 1927 by nine of the most progressive artists and publicity experts.

This sort of practical activity reinforced Schwitters's tendency to simplify and clarify his compositions. The pictorial elements and typographical material in his collages began to be organized in predominantly geometric arrangements, and he sought out and selected his materials with more care. A few tiny bits of cloth and carefully cutout pieces of colored paper came to replace the varicolored profusion of elements used previously, and his figurative and abstract components were fused into a more complete harmony. On the occasion of his Monstre-Merz-Muster-Messe (Monster Merz Sample Fair) held in October, 1926, at Der Sturm, Schwitters wrote: "You ask me why I no longer make use of every kind of material? It is not as if I had managed to achieve artistic form for every sort of materials, something which defies doing, is absolutely impossible, and in the long run is also unimportant. What is important for me is the principle involved. Today it is precise form that I wish to show you, together with pasted and nailed works as before. Not that for me form is the most important thing, since then my art would be merely decorative. No, it is the song that sounded within me while I was at work that I have poured into the form, that now makes itself heard by you too through the form."

In the 1930s Schwitters continued to produce works in which the formal interest was predominant, but his "delight in fabulous invention" broke through over and over again. Often, too, something sentimental, a kind of crypto-romanticism, makes itself felt, though it is always promptly drowned out by the artist's pleasure in everything outrightly absurd.

The materials Schwitters used make up a geographical panorama of the places where he lived and worked (plate 123). The early collages tell of his presence in Halberstadt, Hildesheim, Frankfort, and Basel, whereas later ones show him in Aussig, Prague, and The Hague (colorplate 23). German postage stamps and labels were replaced by Norwegian ones when he took refuge in Oslo after the outbreak of World War II, then by English ones in 1940, when, at the last possible moment, he managed to flee across the North Sea.

During his first years in England his collages took on a somewhat more sober objectivity and neater lightness, in response, some have claimed, to "climatic" influences. However, E. L. T. Mesens, Schwitters's protector in England and himself a devotee of collage, raises the question as to whether the finds that Schwitters brought home from his regular scavenging rambles

in Hanover were not themselves perhaps rather more gloomy than the rubbish to be picked up in the vicinity of Barnes and Ambleside. In any case, it was not until the works of his last years that the full dramatic impact of his early works returned. Then torn and smeared papers again crammed his collages with turbulent density, and an authentic flotsam and jetsam of wood and debris was put together to make reliefs. The intensity and vehemence of the workmanship strongly suggest that Schwitters must have felt death closing in on him and that it would not be granted to him to complete his third "Merz building." He died on January 8, 1948, in Kendal, near Ambleside.

He had constructed a second Merz building in Norway, which was burned out in 1951.

As early as 1920 Schwitters had formulated his own creed: "I value sense and nonsense alike. I favor nonsense, but that is a purely personal matter. I am sorry for nonsense, because up to now it has so seldom been given artistic form, and for that reason I love nonsense." In 1931 he wrote in an article concerning himself and his aims: "I know perfectly well that for me and all other significant personalities of the abstract movement the great time will come at last when we will influence an entire generation, and my only fear is that I personally will not be alive to witness it." We know today how right he was.

"Ich und meine Ziele," in *Merz 21 – erstes Veilchenheft*

See also the exhibition catalogues of the Kestner-Gesellschaft, Hanover, 1956, and of the Marlborough-Gerson Gallery, New York, 1965.

Holland and Belgium

The friendship between Schwitters and the Dutch painter, architect, and poet Christiaan E. M. Küpper, better known as THEO VAN DOESBURG (1883–1931), not only resulted in Schwitters's coming under the influence of the painting of the Stijl movement but also in Van Doesburg's being drawn, for a time at least, into the Dada orbit. After the Dada campaign that Schwitters undertook throughout Holland in 1922 in the company of Van Doesburg and his wife, Petro, he devoted the first number of his magazine *Merz* (January, 1923) to "Holland-Dada" (figure 23). In return, Van Doesburg brought out in Leiden, under the pseudonym I. K. Bonset, a Dadaist magazine *Mécano*, of which four numbers appeared in 1922 and 1923, and which published works by Arp, Max Ernst, Hausmann, and others. The second issue included a collage by Van Doesburg, *La Matière dénaturalisée (Matter Denaturalized)*, in which Dadaist elements such as pieces of newspaper, scraps of cloth, and cutout catalogue and newspaper illustrations were organized in a geometric surface arrangement such as is found in Schwitters's collages of that period. From about this same time dates also the montage portrait of his wife (plate 263) that Van Doesburg composed of double exposures and cutout photographs, utilizing the Dadaist procedures in rather more attractive fashion.

Apart from this we know only one other collage by Van Doesburg in Neo-Plasticist style, a composition of one white and three colored rectangles that he pasted into Fritz Vordemberge-Gildewart's guest book in 1925.

A visit that Schwitters paid in the course of his Dutch tour to another adherent of De Stijl, the sculptor Georges Vantongerloo, provoked much discussion in Antwerp and was probably the incentive for another Antwerp artist, PAUL JOOSTENS (1889–1960), to turn to collage and montage and thereby earn the title of "the Belgian Schwitters."

About 1917 Paul Joostens, very much a lone wolf artistically, was won over to a Cubist style of painting with certain reminiscences of Gleizes and Metzinger. At the beginning of the 1920s his lively compositions became

Figure 23. Page from *Merz 1, Holland-Dada*, 1923

M. Seuphor, who was friendly with Joostens in those years, insists that he began to work in collage in 1922–23.

G. Marlier's biography of 1923, however, reproduces an object made of more modest components.

more static and at the same time more abstract, a development which seems to be connected with his interest in collage. A picture, *The Siren*, originally executed in oil, was reproduced in collage but with marked simplification, and it involved not only pasted papers but also painted cardboard, which was nailed on. Other figurative subjects, *Music Hall* for one, likewise were translated into clearly organized surface compositions enlivened by pieces of paper and cloth in contrasting colors. In *Cockade*, transparent and opaque papers, brick-red cloth, and crumpled silver paper make a Phrygian cap with a game counter as cockade, the whole glued to coarse canvas. To create effects of relief Joostens also had recourse to corrugated cardboard, plaster of Paris, and pompons, and he achieved quite special color effects by putting black and glazed colored papers together on an aluminum ground. What-ever the subject, ironic as in *La Poule de luxe* or undefinably abstract as in *Découpages*, his compositions always preserved a formal rigor. Joostens's own formulation of his lifelong guiding principle was: "The partitioning of the superficies is the basis of painting."

Although the artist himself later pushed the dates of these collages as far back as 1915 to 1918, the date of 1922 found on certain of them corresponds to the information in the biography by Georges Marlier, who, writing in 1923, expressly stated that in recent months Joostens had had the audacity to give up painting and to conceive his compositions entirely in terms of colored papers and other components.

Whereas the influence of Schwitters seems somewhat discernible in Joostens's collages, it is perfectly obvious in the three-dimensional construc-tions that he worked at during those same years. These were architectonic structures made of cubes, cylinders, and rolls, or chests made from old boxes, which he furnished with every imaginable kind of trash and old household wares: funnels, bottles, drawers, razor blades, flower pots holding plants made of wire and string. Skeins and nooses dangling from furniture knobs cannot help but recall Schwitters, as does an old iron pot on a lever coming down on a torso with long wooden arms. On the other hand, Joostens had a bitter, almost macabre quality quite alien to Schwitters, and often he achieved really terrifying effects with his crude pieces of junk. That was especially true of the head *La Java* (plate 119), later destroyed, which was constructed out of wood and corrugated cardboard, decorated with the handle of a pan, a bottle brush, and tin cans, and framed by two matted and tangled tufts of horsehair. According to Joostens himself, this was his first three-dimensional construction. The Paris magazine *L'Effort moderne* repro-duced it in October, 1924, dating it as from that same year, and probably it was not done much earlier than that.

In 1924 Joostens left off doing this sort of Dadaistic work, and only after a long interval did he again produce collages and montages in the old provoc-ative spirit. At an exhibition organized in 1957 by the Galerie Saint-Laurens in Brussels—the only one to maintain rapport with the rather difficult eccentric in his last years—collages executed in that year showed virtually no differences from those done long before. Blasphemous subjects such as *Monsieur the Abbé Goliard Buries Himself After His Fashion* or *Buddhism Tra-versed by Radar* were now spun out with rather more abstruse fantasy. In *Il Santo (The Saint)* leering faces and dismal grimaces are pasted among cutout reproductions of Memling's altarpieces and of views of churches. For

other works Joostens once again turned to three-dimensional materials. Thus, he decked *Sonienwoud's dochterkijn (Sonienwoud's Little Daughter)* with cloth, wood, twine, and a kitchen grater. He also crowned the head of Christ in an *Ecce homo* with bright-colored prongs, a halo made of the metal foil wrapping from a praline, and a little bell, and twisted around the loins a knotted length of cord.

At his death in 1960 Joostens left behind, in the little house in Antwerp where he admitted almost no one, a wealth of paintings and sculptures, drawings and collages, books and manuscripts, evidence of an exceptional activity as both artist and writer.

Cologne

Fundamentally, it was in 1918, after the end of the war, that Dada began in Cologne, specifically at the moment when Max Ernst met Johannes Theodor Baargeld (pseudonym of Alfred Grünewald), the son of a Rhenish banker. Both had rejected the sanctimonious phrases used to glorify the war during four long years and now being replaced by others equally hollow. They aired their opinions in a magazine *Der Ventilator*, which they distributed at the gates of factories, but their insurrectional opinions soon led to its banning by the English occupation authorities.

At that time the whole course of his artistic future still lay open and undecided for MAX ERNST (b. 1891). He had participated in 1913 in the *First Berlin Autumn Salon*, and three years later he exhibited at Der Sturm. From those early years there survive a few watercolors done in 1917, depicting ghostly winged or finned hybrid creatures, forerunners of that very special brand of fantasy which was to be Max Ernst's hallmark in years to come. It was shortly after the war that in a Munich bookshop he chanced upon publications of the Italian Valori Plastici group and was struck especially by De Chirico's so-called "Metaphysical paintings," whose influence is obvious in the series of lithographs, *Fiat Modes*, that Ernst brought out as a portfolio in Cologne in 1919 (figure 24). However, the real bolt from the blue for him came with the first Dada documents to fall into his hands. The existence of Dada arrived like a glimmer of light in the blackout of Germany's collapse, and for Ernst and Baargeld it brought confirmation of what they themselves thought about art.

Together they put out the magazine *Bulletin D* in 1919, and it reproduced one of Max Ernst's earliest Dadaist works, *Fruit of a Long Experience* (Collection Roland Penrose, London), a painted relief assembled from old wood, cardboard, wire, and fragments of a defective bell pull, elements that suggest the influence of Schwitters, though the fact is that he did not visit Ernst in Cologne until shortly afterward. *Bulletin D* also published the catalogue of a modern art exhibition organized by Max Ernst and Baargeld in Cologne, in collaboration with the revolutionary group which used the English name "Stupid" and included Heinrich and Angelika Hoerle, Otto Freundlich, K. A. Raederscheidt, and F. W. Seiwert. Klee and Arp were shown as invited guests.

Arp and Max Ernst had already become acquainted in 1913 at the Werkbund exhibition in Cologne, and the friendship established at that time

John Russell, *Max Ernst*, New York, n.d., can be consulted for illustrations.

Rubin, pl. 85
Another relief has an inscription in large letters, "Sculpto-Peinture", as an ironic allusion on the part of Ernst to Archipenko's experiments with various materials.

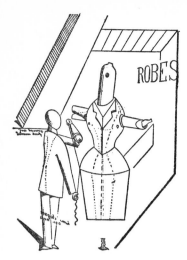

Figure 24. Max Ernst. *Fiat Modes*, one of eight plates. 1919. Lithograph

Figure 25. Announcement of the *Dada-Vorfrühling* exhibition, in the Winter Brewery, Cologne, April, 1920

The French original comes from "Au-delà de la peinture," in *Cahiers d'Art*, no. 6–7, 1936, special number *Max Ernst*. A

underwent a turbulent renewal when Arp left Zurich and settled in Cologne. In 1920 Max Ernst, Baargeld, and Arp founded the group Dada W, and for an entire year their escapades and scandals kept the city and the authorities in a state of exasperation. The climax came with the famous exhibition *Dada-Vorfrühling (Dada–Early Spring)*, held in April of 1920 in the Winter Brewery (figure 25). According to the catalogue, it showed "paintings, sculptures, drawings, *Fluidoskeptrik*, and vulgar dilettantisms." Entrance to the exhibition was through the brewery toilets, and, once past those, the public found itself confronted with such disconcerting art works as Baargeld's *Fluidoskeptrik*, an aquarium filled with a red liquid on which floated a lock of hair and from which a wooden arm reached out. Max Ernst contributed a wooden block to which was attached an ax, together with a label inviting the visitor to make use of it to demolish the art work itself, an invitation that was more than willingly accepted. The proceedings degenerated into a riot, which gave the police an excuse to close down the exhibition, though it was reopened when the "obscene" work of art the police had impounded turned out to be an etching by Dürer. At the reopening a poster proclaimed: "Dada is for law and order."

Some of the works displayed were reproduced in *Die Schammade*, another magazine that Max Ernst and Baargeld published in February, 1920, which contained contributions not only from the Zurich Dadaists Arp, Tzara, and Huelsenbeck but also from the Parisian friends of Dada, among them Picabia, Paul Éluard, Louis Aragon, and André Breton. It reproduced a Dada sculpture by Ernst made of wire, small wheels, screws, and cotton batting; and by Baargeld there was a relief, *antropofiler bandwurm (anthrophiliac tapeworm)* (plate 140), on which were mounted bits and pieces of scrap metal, a baking tin, an iron grater, chains, and a sieve. The title page of the magazine—whose subtitle urged, "Dilettantes, arise!"—was decorated by a drawing by Max Ernst reminiscent of Picabia's *Dessins mécaniques*. Those drawings subsequently inspired Ernst to yet other fantastic machine compositions, to which he added line engravings from technical catalogues cut into pieces and then completed by further drawing. The results of this complicated procedure were supplied with highly suggestive, or at least exhaustive, titles such as *Adieu mon beau pays de Marie Laurencin (Farewell My Beautiful Country of Marie Laurencin)* or *Von minimax dadamax selbst konstruiertes maschinchen für furchtlose bestäubung weiblicher saugnäpfe zu beginn der wechseljahre u. dergl. furchtlose verrichtungen* (translated and abbreviated in the catalogue to *Little Machine Constructed by Minimax Dadamax in Person*, Collection Peggy Guggenheim, Venice). A 1919 picture, *Rechtzeitig erkannte angriffspläne der assimilanzfäden auf die feste DADA 1 : 300000* (approximately, *Attack plans of the assimilative threads discovered in good time on the feasts of DADA 1 : 300000*) (Collection Peggy Guggenheim, Venice), is the earliest example of a collage by Max Ernst, since a circular piece of paper bearing the word "DADA" is pasted on it. A related collage drawing, *Trophy Hypertrophied* (Museum of Modern Art, New York), with line engravings of stage machinery, was submitted in 1920 to the Paris exhibition of the *Section d'Or*, whose jury refused it on the basis that it was not a handmade work of art.

Of the singular experience that sparked his production of highly individual collages, Ernst himself has given a conclusive account: "One rainy day in 1919, in a village on the Rhine, my gaze was caught obsessively by the

pages of an illustrated catalogue. The advertisements showed objects relating to anthropological, microscopic, psychological, mineralogical, and paleontological research. There I found collected the elements of a figuration so remote that its sheer absurdity provoked in me a sudden intensification of my faculties of vision—a hallucinatory succession of contradictory images, double, triple, multiple, piling up with the persistence and rapidity characteristic of erotic memories and visions of half-sleep. Those images, in turn, demanded to be united on new planes, in a new unknown (the plane of contradiction and disagreement). To reproduce what I saw with my inner eye, it sufficed at that time to add to those catalogue pages, by painting or drawing, a touch of color or a couple of pencil strokes, thereby surrounding the objects represented with an exotic landscape, the desert, a sky, a geological cross-section, a floor, a single straight line signifying the horizon. In this way, I could produce a faithful and fixed image of my hallucination and, in so doing, transform the banal pages of an advertising catalogue into dramas revealing my most secret desires."

From the moment this revelation came to him, Max Ernst proceeded to turn out an endless profusion of collages in which "mutually irreconcilable realities are wedded to each other," according to the formula of Lautréamont quoted earlier: "Beautiful as the fortuitous meeting of a sewing machine and an umbrella on an operating table." In those collages, images from physics and alchemy, anatomy and the natural sciences, botany and zoology enter into the most unexpected combinations with objects of everyday life (colorplate 24). Wheels and propellers become vegetable growths, scraps of wallpaper make mountain formations, microscopic webs indulge in acrobatic dancing, and hats go through their paces as if they were marionettes made of glass.

Max Ernst so extended the possibilities of collage that, in Louis Aragon's essay of 1930, *La Peinture au défi*, which treats of the origins and significance of collage, he is declared to be the inventor of collage true and proper, the definitive medium which finally exploited to their full potentiality the papiers collés of the Cubists. Though the Berlin Dadaists may object that they had begun to do montages independently and earlier, it was Max Ernst who gave the medium an artistic significance ranging far beyond anything anyone before him had even imagined. This is because, in assembling his pictorial components into unforeseen and unexpected combinations, he drains away from them whatever they possess in the way of directness, of their own clear and simple nature, and thereby throws open the doors of art to the irrational—which Ernst himself considers the "noblest conquest" that collage has made.

It has become customary to apply the term "collage" to all works in which components belonging to separate intellectual or perceptual categories are combined, even when, as in many instances, nothing in them has been pasted or glued. Max Ernst himself has expressly sanctioned this omnium-gatherum notion in his assertion: *"Ce n'est pas la colle qui fait le collage"* (It is not the paste that makes the collage). According to his own statement, of the fifty-six collages he exhibited in June, 1921, at the Galerie Au Sans Pareil in Paris, only twelve contained pasted-in elements, the remaining forty-four being in all sorts of other techniques. Some had as a basis a drawing, a line etching, or the imprint of some object, and these were gone over with gouache or

variant translation was published in Max Ernst, *Beyond Painting and Other Writings by the Artist and His Friends*, New York, 1948.

Max Ernst was not the first to draw artistic inspiration from illustrated catalogues. As early as 1911 two Englishmen, Edward Verrall Lucas (co-editor of *Punch*) and George Morrow, published a book, *What a Life*, in which an Englishman recounts his life story in pictures cut out of the Whiteley Company catalogue. Each event is associated with an image explained in the text: a bird cage stands for a visit to the Crystal Palace; a pair of gloves laid crosswise represents a deaf-and-dumb woman who expresses herself only through gestures; and so on. Sometimes several illustrations are mounted together to portray certain personalities and their habits. Thus "dear Lady Goosepelt," a chronic invalid living in Bournemouth in enchanting rusticity, is rendered by a donkey pulling a rubbish barrel out of which projects a female bust wearing a hat with a dashing feather.

This genuinely pre-Dada work was singled out at the exhibition of *Fantastic Art, Dada, Surrealism*, Museum of Modern Art, New York, 1936–37, which showed even earlier examples of advertising montages. The French writer Raymond Queneau, in his essay *Bâtons, chiffres et lettres*, Paris, 1959, hails the day on which the book by Lucas and Morrow was published—August 17, 1911—as the birthday of the "coming together of scissors and pastepot for their own autonomous ends", in simpler words, as the day on which collage was born.

watercolor to round out the composition. In many cases, pieces of wallpaper were used as the ground, and the contours of the pattern were so emphasized here and there by outlining with the brush that one has the impression of cutout shapes. Others contain crocheted lace and embroidery, in which one can scarcely make out whether these are real textiles or trompe-l'oeil painting.

From 1920 on, Ernst also used photographs, either glued into the composition or as a base for pasting other elements. In *The Young Bride* a photograph of a nude female model is ruthlessly chopped up "anatomically" and then pieced out according to the artist's fancy. Two cutout arms embrace a stone mask in *Chinese Nightingale*. In *The Slaughter of the Innocents* (plate 126) architectural photographs of facades with columns and windows stretch off into space like railway tracks; human silhouettes spring away from them; an airplane plunges downward. In *Les Pléiades* (Collection René Rasmussen, Paris) a headless female, nude except for leg gear, soars in a void, of which the pavement, the caption informs us, is about to fall down.

Certain plays on words clearly reveal the influence of Arp.

Most of these collages are provided with lengthy titles inscribed in careful handwriting on the upper or lower margin of the picture (plate 125). The labels scarcely help to explain the meaning of what one sees. On the contrary, by exploiting the possibilities of ambiguity and chance arrangement of words, they disconcert the viewer even more. The texts on the early collages are in German, but on the photomontages they are in French, and this distinction became increasingly frequent when Ernst began to welcome closer contacts with the Paris Dadaists.

JOHANNES THEODOR BAARGELD (1891?–1927) followed Max Ernst doggedly through every step of his inventions and discoveries. He began with intricately intertwining but somewhat crude pen drawings in which one shape merges into another, constraining the viewer to seek out the hidden faces and forms as in picture puzzles. He also used wallpaper, isolating some part or other of the pattern with pen and India ink and explaining the subject of his isolated fragment by a text incorporated into the picture. In 1920 he experimented with photomontage, in one case embellishing a fantastic drawing with the portrait of a smiling woman and the severed photograph of a bemedaled officer, mounted partly above, partly below. When the two friends produced youthful self-portraits in montage in 1920, Max Ernst gave himself a companion—an anatomical head attached to a draped bust—identified in an inscription as "Caesar Buonarroti." Baargeld pasted a photograph of his own head, in jockey cap, on an antique female torso and endowed it with the title *Typische Vertikalklitterung der Darstellung des Dadabaargeld (Typical Vertical Articulation of the Representation of the Dadabaargeld)*.

Both are reproduced in Rubin, pls. D-93 and D-91.

The two friends also produced pictures in collaboration, improvising freely on the same canvas and then each developing further the accidental forms he had discovered in the contours painted in by the other. Arp too became wildly enthusiastic about this kind of work in common and joined Max Ernst in the *Fatagaga* series (from *FAbrication de TAbleaux GArantis GAzométriques*; that is, *Fabrication of Pictures Guaranteed to Be Gasometric*), in which each carried further the ideas set down by the other, continually tossing the ball back and forth between them. These are collages made from cutout illustrations, often resembling Duchamp's "ready-mades" in that

Colorplate 25. Joseph Stella. *Profile. c. 1922* ▷

they are only slightly "corrected," though even more often they are fitted into new combinations in a manner characteristic of Ernst himself.

ANGELIKA HOERLE (1899–1923), another friend of Max Ernst, worked in collage about that time, though none of these works survives. A few very subtle drawings from somewhat later years (Yale University Art Gallery, Collection Société Anonyme, New Haven, Conn.) display a Surrealistic tendency to see through things and to allow abstract forms, fantastic living creatures, and real objects to interpenetrate. She died very young during the famine resulting from the postwar inflation in Germany.

Paris

In Paris the Dada supporters among poets and writers were numerous. André Breton, Louis Aragon, Philippe Soupault, Georges Ribemont-Dessaignes, and Paul Éluard brought new vitality into the movement. Yet, in the visual arts, the initiative lay entirely in the hands of Dadaists from the United States, Switzerland, and Germany, who, one by one, went to Paris.

The first to arrive was Jean Crotti, who returned from New York in 1916, bringing with him, as artistic emissary of Marcel Duchamp and his group, Duchamp's sister Suzanne, whom he married three years later.

SUZANNE DUCHAMP (1889–1969) had started out by painting in a somewhat naive style but, back in Paris, went over to compositions reflecting the mechanical interests of her great brother. A work of 1916, *Un et Une menacés (One Male and One Female Threatened)* (figure 26), presents a machine construction in which a rope, with plummet attached, runs over a cogwheel. More mysterious in its effect is her *Multiplication brisée et rétablie (Multiplication Broken and Re-established)* of 1918–19 (plate 107), a composition of floating balloons with gold and silver papers and bright stars pasted on it and including a fragmented poetic text. In the *Relation de deux seuls éloignés (Relation Between Two Remote Individuals)*, painted at various stages from 1916 to 1920, the material was eked out by beads, pebbles, aluminum foil, and small arrow-like, pointed lead rods laid over a ground of checkered gold paper. A composition of 1920, *Ariete*, displays a more naive Dada spirit, with a portrait of Crotti having the characteristic porcelain eyes and suspended in the starry firmament, where it is projected, almost three-dimensionally, by means of dark cast shadows.

Crotti himself, in 1920, produced a number of Dadaist compositions of colored circles and segments of planes, around which dance numerals, letters, and words. Works by Crotti and Suzanne Duchamp were exhibited in April, 1921, in the Galerie Montaigne, set up by Jacques Hébertot in the foyer of the Théâtre des Champs-Élysées. About the same time they launched a new movement, Tabu, in accord with Picabia, whose side they championed in his conflicts with Tzara. In a letter picture, *Explicatif*, Crotti pasted the printed text of one of his poems, "*Tabu en art*," alongside other inscriptions written out in pencil.

Picabia returned to Paris early in 1919, and his magazine *391*, published there from the ninth number on, continued to provide a major forum for Dada. However, it was only when Tzara arrived, in January of 1920, that the real Dada spark caught fire again, and the two confederates, Picabia and

Michel Sanouillet, *Dada à Paris*, Paris, 1965, p. 292

166

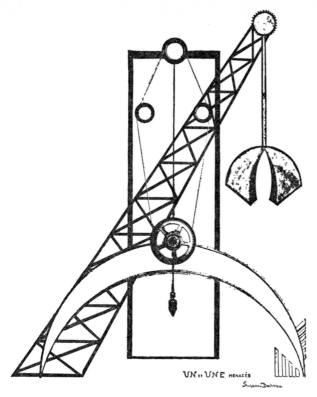

Figure 26. Suzanne Duchamp. *Un et Une menacés*. 1916

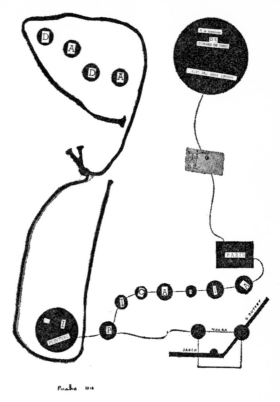

Figure 28. Francis Picabia. *A la mémoire de Léonard de Vinci*. 1919. Collage and drawing

Tzara, did their best to provoke scandals and riots in the good old spirit of Zurich. At a matinee in the Palais des Fêtes on January 23, 1920, organized by the magazine *Littérature*, edited by Breton, Soupault, and Aragon, Picabia exhibited a picture dated that same year, *The Double World*, made up of linear curves and harmless inscriptions, in the middle of which, running from top to bottom, were the letters "LHOOQ" (which, pronounced in French, add up to something like "She has hot pants"). In the eleventh number of *391*, that of February, 1920, he published an inkblot titled *The Blessed Virgin* and explained that the advantage of such "tachistic" painting was that it could not be imitated (though, as is known now, he was grossly mistaken). The following number had on its title page a slightly varied replica by Picabia of Duchamp's *Mona Lisa with Mustache*, also known, because of the magic letters, as *L.H.O.O.Q.* As a feature of the colorful variety program at the Dada manifestation held in April, 1920, in the Maison de l'Oeuvre, Picabia displayed a picture (no longer extant) inscribed on three sides *Portrait de Cézanne*, *Portrait de Renoir*, and *Portrait de Rembrandt* and on the fourth, *Natures Mortes*, and otherwise consisting only of a plush ape hanging on its surface. The toy was a makeshift for the live ape that Picabia had sought in vain in the pet shops along the Seine. This work of art was also reproduced in the magazine *Cannibale*, which Picabia had founded in the same year.

Despite all this, there was no Dadaistic confrontation in the exhibition held at the same time in the Galerie Au Sans Pareil (figure 27), where Picabia was showing some of his New York pictures and a few large "mechanical drawings." Upon occasion, Picabia combined collage and drawing. Thus, on a work of 1919 he pasted the title *A la mémoire de Léonard de Vinci* (figure 28), together with a label written in mirror script, on a black disk which

Figure 27. Francis Picabia. Exhibition catalogue, Paris, 1920. "Mechanical drawing" and typography

Rubin, pl. D-49.

167

Now in the possession of the Galerie Louis Carré, the work was for long displayed in *Le Boeuf sur le Toit*, the cabaret run by Louis Moyses which was the favorite meetingplace of Picabia's friends, immortalized in Milhaud's ballet of the same name.

Likewise in the Galerie Louis Carré, Paris

Sanouillet, *Il movimento Dada*, colorplate LX

No collage of this sort is listed in the catalogue of the Picabia show, Barcelona, Galería Dalmau, November–December, 1922.

gives the impression of a balloon soaring aloft from a linen thread. On this hang other smaller disks, each with a letter of Picabia's name. Another drawing has a page of a book and a section of a tape measure inserted among abstract forms.

Picabia's Christmas greeting to Arp and Max Ernst in 1920 was a photomontage in pure Dada style, *Tableau Rastadada* (plate 129), the main ingredient of which is a pasted-over portrait photo of the artist labeled "*Francis le raté*" (which can mean either "Francis the Flop" or "Francis the Pockmarked"). One of his most bizarre compositions, however, dating from early 1921, is *L'Oeil Cacodylate*. The name came from the remedy used to treat Picabia's ailing eye, and the eye itself is painted on a large canvas, with enough room all around it to accommodate the signatures and witticisms written in by the artist's vast circle of friends, among them the Dadaists Tzara, Duchamp, Ribemont-Dessaignes, the Crottis, the painters Serge Charchoune and Metzinger, Jean and Valentine Hugo, and the musicians of the group of The Six, including Darius Milhaud, who quips: "*Je m'appelle Dada depuis 1892*" (I've been called Dada ever since 1892), the year of his birth. In the midst of these Picabia pasted his own portrait, a few other heads, and a picture of the Fratellini, the clowns who were the rage of the moment in Paris. On another collage, *Chapeau de paille? (Straw Hat?)*, the artist's visiting card, cut out in heart shape, is tied by a string to the printed invitation to the "Réveillon Cacodylate," the New Year's Eve party held in 1921 *chez* Marthe Chenal, a singer at the Paris Opéra and a friend of Picabia.

It was also in the early 1920s that Picabia produced a number of pictures expressing a more naive delight in collage: painted portraits and landscapes trimmed with the most banal objects chosen in a spirit of mingled irony and realism. A woman's face is decorated with matchsticks, hairpins, and old coins (Collection Simone Collinet, Paris). The face of *The Handsome Pigsticker* is surrounded by five pocket combs. A gentleman dressed to the nines has a piece of tape measure for a nose, curtain rings for eyes and mouth, toothpicks to represent his growth of beard, and a bow tie made of writing pens. In *Flirt* (plate 127) a female figure is hidden behind blades of straw, toothpicks, and tightly coiled spirals which make flowers and stars shining out against the dark painted background. Picabia also conjured up Mediterranean landscapes with palm fronds made of fuzzy feathers and trunks made of macaroni (Yale University Art Gallery, Collection Société Anonyme, New Haven, Conn.; Galleria Schwarz, Milan); in one really frugal one matchboxes are piled one above the other, and matchsticks whirl around a leafy tree made of pieces of a tape measure, an object with which the artist was obviously much smitten. Also there is a frame studded with mother-of-pearl buttons surrounding a flower pot with a plant made of toothpicks and their cases, all delicately tinted by Picabia (Galleria Schwarz, Milan).

None of these pictures is dated, and some of them are now certainly assigned to much too early years. In his subsequent "transparent" period, Picabia only occasionally returned to collage; one is the *Man with Shadow* of 1928 (Collection Pedro Vallenilla Echeverría, Caracas), which has clear plastic film pasted into the oil painting.

After Picabia's show, there was one of GEORGES RIBEMONT-DESSAIGNES (b. 1884) in May of 1920, also at the Galerie Au Sans Pareil. His machine drawings, in imitation of Picabia's, occasionally include pasted-in elements

such as a postage stamp. His small volume of memoirs, *Déjà-jadis*, Paris, 1958, gives a vivid picture of people and events in Paris during the Dada years.

One reproduced in *The Little Review*, New York, 1922

JEAN COCTEAU (1892–1963), who entered into every dominant trend of the day and who possessed a marked artistic talent, for drawing in particular, was led by his brief but close friendship with Picabia to try his hand at collages of various materials conceived in the spirit of Dada. Among his happy efforts, a head (plate 134) composed of narrow strips of cardboard and lengths of string is studded with, and held together by, a large number of thumbtacks, and a scrap of paper at the bottom, likewise thumbtacked, bears the signature and date "Jean 1920." During a stay at Villefranche in 1925–26 he once again took up construction, using drawing pins to mount cardboard, cord, plaster, wax, and cloth, and upon occasion resorting also to matchsticks, hairpins, and pipe cleaners. The subjects portrayed—*Orphée, Oedipe, Oiseaux, Barbette*—correspond to the themes of the poems and plays he was writing at the same time. These objects were exhibited in December, 1926, under the title *Poésie plastique* at the Galerie Aux Quatre Chemins in Paris.

Exhibition catalogue, *Jean Cocteau et son temps*, Paris, Musée Jacquemart-André, 1965, nos. 373, 374. The issue of *Échantillons* (no. 6, June–August, 1928) that was shown there contained six photographs of objects assembled by Cocteau.

All this active notwithstanding, for a real impetus toward bona fide collage *à la Dada* Paris had to wait until 1920, when, at the invitation of André Breton, Max Ernst sent his works to an exhibition there. His collages threw Picabia's friends Breton, Aragon, and Soupault into transports of enthusiasm. Their "first fruit" was a collage that Tzara received in December of that year, presumably from the writer Philippe Soupault; its title, *Dada soulève tout (Dada Lifts Everything)*, was exemplified by an illustration from an advertisement of a company making hoisting equipment which showed a crane lifting up the globe of the world. The collage was used on a leaflet distributed by the Dada group in January of 1921, at a soiree where Marinetti lectured on "Tactilism."

However, Ernst's exhibition, announced by Breton under the title *La Mise sous Whisky Marin*, did not take place until May of 1921. The *vernissage* at the Galerie Au Sans Pareil, which Ernst himself could not attend, ended in a Dada manifestation best described as a real hullaballoo. The exhibition unleashed a general passion for collage, and the results were shown at the *Salon Dada*, which opened directly afterward, in June, 1921, at the Galerie Montaigne. To this event the Paris writers, poets, and other Dada partisans contributed their finest collages and montages. Georges Hugnet recalls two objects made by Soupault: *Cité du Retiro*, which was made of a piece of asphalt; and *Portrait of an Unknown Person*, a mirror with a child's balloon fastened to its frame. Dr. Théodore Fraenkel, a close friend of the Dadaists, made a collage of old-fashioned sheets of paper dolls, a cutout silhouette, and a photomontage of hands. Aragon fabricated one with a portrait of Jacques Vaché wreathed in dried flowers and leaves (plate 128).

In much of the literature, this exhibition is persistently wrongly dated as 1920, though not in the two books most important for documented information, Hugnet's *L'Aventure Dada* and Sanouillet's *Dada à Paris*.

Besides the Parisians, at that salon there were contributions from Max Ernst, Arp, Man Ray, Stella, Mehring, and Baargeld, as well as from the Italians Evola, Cantarelli, and Fiozzi.

JACQUES VACHÉ (1896–1919), with whom André Breton became acquainted in 1916 while serving as military surgeon in Nantes, is one of the legendary figures of the history of Dada. His cynical style of life gave him claim, in the eyes of his friends, to be considered the inventor of a Dada-before-Dada. Louis Aragon wrote in *La Peinture au défi* that in Nantes in 1916 Vaché was fashioning collages with elegant Parisian beauties and dandies made of scraps of cloth, and selling them at two francs each. Breton, however, men-

Vaché exercised an irresistible fascination over Breton, who published his "war letters" after Vaché and a friend died in 1919 from the effects of opium.

tions only painted and drawn series of postcards with models of men's fashions and makes no reference to collage. The works of Vaché listed in the catalogue of the *Salon Dada* bear no indication of the medium employed.

During their stay in Tarrenz in the Tirol in September, 1921, Max Ernst, Tzara, and Arp collaborated on a pamphlet titled *Dada Intirol Augrandair, Der Sängerkrieg (Dada Intirol Inopenair, The Singers' Contest)*, subsequently printed in Paris. For the title page Ernst made a collage, *Preparation of Glue from Bones*, showing how the magical elixir on which collage depends is drawn out of a patient on an operating table. He used cutout catalogue illustrations exclusively, without rounding them out with either drawing or painting, thereby discovering the principle he would utilize in his collage books, which certainly number among his most astonishing works.

Paul Éluard, who went to the Tirol with Breton and there came to know Max Ernst in person, subsequently went with his wife, Gala, to visit Ernst in Cologne, where he selected a few collages to serve as illustrations for his book of poems *Répétitions*. As frontispiece there is a "portrait" of Éluard in the guise of a flower tub out of which rises a jingling musical instrument, a form of the ancient sistrum, variously known as "Turkish crescent," "Chinese pavilion, or hat," or "Jingling Johnny" but here consisting of an electric pole with rows of insulators (figure 29). The encounter in the Tirol also led to direct collaboration on another book, *Les Malheurs des Immortels*, published by the Librairie Six in Paris in 1922, with prose poems written jointly by Paul Éluard and Max Ernst and illustrated by the latter with collages made from old woodcut engravings.

Whereas in the illustrations for *Répétitions* the cutout engravings are set together in the style of a child's picture book, the collages of *Les Malheurs des Immortels* assume more dramatic, more anxiety-arousing forms, premonitory of the strange imaginings of the Surrealists.

Having installed himself in Paris in 1922, Max Ernst painted in collage style *The Meeting of Friends* (Collection Dr. Lydia Bau, Hamburg), a group portrait of the Dadaists who assembled at Éluard's house in Saint-Brice. The heads of the friends—augmented by those of Raphael, Dostoevski, and Giorgio de Chirico—are set on bodies just as in the popular montages of soldier portraits.

In the small intimate pictures that Ernst created in the next few years, mostly on the theme of cages and birds, he inserted real materials such as wire rods. Then, in 1924—on the borderline between Dada and Surrealism—he constructed a small panel, *Two Children Are Threatened by a Nightingale* (Museum of Modern Art, New York), which has baffled innumerable biographers of Ernst. The unfortunate children, menaced with death and ruin by a tiny bird in a wasteland scene, inhabit a small house which the artist made of solid materials, as if by so doing he could guarantee them more security. Strips of wood are nailed on the hut, a large wooden button is placed above it like an alarm bell, and a wood-slatted entrance gate swings open on real hinges.

Like Max Ernst, Man Ray too was received with open arms by the Dadaists when he arrived in Paris in June, 1921, and what he brought with him from New York was acclaimed as solid, genuine Dada work. In Paris Man Ray

J. Russell, *Max Ernst*, New York, n.d.

Figure 29. Max Ernst. *Portrait of Éluard*, frontispiece of Paul Éluard, *Répétitions*, 1921. Collage

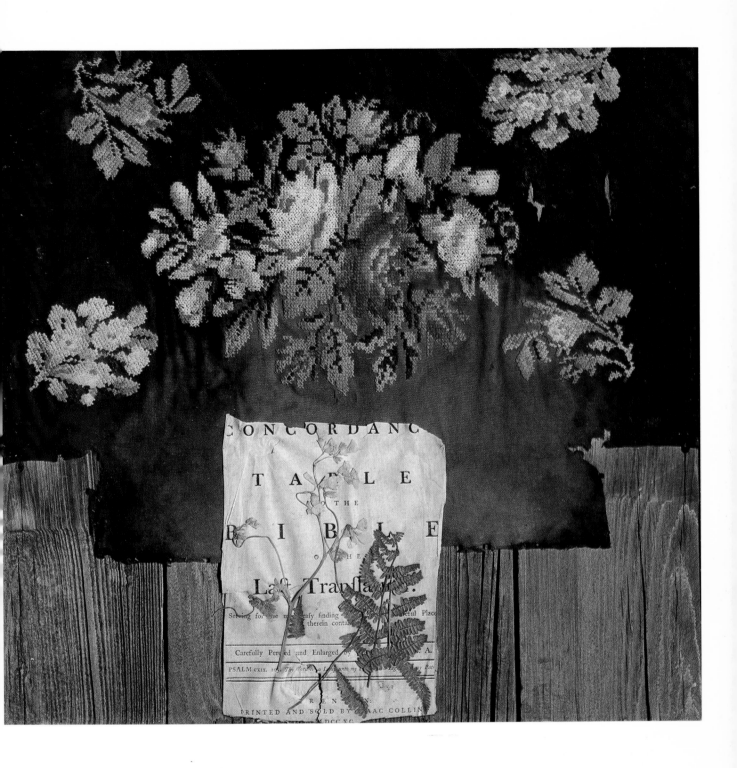

Colorplate 26. Arthur G. Dove. *Grandmother*. 1925

Rubin, pl. 46

continued to work with the same inventive spirit, exploring one technique after another. The first thing he produced after his arrival was a collage, *Transatlantic*, in which a background strewn with matchsticks and other refuse was pasted on one side of a painted chessboard, a map of Paris on the other, to represent the shore he had left and the shore he had reached. There is rather more of New York in a picture made in 1922 of various materials including, as title, a number in six figures, along with a propeller and other shapes cut from sheets of cork and glued on a mechanistic drawing of a spiral and plummet. During his first exhibition, which took place in December, 1921, at the Librairie Six, Man Ray made one of those objects for which he has become famous, his *Gift* (replica of lost original, Collection Mr. and Mrs. Morton G. Neumann, Chicago). To the underside of a flatiron he attached a row of upholsterer's nails, their points directed menacingly outward toward the recipient of the "gift." Two years later, though, there was only affectionate irony in the final material picture of his Dada period, *De quoi écrire un poème (The Wherewithal to Write a Poem)* (plate 105), consisting of a pen with a quill staff and a paper rose stuck through the pleats of a folded piece of black paper lying on a sheet of corrugated cardboard. To its wooden frame Man Ray affixed an old-fashioned metal nameplate, as if he himself wished to rank this picture among the museum pieces.

During Man Ray's first years in Paris, he concerned himself chiefly with photographic experiments, especially images captured without a camera, such as had already been done by Christian Schad in Geneva. These had been preceded by the "*clichés-verre*" he had already worked with in New York, photographic plates into which he incised outlines of, say, heads in profile. This procedure was already in use in Daguerre's time by the painters of the Barbizon school to replace printing from metal or stone plates and presses.

Man Ray also did "aerographs" using an airbrush. Although one of them, *Preconception of Violetta* (private collection, New York), is signed and dated 1919, and is so given when reproduced in such sources as the *Dictionnaire abrégé du Surréalisme*, Paris, 1938, an auction catalogue of Gutekunst & Klipstein, Berne, 1958, and Rubin, pl. 42, Man Ray himself states that that date is incorrect, because he had executed no such works before going to Paris.

In 1937 Breton wrote the foreword for an album of Man Ray's Surrealist photographs, *La Photographie n'est pas l'art (Photography Is Not Art)*; the title was later inverted to *L'Art n'est pas la photographie*.

These Rayographs, as they were called, were made by interposing the most diverse objects—a pipe, a hand lens, eyeglasses, film strips, flowers, net—between the light source and the light-sensitive paper. He also combined these light interruptors with abstract shapes cut out of paper, or sometimes he interposed his own hand. He piled objects into and on top of each other and manipulated the light in order to obtain chiaroscuro compositions of an entirely abstract character. An album of Rayographs appeared in 1922 under the title *Les Champs délicieux* with a foreword by Tzara.

Having returned to Paris in July, 1921, for a few months' visit, Marcel Duchamp lent his weight to the Dada manifestations there. He had brought with him from New York his latest ready-mades, including a collage of April of that year, *Belle Haleine—Eau de Voilette*, based on an advertisement for a flacon of perfume. On its label he pasted a photograph of himself in women's clothing. It was subsequently used for the title page of *New York Dada*. Also in New York he produced the "object," *Why Not Sneeze Rose Sélavy?* (Philadelphia Museum of Art, Louise and Walter Arensberg Collection), a small bird cage with a thermometer and cubes of white marble which resemble lumps of sugar. The work is signed "Rose Sélavy" (the first name later modified to "Rrose"), a pseudonym adopted by Duchamp in 1920 in New York. As he tells it, he chose the most common French girl's name, Rose, simply because it happened to pop into his mind, but then, by analogy with Lloyd, he doubled the first letter in order to make it more interesting.

Man Ray's photograph of Marcel Duchamp "disguised" as Rose Sélavy is reproduced in Rubin, pl. D-48.

As for the "family name," it is simply a rhyming pun on the familiar French phrase, "C'est la vie," as one discovers upon pronouncing it, a play of words rather less suggestive than the famous "LHOOQ."

Among the "corrected ready-mades" belongs the *Obligation pour la roulette de Monte Carlo (Bearer Bond for the Roulette at Monte Carlo)*, which Duchamp produced in 1924 (plate 103). In the center of a roulette wheel rises Man Ray's photograph of Duchamp, his face covered with shaving lather and two horns growing out of his skull. The sheet was published in thirty copies and signed both "Marcel Duchamp" and "Rrose Sélavy."

In later years Duchamp continued from time to time to devote himself to collages and montages. During World War II, which he spent in New York, he published in the magazine *VVV*, 1943, no. 4, an *Allégorie de genre: George Washington*, a map of the United States with its contours manipulated to make a profile of George Washington; on this is stuck a piece of gauze bandage with gold stars and red stripes. For the special number that the magazine *View* devoted to him in March, 1945, he designed a collage in which, in a star-strewn sky, a bottle floats pouring out dense smoke; pasted on it, as label, is a page from Duchamp's old military identification book.

Not to be overlooked among the collage compositions of the time are the many Dadaistic posters, handbills, and invitation cards, as well as the title pages of the numerous short-lived magazines, with their words broken up and spread across the page in uninhibited flights of typographical fancy. One of the most successful of such publications was *Le Coeur à Barbe*, founded in April, 1922, by Éluard, Ribemont-Dessaignes, and Tzara. The magazine— which identified itself as a "*journal transparent*"—was printed on pink paper, and its title page was decorated with amusing figurative vignettes like those used earlier by John Heartfield in 1917 for *Neue Jugend*, though here they are rather more carefully integrated with the text. To this period belong also Iliazd's collage invitation, mentioned in the preceding chapter, and the picture-like page layouts in his Zaum poem *Ledentu le Phare*.

The title page of the first number is reproduced in Rubin, p. 112.

According to Michel Seuphor, the Chilean poet Vincente Huidobro, who went to Paris from Madrid in 1921 and published there his first volume of poems, *Saisons choisies*, began about 1923 to produce poem collages from letters cut out of paper, always in the same colors of green, gray, or white, which he pasted on large sheets of cardboard. Robert and Sonia Delaunay transformed the entrance hall of the apartment on the Boulevard Malesher-bes, where they lived from 1920 on, making it into a collage of pictures and writing rather like Picabia's *L'Oeil Cacodylate*. The members of their large circle of friends, among them Georges Auric, René Crevel, Tzara, and Seuphor, each made a contribution to the walls with poems, inscriptions, pictures, and collages. Mayakovsky, on his second visit to Paris, in 1925, wrote a Russian text on the middle panel of the door, and Sonia Delaunay herself embroidered a poem by Soupault on the curtain of the only window in the room.

Seuphor, "Histoire sommaire du tableau-poème," *XXe Siècle*, 1952. Huidobro had already contributed to the Zurich Dada magazine and published a picture poem in typographical form in the Berlin *Dada-Almanach*.

For the "Bal Transmental" organized in February, 1923, by the Alliance of Russian Artists in Paris and held in the locale of the Bal Bullier in Mont-parnasse, Sonia Delaunay set up a fashion boutique entirely in collage. Not only the splendid costumes of the mannequins—Sonia Delaunay's *robes simultanées*—but also the ceilings and walls were given her characteristic sumptuous coloring by means of pasted papers.

The balls held by that society—the "Bal Banal" of 1924, the "Bal de la Grande Ourse" of 1925, the "Bal Olympique" of 1926—are enshrined in the chronicle of sensational events in Paris. Russian and non-Russian artists shared in the decoration of the loges and booths. The president of the association was Larionov, and its treasurer was SERGEI FOTINSKY (b. 1887), who, for these and other occasions, designed brightly colored posters in collage which were displayed in the Café Caméléon on Boulevard Montparnasse, the gathering place of the Russian artists. Fotinsky also composed collages of his own free invention but has preserved only one, *The Dove That Announces the End of the Flood* (plate 130), an abstract composition with a landscape painted in gouache, on which are affixed colored papers, a real leaf, and a piece of bark in a harmonious blend of colors and materials that lend the picture a spontaneous animation.

Collage was adopted also by the Russian poet and writer ALEXEI REMIZOW (1877–1957) for the membership cards of the Order of the Ape, which he had founded in Russia and then, in the early 1920s, expanded first in Berlin and later in Paris, after settling there in 1923. He took into his "Order" all those personalities—writers, artists, collectors, scientists, or whatever—who had become conspicuous for any out-of-the-way achievement. Besides the legendary "King of the Apes," there were, in descending hierarchies, Princes, Knights, and Bishops, each of whom had his special emblem, generally in collage, on his membership card. Remizow also handed out membership cards generously to children of whom he was especially fond.

Occasionally Remizow wrote out his poems in the old graphic scripts, of which he possessed special knowledge, and he often made collage covers for the copies he gave his friends as gifts. When, during the war, a bombardment blew out the windows of his home in Auteuil, he blocked the openings with sheets of cardboard on which he reproduced the patterns of the destroyed bull's-eye panes and pasted colored papers into them. These were only the beginning, however. Finally his entire workroom was papered with collages on cheap brown cardboard covered with mosaics of dull olive, red, and violet papers, with occasional spots of shimmering tin foil and confectioners' paper, as well as red sealing-wax impressions. Often the regular ticktacktoe pattern was interrupted by individual fields conspicuous for their brighter, more intense tones, but here and there too the whole mosaic tended to condense into a wild, many-layered tangle.

To the fringe activities of Dada belong also the amusing cloth pictures devised about 1924 by the Polish painter ALICA HALICKA (b. 1894), the wife of Louis Marcoussis. From the Cubists and Dadaists who frequented her house, among them Apollinaire, Juan Gris, Tzara, and Crevel, she knew that artists could make use of other means than paint and brush. This led her one day to the idea of inserting into her landscape paintings figures dressed in tiny scraps of splendid fabrics, laces, fringe, ribbons, buttons, and beads. She even gave them heads cut out of illustrations, and to these she glued real pigtails and hair wigs. In her *Bathers*, shells and a fish net lend animation to the beach, and a seagull stands out against the sky; in *Bougival* (plate 131) there are tiny celluloid ducks swimming on the Seine.

As Alica Halicka recounts in her memoirs, these compositions arise spontaneously out of "ideas that are often sentimental, often romantic, often

Remizow, like Khlebnikov, aspired to revitalize the Russian language by a return to word roots. He used a collage procedure in the preparation of a book he called a "syllabary of Russia," which, according to Victor Chklovski (*Zoo*, written in Berlin in March, 1923, published in French, Paris, 1962), was put together from bits and pieces, fragments of books.

Now in the possession of Mme. Reznikov, Cachan, near Paris

Hier (Souvenirs), Paris, 1946

somewhat zany" that flash through her mind. Some of her pictures give evidence of a cheerful frame of mind, and their tender sentiment (which more than verges on *kitsch*) reminds one of the brightly colored folk imagery in Épinal prints, of which, it happens, Marcoussis owned an exceptional collection. In others, one senses a delicate poetry with reminiscences of Polish folk crèches and music boxes, as in the fairytale-like scene of *Roland in Roncevaux* (plate 132), with its mountain and steed cut out of marbled papers, its knight and his squires garbed in brocade braid and strips of beads.

For the first exhibition of these works, held in 1924 in the art gallery of the Paris department store La Grande Maison de Blanc, Princess Lucien Murat wrote the foreword to the catalogue and baptized them "*romances capitonnées*", (quilted romances). They were received very well in the milieu of Parisian *haute couture*, among the dressmaking houses for which Halicka designed textile patterns during the difficult postwar years. Her "romances" found enthusiastic imitators among the window dressers and have a logical succession in today's Pop Art, however opposed to refined taste that trend may be.

It was there that the Winterthur collector Oskar Reinhart acquired *The Blonde Slave*.

"Alica Halicka," *Documents*, no. 3, 1962. Dorothy Dudley, "Four Post-Moderns," *American Magazine of Art*, vol. XXVIII, 1935

Italy

Not much is known about the Italian Dadaists Giulio Evola, Gino Cantarelli, and Aldo Fiozzi, who took part in the Paris *Salon Dada* of 1921. In 1917 GINO CANTARELLI had founded the magazine *Procellaria (Stormy Petrel)*, which, like Prampolini's *Noi*, championed the Dadaists. After the war the contacts became rather more lively, especially with Tzara, who published an article by Evola in *DADAphone* in 1920 and even went to Mantua to meet in person the three artists who had formed a Dada group of their own. In the same year the trio brought out a new magazine, *Bleu*, which lasted for three issues and welcomed contributions from the Paris Dadaists. The second number, that of August–September, 1920, reproduced a material assemblage by ALDO FIOZZI (1896–1941), *Abstract Values of an Individual Y* (plate 139), one of the few true Dada productions of Italian character. It is a relief construction made of wooden elements, spiral springs, a tin-can lid, and the wheel from a toy, the whole transformed into a sarcastic portrait containing, in addition, chemical formulas. Nothing of this Dadaistic spirit survives in a collage of 1931, *Homage to Wireless Telegraphy* (Collection "arc/do," Milan), an objective depiction of an industrial complex with buildings rendered in engineering drawing, a few of which are made to stand out three-dimensionally by having pieces of wood nailed on them.

GIULIO (or JULIUS) EVOLA (b. 1898) published a pro-Dada text titled "News from Friends" in the third number of *Bleu* (January, 1921) and for a time was the most zealous of propagandists for the movement. His own painting had been mystical-abstract, with "inner landscapes" composed of lines, planes, volumes, and signs, but these now became "Dada landscapes," laced through with letters and numerals. Bragaglia's Casa d'Arte in Rome, having offered a one-man show of Evola in 1920, in March and April of the following year presented him, Cantarelli, and Fiozzi in an *Exhibition of the Italian Dada Movement*, the only domestic Dada manifestation ever realized in Italy.

Reproduced in the exhibition catalogue *Dada 1916–1966*, Milan, 1966

Besides the Jazz-Band-Dada-Ball, Evola also organized in Rome a Dada evening in the bar of the Augusteum concert hall, where he presented his poem for several voices "La Parole obscure du Paysage intérieur" (published in Rome in 1921), accompanying it with music by Schoenberg, Satie, and Bartók. Daniela Palazzoli, "Dada in Italia," in the catalogue of the 1966 Dada exhibition in Milan.

Severini and Soffici were in contact with Ciacelli in Paris in 1913–14. In a letter written to Severini from Paris on March 13, 1913, Carrà spoke of him, Giannatasio, "and other blockheads who give themselves out to be Futurists and make an anti-publicity which will have catastrophic consequences for all of us."
C. Belloli, in the exhibition catalogue *40 Futuristi*, Milan, 1962, reproduces a 1928 work by Ciacelli, *The Wooden Horses* (now Collection Antonio Mazzotta, Milan).

La Città dalle Cento Meraviglie, ovvero I Misteri della Città Pentagona, Rome, 1920

Both are in the collection of Dr. Antonio Mazzotta, Milan.

One of them (Yale University Art Gallery, Collection Société Anonyme, New Haven, Conn.) is reproduced in Rubin, pl. 50.

The 1928 volume of the periodical *Der Sturm* published a Dadaistic collage by ARTURO CIACELLI (b. 1883), originally an adherent of the Futurists. It contained clippings from the Swedish newspaper *Politikken* and was produced, presumably, somewhat earlier than the year of its publication, perhaps in the course of a visit to Stockholm. Ciacelli spent some time in Paris, where he knew Delaunay, but lived in Stockholm from 1930 to 1939, in Vienna from 1939 to 1941, and then appears to have returned finally to Stockholm, where he opened a cabaret in which he displayed works by such Italian colleagues as Evola.

Even FILIPPO DE PISIS (1896–1956) at one time adopted the Dadaists' collage technique, but his relations with them remained decidedly external. In 1917 he was enabled to see the Zurich Dada publications by his friend G. Raimondi, who also sent a text by him to Tzara for publication. As an artist, however, in his younger years he was entirely under the influence of De Chirico, whom he met in Ferrara in 1915. The friendly interest was mutual. De Chirico was fascinated by De Pisis's passion for unusual, old-fashioned, and fantastic objects, a trait that suggests Surrealist rather than Dadaist inclinations. He has described the room in which De Pisis lived in his parents' house as a kind of sorcerer's den crammed with stuffed birds, pots and pans and jars, medicine bottles, old books. De Pisis guided his friend through the old alleys and hidden corners of Ferrara—in 1920 he published a book about them, describing his birthplace as "the city of a hundred marvels"—and it was in the shop windows of the Jewish quarter that De Chirico discovered the cakes and sweets "in exceedingly strange and metaphysical forms" which one finds in his still lifes of 1916–17.

When Carrà too went to Ferrara in January of 1917 and joined De Chirico in founding the Metaphysical school, De Pisis—more of a writer in those years than a painter—spoke out for them in newspaper articles. Under their influence, in 1919 he began to paint his own Metaphysical still lifes, into which he introduced collage elements. In *The Fatal Hour*, around a flower motif in a medallion frame, he pasted a playing card and an envelope bearing a seal as complements to the painted elements. Two bright-colored old playing cards are also found on another still life, in the middle of painted objects such as flowers, lemon, matchbox, electric bulb, and biscuit, thrown into relief by sharp cast shadows. Around these objects spreads that extraordinary empty space one finds also in the still lifes that De Chirico and Carrà were doing at the same time. Afterward, however, De Pisis turned away from collage and preferred to render objects in trompe-l'oeil painting.

The United States

Although the instigators of Dada in New York in the early days, the great triumvirate of Marcel Duchamp, Francis Picabia, and Man Ray, soon shifted their activity to Paris, other artists, native Americans, took up the procedures of collage and montage introduced by the Europeans and developed them further in their own fashion. MORTON L. SCHAMBERG (1882–1918) had been one of the youngest exhibitors in the Armory Show in 1913, and from 1916 on he painted mechanistic pictures in the manner of the Duchamp group, calling them *Machine Forms* or *Mechanical Abstractions*. In them, machine

parts became formal elements intermeshing like clockwork. Much more astonishing, however, is his sculpture titled *God* (plate 135), a construction made of plumbing pipes mounted together to form a "knee." The result, a "corrected ready-made" in the spirit of Duchamp, earns for its unfortunately short-lived artist a place alongside Duchamp among the earliest forerunners of Pop Art.

Schamberg was one of the founders in 1917, with Duchamp, Arensberg, Katherine Dreier, and John R. Covert, of the Society of Independent Artists. JOHN R. COVERT (1882–1960), who was elected president, had studied in Munich before World War I and had been in Paris from 1912 to 1914. In 1915, through his cousin Walter Arensberg, he met Duchamp, with whose desire for a revolutionary change in the means of artistic expression he was entirely in sympathy. In a picture of 1916, *The Temptation of Saint Anthony*, Duchamp's influence is obvious in the way the impression of a continuous movement is rendered by segments of planes that interpenetrate. However, its only Dadaistic trait is the title, which has nothing whatsoever to do with this abstract composition.

Covert pushed abstraction even further in four material reliefs of 1919. One consists of simple pieces of painted wood nailed one next to the other in a colorful circular movement, and the foremost board bears the title *Ex Act*. On another, *Brass Band*, surfaces traversed by parallel cords are transformed, through colored shadowing, into geometric bodies recalling the sculptures of Pevsner, and the drum forms were borrowed from Duchamp's *Chocolate Grinder*, for which a sketch exists showing the apparatus spanned by wires in much the same way. In *Vocalization* (Yale University Art Gallery, Collection Société Anonyme, New Haven, Conn.) straight lines are abandoned in favor of curves, and the wooden rods and small blocks in this "musical" composition give the impression of keyboards and scattered keys. The most impressive of these pictures, *Time* (plate 142), has as its ground a geometric drawing including numbers and formulas, over which upholstery studs are nailed in highly organized patterns, while across the entire surface glide strange shadows that themselves assume geometric shapes. The mathematical formulas that Picabia employed as a kind of game and the real materials that, when used by Man Ray, preserve their objective character are both given allegorical significance here.

Covert's artistic activity extended over only a few years. In 1920 he donated six of his pictures to the Société Anonyme, which had been founded in the same year by Marcel Duchamp, Katherine Dreier, and Man Ray and thereby laid the basis for their future collection. Three years later he gave up art altogether to devote himself to business.

Through the Armory Show, the Italo-American painter JOSEPH STELLA (1877–1946) became a personality to be reckoned with among the American avant-garde. He exhibited there a large, visionary painting, *Battle of Light, Coney Island* (Yale University Art Gallery, Collection Société Anonyme, New Haven, Conn.), painted in 1913 after his return from a visit to Europe, where he had become acquainted with the Cubists and Futurists. The vibrating, iridescent faceting of the forms reveals an intermingling of the Futurist way of seeing and the American feeling for life. The various versions of *Brooklyn Bridge*, 1917–18, which launched Stella's fame in America, are a hymn to the age of steel and electricity—in Stella's view, "the creative

In the Museum of Modern Art, New York

Sanouillet, *Il movimento Dada*, colorplate XXXI

G.H. Hamilton, "John Covert, Early American Modern," *Art Journal*, XII, 1952

There are versions in the Whitney Museum of American Art, New York, the Société Anonyme Collection of the Yale University Art Gallery, New Haven, Conn., and elsewhere.

factors in modern art." In the audacious steel structures which each night become suffused with light Stella discovered architectonic perspectives and dynamic tensions out of which he conceived his apotheoses of the metropolis.

Although he exhibited with Duchamp and Crotti at the Montrose Gallery in 1916, those artists had no effect on Stella's painting. Instead, it was Cubist and Futurist reminiscences that supplied the incentive for his lifelong concern with collage. The earliest date for his work in this medium, 1918, is found on a charcoal drawing of a man with a hat seen through a window frame with newspaper clippings pasted into the foreground. This was a study for the *Man in Elevator* (Collection Washington University, St. Louis, Mo.), though there the composition, painted on glass, is reversed and in place of the printed matter are pieces taken apparently from an illustrated carpet catalogue. Its composition in ellipses and segments of circles recalls the early abstract work of Balla or the "heads" by Boccioni, which also have pieces of newspaper pasted on them.

It was shown at the International Collage Exhibition, Rose Fried Gallery, New York, 1956.

With another series of collages, which must have been done before 1922, Stella took an entirely different and wholly unique direction (colorplate 25). These compositions consist of simple, flat shapes, for which he used not only white and colored papers but also printed matter and cigarette or tobacco packages. In *Bookman* the cutout papers make an oval head, in the center of which an angular bit of paper marks the nose. The *Skyscraper*, a subject closely related to Stella's oil paintings, is built up in four stories out of dirtied colored papers, some of which are printed with commercial names and even perforated. The titles of others—*Pegasus, Telephone, Red Seal, Shovel*—have only the vaguest connection with what the shapes suggest or refer only to some bit of text in the picture. Other designs are formed from a few geometrically cutout pieces of paper and scarcely lend themselves to interpretation. The contrast between vivid and pale colors, the old-fashioned designs, and the banal printed matter give these collages their special character. Discarded materials were manipulated by Stella with the same passionate thoroughness as Schwitters, but by cloaking them in colors he deprived them of all association with what they had once been. Stella's collages—of a character absolutely unique in his time—were quite definitely forerunners of the lyrical abstract style of such importance today.

Two of them, *Study for Skyscraper* and *Bookman*, were reproduced in a special Stella number of *The Little Review*, IX (1922), no. 2.

During his lifetime Stella's collages were never exhibited. After his death they were found in the cartons where he carefully preserved every bit and scrap of his work. There too were found all sorts of fine papers, for which he had a particular passion, and together with his personal documents there was a store of Christmas wrapping papers and silver foil, as well as pressed autumn leaves, these too perhaps intended for collages. At all events, Stella himself must have attributed a certain importance to his collages, because he had signed every one of them.

Information from Robert J. Schoelkopf, who has looked after Stella's work in his New York gallery

Just as Stella commemorated his rediscovery of Coney Island in 1912–13 upon his return from a lengthy visit to Europe, so the Uruguayan painter JOAQUÍN TORRES-GARCÍA (1874–1949) celebrated his arrival in New York in pictures originating directly under the impact of the light and life of the great city. In an oil painting, *New York Street Scene* (Yale University Art Gallery, Collection Société Anonyme, New Haven, Conn.), he incorporated collage elements. Within a varicolored mosaic of buildings and vehicles there appears a dizzying profusion of advertisements and electric signs, and,

Colorplate 27. Joan Miró. *Composition.* 1933 ▷

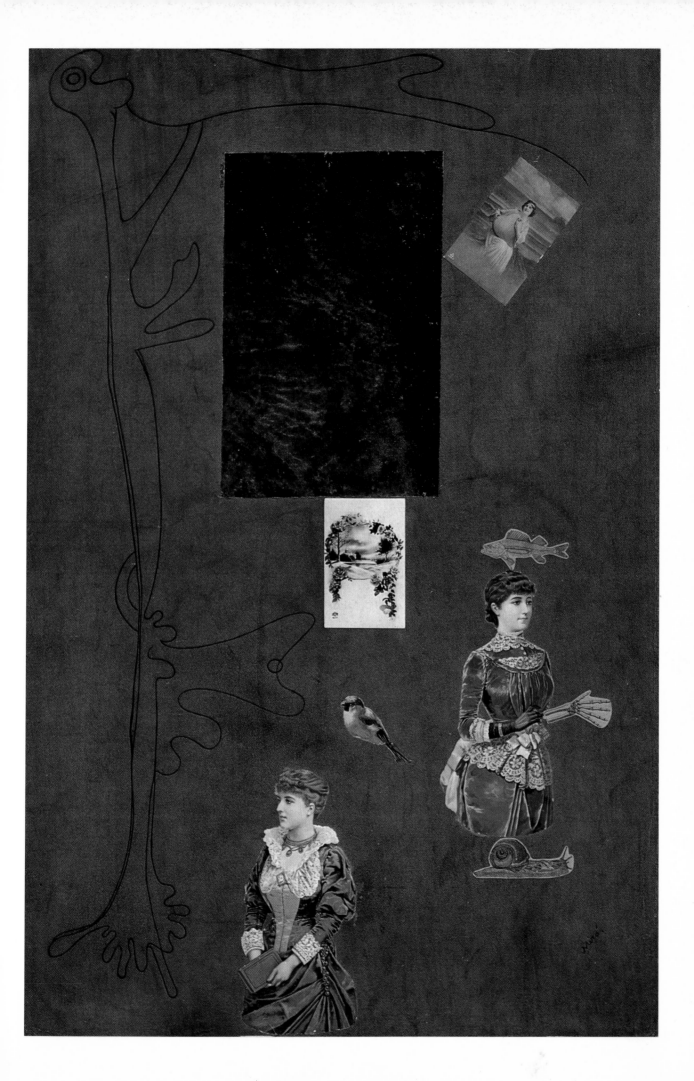

In New York Torres-García also began to nail together small reliefs from pieces of wood, which he painted with patterns and inscriptions and to which upon occasion he even added scraps of cloth. He continued to do such works, with their echoes of Dada, in Italy in 1924 and subsequently in Paris.

Reproduced in James Thrall Soby, *Contemporary Painters*, New York, Museum of Modern Art, 1948, p. 19

along with a painted calendar leaf with the date of September 15, there is pasted in the center of the picture a business letter decorated with a star from an American flag. The way the individual scenes of this picture are rendered simultaneously and interlaced with words may go back to Futurist pictures Torres-García saw in his early years in Barcelona, where he lived from 1901 to 1920 and where, though at a distance, he could follow all the new developments in European art. Some of his works of 1917–18, such as *Feria* and *Port of Barcelona*, herald his later style by the isolation and frontal stratification of their pictorial elements. There too the facades are decked out with signboards and writing like those that dominate in certain pictures of his New York period and give the effect of collage components.

Torres-García's *New York Street Scene* has a certain affinity with a 1922 watercolor by JOHN MARIN (1870–1953), *Lower Manhattan* (Museum of Modern Art, New York), which has a many-pointed star pasted on it. In the early 1920s Marin was underpinning landscape formations and architecture by means of bold strokes, at times with Cubistically segmented forms. Frequently he also pasted pieces of torn paper into his watercolors, though the additions are scarcely noticeable in the midst of his tightly juxtaposed color areas.

The modern aspects of American advertising, with its billboards, electric signs, special packaging, and highly effective typography, fascinated European artists, and it was these that found their way into innumerable Futurist and Dadaist paintings and collages. In America itself, STUART DAVIS (1894–1964) made them the chief subject of his painting. In 1921 he painted a series, including *Lucky Strike*, *Cigarette Paper*, *Bull Durham*, and others, in the form of billboards with words and images juxtaposed exactly as in collages and with materials such as paper, cloth, matches, and twine depicted in painstaking trompe-l'oeil. Even the transparent papers that seem to cover certain areas are rendered illusionistically in paint. In only one, which has a painted imitation of pieces of corrugated cardboard and a dark figure in silhouette and which recalls the Cubistic collages of Laurens, the Dada-style title *ITLKSEZ* is made of letters scattered about and actually pasted in.

That title carries a suggestion of Picabia, but the Dadaist influence became much stronger after the Société Anonyme's international exhibition of 1926 at the Brooklyn Museum, where Davis saw Picabia's *Mediterranean Landscape*, with its macaroni trees, and Duchamp's *Fountain*. To these he owed the awareness that even absurd and unaesthetic objects can be made into works of art. At first, then, he made constructions from pieces of plywood cut out into shapes, on which he mounted old locks and bolts. In 1927 he nailed a polishing glove, an electric fan, and an egg beater on a table and utilized this unique assemblage (an anticipation of Daniel Spoerri's *Accidental Tables*) as a model for a considerable number of still lifes, progressively more abstract in form from one variation to the next.

Not infrequently at later periods Davis introduced into his pictures words or fragments of sentences which came mainly from labels and advertising posters and which, he said, had for him the same content of reality as the objects surrounding them.

A decade after the first appearance of the Duchamp group, something of the pristine Dada spirit recurred in the collages of ARTHUR G. DOVE (1880–1946), a protégé of Stieglitz, who had admitted him to a group exhibition

in 1910 and, two years later, arranged a one-man show for him. At the latter, Dove presented paintings that Stieglitz later defined as "symbolized nature," strong-colored landscapes composed of stylized flat shapes and rhythmic curves. The critic of the *New York Times* found them so abstract that he described them as "just plain pictures that mean nothing at all except that a certain combination of shapes and colors pleases the artist."

Cited in Frederick S. Wight, *Arthur G. Dove*, New York, Downtown Gallery, October, 1935

The fact is, Dove's approach involved capturing in paint impressions received from nature and bringing those impressions into relationship with one another. Contact with landscape was, in reality, so indispensable to him that in 1912 he bought a farm in Westport, Connecticut, where for the next six years he devoted himself to cultivating oysters and breeding chickens. Then, in 1920, he settled in a houseboat and for seven years cast anchor wherever it pleased him along the Long Island coast and the mouth of the Hudson River, taking shelter in winter in Huntington harbor. Sun and storm became the themes of his daily existence, themes to be transmuted into paint. Working in the narrow confines of his cabin, he was limited to small formats, and when he ran out of paints, he utilized whatever materials he had at hand. For landscapes he mounted sand, shells, reeds, and moss on boards; and in *Goin' Fishin'* of 1926 (Phillips Collection, Washington, D.C.) he equipped the fisherman with waterproofed cloth, fishing pole, and all the other paraphernalia required. To Dove, all these materials were "extractions of reality" and in no way abstract elements.

Frederick S. Wight, *Arthur G. Dove*, Los Angeles, 1958

To a number of pictures he also added printed matter and newspaper photographs, introducing an ironic and, at times, even poetic note. His *Grandmother* of 1925 (colorplate 26) incorporates the title page of a Bible Concordance overlaid with dried ferns and glued in front of a wall of weathered wooden shingles, while for background there is an old piece of flowered needlepoint. A collage of 1924 has a Woolworth's price tag pasted under an elegant bouquet made up partly of pressed leaves and grasses, partly of artificial cloth flowers. The following year he created *Miss Woolworth* in person, life-size, wearing gloves and socks from "the family firm." Here there is no mistaking the influence of earlier Dadaist collages such as Dove would have encountered in the Stieglitz circle, but even more of Picabia's later works in the medium.

Dove alternated between material pictures and straightforward collages, inventing for both techniques the most bizarre allegorical figures. *The Intellectual* is made up of a plank to which has been nailed an old scale for weighing fish, a piece of moss-covered bark, a bone in the shape of an amphora, and, as the head, a magnifying glass. *The Critic* (plate 141) is dressed in newspaper and has roller skates and a vacuum cleaner cut out of advertising illustrations, wears a top hat of cardboard, a blinder of dark velvet over his eyes, and a noose of twine around his neck. The most disconcerting transformations, though, were reserved for Dove's portraits of his friends and acquaintances. Their special traits and hobbies are depicted with the appropriate materials. Thus, Ralph Dusenberry, one of the seafarer's traveling companions, is depicted with a sharp bird profile sawed out of wood and installed in front of a painted American flag; below is pasted the music of his favorite song, and a folding ruler frames the entire picture. The portrait of Alfred Stieglitz, 1925, is completely abstract, consisting of a watch spring and some steel wool on a mirror.

In the collection of An American Place, New York. Reproduced in A.H. Barr, Jr., *Fantastic Art, Dada, Surrealism*, 3d ed., New York, 1946 (reprinted New York, 1968)

One cannot help recalling Miró's *Spanish Dancer* of 1926.

This collage and a dozen other works by Dove were included in a show of new and previously unexhibited works by young American artists that Stieglitz organized in 1925 in the Intimate Gallery, a small room in the Anderson Galleries' building. Dove's collages aroused lively critical reaction, ranging from furious rejection to admiring acceptance. Soon afterward he turned to a more sparing, more thoughtful use of his means of expression. In 1926 he composed a few pictures of harbors in simple abstract forms, introducing wood and sand into the painted areas. Yet in the same year he conceived one of the most abstruse of all collages, *Monkey Fur* (plate 143), on which the downy strands of monkey pelt, fastened to a ribbon, surround some pieces of metal so eaten away by rust as to evoke the impression of a half-decomposed face.

Another year along and Dove was drawing his inspiration for a series of pictures from the jazz music to which he was so devoted. Jazz tempi and rhythms were transposed into abstract linear compositions that have something in common with Kandinsky's early *Improvisations*. Here too, in a few instances, he continued to take advantage of material elements, for example, in *Gershwin's Rhapsody in Blue*, a spiral spring standing out from amidst a maze of lines. About this time Dove began to use metallic paints on an aluminum ground. To one of them, the *Hand-Sewing Machine*, he once again glued a bit of cloth. Soon thereafter he gave up collage entirely and returned to his characteristic landscape painting, which he pursued until his death in 1946.

Czechoslovakia

Hausmann, *Courrier Dada*, pp.83ff. and 112ff.

It was Raoul Hausmann who carried the first tidings of Dada from Berlin to Czechoslovakia, which happened to be the land of his forebears. A tour that he undertook with Baader and Huelsenbeck in February of 1920 led via Leipzig to Teplice-Šanov and then on to Prague, where, on March 1, a Dada soiree was held in the Produce Exchange. Baader having judged it more prudent to withdraw at the last moment, Hausmann and Huelsenbeck were left to supply the entire program on their own, and the evening ended in a violent riot. A second propaganda tour in September of 1921, this time with Hannah Höch and Schwitters as Hausmann's confederates, came off more peaceably and, in its organizer's opinion, with equal success. Nevertheless, Hausmann remained convinced that those events in Prague left only unpleasant memories, for, as he has stated, after his appearance there he lost all contact with the Czechs.

Named for a spring flower which also contains the numeral 9

Be that as it may, in the years following World War I Prague maintained sufficient links with the outside world to remain well informed about current European artistic trends. The Devětsil group, organized by the artistic and literary avant-garde in Prague in the fall of 1920, was especially attentive to what was going on in Paris. Its members included the writers and poets Nezval, Seifert, Hora, and Wolker, the painters Jindřich Štyrský, Toyen, and Josef Šima. Karel Teige played a leading role among them as art theorist and propagandist, contributing reports on literature, art, architecture, theater, and film in the Soviet Union and western Europe to the magazines *ReD* (the organ of the Devětsil group), *Disk*, *Pásmo*, and others. Special articles

Pásmo was issued by Cernic and Teige in Prague and Brno about 1922–25. *Disk*, edited by Krejcar,

about Dada appeared in *Pásmo*, which also published works and writings by Man Ray, Schwitters, Ribemont-Dessaignes, and so on.

Early in 1924 Teige launched a new movement, Poetism, in reaction against the doctrinaire Socialist-Communist tendencies that dominated the first years after World War I. It favored a more cheerful poetic approach to life and whatever independent and fantastic forms in art and literature might be appropriate to such an approach. The art form it especially sponsored was the "picture poem" in which text and image were complementary and, at the same time, intensified each other's effect. Many texts were set up in pictorial typographical form in the manner of Apollinaire, for whom Teige had a deep admiration. In the illustrations, seemingly unreconcilable objects were juxtaposed so as to develop between them "lyrical, electrical" tensions; "the more unexpected the union, the more potent the explosion set off by the spark of poetry." Examples published by various magazines in 1924 show that these were typical Dadaistic collages, to which the illustrations used lent their special poetic or eccentric note. In Teige's *L'Embarquement pour Cythère* the views of sailboats, steamships, and dock crane set before the viewers' eyes the pleasures of a sea voyage. In *How I Found Livingstone* (plate 136) by JINDŘICH ŠTYRSKÝ (1899–1942) and TOYEN (Marie Cerminova, b. 1902), a sealed letter with African stamps and a photograph of Negro children astride a giraffe are meant to signify the charms and mysteries of the Black Continent—on which the juxtaposed image of a choirboy kneeling in prayer seems to cast some doubt. Štyrský used the same approach in 1924 for a fantastic, brightly colored collage title page for Vítězslav Nezval's *Pantomime*.

In the summer of 1924 the friends agreed to send home from their travels "touristic picture poems," which, as Teige put it, should entice the recipients themselves to stray in unknown lands of legendary, exotic, and dreamlike landscapes. Picture postcards and pieces cut from land maps and charts of the heavens reflected the zones where each of them spent his holiday. Thus, on his *Greetings from Abroad* Teige glued the sealed envelope of a letter to Seifert, along with the reproduction of a field glass; and Štyrský's *Souvenirs* has a photograph of a beach full of bathing beauties. GEORGE VOSKOVEC (b. 1905), at that time an actor and stage-manager at the Prague Osvobozdené Divadlo, the "Liberated Theater," which took its name from that of Tairov in Moscow, sent from Tunis the most amusing collage of all, *Siphons of the Colonial Siesta* (plate 137), with flags, awnings, a tram ticket, a thermometer scale on which can be read the rising temperature, and other appurtenances of the scene; in an empty space at the bottom is written "Sahara or the Great Desert." Certain elements such as the siphon and newspaper heading recall the Cubist papiers collés, with which Voskovec was acquainted.

In a letter of March 27, 1961, Voskovec has supplied interesting information concerning his artistic evolution and the Prague movement. At seventeen, as a student at a college in Dijon, where he had been sent to learn French, he produced his first letter poem, arranged calligraphically on white paper and framed with lines and colors. The stimulus for this came, on the one hand, from Marinetti's *Mots en liberté*, with their unfettered typography, and from Apollinaire's *Calligrammes*, and, on the other hand, from examples of American advertising, whose challengingly brilliant colors and eye-catching lettering filled him with enthusiasm. In one of those poetical works,

Teige, and Seifert in Prague, never went beyond two numbers, one in 1923, the other in 1925. In 1922 *Devětsil* and *Život II* made their first appearance. Finally, between 1927 and 1931 there were three full volumes of *ReD* (*Revue Devětsilu*).

Štyrský is said to have shown at the Modern Art Bazaar organized by the Devětsil group in 1923.

The "touristic picture poems" mentioned, plus a few others by Teige and Nezval, were reproduced in *Disk*, no. 2, 1925.

Eva Petrová mentions in an article, "Umění Objektu" (with French summary "L'Art de l'objet"), *Výtvarne Umění*, 1966, no. 6–7, other objects that were displayed in the 1920s at exhibitions of the Devětsil group—ball chains, a wax mannequin, the plaster cast of a dancer's leg—which were obviously Dada in character.

written partly in Futurist style, partly in imitation of Walt Whitman, he used an American inscription, which he copied from the label on a can of Libby's condensed milk without understanding a word of it, having chosen it only because its printing struck him as so highly effective.

Voskovec's poems brought him into contact with the Devětsil group in Prague, which accepted him as their youngest member. For a while he led the Dadaist faction but was expelled when he took a part in a sentimental box-office film, though he himself thought of the job as just one more Dadaistic prank.

One of Voskovec's picture poems illustrates the title *Have You Ever Seen the Sea from the Platform of the Street Car?*; and another, *Bonne nuit*, contains reminiscences of Paris and shows a girl in bed, maps on the wall, and the Eiffel Tower in the open background. Voskovec carried out about a dozen such works in Dadaistic spirit, with and without texts. As he recalls, the last was a three-dimensional object titled *Fatamorgana*, a glass case on the floor of which, strewn with coarse sand, was glued a reproduction of a toy warship, while above it, suspended from wires, floated a cigar.

The architect ANTONÍN HEYTHUM (b. 1901) also contrived collages and montages, pasting Paris Métro tickets and castoffs of daily life into compositions of Dadaist character. For the magazine *Pásmo* he designed a title page on which cutout photographs and abstract shapes were combined into a Constructivist composition, and, in addition, he used photomontage in the posters he made for the Liberated Theater. Heythum eventually emigrated to the United States.

The painter REMO (pseudonym of Jiří Jelínek, 1901–1941) collaborated with the Devětsil group and produced *Poèmes photographiques*, texts surrounded with photographs cut into bits; but of him and others we know only what was published or described in the magazines mentioned. Remo began as a Cubist, then went over to a more generalized abstraction, and finally, in 1938, turned to realistic social themes. In mid-career he was killed in Mauthausen concentration camp and today is scarcely remembered by anyone in Czechoslovakia.

A character in Cocteau's play *Orphée*, which opened on January 17, 1923, at the Théâtre des Arts in Paris.

About 1925 Štyrský introduced collage into a few oil paintings. In *Sachova Karsina*, along with the views of landscapes which correspond to the spirit of Poetism, there are also pieces of wallpaper inserted into the rigorous composition; and these, like the painted chessboard patterns, go back to the Cubists' papiers collés. Wallpaper and lace are pasted into *L'Ange Heurtebise*, which he did in Paris in 1926. At about the same time, Štyrský's companion, Toyen, was painting in a naive style imitated from collage. In her *Three Wise Men Out of the East* of 1925, the crown of one king appears to be cut out of newspaper, as do his shallow little basket and the tiny figures marching up from the lower margin of the picture, but they are all only tricks of the brush designed to simulate cutout and pasted paper.

When Štyrský and Toyen moved to Paris in 1925 for a few years, they came under the influence of Surrealism, and upon their return to Prague in 1928–29 they carried the tidings of that new movement.

VII Surrealism

Paris—The Surrealist "Object"—Germany, Czechoslovakia, Denmark, England, the Americas

Paris

> Everything leads us to believe that there is a certain state of mind from
> which life and death, the real and the imaginary, past and future, the
> communicable and the incommunicable, height and depth are no longer
> perceived as contradictory.
>
> André Breton, *Second Manifeste du Surréalisme*, Paris, 1929

With Surrealism came a new interest in collage. André Breton counted
Braque and Picasso among the great progenitors of Surrealism because of
the papiers collés with which, as he saw it, they had opened up new sources
of "unreal reality" for art. On the subject of Braque he waxed downright
poetic: "It is because of him that the unvarying wallpaper pattern that covers
the walls of our rooms has become for us today a tuft of grass on the slope of
an abyss. Without that wallpaper the walls would have disappeared long ago,
and we love those walls, we strive and struggle to love those walls.... It
avails us nothing to reckon constantly with our earthly end, we cannot go
further in disregarding all reality than Braque did when he became a party
to this ultimate flowery lie."

Breton's unreserved admiration, however, was lavished above all on
Picasso, whom the Surrealists claimed as their own, though he never offi-
cially declared himself one of them. From its first issue, in December, 1924,
the magazine *La Révolution Surréaliste* (cf. figure 30) never ceased to repro-
duce works by Picasso, from early Cubist pictures such as the *Demoiselles
d'Avignon* up to his most recent productions, and from one of his earliest
"musical instruments" assembled out of wood, wire, and cardboard (plate
12) up to a version of the *Guitar* of 1926, consisting of no more than an old
dishcloth with a hook in the middle fastening it to the canvas, through which
a bent rod was thrust. In the better-known version the rag is strung with cords,
and alongside it is glued a strip of newspaper smeared with paint. About the
same time Picasso varied this theme in a number of relief pictures. In the
middle of one, dated May, 1926, under the vertically stretched twine, there
is a button sewed to a piece of cloth. Another example (plate 144) is rather
more poetic: a withered, crumbling leaf and a piece of greenish tulle, from
which the "strings" of the instrument descend, are integrated into a pencil
drawing of circular forms linking the various elements of the composition.

Among its spiritual fathers *La Révolution Surréaliste* laid claim also to
Giorgio de Chirico and Paul Klee, and on the basis of their latest works it
also welcomed to the Surrealist ranks the old Dadaists Man Ray and Max
Ernst. From 1926 on, Arp too received this signal honor because of his recent

At the auction of pictures owned
by Kahnweiler in 1921, Breton,
Aragon, and Éluard took advantage
of the ridiculously low prices to
acquire a number of papiers collés
by Braque and Picasso.

André Breton, *Le Surréalisme et la
peinture*, Paris, 1928 (revised,
corrected, and amplified edition,
Paris, 1966)

Figure 30. Title page of *La Révolu-
tion Surréaliste*, no. 5, Paris, 1925

painted reliefs such as *Mountain, Navel, Anchor, Table,* and *Paolo and Francesca,* in which he united into meaningful combinations his basic shapes, such as the bottle, fork, clock, and boot. During 1924 he also treated in paper collage a number of such subjects, including the *Clock;* and to a pasted *Head* of 1926 he added a thick, three-dimensional tongue. In the book *Kunstismen,* which he and El Lissitzky brought out in 1925, he also published a Dadaistic photomontage, the *Glove,* in which there is a photograph of Arp himself, with an immense cardboard glove for a head and its mate on one finger.

The fact that, at the outset, the Surrealists did not produce art has an explanation: the proposal to mobilize the creative powers of the subconscious and leave it to them to evolve the new forms of expression was easier to realize in literature than in the various visual arts. The *écriture automatique*—spontaneous, uncontrolled writing of chains of free associations of thoughts and images—could not be directly adopted by the artists. At the spiritualist séances conducted by Breton, the attempt was made to place the participants in a hypnotic state in which they would execute pictures and drawings. However, it turned out that the most gifted of the mediums was the poet Robert Desnos, who, under trance, produced naive pictures in which objects and words appeared in arbitrary juxtapositions. In 1924 or 1925 he painted in that manner *Breton's Death,* a nocturnal landscape with a skyscraper, a palace, and the Eiffel Tower in the background as emblems of New York, Barcelona, and Paris; the open space was filled with playing cards, a ladder, and a table with a compass whose needle pointed to "North" and "Poetry." In the isolation of its elements the painting had much in common with the principle of collage.

At first, under the literary influence of the Surrealists, Max Ernst created a few picture poems with poetic texts: in 1923 *In a City Full of Mysteries and Poems* (Collection J. B. Urvater, Brussels) and the next year *Who Is the Great Invalid?* (Collection Mr. and Mrs. Man Ray, Paris). In these the texts are distributed across the entire surface of the picture, interpenetrating and dominating the painting. However, in 1925 Ernst found his own method of allowing forces independent of conscious formal organization to intervene in the artistic conception. This was *frottage,* a procedure in which he covered all sorts of objects with thin paper and then rubbed over them with soft pencil, transferring to the paper accidental contours which he could then convert into drawings and complete on the basis of what they suggested to him. The consequence was a new period of "passive–active" productivity which permitted him "to be present as a spectator at the birth of his works."

Only ANDRÉ MASSON (b. 1896) attempted during 1924–25 to realize in drawings an equivalent for the highly touted "automatic writing," setting down on paper an abstract whirl of lines which anticipated the Informal painting of Pollock, Tobey, and their followers. Nevertheless, within his dramatic lines there soon appeared suggestions of those fish, birds, horses' heads, and fruits that Masson associated with the four elements. These were succeeded by mythological "battles of animals," compositions full of dynamic tension in which he was able to express the heightened intensity of life that arises out of the proximity of death. After that, he began to disentangle the tortuous contours again, and the individual forms became more clearly apparent and took on symbolic meaning. Head, beak, wing, fin were enough now to characterize the different species of animals.

Reproduced in the exhibition catalogue, *Arp,* Milan, Galleria Schwarz, 1965

Reproduced in L. Aragon, *La Peinture au défi*

The procedure was used for the drawings of the *Histoire naturelle,* which was published in 1926 by the Galerie Jeanne Bucher, Paris, with a foreword by Arp.

In 1927 Masson took to gluing delicately colored feathers into these drawings in an attempt to render the quivering motion of bird flight (plate 150). In *Animal Heads*, along with the feather there is also a painted red cherry, intended to signify that the bird is eating a cherry. Other feathers fly around the head of a horse and, simultaneously, convey the image of the tracks left in the sand by the onrushing horse. From 1928 on, in order to make the forces of the earth visible in the most insignificant and most changeable of their components, Masson began to introduce real sand into many of his pictures and to dissolve specks of red paint in the sand like drops of blood.

Sand paintings by Masson are reproduced in Rubin, pls. 149–151, colorplate XXII.

For his collages Masson used only materials taken directly from nature, because for him they alone possessed a living radiation. In the later 1930s he scoured the Mediterranean beaches for objects suitable for new compositions. Thus, in 1937 he depicted the *Bottom of the Sea*, covered with waves of sand flowing around shells and frayed algae. Out of pebbles, seaweed, shells, ropes, and fishbones he assembled demoniac creatures such as *Grande Dame*, *Caryatid*, and *Ludion* (plate 146).

In the relief pictures of similar character that Masson composed in America during World War II, he more often had recourse to brush and paints to complete the shapes and forms he discovered pre-existent in his natural materials. The *Souvenir de Long Island* of 1944 has drawn lines making a dancing hobgoblin whose face is a fragment of glass, whose vertebral column belonged originally to a fish, and whose hands are tiny snail shells. Two flat stones framed in paint make a *Torso with Stars* surrounded by the most bizarre trophies snatched from the sea: a starfish of blue glass, a petrified sponge bedded in gravel, and a star coral from the island of Martinique, where Masson spent the first year of the war.

Along with these material pictures, upon arriving in New York in 1941, Masson produced a collage in more traditional technique, *The Street Singer* (plate 148). This is a pastel drawing of a female figure with collage additions including a page of music from an old *chanson* that Masson had found in the garret of his house, a red-tinged maple leaf, and four transparent wings of a grasshopper which form the singer's open mouth. In the poetry of this picture one senses Masson's special relationship to collage. It attracts him, he says, as the medium in which one can reproduce an emotional content most directly and in which the mood that emanates from the materials is conveyed effectively from the artist to the viewer.

Michel Leiris and Georges Limbourg, *André Masson and His Universe*, London, 1947

JOAN MIRÓ (b. 1893) has had a rather more fundamental concern with collage and montage, because they play a certain role in the relationship between content and form, between reality and abstraction, which has been his constant preoccupation. He has utilized those techniques at the most diverse periods, not so much in response to general trends and movements in art as to the specific problems that he was grappling with at those times. Miró has always maintained an energetic independence from all dominant trends, and when he does open himself to outside influences, often they do not come to fruition in his painting until long afterward.

Jacques Dupin, *Miró*, New York, 1962, contains an extensively illustrated catalogue raisonné.

Between 1915 and 1917 Miró faced up to the quite separate problems raised by Cézanne, Van Gogh, and the Fauves. Then, in 1917, he had his first contact with Dada, when Picabia went to Barcelona and published the

magazine *391* there. However, what interested Miró more at that time was Cubism, which he had come to know through the innumerable publications that, the war notwithstanding, continued to pour into Spain. It is obvious that he was struck most by the real printed matter, newspapers, and labels that the Cubists put into their pictures. In *La Publicidad and the Vase of Flowers* of 1916–17 (Collection Mr. and Mrs. J. W. Alsdorf, Winnetka, Ill.) he pasted in a piece of newspaper which immediately catches the eye within the lively patterning of the carpet background of the still life. Even more startling is the *Portrait of E.C. Ricart* of 1917 (Collection Mr. and Mrs. Samuel A. Marx, Chicago), where, behind the likeness of the painter with whom Miró shared a studio in Barcelona, there is a disproportionately large Japanese woodcut setting up a certain confusion within the clear relationship between figure and space on which the composition is based. The woodcut's deftly sketched and concentrated forms are in sharp contrast with the hard stripes of the sitter's jacket painted in the raw colors Miró had borrowed from the Fauves. In the still life *Nord-Sud* (Galerie Maeght, Paris) the title of the magazine edited by Reverdy is painted in alongside a similarly painted volume of Goethe; but in 1918, in the *Still Life with Coffee Grinder* (Galerie Maeght, Paris), Miró followed the example of the Cubists' papiers collés and pasted on it the advertisement of a New York picture postcard company. Thereafter, however, he avoided collage, and in the *Spanish Card Game* (Collection Mr. and Mrs. John Cowles, Minneapolis) the old playing cards are rendered in paint. Painted pieces of newspaper are found in a number of other pictures, seeming entirely appropriate in the *Table with Glove* of 1921, but unexpected in the *Peasant Farmstead* of 1921–22 (Collection Mrs. Ernest Hemingway, New York), a depiction of Spanish country life rendered like a sheet of paper cutouts, in which the French newspaper *L'Intransigeant* seen lying on the ground next to the sprinkling can really has nothing to do with the subject.

It was in 1919 that Miró went to Paris for the first time and looked up Picasso, who welcomed his countryman cordially. During a second visit in the course of the winter, he met Reverdy and Tzara, who persuaded him to take part in the Dada Festival at the Salle Gaveau in May of 1920. At the end of that year he settled in a studio in Rue Blomet, where his neighbor was Masson. A close friendship grew up between the two painters, which left visible traces in the painting of the Frenchman. Through Masson, Miró came into contact with the poets and writers who would later form the Surrealist group, and he took part in their gatherings, though without calling attention to himself. After meeting Breton, Aragon, and Éluard, he joined their group in 1924 and the following year exhibited with them for the first time at the Galerie Pierre (cf. figure 31).

In the paintings and drawings of that year Miró found his own style of expression, akin to that of the Surrealists only to the extent that he too withdrew from reality into a mystical world of dreams. There, living creatures and inanimate things became mere patterns and signs suspended between heaven and earth, as if brought together and separated by forces of attraction and repulsion. Between them appear all sorts of hermetic inscriptions, along with others that introduce notes of reality into their unreal surroundings. Words explain certain objects that are only hinted at in the painting; numerals assert precise values in spheres where everything is beyond reckoning. In

Figure 31. Invitation to the Surrealist exhibition in the Galerie Pierre, Paris, 1925

Colorplate 28. Max Ernst. *The Postman Horse.* 1932

the painting *The Gentleman*, of 1924, the single word "yes" makes it clear that the schematically sketched figure is meant to be an Englishman, and the Roman numerals XII tell the hour that the huge-footed man sets off on his way. In the watercolor drawing of *The Writer* (Collection Pierre Janlet, Brussels), the word "*encre*" is written near the ink bottle, and there are two postage stamps pasted in the upper right corner. At the same place in another picture of 1924 (Collection Mme. Simone Collinet, Paris) Miró inserted a cutout leaf.

Rubin, p. 169

By introducing labels such as *The Smile of My Blonde Girl* or *This Is the Color of My Dreams*, Miró transformed other abstract representations into colored picture poems. In one work of this sort done in 1926, *A Bird Pursues a Bee...* (private collection, New York), the word "*poursuit*" executes an appropriate curve and tiny feathers are glued above the bird, just as Masson was to do in his drawings of the following year.

In 1927 Miró came into contact with Max Ernst and Arp. Arp's world of embryonic forms so matched his that many works by the two artists from about this time are astonishingly similar. Most probably Miró's dealings with the two Dadaists awakened related tendencies already latent in his own mentality. An anti-painting mood that suddenly drove out all dreamlike visions led, in 1928, to the material pictures of *Spanish Dancers*, in which an ironic Dadaistic spirit comes to the fore. In the first version (plate 152) the figure of the dancer is composed of a piece of sandpaper, a large nail hanging from a length of twine, and a mechanical-drawing triangle. A string coiling around the figure represents the movement of the dance, which likewise is suggested by the scraps of crumpled paper near the head and by a tuft of hair flying away from it. In another version, a doll's shoe—meant to stand for a delicate ballet slipper—dangles from a long string tied to a nail hammered into an empty white area. In the final work of the series, a hatpin and a small feather stuck on a white ground suffice to represent the dancer's straight-backed posture and soaring agility. The blend of formal rigor and humor, of objectivity and symbolic significance that one finds in Miró's other pictures contributes here to a light-hearted poetry.

Dupin, catalogue, pls. 243–247

After these material pictures, while spending the summer of 1929 in Montroig, where he regularly went each year for a few months' work, Miró executed a series of collages true and proper. Underlying them were systematic studies concerned with the relationship between line and plane and between plane and space, as well as with the specific color and textural values inherent in the straw matting and coarse papers he used. Miró cut his papers deliberately into irregular rectangular, round, and oval shapes and pasted some of them so that their edges stood away from the ground, casting shadows which intensify the effect of relief.

Dupin, catalogue, pls. 248–259

In all the collages dated "summer, 1929," the pasted papers make up the ground plan of compositions which owe their form to the distribution of color areas in space. Miró outlined them with slender line drawings in flowing contours from which emerge heads and female figures, hobgoblins and fabulous beasts, cocks and web-footed fowl. Out of a female figure grows something almost like a dancing elephant in one collage (Collection M.P. Bruguière, Issy-les-Moulineaux). A composition of four circular shapes glued one above the other has a small chair drawn on it in perspective foreshortening, and this is enough to convey the notion of space within the

flat surface planes. Yet another has flying hats or parachutes rising into the sky (plate 149), and in another a torn sheet of music surrounded by bright scraps of paper appears in the tail of a comet (plate 151). From 1930 on, Miró utilized other kinds of printed matter also. Piled-up airmail stickers proclaim "*Par Avion*" as they lead mythical creatures into the dark ether (formerly Collection A. Lefèvre, Paris), and pasted on a somewhat later collage dating from 1934 (Collection Georges Hugnet, Paris) is a Spanish newspaper with a photo of a movie star.

There was a phase, in 1929, when Miró utilized printed reproductions of pictures—specifically a portrait by Constable and Raphael's *La Fornarina*—as the point of departure for pictorial composition, not in the form of collage but as prototypes for "imaginary portraits." However, the most astounding metamorphosis was that of a Diesel motor from an advertisement of the Junkers Works which, in a series of sketches, became *Queen Louise of Prussia.*

Dupin, catalogue, pls. 239–242

Miró worked out a number of new pictorial themes in 1933 with the aid of collages from cutout illustrations of machines and tools. He explained later that he accumulated these clippings day after day and used them as the points of departure for many pictures during that period. He did not copy them but, instead, allowed them only to suggest shapes. From those collages came, between March and June of 1933, eighteen large canvases of a fantastic world of forms bearing no reflection of the spirit of engineering illustrations. On the other hand, they are quite certainly indebted to the cut and pasted sketches for their spatial articulation, for clarification of their color and formal values, and for the diversity of their pictorial elements.

J.J. Sweeney, "Miró," *Art News Annual*, New York, 1954, pp. 185–186
Miró says that with the same aim he collected mountains of torn posters, intending to utilize them in collages, but he never got around to doing so.

When Miró was invited to join the Abstraction-Création group in 1932, he refused indignantly: "As if the signs that I set down on canvas do not originate in a concrete conception from the moment they are born in my head, nor correspond to a profound reality, nor belong to the world of real things!"

During that year Miró also produced a series of collages in which such "found" images were no longer transformed but, instead, incorporated just as they were into the compositions to make up a gaily colored anthology of picture postcards in blue or sepia—family snapshots, sentimental and coquettish pictures of girls, brightly colored old-fashioned images from sheets of pictures and paper dolls of the beginning of this century, plus cutout hats and stars and butterflies and what have you. He distributed these across the picture surface and then, in his usual way, drew lines around them to make new figures (colorplate 27). Zervos, who watched Miró work at these pictures in his studio, reports that he simply pasted in any image whatsoever and then drew around it the form it evoked in his fancy. That new form in turn demanded to be completed pictorially, and so on with each new addition until the picture as a whole had been given the most intensive poetic expression. Not only do the ghostlike, alarming creatures that flowed from his pen contrast with the harmless illustrations of the collage elements, but in putting them together Miró further intensified the effect of alienation, of mutual estrangement. He juxtaposed phantoms and worms with a postcard view of cows that safely graze; to the arm of a modishly attired woman he attached a macabre skeleton's hand, and so forth. The displacement of natural proportions and the intersection of the real and the unreal lead to images in which the lurking mystery and ambiguity of Surrealism are expressed in a playful form. Collage proves to be the ideal medium for such content.

C. Zervos, "L'Oeuvre de Joan Miró de 1917 à 1933," *Cahiers d'Art*, 1934

Dupin, catalogue, pls. 352–364

By 1934 Miró was ready to undertake new experiments in collage, this time of a more objective character. He painted black outlines and silhouettes on coarse-grained sandpaper, inserting between them cutout pieces of white

The best-known of these is in the Philadelphia Museum of Art, A.E. Gallatin Collection.

paper on which he carried further and completed in line drawing the forms suggested by his painted outlines. On one occasion he used as ground a crumpled piece of aluminum foil to provide a mysterious background for the bright and dark figures (Galerie Le Point Cardinal, Paris).

Along with collages, though, Miró continued his interest in using various materials. In 1931 he worked on a number of "painting objects," using natural items such as shells, cork, and bones or, instead, wire netting, sheets of metal, rings, disassembled clockworks, and the like. He mounted these on boards and connected them one to the other by lines and shapes which gave them meaning. Once he painted an old window shutter with its iron hinges (Collection William N. Copley, Paris), nailed on it a smaller oil painting garnished with bits of string and other findings, and stuck a large feather alongside it. In other pictures he affixed more massive objects: a lock, a bell, or a heavy chain, the last binding to earth the ephemeral fabulous creatures in *Man and Woman* (Collection A. Breton, Paris).

After intervening phases devoted to various collage series, in 1935 Miró began to paint dramatic works in which maliciously grimacing faces pop up here and there within the gloomy coloring. Two of them, both titled *Rope and Figures*, have thick coiled ropes nailed into them, vertically in one, diagonally in the other. Though Miró's biographer Dupin sees in them "helpers of mankind," whose services are especially propitious in the life of the peasant, one is rather more inclined to sense in them some secret menace. There is a wholly tragic character in the *Two Persons* (Collection Jacques Gelman, Lomas, Mexico), on which nails and ropes are stuck into one of the bodies. Unlike these is a material picture of 1936, a plywood panel strung crosswise with string and including Dadaist paraphernalia such as a matchbox and a photograph of a nude female.

From time to time in the ensuing years Miró adopted unexpected materials. Thus, in 1937 he glued matchsticks to his *Romantic Catalan Peasants*, and the next year he embroidered a perforated cardboard with red yarn to make a starry constellation above an uncanny scene.

From the close of the 1930s Miró's interest has been virtually concentrated on painting and drawing, plus, in the last decade, ceramics. Nevertheless, even in the later period he continued with collage from time to time in his graphic works. Thus, his sketches for the lithographs on the covers of two de luxe publications, Tristan Tzara's *Parler seul* (Paris, Éditions Maeght, 1948–50) and André Frenaud's *Noël au chemin de fer* (Paris, Éditions PAB, 1959), were in collage. Similarly, among the colored woodcuts for Paul Éluard's *À toute épreuve* (Geneva, 1958), a few plates contain collage elements, for the most part colored and frayed papers, though for the double-page illustration of the poem "*Confection de bon amour*" there is also an old-fashioned, romantic print of a pirate. Two hundred sheets were used in the printing process to attain the multiple stratification in which Miró's cryptic message finds its full resonance.

The Surrealists acquired a new meeting place in 1924, the house in Rue du Château that Marcel Duhamel shared with Jacques Prévert and Yves Tanguy. Prévert and Tanguy had become acquainted in 1920, while doing their military service in Lunéville, and two years later they met again in Paris. At the outset their interest tended to modern literature more than art. In Rue du

Reproduced in H. Janis and R. Blesh, *Collage*, Philadelphia, 1962, p. 142

Museum of Modern Art, New York, and Collection Mr. and Mrs. Morton G. Neumann, Chicago

Dupin, catalogue, pl. 443

The woodcuts were executed by Jacques Frélaud in the Atelier Lacourière in Paris.
Exhibition catalogue, *Miro*, London, Tate Gallery, 1964.

Château YVES TANGUY (1900–1955), who had previously produced only drawings, experimented with small oil paintings, in which, in "primitive" or "naive" fashion, he reproduced whatever he happened to notice in the street. A casual incident soon turned his efforts toward a more positive direction. One day in 1923, from the rear platform of a Paris bus, he caught a glimpse of a picture by De Chirico in the window of the Galerie Paul Guillaume and was so struck by it that he jumped off to look at it close up. The consequences are obvious in one of his oil paintings, *La Rue de la Santé*, where an empty street leads off into a far distance.

Reproduced in Marcel Jean, *The History of Surrealist Painting*, New York, 1960, reprinted 1967, p. 162

Soon Tanguy began to render occasional themes in real materials rather than in paint. Real wires stretch across the *Rue Gibbs*; cotton-wool steam pours out of the chimneys of his *Ship*, large as life and set naively dead center in the picture. Steps made of matchsticks occur in the *Lighthouse* (private collection, Paris), a cardboard cutout pasted on the water with a little boat folded from a sheet of paper as children do.

After 1925, when Breton and his friends frequented the house in Rue du Château, Tanguy's style slowly but definitely began to veer toward Surrealism. What had once been scattered and isolated elements in his pictures now began to coalesce, as if some magic fluid were binding them together. In the collage *Fantomas* (plate 154)—which looks as if it could have been put together under trance during one of the famous spiritualist séances—simmering colors make a dense ground around the figures, material or disembodied, which are separated by folding screens, blank or figured, sometimes with patterns such as a square with floral ornaments that could easily be mistaken for collage. Despite appearances, however, in only one area of the picture are there cutout shapes of cardboard, and these rise from the picture plane in sculptural fashion, while the collage additions are limited to a glued-on mustache and a stiff collar.

In another set of pictures from 1926 Tanguy filled broad landscapes with milky mists of color in which contours are effaced and grasses and bushes unravel fuzzily. Geometric bodies rise like signals in the midst of these canvases, and in uncanny fashion tiny human figures and animals pop up here and there or shoot through the air. Almost every picture has some small details pasted in, though they are scarcely distinguishable from what is painted. An Indian-like personage looms up out of the water in the background of *Je suis venu comme j'avais promis, Adieu (I Came as I Had Promised, Farewell)* (plate 153). In *Fear* a black arrow plummets down on a desert landscape in which a riderless horse and a fleeing man are drawn in. *Genesis* (Collection Mme. Hélène Anavie, Pauillac, France) has an open hand emerging from behind a tall bush. Given the unreal atmosphere of these pictures, such "real" components reinforce the impression of enigmatic happenings and interconnections.

Jean, colorplate p. 166

As early as 1927 collage again disappeared from Tanguy's works, though it was then that words, letters, and numerals began to play a greater role. One of the characteristic pictures of this period, *He Did What He Wanted* (Collection Richard S. Zeisler, New York), has letters in various sizes and styles scattered across the base of an inverted, seven-sided cone, and the mystery is deepened by a small fir tree with numbered branches.

James Thrall Soby, *Yves Tanguy*, New York, Museum of Modern Art, 1955; Rubin, pl. 172

Miró's influence can be traced in Tanguy's entire pictorial conception, and the Catalan artist's compositions, shot through with words and letters,

Kay Sage Tanguy, ed., *Yves Tanguy: A Summary of His Works*, New York, Pierre Matisse, 1963.

may well have provided the stimulus for Tanguy's use of letter elements. On the other hand that element may go back to the posters, shop signs, and handbills that, according to Marcel Jean, the denizens of Rue du Château carried home from their nightly expeditions for booty with which to paper their walls. In any case, they were acquainted with the amateur collages of the nineteenth century. The issue of June 1, 1926, of *La Révolution Surréaliste*, which published for the first time a drawing by Tanguy, also included a photograph of an old-fashioned folding screen pasted all over with small Baroque genre pictures, sentimental chromolithographs, flowers, butterflies, and a general hodgepodge of images. The title page of the following number (figure 32) had a profile head with its cranium decorated in like manner with completely unrelated little pictures, and it could very well have been designed in Rue du Château. Certainly Jacques Prévert—who has since become one of the most inventive and productive practitioners of montage—had already at that time resorted to scissors and the paste pot, even if he now insists that he did absolutely nothing in the way of literature and art during those years because he, like all the others, had been left by their host and "protector" Duhamel to fend for himself for his daily bread. In any case, he seems not to have preserved anything he may have done in that period.

It was the habitués of Rue du Château who, in 1925, invented the *cadavre exquis* (exquisite corpse) game which was to play such a great role in the Surrealist movement (plates 155, 157, figure 33). This was a variation of the familiar children's game in which each participant writes the subject of a sentence on a slip of paper, then conceals what he has written by folding it

At the exhibition *Le Surréalisme: Sources, histoire, affinités*, Paris, Galerie Charpentier, 1964, there were five leaves of a folding screen owned by Tanguy with documentary pictures up to 1939

About 1930 Valentine Hugo received as a gift from Princess Jean-Luis de Fancigny-Lucinge one of her scrap screens brightly decorated in the same style.

N° 8 — Deuxieme année 1 Décembre 1926

LA RÉVOLUTION SURRÉALISTE

CE QUI MANQUE C'EST LA

A TOUS DIALECTIQUE

CES MESSIEURS (ENGELS)

SOMMAIRE
Revue de la Presse : P. Eluard et B. Péret.
TEXTES SURRÉALISTES :
Pierre Unik, Cl.-A. Puget.
Moi, l'abeille j'étais chevelure : Louis Aragon
D. A. F. de Sade, écrivain fantastique et
révolutionnaire : P. Eluard.
POÈMES
Max Morise, André Breton, Benjamin Péret,
Michel Leiris.
Dzerjinski, président de la Tchéka :
Pierre de Massot.
Lettre à la voyante : Antonin Artaud.
Opération : règle d'étroit : Pierre Brasseur.
Les dessous d'une vie ou la pyramide
humaine : Paul Eluard.
Confession d'un enfant du siecle :
Robert Desnos.
L'ccello le puil : Antonin Artaud.
CHRONIQUES :
La saison des bains de ciel : G. Ribemont-
Dessaignes.
Correspondance : Marcel Noll, E. Gengenbach.
Légitime défense : André Breton.
ILLUSTRATIONS :
Max Ernst, Georges Malkine, André Masson, Joan
Miro, Man Ray, Yves Tanguy, Paolo Uccello.

ADMINISTRATION : 16, Rue Jacques-Callot, PARIS (VIᵉ)

ABONNEMENT,
les 12 Numéros :
France : 55 francs
Étranger : 100 francs
Dépositaire général : Librairie GALLIMARD
15, Boulevard Raspail, 15
PARIS (VII)
LE NUMÉRO :
France : 5 francs
Étranger : 7 francs

Figure 32. Title page of *La Révolution Surréaliste*, no. 8, Paris, 1926

Figure 33. Yves Tanguy, Man Ray, Max Morise, and Joan Miró. *Cadavre exquis*. c. 1926. Drawing

over, and passes it on to the next player for the predicate, and so on. The first complete sentence arrived at by this method in Rue du Château was "*Le cadavre exquis boira le vin nouveau*" (the exquisite corpse will drink the new wine), whence the name that has stuck to it. The procedure was soon extended to drawing, resulting in satisfactorily grotesque figures. Besides Breton, Prévert, and Tanguy, the game was played by Benjamin Péret, Paul Naville, and other friends, and new teams were constantly being formed. In 1930 there were Breton, Valentine Hugo, Tristan Tzara, and Greta Knutson. At another time a series of successful works came from the pens of the team of Arp, Sophie Taeuber, Raoul Hausmann, Marcel Jean, and Oscar Dominguez.

A number of examples were published in *La Révolution Surréaliste*, October, 1927. See Rubin, p. 278 and pl. 288.

When SALVADOR DALI (b. 1904) joined the group in Paris in 1928–29, he brought new blood to the Surrealist movement, which was not able to boast of many genuine painters. In his autobiography Dali tells amusing stories of his own progress from one adventure to another, and among the many anecdotes one depicts his first experiments with collage.

As Dali tells it, he began to paint as a very young schoolboy, and one day it occurred to him that one could simulate sources of light. At first he piled up his paint so massively that it really did cast shadows. Still, the effect was not really what he wanted, and to increase the impression of relief even more he began to glue in stones and to paint them in glowing colors. In his own words: "One of the most successful paintings of this kind was a large sunset with scarlet clouds. The sky was filled with stones of every dimension, some of them as large as an apple! This painting was hung for a time in my parents' dining room, and I remember that during the peaceful family gatherings after the evening meal we would sometimes be startled by the sound of something dropping on the mosaic. My mother would stop sewing for a moment and listen, but my father would always reassure her with the words, 'It's nothing—it's just another stone that's dropped from our child's sky!' Being too heavy and the coat of paint too thin to keep them attached to the canvas, which eventually would crack, these stones which served as kernels to large pieces of clouds illuminated by the setting sun would come tumbling down on the tiled floor with a loud noise. With a worried look, my father would add, 'The ideas are good, but who would ever buy a painting which would eventually disappear while their house got cluttered up with stones?'" Dire predictions notwithstanding, the young Dali did have a certain success in the art exhibitions of his native Figueras with these works from what his parents dubbed his "Stone Age."

The Secret Life of Salvador Dali, New York, 1942, p. 150

From a visit to Paris in 1920 Dali's parents brought him the catalogue of a Futurist show, and soon he discovered from magazines that he chanced on the existence of the French Cubists and Italian Metaphysical painters such as De Chirico and Carrà. Before long he found himself having to defend these modern art movements when, between 1921 and 1924, he attended the Academy of Fine Arts in Madrid, whose professors had by then gone about as far as Impressionism. On one occasion, when he took into the studio a monograph on Braque, it excited the interest of the other students but infuriated their professors. Unintimidated, the young radical began to try his hand at Cubistic compositions and in 1923 also produced a collage drawing (plate 164)—a still life with bottle, jug, fish on a plate, and guitar, into which he pasted scraps of Spanish and French newspapers. The very

Dali, Paris, Éditions Le Soleil Noir, 1968, to which Max Gérard has kindly called my attention

conspicuous bit of chessboard reveals the influence of Juan Gris, whom Dali admired very much and whom he imitated also in a *Harlequin* of 1925, in which various materials such as cardboard, folded paper, and the like were imitated by the brush. A year later he used gouache for a *Self-Portrait* (private collection) but, in Cubist manner, pasted into it newspaper clippings and strips of packing materials. The face takes form in the midst of narrow fragmented shapes rising straight up like the buttresses of a cathedral, themselves an expression of the "mystique of Gothic Cubism" that the painter had recently discovered for himself.

Dali's first brief visit to Paris took place in 1928, and he was taken by the Spanish painter Diego Ortiz to visit Picasso's studio. The result was that, back in Figueras, he painted a few large abstract pictures on which he hung, by thick string, such objects as spoons, keys, and pieces of cork. Miró too may have had some influence on these, for he visited Dali in the summer of 1928.

In later pictures from the same year, for example *Woman Bathing* and *Dit gros (Coarsely Spoken)* (both in the Salvador Dali Museum Collection, The Reynolds Morse Foundation, Cleveland), the surface is covered with a thick layer of sand and gravel. Unlike Masson, who with his discreet sand tracks alluded only symbolically to the nature of the soil, Dali reproduced the beach with overt naturalism, and in consequence the figures, painted in a fully Surrealist manner, emerge as even more fantastic.

Dali's decisive stimulus toward Surrealism came in Spain itself during 1928, when he collaborated with Luis Buñuel on the film *Un Chien andalou*. Buñuel started with the idea of taking any daily newspaper and rendering in film every last item in it, from the political and general news to the comics pages until, at the end, a café waiter sweeps the newspaper off the sidewalk into the gutter. The "story line" struck Dali as something less than sensational, and he sketched out a much more daring scenario, for which Buñuel then had to devise the staging and carry out the montage. The result was a film radically different from such previous avant-garde experiments as the René Clair and Picabia *Entr'acte* of 1924 or Hans Richter's *Vormittags-Spuk (Ghost Before Breakfast)* of 1927. Although these involved mixtures of the banal and the grotesque, shifts in tempo and close and long shots, they remained basically tied to the acted-out anecdote, whereas *Un Chien andalou* is made up of entirely unreal passages, each having all the reality possible to a camera image but, lined up one after the other in a dreamlike sequence, adding up to an audacious venture that leaves the audience breathless.

Buñuel and Dali went to Paris early in 1929, and it was during that visit that Miró introduced Dali to Éluard and saw to it that Breton became interested in him. This sufficed to establish Dali's subsequent ties with Surrealism. During the summer Éluard visited him in Cadaqués, accompanied by his wife, Gala, who was to become Dali's great love and finally his wife. The Paris art dealer Camille Goemans was also there, to arrange Dali's first one-man show in Paris, which was held in November and December and was preceded, on October 1, by the world première of *Un Chien andalou*. The Surrealists promptly laid claim to the film as their spiritual offspring, and Breton published the scenario in the last number of *La Révolution Surréaliste* (December 15, 1929), along with photographs of Dali's latest

The same realistic approach was used in the *William Tell* of 1930, in which a real branch comes off the tree trunk in the lower corner.

Le Surréalisme au Service de la Révolution, no. 4, December, 1931

Colorplate 29. William Freddie. *Portrait of My Father.* 1937

pictures, which had created something of a sensation in the Galerie Goemans. Dali saw to it that, by appearance and manner at least, he would soon push his way to the forefront of the Surrealist circle.

The works that established Dali's fame were the outcome of exercises he undertook in the summer of 1929 to apply to painting the Surrealists' proposal that the subconscious be allowed to dictate automatic conceptions. As he tells it in his autobiography, he spent entire days in front of his easel like a medium waiting for pictorial visions to come into focus on the canvas. At times he beheld them in a clearly defined composition and was able to paint them at one sitting. At other times he waited for hours, brush in motionless hand, while nothing happened. Once at work, he "switched on" his special "paranoiac" capacities for producing images and attempted to give simultaneous pictorial form to the visions that came tumbling in on him. In this manner he created dreamlike compositions that were particularly unsettling to the viewer because all details are rendered with extreme fidelity, thereby making the unreal appear hallucinatingly real.

This mystification was pushed even further when he also pasted fragments of color prints and photographs into his trompe-l'oeil paintings. Thus, because the images came to him from contemplating pebbles on the beach at Cadaqués, he inserted cutout colored prints of lions' heads and half of a girl's face into the curious picture titled *Accommodations of Desire* (Collection Wright S. Ludington, Santa Barbara, Calif.), the stones having grown in his imagination and expanded like burgeoning seeds to call forth ideal images which seemed to fit naturally. Those images culminated in a love scene which takes place "under the sign of the Lion." In an alternation of lurid light and deep shadow the shore stretches away to unfathomable depths, set apart from the sky by no more than a narrow strip of light-drenched sea.

At about the same time Dali produced a small picture baptized by Éluard *Le Jeu lugubre (The Lugubrious Game)* (Collection Claude Hersant, Neuilly), in which the most heterogeneous elements are united in tragicomic actions. Hats, stones, and heads swirl around an embryo-like creature; a woman's head without body is kissed by a grasshopper; a bearded man in the foreground turns his back to exhibit his muck-bespattered pants. At the opposite side a statue with a gigantic hand rises from a pedestal on which are incised in diminishing size the indications "*gramme*," "*centigramme*," "*milligramme*." Juxtaposed with the extremely illusionistic three-dimensional painted objects, the collage details such as a chromolithograph of a girl's head, a hand with a cigarette, and so on, appear so paltry and flat as to suggest that Dali aimed to demonstrate just how little expressive force the "real" elements in his picture exert, in comparison with those brought forth by the artist's own power of imagination and his brush.

The influence of De Chirico, seen here in the characteristic architecture stretching out into the depths, is conspicuous also in such pictures as *Illumined Pleasures* (Museum of Modern Art, New York) and *First Days of Spring*. In both of them Dali follows the Metaphysical example and introduces pictures within pictures in order to establish different compositional zones of space and reality. In *Illumined Pleasures* three boxes resembling television screens are lined up, and in each an entirely different and unrelated scene is taking

Rubin, colorplate XXXI

Rubin, colorplate XXXII

Rubin, colorplate XXX
If no collection is indicated, all these works belong to the Salvador Dali Museum Collection, The Reynolds Morse Foundation, Cleveland, Ohio.

place. The distinction in character is emphasized still more by the fact that the scenes are partly pasted in, partly painted. Two similar boxes are found in the *First Days of Spring*, one pasted over with a varicolored patterned paper, the other with the advertisement of a shipping line playing up the delights of shipboard sport. In the middle ground a faded baby photo is set like a stop sign into the perspective lines that plunge backward to the vanishing point, while at the side a three-dimensional child's rosy face stands out from the painting. Dali obviously has a special weakness for banal and saccharine portraits of this sort. In *The Remorse of Conscience* of 1930 (plate 162) a sentimental head of a young girl is pasted into the middle of an ornamental decoration that reveals Dali's passion for Art Nouveau. The *Sphinx*, stretched out in the sand in a picture of 1937 (Collection Joseph Foret, Paris), wears Shirley Temple's head, and below it is pasted a sarcastic little label saying "Technicolor."

Basically, however, the collage elements in Dali's pictures play only an ephemeral role as capricious trimmings he cannot resist adding to his compositions from time to time. He himself has defined his painting as "handmade photography," and what really interests him are the stunning effects he knows how to conjure up with his brush. His pictures—often praised or blamed in the realm of taste—are painted with masterly craftsmanship, and their magic resides in the interplay of ultraveristic and illusionistic elements.

More recently Dali has used collage on only one occasion, in illustrating Alarcón's *El Sombrero de tres picos*, though he has pasted brightly colored cutout butterflies into various drawings.

Toward the close of the 1920s the various Surrealist experiments reawakened a general interest in collage, and early in 1930 there was an exhibition at the Galerie Goemans in Paris of works in that medium by the Cubists Braque, Picasso, and Juan Gris, the Dadaists Arp, Max Ernst, Duchamp, Man Ray, and Picabia, and the Surrealists Miró, Tanguy, Dali, and Magritte. For the illustrated catalogue Louis Aragon wrote an essay titled *La Peinture au défi (A Challenge to Painting)*. The first really basic writing on the subject of collage, it dealt also with the historical development of the medium. According to Aragon, the decisive change was brought about by Max Ernst, who utilized the "borrowed elements" in newer and more many-sided ways so that new creatures, new things arose out of mysterious metamorphoses: "The proper place to seize Max Ernst's intentions is where, with a bit of color and a couple of pencil lines, he attempts to acclimatize a phantom in the alien landscape to which he has just consigned him, or at that point where he puts into the newcomer's hand some object he cannot in fact grasp."

In addition to works by the artists participating in the exhibition, Aragon reproduced montages by the Russians Lissitzky and Rodchenko, but what he dismissed as "*tentatives sans lendemain*," the "short-lived experiments" in collage from Switzerland and Germany, were of no interest to him, and there is not so much as a mention of Schwitters.

Due justice, however, was done to the neglected German Dadaists in 1931, when Tzara published an article about collage. Ever since the Dada days in Zurich Tzara had been following firsthand the development of the medium, and his essay goes into its real essence more deeply and more convincingly than Aragon's. For him, the introduction of papiers collés into art represents "the most poetic, the most revolutionary moment in the evolution of

In *Cahiers d'Art*, vol. 6, no. 2, 1931, pp. 61–64

painting." With materials ephemeral by nature, of and for a particular time, a new spirit made its way into art and opened up the most immense perspectives. "A shape cut out of a newspaper," he wrote, "and incorporated into a drawing or painting, is a veritable embodiment of that which is universally understandable, a piece of everyday reality which enters into relationship with every other reality that the spirit has created. The diversity of the materials, which arouse tactile sensations, gives the picture a new depth."

Among the works by Surrealists mentioned in Aragon's essay are the collages and collage objects of Malkine, very few of which have survived the years. In the early 1920s GEORGES MALKINE (b. 1901), Russian on his father's side, Danish on his mother's, became a close friend of the poet Robert Desnos, with whose aesthetic approach his had much in common. Through Desnos he came to frequent Rue Blomet and met Masson and later the trio of Rue du Château—Prévert, Tanguy, and Duhamel. Malkine's drawings were published in *La Révolution Surréaliste*, dreamlike happenings executed with all the graphic precision of stark contrasts in black and white. A collage of 1926, *Pique-Dame* (Collection Lise Deharme, Paris), shows an abandoned landscape in which the queen of spades and trees cut out of playing cards of the spades suit are mirrored in the water. Similarly suggestive of collage is one of the drawings published in *La Révolution Surréaliste* (no. 11), with cherries on a beach and a domino piece set in front of a reflecting disk. Malkine soon went over from figuration to abstraction, in which, as Aragon explains, he concerned himself especially with the question of whether or not one should paint in a regular, even flow of tones of a single color. In his abstract compositions brightly colored shapes whirl about in space, and between them are pasted pieces of paper and cloth which accentuate the playful interpenetration of two- and three-dimensional elements.

After exhibiting in 1927 in the Galerie Surréaliste in Rue Jacques Callot, Malkine disappeared from Paris to wander about in the South Sea Islands, where, as it was put in the biographical note in the Galerie Charpentier catalogue, "he went to continue, as a free lance, his passionate hunt for the unforeseen." An exhibition, *Hommage à Malkine*, organized by the Galerie Mona Lisa in 1966 reminded the Paris art public of this forgotten Surrealist.

Another participant in the 1930 collage exhibition at the Galerie Goemans was RENÉ MAGRITTE (1898–1967), who, with E. L. T. Mesens, figures among the foremost champions of modern art and literature in Belgium. As early as 1921 Mesens was in touch with the Paris Dadaists and became acquainted with Tzara, Soupault, and Picabia, the last of whom called attention to him and Magritte in 1924 in the final issue of *391*. In much the same spirit as Picabia, the two Belgian artists brought out in Brussels in 1925 a magazine they called *Oesophage*, whose motto was "*Hop là hop là.*" After one issue it was replaced by a magazine of the same sort, *Marie*, a "semimonthly for gilded youth," which ran to four issues. In October of 1926 Mesens established direct personal contact with the Paris Surrealists, and this led to the founding of a Belgian group, which, besides Mesens and Magritte, included Marcel Leconte, Paul Nougé, and Camille Goemans, the last of whom soon afterward opened a gallery in Paris.

He illustrated Desnos's poem *The Night of Loveless Nights*, Paris, 1930.

Shown at the *Surréalisme* exhibition, Paris, Galerie Charpentier, 1964

A few were reproduced in *Cahiers d'Art*, 1926.

From a visit to Paris Mesens took back to Brussels a copy of Max Ernst's book *Les Malheurs des Immortels*, which made a profound impression on Magritte. Nevertheless, Magritte's collages of 1925 and 1926 remained within the general line of his painting, which owed most to De Chirico, out of whose Metaphysical art the Belgian artist developed his own Surrealistic style characterized by a bizarre interpenetration of reality and unreality. Individual objects are rendered with naturalistic exactitude, but isolation and silence give rise to a magical distance which appears to stretch between the objects and, at one and the same time, to estrange and unite them. Like De Chirico, Magritte loved vast architectural edifices untenanted by any human creature and stretching away inexorably into remote depths. In these open, undefined spaces, where the light falling from above casts sharp shadows, Magritte wiped out the barriers between domestic interiors and the outside world, displaced things from one into the other so as to create a no man's land in which all the laws of art stand repealed. Human figures metamorphose into statues or marionettes, are dismantled and dismembered, equipped with mechanical functions and contrivances. For Magritte everything that exists was equivocal, subject to change without notice, and, in the same way as he provided things with whatever shapes or colors he pleased, he also used collage elements to give them a material embodiment conforming only to his own imagination.

For his collages he was particularly fond of cutting up sheets of music (plate 163), evoking special effects of surprise by simply ignoring any lyrical associations they might have. Sheets of music become trees and monuments standing in desolate landscapes, landmarks and figures to startle the *Nocturnal Stroller* out of his dreams. In *Racines délicieuses (Delicious Roots)* (plate 165) they become sections of collapsed walls, in front of which inexplicable objects find themselves gathered: a crystal vase, a ball of thread, a bent-over female figure in underclothing, on whose back some sort of container holds the woman's permanent-waved head.

Aragon reproduced in his essay a collage by Magritte of another type, with pieces of corrugated cardboard in leaf shapes which supply the word *"feuilles"* (leaves) missing from the large title incorporated into the picture, *Les ... naissent en hiver (The ... are born in winter)*. Words and titles play such an important role in Magritte's art that optical visions and mental reflections constantly interpenetrate. Often he identified things with words that give them an entirely different meaning. To explain this he argued that a thing never has the same function as its name or its image, and that, in a picture, names can denote specific things, just as forms can denote nonspecific things and vice versa. Therefore he attributed equal significance to specific and unspecific forms. In a drawing of 1929 Magritte labeled three female nudes as, respectively, "tree," "cast shadow," and "wall" (figure 34), and in another drawing a milestone is identified as "person who bursts out laughing." Since he placed the probable and the improbable on the same plane and depicted both with the same matter-of-factness and sharp clarity, Magritte succeeded in instilling into his pictures a special alarming atmosphere, in which what appears to be merely humorous often reveals itself to be of the stuff of nightmares.

Magritte spent the years 1927 to 1930 in Paris in close contact with Breton, Éluard, and their circle. In 1929 he and his wife went to Cadaqués to visit

"Les Mots et les images," *La Révolution Surréaliste*, Paris, December 15, 1929, pp. 32–33; translated by E.L.T. Mesens as "Word vs Image" in the exhibition catalogue *René Magritte*, New York, Sidney Janis Gallery, 1954

Figure 34. René Magritte. Drawing published in *Variétés*, no. 8, Brussels, 1929

Dali, with whom he shared a mutual admiration for De Chirico. Two years later he settled down in Brussels, where he continued to pursue his independent way up to his death, while remaining one of the most vital representatives of Surrealism.

According to his own account, E.L.T. MESENS (b. 1903) began to work in collage as early as 1926, having already published poems and songs. His early productions, some of which were reproduced in the Belgian periodical *Variétés*, occasionally combined collage and "Rayograph," as in the charming piece titled *Je ne pense qu'à vous (I Think Only of You)* (plate 175), which initially he called *Portrait of a Poem*. The background is a piece of photosensitive paper with a large unexposed area in roughly the shape of a head in profile. Pasted around and on this form, in a graceful arrangement, are small figures cut out of fashion magazines and illustrated catalogues. Mesens's debt to Max Ernst is apparent in his liking for old-fashioned engravings as collage material. For the third version of *Instruction obligatoire* of 1930 he used such prints to construct a romantic landscape with exotic plants and the standard trimmings of the Wild West. In *Mask to Insult the Aesthetes* of 1929 (Collection the artist) he superimposed on the face of an elegantly dressed young woman a mask assembled in Dada fashion out of bits of postcards and advertisements. A cut-and-pasted title page also adorns the small volume *Alphabet sourd-aveugle*, published in Brussels in 1933 with a foreword by Éluard, evidence of the good relations that Mesens maintained with the Paris Surrealists.

Figure 35. Max Ernst. *The Immaculate Conception*. Collage from *La Femme 100 Têtes*, Paris, 1929

Before Surrealism spread to other countries, the center of the movement in the early 1930s continued to be Paris. There, collage came more and more under the dominating influence of MAX ERNST, once he had published, in rapid succession, three books of key importance: *La Femme 100 Têtes* in 1929 (figure 35), *Rêve d'une petite fille qui voulut entrer au Carmel* in 1930, and *Une Semaine de Bonté, ou les sept Éléments capitaux* in 1934. With these books Max Ernst carried to a high pitch the style of illustration he had pioneered in 1922 in *Les Malheurs des Immortels*. The pictorial elements, taken as before from penny dreadfuls and technical catalogues, are so seamlessly fused in the process of printing that one never questions the metamorphoses which transform harmless citizens into horrendous monsters and spur into action both skeletons and everyday objects. The ultimate and darkest corner of the subconscious is explored and illuminated as if by searchlights. In their ambiguity things take on unexpected dimensions, reaching out or fading into some twilight zone. At times erotic obsessions give rise to images of wishful thinking that have an air of lyrical enchantment and are set in fairy-tale landscapes. More often, however, the scene rushes to a dramatic climax, and the viewer is an eyewitness to the agonizing course of anxiety dreams. Vision after vision pours out inexhaustibly until the spectator is aghast, breathless.

Along with these major works, during the same years Max Ernst produced a considerable number of other collages, five of them in 1929 for Arp's book of poems *Weisst du schwarzt du*, published in Zurich in 1930, and eight enchanting small ones, in part colored, which he himself defined as *poèmes visibles* and gave to Valentine Hugo. These subsequently appeared in book form in 1947, together with "visible poems" by Paul Éluard, under the title *À l'intérieur de la vue*.

About 1930–32 Ernst also designed a series of single sheets combining drawing, frottage, and collage (cf. figure 36). Once again he took pages from a book of natural history and pasted on them isolated details, varicolored marble papers, smeared blotting papers, corrugated cardboard, plus painted and cutout butterflies and chromolithographs of botanical illustrations. Certain of these pictures carry the title *Loplop Introduces*, which means that they are connected with the "Superior of the Birds," whose first appearance was in *La Femme 100 Têtes*, in a collage headed "Loplop, the Superior of the Birds, has become flesh without flesh and will live among us." Loplop is, so to speak, Max Ernst's private phantom, formed out of childhood impressions, a totemistic animal creature wearing a bird's head. On a work comprising a variety of materials, begun in 1930 but completed in 1936, *Loplop Introduces a Young Girl* (private collection, Paris), the bird-man leans over a frame enclosing a weirdly assorted collection of elements: an antique coin with a female head standing for the "young girl" of the title, a multicolored stone suspended from a cord, a metal disk from which protrudes a switch of dark hair, and so forth. However, on the collage drawings a large hand or a monstrous beak usually suffices to signify the presence of the invisible creature which has conjured up the haunted assemblage of unrelated images in these pictures.

In other collages, however, the Surrealist appurtenances make way for rather more picturesque elements, picture postcards and photographs for instance, that have more in common with Dada (plate 166). On *The Postman*

Figure 36. Max Ernst. *Facile.*
Frottage reproduced in *Histoire Naturelle*, 1925

As he tells it in his biographical notices, this Loplop has been visiting daily for years, showing him the most extraordinary things.

Reproduced in John Russell, *Max Ernst*, New York, 1967, pl. 57, as are most of the works mentioned in these pages

It is signed and dated 1932.

This later version is titled *Loplop Introduces Members of the Surrealist Group*.

Paris, Éditions Nicolas Flanel

Russell reproduces this (pl. 58) with the title *Loplop Introduces a Flower*

Rubin, colorplate LV

Similar props are used today by Robert Rauschenberg in his designs for the Merce Cunningham Ballet.

Horse (colorplate 28) a torn envelope contains a photo of seductive beauties, and a rosy-cheeked face cut out of a package peeks through a round opening in a piece of marbled paper that forms the highly stylized body of a monumental figure whose neck is adorned with an elegant beaded bowknot. Once again, in 1931, Ernst returned to the theme of *Le Rendez-vous des amis* that he had painted in oil in 1922 (Collection Dr. Lydia Bau, Hamburg), this time, however, using photomontage with portraits of his Surrealist friends interlaced with all sorts of illustrations (Museum of Modern Art, New York). Ernst himself stands in the middle, flanked by Dali and some film star or other. Tanguy, Aragon, and Alberto Giacometti are being carried down from heaven by bodiless hands and arms, while the heads of Breton and Man Ray slither up amidst worms and serpents out of the water of a gloomy cave.

Max Ernst was stimulated to outdo himself in irony, however, by the discovery of a Catholic devotional book with moralizing tales and anecdotes printed in a typographic script and framed by stylized vine tendrils. Juxtaposing pages from this book with Surrealist drawings or catalogue illustrations, he arrived at such grotesqueries as a cutout picture of a cow being milked by a squatting top-hatted gentleman. Much more serious is the *Homage to a Little Girl Named Violette* (plate 169), in which, behind two pious texts titled "*La Violette*" and "*Amour de ses Parents*," are drawn, like apparitions, on one side a girl, on the other a monster, while tucked in a corner is a registered letter addressed to Max Ernst. The collage was executed in 1933 as Ernst's contribution to the brochure *Violette Nozières*, in which sixteen of the most famous Parisian Surrealists published texts and pictures expressing their sympathy for that notorious young woman on trial for poisoning her parents.

Only rarely during those years did Ernst combine collage and oil painting. In two related pictures of 1930 and 1931, both titled *Sea, Sun, and Earthquake*, he glued across the surface of the water—painted in parallel stripes of bright colors—large rectangles of old-fashioned wallpaper borders of an ornamental character that evokes the echo of a specific bygone time within these timeless landscapes. There is even starker contrast in *Anthropomorphic Figure, Flower, and Shell* of 1931 (Galerie Le Point Cardinal, Paris), an oil painting on which a sheet of sentimental paper cutouts of birds on blossoming branches is set against the rigorous linear construction of the figure. Eventually Ernst went so far in playing off opposites against one another, in the *Vox Angelica* of 1943 (Collection Mr. and Mrs. Julien Levy, Bridgewater, Conn.), as to install images of wholly dissimilar nature—figurative, abstract, patently two-dimensional or apparently three-dimensional—in individual compartments marked off on the canvas by strips of imitation wood paper, so that, viewed as a whole, the picture is something like the "quodlibets" mentioned in the opening pages of this book.

Ernst turned to collage also in designing sets (plate 167) for a ballet after Jarry's *Ubu enchaîné*, presented in 1937 at the Comédie des Champs-Élysées under the direction of Sylvain Itkine. Fantastic obelisks rise up before a landscape drawn in colored chalks, and from chains that link them hang a tandem bicycle, a chair, and an open umbrella, all taken from Ernst's vast supply of old mail-order catalogues. On the stage, those objects, life size and actual, floated in the air as a sign of the unhinged world that was envisaged

Colorplate 30. Ben Nicholson. *Collage.* 1933 ▷

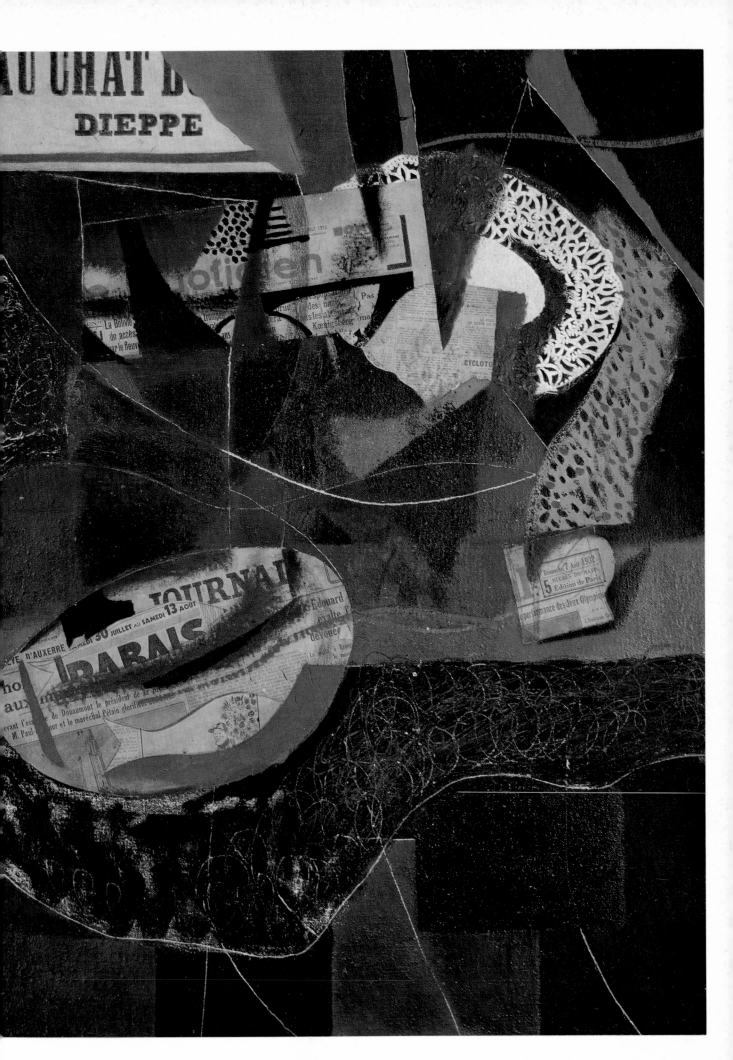

Figure 37. Max Ernst. Cover of special number of *Cahiers d'Art*, Paris, 1937

Color reproductions of these material pictures and collages can be found in the exhibition catalogues of the Galerie Iolas, Paris: *Le Musée de l'Homme suivi de la pêche au soleil levant*, 1965; and *Le Néant et son double*, 1968; and in the catalogue *De la St.-Joseph à la St.-Pacôme : Déchets d'atelier de Max Ernst*, Vence, France, Galerie Alphonse Chave, 1968.

by Jarry, whom the Dadaists and Surrealists venerated as one of their great ancestors.

It would be quite impossible to enumerate everything in the way of collage that Max Ernst has done in the intervening years. He used the medium, in the style indelibly associated with him, to illustrate Leonora Carrington's book *La Dame ovale* in 1939; in 1949 he prepared "paramyths" for a small volume, *At Eye Level*, put out by the Copley Galleries in Beverly Hills; in 1962 he did *Die Nacktheit der Frau* for the Galerie Der Spiegel in Cologne. For Patrick Waldberg's biography of him in 1958 he provided initial letters for each chapter, which he made from montages of old engravings. His title pages and illustrations for other publications are almost beyond counting (figure 37).

Nevertheless, his works of more recent years, combining painting and material collage, are more astounding than anything that preceded them. The curtain-raiser to these was a large picture of 1958, *Fishing at Sunrise*, which has Chinese pigtails dangling from a plank painted with mermaids. Then in 1965 he began a long series of small material pictures blending poetry and humor in most delectable manner (plate 168). They include such old Victorian accessories as flowered wallpapers, lace doilies, and pastry papers, as well as wooden lattices that serve as cages from which the birds have escaped or walls behind which flowers sprout. He discovers heads in objects as banal as a carpenter's plane, a chopping board, or frame stands, and enlivens portraits with velvet and silk neckties or pompous stiff collars. The ground is always painted in colors chosen to enhance or set off these materials. Certainly Max Ernst's vein of discovery and invention is inexhaustible, and he remains to date the great master in his medium.

Ernst's collage style, with its close relationship to graphic techniques, was welcomed with an enthusiasm still felt today. Innumerable artists adopted it at one time or another, some exploiting it for more or less playful experiments, others trying out its possibilities for commercial art, while still others recognized in it their own native language, on which they could enlarge. Among Ernst's most faithful disciples is MAX BUCAILLE (b. 1906), whose work is known to only a small circle of connoisseurs. He used collage as early as 1930 to illustrate his own poems, a first slim volume, *Images concrètes de l'insolite*, appearing in 1936, followed a year later by *Les Pays égarés* and in 1939 by *Les Cris de la Fée*. In 1934 his broad, empty stretches of seashore peopled only by phantoms showed unmistakably the influence of Dali, but when he began to use old eighteenth- and nineteenth-century engravings, his images became both more intimate and more compelling (figure 38). The miraculous or marvelous now appeared in romantic guise and, through interweaving real and unreal elements, took on a dreamlike intensity. Bucaille permits harmless tiny supernumeraries to wander into his jagged mountain landscapes for their own pleasure. He displays enormous sphinx heads in wastelands, populates heaven and earth with bugbears in animal and human shapes, and then, in the midst of some scene of reverie, he makes everything suddenly freeze to a stop, petrify. His Surrealistic fantasies are constantly being extended to new realms, and in more recent collages, such as the title page for Noël Arnaud's *L'État d'ébauche* of 1951,

Figure 38. Max Bucaille. Collage from *Le Scaphandrier des rêves*, Paris, 1950

he succeeds in conferring a new and incorporeal significance on the ephemeral elements, despite the rigor of the composition as a whole.

At first, however, Ernst's imitators came from the narrower confines of his own circle of Surrealist-minded friends. In 1934, in the last number of the magazine *Le Surréalisme au Service de la Révolution*, which had replaced *La Révolution Surréaliste* in 1930, André Breton published two of his own montages. One, *The Egg and the Church*, has a photograph of one of his women friends dressed in bishop's full regalia, and the other, *Le temps de chien (Beastly Weather)*, shows a conscientious gendarme barring the way to a passer-by in a wilderness landscape. The number also included a dramatic collage by Paul Éluard, *The Women of Martinique Had Come Down off Their Platform*. Éluard's work in this medium, like his drawing, shows a decided artistic talent. Some of his collages can be found in other Surrealist publications, and Valentine Hugo owned a highly expressive example done in 1934, *The Venetian Night* (plate 176), with a city smothered in smoke in the background and, stretching in front of it, a broad empty building site on which an elderly couple sit tranquilly at a table at the lower left margin, leafing through an album by candlelight.

VALENTINE HUGO (1887–1967), the only woman officially recognized as a member of the Paris Surrealist group of artists, had, from her earliest efforts, undertaken all sort of experiments in the use of out-of-the-way materials. As a student at the École des Beaux-Arts she was wildly enthusiastic about theater, music, and dance, and in particular about Diaghilev's Ballets Russes, all of whose great premieres she attended—*Les Sylphides* in 1910, *Petrushka*

Among the many Surrealist documents owned by Valentine Hugo there was a book of poems by Don Ángel de Saavedra, published in Madrid in 1930, with collages in the manner of Max Ernst by Adelia de Acevedo, a friend of the Spanish writer Eugenio d'Ors.

The various dance movements that Valentine Hugo drew in coordination with the music itself at the première of *Le Sacre du printemps* remain among the most interesting documents of that memorable occasion.

Because Valentine Hugo was seriously ill at about that time, the actual execution of the collages was taken over by her husband, Jean Hugo.

Patrick Waldberg, *Surrealism*, New York, 1965, pl. 72

No one has as yet made out whether the letter concerns the arms trade that Rimbaud carried out for the ruler during his sojourn of 1883–88 in Abyssinia.

in 1911, *Le Spectre de la Rose* in 1912, and, a year later, *Le Sacre du printemps*. During the performances she made sketches, which she subsequently translated into encaustic paintings on wood, shown with great success in the Galerie Montaigne in 1913. Sitting out the war in Boulogne-sur-Mer, she transposed a number of these drawings into woodcuts, some of which she colored and further decorated with pasted papers, dressing the sylphids in shimmering gold and silver papers and pasting tiny sequins cut out of red, green, and gold paper all over the dancer's costume in her picture of Nijinsky's famous leap in *Le Spectre de la Rose*.

She used the same technique in 1922 for her woodcut portrait of the heroine in an edition of Francis Jammes's *Almaïde d'Étremont*, surrounding the elegant head of the girl with silver foil and setting into her hair a rose cut from gleaming red tin foil. Francis Jammes was so delighted with the portrait that, the year after, he turned over to her the task of illustrating his *Pomme d'anis*, for the cover of which she made a similar portrait of a girl, gluing a piece of woven raffia behind the golden hair to make a straw hat and decorating the neck with a collar of pastry lace. Unfortunately, the de luxe edition for which this original collage was conceived was never carried through because of the publisher's indecision.

The same approach served about ten years later for a collage based on portrait photos of the Surrealists, whose group she had joined in 1931. The twelve heads (Breton, her special favorite, appears three times!) are surrounded by paper lace and green foliage, and the title *Surréalisme* is written in old-fashioned, flower-decorated letters scattered across the picture. At the bottom are a dedication to Jacqueline, Breton's second wife, and the two dates "11/32" and "12/34."

At the same time Valentine Hugo was introducing new materials into her painting. In 1931 she painted a group portrait of her poet friends Breton, Éluard, Tzara, René Crevel, and René Char. Their heads appear magically illuminated in the sky surrounded by the appropriate planets, and in the lower part of the picture are pasted photos, in negative prints, of the poems they had dedicated to her. The constellations of the zodiac, originally painted in glowing green, yellow, and red, were replaced in a later version (Collection H. Matarasso, Nice) by similarly colored tacks. In 1933 she produced a romantic portrait of Arthur Rimbaud (plate 161), whose head emerges from murky water while exotic birds press a laurel wreath on his brow. Tiny white stones in strass gleam like glowworms in the midst of the opalescent colors and shower down on the ground like flickering lightning. Pasted among them are cut-up strips of a letter from Rimbaud in an Abyssinian language with the seal of Menelik inscribed as follows: "Menelik II, the Elect of the Lord, King of Kings of Ethiopia, who triumphed over the lions of the Tribe of Judah."

Strass stones are used in the same way to decorate the earrings and scarf in the portrait of the Uruguayan poetess Susana Soca (Collection Señora de Soca, Montevideo, Uruguay), and in the equally stylized portrait of that lady's toucan Valentine Hugo nailed a chased-silver clasp below the large-beaked tropical bird. These glittering additions underscore the precious quality of the painting itself; in its minutely executed details the dreamlike character of earlier Surrealistic pictures tends toward something harder, more mineral.

Valentine Hugo also joined in the invention of those "objects" that became the rage among the Surrealists in the early 1930s. As early as 1927 Breton had urged his disciples to put together the things that appeared to them in dreams. The December, 1931, issue of *Le Surréalisme au Service de la Révolution* dealt especially with that theme, and in it Breton described and interpreted an "*objet-fantôme*" that had appeared to him during the days of the "*cadavres exquis*": a white envelope closed with a red seal, framed by eyelashes, with a handle at the side. Under the title *Poids et couleurs (Weights and Colors)* Tanguy published sketches of objects in the shape and size of hands and fingers which were to be executed in the most diverse materials: pink plush, transparent celluloid, flesh-colored wax, at times with a covering of glaring scarlet woven straw, at others crowned by tufts of hair.

One is reproduced in Rubin, p. 265.

Dali surpassed all the others by propagating "objects of symbolic function," that is, objects based on erotic wishful thinking and equipped with mechanical devices which, in symbolic form, would release obsessions. His own creation was a woman's shoe holding a glass of lukewarm milk, above which hung on a string a tiny picture of another shoe and a lump of sugar, which, by means of a lever, could be dipped into the milk, where it would dissolve. Dali's friends promptly followed his lead. His companion, Gala Éluard, fabricated a box with two symbolic breasts of sponge and wire fastened to flexible metal rods which, when released, shot one of the breasts into a bowl filled with flour, the other into a wire brush (plate 172). On a board covered with green vegetation alongside a bicycle saddle, Breton mounted a wooden globe and another object that it would be difficult to identify, a catapult that shot a green bonbon onto a bell, plus an assortment of other and even more improbable components. Whereas these bizarre assemblages are scarcely open to interpretation without accessory explanations, a relief by Valentine Hugo seems to be less the result of calculation than the product of a metaphorical vision. On a carpet marked off for games and provided with numbers, beneath crisscrossing wires there are two hands, of which one, in a red glove with ermine cuff, places its index finger in the white glove of the other, which is holding a gambling die. Here one senses some secret link between the objects that titillates our fantasy.

Rubin, pl. 253

Rubin, pl. 254

It the same issue of the magazine, ALBERTO GIACOMETTI (1901–1966) published seven *Mobile and Mute Objects*, sketches of or for various sculptures such as the *Suspended Ball* (Kunsthalle, Basel, on loan from the Stiftung Alberto Giacometti), the *Cage* (Collection Aimé Maeght, Paris), and the *Disagreeable Object* (private collection, New York), which were executed in plaster, wood, or metal. Giacometti was the only sculptor to join up, temporarily at least, with the Surrealists, though his consistently sculptural conceptions are quite different from their works, with their heavy freight of anecdote and literary reference. In his conceptions, the relationships arising between the fantastic objects are expressed more directly and arouse greater anxiety.

In the Surrealist production of the 1930s, material assemblages and collages ran parallel courses. Now and again it was "objects" that met with greater favor, insofar as they permitted direct combination of entirely heterogeneous things, whereas collage demanded greater amalgamation and, in consequence, transformation of its component elements.

True to form, it was Picasso who undertook the most varied experiments, leaping from one technique to another. During a summer holiday in Juan-

In the first number of *Minotaure*, May, 1933

As early as 1922 Mansurov in Leningrad was introducing butterflies into his material pictures (see plates 89, 90).

Both are reproduced in Rubin, pls. 274, 275. See also D.-H. Kahnweiler, *Les Sculptures de Picasso*, photographs by Brassaï, Paris, 1949.

Nos. 260–266 in the catalogue, *Hommage à Pablo Picasso*, 1966–67, in Paris

In the 1940s Laurens also underlaid his figurative drawings with collages of colored papers.
A.H. Barr, Jr., *40 Years of Picasso* New York, 1939, gives the date of the series as 1932. The *Picasso* auction catalogue of Kornfeld and Klipstein, Bern, 1964, reproduces a *Female Diver* with the date 1933. The exhibition catalogue *P. Picasso, das graphische Werk*, Zurich, Kunsthaus, 1954, shows five printing variants of the *Female Diver* of 1933. In the exhibition catalogue *Collage and Objects*, London, Institute of Contemporary Arts, 1954, one example of the *Bathers* (Collection Roland

les-Pins, he made a number of remarkable reliefs with all sorts of things picked up on the beach, covering them with sand and mounting them on planks to give the effect of thoroughly weatherworn panels. In one such work dated August 22, 1930 (plate 147), along with sand-covered seaweed and shapes cut out of cardboard, there is an old glove stiffened with plaster, and the whole is inserted into a wooden frame. In others one finds such things as children's toy boats.

When Breton visited Picasso in 1933 at the château of Boisgeloup near Gisors, where he had installed himself the year before, he was particularly fascinated by a relief with two dancing figures made of grass, matches, withered leaves, and an impaled butterfly. In an article dealing with "Picasso in his element" he said of it: "It was in 1933 that, for the first time, a real butterfly could be incorporated into a picture without everything around it immediately collapsing into dust, without the topsy-turvy sort of representational image that might be evoked by its presence in this place, setting at naught the system of human representational imagery of which it is a part." Even if, as the fact is, Picasso was not the first to make use of a real butterfly, Breton was right in pointing to the new magical significance that such natural elements take on in Picasso's compositions.

Along with the iron sculptures Picasso had been creating since 1930 under the guidance of his Spanish friend Julio González, Breton also discovered in his studio two genuine Surrealist sculptures, both now lost. One was made up of a tree root stuck into a flower pot and decorated with a red feather duster and a bull's horn. The other was virtually Dadaist: a cast-iron armature from which dangled all sorts of brightly colored toys—little dolls, airplanes, celluloid birds, hussars' caps, and so on—while on the base stood a shoemaker's last.

Besides these, in 1935 Picasso fitted out a series of small figures with everyday materials. Two jointed wooden manikins wear clothes made of scraps of various colored cloths. A "person" (plate 145) consists of a wooden lath with a green tin-can lid as a head, from which dangles twine hair, the body being made of a small wooden shield to which is nailed a doll's arm. Another one, larger, with a globular head and limbs crisscrossed by string, holds two garden rakes in its hands. Here we have Picasso's special gift: a visionary fantasy in which realism and abstraction are equally rooted.

Between 1932 and 1935 Picasso produced a certain number of genuine collages for which he used his own engravings of bathers and divers, pasting each onto an abstract composition of thin papers, each of a different color, and this background makes its presence felt like a shadow behind the stippled outlines of the figures. The approximately fifty prints were struck off by Picasso himself and mostly distributed among his friends.

For the cover of the first issue of *Minotaure* (May, 1933) Picasso designed a highly impressive collage of crumpled silver paper, green ribbon, a wallpaper border, a cake plate of paper lace, and an artificial leaf, all thumbtacked to corrugated cardboard, with the center occupied by a drawing of the legendary monster with bull's head and human body. Despite a rather casual arrangement, the composition possesses an inner conciseness to which the odds and ends of colored materials lend a naive poetry.

The figure of the minotaur—Picasso's incessant preoccupation about this time, to which he devoted no less than eleven sheets of the series of etchings

for the art dealer Vollard—was no newcomer to Picasso's imagery. In 1928 a running minotaur appeared in an oil painting, and this was preceded by a large drawing dated January 1, 1928, in which are glued pieces of wallpaper. A related composition sketch with brocade wallpaper (Collection Mme. Marie Cuttoli, Paris) is connected with the tapestry now in the museum at Antibes.

Picasso used collage also in the cartoons for other tapestries to be woven in the workshop of Madame Cuttoli. On the preparatory drawing for one of them, *The Peasant's Wife*, vague wallpaper patterns are merely indicated by pastel drawing; but on the cartoon for the *Seated Woman* (in the possession of Madame Cuttoli) large pieces of old wallpaper are inserted between the figures in profile and, just as in the early papiers collés, function as two-dimensional elements within a spatial depth. Then again, wallpaper patterns are punctiliously painted in graduated colors in an oil painting of 1936, *Woman with Watch*. In 1937–38 collage was used extensively in another cartoon commissioned by Madame Cuttoli, *Woman at Toilette*, the dimensions of which—9 feet 10⅛ inches by 14 feet 5¼ inches—make it the largest collage by Picasso that we know. The walls in the picture are covered with wallpaper in imitation masonry pattern, strips of another wallpaper with maps in illusionistic relief levels are used for the costume of the lady's maid, and the young woman whose hair is being combed by the maid looks into a mirror at her face, which is composed of papers with floral designs. Textures and color combinations are so diversified here that for long they constituted an obstacle to the execution of the tapestry, and it was not until May, 1970, that the French national workshops, the Manufacture des Gobelins, finally wove two versions, one in the colors of the collage, the other in black and white.

In the 1940s Picasso began to think in terms of still other materials. About 1943 he produced the very important bronze *Bull's Head* (Collection the artist), cast from an assemblage of a bicycle saddle and handle bars, but along with this he also made smaller and less imposing objects of tin bottle caps or constructions of match or cigarette boxes. He fabricated masks, faces, figures, and animals from pieces of newspaper and torn papers, attached them by thumbtacks to cardboard cartons, and often also sewed scraps of cloth on them. In the *Woman with Yellow Blouse* of 1943 (Collection Schapiro, New York) shreds of paper are strewn about in the watercolor drawing with an Impressionistic casualness. Likewise in certain drawings of the *Faun* series of 1942 there are pasted pieces of black paper. However, in these cases, collage is no more than one means among others that Picasso adopted to realize his unfailingly spontaneous intuitions.

Around the hard core of official Surrealists, few in number, innumerable other artists grouped themselves in the course of time, briefly in most cases and often somewhat at a tangent. Among these is the Swiss SERGE BRIGNONI (b. 1903), who, when not painting or sculpturing, devotes himself to collage in particular. From 1924 to 1940, with occasional interruptions, he lived in Paris. Of a first series of collages (Collection Robert Spreng, Basel) all are dated 1931 and clearly hark back to the Cubists, especially to Picasso, of whom Brignoni was seeing a good deal at that time. These are drawings of still lifes and other figurative subjects with areas of color added in ink and gouache, but also with all sorts of pasted papers and printed matter in color

Penrose, London) is dated 1934, another (private collection), 1935.

Rubin, pl. 292

Catalogue, *Hommage à Pablo Picasso*, Paris, 1966–67, pl. 165

Rubin, pl. 309.
Catalogue, Paris, 1966–67, pl. 276

harmonies that are entirely independent of the forms of the composition and therefore introduce a note of marked diversity. On one of these collages, *The Beloved Soars Above All*, done while Brignoni was awaiting the return of his young wife from a visit to her parents in Chile, flecks of paint alongside a female figure make up a color scale which expresses the gamut of his feelings during that period. Cubist reminiscences are most marked in a *Still Life with Bottle*, in which the usual strips of French tobacco packages recur between pasted pieces of paper and printed matter. Cuttings from Italian books or newspapers in various type faces cover the ground with black-and-white texturing, to which a bit of red paper and watercolor tones of pale blue add a touch of color.

Brignoni's turn to Surrealism is plain to read in a collage of 1932, *Variations of the Forms*. Over a drawing of biological–vegetal forms, such as would thenceforth dominate in his painting, he pasted pieces of brown paper with all sorts of drawings, and the effect of layer upon layer that results gives the picture an atmosphere of unreality.

Brignoni says that frequently he fabricates the material for his collages while at the café. He always carries a small pair of scissors with him, and while he sits at leisure he passes the time cutting shapes out of any paper or newspaper at hand. These serve him later as points of departure for his pictorial compositions in the same way as the innumerable drawings in which he jots down passing ideas while chatting with friends.

During the 1930s Brignoni worked out in his painting and sculpture a world of forms peopled by his own brand of Surrealist creatures: figures of wood and iron in which vegetable and animal elements intermingle; drawings and etchings with growths of marine flora, corals, algae, and so forth intertwined in flowing shapes and lines. In 1938 a new series of collages grew out of these engravings and drawings (their linear precision is such that one can scarcely tell offhand which technique was used), which Brignoni cut into figurative shapes and pasted together into new compositions. Along with these he made use of color cards from a paint manufacturer with the various shades laid out in small oblongs. In one collage, *Only Cadavers Have Sunk at That Depth*, these color scales become ladders running up and down, and alongside them his mysterious drawn or engraved figures twist and squirm in forceful gesticulations. Whereas the effect here depends entirely on the contrast between pictorial elements, the individual shapes in *Blossoms of Star Coral* (plate 180) have a definite formal relationship to one another. The background consists of a photograph of a vetch blossom surrounded by large leaves, out of which rise animal–vegetable creatures that seem to be carrying on some sort of dramatic dialogue. The diffuse gray tonality of the photocopy makes the hard black-and-white crosshatching of the drawing stand out sharply. Subjective and formal interests are always in equilibrium with Brignoni, and he is never at a loss to bring his forms, colors, and materials into harmony.

Something of a special place within the Surrealist movement is held by CAMILLE BRYEN (b. 1907). From the time he went to Paris from Nantes in 1926, as poet, painter, and draftsman he has plunged into every new adventure launched by the various avant-garde currents, without ever really committing himself to any one tendency: "I have attached myself to people,

Jean Grenier, *Entretiens avec dix-sept peintres non-figuratifs*, Paris, 1963

Colorplate 31. John Piper. *Hope Inn.* 1933

not to movements," is how he put it once in an interview. His special sympathies, however, were with the Dadaists, "the Knights of the Tabula Rasa," to whom he felt himself attracted because of his innate opposition to everything traditional and established. In 1932 he published on his own, with the sponsorship of various of the founding fathers of Dada, a small illustrated book of poems, *Expériences*, containing plays on words and verbal tricks and distortions that could have originated with Arp or Tzara, as well as a phonetic "sound poem" similar to those by Hugo Ball, Schwitters, and Hausmann. Certain poems follow the lead of Apollinaire and are set up typographically so as to form an image, while others are assembled from strips of text cut out and juxtaposed seemingly at random. One such poem carries what amounts to a headline proclaiming *"Le sang travaille"* (Blood in torment), and in it are pasted a portrait of the young Goethe and a smiling woman's head. Elsewhere, a grotesque figurative outline drawing surrounds a flimsy little bus ticket. For his illustrations Bryen tried his hand at all the techniques of montage and collage. In one case he took from the magazine *Détective* a photograph of the hand of a murderer, cut out two wrinkled fingers, and made peacock feathers grow out of the quick of one nail. More typically Dadaistic is a collage with a view of the University of Bonn and, soaring overhead, a winged state coach and a classical statue of a female torso with the head of Kaiser Wilhelm II. Two illustrations were contributed by Manon Thiébaut, a friend of Bryen, in one of which a photo of a head printed in negative is placed on a draped skeleton.

During the years that followed, Bryen continued to produce collages of Dadaistic or Surrealistic character. Especially attracted by advertising slogans about 1934, he set about illustrating them in grotesque collages. One such is his *Take Care of Your Teeth*, in which a youthful beauty with elegantly marcel-waved hair is being shipped off by balloon; an undefinable reddish mass seals her mouth, and that organ reappears below the gondola of the balloon, this time covered with pink worms. A trifle more comfortable in effect is a collage, *Montage social du montage du coup* (more or less, *Social Montage of the Hatching of the Plot*) (plate 156), exhibited by Bryen at the 1938 *Salon des Surindépendants*. Its main ingredients are a printed obituary for a painter, a page from a family album with portrait photos in postage-stamp format, and small pictures from advertisements. Two pasted elements are hinged: one, a crowned head advertising Carlsbad Coffee Flavoring, which, when opened, shows the same head in a black-and-white print; the other, a door behind which is concealed a Greek statue.

With the daring objects he constructed in 1934 and 1935 Bryen proved himself a true Surrealist. To a tree in the Forest of Meudon near Paris he attached *The Breast of the Forest*, a breast made of plaster into which he stuck a soup spoon holding homeopathic pills which had been prescribed for him and which he got rid of by means of this work of art. Later he turned out *Objets à fonctionnement*, with mechanical inventions *à la Dali* or electric bulbs which could be turned on and off. These were mysterious boxes in which everyday and macabre objects were brought into somewhat contrived relationships. Thus, in *Les États de la Mort* (*The Ranks of Death*) a cock is mounted in the medallion head on a gravestone, and from it water flows onto a coffin lid hollowed out in the shape of a leg and then covered with salt. The last object of this period, *The Machine to Fabricate Objects in*

Some of these are reproduced in the slim volume *L'Aventure des objets*, which appeared in 1937 with a foreword by J.H. Levesque.

Reproduced in the exhibition catalogue *Cinquante ans de collages*, Saint-Étienne, 1964, no. 41

My Mind of 1938, is a framed wall mirror with eyes painted on it and the title written in the pupils.

Alongside these, Bryen also carried out entirely different experiments with materials. In a two-part picture of 1935, *Wax and Candle*, half of a piece of cardboard is covered with wax drippings, the other blackened by smoke. This procedure of "*fumage*," in which smoke is used as a medium, was also exploited about the same time by the Austrian painter WOLFGANG PAALEN (1905–1959), and both artists drew from it "Informal" pictures that were very modern in taste. Similarly, Bryen's collage of 1948, *La Broderie du feu (The Embroidery of Fire)*, owes its origins to fire, scraps of charred canvas being used to make a mysterious landscape. Upon occasion Bryen still introduces collage elements into his drawings and gouaches, generally small pieces of torn paper that whirl around and pile up amid forceful linear structures.

The cult of the object reached its climax in an exhibition held at the Galerie Charles Ratton in Paris in May, 1936. There, along with the most heterogeneous "natural, found, and reworked objects" ferreted out of ethnological collections, scientific institutes, antique shops, and junk dealers, there were also displayed the latest creations of the Surrealists. Conspicuous among them was an *Objet poétique* by Miró (Museum of Modern Art, New York), a hollowed-out block of wood in which a doll's leg was suspended and which was placed on a man's hat and crowned with a stuffed parrot. This Dadaistic assemblage was, however, less shocking than a figure that Miró showed in the 1931 *Salon des Surindépendants* (plate 171), a scroll-sawed wooden clotheshorse with a large knob for a head and an enormous wooden phallus, the whole trimmed with an open umbrella and a spray of artificial flowers.

Other artists gave their works a more specifically Surrealist cast, imposing a new significance on everyday objects by reworking or renaming them. Maurice Henry exhibited a small violin swathed in bandages titled *Hommage à Paganini*, and Man Ray signed and dated "1935" a clay pipe with a glass soap bubble and the inscription *Ce qui nous manque à nous tous (What We All Need)* (Collection Charles Ratton, Paris). To be on the safe side, Man Ray's *Object for Destruction* was not put on public display. This was a metronome to whose pendulum was affixed, by a paper clip, a large eye (figure 39). The "Instructions for Use" read: "Cut the eye out of the photograph of a person you love but no longer see. Attach it to the pendulum of a metronome and regulate the weight according to the tempo desired. With a single well-aimed blow of a hammer try to destroy the object." These directions were taken literally during a Paris showing in 1957. Man Ray put together a new one for the *Art of Assemblage* exhibition at the Museum of Modern Art, New York, 1961, and since then there have been further replicas.

Arp showed an enigmatic object called *Maimed and Stateless* (Collection Peggy Guggenheim, Venice), formed out of crumpled newspaper and giving the impression that it might equally well conceal a fully opened blossom with erect pistils or an ashtray with a pestle. He had already fashioned another Surrealist object, a book nailed open and strewn with sawdust to match the title, *Sciure de gamme* (literally, *Sawdust of Gamut*), of a book of poems published in Paris in 1938.

Rubin, pl. 257

It was published in *Le Surréalisme au Service de la Révolution*, no. 3, 1931.

Rubin, pl. 267

Now in the collection of Max Ernst, it was shown at the *Collages surréalistes* exhibition, Paris, Galerie Le Point Cardinal, 1963.

Rubin, pl. 269.
Her first collage, *Notebook of a Schoolgirl* (Collection André Breton, Paris), was done in 1930 before she knew anything of the Surrealists. On it there are two hares, one red and in profile, the other white and standing on its head, pasted between mathematical formulas.

Figure 39. Man Ray. *Object for Destruction.* 1932. Assemblage

Rubin, pl. 264

The greatest furore, though, was caused by MÉRET OPPENHEIM (b. 1913) with a tea cup, saucer, and spoon completely lined with fur (Museum of Modern Art, New York), an object that since then has turned up without fail at every Surrealist exhibition. While attached to the Surrealist circle in the 1930s, Méret Oppenheim also tried collages, though they do not evince the same daring inventiveness. About 1934 or 1935 she painted a *Portrait of Max Ernst* with varicolored hieroglyphs over a long hook connected, by a cutout and pasted chain of gold paper, to a clot of color which may stand for a curly-haired head. For title she introduced the last line of one of her own poems, which reads in full: "By berries one nourishes oneself, with the shoe one honors oneself. Heads up! the loveliest vowel evacuates itself!"

MAURICE HENRY (b. 1907) originally belonged to the circle of collaborators on the literary and philosophical review *Le Grand Jeu*, in which he published poems and drawings from 1926 on. However, he joined the Surrealists in 1933 and thereafter took part in their exhibitions and other manifestations. About 1935 he composed a series of strange line drawings within whose contours the shape of one object grows out of another, and in which he pasted elements that encroach disconcertingly on what is already there to suggest enigmatic relationships (plate 159). During the same year he also produced poem collages (plate 158), variations of the painted poem pictures of Max Ernst and Miró, in a technique that since then has been much imitated. Into elegantly handwritten lines of verse he introduced cutout illustrations which, as in rebuses, replace words and ideas with images. The aura of quaint old Victoriana brings a note of cheerful irony into his Surrealist context.

Henry's conceptions tend toward mystification, and, side by side with his satirical drawings for the daily press, he does others that are full of unreal happenings. Most recently he has been exploring new materials. Out of crumpled and moistened paper he forms sculptures and reliefs, which he paints in bright colors. Here and there faces and objects take shape among the abstract structures.

ANDRÉ BRETON (1896–1966) counted "poem collages" as a separate category of his "poem objects." They all carry precise dates of execution, because Breton wished to affirm that each arose out of a particular moment or a particular situation. The first work of this sort known to us was a gift to Valentine Hugo and is dated January 12, 1934. Beneath the three-line poem a small pocket knife is fastened crosswise with twine, and its pinkish color introduces a touch of delicate lyricism into the picture. Between the lines of his other poem collages Breton mounted objects embodying in one way or another the dream content of the poem. A book-object (Collection Roland Penrose, London), dated January 12, 1935, carries the text *À l'intersection des lignes de forces invisibles* (At the intersection of the invisible lines of forces) and contains typically Surrealist equivocal materials such as two dove's wings in porcelain, an egg, and a broken mirror. Other examples from 1937 are more emotive. On one, dedicated to his wife, *For Jacqueline* (Collection Mr. and Mrs. E. A. Bergman, Chicago), there is, among other things, a withered transparent leaf pasted over a playing card. On another (private collection), which begins with the words "*Madame, vous m'êtes apparue...,*" a white mouse, three small stars, and a three-dimensional ornament illustrate the tangled forms of nocturnal experience. More dramatic in its effect is a

poem object of 1941, *Ces terrains vagues...* (Museum of Modern Art, New York), with a carved wooden bust whose mouth is a keyhole, two boxing gloves chained together, a portrait in a metal frame, and a lantern to symbolize the "house of my heart" spoken of in the text. The words unfailingly spin their webs around the objects and mute their realistic tangibility.

Breton's poem objects were seconded by the "book-objects" of GEORGES HUGNET (b. 1906). For the publications of his Surrealist poet friends he designed covers in material collages, using fantastic elements related to the spirit of the poems. A selection of these book-objects, executed by the bookbinder Louis Christy, was displayed at the Galerie Charles Ratton in 1936; and the following year the review *Minotaure* published those for Breton's *L'Amour fou*, Éluard's *Défense de savoir*, and Valentine Penrose's *Herbe à la Lune*.

In 1934 Hugnet brought out his *Petite Anthologie poétique du Surréalisme*. This was the first anthology of Surrealist poetry, and it was illustrated with engravings by various Parisian artists. Two years later, also with the Éditions de la Galerie Jeanne Bucher, he published his own poem *La septième face du dé*, an album of twenty color reproductions of "*poèmes-découpages*" (plate 178) for the cover of which Marcel Duchamp designed a cigarette collage. With its very striking page layouts combining text and illustrations, the book ranks among the most astounding of Surrealist publications. The poems are broken up into strips of assorted type faces and sizes and scattered about among a great variety of photographs and reproductions used as pictorial elements. Small vignettes and old-style engravings are pasted here and there throughout the texts, and there are occasional full-page photomontages. Hugnet glued colored shells, snails, corals, and the like to black-and-white photos, or cut the shapes of eyes or mouths out of red and green papers. The images themselves express an amalgam of suppressed desires and anxiety feelings. Amid bodies chopped into bits appear gloomy landscapes with ruins where lions stalk, or an abandoned city of tents left to become a lair of vipers. Detached or crossed legs float between machines and the skeletons of buildings; a leg wearing a shoe towers up out of the water that rises steadily above the floor in the dormitory of a girl's boarding school. Ghostly voyagers with bandaged faces sit in a train compartment; a girl, writhing, holds on her lap a bluish skeleton.

Certainly there are unmistakable influences of Max Ernst in Hugnet's hybrid creatures—half man, half bird—and in his use of illustrations from books of natural science and orthopedics. Nevertheless, for his treatment of composition Hugnet looks rather to film technique, exploiting erratic jumps in sequence and overlapping of scenes, while in the midst of everything the strings of words burst through like disconnected, broadcast, "stop-press" announcements.

More recently Hugnet has developed more typical collages, utilizing all sorts of wonderful material. Among them are small poetic pictures fabricated from the burned paper salvaged from cigarette butts or the "rosettes" shaved by a pencil sharpener, which he touches up with color and converts into flowers. He reworks stones and bark into Surrealist images or takes his inspiration for colored drawings from spots of red wine on a tablecloth. He is an avid collector of curiosities—old knickknacks, toys, furnishings in *fin de siècle* taste—and, as he himself says, all these gewgaws, together with the

Rubin, pl. 287. Exhibition catalogue, *The Art of Assemblage*, New York, Museum of Modern Art, 1961, pl. 67

A second book of this sort, *Huit jours à Trebaumec*, awaited publication at the time of this writing. Hugnet published on his own a volume titled *1961* (in that year), which is illustrated with four full-page photomontages.

works of art he receives as gifts from his artist friends, make of his country house on the Île de Ré nothing less than a life-size collage.

To illustrate his various books of poetry Hugnet has been able to call on Picasso, Arp, Miró, and Dali. One of the most delightful of them is his small *Oeillades ciselées en branches* (published by the Galerie Jeanne Bucher in 1939), with drawings by the Berlin artist HANS BELLMER (b. 1902), some of them with collage (figure 40). Bits of old-fashioned doilies in pale pink bobbin lace are inserted into delicate pen drawings of girls, introducing a gentle color into the mat tones of India ink. The cover of the book, which is no larger than a pocket breviary, is adorned with a cake doily, on which has been pasted a colorful little medallion of rosebuds. Thirty de luxe copies, ten of them printed on sky-blue paper, were perfumed to intensify the fragrance these poems and drawings exhale.

Bellmer produced a number of such collages in Berlin during January and February of 1938, when his wife lay dying in a hospital. To distract her, at each of his daily visits he never failed to take a couple of drawings done, however weary he might be, the night before. Often he found himself without an idea in his head, and the blank sheet of white paper dismayed him so much that, in desperation, he pasted on it whatever he could lay hands on, hoping to find in it some point of departure for the promised drawing. Thus, from a torn tram ticket, pieces of a package of Rot-Händle tobacco, the paper of a half-smoked cigarette, a burned red match, and shreds of tobacco and cloth came, on February 4, 1938, his *Odds and Ends from the Coat Pocket of Gasahl Gaboya* (plate 170). The unlikely name Gasahl Gaboya was an invention by Bellmer in the spirit of Karl May, every German schoolboy's favorite author of cowboy-and-Indian stories. Around the meaningless scraps scattered over the surface of the paper, Bellmer drew delicate bundles of lines to construct an open piazza, where young girls amuse themselves with bicycle and hoop; across the background extends a palace copied from the decoration on a Brazilian cigar box. In Bellmer's works of this period the collage elements of bits of colored paper, metal foil, or scraps of lace are, for the most part, no more than tiny fragments that melt into the unreal atmosphere of drawings permeated with personal sensitivity and erotic feeling.

After his wife's death, in February, 1938, Bellmer made a kind of memory chest out of matchboxes (Collection Galerie André-François Petit, Paris), in which he placed odd souvenirs of their life together—an artificial rose, a pocket knife, a shell, a marble, screws, splinters of wood. Some parts were left closed and empty, as if to add their mute eloquence to the more emphatic voices of the humble mementos displayed. Only once after this did Bellmer return to collage, in the oil paintings of the *Céphalopode* series such as the *Self-Portrait with Unica Zürn* of 1955 (Collection Galerie André-François Petit, Paris), which is trimmed with crumpled cloth and tulle.

Bellmer started out with a good fund of information about collage and montage, having worked in 1924 as typographer for the Malik-Verlag, where he came into contact with Heartfield and Grosz, the latter of whom exercised a certain influence on Bellmer's drawing style of that time. In ensuing years he earned his living as a commercial graphics artist and ran an advertising agency. When the Nazis came to power, he revolted most energetically against the official policy toward art and culture and swore to pro-

This and other works by Bellmer are in the collection of Jean Brun, Dijon, and further collage drawings are the property of the Galerie André-François Petit, Paris.

Figure 40. Hans Bellmer. Illustration for Georges Hugnet, *Oeillades ciselées en branches*, Paris, 1939. Drawing

duce absolutely nothing more that could be useful in any way whatsoever to the state. He buried himself in his childhood memories, the most private of realms and the only one where he could preserve his artistic freedom. After a performance of *The Tales of Hoffmann* the idea came to him that he could make a puppet or doll all for himself. He began, in 1933, by putting together a mechanical construction out of which he gradually developed something like a human figure. However, it was not until 1936 that he succeeded in endowing a second and almost life-size model with real freedom of movement by means of ball-and-socket joints imitated from those used in artists' lay figures of Dürer's time that he found in the Kaiser-Friedrich-Museum in Berlin. These made possible highly audacious poses on which Bellmer rang constantly new changes (figure 41). He stripped the torso of its legs and used them to make a monstrous creature with two pairs of legs dovetailed together. He dressed his doll with underclothing, ribbons, garters, lace, and shoes, glued hair on her, and covered her face with a masklike coat of plaster, through which the piercing eyes seemed to gaze anxiously. So much does Bellmer's ingenious contrivance at times take on the appearance of nature that one expects her to spring to life at the hands of her Pygmalion, but there is, nevertheless, a troubling magic about her that creates an insurmountable distance between her and us.

Various poses in Rubin, pls. 276 a, b, c, d, and 277. The "doll" has, obviously, remained in the possession of her creator.

In 1937, at Karlsruhe in Upper Silesia, Bellmer constructed a second "articulated object," the *Machine Gun in a State of Grace* (Museum of Modern Art, New York), a machine-like armature into which are set fully modeled, painted parts of a female body. This hybrid creation, however, lacks the fascination that is so naturally exerted by Bellmer's large doll.

Rubin, pl. 279, where it is titled merely *The Machine-Gunneress*

As early as 1935 Bellmer was in touch with the Paris Surrealists, and in that year *Minotaure* published the first photos of his doll. The next year he went in person to Paris to show her off in the Galerie Charles Ratton, but it was not until after his wife's death in 1938 that he settled there permanently.

Éluard wrote poetic texts for an album *Les jeux de la poupée*, which appeared in Paris in 1949 with hand-colored photographs by Bellmer.

Bellmer's doll, which turned men's heads for years in all the Surrealist manifestations, acquired a rather decadent progeny in the numerous female mannequins that peopled the "Surrealist Street" at the *Exposition Internationale du Surréalisme*, held in 1938 at the Galerie Beaux-Arts in Paris—creatures fitted out with the most fantastic costumes and attributes by Max Ernst, Miró, Man Ray, Duchamp, Masson (plate 173), Dominguez, Marcel Jean, Léo Malet, Matta, Dali, Seligmann, and others. This most spectacular of all Surrealist manifestations was organized by Breton and Éluard under the aegis of Marcel Duchamp, who decorated the main room. In its middle there was a slimy pool with reeds and water lilies, and in the dark corners stood sumptuous beds; but woe to those who, unsuspectingly, ventured to try out the beds; they ended covered with feathers and with the coal dust that trickled down from the 1,200 sacks suspended from the ceiling. At the *vernissage* the lights flashed on and off, loudspeakers blared Prussian military marches, rain fell in Dali's taxi (plate 174), and wild dances were performed between and around the exhibits. Even the sense of smell was titillated with the aroma of freshly roasted coffee. Today's Pop Art "happenings" can scarcely outdo those of 1938, and then, as now, not everyone was of one mind about these great new conquests in the realm of art.

Fifteen original photographs of those mannequins were published in Man Ray, *Les Mannequins—Résurrection des Mannequins*, Paris, 1966.

Figure 41. Hans Bellmer. Illustration for his untitled essay on dolls, *Cahiers d'Art*, no. 1–2, Paris, 1936

On the occasion of this exhibition a *Dictionnaire abrégé du Surréalisme* was published. It contained entries for forerunners, members, fellow-travelers, and the like, and definitions and descriptions of the new categories of art and the new techniques they had invented. Under the heading "*Décollage*" was expounded an idea which points to Léo Malet as another of the ancestors of present-day "*affiches lacérées*." According to the *Dictionnaire*, "Léo Malet proposed to popularize the procedure whereby a poster is ripped at certain places in such a way as to allow the fragmentary part or parts they covered to come into view, thus exploiting the expressive possibilities of alienation and confusion in the over-all image obtained." Malet also invented objects with mirror effects, placing a mirror in front of a photo so that one sees simultaneously the image and its reflection.

Rubin, pl. 285. The *Ultra-Furniture* was destroyed by a hurricane in Sugar Loaf, New York, in 1949. The *Dictionnaire* includes another poem object by Breton, with the text "*Pour la toilette des jeunes filles pendant les longues nuits d'automne.*"

Kurt Seligmann's *Ultra-Furniture*, a taboret resting on four female legs in stockings and shoes, was another great attraction at the exhibition, and the *Dictionnaire* reproduced his photomontage *The Surrealist Animals* (plate 179), in which engraved, drawn, photographed, or painted pictures of several species of animals are set into a kind of architectonic Noah's ark afloat on the high seas.

Rubin, pl. 286

The Romanian-born VICTOR BRAUNER (1903–1966) [the *Dictionnaire* dubbed him "*Botte rose blanche*" ("rose-white boot" or "bucket" or "bunch of flowers" or something more hermetic)] did not return to Paris from a sojourn in his homeland until after the exhibition. In 1937 he conceived a highly dramatic object that could well have figured in that show, a *Wolf-Table* (Collection Mme. Victor Brauner, Paris), a low, small table of which one leg is carved into the shape of an animal's paw, while the head and tail of a stuffed wolf project from the table top itself.

From 1930 to 1934 Brauner lived in Rue du Moulin-Vert in the Fourteenth Arrondissement, in the same studio building as Giacometti and Tanguy. Through them he came into contact with the Surrealists, and Tanguy was responsible also for his discovery of De Chirico, who was thenceforth to have a marked influence on his painting. However, Brauner's figures soon shook off the Metaphysical immobility typical of De Chirico's and, instead, underwent weird metamorphoses. Thus, Brauner portrayed *The Strange Case of Mr. K* (Collection Mme. André Breton, Paris) on a panel divided into forty rectangular compartments, in which Mr. K is shown naked, decorated with military orders, in swallow-tailed coat, in priest's cassock, encased in a map of the world or in some sort of building, coupling in obscene poses with a female figure, and so forth. The oil painting was followed by a material collage, an enormous diptych titled *The Power of Concentration of Mr. K*, in which the same individual is shown with impressively martial mustachios and fat belly, once light on dark, once dark on light, once with his body covered with tiny pink celluloid dolls that squirm all over him like tadpoles, then again with mushrooms, little beets, and other sham vegetables that run down his front like an accumulation of military orders.

Rubin, pls. 312, 312a

After a one-man show in 1934 at the Galerie Pierre, which was anything but a success, even though Breton himself wrote the preface to the catalogue, Brauner returned to Romania, where he did his best to promote the cause of Surrealism. For a collection of essays on Dada and Surrealism brought out in 1936 by the critic Sasha Pana, Brauner drew an illustration which he

Colorplate 32. Joseph Cornell. *Hôtel de l'Europe—Olga Carini Aguzzi.* 1954 ▷

framed with photos of his Paris friends. As he had already done in the past, he continued on occasion to make collages, though he never took them very seriously and seldom preserved them. A first one, done in 1929, was a drawing in which an alarm clock, cut out of a newspaper advertisement, was equipped with roots and planted in a desolate yard alongside a leafless tree. The influence of Max Ernst is obvious in a collage of 1937, in which a print of a machine model is made the theater of a dramatic action. The machine is set on the head of a dignified gentleman, whose beard, caught in the mechanism, makes a veritable mountain of floss on the ground beside a heavily veiled woman who leans on a piston. Rather more of Brauner's own style is found in a picture of the following year under the punning title *Faux collage-faux-col-âge* (more or less: *False Collage-False-Collar-Age*), well suited to the hide-and-seek game of the picture's shapes and forms. The skeleton of a sea horse dangles on the rim of a top hat, which, together with the head that wears it, dissolves into the dark silhouette of an amphora.

Returned to Paris, Brauner once again turned to material pictures in the manner of his *Mr. K* and, in 1938, produced the *Edible Portrait* (plate 160), its face and neck strewn all over with lentils glued on a gold background, and its large white eyes and full rosy mouth torn out of paper and pasted on. In its rigorous frontality the face stares back at us tensely, shot through with a jumble of lentils.

Brauner's painting went through a change in 1938, due in part at least to an unfortunate brawl in the studio of the painter Oscar Dominguez, in which he lost his left eye, a misfortune already prophesied, mysteriously enough, in 1931, when he painted a *Self-Portrait with Ruined Eye* (Collection Mme. Victor Brauner, Paris). Thereafter his work became markedly esoteric and ambiguous. Bodies and objects appear in floating transparency, as if seen simultaneously by one and both eyes, and his tendency toward mysticism more and more gained the upper hand to evolve a magical world of forms.

During the war years, spent in a village in the French Alps, Brauner incised drawings into layers of wax, a technique much like that of the anonymous grafitti scratched into walls and, like those, giving rise to similarly primitive, directly conceived figures and scenes. Along with these Brauner also filled small boxes with meaningless and unimportant things picked up from the ground. He formed ghostly little figures from stones and tiny bones, fitted out little wax dolls with bits of gauze and untidy knots of hair, and attached them with rusty nails and twisted wires to make *Lovers* or apparitions of the *Night*. Behind them can be made out numerals and signs, pictures of animals, or texts which cannot be deciphered nor even guessed at, but from which good and evil spirits seem to speak. What is normally concealed in the background here forces its way into our attention, but a poetic magic plays over the irony and casts its spell on the bizarre materials.

In Paris, before World War II, the American-born painter HENRI GOETZ (b. 1909) and his Dutch, Java-born wife, CHRISTINE BOUMEESTER (b. 1904), were producing collages and montages which owed more to their own imaginations than to influences from their environment. Goetz started out in 1938 with "painted" collages, "corrected masterworks" that have nothing to do with the Dadaist prototypes by Marcel Duchamp but do correspond to some extent to a Surrealist approach. Using colored reproductions of pictures by eighteenth-century masters such as Fragonard, Rigaud, and

Gainsborough, he subjected them to mysterious transformations by painting into them fantastic forms in such subtle shades of color and so perfectly integrated with the elements of the original that today Goetz himself can scarcely make out just where the lines of separation lie.

Christine Boumeester's experiments took a quite different tack. To an abstract landscape of 1938 in watercolor and black chalk, *Armenian Paper*, she added a small paper giving off incense when burned (whence the title); and in another colored composition, *Barnabé*, she pasted a newspaper advertisement for a Fernandel film which makes a harsh contrast within the context.

Both she and Goetz subsequently made more usual types of collages out of newspaper illustrations. Thus in 1940 Goetz used fragments of photos in a *Portrait* (plate 177), whose head he delineated with transparent dark blue and red papers. Among the realistic photos he also mounted a few Surrealist elements such as a drawing of a billy goat and a picture of a horse's head looking through the window opening in a collapsed wall. The dark letters of a torn piece of poster make the total image even more puzzling. For her part, Christine Boumeester utilizes entire pages of illustrated newspapers and pastes into them cuttings in the same color tonalities so as to make completely unified visions. In a photograph of Piazza San Pietro in Rome, with priests and dark-cowled monks in the foreground, the outspread arms of the pope embrace the cupola of the basilica, while pieces of an open umbrella and a wagon wheel rise from the pavement. Fabulous events take place in a romantic colored landscape of 1940: large hands fly around a sailboat on a stormy sea; a wide-open eye appears on its bow; the sail metamorphoses into a Christmas tree complete with trimmings; a medieval damsel rides a white horse through the waves. In the collages she has begun to do again in recent years, the shapes, colors, and materials are subtly harmonized, and the bits of paper pasted into indefinable landscapes and architecture serve only to emphasize individual textures and structures.

Before the war Goetz maintained merely tenuous connections with the Surrealists, though he was friendly with Dominguez and Raoul Ubac. Initially he resented the fact that Breton insisted on pointing out objective allusions in his pictures, which he himself thought of as completely abstract. Only when Breton returned from America after the end of the war did the relationship grow closer, and it was about 1947 or 1948 that Goetz at last officially joined the Surrealist movement.

Like Man Ray, his senior by twenty years, RAOUL UBAC (b. 1910) also contributed to the Surrealist movement as an experimental photographer. His interest in photography was aroused by a sojourn on the Dalmatian island of Hvar, where he found stones in natural groupings which so fascinated him that he tried to perpetuate them in drawings and photographs. Later, in Paris, he came into contact with Surrealist artists, including Bryen, with whom in 1934, using the pseudonym Raoul Michelet, he published a small volume titled *Actuation poétique*, to which he contributed photos. His real link with the Surrealists, however, came through his countryman Magritte, who arranged for him to take part in the Surrealist exhibition of 1935 at La Louvière in Belgium.

Influences from Magritte and from his venerated De Chirico are plain to see in Ubac's photomontages of 1936. In one, bearing a dedication to De

An exhibition of these small pictures was arranged at the Galerie Gómez in Paris but never took place because of the outbreak of the war.

Works by both artists are reproduced in the exhibition catalogue *Cinquante ans de collage*, Saint-Étienne, 1964.

His birthplace, Malmédy, near the Belgian-German border, was returned to Belgium in the peace treaty of 1920.

223

W.H. Allner, "Raoul Ubac: Surrealismus in der Photographie," *Graphis*, no. 9–10, 1945

At the *Raoul Ubac* exhibition, Paris, Musée National d'Art Moderne, 1968, a few such pictures were shown under the title *Le Combat de Penthésilée*.

Photographs by Ubac were published in *Minotaure*, nos. 10–13, 1937–39. No. 10 also contained photomontages by Jean Lévy, who wrote his own commentary under the pseudonym Gilbert Lély.

Chirico, there is an empty street leading deep into the distance and bordered on one side by a wall covered with incised figures; on this headless statues are lined up, one of which, heavily veiled, has stepped down from her pedestal. Another photomontage, *The Room*, shows an unmade bed with a sheet slipping off it; a piece of the sheet has come loose and stands on the floor as a cube. The empty room with a door opening on a landscape is conceived entirely in the spirit of Magritte.

In 1937 Ubac began to follow Man Ray's lead in solarizing his photographs and in giving them the effect of relief by printing the same negative twice on the same sheet but with a slight displacement. Then he cut out these and other prints and assembled them in collages, which he photographed anew and to which he added other photographs. Thin strips of fragmented bodies and disjointed limbs are laid out in vertical rhythms between traces of pebbles and shards, and these fragments, raised in relief above the background, convey a vision of tragic destruction (plate 182). He went even further in experiments in using photography to draw from visible forms others lying latent and concealed within them. By warming, the gelatin layer of the exposed paper is made to melt, so that the contours of images break down into granular structures and then harden into "fossils." Objects and buildings, the Paris Opéra, the Eiffel Tower, the Bourse, and so forth, thereby take on the appearance of petrified panels on which only vague contours can be discerned. After using these "photo-imprints" in 1942 to illustrate Jean Lescure's poems *L'Exercise de la pureté*, Ubac gave up photography, though soon thereafter he began to produce analogous structural forms on slabs of slate.

Picasso too tried his hand in 1937 at this sort of experiment. Working in Man Ray's studio, he went back to the process of "*clichés-verre*" (prints from glass plates), for which, instead of the usual unexposed plates, he made use of certain of Man Ray's Rayographs by incising contours into them. Thus, for example, he engraved a *Portrait of Dora Maar* in a Rayograph which itself was based on tulle and laces. Georges Hugnet, who published the results in the same year in an article "Picasso photographe?" in *Cahiers d'Art*, explains that Picasso was interested in combining mechanical—that is, photographic—procedures of reproduction with original engraving, and he states that he himself had also seen some attempts at original photos with engraving.

Later Picasso combined photography and collage in the album *Diurnes*, on which he collaborated with Jacques Villers and which appeared in 1960 with texts by Jacques Prévert. He cut mythological figures and heads out of Villers's photographs and photograms and pasted on them eyes, noses, and mouths made of black paper. From sharply contrasted photographs of walls and roofs streaked with shadows, or from exposed mat-surfaced papers on which leaves and flowers had left blank white shapes, in which the added black papers appear to carve out holes and notches, he brought into being heads resembling nothing so much as mirages conjured up by some malevolent spirit.

Arp's collages carry over from the Surrealist years right into the art of today. He pioneered new ways with collage in 1930, when he began to tear up papers and combine the fragments into arbitrary compositions. Disappointed by the fact that the perfection he and Sophie Taeuber had sought to

give their geometric collages during the war did not withstand the passing of the years—that the paper went yellow, and the colors faded, and the cardboard buckled—he reacted by deliberately mishandling his materials. He spilled India ink and size over sheets of paper in order to provide a raw material of absolutely no worth in itself. He tore and cut up drawings and prints, pasted shreds of paper on blocks of wood, which he then smeared over to make new "proofs," once again to be broken up and reworked over and over (plate 181).

Nevertheless, as time went by, Arp felt the need to give some positive value to this destruction of material and to use the forms arrived at accidentally as fragments that could be combined into new compositions. At that point he began to close up the broken contours and produce new figurations by bringing the fragments into some sort of vital interrelationship. In these works the transparent structures of graphic prints intertwine into eerie ornaments, and the vestiges of black India-ink drawings metamorphose into alarming signs on gray-flecked grounds. In his *Collage-Trompe-l'Oeil* of 1947 the cut-up photos of a three-dimensional relief, pasted on a green-toned ground, create spatial ambiguity.

In 1938 *Minotaure* published four such *"papiers déchirés et interprétés."*

In all these manipulations Arp was pursuing his own idea of separation and reunion, of death and resurrection. He held to his belief that deeper processes of life are disclosed by chance as it guides the hands that tear the paper and thereby allows forms to arise without premeditation; and this approach is part and parcel of the Surrealist way of thinking.

Germany

In Germany, the only real contribution to Surrealist collage was made by FRANZ ROH (1890–1965). The idea came to him in the course of his work as an art historian, when one day, having spread a number of reproductions in front of him, he discovered that certain unrelated images, when looked at in unexpected combinations and juxtapositions, acquire a new and deeper meaning. Encouraged by Max Ernst, he began in the 1920s to assemble montages in the spirit of that artist. Later he was able to devote more time to them, once the Nazis came to power and he was obliged to cease his activity as a writer. Like Ernst, he favored old-fashioned printed illustrations, which could be taken to pieces and shuffled around, and for backgrounds he took engravings of romantic landscapes and views of cities, pasting into them foreign elements without regard for natural proportions. Out of these he invented extremely adventurous and hair-raising scenes, in which at times his grotesque humor approaches the threshold of icy terror, and even a harmless joke conveys some deep significance. Perfectly innocent animals swell up into gigantic freaks and spread panic in safe-and-sane domestic interiors and in the streets and public places (figure 42). Plants and objects unite in uncanny metamorphoses. Hands become independent, act on their own to carry out suggestive maneuvers, and eyes and ears keep watch over mysterious developments.

Exhibitions: *Franz Roh: Collagen*, Munich, Kunstkabinett Otto Stangl, 1961; and *Franz Roh: Metamorphosen—Gegenständliche Collagen*, Wuppertal, Galerie Parnass, 1963

Roh based his compositions on a carefully worked out distribution of graphic textures and of areas in light or shade, knitting together his heterogeneous elements in such a way as to leave something of their joinings

Figure 42. Franz Roh. *She covers the fire with her shield, and yet the human shadows rage.* 1933. Collage

Miroslav Lamač, "Koláž v současném českém uměni," *Výtvarné umění*, no. 6–7, 1966 (with German summary, "Collagen in der tschechischen Kunst von heute")

visible and thereby to create a source of tensions. His chief concern was to show the interrelationships which, in a world that has come apart at the seams, somehow do hold together the scattered but nevertheless intact components. He believed that the principle of montage also plays its part in the structure of family and state, whose good functioning, he thought, depends on the preservation of individual independence by the various members of the community.

Czechoslovakia

ADOLF HOFFMEISTER (b. 1902) is generally conceded to be the grand master of collage in Czechoslovakia, but he can be counted among the Surrealists only to the extent that, as much at home in Paris as in Prague, he maintains friendly relations with all the adherents of the movement, as is shown by his many portraits of them. From his youth, Hoffmeister's talent and interest have centered on portrait caricatures, and there are few writers or artists of note whose features he has not recorded with infallibly aimed darts of humor. In Paris in 1927 he drew the Surrealists Soupault and Ribemont-Dessaignes, as well as the collaborators on the review *Le Grand Jeu*, among whom was his countryman Josef Šima. Hoffmeister's *Faces* were exhibited in November of 1928 at the Galerie d'Art Contemporain in Boulevard Raspail.

226

It was in 1928 that Hoffmeister began to introduce isolated collage elements into many of his portraits, using illustrations or cutout words which, either in earnest or humorously, in some way characterize the sitter. Thus, in a drawing from that year, with the title *Globe and Cross*, the English Catholic humorist G. K. Chesterton soars in the air with one foot on a cross and with a globe of the world filling his paunch (figure 43).

A 1930 portrait of George Grosz shows that Hoffmeister was also acquainted with the Berlin Dadaists. In 1934 he attended a show of John Heartfield's photomontages held at the Maison de la Culture in Paris, and their pungent political criticism and hard-hitting impact made a great impression on him. Nevertheless, his preference remained for Surrealists such as Max Ernst, whose portrait, titled *First Collage*, has pasted on it pictures of a book, a bird cage, a revolver, and two sleeping girls, though to his drawing of Aragon he added only a symbolic red flag and to that of Ehrenburg a red star. Other Russian writers, however, received somewhat more colorful depictions: Pasternak's portrait, on which is pasted his photograph, is drawn on red cardboard; and Tretyakov is dressed in a green paper with Chinese characters, his arms embracing a picturesque view of a Chinese city.

Although Hoffmeister had connections with Štyrský, Toyen, and Vitězslav Nezval in the early 1930s and did portraits of them, he held aloof from the Surrealist group that those artists, together with Teige, Vincenc Makovský, and others, organized in 1934. The new group had much give and take with the Parisians, and Štyrský and Toyen, who had been present at the birth of the movement in Paris, threw their influence behind it and carried on their own work according to the Surrealist canons.

All this activity induced Jindřich Štyrský to return to collage, and in 1934 he produced a series of sixty of them titled *Stekovaci Cabinet*, which means something like "housemovers' agency." The "moving" meant that complete objects had been taken apart and then reassembled into a colorful confusion. All sorts of cutout illustrations were combined into compositions in which proportions were altered as arbitrarily as distances. Štyrský delighted in grotesque inventions: two gigantic shoes perform a balancing act above a bathtub (plate 183), a sewing machine soars above a battlefield, two elegantly stockinged female legs end up in rosy pink hams, a man's sock stands up from a cake like a big toe. Though most objects are presented without backgrounds as if in empty space, upon occasion Štyrský utilized banal and trashy colored prints, which he reworked with a few minor additions in the manner of Marcel Duchamp. In other instances he followed the lead of Max Ernst and pasted illustrations of orthopedic appliances or anatomical diagrams into his collages, as on the cover for a 1936 Surrealist publication, where he transformed a love scene into something terrifying.

Štyrský and Toyen collaborated on illustrations for a volume of the collected works of the Czech writer K. H. Macha on the occasion of his centenary in 1935. Among them were collages in a fantastic-romantic style more suggestive of Toyen than of the usually sarcastic Štyrský. Toyen's poetic gift made her sympathetic to the contemporary poets, and she designed a very romantic title page in collage for Nezval's *Řetěz Štěstí (Fortune's Chains)* (figure 44). She struck a more specifically Surrealist note in a montage for the cover of the Czech edition of Breton's *Les Vases communicants* (figure 44), as did Štyrský in his cover for Éluard's *La Rose publique*.

Figure 43. Adolf Hoffmeister. *Globe and Cross*. 1928. Drawing and collage

M. Lamač, *Výtvarné dílo Adolfo Hoffmeistera*, Prague, 1966

Vratislav Effenberger, "Surrealismus v tvorbě Jindřicha Štryského a Toyen", *Výtvarné umění*, no. 5, 1967 (with full translation in French)

Both books appeared in 1935, after Breton and Éluard had visited Prague early in that same year and given lectures, read from their own works at the evenings organized in their honor, and in general allowed themselves to be fêted as the greatest living French poets. The Prague group organized a Surrealist exhibition and published the first *International Surrealist Bulletin*, in which the Czech writers Nezval and Zavis Kalandra championed the revolutionary aims of Surrealism and declared themselves at one with the Parisians in that regard.

On April 1 the magazine *Světozor* put out a parodistic special number copiously illustrated with photomontages signed by Štyrský, Teige, and others using invented or jumbled names. The highly successful, rhythmically articulated compositions they produced (plate 184) are proof of the mastery of the medium achieved by the young Prague artists, who undoubtedly had learned much from John Heartfield when he emigrated to Prague in 1933 and began to publish a political photomontage each week in the local left-wing press.

It was KAREL TEIGE (1900–1951), however, who arrived at new Surrealist forms of photomontage which went far beyond skylarking and clever satire. As ideological leader of the progressive artists of Prague, he took an active part in the various steps of the development of collage there. After early poem collages, from 1927 to 1929 he designed title pages for the magazine *ReD*, incorporating collage and montage elements into modern typographical page layouts. For the Czech edition of Breton's essay *What Is Surrealism?* in 1935 and for Nezval's *Woman in the Plural* in the following year, he designed book covers similar to those made by Štyrský and Toyen (cf. figure 44).

Beyond all these activities more or less connected with publicity, from 1936 to his death Teige also continued to make photomontages of a private character and showed them to only a few friends. These constitute a continuous sequence of fantastic visions in which he cast off the oppressiveness of daily life. For these he used magazine illustrations, pasting into them here and there photos and prints so that disconcertingly disproportionate apparitions loom up unexpectedly in streets and landscapes. Fragments of nude photos make sculptural torsos haunting vast empty piazzas (plate 189). Arms and legs join in dance poses or make candelabra for some ungodly liturgical rite. Bodies are penetrated by solid objects, submit without protest to nightmarish transformations. A slender female figure (plate 188), with wings coming from her breasts and a basket filled with a large clenched fist for her head, stands in a landscape surrounded by a frame which makes her look as if she were appearing on a picture screen. In front of this, across a patch of ground strewn with stones and machines, the shadowy silhouette of a woman looks on from behind a balustrade like that in a theater box. Naturalistic and metaphysical elements, eroticism and black humor combine in these collages, in which Teige pushed to their limits the utmost possibilities of Surrealism.

Not only collage and montage but also sculpture and reliefs combining various materials were produced in the 1930s in Prague, and interest in such works was stimulated by a lecture given there by Breton in 1935 on "the Surrealist situation of the object and the situation of the Surrealist object."

Figure 44. Toyen. Covers for Czech editions of André Breton, *Les Vases communicants*, and Vitězslav Nezval, *Řetěz Štěstí (Fortune's Chains)*, Prague, 1935. Collage

The sculptor VINCENC MAKOVSKÝ (1900–1966), who was active in the Surrealist group, had already experimented with new and unconventional materials as early as 1929 or 1930. For instance, in a relief of a reclining woman an iron rod and a verdigris-covered sheet of metal appear among abstract blocklike shapes. After stone sculpture of dreamlike character such as a *Young Girl with Child* of 1933, in his Surrealist phase Makovský made plaster of Paris reliefs which he painted with dirty colors and into which he stuffed scraps of cloth, ropes, and so on.

Reproduced under the title *Composition* in the exhibition catalogue *Sculpture Tchécoslovaque de Myslbek à nos jours*, Paris, Musée Rodin, 1968

There are reproductions of his works in the above-mentioned *International Surrealist Bulletin*.

In 1934, the sculptor LADISLAV ZÍVR (b. 1909) gave a touch of Surrealism to a painted wooden relief of three women with black veils by adding a glass eye and metal shavings. A year later, however, he produced true Surrealist objects, hanging wires, cords, nets, and the like on wax or terra-cotta sculptures. Lautréamont's *Les Chants de Maldoror* inspired FRANTIŠEK GROSS (b. 1909) in 1937 to produce some remarkable assemblages, typical of which is *It Is a Man, a Stone, or a Tree That Will Begin* (plate 186). Here everyday objects such as a spoon, scissors, syringe, buttons, and pieces of wood are mounted in a painting which unifies them into a single fantastic expression.

Reliefs by Makovský and Zívr can be seen in the collection of Czechoslovak sculpture in the Castle of Zbraslav.

M. Lamač, "Pokus o 'desifraci' Františka Grosse," *Výtvarné umění*, no. 5, 1967 (with translation "Trying to Decipher František Gross"). This is an interview.

About 1930 Gross found in French magazines reproductions of works by Marcel Duchamp, Picabia, and Max Ernst and was fascinated particularly by their mechanical inventions. He was eventually led to create pictures of imaginary machines, as in his *Hot Jazz Sextet* of 1936, which points to a

Václav Zykmund, "František Gross," *Výtvarné umění,* no. 5, 1967 (with Russian translation)

The works of Rykr are in the museum at Chotěboř.

Jindřich Chalupecký, "Zdeněk Rykr," *Výtvarné umění,* no. 8, 1964 (with summary in German)

Eva Petrová, "Umění objektu," *Výtvarné umění,* no. 6–7, 1966 (with French translation, "L'Art de l'objet")

Exhibition catalogue, *Objekt,* Prague, Galerie Špálova, 1965

František Smejkal, "Heisler," *Výtvarné umění,* no. 9, 1965 (with summary in French)

Heisler also wrote texts for a series of grotesque photographs in 1935, *Na lehlách těchto dní (On the Needles of Our Days),* which Štyrský had contrived out of "idiotic paintings," but the present writer knows nothing more of them.

Reproduced in the exhibition catalogue, *Exposition internationale du surréalisme,* Paris, Galerie Daniel Cordier, 1959–60

certain relationship to the humor of Miró. Gross has persisted to the present in this style based on decorative flat areas. In a picture of 1964, *Monument of Art,* the names of all the artists he reveres, from the Cubists to the Surrealists to Jackson Pollock, are written around the framework, but that of Miró appears in large letters directly beneath the central axis and that of Max Ernst on a ring in the middle.

Oddly enough, the most independent and astounding experiments with materials were conducted by an artist who had no connections with the Surrealist movement, ZDENĚK RYKR (1900–1940). In 1934 he went back to Schwitters's sources and mounted together all sorts of casually collected rubbish: bones, rags, sheet metal, smashed dishes, feathers, leaves, old newspapers, posters, and illustrations of every kind. Revolt was not enough, however, and he soon returned to a more artistic, more thoughtful approach. In a sequence of material reliefs of 1935 grouped under the title *Orient,* Rykr arranged small stones, narrow strips of paper, thin pieces of wood, and lengths of string on painted grounds in compositions of a nature-oriented poetry. These were followed a year later by *Glass* (plate 187), a cycle of assemblages of materials pressed between two sheets of glass. In the midst of scraps of crumpled paper, blades of straw, shreds of cloth, and bits of twine emerge primitive human figures, animals, and dwellings somehow reminiscent of the images found in prehistoric cave paintings. Some critics have even claimed Rykr's work as a forerunner of the *Art brut* launched by Jean Dubuffet.

Rykr went to Paris in 1936 and exhibited at the *Salon des Surindépendants* of that year and in a group show at the Galerie L'Équipe the year after. In Prague too, in the next year, he exhibited together with Léger, Masson, Jean Lurçat, and Delaunay, with whom he had been in contact in Paris, obviously steering clear of the Surrealists at home and abroad.

Their second exhibition, the last before war broke out, was organized in 1938 by the Prague Surrealists. During that year they were joined by the poet JINDŘICH HEISLER (1914–1953). A close friend of Toyen, he hid out in her house during the war years, and there they collaborated on joint projects. Heisler wrote poetic texts for Toyen's cycles of drawings, and in turn she derived artistic ideas from his poems. With Toyen's help, in 1941 he was able to cast his *Casemates of Sleep* in the form of picture poems, with the texts composed in cutout letters pasted on large sheets and surrounded by three-dimensional material (plate 185). He covered the grounds with crumbled coal and sugar or moth balls and then embedded miscellaneous objects such as broken bottle necks, toy figures of animals, or plants. In 1944 Heisler composed a sequence of "photo-graphics," *Of the Same Kidney*—unearthly compositions made from gelatin, glycerine, soap lather, and splinters of brushwood, modeled on flat slabs and then illuminated. Besides these he also produced highly inventive photomontages, one of which, *Espalier,* 1944, involves a photograph of a nude girl whose back is cut open to reveal a five-branched candelabrum decorated with branches, fruit, and a bird.

Throughout the war the Prague Surrealists could carry on their activities only clandestinely. Whatever books they published were in small editions intended for their immediate circle of friends. In 1941, a year before his death, Štyrský initiated a new series of collages, *Cardinals,* caricaturing with

Colorplate 33. Ella Bergmann-Michel. *Of the Moon's Light*. 1922

Toyen managed to take these with her when she emigrated to France.

Georges Goldfayn, "Jindřich Heisler," *Phases*, no. 8, 1963

Ilya Ehrenburg writes about Nezval as a personality in *People and Life*, London, 1961.

mordant acrimony the Princes of the Church in various countries, among them France, Germany, and the United States. As for Toyen, in 1946 she published two cycles of drawings done in Prague during the war, *The Shooting Match* and *Hide Yourself, War*, visionary impressions rendered in compositions of isolated elements conforming to the category that Marcel Jean calls "drawn collages." However, she did turn to genuine collage at least once again, in her *Natural Law* of 1946 (plate 190), which depicts a multistoried apartment house, cut away in front to show the interiors linked by a staircase leading to the roof. Within its stagelike interiors and exteriors, dreamlike scenes are being played, and here and there, amid the naturalistic painted details, cutout illustrations are pasted in.

Soon after Toyen and Heisler emigrated to Paris in 1947, Heisler, who had already produced Surrealist objects in Prague, exhibited at a Surrealist show in the Galerie Maeght. His contribution was an altar dedicated to the playwright Alfred Jarry, author of *Ubu Roi*, and it included a weathercock set in motion by white mice. During 1950 and 1951, for his friends Toyen, Breton, and Péret, he made "book-objects"—boxes with open sides in which paltry odds and ends, little stones, glass marbles, labels, and so forth, were arranged like lines of verse. The one made for Péret had a doll's spoon and shoe, safety pins, a flower of glass splinters, a little fish, and other findings juxtaposed to a magical abstract drawing. By his loving handling and arrangement, Heisler endowed these trivia with a strange charm. Subsequently he invented a "collage alphabet" of letters put together, in the manner of Max Ernst, out of old engravings, which, when assembled, made terrifying word images.

Hoffmeister continued to turn out collages in Prague, still reflecting his Surrealist links. Three of them from 1959 depict *The World of Max Ernst*, *The Games of Joan Miró*, and *The Breath of Surrealism*; and a very fine series from 1960, *Nezvaliáda*, is devoted to Nezval, the great poet of Czechoslovak Surrealism. Beginning with *The Birth of a Genius in Moravia*, where Nezval's squat, bull-necked figure breaks out of its egg in a wash basket, we are shown his achievements, favorite pursuits, and functions as *Guardian Muse of Czech Poetry*, as *Composer*, as *Mead Drinker*, and so on in scenes of jovial irony, one of the most grotesque of which shows Nezval visiting Edison and reading to him with extravagant declamatory gestures from an opus dedicated to the inventor. Hoffmeister's portraits in collage and drawing of Léger, Picasso, Chagall, Kupka, and Ernst were exhibited in the Czech Pavilion at the Venice *Biennale* of 1964.

By means of collage Hoffmeister creates truly unique images. In the *Typographical Landscapes* from his travels in France, Italy, Hungary, and elsewhere, the houses, mountains, valleys, and trees are all composed of pieces of printed matter. In that of the *Caucasus* (plate 191) the main features of the setting are made of cut-up texts in Russian and Georgian characters of all sizes and degrees of blackness, while the other essential contours are sketched in with brush and India ink. Hoffmeister has illustrated Jules Verne's *Around the World in Eighty Days* in the style of old mail-order catalogues, and for Mayakovsky's book for children, *Of Things Gay and Grave*, he provided collage illustrations in a naive geometric style somewhat like that devised by Lissitzky in 1923 for another children's book, *For the Voice*.

Like the Czech Rykr, the Dane HENRY HEERUP (b. 1907) is one of those artists who follow Vincent van Gogh's lead in rummaging through dustbins and dumps, finding their material in anything that possesses some kind of shape or color. His mania for collecting, in which he resembles Schwitters, revealed its first symptoms in his earliest childhood, when, at the circus, he was overcome by the desire to pick up all the colored admission tickets the public had discarded. Even as a student at the Copenhagen Academy of Fine Arts he found he could not resist the compulsion to steal as common a thing as a curtain rod. He began by studying painting and developed a personal expressive style of a folklike colorfulness but then, despite his teacher's disapproval, insisted on trying his hand at sculpture. When he discovered that strange figures lie dormant in blocks of stone, he took to dragging anything he could get hold of into his garden, which soon, under his hands, became populated by gnomes and trolls. From the expeditions into the country that he undertook on his bicycle he carried home other things too—leaves, flowers, feathers, but especially all kinds of junk that he could add to the steadily growing stock of material for future works.

About 1930 he made small statues, which he trimmed with odds and ends from his "collection," beginning with an ape he modeled from life at the zoo and then at home added blue and green marbles, having, as he explained, "found what was lacking." What interested him was "combining something painterly and something sculptural" so as to bring out contrasts in materials. He set his clay figures on pedestals of broken pieces of gutter pipe and fastened them with large bent nails. Alongside a group of a seated *Woman and Child* (Collection the artist) he erected a kind of landmark of iron hooks, empty rifle cartridges, and screws, and inserted into it a broken mussel shell. He used a pine cone to crown a *Pan* (private collection) made from a spiral pipe. Among his most disconcerting compositions is a relief (plate 192) consisting of a raveled knitted mitten nailed below a child's head modeled in clay and surrounded by an iron band.

Shortly after 1930 Heerup produced his first thoroughgoing *Rubbish Models* made up exclusively of junk, which stimulated him to the most venturesome innovations. Although he knew nothing about his Dadaist predecessors, he must have read about the *Art from the Trenches* exhibition held in Copenhagen during the war, which had led his compatriot Vilhelm Lundstrøm to the idea of his "packing-case pictures." Daring as the latter was in his time, Heerup went well beyond him in utilizing old materials purely for themselves, without disguises.

After his marriage in 1933 Heerup opened a small art gallery in an attempt to supplement his meager income. Among the displays were his *Rubbish Models*, and he even found a buyer for one of the most scurrilous objects ever made, a dried and lacquered rat attached by a gilded cord to the spring of a bicycle seat and nailed to a wooden cross (Collection Niels Rue, Copenhagen). In 1934 he carved out of a tree trunk his *Gramophone Man* (Collection Anna and Kresten Krestensen, Gentofte, Denmark), which he painted in bright colors and decorated with a flower, a heart, the cross of an order, a pot lid, and other bric-a-brac, clapping on it, as a final touch, an old-fashioned curved gramophone horn by way of a hat. About 1937 he produced a relief

(plate 194) on which clothespins, a folding ruler, a knife handle, buttons, and metal fittings are mounted densely one against the other and surmounted by the spout of a coffee pot. The coffee pot itself was saved for another work of art, the *Coffee God* (Collection the artist), where it serves as pedestal for a wooden bust. On another occasion an old iron oven was converted into a piece of sculpture.

From 1934 to 1937 Heerup participated in the exhibitions of the Linien (Line) group, which included Richard Mortensen, Eiler Bille, Egill Jacobsen, and Carl Henning Pedersen, and later he joined the CoBrA group, though basically he has always gone his own way, regardless of fads and fashions.

During the war, when Denmark lived under the heel of the Nazi occupier, a sharper sarcasm broke through in Heerup's images. In 1941 he assembled an austere wooden bust, *Christ with the Crown of Thorns* (Collection Ole Schwalbe, Denmark), incorporating tangled string, wire flowers, and metal prongs. Harder-hitting and more agitated in general effect is *Death, the Reaper* of 1943 (Louisiana Museum, Humblebaek, Denmark), in which Death, in lieu of a scythe, swings an old chair leg and arrives in a conveyance to which are fastened a curved mudguard and the wooden wheel of a toy wagon. During the same years Heerup also devised somber animal masks by nailing together old fragments of furniture with buttons and knobs and mounting them on an old scrub brush or crowning them with a carpet beater. He constructed a *Peacock* (Collection the artist) out of knots of roots, barrel staves, hose, and wire netting, and this was succeeded by other fabulous beasts assembled from his motley plunder and set out in his garden exposed to sun and rain. Some of his more recent works have a cheerful, childlike poetry, as in the relief of the *Seagull Girl* of 1955 (Collection the artist), a bird body covered with seagull feathers and topped by a smiling doll's head wearing a battered kitchen sieve as a hat. In *Village* of 1960 (Collection the artist) a bright-colored cock rises alongside a wooden church tower on a rubbish heap, along with a flower pot, a horseshoe, stones, bottle caps, chains, and so on.

He exhibited thirty-five stone sculptures and reliefs at the Venice *Biennale* of 1962.
See also *Signum*, vol. 3, no. 2, 1963; exhibition catalogue *Henry Heerup*, Paris, Maison de Danemark; and Preben Wilmann, *Heerup*, Munksgaard, 1962.

Although Heerup is widely recognized as a painter and sculptor, his *Rubbish Models* have remained scarcely known outside of Denmark. Yet it is precisely because of them that this extraordinarily gifted collector of trash, who understands how to awaken to new life every object he stumbles on and every broken bit of secondhand material, takes an authentic and incontestable place among the forerunners of present-day Pop Art.

Surrealism true and proper reared its head for the first time in Denmark at an exhibition of Surrealist and Cubist art held in January of 1935 in Copenhagen, which included not only native artists but also some invited guests from Sweden and France. Led by the painter Vilhelm Bjerke-Petersen and William Freddie, the movement gained ground, and its diffusion was spurred by the four issues of the magazine *Konkretion*, brought out in 1935 and 1936.

WILLIAM FREDDIE, pseudonym of Frederick Wilhelm Carlsen (b. 1909), furnished so much material for scandal in the decisive years of the movement that even Dali can scarcely match his record. Nevertheless, he began his career with very sober Constructivist works, and he still has a wooden relief he made in 1927–28 that is a strictly objective composition of straight lines,

rectangles, and circles, though yellow, brown, gray, and bluish tones lend it a certain warmth. A wooden molding and a piece of frame nailed into a collage of 1928 reminds one of the early efforts of Vordemberge-Gildewart. The first symptoms of Surrealism in Freddie's work are found in a material collage of 1933, *Nocturne* (plate 195). Its abstract forms, made from corrugated cardboard or crumpled paper and a small block of wood, are joined by the cutout and pasted photograph of an illuminated hand that seems to foreshadow the coming of disquieting times.

By 1935 Freddie had achieved a fully Surrealist composition, *Salomonic Inspirations* (Collection the artist), a color print of Rubens's *Judgment of Solomon* on which he pasted grotesque pictorial elements that completely transform the picture. One of the mothers holds a horse on her lap, the mouths are covered by animal-like goggle eyes, a large wine glass is jammed down over one of the priests, and in the center an anatomical photograph of the lobes of the lungs looks like the yawning of the abyss. These accretions were selected in order to demolish the Baroque pathos of Rubens's painting.

Freddie began in 1936 to fabricate objects more or less on the model of Dali's, among them the ominous female bust *Sex-Paralysappeal* (Moderna Museet, Stockholm). The more innocuous *Italian Girl* (Collection the artist) has a rubber overshoe over the nose, and hung on a rope around the neck is a framed self-portrait of the artist, to which is nailed a toy boat. That same year Freddie was invited to show in the *International Surrealist Exhibition* at the New Burlington Galleries in London, but his works were confiscated by the English customs authorities as an offense against decency. At the very last moment the intercession of the exhibition committee at least averted the burning of the works, as the law required, and managed to get them shipped back to Copenhagen.

A year later Freddie met with even greater difficulties when the police confiscated his "Sex-Surrealist Works" at the opening of a show in Copenhagen. These comprised two pictures and an object, *Zola's Writing Desk* (Louisiana Museum, Humblebaek, Denmark), which consisted of the bust of a clothing-shop dummy mounted horizontally on a pedestal with, affixed to it, a revolver and an inkwell with penholder, and dangling from it was a bottle inside which floated a tiny celluloid doll. To be on the safe side, Freddie hid the revolver in his pocket during the raid and had to endure the agonies of the damned in the course of the police hearing lest he be searched. He was sentenced to ten days in jail on the charge of "pornography" (he had to serve only half of them), and his works had to be surrendered to the Criminal Museum of the municipal police. As if that were not enough, in 1937 the German Embassy in Copenhagen protested against his *Meditation on Anti-Nazi Love* (Museum, Silkeborg, Denmark), which included a pasted portrait of Hitler, and he was declared *persona non grata* in Germany.

From time to time Freddie enjoys enhancing the outright nonsense of his works by giving them preposterous titles and "program notes." Thus a relief of 1937 (plate 193) consists of no more than a doll's crocheted bootie stiffened in plaster and a dismantled pair of wooden shoe trees laid out on the background, but it bears the following legend-cum-title: *The pink shoes of Mrs. Simpson, woven from thyme in blossom, travel lonely on the P.L.M. [Paris-Lyons-Mediterranean] line. To believe that the choral societies of the small garrison towns played "La Madelon" would be to profane the solemn mission of*

In his use of photographs in non-figurative compositions also, Freddie follows the example of Vordemberge-Gildewart.

Twenty-five years later, when preparing for a retrospective exhibition, Freddie petitioned for the return of his works. However, not only was his request refused but also the replicas he had made in the meantime were seized by the police at the opening of the show. He thereupon instituted suit, and after a trial that dragged on for two years the originals as well as the copies were finally handed back to him.

the pink shoes. *The Eiffel Tower, Buckingham Palace, and the Statue of Liberty warbled the heroic tune that brought all the watches of the world to a standstill.* A small label with the title *Take the Fork out of the Butterfly's Eye* (Collection the artist) is glued on a photomontage, also from 1937, in which words and cutout illustrations, Freddie's portrait, two female legs in stockings, fragments of a nude photo, a newspaper picture of a dead soldier, and so forth are distributed across a photograph of a honeycombed sheet of fiberboard.

Nevertheless, despite all these scandalous and provocative works, Freddie produced others of more unruffled character, such as the 1937 *Portrait of My Father* (colorplate 29), with its array of heterogeneous everyday or sentimental objects having some reference to the life of that gentleman, beginning with a tiny doll (an allusion to the as yet unborn "I") and ending with the heavy door chain whose bolt is drawn when human existence ends. Here, in a way, Freddie anticipates the "Neo-Realistic" portraits by Fernandez Arman, who simply empties into transparent boxes the contents of wastebaskets, which, he says, reflect the personalities of his "sitters." Unlike him, though, Freddie makes a thoughtful selection from the materials on hand, and because he lays them out as if in the glass showcase of a shop, they take on a remarkably forceful and impressive quality. Using the same approach, in 1938 he portrayed his own family (Collection the artist), surrounding their framed photos with string and nails which, to all intents and appearances, were meant for hanging the pictures but which nonetheless arouse quite different and disturbing associations.

In 1944 Freddie eluded the persecutions of the German occupation by fleeing to Sweden. In Stockholm, where he lived up to 1952, he continued to work in his Surrealist idiom, and some pictures of this period take on symbolic forms that recall Brauner's magical works. From 1955 on, he turned to a richly painted, abstract style, still using frequent collage elements. Once again, in *The Pair After Us* of 1960 (Collection H. Klarskov, Copenhagen), he pasted in cutout illustrations of typical Surrealist character, and his *Portrait of Richard Wagner* of a year later (Collection the artist) is covered with clothespins and shows that his old sarcasm can still break through upon occasion.

England

It is difficult to make any clear distinctions among the various artistic tendencies that appeared in England, one after the other, between the two World Wars. When the English younger generation, for so long isolated, set about making connection with the artistic mainstream on the Continent, it went through each of the stages it had missed, but in a condensed and concentrated form. Painters and sculptors such as Ben Nicholson, Barbara Hepworth, and Ceri Richards went to France, where, seeing firsthand what Picasso and Braque were doing, they discovered retroactively the Cubist roots of their own art. Subsequently English artists began to come to terms with Constructivism when the Nazis took power and the ensuing emigration from Germany took Gropius, Moholy-Nagy, and Gabo to London as early as 1934 and 1935. The influence of nonfigurative art was given added impetus when Mondrian too went there from Paris in 1938. Meanwhile,

In 1950 Freddie made a Surrealist film, *Spiste horisonter (Devoured Horizons)*, with images that are a blend of romantic poetry and eroticism.

Roland Penrose and other habitués of the Paris art circles were able to keep their countrymen informed of the ideas and aims of Surrealism. Consequently artists often responded to one stimulus after the other, rethought each of them in terms of the native tradition, and transformed them into something that could be called English. With new approaches came new techniques. Within a few years innumerable collages and material pictures appeared, and they reflected the most diverse stylistic prototypes.

The first modern collages of English origin that we know are found in the work of EDWARD BURRA (b. 1905) at the close of the 1920s. It was about that time that Burra's painting shifted toward a Surrealism marked by influences from Dali but also from the Vorticism of Wyndham Lewis, though Burra's impulse to cut and paste probably went back to stimuli and impressions of earlier date than those. His subject matter centered around scenes of the underworld, night life, sailors' bordels, and pothouses, and inevitably the name of George Grosz leaps to mind, though, in fact, Burra found models also in the earlier work of Otto Dix, whose coarsely caricatured low-life types are even closer to his own. Like Dix, at the outset Burra interpolated collage elements sparingly into the mass of painted figurative details in his pictures. The deliberately offensive realism that such elements take on with the Berlin Dadaists dissolves, with Burra, into Surrealist fantasy. One of his collages of 1929, *The Eruption of Vesuvius*, has three ghostlike female figures in a dim locale, two of them with clockwork where their faces should be, the third with a table top on her legs in place of her belly, and on the table are a cup, jug, and a large bowl filled with heads cut out of various prints. Burra uses the same montage procedures in his paintings, putting together weirdly assorted abstract and animal components to make unearthly hybrid creatures. More recently his collages incorporate a diversity of pictorial elements such as picture postcards, fashion plates, and cutout illustrations of all sorts, which he binds together and completes with line drawing (plate 203). These have a certain affinity with Miró's collage series of 1933, though Miró's various ingredients are isolated and opposed, influencing one another from a distance, so to speak, whereas with Burra they intermingle and intersect in a varicolored hurly-burly.

Unexpectedly enough, in 1933 collage occasionally began to appear in the paintings of BEN NICHOLSON (b. 1894), largely as a result of his conversion to abstraction under the impact of Cubism. The year before, he had met Picasso and Braque in Paris, and soon thereafter he and Barbara Hepworth visited the latter in his studio in Varengeville. In the still lifes that Nicholson painted during that year in France, he attempted to develop pictorial space out of the stratification of planes, and, like the Cubists, he included painted words and texts as two-dimensional elements. The words "Talc de Coty" on the label of a flat container fills the geometric middle field of a still life from 1932 (Collection Margaret Gardiner, London); a newspaper with the painted title *Journal de Rouen* makes up the background of another still life (Foundation Edward F. W. James, West Dean, Sussex).

Nicholson has written about the origins of his most impressive painting of this sort, *Au Chat Botté* (City Art Galleries, Manchester, England). The words, in glowing red letters, struck his eye one day from the window of a shop in Dieppe, and since he knew little French at that time, they seemed to

Vorticism (from "vortex") was founded by Lewis in 1914, forging Cubism and Futurism into a unique and personal style, which nevertheless gained few followers or imitators of any distinction.

John Rothenstein, *Edward Burra*, Harmondsworth, Penguin Books, 1945; and John Rothenstein, *The London Magazine*, March, 1964

Reproduced in *Unit One*, the programmatic publication of modern English art edited by Herbert Read in 1934. It is difficult to ascertain whether anything has survived of Burra's earlier collages.

Reproductions of most of the works mentioned will be found in *Ben Nicholson: Drawings, Paintings, and Reliefs*, introduction by John Russell, New York, 1967.

In "Notes on Abstract Art," *Horizon*, October, 1941

him particularly mysterious. He found childhood memories of the tale of Puss-in-Boots coming back to him, and in that poetic mood he saw in his mind's eye a picture split into three layers: "This name was printed in very lovely red lettering on the glass window—*giving one plane*—and in this window were reflections of what was behind me as I looked in—*giving a second plane*—while through the window objects on a table were performing a kind of ballet and forming the 'eye' or life-point of the painting—*giving a third plane*. These three planes and all their subsidiary planes were interchangeable, so that you could not tell which was real and which unreal, what was reflected and what unreflected, and this created, as I see now, some kind of space or an imaginative world in which one could live."

The words "Au Chat Botté" and "Dieppe" turn up again in a collage still life of January 27, 1933 (colorplate 30), where the pasted printed matter intensifies the unreal character. The still-life objects, a beaker and an oval platter with a fish, are cut out of newspaper, and a plate is made from pastry-shop lace. Painted shadow shapes encroach on these paper objects and convey a sense of indeterminate spatial depth, and the collage components lose all feeling of reality within the web of linear contours and the delicate colored textures. In his article Nicholson tells that, at that time, he still felt himself bound to the actual shapes of the objects but soon acquired the freedom to observe them simultaneously from all sides and to transfer colors, at his own discretion, from one object to another.

Nicholson produced two further collages in 1933, both of them with the heading of the newspaper *Le Petit Provençal* as collage element. On one (plate 198), pieces of the newspaper partly cover a head drawn in black outlines on a scratched and eroded background, making it seem hallucinatory. On the other (formerly Collection Herbert Read) newspapers, striped wallpaper, and a picture postcard from Spain make a composition of rectangles, of which one contains a diagonally placed outline drawing of a "simultaneous portrait" and thereby introduces an almost mystical note into a purely objective picture. The horizontal–vertical disposition of the planes testifies to the influence of Mondrian, whom Nicholson met in Paris in 1933 and who played a decisive part in his changeover to a completely nonrepresentational style.

December of 1933 saw the birth of Nicholson's first white reliefs of rectangles and circles, in which only light and shadow make the forms stand

He continued to work in the same Constructivist style up to 1945.

out. Out of the superimposed layers of cardboard or fiberboard that compose the ground, Nicholson cut away his forms, removing sometimes one, sometimes several layers to produce extremely slight differences in the level of relief. Occasionally the procedure was reversed, and the shapes were cut out first and then assembled into a composition. After having painted a series of numbers and a bus ticket into the system of flat planes of a picture for the first time in 1940, in another picture of two years later Nicholson pasted real tickets, newspaper clippings, and a label with "593" in large numerals (Collection Ian Gibson-Smith, London). In another collage, *396* (plate 211), of a few years later, the textural values are enhanced by the use of fibrous cardboard, a bit of embroidery canvas, and a scrap of patterned paper, and for signature the artist's name is cut out of his visiting card. For all his mathematical precision, Nicholson always succeeds in imparting a touch of the incalculable to the calculable by his subtle "dosage" and "tuning" of

all formal and color values, and his sober compositions always exhale a breath of poetry.

Cubist prototypes are reflected likewise in the first collage experiments by JOHN PIPER (b. 1903). In his *Collage with Black Head and Flower* of 1933 (Collection the artist), below the vase there is a painted package of Gauloises cigarettes with a real revenue stamp pasted on it, a motif familiar from Cubist papiers collés. The black head in profile is surrounded by a lace pattern impressed into the paint. Real pastry-shop lace makes a "naturalistic" draped curtain over an open window in Piper's watercolor of *Beach Houses* (private collection). The practice of replacing painted objects with appropriate materials led in the same year to a series of astounding scenes of the coast, in which collage elements predominated. Thus, in *Hope Inn* (colorplate 31), engravings of starfish, fish, shells, coral, and the like, cut out of the catalogue of an aquarium dealer, cover the foreground, which is invaded by other aquatic creatures sketched in rapidly in paint on fields of color. Above these rise crags and cliffs made of newspaper and wrapping paper, across the sky float clouds of strips of plain or marbled papers, and the name of the lonely, isolated inn appears in large painted letters. In Piper's somber landscapes, bathed in livid smeared colors, both genuine and imitated collage elements evoke a hidden zone of secret life.

Piper himself has said of these pictures: "Pure abstraction is undernourished. It should at least be allowed to feed on a bare beach with boxes and broken bottles, washed-up objects, crates, tins, waterlogged sand-shoes, banana-skins, starfish, cuttlefish, dead seagulls, sides of boxes with 'This Side Up' on them, fragments of sea-chewed linoleum with washed-out patterns."

Shortly after this collage series, Piper evolved a more rigorously abstract style. He began in 1934 with reliefs on which perforated sheets of metal or white and colored wooden slats and metal rods are joined by circular links and mounted over ground compositions composed of flat geometric shapes. Later, he laid canvas over wooden panels and, like Nicholson in his reliefs, cut out certain shapes with hair-sharp contours and then filled the resulting space with colors much like those used in his more orthodox canvases. Occasionally too the canvas is torn on one side, so that a more active contour emerges between the precisely cut shapes. Piper aimed, by these means, to achieve subtle variations in relief which would create the impression of gradated levels in spatial depth, an impression enhanced by the fact that he disposed his pictorial elements obliquely. Rectangles, trapezoids, and semicircles interpenetrate in these compositions, and many of the fields of color stand out like windows against the dark or light background. For certain sketches (plate 196) Piper also utilized papers of various colors and patterns in addition to other diversified textures such as striping, hatching, and shading executed by hand.

For all his intensive concern with technical means in an abstract Constructivist style, Piper soon realized that this alone was not enough for him. In an article published in *The Painter's Object*, edited in 1937 by his wife, Myfanwy Evans, Piper stated that what interested him in nonobjective art was not merely evoking the impression of space but also conveying thereby something of the spirit of the sea, for him the great source of inspiration. For that reason, he said, he interpolated in his rigorous mechanistic construc-

S. John Woods, *John Piper, 1932–1954*, London, n.d., pls. 6 and 7

The composition can be compared with the *Boats on the Shore* (Collection W. Schniewind, Neviges, Germany), which Braque painted in 1929 in the vicinity of Dieppe.

J. Piper, "Abstraction of the Beach," *XXe Siècle*, 1938, no. 3

The Painter's Object, London, 1937

On a view of *Sidmouth* from 1946 (Marlborough New London Gallery, London) he inserted a strip of paper with floral motifs in white on black that stands out from the background; and in *Rowlestone Tympanon with Hanging Lamp* of 1952 (private collection) there are printed papers pasted among the painted decorative motifs.
Exhibition catalogues: *John Piper, Recent Work*, 1963; and *John Piper, Retrospective Exhibition*, 1964; both London, Marlborough New London Gallery

Catalogue, *Trois artistes britanniques*, Paris, Musée National d'Art Moderne, 1963; previously exhibited at the Venice *Biennale*

tions such things as sail forms, rope, and other nautical gear, though these do not basically alter the abstract character of the works.

From 1936 to 1939 Piper used collage for a number of coastal landscapes, which were wholly lacking in the various illustrative details still present in his earlier abstractions. Here the occasional collage elements stand out much more markedly in landscapes and architecture built up out of large surface areas. In his view of *Newhaven* of 1936 (Marlborough New London Gallery, London), along with tar paper, newspaper, and marbled book papers, he also pasted in a cutout India-ink drawing of a steamship on the sea. In later works, pieces of cut-up chromolithographs and printed music paper or scraps of used blotting paper are spread across the sand and dunes, mingling their indeterminate graphic textures with the impressionistic brush strokes and stippling.

From 1940 on, collage appeared only exceptionally in Piper's paintings. However, in 1961 he turned to it again in his gouaches on the theme of the English coastline, a theme eternally the same but, for him, inexhaustible. In these, however, the natural formations are no more than implied by broad strokes of movement. In *Port Trwyn III* of 1963 (Marlborough New London Gallery, London) all contours disappear in dark waves of color that coalesce, split apart, allow patches of light to shimmer through them; and strips of painted papers cover certain of the shadow-like forms.

More recently, Piper has developed his own unique graphic collage procedure, combining pieces of black-and-white and colored lithographs with torn papers and then printing directly over them so that the contours and textures intermesh. His individual prints and book illustrations in this technique have been much imitated in England.

At the same time as Piper, his neighbor in the London suburb of Hammersmith CERI RICHARDS (b. 1903) was creating reliefs in typical abstract style. Although he took part in the 1933 *Objective Abstractions* exhibition at the Zwemmer Gallery in London, the art of pure form and color relationships —which Nicholson and Piper envisaged at the time as their salvation—was so fundamentally alien to Richards that he was unable to follow their lead; and he adopted new three-dimensional techniques only for what they could offer to his own somewhat romantic approach. In 1934 he used carpenters' tools to produce small pictures with simple shapes in wood, sheet metal, or cardboard, inserting among them a sheet of music or a drawing suggesting a piano keyboard and thereby converting them into "musical" subjects. Cubist reminiscences return in compositions of 1935 such as *Man with Pipe* and the *Head* (both Collection Mrs. Frances R. Richards, London). On the latter he pasted a piece of newspaper in the midst of painted forms which have shadows cast on them by nailed-in wooden elements. The relief of *The Sculptor in His Studio* of 1937 (plate 200) is a veritable demonstration of the interplay of flat planes and space within a remarkable abstract vision. Wood-patterned papers are glued between pieces of real wood, linear projections lead the eye into depth, and light and shade enliven the mat yellow-brown color of both the painting and the material.

Surrealist tendencies began to appear in his work in 1936, in the bird shapes that occur in his painted wooden reliefs. They assume more definitive form beginning with the *Two Females* of 1938 (Tate Gallery, London), in

Colorplate 34. Lázlo Moholy-Nagy. *Black-Red Equilibrium.* c. 1922

which one figure is painted, the other in relief, and both suggest Baroque vases in a style recalling Graham Sutherland's. *The Variable Costerwoman* of the same year (plate 201) undergoes a decidedly humorous metamorphosis, contrived as she is from a thoroughly odd selection of materials: a length of rope makes a headdress outlining the white wooden board that stands for the head; on the breast shine two rosettes, one made of a ball chain, the other decorated with a wreath of mother-of-pearl buttons; and in front of the "figure" there is a broken semicircular sheet of perforated metal which resembles a fan and is fastened by string to the wood planks of the background.

Although Richards contributed to the exhibition of *Surrealist Objects and Poems* held in 1937 in London, his flirtation with Surrealism was soon broken off. For a long time he devoted himself exclusively to painting, but in the series of pictures on the theme of *La Cathédrale engloutie*, which he began in 1959 as an attempt to translate Debussy's prelude on that subject into more or less tranquil or animated color compositions, he resorted again to material collage by 1961. In one relief (Marlborough New London Gallery, London) metal bells of all sizes are assembled in a well-defined, closed picture area, and among the wreckage at the bottom of the sea there is not only a large crab but also a rosary with crucifix. Torn sheets of music and another piece of board covered with bells are glued on a wooden form garnished with metal buttons in the *Gothic Image* of the following year (Collection the artist), once again exuding that musical atmosphere which in Richards's works always prevails over his constructive objectivity.

Abstract art likewise led PAULE VÉZELAY (b. 1893) to collages and material pictures. She lived in Paris from 1923 to 1939, working in painting, graphic techniques, and sculpture, and exhibiting frequently at the Galerie Jeanne Bucher. About 1928 she turned to a nonobjective style in painting, based on simpler, more geometric compositions. Eventually the influence of Arp, especially conspicuous in her sculpture, made itself felt in the formal vocabulary of her paintings and collages also. For her *Lines in Space no. 4* of 1936 (plate 207), she pasted on her canvas paper shapes in Arp's manner and then stretched crisscrossing cotton threads over them in order to introduce the third dimension into what was otherwise a completely flat composition. With the same aim she filled a small white box with delicate, evocative objects such as dried leaves, tiny feathers, fishing-flies, and flint pebbles, and these too were linked by thin threads to make an intimate composition possessing its own special charm.

Soon afterward she made an abstract collage of linear curves spreading into sickle forms, all cut out of white paper and pasted to a black ground. Later she designed analogous compositions of simple, rhythmically grouped shapes in tones of black, white, and gray. However, her *Noir et blanc* collage of 1946 (plate 213) is rather more Surrealist, with its plain, speckled, and patterned papers cut to suggest cornucopias, painted Easter eggs, and twisted hearts. Perhaps Paule Vézelay's most successful works are the small, white wooden shadow boxes in which flexible white and colored wires twine around each other in animated curves and cast delicate shadows in the background. It is in these that the element of play breaks through to enliven so skillfully the ordinary practical materials that she uses.

Exhibition catalogue, *Englische Kunst der Gegenwart: Profile III*, Bochum, Städtische Kunstgalerie, 1964

The great rage for Surrealism was launched in London by the international exhibition that opened in June, 1936, at the New Burlington Galleries and showed sixty-eight artists from fourteen countries (figure 45). The illustrious ancestors—Brancusi, Marcel Duchamp, Arp, Picasso, Picabia, De Chirico, Klee, Man Ray—served as prelude to the more recent generations of dyed-in-the-wool Surrealists, who had extended the style to every medium, to paintings, drawings, sculptures, collages, and objects. Paris set the tone: Breton, Éluard, and Dali gave lectures and were lavishly fêted in return. The Belgian section was organized by Mesens, the Scandinavian by the Danish painter Bjerke-Petersen. Nevertheless, the English committee, headed by Roland Penrose, the initiator of the exhibition, and including Herbert Read, Paul Nash, and Henry Moore, took care to guarantee that native artists would be given a fair showing. Besides the committee, a number of participants including Humphrey Jennings, Ruppert Lee, Merlyn Evans, and Eileen Agar took the occasion to join the London Surrealist group, whose goals were laid down in the *International Bulletin of Surrealism* for September, 1936.

Most of them also took part in the great exhibition of *Fantastic Art, Dada, Surrealism* at The Museum of Modern Art, New York, from December, 1936, through January, 1937.

PAUL NASH (1889–1946) was particularly conspicuous at this and subsequent exhibitions. A man who had found his own way to Surrealism, he began by accumulating a stock of photographs on his travels through France, Spain, and Morocco and, later, in the British Isles; and through them he discovered that there were things in nature which, as he put it, awakened imaginative conceptions belonging to the world of dreams and which, liberated from their usual contexts and associations, opened the gates to other and wholly unexpected meanings. Mostly it was along the English coasts that Nash made the finds that stimulated him to create his own "objects": birds' nests and branches, which became *Homes Without Hands*; stones and pebbles polished by the waves, which were the origin of his *Nest of Savage Stones*. At the London 1937 *Surrealist Objects and Poems* exhibition Nash was represented in all sections with "reworked," "dreamlike" objects, object collages, and "things of daily use."

SURREALISM
CATALOGUE·PRICE SIXPENCE

Figure 45. Catalogue cover for the *International Surrealist Exhibition*, New Burlington Galleries, London, 1936

He also turned out an even greater number of regulation collages, of which unfortunately only a few have survived. At the international show in 1936 he exhibited a *Landscape at Large* in which pieces of pine bark, slate, and the inside of an envelope are transformed into the structures of a landscape. The catalogue of a show of watercolors, drawings, collages, and objects by Nash that took place in 1937 at the Redfern Gallery in London includes two collages: one a self-portrait from 1934, the other the *Portrait of Lunar Hornet* (plate 202), which comprises a topographical map of a mountainous region cut out to form a catlike creature whose head is covered with a dark paper and whose tail is a curling tree root.

Reproduced in Herbert Read, *Paul Nash*, London, 1937, pl. 10. All the collages of Nash's Surrealist phase seem to be lost.

An avid collector and connoisseur of both collages and objects, ROLAND PENROSE (b. 1900) has also been an active practitioner in both fields. At the 1936 exhibition he was especially acclaimed for an object titled *The Last Voyage of Captain Cook* (Collection the artist), a globe of the world made of wire and enclosing a female torso. The next year, in a series of collages, he mounted colored picture postcards of scenery, spreading them out fanwise or, by inverting half of them, making an image and mirror image. The result was strange Mediterranean landscapes with sailboats, cliffs, urns, girls

He owns works by his Paris friends Picasso, Braque, Max Ernst, Miró, Arp, Dali, Breton, and Man Ray.

Rubin, pl. 265

This ink-blot process, invented long before by Victor Hugo and Justinus Kerner, was discovered all over again in Paris in those years by Oscar Dominguez and was adopted by innumerable Surrealists as a source of "automatic art."

festively arrayed in native costume, and the like, which, through rhythmic repetition of the motifs, seem to be in continuous movement. Often the picture areas are linked by radiating lines that seem to emerge from an invisible *camera obscura*. Between the figurative illustrations there are also decalcomanias and blots of gouache and ink, their undefined, irregular contours contrasting with the objective distinctness of the postcard pictures.

The collages that Penrose conceived in Paris in 1938 combine drawing and illustrations in rather more fantastic compositions. In *Miss Sacré-Coeur* (plate 199) postcards of the basilica in Montmartre form the breasts of a black female figure, a winged Asiatic king-god sits on the crescent moon that frames her head, and her outstretched hand is made up of cut-up postcards of the Eiffel Tower. More dreamlike, however, is the landscape *Le grand jour* (plate 212), an oil painting based on a preparatory collage. There, a star, a fish, a fashion plate, and a cluster of houses are projected on the sky, while from the earth, between mountain ranges like theatrical scenery wings, a hand is thrust upward beside an object that defies description. In *The Lion of Belfort* (Collection the artist) a white dove forms with the lion an animal twosome that one meets again in a drawing of a figure standing on his head and reminds one of Max Ernst's imagery, with which Penrose was well acquainted.

Among the most active adherents of the Surrealist group is EILEEN AGAR (b. 1901), who has never been at a loss for ideas and flights of fancy to astound her public. From 1928 to 1930 she studied in Paris and thereafter remained in friendly contact with the Breton circle and with Éluard in particular. In the early 1930s she was painting abstract nonfigurative pictures, and it was only when she was converted to Surrealism that she discovered her true fantastic vein, which she then proceeded to exploit in great numbers of collages and objects. One of her earliest constructions involved the red tracks of a toy railroad, which, mounted vertically, were transformed into tiny railway compartments. Another object, from 1936, used for the title page of the London Gallery's exhibition of objects, is the *Angel of Anarchy*, tricked out with lace, feathers, and tufts of hair, between two wire figures, of which one has a leaf for a head, the other a doorknob. No less grotesque is the group of *David and Jonathan*, which was published in the London *International Bulletin of Surrealism*.

Since 1936 Eileen Agar has also been turning out collages, and in these the forms and materials are more harmoniously blended. She cuts out silhouette heads in profile and surrounds them with "precious stones"—jewels and ornamental stones from an illustrated catalogue that her husband publishes. In *Woman Reading* (plate 206) she pasted newspaper over parts of the silhouette and then spread across it a pressed branch of stinging nettle with its flowers. Among the loveliest of these compositions is the collage *Foot in Hand* of 1939 (plate 197), in which abstract and figurative elements interpenetrate. Lace and tulle, colored and printed papers, a confectioner's paper, and two colorful butterflies are interwoven, as it were, in a play of transparency and solidity, of clarity and camouflage. In a later still life set in an old Baroque-style frame, spotted butterfly wings make a splendid flower alongside a large and varicolored snake. Similarly redolent of a fairytale atmosphere, the *Fish-Circus* of 1939 (Collection the artist) has a red starfish, a

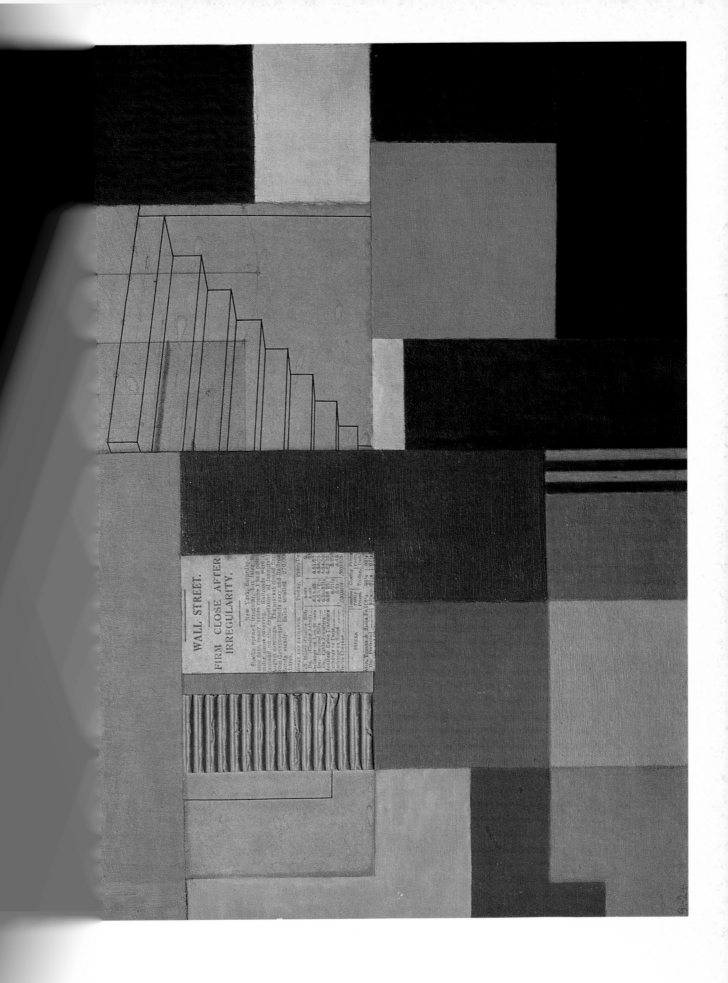

WALL STREET.

FIRM CLOSE AFTER
IRREGULARITY.

h Vordemberge-Gildewart. *Construction with Wall Street.* 1924

large fish, and part of an elephant surrounded by papers in bright checker-board patterns, and the composition is completed by India-ink drawing and shaded with rose-violet and bluish watercolor. In their individual expression and painstaking execution these pictures have something in common with Ella Bergmann-Michel's early collages, to be discussed in the next chapter.

During the war, Eileen Agar's work lost something of its playful gaiety, and its forms became harder in character. Cubist reminiscences can be found in a portrait, *Fighter Pilot*, done in 1940 (Collection the artist), and one is reminded of Arp by a relief picture of 1942 with a cord and red seal stretched across a white shape. Later, however, her own natural bent toward fantasy once again gained the upper hand, and her works since then have been unfailingly amusing.

Unfortunately, a great deal of what was produced in England in the collage medium can no longer be traced. The London artists have become widely scattered all over the world. Many no longer care to rummage through old portfolios to bring to light long-forgotten works produced in a mood of high spirits and passing enthusiasm, or they no longer have the slightest idea of what has become of such things. JOHN BANTING (b. 1902), for one, cannot recall what he submitted to the international exhibition of 1936 in the way of pictures and objects, though he does remember a construction from 1925 in Paris, in which he mounted together a small glass ball, a glass rod, and a length of cord. From his Surrealist phase he still has two photomontages with photographs of athletes, who, on one of them, make up a tree trunk and, on the other, cover with their bright colors a small female torso in papier-mâché.

Other photomontages are mentioned or reproduced in the various Surrealist publications. The anthology of essays, *Surrealism*, edited by Herbert Read in 1936, included a reproduction of a work by LEN LYE, who had exhibited photograms at the New Burlington Galleries in 1930. The work reproduced, *Marks and Spenser in a Japanese Garden*, 1930, appears to have cutout photographs pasted into loosely stippled painting. The title page of *A Short Survey of Surrealism* by the poet DAVID GASCOYNE (b. 1916) has a collage which may well be by the author himself, a frequent exhibitor in Surrealist shows. It has pairs of doves and clasped hands arranged one behind the other in perspective vanishing lines. The catalogue of the 1937 London show of objects reproduced a very impressive collage by MERLYN EVANS (b. 1910), *Fleurs du mal* (plate 209), on which masklike faces, black birds, and elegant long hands are united in a dreamlike vision. Likewise in that catalogue there were collages by ROBERT BAXTER, one of which, *Bird's-eye View* (plate 205), displays a landscape with added photos and reproductions symbolizing the development of art and technology from antiquity to modern times. A collage published in 1937 by Myfanwy Evans in *The Painter's Object* gives an idea of the kind of work done by JULIAN TREVELYAN (b. 1910); a city rises up with towers of newspaper columns, and overhead a full moon in corrugated cardboard and clouds of paper lace are pasted on the sky.

Even in the midst of the war the Surrealists remaining in London managed to maintain contact with one another and to recruit new members for their "soirees," at which they revived the game of *cadavres exquis*. In 1940 they were joined by CONROY MADDOX (b. 1920), who had already established

In the early 1920s Len Lye began to experiment with abstract films, incising "signs" directly into the celluloid to obtain a continuous movement. According to F. Popper, *Naissance de l'Art cinétique*, Paris, 1967, one such film, *Tusalava*, had its premiere in 1928.

London, Cobden-Sanderson, 1935

After a sojourn in Paris in 1931, Evans began painting in an energetic Cubist style. In 1938 he moved to South Africa but, after some years, returned to England.

Only extensive specialized research might track down the collages known to have been done in 1936–37 by N. Dawson, Humphry Hennings, Edith Rimmington, and the Australians James Cant and Eric Smith.

connections with the Paris Surrealists in 1937. Young as he was, before the war he had begun to do "collage paintings" in which illustrations pasted in landscapes and empty interiors assume nightmare dimensions and arouse dramatic tensions. Less disquieting is his *Uncertainty of the Day*, 1940 (plate 210), with its three harmless citizens out for a stroll in a desert landscape between the gigantic pincer-like legs of a kicking infant. In a later example, *In the Warehouses of Convulsions*, published in the magazine *Free Unions* in 1946, the space is enlivened with cutout photos of nude women stepping out of coffin-like boxes in a composition based entirely on the contrast between bare wall surfaces and well-modeled bodies.

Maddox continues to be active in London as painter, critic, and lecturer on modern art and still works in collage. A series on the theme of Dr. Charcot's historic psychiatric experiments at La Salpetrière in Paris indicates that he has remained faithful to his earlier subject matter, though in other works he renders aspects of present-day civilization rather in the manner of the English variant of Pop Art.

The issue of *Free Unions* edited by Simon Watson-Taylor as a survey of the postwar literary and artistic activity of the Surrealists reproduces an amusing collage, *La Stratégie militaire* of 1944 by Valentine Penrose, somewhat in the style of Max Ernst. Among the drawings, one from 1944 by the Frenchman JACQUES B. BRUNIUS (1906–1967), *Ad nauseam* (plate 204), is based on collage: a man's head with frozen eyebrows and beard rises up in a foggy landscape, and from his mouth emerge a woman's legs, from his closed eyes her arms twirling veils; the face of the same man, this time with eyes open, reappears like a seal or sign on his own forehead, but is visually connected with the arms and legs to form an ambiguous figure.

Brunius, who was one of the film directors in the entourage of Luis Buñuel and René Clair in France, in his earlier years promulgated the proverb: "*Les collages forment la jeunesse*" (Collages mold youth). In Paris before the war he made innumerable collages, though few survive. One of the first of them, *La Mélusine sans-culotte* (plate 208), dated July 14, 1936, has strange animals undergoing Surrealist metamorphoses. During the war Brunius worked in London for the BBC radio program *Frenchmen Speak to Frenchmen*, and there he joined the local Surrealists, continuing to work at his collages. One of these, the *Matador cavernicole* of 1943, possesses a certain interest for us today, since its motif of the cave with bull and bullfighter is repeated to make a continuous frieze of the sort so common now in Pop Art. In 1946 Brunius devised a charming collage object, *A Nasty Melody* (now destroyed), a small shadow box in which all sorts of odds and ends inimical to music are mounted over and alongside staves of music, while candles burn overhead. About 1960 he created a number of fantastic portraits set in unreal landscapes and evoking effects of transparency and reflection by the use of blurred photographic prints. Quite another spirit is manifested in a collage titled *The Sex of Angels Is Blue* (Collection Ragnar von Holten, Stockholm), in which railway tracks densely occupied by trains make an abstract spatial construction around three pretty-pretty Raphaelesque angels in perspective foreshortening.

Brunius's *Nasty Melody* had a prototype in E.L.T. Mesens's *Completed Complete Score for Marcel Duchamp's Band* of 1945 (figure 46), published in *Free Unions*, which consists of two pages of musical score with winged and

Brunius made a film, *Violon d'Ingres*, about the "primitive" Sunday artist, and at the outbreak of the war he had been planning a film about Baron Münchhausen in collaboration with Hans Richter, Jacques Prévert, and Maurice Henry.

Collages by Brunius, along with others by Štyrský, Toyen, and Heisler, were shown at the exhibition *La cinquième saison* organized by E. Jaguer at the Galerie du Ranelagh in Paris in 1962.

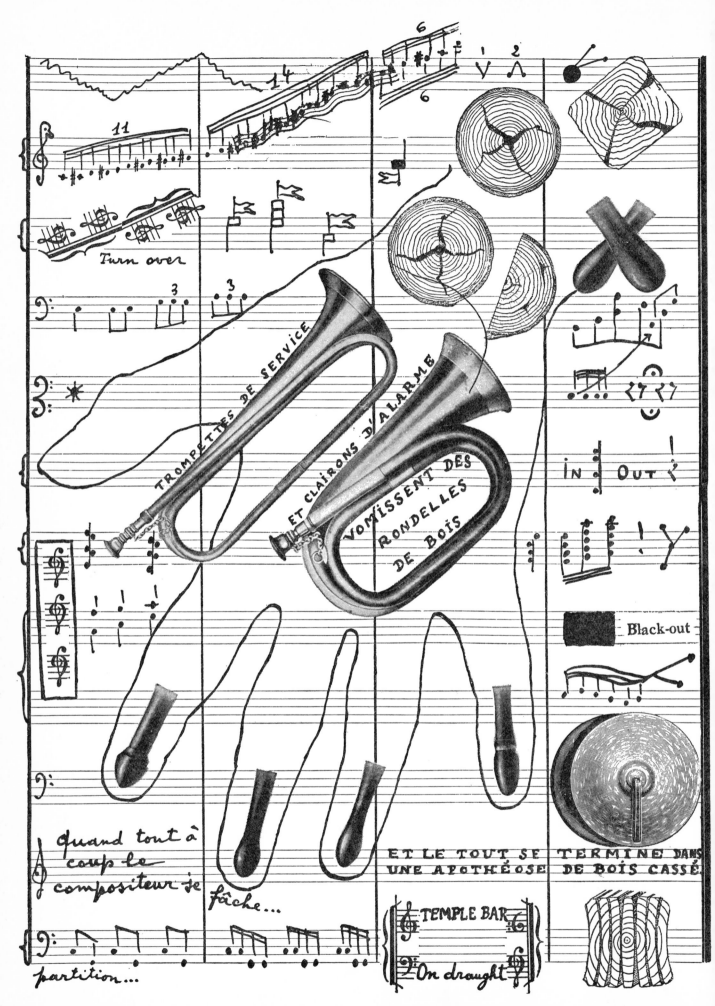

Figure 46. E.L.T. Mesens. *The Completed Complete Score for Marcel Duchamp's Band*, right-hand page. 1945. Ink and collage, 11¾ x 9". Musées Royaux des Beaux-Arts de Belgique, Brussels

pennanted notes, pictures of instruments either drawn or pasted in, and charming little printed vignettes. A first version was prepared in 1943 for a book of poems, *Troisième Force*, which included among its "*pièces détachées*" a collage in two parts, one printed black on white, the other white on black, with a system of coordinates complete with identifying letters. Into this composition are pasted two male figures in knit underwear—obviously taken from a mail-order catalogue—whose eyes meet at an object resembling a milestone.

Mesens moved to London from Brussels in 1938, took over the London Gallery, and edited the *London Bulletin* from 1938 to 1940. During the difficult war years he strove to keep the Surrealist movement alive, and in 1945 he promptly organized the first postwar exhibition, *Diversity Surrealist*.

Mesens also deserves credit for having done everything in his power to call public attention to Schwitters during the latter's years in England.

In 1954 Mesens launched out on a new collage period, which has kept him fully occupied ever since and has been marked by works combining Surrealist tendencies with more contemporary currents. At first, more or less neutral pictorial elements—strips of printed text, pages from calendars, tram tickets, and the like—were set in geometric arrangements, though never merely diagrammatic or schematic. Then Mesens found a way to relax such strict compositions, using delicately patterned tissue papers or painting gay spots of color. Following the general trend in art of those years, his forms subsequently became freer and more animated. He tore and crumpled newspaper and other papers or charred them to make landscapes with jagged contours. For his *Depressed Garden* (its punning French title is *Jardin (ou Chardin) déprimé*) he also utilized corrugated cardboard drenched in bright-colored gouache, and in *Spy* he perforated a piece of cardboard and drew string through the holes. More recently his Surrealist bent has come to the fore more strongly. He combines the most unlikely things, and among his "handmade word games" he now often includes titles in which he pushes even further his arbitrary perversions of meaning. Often the playful mockery prevails, but at other times a gentle poetry wins through. His motto, "I dream, so I make what pleases me," characterizes the mentality and the shifts in mood that account for these pictures. With the painstaking execution of his compositions, in which form and content are sensitively attuned, Mesens perpetuates the best tradition of the art of collage.

Reproduced in *Art News and Review*, London, Vol. IX, no. 4, August, 1957

Exhibition catalogue *E.L.T. Mesens*, Brussels, Palais des Beaux-Arts, 1959. The Council of Europe exhibition *L'Art en Europe autour de 1925*, Strasbourg, 1970, included a number of collages from the 1920s with a variety of elements, among them line drawings, line engravings, printed matter, and Rayographs.

The Americas

During the war a number of the Parisian Surrealists took cover in the United States. By 1942 Max Ernst, Breton, Marcel Duchamp, Tanguy, Masson, and Seligmann were all to be found in New York, where they went on working, helped found the magazine *VVV*, and, in October of 1942, as a benefit for the French war-relief program, organized an extensive exhibition called *First Papers of Surrealism*, featuring both European emigrants and native Americans.

Among the participants was LAURENCE VAIL (1891–1968), who had lived in Paris before the war and had been associated with the Dadaists from an early date, though his own bizarre Surrealist collages were initiated in America, without contact with the Paris group. In the collection of Peggy Guggenheim, whose first husband was Laurence Vail, there is a three-

Picabia published a contribution from him in 1924 in the last number of his review *391*.

paneled wall screen in collage that he assembled in 1940–41. A daring counterpart to the screen that Hans Christian Andersen decorated in 1873–74 with a motley collection of cutouts, the portion of Vail's screen pictured here (plate 214) even has a certain relationship to one of the wings of Andersen's: between a dense accumulation of heterogeneous buildings set every which way in space, a veritable sea of people advances in some sort of monster mass demonstration led by a string orchestra sawing away in the foreground. Far more fantastic, however, are the side panels, where, as if in a gigantic explosion, the most grotesque evidences of human existence whirl around and through one another: faces and masks, hats, shoes, gloves, hot-water bottles, wheels, blown-out tires, and so forth. Frogs and chickens peer out of strands of hair, a bundle of asparagus sprouts from a map, and everywhere in the midst of all this debris seductive chorus girls pop up.

In subsequent years Vail exploited his inexhaustible stock of cutout color reproductions to cover all sorts of bottles with collages of endless diversity in both form and genre: sometimes flower decorations in Baroque taste; at other times Chinoiseries and exotic landscapes; and a special style for poison bottles, with death's heads and other bogies to warn the user (plate 217). The stoppers are no less varied, being capped with arrows, brushes, a pair of spectacles without glass, a toy airplane, branches, dried flowers, stuffed birds' heads, and so forth.

Vail went on to fabricate objects of innumerable shapes and meanings to fill the attic of his Paris home, which he converted into a strange sanctuary constantly enriched by new creations. The most inconceivable finds and mementos of a long life were incorporated into his objects: broken toys and household rubbish, shaving equipment, knives and scissors, but also bones and shells and dried plants. Often he dipped such things into a mass of clay and wire to form them into heads and busts. In all his objects there is something unearthly and even blasphemous in feeling, something that suggests weird and highly effective décors for a Surrealist theater.

Among the native American Surrealists JOSEPH CORNELL (b. 1903) occupies a special place, having had at first only a tenuous and indirect connection with the Paris group and then soon finding his own entirely personal way. When he happened on Max Ernst's *Femmes 100 Têtes* in 1930, he was stimulated to try his hand at collage, and two years later he was able to exhibit the results in a Surrealist group show at the Julien Levy Gallery in New York. A collage from 1932 (now lost) was conceived entirely in the spirit of Max Ernst, with a woman from a fashion illustration laid athwart Lautréamont's legendary sewing machine, which is stitching her to the equally famous operating table, while, at the same time, globes of fruit grow out of the figure and the apparatus. At the *Fantastic Art, Dada, Surrealism* exhibition at The Museum of Modern Art in New York, 1936–37, Cornell showed an assemblage titled *Soap Bubble Set* (The Wadsworth Atheneum, Hartford, Conn.), a weird still life including a colored egg in a wine glass, a doll's head on a pedestal, a pipe, a strip of circular shapes, wooden cylinders pasted over with old engravings, and other elements. Cornell's unique expression is often realized in wall chests or shadow boxes, permitting him to combine, behind glass, unexpected objects side by side with images and texts (plate 216). Magic and sorcery, folklike naiveté and erudition are jumbled together

Figure 47. Catalogue cover for the Surrealist exhibition in Tenerife, Canary Islands, 1935

It is reproduced in the *Dictionnaire abrégé du Surréalisme*, Paris, 1938, and in Rubin, pl. 270.

Rubin, pl. D-159

in his mysterious juxtapositions of receptacles and glasses, spheres and cubes, astronomical charts and zodiacs, old copperplate engravings and picture postcards (plate 215). No action links these disparate items, but nevertheless, remotely and silently, they have their effect on one another. A special Surrealist note appears in a series of works beginning in the 1940s with cutout colored reproductions of parrots and cockatoos, sometimes perched on real cornices or branches and surrounded by numbers, feathers, and corks, as if in some busy marketplace, while the backgrounds of pasted business advertisements and hotel prospectuses seem to invite the viewer to distant continents (colorplate 32). In the course of the years Cornell has sloughed off the merely picturesque, and his curio cases have become more abstract, three-dimensional constructions of a few hand-picked materials and shapes, most often with some symbolic meaning.

After Prague and Tenerife (figure 47), after London and New York, the Surrealist movement reached South America too. A group formed in Chile in July, 1938, took the name Mandragora (Mandrake) and published a magazine of the same name. Art was represented by Jorge Cáceres and Braulio Arenas, who produced Surrealist paintings, drawings, collages, sculptures, and objects. Poems by Enrique Gómez-Correa were published in *Mandragora* in 1945, with illustrations by Cáceres that exploited all the procedures of collage and montage. While the collages reveal the paternity of Max Ernst, certain of the photomontages show more independence. The illustration on the title page consists of two photographic exposures super-imposed, a female nude and a view of a shore with natives. On another, three portraits of veiled young women are mounted with such accessories as gloves, cloths, button-top boots, and pencils. The Chilean group is especially interesting in that, unlike the Surrealist centers in New York and Mexico, where European emigrants played the decisive role, it was native artists who set the tone.

VIII Constructivism and Propaganda

New Trends in Germany—Hungary—The Bauhaus and Its Circle—Non-Bauhaus Constructivists in Germany and Elsewhere—Commercial Art and Political Propaganda

New Trends in Germany

With the creation of the Bauhaus, Constructivist tendencies came to prevail in Germany, and it was inevitable that they should affect collage too. Before then, however, there were certain artists who occupied a central position amid Expressionism, Dada, and Constructivism and who also concerned themselves with that medium. Among them, a special role was played by Robert Michel and his wife, Ella Bergmann-Michel, who had met in 1917 as students at the Grand Ducal College of Fine Arts in Weimar, where the Belgian architect Henry van de Velde had introduced into the school workshops the pedagogical principles that would be realized fully only with the opening of the Bauhaus in April, 1919.

ROBERT MICHEL (b. 1897) had been severely wounded in 1916 in an airplane crash, and after a time in the hospital he was released in 1917 to study in Weimar. His drawings between 1917 and 1919 testify to the impact of his experiences as an airman. They have titles like *Between Sky and Earth* or, vice versa, *Between Earth and Sky* and show linear projections cutting across a space occupied by propellers, wheels, and screws. These India-ink drawings led to his first collages, in which rotating cogwheels intermesh in complicated mechanisms.

For Michel the interest in mechanics characteristic of Marcel Duchamp and his circle had another and more real basis. Whereas Picabia especially delighted in inventing fantastic mechanical contraptions, Michel was obsessed by the dynamics of real, functioning motors and strove to translate them into abstract rhythms. Finding it difficult during those war years to procure good paint, and forced to make do with India ink, Michel took to cutting up the prospectuses of airplane plants and completing their brown or blue printing by spraying the paper with ink in harmonious colors. On pictures of gears and wheels he pasted strips of lined paper or music and then strewed about numerals, names, and fragments of words from which he drew such titles as *MANN-ES-MANNBILD (Man-It-Man Picture)* (plate 222) or *Newest School of Velocity*, which laced these products of abstract precision with a dash of Dadaist irony. Upon occasion he also introduced concrete materials, as in the *Big Clock* of February, 1919, where he placed an airplane speedometer—souvenir of the crash he survived—in the center and surrounded it with small metal wheels, brass wires, wooden rings, and buttons and cockades of the bygone Kaiser's era. There was a time when Michel liked particularly to hang his own pocket watch in the picture, because its audible ticking reinforced for him the significance of his work.

As an alien, Van de Velde could not continue to teach in Germany during World War I, but as a civilian internee he could still remain in contact with the Weimar circle.

252

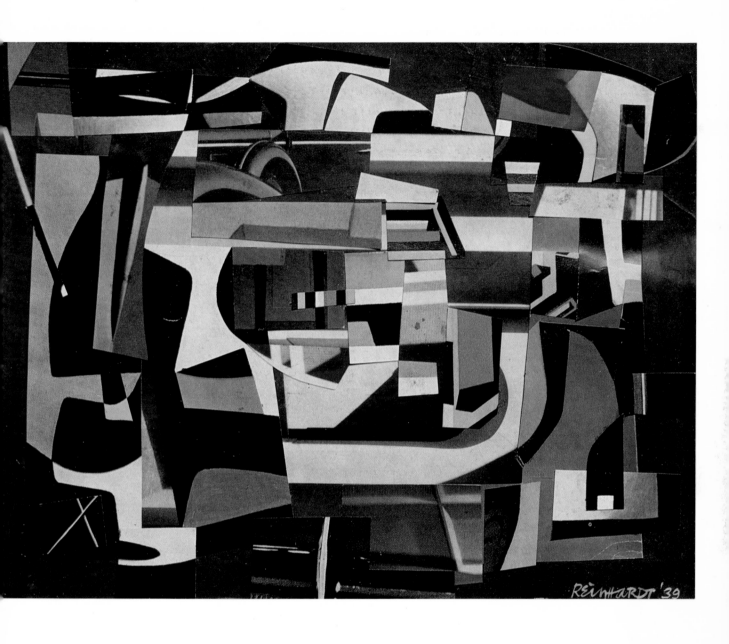

orplate 36. Ad Reinhardt. *Collage.* 1939

In a few of his collages of about 1921 the Dadaist spirit assumed burlesque forms. Along with the bull's-eye target in *Shooting Match* there is a knight on horseback whose head and armor are formed by rows of numbers. As a flippant allusion to Franz Marc's *Blue Horses*, Michel pasted into another picture a brown pony. He himself did not take this sort of thing seriously, and such collages were soon superseded by new experiments in a more Constructivist style.

For ELLA BERGMANN-MICHEL (b. 1896) the quest for new abstract forms of expression went hand in hand, from the start, with her pleasure in unconventional materials. In her home town of Paderborn in 1917/18 she put together a relief, *Sunday for Everyman* (plate 218), nailing into it wooden odds and ends from the flea market even before Schwitters had ventured on such discoveries. As with Michel, the underlying composition consists of revolving disks together with several much smaller disks that peep out here and there like eyes. Orange, violet, green, and silver papers lend the picture a cheerful, almost folk coloration. Besides the pieces of wood, there was also originally a real rabbit pelt, but over the years the moths got the best of it.

Words and texts introduced a touch of Dada into her subsequent collages. One from November of 1918, *People with Heads Are Rare*, is packed with ironic allusions to current events. Between cut-up world maps from an old atlas, leaves from a calendar announce the day and hour of "Cosmic Beginning" and "End of the World," while the Workers' Councils *(Arbeiterräte)* of the recently founded Weimar Republic are rebaptized *Arbeits-Räder für Kunst* ("Work Wheels for Art"). The literary and artistic debates of the time are commemorated by the names of the pre-Dada poet Paul Scheerbart, the novelist Johannes Schlaf (whose name, meaning "sleep," is accompanied by the words "*Ruhe sanft*," "Have a good rest!"), and the critic Adolf Behne, in the last case surrounded by quotations from his grandiloquent theories of art. All these disparate components are tied together in a highly balanced, closed composition. One of the strips of text reads, "This is the task of Cubism," perhaps an allusion to the roots of this distinctive sense of form.

In certain of Bergmann-Michel's collages of 1919 this feeling for form is linked with an individual poetic sense. On *Fishes* (plate 220), which is based on a pen drawing in delicate hatching, varicolored little fishes cut from a zoology book sport in a pool rimmed by a narrow strip of silver paper, and at either side tiny passenger balloons take to the air. On another, the verse "*Fischlein rot stech dich tot*" (Little red fish sting you dead) communicates the storybook atmosphere of the work.

In October, 1920, the Michels left Weimar to settle in the family property, a former smelting mill in the Taunus Mountains region not far from Frankfort. The lively artistic climate in Weimar, which showed such promise during the few years that the National Assembly was in session there, became a thing of the past when the seat of government was moved to Berlin. Artistic activity was soon entirely dominated by the recently organized Bauhaus, led by Walter Gropius. At the outset he entered into an alliance with local Weimar artists, including the Michels, Johannes Molzahn, and Peter Röhr, and even borrowed pictures from them so that the first visitors to the school would not find the walls depressingly bare. Friendly contacts developed between the Michels and a few of the teachers, in particular the architect Adolf Meyer. In the long run, however, the dogmatic

spirit of the Bauhaus did not appeal to Robert Michel, and he preferred to shift his field of activity to Frankfort, where he made a name for himself in the 1920s as a designer of modern shops and service stations.

The collages he began to create again in 1923 are full of architectural and mechanical drawing in the form of blueprints or photocopies, in order, as he put it, to have his own materials and not borrowings. He worked over the black tones of photographic prints with gouache and juxtaposed them with isolated livelier colors in some parts of his pictures. Occasionally, by spraying with metal filings and powdered colors, he prepared his own papers in delicate shades of grayish white and beige, and on these he left certain areas and shapes blank and emphasized others by means of prominent lines drawn in ink. He also drew on extremely thin paper, which he then pasted drawing side down over tinted, hard grounds to obtain the effect of transparency.

Michel defines this procedure as "total collage."

Along with mechanical elements such as wheels, levers, and pistons, quite often Michel uses distinctive numerals, for example, an 8 formed from two perfect circles. However, he reserves a special role for locks and keys and has composed a series of *Yale Pictures*, named after the inventor of the safety lock, who is occasionally referred to in the titles as "Opa-Yale" or "Little Grandpa Yale." In time, Michel's compositions became simpler and tended to coalesce into abstract formulas in the center of the picture. In the series of *Alu-Paradise Pictures* of 1930 (plate 219) the ground is sprinkled with aluminum powder, which, with its metallic sheen, encases the well-defined drawn and pasted shapes and lessens their harshness.

In 1933 Michel gave up all artistic activity to devote himself to practical tasks. It is only in the last decade or so that he has returned with some enthusiasm to drawing and collage, and his craftsmanship and technical procedures have become steadily richer and more refined. The photocopies of drawings are now of highest quality, and for coloring he uses not only aluminum but also copper powder in yellowish or reddish tones. Now his rectangular fields are invaded by flowing, curving forms, which often taper off to thin points. The abstract motifs are placed vertically or diagonally in the picture field, framed by bright lines or elevated above the background by dark backings, and they give the impression of an exquisitely ordered chamber music in which each variation possesses its own sonority.

He devoted himself entirely to fish breeding, into which he introduced new scientific methods.

For her part, in 1922 Ella Bergmann-Michel began to produce paintings and collages of a more objective, more scientific conception, in which she was primarily interested in ways of establishing relationships between light and color, surface plane and spatial depth (colorplate 33). For these she utilized small rectangles of color, gradated according to the range of the spectrum, which she cut out of an old book on physics and pasted on and alongside geometric black fields, linking them by lines, arrows, and cones of rays which project the flat planes into depth. Since 1926 she has been preparing her own color scales out of paper she tints in subtly refined shades. She illuminates black areas through light inner structures, breaks down gray into fine nuances, juxtaposes gleaming white paper against the more mat surface of the background, and so on, and also makes use of thin waxed papers which permit the colors of the background to shine through.

The architect Mart Stam hung such pictures in his apartment block in the Stuttgart Weissenhof housing project designed in 1927 by leading modern architects.

For her, rigorous horizontal–vertical compositions proved to be a passing phase soon to become more relaxed. From 1928 on, indeterminate biological forms crop up within the geometric planes. Thus, in a collage of that year,

255

During those years Ella Bergmann
regularly spent the summer months
in London.

Between Day and Night, a white embryo-like being with soft contours grows out of the austere rectangular surface fields. Surrealist tendencies, first evident in a series of India-ink drawings between 1921 and 1923, are combined with Constructivist principles of composition in her paintings and drawings of the 1930s. Masks and animal and plant forms appeared then, and they have returned in certain collages of the last decade. For these, Ella Bergmann-Michel cuts trial runs of her engravings into innumerable tiny elements, which she reassembles in mysterious silhouettes. Playful fantasy and formal discipline complement each other in her work, sometimes one, sometimes the other predominating.

Before the war JOHANNES MOLZAHN (1892–1965) had been a student at the Grand Ducal College of Fine Arts in Weimar, and it was there, upon his return in 1918, that he met the Michels. By that time he had arrived at a distinctive Expressionistic style of painting in which schematized figures and heads were integrated into spatial constructions of planes and lines. About 1919 the human figure disappeared entirely from his work, making way for abstract compositions of volutes and ribbon forms interpenetrating in animated spirals and loops. From 1918 to 1920 Molzahn participated each year in exhibitions at Der Sturm in Berlin, and in 1919 he published in the gallery's magazine a "Manifesto of Absolute Expressionism," an emotion-laden confession of belief in the cosmic forces he was striving to embody in his pictures.

During his Weimar period Molzahn introduced new technical procedures and qualities into his painting, incising lines, spirals, and signs into the layer of paint, pressing lace cloth into it to transfer the pattern, and pasting in paper elements. The earliest example known to us of this approach, *Phenomena* of 1919, has in its center a cutout drawing pasted over a globe shape. Pasted elements in watercolors and oil paintings of 1920 include pages from an old almanac with the constellations of the zodiac and weather prophecies, or pieces of maps and an old print of a ship, as in *Columbus—a New Voyage* (plate 223). Similar materials appear in *Zeit-Taster (Antenna of the Times),* but juxtaposed to them is a leaf from a modern calendar, and the entire surface is covered with small wheels to demonstrate how time runs on. In the oil painting *New Lands* (plate 221) a real cogwheel is mounted on a map of the world, and an American matchbox and the label of a cigar box with a picture of two Brazilians smoking are there to represent those faraway places. On another, *Mit wertvollen Glühbirnen (With Valuable Electric Bulbs),*

It was reproduced in Hans Arp and
El Lissitzky, *Die Kunstismen
1914–1924,* Zurich, 1925.

there is a great accumulation of machine parts, axletrees, bands running across spools, and the like, which may very well be inspired by Robert Michel, as may be also the Dadaistic letterhead for a company named "Dali-Glühbirnen." There is more than a hint of Dada in *Proposal for Political Mourning Ceremonies,* which is dated 1923 in the center of the picture and includes pasted instructions for the use of crystalline saccharine.

According to Molzahn, in those years collage meant for him "a very apt formal means of concretizing and differentiating a statement," an opinion in which, he states, he differs from his old friend Schwitters, for whom the medium was in itself a fundamental means of representation. As a matter of fact, collage elements play only an accessory role in Molzahn's painting, where they remain submerged under the warm color harmonies.

It is worthy of note that these Weimar painters produced highly individual work, in which there is an interplay of Dadaistic reminiscences, the cult of the machine, and Constructivist tendencies, but in which each artist achieved and maintained his own personal style. The group broke up in 1920, and Molzahn moved first to Soest, then in 1923 to the School of Applied Arts in Magdeburg, and in 1928 to the Academy in Breslau, where he was joined the following year by Oskar Schlemmer and in 1931 by Georg Muche, both staunch pillars of the Bauhaus movement. Like so many of his colleagues, Molzahn eventually had to take refuge in the United States, where he taught at the University of Washington, Moholy-Nagy's Institute of Design in Chicago, the New School for Social Research in New York, and elsewhere. He returned to Munich in 1959 and died there six years later.

The Dresden painter EDMUND KESTING (b. 1892) also had connections with Der Sturm. Early in the 1920s he undertook quite personal experiments in collage and montage. Landscapes in Expressionist style, with the pictorial space filled with elements staggered in depth, led him in 1920 to the idea of "breaking through the restriction of a picture to its surface plane" and of substituting obliquely disposed components for the conventionally uniform level of the canvas or panel. Toward this end, he stretched his canvas partly over and partly under the stretchers, thereby creating differences in level, and he intensified the effect of relief by using light and shade to make the painted shapes stand out more sculpturally. The exposed parts of the stretcher look something like a stage ramp, behind which rise colored scenery wings, and it is not surprising that his compositions did eventually inspire certain stage designs.

In so doing, Kesting altered the Cubist principle of composition, that space should be made visible by the stratification of planes.

Kesting soon began to mount various materials into these pictures. In his *Seven* of 1922, a metal ring and a disk set on rods project above the surface and oscillate independently like pendulums. Elsewhere he nailed in pieces of wood and patterned cloth, screwed pieces of metal to the picture, stretched strings and wires across painted abstract forms that came to resemble imaginary buildings. In one of these "pictorial architectures," *Spiral* of 1923, besides wooden elements there is a glass eye around which a spiral revolves, and the movement is carried further by linear projections leading out of the surface plane and into the picture depth and prolonging themselves on the frame in the foreground as if in a mirror. Somewhat more light-hearted is a material picture of 1925 which has hearts sawed out of painted boards and underlaid with wire netting.

Besides his "pictures with interlaced canvas," Kesting also produces paper collages he calls "cut graphics" (plate 224). He cuts into drawing paper and then folds, bends, or rolls the resulting free-ended strips and points to make reliefs in which light and shadow are essential components. He covers and surrounds his three-dimensional forms with brush stippling and delicate patterns in gradated colors so as to reinforce even more the notion of projecting and receding surfaces; and at times he also enlivens the compositions with crumpled colored papers, candy wrappings, and colored stars, or weaves the strips into flat wickerwork patterns. During the inflation years, when such things had no value, he used paper money and postage stamps in his collages (plate 226), sometimes with state loan-office cash orders or a

One of his "cut graphics" of 1923 with collage elements is in the Société Anonyme Collection, Yale University Art Gallery, New Haven, Conn.

thousand-mark bill emerging clearly from the melee, at other times distributing over and between the folds of paper dozens of postage stamps in values from ten pfennigs to ten million marks. In 1924 in a typographical collage he used million- and billion-mark notes surrounded by wise old proverbs and stretched over the whole picture a wire net with key points emphasized by devalued coins glued to them. This picture, titled *Money—Devil—Men*, was reproduced in 1925 in *Der Sturm*, which two years later also published a number of his "pictorial architectures." Kesting remained in contact with Herwarth Walden, who visited him in Dresden in 1932 on his way to the Soviet Union, where subsequently all trace of him was lost.

In the course of the 1920s, in addition to painting and graphic art Kesting also took up photography, there too indulging in all sorts of experiments. He produced photograms from transparent webs and delicately fibered plants, and achieved highly refined chiaroscuro compositions by exploiting superimposed printing, screening, and solarization. His specialty was "simultaneous portraits," in which he printed two or more photographs of heads combined and superimposed. More recently he has been experimenting with colored photograms, treating light-sensitive papers with various chemicals to obtain nuances of color ranging from lightest blue to deepest black in gleaming metallic or mat tones.

Hungary

The cultural give and take between eastern and western European countries after World War I owed a great deal to the Hungarians Lajos Kassák and László Moholy-Nagy. As poet, painter, and journalist, LAJOS KASSÁK (1887–1967) became interested early in all modern movements. He traveled about through half of Europe and in 1914 visited Paris. In that year he founded the magazine *Tett (Action)*, which was placed under ban during the war. In 1917, together with Moholy-Nagy, Alexander Barta, and Sándor Bortnyik, he organized the artists' group Ma (Today) and edited a magazine of the same name, which first appeared in Budapest and then, after 1920, in Vienna, where Kassák emigrated following the fall of the abortive Communist government in Hungary. As a special publication of *Ma*, in 1922 he and Moholy-Nagy brought out a *Buch neuer Künstler*, the first all-embracing survey of avant-garde painters and sculptors in the various countries of Europe, including Futurists, Cubists, Dadaists, Neo-Plasticists, and the Russians Kandinsky, Tatlin, Malevich, and Lissitzky. It was, in fact, the Suprematist and Constructivist works of Lissitzky that constituted the major influence on the painting of both Kassák and Moholy-Nagy.

Kassák produced a few typographical collages in 1920 that were quite certainly influenced by the Berlin Dadaists. In *Clock*, letters cut out every which way are pasted around a clock dial, and appropriate fragments of words make up another titled *Noise*. However, one of his early genuine collages (plate 229), a geometric composition of planes with colored papers and printed matter, includes certain documents that testify to Kassák's connections with the Paris Dada group: invitations to the Dada manifestation of March 27, 1921, and to their kangaroo-court "trial" on May 13 of the writer Maurice Barrès (for "crimes against the security of the spirit").

On that occasion Kesting painted the last known portrait of Walden.

A book about his photographic experiments, *Ein Maler sieht durchs Objektiv*, was published in Halle in 1958.

These collages, dated in the Italian manner "920," were shown in the Dada exhibitions of 1966 in Zurich and Paris.

A clipping from a Hungarian newspaper for July 10, 1921, which is also included, suggests that the collage was done in that year, though the date, obviously added later, is 1922.

The scalloped, festoon-like shapes intermingled here with geometric forms are not used in the more Constructivist compositions that Kassák called "pictorial architectures," nor is his native folklike, bright color, which is scaled down to more muted color harmonies. For collages in the same style, Kassák varied the surface textures by using smooth, watered, painted, or printed papers, and he continued to paste into them letters and strips of words in Dadaist manner. Thus, in a rigorous surface composition of 1922, entirely made from papers in shaded beige-yellowish and brownish red tones, there is an arbitrary sequence of letters that recalls Hausmann's phonetic posters.

These are also closely related to Balla's early abstract collages.

A very impressive collage with a large red circular form on a light ground is reproduced in color in the catalogue of the exhibition organized at the Galerie Fenyes in Budapest in 1967 on the occasion of Kassák's eightieth—and last—birthday.

Kassák utilized the same style, with half-painted, half-pasted texts, in his sketches for commercial projects such as a newspaper kiosk with postal counter in 1922 and a poster advertising cigarettes in 1923. About that time also he was active in typography and book design and was engaged in constructing reliefs from a variety of materials such as wood, sheet metal, and corrugated cardboard, which he completed with brush and paint. Kassák's artistic work, as well as his poems and prose writings, made him very much a pathbreaker in Hungary until the political situation forced him to retire from public attention.

Reproduced in Jan Tschichold, *Die neue Typographie*, Berlin, 1928

The collages of his last years that were shown in 1965 at the Galerie Klihm in Munich (plate 230) reveal that Kassák had renounced the nonrepresentational art he had once championed so categorically and returned to a type of figuration that mingles Dadaist and Surrealist tendencies, humor and dreamlike visions. At the very last, though, there were again abstract collages containing not only colored papers but also cutout illustrations.

LÁSZLÓ MOHOLY-NAGY (1895–1946) began to draw and paint in 1916 as a patient in a military hospital in Odessa recuperating from a war wound. After discharge from the army he continued his self-taught activities in Budapest, drawing portraits and figurative scenes in a tortuous Expressionistic style but also, along with these, landscapes in which, about 1919, he achieved a clarification of the surface planes of his images.

Michel Seuphor tells that, along with Marinetti and Schwitters, Kassák attended the literary evenings that he and Paul Dermée organized in 1927 at the Galerie du Sacre du Printemps, where "poetry in every language was recited, sometimes to the accompaniment of a hurdy-gurdy." *Abstract Painting*, New York, 1962, p. 108

After a sojourn in Vienna, in 1920 he moved to Berlin, where he began to work on "farm pictures," in which the natural formations of a landscape were transposed into abstract fields of color, and "railway pictures," architectonic representations, with towers and bridges interpenetrating and intersecting and recognizable technical details such as wires and iron grating. The mobile platform used by the workers in Berlin to repair the tramway cables inspired him to attempt a *Construction*, which was subsequently to lead him to other entirely imaginary machinery. These differed from the Dadaist creations of Picabia, Max Ernst, and the others in their mathematical precision and down-to-earth objectivity. Some of them incorporate collage elements, for example *Perpe* (from "*perpetuum*," as in "*perpetuum mobile*"; plate 228), an open, airy structure of beams, pylons, and wheels with bright-colored papers inserted among the light watercolor forms. On another collage, which takes its title from the large letters *PN* in it (plate 225), two small wheels are covered with tin foil, and a label with writing is pasted on the platform supporting the "machinery."

L. Moholy-Nagy, *Vision in Motion*, Chicago, 1947, p. 142

There is something of Hungarian folk art in the gay coloring of these pictures, as also in those that Kassák was producing at the same time.

Moholy used the same composition for a linoleum block dated 1922. Reproduced in Nell Walden and Lothar Schreyer, *Der Sturm*, Baden-Baden, 1954

At about this same time Hannah Höch gave Moholy-Nagy one of her photomontages.

Munich, 1929. Translated as *The New Vision: From Material to Architecture*, New York, 1938

Relief S is dated 1920 in the published book. Moholy-Nagy himself wrote the date of 1922 on the photograph of *Relief h* that appears in our plate 227.

Moholy-Nagy met El Lissitzky in 1921 at the First International Congress of Progressive Artists in Düsseldorf, and the following year he visited the comprehensive exhibition of Russian art in Berlin.

In *De Stijl*, no. 7, 1922

Letter to Erich Buchholz, Dessau, 1928, published in the catalogue of the *Bauhaus* exhibition, Frankfort on the Main, 1964, p. 53

Vision in Motion, pp. 187 ff.

It was about 1920 that letters and numerals became basic pictorial elements for Moholy-Nagy. In the *Great Feeling Machine* letters and numbers and wheels dance around a disk, and in an India-ink drawing—recently labeled *Dada-Collage*, though nothing at all is pasted in or on it—fragments of words fly out centrifugally into space. Such typographical elements, however, are used more sparingly in Moholy's actual collages. An early collage with an architectonic construction (Collection Carlos Raúl Villanueva, Caracas, Venezuela) has a large painted letter "A" stenciled into it, and beneath the architectural structure covered with shiny paper is pasted a small shield with the number 11. In other small collages, isolated large printed letters form the basis for more abstract compositions, for example a "D" (for Dada?) on a sheet with bright-colored clockwork, which is dedicated to Hannah Höch (now Collection Eric Estorick, London).

Letters and numerals are also found in a few reliefs that Moholy-Nagy assembled out of a remarkable variety of materials. In his book *Von Material zu Architektur* he explains that these works originated in his interests in effects of depth and height. He illustrates this with his *Relief S*, which unites a cogwheel, a three-dimensional number 1, pieces of wood, and a strip of glass projecting out several centimeters, the whole mounted on a construction of metal rods and, when appropriately illuminated, casting shadows on the ground. The *Relief h* of 1922 (plate 227) has, in addition to the lower-case letter "h," a spool of thread, a painted wooden bracket, and the two halves of a disassembled electric bell, which are linked by wires stretched somewhat above the surface of the relief. In the clear and sober organization of the composition these materials lose nothing of their objective, practical aspect.

During 1922 the last allusions to real objects disappeared from Moholy-Nagy's work, and he turned to the pure abstraction derived from the Russian Suprematists and Constructivists. His oil paintings and collages of that year are based on elementary geometric forms in rigorously vertical–horizontal dispositions, with colored strips intersecting to make static, linear armatures in carefully calibrated equilibrium (colorplate 34). The colored papers he used in collages, often laid out in parallel strips, strengthen the impression that precision is the ultimate goal. By 1923, however, diagonals tend to predominate, and the formal elements are more loosely distributed in space. As in Man Ray's *Revolving Doors*, Moholy-Nagy used intermediate tones in his collages to indicate transparency where the forms overlap. The six lithographs of the album that the Kestner-Gesellschaft brought out in Hanover in 1923 give a good idea of the diversity of his constructions of that year.

During his time in Berlin Moholy-Nagy also began to work with photograms. The idea came to him, as he explained in an article in 1922, during a walking trip with his wife, Lucia, in the Rhön Mountains, when he pondered over the question of how modern reproducing apparatus and procedures such as phonographs and photographs could be pressed into service for art. His own method involved distributing such simple objects as eggs, spools, rods, and sheet-metal forms on photosensitive paper and, by means of raking light, producing variable shadows in soft, gray tones to enrich the otherwise purely black-and-white contrast. Later he also utilized transparent materials —wire netting, webs, clear plastic film, incised glass plates, and so forth—to create completely nonobjective, nonrational compositions in light alone.

Moholy-Nagy continued these photographic experiments, as well as collage, along with his painting when he was called to the Weimar Bauhaus in 1923 to take over the direction of the class in metalwork and the basic course. With the collapse of the Bauhaus under Nazism, he emigrated and in 1937 founded the highly influential Institute of Design in Chicago.

Lucia Moholy, a trained photographer, assisted him in all these experiments, and his *Self-Portrait*, with head in profile, can scarcely have been photographed without help.

The Bauhaus and Its Circle

Collage and montage were assigned a new function and new tasks with the growth of a specific interest in the means of artistic expression as such—the which, when, why, and how of particular techniques—when the teaching of art came to be placed on a wholly new basis. The guiding principle of the Bauhaus, the idea that the basis of art education must be instruction in the nature and use of materials, had already been worked out by ADOLF HÖLZEL (1853–1934), who became a teacher in the Stuttgart Academy of Fine Arts as far back as 1907. He was the first to insist on the primacy of the technical means in the conception of a picture, arguing that those means "have their justification in and for themselves and have no need of what is merely an accessory factor, representation, and, indeed, are harmed by it." His own compositions were based purely on flat shapes and colors, which he sought to bring into harmony, and as early as 1910 he was creating abstract works on subjects that could scarcely even be guessed. Interested in all techniques, Hölzel even called for modernizing mural painting and stained glass.

In 1916 he was commissioned to decorate the board room of the Bahlsen biscuit factory in Hanover with stained-glass windows. For the sketches for three religious subjects, *Annunciation* (plate 236), *Adoration*, and *Prayer of the Children* (plate 235), he selected collage as the medium best adapted to working out the disposition of colors and planes. To forms painted in oils, he added torn, painted, and crumpled papers, tin foil, glazed paper, scraps of cloth, and a paper of pins without the pins, things which in themselves do not attract attention but do enrich the treatment by contributing varied textural qualities. He had, in fact, proceeded similarly in a few earlier oil paintings, introducing here and there papers in special tints.

Hölzel also initiated his students into the art of collage. LILY HILDEBRANDT (b. 1887), who was among them in Stuttgart, has preserved one of her collages, *Munich, 1916* (plate 233), made from torn, marbled and colored, glazed papers and conceived as a landscape. The abstract shapes, arranged spontaneously according to Hölzel's precepts, give the collage its surprisingly modern character. The title *Munich, 1916* suggests that she executed this particular work during one of her visits to that city, but she recalls others that she created in Hölzel's workshop in Stuttgart.

JOHANNES ITTEN (1888–1967), who studied with Hölzel in Stuttgart from 1913 to 1916, mentions in his book about the Bauhaus that as early as 1915 or 1916 he was working at compositions of geometric abstract forms and at montages of natural materials. However, all he preserved from that period was one somewhat later collage (plate 231), an India-ink drawing with flower motifs in a nervous and energetic hand, to which he added tin foil

The recently published *Bauhaus and Bauhaus People*, ed. Eckhard Neumann, New York, Van Nostrand Reinhold, 1970, provides a new source of biographical information.

They came into the possession of the Pelikan Works in Hanover, whose proprietor, Günther Wagner, after seeing a Hölzel show in the Kestner-Gesellschaft galleries in 1918, bought up all the artist's work.
As far back as 1892 Henry van de Velde had executed a sketch for a cloth appliqué panel, *The Vigil of the Angels*, with the *Adoration* in a collage of cutout colored papers, but it has not survived. See *Henry van de Velde, Geschichte meines Lebens*, ed. H. Curjel, Munich, 1962, p. 65 and note p. 479.

In 1918 Lily Hildebrandt used collage for illustrations for a children's book, *Klein Rainers Weltreise*.

J. Itten, *Mein Vorkurs am Bauhaus: Gestaltungs- und Formenlehre*, Ravensburg, 1963; translation, London, 1964

His wife advises that many years later he erroneously dated this work 1919, but when she called his attention to it, he altered the last figure to 7.

One of Itten's pupils recalls: "Itten urged us to keep our eyes open, while out walking, for rubbish heaps, refuse dumps, garbage buckets, and scrap deposits as sources of material by means of which to make images (sculptures) which would bring out unequivocally the essential and the antagonistic properties of individual materials" (Alfred Arndt, "Wie ich an das Bauhaus in Weimar kam," in the exhibition catalogue *Bauhaus*, Frankfort on the Main, Göppinger Galerie, 1964). Another student writes about Albers's teaching: "We had to make everything out of everything and anything. We ran around to the scrap heaps of the Junkers factory . . . and to the city dump. We foraged for treasures at the backs of the houses of the people from whom we rented our rooms, and with what we found we put together real marvels in the basic course. Albers urged the students to make use of rubbish for the simple reason that he found it too expensive to provide fresh materials for their class exercises" (exhibition catalogue, *Hans Fischli*, Zurich, Kunsthaus, 1968).
See reproduction in *Bauhaus 1919–1928*, eds. Herbert Bayer, Walter Gropius, and Ise Gropius, Museum of Modern Art, New York, 1938, p. 33 (later editions 1952, 1959). See also *The Bauhaus: Weimar, Dessau, Berlin, Chicago*, Cambridge, Mass., 1969.

Moholy-Nagy based his teaching on the "tactilism" propounded by Marinetti in a manifesto of 1921 as a guide to understanding materials by way of the sense of touch. The theory is discussed in *The New Vision*.

and crepe and tissue paper in abstract shapes that convey a lively feeling of a work constructed layer upon layer.

Hölzel's pedagogic ideas, published in 1916 as an essay on the training of the painter, were the decisive influence on Itten, who, in that same year, opened an art school in Vienna, where he worked out his own system of teaching, adding to Hölzel's ideas the methods of teaching children as expounded by Czizek, which were derived from the principles of the Montessori school.

Shortly after founding the Bauhaus in 1919 Gropius invited Itten to Weimar and assigned to him the direction of the first basic course, a program oriented mainly toward familiarizing the students with materials as a way to help them arrive at an understanding of their own particular talents and interests. Great quantities of materials—wood, glass, metals, stone, tree bark, spun and woven fabrics, furs, and so forth—were taken in hand, pored over and felt, so that the students could grasp for themselves the unique optical and tactile properties of each of them. Then, with no model to go by, "strictly from their own inner feeling," they were set to represent those properties by graphic means. Collages and montages of all sorts of raw materials were put together as illustrations of the contrasts between hard and soft, dull and shiny, transparent and opaque, and other qualities.

Out of this theoretical approach came material pictures reflecting the most diverse tendencies. The young HANNS HOFFMANN (b. 1899) (not to be confused with Hans Hofmann) combined scraps of cloth, sheet metal, a rope, a feather, an underwear button, and other odds and ends into a fantastic assemblage which still seems decidedly modern (plate 243). Erich Dieckmann, on the other hand, used differently textured materials to make a relief of clear geometric organization. While Nicholas Vasilieff was erecting a Constructivist tower of blocks, round forms, and bands, Max Bronstein (b. 1896), who now lives and works in Israel under the name of Mordechai Ardon, was turning a round straw seat, a feather duster, and other indefinable bits and pieces into a genuine Dada object.

When Itten left the Bauhaus in 1923, he was replaced for the course in materials by Josef Albers, one of his pupils, who continued to teach it when, soon thereafter, Moholy-Nagy himself took over the general direction of the basic studies. Moholy-Nagy deepened the investigations into materials and the practical exercises in their use by distinguishing, within the "structures" of the various raw materials, two quite different aspects: "textures," which reveal themselves by surface inspection; and "treatments," which come only through actually working the material. The compositions in various materials that the students of drawing and painting had to execute as practical exercises showed the same geometric organization as that underlying Moholy-Nagy's own pictures, whereas their three-dimensional constructions in metal, wood, glass, or other substances quite definitely followed Russian prototypes.

JOSEF ALBERS (b. 1888) was appointed master after the Bauhaus moved to Dessau. He had his students in the basic course undertake interesting experiments with paper also, insisting always that they were never to avail themselves of standard conventional methods, "not with the aim of doing it differently but rather in order not to do as the others do." Thus, since in crafts and industry paper is generally pasted flat and on one side only, Albers

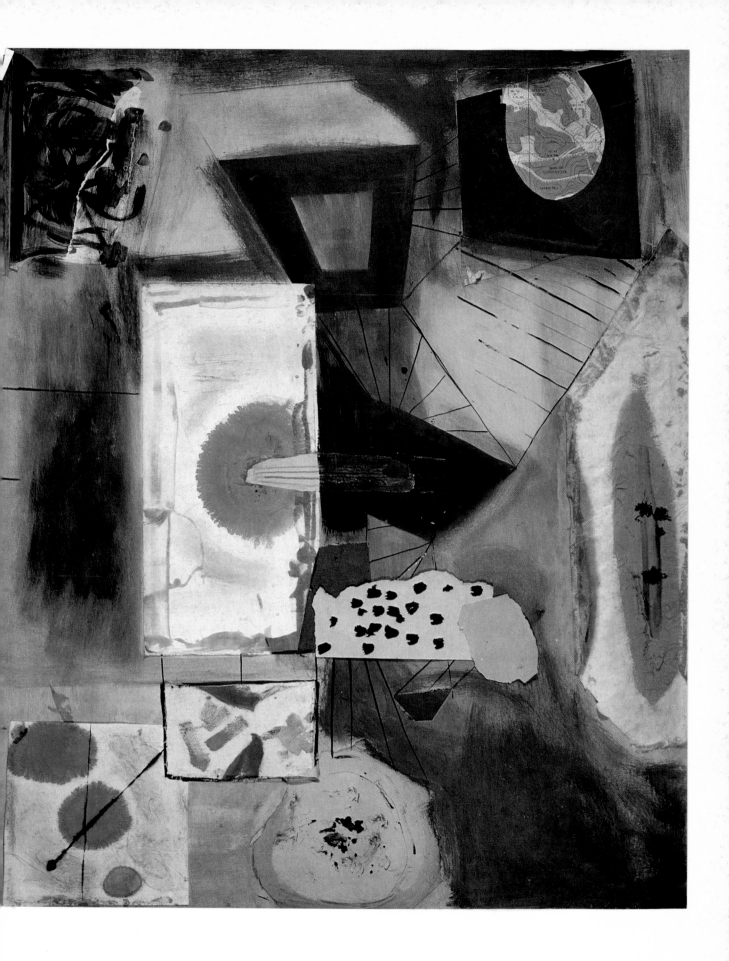

Colorplate 37. Robert Motherwell. *The Joy of Living.* 1943

Bauhaus 1919–1928, p. 117ff.

The same book, p. 117, reproduces a student work by Margrit Fischer with pastry-shop lace affixed in broad curves to a newspaper.

Albers too emigrated in 1933 to the United States, where he taught at Black Mountain College and then at Yale University.

Composition on Pink of 1916 in the Museum des 20. Jahrhunderts, Vienna; reconstructed in 1930

Oskar Schlemmer, *Briefe und Tagebücher*, ed. Tut Schlemmer, Munich, 1958, p. 277

encouraged the students to use it "upright, unevenly, in plastic movement, on both sides, and set on edge. . . . Instead of pasting, we shall tie it up, pin it, sew it, rivet it, in short affix it differently and investigate just how it responds to the demands of stress and strain." Following his instructions, the students cut into paper and bent and folded it to make three-dimensional reliefs—much like Kesting's "cut graphics"—and spatial constructions. Along with these they made genuine collages, affixing rolled-up strips of paper on newspaper or some other base in order to establish a relationship between extension on the surface and in depth. For these three-dimensional conceptions Albers also recommended other less usual materials, such as corrugated cardboard, wire screening, matchboxes, phonograph needles, razor blades, and so forth, many of them already utilized by the Cubists and Dadaists.

In his own work Albers was particularly interested in stained glass, and in 1921 he made two reliefs, one from fragments of colored glass bottles in all sorts of shapes (Collection the artist, New Haven, Conn.), the other from regular glass mosaic squares covered by different types of wire grating. Both are basically closer to material collages than to work in glass.

This interest in materials was shared by OSKAR SCHLEMMER (1888–1943), who took over the direction of the Bauhaus workshop for wall painting in 1923 and, soon thereafter, also those for wood and stone sculpture. Another of Hölzel's pupils at the Stuttgart Academy, it was there that, about 1915, Schlemmer embarked upon abstract compositions, sometimes incorporating into them human figures broken down into flat forms and circles and projected frontally in the plane of the picture or in superimposed levels. In some of his reliefs he mounted wooden, metal, and papier-mâché parts over a painted ground or inserted sheets of glass or metal; and in one, titled *Relief H*, he fitted glass spheres into an abstract figure made of bronze-coated plaster.

In Weimar, Schlemmer's main concern was with depicting the human figure in wall decorations executed in paint and relief. Nevertheless, in 1923 he produced a version in collage of one of his most abstract conceptions, the *Mythical Figure* (plate 237). Here, in the only true collage he is known to have done, a stylized body is stretched out horizontally, with a vertical profile head, against a ground of pasted papers lined and striped to accentuate the horizontal and vertical axes of the figure. The colors are in well-matched, mat tones of yellow, brown, and gray. The "mythical," a frequent subject in Schlemmer's writings, signified for him the incalculable, the intuitive factor that lies at the base of every pictorial conception and acquires its legitimate form through measure and law. Schlemmer himself viewed the *Mythical Figure* as one of his most essential pictures, one of the few that, as he wrote in his journal, "should not be omitted from a retrospective exhibition."

Schlemmer again had recourse to paper shapes in 1931, in his studies for wire sculptures, which led him to invent a new type of material picture. For the home of Dr. Rabe in Zwenkau, Saxony, he executed wall decorations in which he mounted wire frames that superimpose precise contours on figures otherwise merely sketched in with flowing curves and light colors, so that lines and shadows flow in and out of one another in such a way that the figures seem to rise out of waves of light.

Specific materials also played an important part in the costumes for the pantomime ballets, *The Triadic Ballet* (figure 48) and *The Figural Cabinet*, which Schlemmer and his students designed and staged in Weimar in 1922 and 1923. He dressed his dancers in padded and stiffened sheaths of cloth which reproduced, in sculptural abstraction, the forms and mechanical functions of the human body. His eventual goal was "to replace the old costumes, with their eternal, inevitable veils," by new materials such as "light-weight aluminum but also rubber, celluloid, flexible and unbreakable glass—the arsenal of materials as yet known and utilized only in industry and science." For these ballets there exist also photomontages, stage pictures in which photographs of the dancers have been mounted, and figurines on which portrait heads have been set (plate 238). For *The Mechanical Ballet* his pupils constructed something like shields of hard metal in geometric forms mounted one above the other in different colors for the dancers to hold in front of them on the stage.

Schlemmer's pupil ALEXANDER (XANTI) SCHAWINSKY (b. 1904) designed scenery and costumes for plays and ballets put on by the Bauhaus theater workshop in Dessau, and when Josef Albers invited him in 1936 to head the stage-design studio at Black Mountain College in North Carolina, he applied the same creative principles there. For his "spectodramas" he devised many-layered, varicolored paper collages to be carried across the stage by actors who remained invisible behind them.

FRIEDL DICKER (1898–1944) was one of the pupils of Itten who followed him to the Bauhaus from Vienna. The figure in her relief *The Cellist* (plate 232) is related to those in the reliefs by Schlemmer and by the sculptor and ceramist Kurt Schwerdtfeger dating from 1923. It is encased in a geometric composition of planes in which are mounted wood, metal, pins with shiny heads, and glass balls, quite certainly an attempt to play on the contrast between lusterless and gleaming materials, an effect further emphasized by the reflections of light from the glass and metal components.

HERBERT BAYER (b. 1900) went to the Bauhaus as a student in 1921. The following year he produced a drawing with watercolor and collage, *The Five* (plate 245), where a highly stylized violoncellist appears in five variants within a system of coordinates for which the instrument itself sets up the diagonals. From one variation to the next the "player" is more and more swallowed up by his instrument, which, in the final form, has itself become a large abstract hieroglyph superimposed on concentric circles. The figure, reduced to a diagram with round head and heart-shaped torso, is recognizably taken over from Schlemmer, and the lined papers pasted on the drawing are much like those of Schlemmer's *Mythical Figure*, though the manner of inserting the pieces of paper into the drawing as color and material elements recalls even more the Cubist papiers collés. Collage was used also in a drawing from 1923 of *Glass Bottles on a Table*, a typical Cubist subject, though here the still life is projected into free space. The neck of one bottle is filled with a silver paper that represents the reflections of the liquid, and a small oval in gold paper floats crosswise in the air in the company of other mysterious celestial bodies that could well be borrowed from Miró's own special world of images.

Oskar Schlemmer, "Der theatralische Kostümtanz," in *Europa*, ed. Carl Einstein and Paul Westheim, Potsdam, 1925

Reproductions in the exhibition catalogue *Oskar Schlemmer und die abstrakte Bühne*, Zurich, Kunstgewerbemuseum, 1961; and O. Schlemmer, L. Moholy-Nagy, and F. Molnar, *Die Bühne im Bauhaus*, Munich, 1925 (facsimile reprint Mainz and Berlin, 1967)

The work is lost, but the photograph reproduced here was found among the papers of Prof. Hildebrandt in Stuttgart. Friedl Dicker died in the gas chamber at Auschwitz.

Figure 48. Program for Oskar Schlemmer's *Triadic Ballet* (*Das Triadische Ballett*), Weimar, 1935

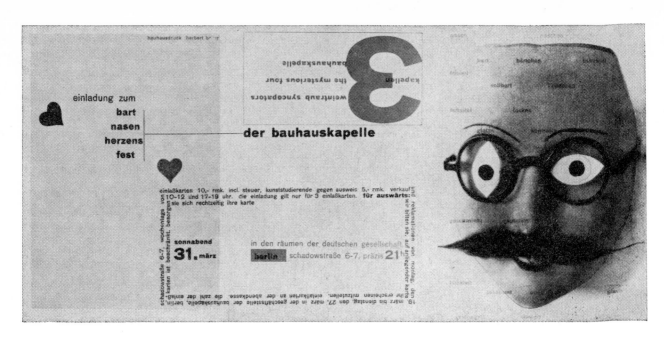

Figure 49. Herbert Bayer. Invitation to the Beard, Nose, and Heart Party *(Bart-, Nasen-, Herzensfest)*, Berlin Bauhaus, 1928

The use of the medium was probably stimulated also by the "metropolis" collages that Paul Citroen was doing at the Bauhaus.

Personal contact with the Dadaists was established in 1922 at the Congress for Modern Art, when not only the exponents of Constructivism and Neo-Plasticism were in Weimar but also Schwitters, Richter, Arp, and Tzara, who saw to it that the proceedings ended in the genuine Dada spirit.

Reproduced in *Bauhaus 1919–1928*, p. 179

Over and beyond its usefulness as a tool in teaching, collage was the favorite medium at the Bauhaus for all sorts of practical tasks such as the posters and invitations to special events which were Weimar's rather belated contribution to the Dada movement. For one of the Bauhaus dances in 1923 or 1924 Bayer made a collage poster with a grotesquely decorated full-moon face, paper medals, an advertisement for the famous Bauhauskapelle (the school jazz band), a photo of a dancing couple, and the like, promising the most enchanting attractions. Collages in all styles were fabricated as birthday gifts for Gropius and others. In October, 1925, LOU SCHEPER (b. 1901) sent to Alma Buscher and Werner Siedhof, dancers in Schlemmer's ballets, a most elaborate card congratulating them on their engagement (plate 241), illustrated with brightly colored drawings and with texts in part handwritten, in part assembled from cutout printed words. From a trip to Yugoslavia Helene Schmidt-Nonne sent back a "picture report" made of maps, railway tickets, and views of the local curiosities, much like the "touristic picture poems" the Czechs were exchanging in 1924. For the *Bart-, Nasen-, Herzensfest* (Beard, Nose, and Heart Party) organized by the Bauhauskapelle in 1928, Bayer designed an invitation card (figure 49) with cutout hearts and a photograph of a mustachioed mask integrated into the printed matter; and for the poster Alexander (Xanti) Schawinsky prepared a material collage on which an individual in every kind of Mardi Gras trappings looked through the frame and stretched out a hand holding playing cards. A double portrait in the same fantastic idiom is found on a photomontage that Schawinsky and A. Boggeri sent from Italy in 1934 as a New Year's card (plate 240).

The photomontages that Moholy-Nagy began to make in 1924 likewise have at least a strain of Dada in them. He called these works "photo-sculptures" and, in his book *Malerei, Fotografie, Film*, 1925, described them as "assembled out of various photographs ... an experimental method of simultaneous representation." They compressed, as he said, interpenetration of visual and verbal wit in an uncanny union of the imaginary with the real,

266

but at the same time they could narrate, stand solidly on their own, in a way more real than life itself.

For his photo-sculptures Moholy-Nagy used positive and negative prints, differently lighted sharp or blurred photos, others printed in superimposition, and so forth. Unlike the Berlin Dadaists, whose montages involve a dense and varicolored accumulation of heterogeneous elements, Moholy-Nagy's interest lay in carefully worked-out pictorial compositions. By preference he placed individual cutout photos in an open pictorial space and then led the eye from them into the picture depth by means of linear projections. Because of their isolation, the figurative details stand out as extremely sculpturesque, and the abrupt alternation of close and distant views gives rise to an immediate optical tension.

The themes exploited are a mélange of untrammeled fantasy and gay mockery, which upon occasion slips over into sharp criticism of the political and social relationships of the time. Titles such as *Leda and the Swan*, *Chicken Is Chicken*, and *My Name Is Hare* (plate 262) underscore the grotesque or satirical content of the pictures.

Moholy-Nagy also used collage and montage in designs for posters, magazine covers, and the like, combining them with his special interest, carefully conceived typographical layout. From "typo-posters" based on effective layout of the printed matter he went on to "typo-photos," in which he mounted photographs and letters together, as in the March, 1923, issue of the American periodical *Broom*, which appeared irregularly from November, 1921, to January, 1924, and was published first in Rome, then in Berlin, and finally in New York.

In the execution of such commercial-art commissions, Moholy-Nagy could count especially on the help of Bayer, who was taken on in Dessau in 1925 to teach typography and advertising art, and of JOOST SCHMIDT (1893–1948), who in addition to heading the sculpture workshop also taught lettering. For a publicity pamphlet for the city of Dessau in 1928, Schmidt devised a montage with photographs of the castle and park, a Junkers airplane, and products of the local machine industry, all distributed across an aerial view of the city. For the *Gas and Water Exposition* that took place in Berlin in the same year, he and Schawinsky designed the stand for the Dessau Junkers Works. Its walls were covered with a montage of photos and texts plus a poster by Schawinsky, asking "What are you doing for your health?", which, with its sports photos set into linear projections, was clearly influenced by Moholy-Nagy's photo-sculptures.

During the last period of the Bauhaus, the students in Joost Schmidt's classes in applied graphics also received systematic instruction in the composition of photomontages. His teaching approach involved either distributing newspapers and requiring the students to organize a composition from all the pictures on a particular page or assigning themes which they had to exploit in a number of variations.

It was not until 1929 that the Bauhaus offered a specific course in photography, but thereafter, and until the school was closed down, it was taught by WALTER PETERHANS (1897–1960), who had attended the Leipzig Academy of Graphic Arts and Book Design, where he had been especially concerned with the processes of line etching and reproduction photography. To acquaint his students with the multiple possibilities of photographic render-

Four of these photo-sculptures were reproduced in the English edition, Moholy-Nagy, *Painting, Photography, Film*, London, Cambridge, Mass., 1969, pp. 108–11.

The montage *Chicken Is Chicken*, in which there are three bold sportswomen along with a brood of chicks escaping from their shells, was later used by Moholy-Nagy as the basis for a film. Sequences of images and ideas, real and fantastic happenings, interpenetrate in a Surrealist dreamlike approach.

He also designed a title page for Vol. 4, no. 4, of *Broom*, illustrated in *Painting, Photography, Film*, p. 112, but when that number appeared, it carried a title page by Man Ray.

The exhibition catalogue *50 Jahre Bauhaus*, Stuttgart, 1968, p. 165, reproduces an interesting photo collage, *Klare Trennung (Clear Separation)*, by Joost Schmidt's pupil Kurt Kranz.

ing, such as shooting from below or obliquely, changing the lighting, printing with hard or soft contrast, he composed still lifes from a wide selection of objects, making something very like true material collages.

For one of his first photographs of this sort, he arranged on a grained plank starflowers, lemon peel, unleavened bread, eggshells, a fir branch, a herring, and a fishbone, and then interposed a sheet of glass to accentuate the shadows. After the Bauhaus moved to Berlin in 1932, Peterhans produced his *Grünewald Still Life* (plate 242), in which newspapers are spread above and below a sheet of glass so that the still-life objects are raised above the graphic component; interspersed among poetic branches, blossoms, and grass blades there are such prosaic items as a piece of Swiss cheese, a cigarette butt, and the wrapper from a Maggi beef cube. For another such assemblage Peterhans placed combs and small balls on a patterned textile in such a way as to make their shadows intersect with the linear design on the cloth. He achieved extremely subtle tonal values in his still lifes by using loosely puffed-out, transparent woven fabrics, tulles, and laces. He also utilized magnifying glasses and satiny papers to obtain reflections, and by means of soft gray and silver tones he made cloudlike images in which all objective contours dissolve away.

After the Nazis forced the Bauhaus to close in April of 1933, Peterhans taught for the next two years at the Reimann-Häring School in Berlin and then emigrated to America, where, in 1938, he was engaged by the Illinois Institute of Technology in Chicago to give courses in visual training, artistic analysis, and art history.

Meanwhile, in 1928 Moholy-Nagy and Bayer had left the Dessau Bauhaus, together with Gropius, and gone to work in Berlin. When Gropius was given the task of organizing the German section at the international exhibition of applied arts in the Grand Palais in Paris, he called on his two associates to prepare the display walls and on Bayer in particular to design the catalogue in photomontage style. Both Peterhans and Bayer were much sought after in Berlin by industrial firms, agencies, magazines, and the like, and made a substantial contribution to new visual forms in commercial art. Moholy-Nagy also designed scenery for Erwin Piscator's theater and for the Berlin Staatsoper, notably a *Madame Butterfly* in 1930, with the entire panorama of Nagasaki in collage.

After 1928 Bayer too began to produce collages and montages of more purely imaginative character, and in these, as in his paintings of that time, there are Surrealist traits which often bring to mind Magritte. Bayer envisioned "impossible situations," placing windows and pieces of furniture in the open sky as if to contrast unformed nature with the solid products of men's labors. In typical Surrealist fashion he played with pictures within pictures; he put a frame around a detail from a romantic landscape and dubbed the resultant collage *A Look at Life*. He broke down the relationship between reality and its artistic rendering (which had been one of the chief tasks in the Bauhaus course in the use of materials) in a collage titled *Atelier-Strand (Studio-Beach)*, dated August 28, 1928, in which, along with the sketchily drawn contours of a female figure in bathing suit, her head lost in the clouds, the model herself appears in a "naughty" photo from the turn of the century. Four years later he was producing occasional photomontages

of hallucinatory impact, such as the mirrored *Self-Portrait* (plate 247), in which a cross-section—seemingly of plaster or stone—has been cut out of his upraised left arm and is being clasped to his nude breast by his right hand. In *Lonely Metropolitan* (plate 246) the two gigantic hands of the solitary big-city dweller rise up in front of a bleak row of windows, and from their palms two wide-open eyes stare out. The dramatic effect of these collages is due, in considerable measure, to the skillful use of light and shadow.

Now and then collage elements are found in the works of PAUL KLEE (1879–1940) after his Bauhaus period, some of them from his time in Düsseldorf, where he taught at the Academy from 1930 to 1933, others from after his move to Bern in 1933. Nevertheless, these added elements have little relationship to real collage and represent merely another of the many techniques and materials of painting with which Klee was experimenting at about that time. He tried chalk and plaster for his grounds, used watercolor, oil, and tempera alone or in mixtures, varnished and waxed his pictures, and even painted on all sorts of cloth—silk, linen, muslin, damask—as a way of giving his paint a special consistency. For *May* (Collection Mr. and Mrs. Arnold H. Maremont, Winnetka, Ill.), a small panel dating from 1933, he covered the gesso ground with cheesecloth, painted in oil mixed with watercolor, and then waxed the picture, and here the loose weave gives the paint an exceptional fragility. For the oil painting *Destroyed Land* of 1934 (plate 239), torn cotton damask was spread over the canvas, and to it was glued still another single scrap of frayed cloth traversed by the schematic lines that divide the chaos of colors into separate compartments. Although Klee more than once meticulously painted woven textures to convey the impression of real cloth sewed to the picture, the dragon in his *Saint George* of 1936 wears real rags. Nevertheless, like all the materials he used, such textiles are so perfectly integrated in the over-all color scheme that one scarcely recognizes them as cloth.

Related to the Bauhaus are the collages of two other artists, Otto Nebel and Henri Nouveau, both of whom received the decisive impetus from Klee and Kandinsky. According to what he himself says, OTTO NEBEL (b. 1892) had already begun to work in collage in 1921 in Berlin, where, after his release from an English prisoner-of-war camp, he joined the group around Der Sturm and became known for his poems, drawings, and paintings. Quite early he interested himself in nonrepresentational compositions. During a visit to Weimar in 1925 he became friendly with Klee and Kandinsky and soon thereafter executed his first linoleum cut, visibly under Bauhaus influence. Catalogues of various exhibitions between 1923 and 1925 list collages by him, but none has survived, since he lost all his works during the Nazi period. The earliest of his collages known to us, *Terra Cotta: Stone Carrier*, is dated 1935 and belongs to a series of works with figures which, about 1934, began to replace his previous architectural style and are built up from flat surface forms transformed, by means of gradated shading, into spatial elements.

Art publications of the Galerie Nierendorf, Berlin, no. 9, *Otto Nebel*, Berlin, 1966, pl. 26

A more comprehensive acquaintance with Nebel as a collage artist, however, is based on works of the last ten years or so, compositions in small format (plate 234) born out of their author's manifest delight in such materials as small-patterned papers, scraps of lace, tin foil, candy wrappers, and sometimes also snippets of photos and engravings. Often the tiny shapes are care-

fully cut out in straight edges and angles and arranged in rhythmic series and sequence, but equally often bits of torn paper are strewn loosely and casually across a ground covered with light *frottage* textures or with delicate drawn or printed signs; and the forms and colors are always subtly harmonized. The general designation Nebel applies to his works of recent years, *Permanence poétique*, sums up the quintessence of what he expresses through collage.

The Hungarian painter and composer HENRI NOUVEAU (Hendrik Neugeboren) (1901–1959) remained deeply impressed by the first works of Kandinsky that he saw at the early age of sixteen. In 1921 he went to Berlin to study music, and his predilection for Bach led him to appreciate a visual art based on the analogous, rigorous formal principles he found in Kandinsky, whose influence is obvious in the abstract drawings that Nouveau began to try in 1923. He soon abandoned his attempts to use gouache, because the wet paint made the paper buckle and therefore distort the forms in which he was aiming at maximum definition.

Nouveau moved to Paris in 1925, and toward the end of that year he chanced upon an illustrated catalogue of plain-colored carpets, which prompted him to attempt collages. Glue struck him as a neater and cleaner substance than oil paints, and in his diary he argued: "Why should I waste my time producing a plain-colored surface when it can be cut out in a matter of minutes?" Between 1925 and 1931 he concentrated exclusively on collage. During that period, he was in Berlin again from 1927 to 1929, and in 1928 he visited the Bauhaus in Dessau, where he came to know Klee and Kandinsky in person. Although Klee's mysterious world of images was not without fascination for him, he was equally attracted by Kandinsky's clear organization of planes and surfaces, and from those two models he developed a personal style, a blend of restrained poetry and extreme formal precision.

Nouveau made careful preparatory drawings for his collages, marking them with the colors to be used. He then cut the elements out of the appropriate papers and put them together in a precisely sequential pattern, restricting his shapes to segments of circles, acute and obtuse triangles, and occasional billowing curves (plate 244). He chose lighter or darker color scales according to the character of the picture in hand, often with a startling brick red or orange standing out against an over-all scale of gray, white, and black, or with mat or shiny browns and grays surrounding a more vivid yellow or blue. Upon occasion he replaced his usual neutral ground with strong-colored paper, and later on, besides monochromatic and smooth papers, he adopted marbled and rough ones.

Initially his compositions spread across the entire surface, but in time they came to be concentrated in the middle of the picture. Although he never pasted one paper over another, he always calculated the shades of color so that he was able to obtain an effect of spatial stratification. He clung to small formats, mounted his finished collages in carefully selected passe-partouts, and stretched fine white threads across them, a device that lends his pictures something of the studied style of chamber music, the genre which Nouveau, as a composer, likewise preferred. One senses in them feelings that the artist dared express only in this "translated" form.

In the last phase of Nouveau's collages, in Paris between 1929 and 1931, now and then there occurred clearer allusions to figuration. The outlandish

visionary apparitions that haunted him at every step are treated with a dash of irony, though certain odd objects, such as a *Metaclavier* or a *Thermos Bottle*, came about by accidental combination of shapes and only retrospectively suggested their title to the artist. His attempts in 1931 to combine collage with gouache proved unsatisfactory, and he thereupon gave up his long-favored medium to devote himself entirely to painting.

Exhibition catalogues, *Henri Nouveau*, Paris, Galerie de France, 1959; and *Henri Nouveau*, Darmstadt, Bauhaus-Archiv, 1966

Non-Bauhaus Constructivists in Germany and Elsewhere

WILLI BAUMEISTER (1889–1955) appears to have dabbled in collage as early as 1911, when he corresponded with Oskar Schlemmer by means of "collage letters," and in the course of the next four years he expanded these "print-and-picture communications" to include also photomontages and what he described as "distorted photos." Schlemmer's widow and other friends of Baumeister's youth recall these letters put together from cutout and pasted strings of words and illustrations, but none seems to have survived.

In his autobiographical notice published in H. and B. Rasch, *Gefesselter Blick*, Stuttgart, 1930

The lifelong friendship between Baumeister and Schlemmer began in 1909 in Hölzel's Stuttgart atelier. During the postwar years they pursued the same goal of liberating painting from its traditional framework and adapting it to large wall surfaces, and, like Schlemmer, Baumeister too reduced the human figure to abstract formulas. For one of the very first of the *Mauerbilder*, the mural paintings he began to produce in 1919, he made a preliminary sketch in collage, incorporating an abstract figure into a system of planes composed of distinct fields cut out of paper and painted, some completely filled with color, others only lightly shaded or stippled by fleet brushwork. In the nonfigurative compositions of the *Flächenkräfte (Planes of Force)* series of 1920, he sought to create tension between the separate geometric fields by differentiating the shading and brushwork, and he further emphasized the contrast between smooth and rough papers by an admixture of sand. In his figure compositions up to 1923, he occasionally stressed the contours by using papier mâché and plywood to raise the forms above the picture surface.

Will Grohmann, *Willi Baumeister, Life and Work*, New York, c. 1966, colorplate p. 39

In 1922 Baumeister devoted himself to "machine pictures," initially abstract compositions into which he more and more introduced human figures, much as did Léger, with whom he became acquainted in Paris in 1924. From 1927 on he produced "sports pictures," with gymnasts, swimmers, football and tennis players, and in these he strove to bring fleeting movements and gestures into harmony with the schematized types and norms of the figures and their attributes, which he laid out frontally across the picture surface in a procedure not unlike that of Synthetic Cubism. For these pictures he made what he called "photo-drawings," drawings into which he pasted cutout photographs. Two such photo-drawings were included in the *Sport und Maschine* album brought out in 1929 by the Galerie Flechtheim, which presented the basic formulations of those two themes in twenty original phototypes. In *Mechanic*, the photos, which show in actual function the wheels and gears that are merely projected diagramatically in the drawing, serve to juxtapose and contrast the filled and empty surfaces and, coincidentally, to introduce the concept of time into a static represen-

Reproduced in Roh and Tschichold, *Foto-Auge*, pl. 76

The nine charter members were Baumeister, Max Burchartz, Walter Dexel, César Domela, Michel, Schwitters, Georg Trump, Tschichold, and Vordemberge-Gildewart.

Exhibition catalogue, *Collagen*, Zurich, 1968, p. 182

New edition, Cologne, 1960

The one not reproduced here is in a private collection.

tation. Baumeister used photographs in other such works to create an impression of the spatial dimension, as an accessory pictorial factor within otherwise purely surface compositions. He thereby carried further the principle of Cubist papiers collés, in which the collage elements are used to bring out the color and physical properties of the objects delineated. In *Female Swimmer* the fully modeled body in the photograph contrasts with the flat, strictly two-dimensional outline drawing of the trees. Elsewhere the cutout figure of a diver cuts diagonally into the picture depth, while a motorboat on the water heads diagonally toward the viewer. The photo-drawing *Tennis Player* (plate 248) incorporates photographs of an actual match and the spectators' stands into a schematic drawing of a player with racket and balls. This was apparently the original impetus for several oil paintings by Baumeister between 1928 and 1934, in which the motifs of the individual player in space and the summarily grouped body of spectators recur in varying proportions and degrees of distance.

During the 1920s Baumeister was concerned also with book and advertising design, and in 1927 he joined the "ring of new publicity designers" (written without capital letters), which grouped a number of well-known artists and publicity specialists. The book devoted to them in 1930, *Gefesselter Blick (Spellbound Gaze)*, has on its title page one of Baumeister's photo-drawings (plate 250), with the portrait of a girl, one of whose eyes has been cut out and placed to the side as part of an abstract drawing. The book also reproduces a photomontage advertising a German linoleum company and two other photo-drawings. On one of the latter, which includes its title *Cheerful Photo-Drawing*, three photographic prints are pasted around a grotesque figure: a man's head, a leg, and, on an excessively long arm, a hand with outstretched finger tapping the sole of a foot. About the other, which involves an athlete on whose torso is pasted a photographic detail of a muscular chest, Baumeister says in the text: "Extreme tension arises between the soft naturalness of the photograph and the precisely drawn lines."

In an essay, *"Rhythmus als Zeitkörper"* ("Rhythm as Embodiment of Time"), written in the winter of 1943 and included in the second part of the book *Das Unbekannte in der Kunst (The Unknown in Art)*, Baumeister discusses the fundamental significance of collage and photomontage in modern art, pointing to the twofold function—optical and objective–psychological—that the pasted components have in the Cubists' pictures, and making particular mention of the fragments of photographs that the Cubists' successors mounted into their paintings. This is how he describes the making of a photomontage: "It begins with a piece cut out of a photograph (head, body, or something else). Such a fragment, detached from its original background . . . is laid, isolated, on a piece of white paper. For all that, practically speaking, it remains on the surface, there occurs nevertheless, and impressively, a phenomenon involving a body in space. To the highest measure it is distinguished from all the usual natural aspects and from the usual naturalistic impressions based on perspective."

A certain number of photo-drawings, probably more or less contemporary with the essay, appear to have been put together in exactly the way described—by beginning with fragments of photographs and drawing over them with linear curves and hatches to effect pictorial compositions. Two of them could well illustrate ancient Greek texts, with their fragments of antique

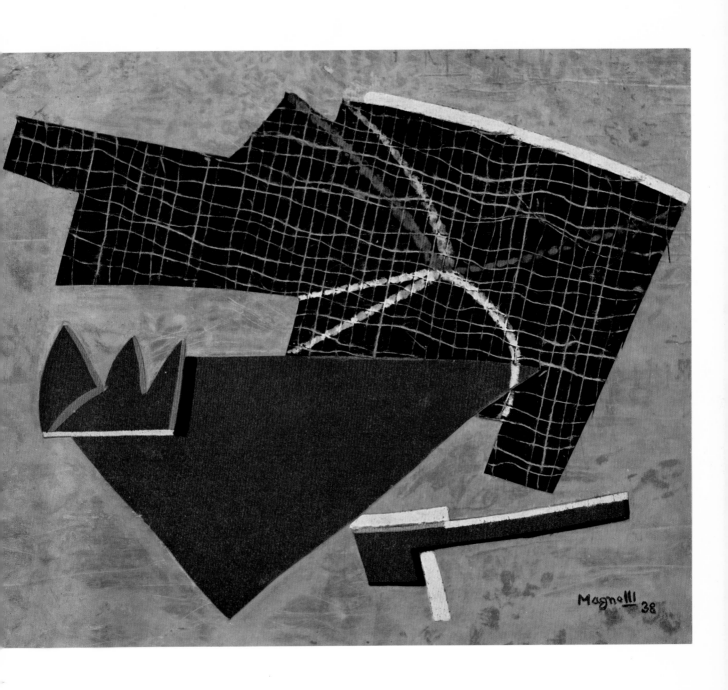

Colorplate 38. Alberto Magnelli. Untitled. 1938

torsos embraced by lines that twist like vines climbing out of mysterious waters (plate 251). On a third example (plate 249) hieroglyphs, given relief by chalk shading, cover the ground like tracks in the sand; and the bearded head, perhaps intended to recall some detail of an Assyrian statue of Gilgamesh, suggests that this sheet may be one of those illustrations of the epic of that legendary king-hero of Uruk which were Baumeister's chief concern during the 1940s and for which he steeped himself in the study of archaic cultures, Sumerian and Babylonian in particular.

Compare the eighth-century B.C. reliefs from the citadel of Sargon II at Khorsabad, now in the Louvre. Exhibition, *Gilgamesch*, Hamburg, Museum für Kunst und Gewerbe, 1964

In his last years Baumeister also executed compositions for the *Monturi* and *Montaru* series in collage, using torn papers fixed to shaded grounds and tiny white shreds of paper distributed around the large black areas, then going over and finishing them with colored chalks and drawn scrolls and volutes. With these means and materials he was able to confer on these sketchy works the same expressive power that characterizes his large oil paintings.

Among the artists who mapped out their own Constructivist paths independently of the Bauhaus, and who also championed new means of expression, FRIEDRICH (FRITZ) VORDEMBERGE-GILDEWART (1899–1962) was one of the foremost of those who, as he himself put it, "learned pictorial thinking from the material itself."

Letter of October 22, 1952

Vordemberge-Gildewart studied architecture and sculpture at the School of Applied Arts and the Technical College in Hanover, and as early as 1919 he began to work on reliefs and drawings in elementary forms which, at first, exhibited a certain diversity but soon became more simplified, in accord with the Neo-Plasticist ideas of the Dutch De Stijl group, which he joined in 1924. A drawing of 1923 has a rectangular piece of newspaper pasted into it. In another (Collection Vicomtesse de Noailles, Paris) paper and lace elements inject specific textural values among the lines and planes. An oil painting of the following year, *Construction with Wall Street* (colorplate 35), incorporates among its colored rectangles a piece of corrugated cardboard, a newspaper cutting, and an architectural drawing; and the vertical furrows of the corrugated cardboard are echoed by the painted horizontal stripes in another area at the right edge of the picture, while the flight of stairs of the drawing, placed in the upper-left part of the composition, leads away from the surface plane into the depth.

Subsequently he turned to relief pictures, using pasted papers, wood, wire, and other materials. Once he included a piece of milk glass; another time he nailed a T-square to a painted panel so that the upper and lower ends project beyond the area. Eventually he even made use of old-fashioned picture frames saved from the days when he was learning cabinetmaking. A complete frame is incorporated into a picture from 1925, painted in shades of mat gray and yellowish white. The *Composition no. 19* of 1926 (plate 253) joins two lengths of red-streaked frame molding to make an open right angle which is laid over a painted T shape, and nearby is a wooden hemisphere, a formal element that reappears in many of his subsequent constructions.

Between 1926 and 1928 Vordemberge-Gildewart also made collages in which, for the most part, he combined cutout photos and illustrations with abstract pictorial elements. In one of these he placed a photograph of a

Negro child between a wedge-shaped piece of newspaper and a scrap of lace and put these in front of two geometric, flat shapes drawn in black India ink, an exploitation of contrasts seemingly influenced by Dada and perhaps also derived from Schwitters, of whom Vordemberge-Gildewart saw a great deal in Hanover, or from Arp, whose likeness he included in a collage of 1927 (plate 252). In this portrayal the Dadaistic components—the numeral 9 connected to the bell of a brass instrument—are integrated into a rigorous composition of lines, planes, and volumes. The touch of Dada is more provocative in a collage from 1928, *Architecture—No Optical Value*, in which, above and below an architectural drawing laid out on a diagonal, there appears twice the same mutilated photograph of a seated girl. Only her legs and the unsupported shoulder straps of her undergarment can be seen in empty space.

One cannot help recalling the Proun pictures by Lissitzky, who also spent some time in Hanover.

For a number of other collages Vordemberge-Gildewart utilized a shiny black paper on which isolated objective elements are linked only by optical relationships. For one of these (plate 254) he cut the head of a chimpanzee out of Paul Eipper's book of animal photographs, *Tiere sehen dich an*, and pasted the "negative" shape that resulted from the cutting process, as an abstract form, below the simian head. Finally he added a separate small abstract collage of colored papers as the third element. He varied surface and depth dimensions by juxtaposing an egg shape cut from newspaper, a photograph of a well-modeled leg emerging from under a short pleated skirt, and a construction made of varicolored tubes and rods. By pasting arbitrary fragments of photographs upside down or in anything but the normal position, he drained away their realistic aspect and converted them into nonrepresentational pictorial components fully in line with his repertory of abstract forms.

Following a long period of concentrating exclusively on painting, a phase marked by ever more subtle counterbalancing of formal and color values, after World War II Vordemberge-Gildewart began a new series of collages in which he, like Arp, let the laws of chance dictate the results. Across the surface he distributed torn or carelessly cut smooth or roughened papers, white on white or black on black, allowing an occasional piece to curl up. By such means light and shadow became factors in the compositions and lent them a certain discreet animation. The seriousness with which Vordemberge-Gildewart viewed his work in collage is apparent from his often-quoted motto: "Collage is more powerful than the sum of fantasy plus bravura in the manipulation of the brush."

Among Vordemberge-Gildewart's circle of friends in Hanover, ERIKA SCHNEIDER, an artist of Russian and German extraction, was especially admired. She "signed" his guest book on September 13, 1925, with a collage made of a piece of paper lace and black shapes, one of which represented a pointed shoe (plate 257). Here a certain playful approach is combined with a marked feeling for composition and material.

Vordemberge-Gildewart wrote to H. Hildebrandt on August 24, 1928: "She makes tremendously significant collages, photomontages, typographical works, and other things and has really earned the right to figure in any eventual new edition" (of Hildebrandt's *Die Kunst des 19. und 20. Jahrhunderts*).

WALTER DEXEL (b. 1890) studied both painting and art history in Munich and Jena, and in the latter city took over the direction of the art association, where, through lectures and exhibitions, he attempted to stir up some interest in modern art. His own painting follows the example of Cézanne in form but that of the Expressionists in color. The Berlin gallery of Der Sturm

exhibited a number of his works in 1918, among them paintings done on the back of sheets of glass, a technique he had learned from the painters of the Blaue Reiter group in Munich.

Dexel maintained close ties with the Bauhaus from the time of its foundation. Among its teachers he was particularly attracted to Theo van Doesburg, who was there from 1921 to 1923 and gathered a group of supporters to whom he introduced the ideas of the Stijl group. At about that time Dexel was painting "machine pictures," locomotives and airplanes set in a geometric arrangement of planes. Then, in 1922, he changed to nonrepresentational compositions constructed in the manner of the Neo-Plasticists, confining himself to horizontally and vertically disposed rectangles. Later, for "perpendicular and level beams," he also had recourse to "circular and cutout disks and hooks," that is, to angles creating diagonals. For the most part Dexel restricted his color schemes to bright red or blue accents within an over-all black-and-white contrast, though at times he harmonized these with related colors such as yellow and orange.

For some sketches and pictures he turned to collage because of its adaptability to the formal simplification for which he was striving. Like Moholy-Nagy, he occasionally based collage compositions on large printed letters, though Dexel tended to make these dominate the pictorial field more emphatically. He had already tried his hand at modern typography in preparing invitations and other printed matter for the art association; later he went on to combine typographical layout with collage in designs for posters. During 1927 and 1928 he designed a number of book covers in which photographs are integrated into the forms and colors of an over-all design. As a member of the "ring of new publicity designers" he worked in Frankfort under the architects Adolf Meyer and Ernest May in designing shop facades and sales stands. In 1928 he was invited to Magdeburg to teach graphic design in the school of applied arts there.

After having worked for some time in a consistently nonfigurative style, in 1930 his abstract compositions began suddenly to assume the aspect of heads. The *Monocle Face* (figure 50) was executed in collage, with narrow strips of paper laid at right angles and a cutout circle as the monocle, which appears to cast a colored shadow on the paper. This was followed by caricature drawings of contemporary individuals and events—*The Black Marketeer, Green Week, The Jesuit, Hugenberg, Steel Helmet*, and the like—in which the characteristic features were reduced to the sparest of graphic formulas. Among these were a few collages such as *Deutschnational* of 1933 (figure 50), a model of correctness and obtuse insipidity portrayed chiefly by striped and patterned papers.

Classed as a "degenerate artist," Dexel was ousted from his post in 1935. In the ensuing years he devoted himself to the history and modern development of applied art forms, and in 1942, on his own plans, he set up in Brunswick a "form collection," consisting of models of good design.

Like Vordemberge-Gildewart, the Belgian VICTOR SERVRANCKX (1897–1965) could also say that he had found the way to art via materials themselves. As he tells it, as early as the age of eight or nine he was making strange statues and reliefs from anything he could put his hands on in the country district where he lived: wood, bark, cork, moss, metal, glass, jute, stones, gravel, sand, feathers, butterfly wings, entire insects. In the art works that

There is a *Locomotive* of 1918 in the Galerie des 20. Jahrhunderts, Berlin.

His own terms, as used in connection with his exhibitions of 1964 to 1968 at the Galerie Klihm, Munich

The Hard P Picture of 1925 was a sketch in collage for an underglass painting now in the Städtische Galerie, Wiesbaden.

Exhibition catalogue, *Walter Dexel, 1912–1932*, Brunswick, Städtisches Museum, 1962

Exhibition *Konstruktive Malerei 1915–1930*, Frankfort on the Main, Kunstverein, 1967

Letter of April 26, 1961

Figure 50. Walter Dexel. *Monocle Face* (left). 1930. *Deutschnational* (right). 1933. Cut paper

resulted, he singled out details here and there to be painted over, but usually he let the natural colors of the materials stand out on their own. At sixteen he was apprenticed to a carpet factory, where his main work involved putting together the colors, though he eventually came to be in charge of the artistic direction. At the same time he attended the Academy of Fine Arts in Brussels, and when he finished the course in 1917 and won the first prize, one of his teachers persuaded the Galerie Giroux to exhibit his abstract pictures, the first nonfigurative art works, as it turned out, ever shown in Belgium.

Michel Seuphor, *L'Art abstrait, ses origines, ses premiers maîtres*, Paris, 1950

Among the works that Servranckx displayed there was a collage titled *Opus I—1915* with a painted disk from the center of which vegetable forms in colored papers poured out. This odd theme was varied five years later in his *Opus I—1920*, in which fiery rivers of color rise from the circling globe of the world. In another collage, *Opus V—1919* (plate 256) mobile round bodies in mat gold tones that tend to melt into the textured background are contrasted with geometric forms in striking colors: a reddish-gold hoop above, a light-green disk with red border below, a brick-red diagonal stripe across the center, a transparent band of delicate pink in the lower part of the picture.

Servranckx's style changed markedly about 1922, when he came into contact in Paris with the painters of the Effort Moderne group, who were being launched by the Galerie Léonce Rosenberg. He began to paint machines and cities in a frontal, flat surface plane, obviously influenced by Fernand Léger and Amédée Ozenfant, but at the same time he was working on new and entirely nonrepresentational composition in the spirit of the

Dutch Neo-Plasticists. In 1924 he created a collage of monochromatic rectangles and circles overlying vertically striped papers, a composition so precise that it could scarcely be achieved except with the scissors. An article published in 1924 in the Hungarian magazine *Ma* says of pictures of this sort that "everything is exactly where it should be, there is nothing in excess and at the same time nothing too little." That same year Servranckx also painted *The Most Quadratic Rectangle* in a single shade of color, thereby, like Rodchenko before him, drawing the ultimate conclusion from the rediscovery of the fundamental means of artistic creation.

After 1926 Servranckx once again turned away from measure and order to produce pictures of more complete formal freedom. For these he returned to the cosmic themes of his youth, though now with a more dramatic character. A temporary flirtation with Surrealist tendencies in the early 1940s resulted in a few remarkable objects and material pictures such as his *Opus II—1941*, in which scraps of cloth are mounted on a perforated board, and strings are stretched across them to make a caricatured crucifix. In the end, however, the tireless experimenter now and then went back to his old compositional schemes based on simple geometric elements, but made them stand out against their lightly shaded backgrounds as if set in space.

Although a number of foreign adherents of De Stijl produced Neo-Plasticist collages, surprisingly few examples can be found among the works of the Dutch founders of the movement. In contrast to Arp and Sophie Taeuber, who executed their rectangular compositions with paper and papercutter in order to exclude any trace of subjectivity that the pressure of a hand might inject, Mondrian considered painstaking work with the brush to be the indispensable factor for expressing, within the elementary forms he used, the spiritual content to which he attributed such great significance.

Besides Van Doesburg, who produced a few collages under the influence of Schwitters, VILMOS HUSZÁR (1884–1960) also tried collage briefly, after the Dada tour that Schwitters and Van Doesburg undertook through Holland at the close of 1922 had called his attention to that medium. Huszár had moved to Holland from Hungary in 1905 and was one of the founders of De Stijl, along with Mondrian, Van Doesburg, Bart van der Leck, and Georges Vantongerloo. It was Huszár who designed the title page for the first number of the magazine *De Stijl*, which appeared in October, 1917. In addition to painting, he worked in the same Neo-Plasticist style on projects for stained-glass windows and stage sets. Among the latter is a large collage from 1923 (Collection Silvia Pizitz, New York), the only one by him known to us. In it the uncompromising horizontal–vertical arrangement, in which as early as 1922 Huszár was introducing the diagonals that Mondrian despised, is completely relaxed. Rectangles in various shades of color are loosely distributed across a black ground and completed by white linear projections suggesting a graduated recession in depth. By means of transparent layering, however, spatial definition is underplayed, and the composition is bathed in a diffuse atmosphere.

Other supporters of De Stijl, among them CÉSAR DOMELA (NIEUWENHUIS) (b. 1900), made material constructions as a step toward liberating Neo-

Reproduced in *Edda*, no. 1, 1958

Marcel Duchateau, *Servranckx*, published by the artist himself, without indication of place or date, includes works executed between 1914 and 1958.

The colored papers that Mondrian pasted into his unfinished painting *Victory Boogie-Woogie* of 1943–44 (Museum of Modern Art, New York) can be considered no more than provisional aids in his working process.

M. Seuphor, *Abstract Painting*, New York, 1962, colorplate 74

Plasticist painting from the tyranny of the two-dimensional picture and translating it into spatial terms. Domela had painted his first abstract flat-plane composition as early as 1923, a year before he met Mondrian in Paris. This encounter so confirmed the ideas Domela had been working out for himself that he promptly joined De Stijl. He moved to Berlin in 1927, where, two years later, he turned away from his oil paintings, with their diagonal Neo-Plasticist compositions, to make reliefs of metal sheets and rods stratified in space by means of interposed Plexiglas disks, or of copper plates incised with small squares, sometimes divided into color areas and mounted on glass, sometimes in rectangular pieces laid on black ebonite. All these various materials were employed in order to break up the surface plane without robbing the compositions of their geometric rigor.

There is a *Construction* from 1929 in the Philadelphia Museum of Art, A. E. Gallatin Collection.

In the course of the 1930s, to his straight lines and angles Domela added curves and circular forms, which he painted, cut out of wood, or shaped from bands of metal. Some of his relief pictures have ordinary collages as their ground. Thus, in one small picture of 1936 two thin metal rods are laid diagonally across shapes of blue paper, black cardboard, and wood patterns. In another slightly later (plate 255), smooth, granular, plain-colored, and striped papers make up a basic composition with a diversity of shapes and with a gleaming red contrasting with the mat colors of the papers. Above this is affixed a transparent disk, and metal bands and bars lead in open curves into the spatial depth.

After 1940 the play of lines became more animated. For his reliefs Domela now utilized the most diverse kinds of woods, contrasting their dull tones with gleaming metals and often surrounding them with highly unexpected colors. Once again in 1945 he produced an authentic collage with an oval ground of dark, ribbed tar paper and elements in light-colored, fibrous rag paper, over which play bright-colored ornamental motifs in narrow strips. This is one of the rare examples in which Domela added only paper textures, without other materials, as a third factor along with form and color.

Exhibition catalogue, *César Domela*, The Hague, Gemeentemuseum, 1960
Marcel Brion, *Domela*, Paris, Le Musée de Poche, 1961

JEAN GORIN (b. 1899) discovered Neo-Plasticism in 1926 and, after meeting Mondrian in the following year, became his most committed French disciple. He remained faithful longer than Domela to elementary right-angled compositions in the primary colors, blue, red, and yellow, though from 1930 on he too tempered them somewhat with superimposed plaques and rods. It was not until the 1940s that he could bring himself to use diagonals, and in his reliefs he began to mount white and colored wooden moldings one above the other at well-defined intervals so as to create light and shadow within the composition. The same geometric approach was used for his architectural designs.

A rather more specific interest in materials was manifested in the experiments undertaken in Hanover by CARL BUCHHEISTER (1890–1964). According to his own biographical notes, he turned to nonrepresentational painting as early as 1923, and four years later, together with Schwitters and Vordemberge-Gildewart, he founded a group of abstract artists. About 1926 he was painting compositions of superimposed triangles or rectangles in gradated shades of either red and green or blue and yellow. Eventually he simplified his system of planes and replaced color values by textural, material values.

Exhibition catalogue, *Konstruktive Malerei 1915–1930*, Frankfort on the Main, Kunstverein, 1967

In a strict rectangular composition of 1931, one field is roughened by a mixture of sand and oil paint and thereby raised above the surface, another is differentiated by being made of a block of wood, while a strip of glass painted black is mounted along the upper margin and is matched by a length of red wooden molding below, the two being spanned by a gray thread that bisects the picture vertically. In *White Diagonal* (plate 258) the relief elements stand out against a white ground, and the material includes two pieces of aluminum, one flat and painted in gray, the other slightly rolled and pasted over with tissue paper to cut down the silvery sheen of the metal. Buchheister executed a number of such reliefs as models for multiple reproduction, by which he wished to fight the capitalistic system of demanding excessive prices for original art works.

After World War II Buchheister ventured into new paths, and the austere geometry of his painting was transformed into a fantastic repertory of cosmic forms, for which he mobilized all techniques and materials, mixing oil paints, India ink, lacquer, and resin with sand, sawdust, ashes, and glass splinters, and using in addition cotton wadding, strings, wire, wood, and so forth. By these means he formed astonishing material pictures characterized by a blend of improvisation and thoughtful planning, seriousness and humor.

Catalogue and reproductions in the second number of the review *Cercle et Carré*, Paris, 1930

M. Seuphor, *Le Style et le Cri*, Paris, 1968, pp. 109–123; C. Schaefer, *Joaquín Torres-García*, Buenos Aires, 1945

That Torres-García kept up his ties with the old Dadaists is evidenced by a picture he painted in Ascona in 1931, which has a manikin figure identified with the name Van Rees.

The three Hanoverians, Buchheister, Schwitters, and Vordemberge-Gildewart, together with Baumeister, took part in Paris in a 1931 exhibition of the Cercle et Carré group founded by Michel Seuphor and Torres-García. This was a survey of the development of nonrepresentational art in various countries, though Torres-García himself constituted one of the few exceptions still devoted to figurative work. After his sojourns in the United States and Italy, which have been discussed earlier, Torres-García settled in Paris in 1924, and four years later he became acquainted with Theo van Doesburg and Mondrian. Following their example, he divided his pictures into rectangular compartments, to which he consigned the figurative images he was not willing to relinquish, simply outlining them in the manner of children's drawings. Even while he considered himself firmly committed to Constructivism, basically this meant for him no more than order and articulation of the composition. Besides painting, he nailed together reliefs from sawed and painted boards and wooden blocks to make what he called "plastic objects" (plate 259), which retain recognizable shapes of still lifes, masks, and heads. Essentially these followed the line of Arp's and Schwitters's Dadaist wooden reliefs, and the fact is that Torres-García was closer to those artists than he was able to admit.

In 1932 he returned by way of Madrid to Montevideo, where he founded the Asociación de Arte Constructivo. Even in his later pictures he remained faithful to a collage-like approach to composition, with objects from daily life, symbols, numerals, and the like arranged as if in small showcases.

Another participant in the Cercle et Carré exhibition was the Swiss HANNS ROBERT WELTI (1894–1934), a self-taught artist who tried his hand at painting, sculpture, and collage, each in turn, encouraged by a circle of artist friends from whom he learned about the various trends and movements. Constructivist tendencies are evident in a sculpture of geometric planes and

Information from the Galerie Suzanne Bollag, Zurich

volumes that was reproduced in the second number of the review *Cercle et Carré*. On the other hand, a relief titled *Tied-up Wood*—three old planks nailed together and tied around by a cord—is to be ascribed rather to Welti's friendship with Schwitters, as are also the collages he attempted between 1928 and 1930. In the latter there are bits of gold and silver leaf, flimsy speckled tissue paper, and candy wrappers, along with newspaper clippings and labels in French which suggest that they date from one of the artist's numerous sojourns in Paris. As grounds he used wooden panels that had already served for oil paintings, and to these he glued his collage elements, then going over the whole with a thick, granular impasto of color until all the elements coalesced into areas of diversified textures. His compositions were based on geometric fields laid out on the surface and conceived so as to be equally valid viewed horizontally or vertically, but the formal discipline of these works is moderated by the poetic overtones of their shimmering material (plate 261).

Exhibition catalogue *Konkrete Kunst*, Zurich, 1960, p. 22

Among the members of the Cercle et Carré group was also Seuphor's friend, the Dutch painter and printer HENDRIK NICOLAAS WERKMAN (1882–1945), who produced monotypes conforming to the principles of collage in that he utilized only pre-existing prefabricated materials. In 1923 Werkman opened a small printing plant in Groningen and experimented with his first pictorial composition, *Chimneys*, utilizing the backs of printing plates for posters to make vertical rectangles of various widths. Before long he also took advantage of the letters and numerals on the front of such plates, arranging them in slabs or planes, underlaying and surrounding them with block shapes (plate 260). He printed the individual elements one after the other, running the paper through the hand press several times. By altering the quantity of pigment and the viscosity of the ink from one printing to the next, he obtained varying tones of black and gray. Later he proceeded in the same way with colored inks, graduating the tones by successive over-printings. At times also he stopped out certain areas of the paper or juxta-posed positive and negative shapes. He was tireless in the search for new possibilities by which, as he put it, he could elicit a personal expression from down-to-earth material that might seem to offer little. He did, in fact, combine these ordinary formal elements into a great number of abstractions packed with movement and tension. His compositions became more relaxed when, in 1929, he began to stamp small letters and vignettes from his type case directly on paper without recourse to the press. Later, however, he returned to figurative subjects in the Expressionistic style, which had been his starting point in his early drawings.

Before him, the Dutch architect Johannes Lauweriks had produced typographical compositions from printers' type blocks in 1918–20, when he was working with Van de Velde and Peter Behrens on the buildings of the residential garden city near Hagen, Westphalia, promoted by the art patron Karl Ernst Osthaus (information from Robert Michel, Eppstein im Taunus).

There are examples in Seuphor, *Abstract Painting*, pp. 97, 98.

Exhibition catalogue, *Hendrik Nicolaas Werkman*, Bochum, Städtische Kunstgalerie, 1961

Between 1923 and 1926 Werkman issued single-handed a magazine of modern art with an English title, *The Next Call*, which he sent to friends and artists all over the world; and during the war he printed and distributed pamphlets and poems intended to strengthen the spirit of resistance to Nazi oppression. In April, 1945, he was taken prisoner by the occupation authori-ties and executed just a few days before the war ended.

During 1922 and 1923, which he spent mostly in Berlin, the Polish painter HENRYK BERLEWI (1894–1967) was concerned with using ordinary, standardized materials for artistic purposes. He began by delving thoroughly into the means and materials being used by painters in various countries,

Figure 51. Henryk Berlewi.
Mechano-Facture. 1924. Stenciled
and cut paper

notably by Picasso and Braque in France, Schwitters and Baumeister in
Germany, and the Valori Plastici group in Italy. What interested him was
not the materials as such but rather, and exclusively, the specific values they
could bring out in painting. Although he explored the special effects that
can be obtained from sand, glass, cork, wood, and so on, he finally rejected
all of them because they add an element of relief, whereas he saw his goal
as the renewal of purely two-dimensional painting. In his opinion the
"fetishistic cult of materials" led to ever more complicated artistic solutions
of an individual, personal character in contradiction to the spirit of the
times, which called for clear and universally valid forms of expression.

As a substitute for the chaotic nature of materials, and to obtain unified
and precise formal elements, Berlewi made stencils of sheet metal perforated
at regular intervals. This gave him a pattern of dots which he utilized in
three versions—white on black, black on white, black on gray—in a *Still
Life with Bottles* (Galerie des 20. Jahrhunderts, Nationalgalerie, Berlin), which
he showed in the hall of the November Group at the *Grosse Berlin Kunst-
ausstellung (Great Berlin Art Exhibition)* held in the fall of 1922. In 1923 he
produced his first fully nonrepresentational composition in what he dubbed
"*mechano-facture*," whereby he obtained a large dotted rectangle by using a
single stencil. Subsequently he fabricated elements with equidistant stripes,
and in 1924 he also made collages of vertical and horizontal arrangements of

pieces of paper textured by *mechano-facture* (figure 51). Other compositions, with forms rising and descending in rhythmic series, remind one of the abstract film strips of Victor Eggeling, with whom Berlewi had become acquainted in Berlin. He developed his *mechano-facture* into an ever richer instrument, setting up contrasts between dots and checkerboard patterns, straight lines and curves, open and closed planes.

In the fall of 1923 Berlewi returned to Warsaw, where, with Mieczyslaw Szczuka, Teresa Zarnower, Henryk Stażewski, and Wladislaw Strzemiński, he founded the Blok group. In March of the next year he published a pamphlet about his *mechano-facture* and organized an exhibition in the Warsaw salesrooms of the Austro-Daimler Automobile Works, where, it seemed to him, his pictures were more at home than in an art gallery. For that show he made a poster in "typo-montage" with highly effective black and red printing. The Berlin gallery of Der Sturm took over the exhibition in 1924 and published his manifesto in their review. With Alexander Wat and Stanislaw Brucz, Berlewi opened an advertising agency in Warsaw, promoting modern typographical layout and rational production methods.

Catalogue, *Précurseurs de l'Art abstrait en Pologne*, Paris, Galerie Denise René, 1957;
Berlewi: Témoignages, Paris, 1965;
Catalogue, *H. Berlewi*, Bremen, Galerie Revolle, 1967

After giving up this abstract-mechanical approach in 1926, he did not return to it until 1957. Although the basic elements remained the same, his new pictures were structurally more elaborate and had more animation in their treatment of color nuances.

Commercial Art and Political Propaganda

During the 1920s the European countries did their best to catch up with the American lead in the field of modern advertising design. Collage and, above all, photomontage offered new possibilities that fostered a great leap forward.

In Germany MAX BURCHARTZ (1887–1961) was one of the first to champion the practical application of photomontage. Between 1919 and 1923 he lived in Weimar, where he maintained friendly contacts with the Bauhaus and with Theo van Doesburg in particular. Under that influence, Burchartz gave up the figurative style which had already brought him some success and instead set to painting in the Neo-Plasticist, uncompromisingly two-dimensional approach, though he soon began to develop spatial constructions out of this. Thoroughly convinced of the Bauhaus thesis that contemporary artistic creation must be extended to all realms of public life, in 1924 Burchartz and J. Canis opened in Bochum an advertising agency that lived up to its name Werbe-Bau (Advertising Construction), in that it undertook the planning and execution of any kind of enterprise. Typical of their approach was a four-page prospectus for the Bochum Verein, with photomontages of the steel mill and explanatory texts coordinated in a highly effective layout. Burchartz also prepared large photomontages of industrial zones, the city of Dortmund, and the mining installations at Gelsenkirchen, sometimes disposing his cutout photographs along perspective lines that carry the eye into the far distance.

In 1926 Burchartz joined the Folkwang School in Essen as teacher of applied graphics, photography, typography, and principles of advertising, while Canis continued his activities in his own firm. At Essen Burchartz

began combining photographs with graphic techniques. For the jubilee celebration of a gentlemen's club named Zylinder (Top Hat) he devised an amusing montage (plate 264) in which the same photograph of a hand holding a top hat appears in ten different positions against a vertically striped background, with the name of a club member written inside each of the hats. He constantly expanded the procedures available to montage, profiting from all the varied possibilities of photography. Thus, in a photomontage for the electrical firm whose bulletins and magazines he designed during the 1930s, he interplayed light and shadow, mirror reflections, and effects of transparency to such an extent that the realistic shots became transformed into an extremely dynamic abstract composition.

After many years of teaching and concern with commercial commissions, in the last years of his life Burchartz returned with renewed enthusiasm to "fine" art, seeking new solutions, some of them in collage. About 1957–58 he used lined and dotted photoengraving screen papers which he cut up and tore and then assembled into subtle graphic structures, at times using brush and India ink to introduce enigmatic dark signs into them. For New Year's greetings in 1959 and 1960 he sent collages in which isolated arbitrary forms and lines brought a note of animation into an over-all mechanical pattern.

Both reproduced in the exhibition catalogue *Werbegrafik 1920–1930*, Frankfort on the Main, 1963, p. 38

Reproduced in Roh and Tschichold, *Foto-Auge*, pl. 63

From 1925 on, the generally acknowledged leader in the graphic field in Frankfort was HANS LEISTIKOW (1892–1962), who had previously worked in applied graphics in Breslau. He described himself as a "printing consultant," and his studio in the town hall turned out posters, prospectuses, magazine covers, and the like, using all the techniques of painting, typography, collage, and photomontage. For the celebrations in August of 1926 at the formal opening of a new bridge across the Main, his poster consisted of an effective design of colored circles. On the same occasion Oskar Schlemmer created a poster to advertise his own theatrical cabaret, the *Grosse Brücken Revue*, with one of his characteristic marionette figures taking shape out of waves of printed matter. The friendship between the two artists had at least one interesting result when, in a photomontage of that period, Leistikow placed portions of Schlemmer's pictures and reliefs alongside a view of a modern block of houses to show the kind of art related to that style of architecture. For the magazine *Das neue Frankfurt*, founded in 1927 by Ernst May and F. Wichert, Leistikow and his sister Grete provided a number of title pages, among them one for the issue of November, 1929, devoted to problems of cheaper housing. This combined newspaper clippings and photos in an effective synthesis of the procedures of collage and photomontage (plate 268). The Leistikows had recourse also to photograms in their posters for a cigarette manufacturer. In 1930 Leistikow accompanied Ernst May to the Soviet Union, where the Frankfort architect and his coworkers remained for three years devising large-scale city-planning schemes. The documents of that undertaking were later published by Professor May in a portfolio with a photomontage by Leistikow on its cover.

New ideas in advertising art were also introduced by the film posters produced by JAN TSCHICHOLD (b. 1902) about 1927 for the Phoebus-Palast Cinema in Munich. In simple, broadly conceived, two-dimensional compositions he laid out precise photographic details and texts so that they completed and complemented each other as pictorial elements, as in the

Colorplate 39. Mimmo Rotella. *Announcement*. 1960

poster for *Die Frau ohne Namen* (plate 265). There the letters of the title diminish along with the receding linear projections, and at the same time a series of dramatic stills from the film grow larger and larger as they shoot forward.

Even past the mid-1920s the influence of Dadaist photomontage remained active in Berlin. The avant-garde photographer UMBO (Otto Umbehr) achieved "simultaneous portraits" by printing together several exposures, but he also made photomontages of authentic Dada character. His portrait of Egon Erwin Kisch, *The High-Speed Reporter* (plate 266), shows that gentleman armed with camera, recording apparatus, watch, typewriter, and fountain pen, one foot in an automobile, the other in an airplane, dashing across a landscape high above a mob of people presented in negative printing that makes them look like shadows. In another montage of the same period, *Perspectives of the Street*, airplanes loop-the-loop between sky and skyscrapers, while a top-hatted gentleman, a boxer, and babies in swaddling clothes occupy the street below.

The Leipzig workers' paper *Kulturwille* was supplied by MAX SCHWIMMER (1887–1948) with photomontage title pages which derived their effectiveness from the superposition and interpenetration of a great number of elements.

JOHN HEARTFIELD also exploited Dadaistic collage in his title pages for the sports magazine *Arena*. On that for February/March, 1927, the letters of the title and notes of music whirl among dancing legs and saxophones, with blue, red, and black printing to isolate and emphasize the elements. He contributed montages of the same sort, but overtly political in content, to the Communist satirical weekly *Der Knuppel*, on which Schmalhausen, Schlichter, and Dix from the old Dada circle also collaborated. On a poster, *Under the Sign of Rationalization* (plate 272), a robot made of machine parts and speedometers peddles the Socialist paper *Vorwärts*. In 1928 Heartfield used a collage of an armored cruiser depicted entirely from newspaper clippings to pillory the position of the Social Democrats, and two years later he used the familiar style of the Dadaist typographical collages to surround a portrait of the Belgian Socialist leader Émile Vandervelde with great heaps of cutout strips of words.

However, the works of Heartfield that really won him imitators were the photomontage jackets he designed for the Malik-Verlag books. For those he used mostly pictures clipped from illustrated magazines, though occasionally he had new ones made especially by his photographer to match something particular in the book in hand. He used photomontage in this way for the first time in 1925, for the jacket of the German edition of John Dos Passos's *Three Soldiers*, exploiting the contrast between the images on the front and the back of the jacket.

Kurt Tucholsky and Heartfield collaborated in 1929 on a book published by the Neue Deutsche Verlag titled *Deutschland, Deutschland über alles* and subtitled *A Picture Book by K. Tucholsky and Many Photographers, Mounted by John Heartfield*. The title page was decorated by Heartfield with the composite portrait of a half-civilian, half-military potentate, top hat cocked over helmet, half in stiff collar, half in uniform with a distinguished service medal (plate 273). In the printing the old national colors—black, white, and red—and the new ones—black, red, and gold (or yellow)—were made to interpenetrate. Within the book itself, text, photos, and photomontages

Both are in the possession of Paul Citroen, Wassenaar, Holland.

Two examples from 1928 are reproduced in the exhibition catalogue, *Die Fotomontage*, Ingolstadt, 1969.

Wieland Herzfelde, *John Heartfield, Leben und Werk*, Dresden, 1962

complemented one another in presenting a satirical kaleidoscope of political and cultural life in Germany. Among the most aggressive of the illustrations is a montage of grotesque portraits of a number of odd-looking persons in uniform, bearing the same title as Paul Eipper's recently published book of photographs, *Tiere sehen dich an (Animals Look at You)*.

The legs dancing the Charleston on Heartfield's title page for *Arena* appear again in 1927 on a poster by F. A. FLACHSLANDER for Ernst Křenek's jazz opera *Jonny spielt auf* (plate 271), a good example of the style of collage typical of Berlin. The densely packed photos and illustrations of all kinds and sizes reveal their Dada ancestry, but they are integrated into a diagonally articulated composition that clearly shows the influence of Constructivist painting; and it is precisely the careful grouping of the photographic components, and their virtually three-dimensional projection from the light background, that gives the poster its impact.

In a poster for the Scala Theater that César Domela assembled from photos of clowns, blues singers, and chorus girls, there is something of the jazz rhythms that were the craze in Berlin at the time, despite its somewhat tight organization. Domela relied much on photomontage for his publicity work during his Berlin years, and in 1928 he dramatically demonstrated its possibilities in a trick-photography animated film in which he showed the pictorial elements coming together each in turn. In the posters and pamphlets he prepared for the Hamburg municipal travel bureau, the Ruths-Wärme-speicher Company, the AEG electrical association, and other organizations, his aim, as he put it, was to condense into a single picture all the images that might occur successively in the course of a film. As a consequence, the photos interlock to make a dense mosaic broken over its surface in all directions because of the shifts in perspective of the separate components. Later he tended to unify his compositions somewhat more, and in photomontages created for the electrical industry during the 1930s he combined a few isolated and sharply lighted photos into hard-hitting, highly effective structures.

Writing in the foreword to the catalogue of the photomontage exhibition he organized in 1931 at the old Museum of Applied Arts in Berlin, Domela explained that for a good photomontage one needs "knowledge of the structure of the photograph, of how to divide and lay out the planes, and of how to construct a composition." Running diagonally across the title page of his catalogue is a strip of montage that demonstrates what fantastic sequences of images can be produced with no more than scissors and paste, and for the entrance hall of the exhibition he composed a huge mural of photographs of the various Berlin museum buildings and the masterworks of painting and sculpture they housed (plate 269).

After emigrating to Paris in 1933, Domela gave up photomontage except for one more poster in 1937, for an exhibition at the Galerie Mai organized by French and Spanish anarchist associations to raise money for the fighters in the Spanish Civil War.

The international *Film und Foto* exhibition presented in Stuttgart in 1929 by the association of arts and crafts workers, the Deutsche Werkbund, focused public interest on experimental photography as both fine and applied art. The Swiss photographer HANS FINSLER, who exhibited remarkable photographs of cloths and objects, also produced an amusing photomontage

in which he substituted the heads of Gropius and Moholy-Nagy for those of Goethe and Schiller in the famous monument at Weimar (plate 270); and, punning on *Neue Sachlichkeit*, the "new objectivity" which was the slogan of their movement, dubbed it *Sachte Neulichkeit*, which suggests that their innovations were rather cautious. From that time on, one book after another appeared on photography: the Roh and Tschichold *Foto-Auge*; Werner Graeff's *Es kommt der neue Fotograf* (Berlin, Verlag H. Reckendorf, 1929); the books by Albert Renger-Patzsch; and Heinz and Bodo Rasch's *Gefesselter Blick*. The Lithuanian-born painter MOSES VOROBEICHIC, who had gone to the Bauhaus in 1927 to study with Moholy-Nagy, contributed in 1931 to a series of picture books published by the Orell-Füssli Verlag, of Zurich and Leipzig, a small volume, *Ein Ghetto im Osten (Wilna)*, devoted to the Jewish quarter in Vilna and containing photographs and photomontages, along with an introductory text by S. Chneour. His usual procedure was to set a number of prints of the same detail into rhythmic sequences so neatly joined as to show no seams. He also combined positive and negative prints. Using oblique shots of the Strashun Library he constructed a hemmed-in space, and in another montage, *The Alleys Are Lovely*, he combined three perspective shots of streets to lead the eye far into the distance. A second book of photographs, *Paris*, was published by Corti in Paris in 1934 under the pseudonym "Moi Ver" and with a foreword by Fernand Léger. The artist changed his name once more in 1934, this time to Moshe Raviv, when he settled in Israel and continued, during his first years there, to use photomontage for advertisements and posters.

By and large, Domela's Berlin exhibition of 1931 offered a definitive survey of the special techniques and problems of photomontage. Along with the historical forerunners of the eighteenth and nineteenth centuries, three sections were devoted respectively to works of "fine" art, advertising and book design, and political propaganda. Soviet artists were generously represented, and the Bund Revolutionärer Bildender Künstler Deutschlands (League of Revolutionary Pictorial Artists of Germany) had a section to itself. Its members included Keilson and Lex (Alice Lex-Nerlinger, b. 1893), and among the group's contributions, today all but lost, the critical writings by Pewas (Paul Ewald Schulz) and Eggert remain outstanding.

Among the propaganda pieces, the catalogue reproduced a photomontage by GÜNTER HIRSCHEL-PROTSCH, *Apotheosis of the Poison-Gas War*, especially remarkable for its combination of heterogeneous components in arbitrarily differing relationships of size: out of a gun barrel, on which a girl dances naked except for a gas mask, a horde of headless athletes charges swinging a banner with a death's head, while, beneath this, air-raid defense men carry the disproportionately large head of a girl on a stretcher. Hirschel-Protsch, a member of the Junge Schlesien group in Breslau, had already begun in the mid-1920s to execute satirical photomontages, sometimes merely amusing, sometimes downright caustic. At the Stuttgart exhibition he showed a series entitled *Life and Goings-on in America*, which suggests an affinity with the montages by Grosz and Heartfield during their Dada years.

OSKAR NERLINGER (1893–1969) was slow to become involved in political propaganda. After settling in Berlin in 1919, two years later he joined the group around Der Sturm and in the following years regularly showed there his abstract-geometric compositions. Besides paintings and linoleum

In those years in Germany, revolutionary artists seldom signed their Christian names and often relied on pseudonyms, with the result that today it is often difficult to reconstruct their artistic personalities and work.

One of them from 1927 was published by Kassák in the Hungarian review *Dokumentum*.

288

blocks he worked in collage, cutting his elements from fibrous cardboard of various tonalities, which gave his pictures a uniquely restrained color quality. In 1925 he became head of the Group of Abstractionists which participated, the next year, in the *Grosse Berlin Kunstausstellung*. For their exhibit he designed the typography of the catalogue and decorated its title page with a montage of photographs of the works displayed. At Domela's 1931 exhibition he used the pseudonym "R. Nilgreen" to show photomontages with quite harmless persiflage such as *"Darling" (Dedicated to the German Cinema)*, which had a tower built of stylish or sentimental shots of film stars. Subsequently he tried other experiments with photography, utilizing blurred prints, combining photomontage and spray procedures, and making "light-photograms." Later still he devoted propagandistic montages to the Soviet Union.

Not long ago Eckhard Neumann of Frankfort on the Main acquired two collages of this type, composed of simple rectangles, rods, and circular forms. One is signed "Nerlinger 22," the other, "ON 23."

However, it remained for John Heartfield to develop photomontage into a really effective tool of political agitation. As early as 1924 he made his first poster-like composition, *After Ten Years: Fathers and Sons*, in which little boys dressed as cadets and carrying guns on their shoulders march past a general bedecked with medals, while behind them rise up gigantic skeletons. Along with election posters for the Communist Party, it was mainly through the title pages of the Communist publications *Rote Fahne* and *AIZ (Arbeiter-Illustrierte Zeitung)* that Heartfield contributed to the political struggle and warned against the steadily growing National Socialist movement. After his escape to Prague in 1933 his photomontages became considerably more aggressive, and they were distributed clandestinely in Germany (plates 274, 275).

A. Scharf, "J. Heartfield, Berlin Dada and the Weapon of Photomontage," *Studio International*, no. 904, 1968

Heartfield chose his pictorial material from all kinds of illustrated periodicals, and he had an unfailing eye for what might be exploitable for propaganda purposes. He intensified the effectiveness of authentic and convincing photographs by disconcerting combinations and juxtapositions. His victims and scapegoats underwent the most grotesque metamorphoses, tricked out in nonsensical or macabre trappings. Normal relations in size were inverted in order, as he saw it, to set right what he considered dubious hierarchies of values. Photographs were grouped to reveal, simultaneously, past, future, and present. Both Dada and Surrealism had their share in these nightmarish visions, and purely photographic techniques were also pressed into service as needed. Thus, Heartfield's poster for the Crisis-Party Day of the German Social Democratic Party had a tiger's head in negative printing mounted on a burgher's body; and, at a later date, for a performance of Mikhail Pogodin's play *Friends* at the Moscow Revolutionary Theater in 1935, he made a photomontage to be projected on the back of the stage with the gigantic figure of Lenin looming like a vast shadow over the city.

A large number of Heartfield's photomontages were displayed in the *Film und Foto* exhibition of 1929.

Heartfield's photomontages are not all of equal excellence. Often the anecdotal details are overelaborated and confuse the total impression, and not infrequently the symbolic content of his posters is all too rhetorical and bathetic. Nevertheless, it must be remembered that they were addressed to the masses, and Heartfield can be credited with having provided a visual equivalent for political propaganda which opened new paths artistically both within and outside Germany.

At the 1931 Berlin exhibition, besides the Bauhaus specialists headed by Moholy-Nagy and Bayer, the section of applied photomontage included

also Domela's Dutch compatriots PIET ZWART (b. 1885) and PAUL SCHUITEMA (b. 1897). Both achieved an excellent balance between image and text in advertising prospectuses such as those prepared by Zwart for a Delft cable factory and by Schuitema for the Berkel-Wagen Company of Rotterdam (figure 52). Their texts are often set on the diagonal, so as to break up the surface spatially. In Zwart's montages, besides photographs there are also mechanical drawings and city plans deriving from his activities as architect. About 1931 he designed a prospectus for an advertising agency with a title collage made up of examples of all the types of commissions the agency would undertake: trade-marks, packaging, advertisements, invitations, letterheads, illustrated advertising leaflets, and so forth (plate 282). The turbulent accumulation of pictorial elements recalls the compositional approach of Dadaist collages by Hausmann and Heartfield. In actual execution, Zwart worked with differentiated tones of gray and black, which, in the texts, lead the attention from one word to another and, in the photos, bring about juxtapositions of close and distant views. On an advertising leaflet for the Dutch national wireless service, the photographic motifs are reduced to circular forms and superimposed in printing so as to give a sense of spatial depth as well as animation, and a rolled-up strip of telegram stands out against the dark background.

Schuitema too took advantage of the most varied photographic possibilities. On the catalogue page of a commercial prospectus, he mounted three photographs of industrial conduits at open angles to make a dynamic construction in depth. In another photomontage, *Gramophone*, the individual forms dissolve in flowing curves of light and movement. Upon occasion, Schuitema, like Baumeister, also introduces photographs into line drawings.

Among the Czechs, KAREL TEIGE gained most prominence in Germany. At the *Film und Foto* exhibition he showed photomontages from his picture book *ABC*, and there, as well as at the Berlin exhibition, also examples of photomontages he had produced in Prague for book covers and the title pages of the reviews *ReD* and *Život*. He also made compositions from the components of the printer's type case, with lines, bars, letters, vignettes, and so forth, more facile and pleasant variants of the monotypes from printing blocks that Werkman made in Holland. Of these "typo-montages" Teige said: "The eye wanders around and across them, over and over again discovering new perspectives."

Nevertheless, the real credit for modernizing Czechoslovakian applied graphics goes to LADISLAV SUTNAR (b. 1897). After his studies and first commercial jobs in Prague, Sutnar traveled during the 1920s in France, Italy, and Germany, where he visited the Bauhaus. For the 1927 international book fair in Leipzig he set up the Czechoslovak hall and decorated the ceiling with abstract painting in brilliant colors. His first book-jacket designs consisted of simple rectangles and circles into which the title was inserted as a "functional" pictorial element. Then, about 1930, he added photographs in order to bring a spatial dimension into these flat compositions, and later he stressed the extension into depth by drawing linear projections that take on the appearance of paved city squares. For a title page of the magazine *Žijeme* in 1931 (plate 278) he set within these diagrammatic projections three cutout photos of Charlie Chaplin, identical except in size, which are ar-

Figure 52. Paul Schuitema. Advertising brochure for Berkel-Wagen Company, Rotterdam. 1928. Type, drawing, and photomontage

ranged to diminish with distance and to stand perpendicular to the tilted plane of pseudo paving squares. A rather similar composition was used for the dust jacket of a book on the "minimum house." There tiny figures cut across the paving-square fields spread out to the middle ground, where a red square halts their movement; the diagonally ascending title creates a counterweight to the graphic linear network.

Reproduced in *Die Neue Graphik*, no. 118

From 1929 on, Sutnar was art director of a large publishing house, Druzstevni Prace, and edited his own magazine of graphic arts and art education. He was appointed director of the State School for Graphic Arts in Prague in 1932 and, as one of his official duties, was expected to design the Czech sections for international expositions. In 1939 he brought to the United States his model for the Czech pavilion for the New York World's Fair and took the occasion to remain, opening his own advertising agency in New York. In all his publicity activities he aims at a kind of "visual information" addressed simultaneously to the viewer's eye and curiosity. Aware of new industrial developments, he is constantly on the lookout for new solutions in his own field.

Exhibition catalogue, *Ladislav Sutnar, Visual Design in Action*, Cincinnati, Contemporary Arts Center, 1961

The Hungarian painter LAJOS VAJDA (1908–1941) had taken part in the Constructivist movement in Budapest, but, while living in Paris from 1930 to 1934, he produced a series of photomontages of political character clearly under Surrealist influence. After returning to Budapest, he plunged into the study of folk art and icon painting and, about 1937, arrived at a singularly impressive style in watercolored India-ink drawings, with simple objects set into systems of planes to appear as scarcely more than shadows within a complex of transparent overlappings and superpositions. Further, collage elements are also introduced, especially written or printed matter, often with Hebrew characters or in the form of fragments of correspondence, as if to offer the artist himself human and spiritual reassurance in a crumbling world of appearances. It is characteristic of Vajda that he did not sign a single one of his works. His premature death left posterity little from which to reconstruct a living artistic personality.

Exhibition catalogue *Die Fotomontage*, Ingolstadt, 1969, and the illustrated brochure for the exhibition *Lajos Vajda*, Paris, Galerie Facchetti, 1968

Photomontage was introduced into Poland by MIECZYSLAW SZCZUKA (1898–1927), the most versatile of the modern artists who imparted a new impulse to Polish art after World War I. He sought modern solutions in the fields of painting, sculpture, architecture, film and stage design; and to a certain extent the solutions he found were influenced by those of the Russians. While his sculpture dating between 1921 and 1923, in cement, sheet metal, iron, glass, wood, and plaster, was inspired by Constructivist examples, his painting clearly reflected Suprematist tendencies. These became known in Poland when Wladyslaw Strzemiński returned to Warsaw in 1922 with his wife, the painter and sculptress Katarzyna Kobro, after studying with Malevich at the Vitebsk Academy. In the fall of 1923, together with the Strzemińskis, Henryk Stażewski, and Henryk Berlewi, Szczuka and his companion, Teresa Zarnower, founded the Blok group, and the couple took over the editing of the *Blok* review, first issued in March of 1924. Following the example of the trilingual magazine *Vyeshch/Objet/Gegenstand*, edited in the Soviet Union by Lissitzky and Ehrenburg, the text and illustrations in *Blok* were laid out in geometric compositions.

The magazine spoke out in favor of modern art in Poland and abroad, as

well as for new forms in industrial design, and Szczuka published in it a number of his photomontages glorifying the achievements of industry and engineering. His pictorial elements are distributed clearly and without confusion across the picture surface, and plain or patterned colored papers are interpolated among the cutout illustrations. Pylons and cross girders often provide the structure for his compositions, as in *Kemal's Constructive Program* (plate 276), which has to do with urban development and transport systems. Other collages have anecdotal details which, mounted every which way in entirely arbitrary proportions, bear more than a hint of Dada. Typical of these is the cover Szczuka designed in 1924 for a book of poems by Anatol Stern and Bruno Jasieński, *Ziemia na Lewo (The World to the Left)* (plate 281), in which he combined photomontage and typomontage. Standing out prominently, between the authors' portraits pasted on newspaper clippings, is a steering wheel boldly marked for a "turn to the left" by a red wedge. Above and below there are the title, cutout pictures, ornamental moldings, and a red dot—all laid out loosely and rather arbitrarily in the manner of the authors' "Futuristic" poetry, which concerns itself little with the rules of syntax and spelling.

In 1920 Anatol Stern, together with Alexander Wat, brought out the first Polish "almanac" of Futurist poetry; and in 1921 Bruno Jasieński issued a *Manifesto of Polish Futurism*.

H. Berlewi, "Funktionelle Grafik der zwanziger Jahre in Polen," *Neue Grafik*, Olten, Switzerland, no. 9, March, 1961

In 1927 Szczuka undertook the book design for Stern's *Europa*, a poetic hymn to the splendors and miseries of the continent, which was finally published in Warsaw two years later. Ironic drawings and vignettes, a strip of pictures of a boxing bout, a map of Europe striped across with the cry of alarm "SOS" are among the elements that frame the text, which is broken up by red and black strips and patches in a page layout based entirely on collage. The pictorial elements are more tightly organized in Szczuka's posters, such as those of 1926 calling for amnesty and for aid to children, and in his book covers and the title pages of 1927 for the periodical *Dźwignia*, in which his photomontages were often complemented by drawing to accentuate the alternation of plane surface and spatial depth.

TERESA ZARNOWER too used photomontage for book jackets and posters (plate 267). The compositions she published in *Blok* were more static and symmetrical than those produced at the time by Szczuka and were, in fact, closer to Neo-Plasticist than to Suprematist painting. Her book covers, such as one of 1927 for a volume of Mayakovsky, reveal a sparing use of pictorial means, though the one for Stern's *Europa* is rather more like Surrealist photomontage, with two apes leering down at a Europe in which high society enjoys its festivities while military rearmament strides rapidly ahead.

Anatol Stern and Mieczyslaw Berman, *Mieczyslaw Szczuka*, Warsaw, 1965

MIECZYSLAW BERMAN (b. 1903) brought out his first photomontages in 1927, the year of Szczuka's death. Initially inspired by such Russian Constructivists as Lissitzky, Rodchenko, and Klutsis, from 1930 on he turned to bitter political satire after the manner of John Heartfield (plate 280). The Nazi régime was his special target, and among his most successful works is one from 1935 called *Family Tree*, in which four apes wearing Nazi caps, belts, and swastika armbands swing from a withered bough twisted into swastika shape.

Berman showed a first series of photomontages in Warsaw in 1936 at an exhibition of an artists' group he himself had organized under the name of The Phrygian Cap to proclaim its revolutionary sympathies. When the German army marched into Poland in 1939, Berman fled to the Soviet

Union, where he continued to turn out propagandistic photomontages, many of which were published by the Polish underground press. It was there that he did the cycles *Blood and Gold*, *The Way It Was*, *Blood and Iron*, and *Reaction*, the last of which he was still working on when he returned to Warsaw in 1946.

Berman's propaganda approach involves counterposing "revolution" to "reaction," gibing at the Nazis' boasts of victory by confronting them with shots of war cripples, dead bodies, and ruins. To ridicule the assertion of the racial theorist Hans Günther that "the dimensions of the head are more important than its contents," he slices off a portion of the skull of an SS leader to demonstrate that all it contained was a tray with a bottle of beer and a sausage (plate 279). Often his figures are subjected to Surrealistic metamorphoses: a rifle grows out of the head of a harmless burgher; between the military kepi and the neck of an army officer a beggar's hand rakes in coins. On a montage dating from 1944, *The Cabinet Meets*, gesticulating jointed manikins sit around a table littered with briefcases. Berman's *Acropolis* of 1958 has ancient Greek torsos wearing the heads of Hitler and his helmeted troops, and amid the ruins are tables spread with lists in which, as in the ruined cities of Germany after the war, survivors seek traces of their families.

Berman's compositions frequently comprise only a few striking cutout photographic details, plus large symbolic shapes, acquiring thereby a poster-like effectiveness enhanced by color printing. In other cases, though, by utilizing more refined means, he achieves a telescoping of reality and unreality, an oscillation between close and distant views, and a carefully calculated allotment of light and shadow; and it is these characteristics that raise his photomontages above topical propaganda to become artistic pictorial documents.

Berman has also delved into the history of photomontage, and in the introduction to his small volume on the satirical poster he mentions works by the painter WLADYSLAW DASZEWSKI (b. 1902) and reproduces his photomontage of 1932 titled *Unemployed* (plate 277), in which large photographs of prostitutes and caricature drawings of profiteers are set against a background of factories to make a scene reminiscent of George Grosz. From 1927 to the war Daszewski contributed political photomontages to the Polish magazine *Ze Świata* and in various literary periodicals he published caricatures in colored collage. In addition, he illustrated books of poems by Julian Tuwim and Antoni Slonimski, members of the Skamander group of avant-garde Polish poets; and by his own admission he was much influenced by Rodchenko in the photomontages he prepared for a book by Slonimski published about 1929 or 1930, the title of which can be rendered as *The Eye in the Eye*.

Satyra-Plakat Mieczyslawa Bermana, Warsaw, 1961

Ignacy Witz, *Fotomontaze Mieczyslawa Bermana*, Warsaw, 1964

IX A Glance at Recent Trends in Collage

New Abstractionists in the United States—Developments in 1930s Paris—From Informal Art to Pop and Op

Paintings by Gallatin, New York, Wittenborn Gallery, 1948

"The American Abstract Artists: A Chronicle, 1936–56," in *The World of Abstract Art*, ed. American Abstract Artists, New York, Wittenborn, 1957

In the United States the 1930s brought a certain interest in collage and material assemblage as adjuncts to the abstract art which, about that time, was winning more and more enthusiastic converts. The American movement, like the English of the same period, was sparked by artists who had had direct contact with Paris. Among them, the real pioneer was the painter and collector ALBERT E. GALLATIN (1882–1952), who made regular visits to Paris between 1921 and 1938 and brought back works by Picasso, Braque, Gris, Léger, Arp, and Miró, which became the nucleus for his Museum of Living Art, first housed in New York University and then, in 1943, incorporated into the Philadelphia Museum of Art. Gallatin himself painted abstract pictures, blending Cubist and Constructivist tendencies, but in 1937 he began to produce collages that included such realistic elements as Metro tickets, admission tickets, clockfaces, and the like. A still life from 1940 pokes tongue-in-cheek fun at the ancestral prototypes of all this, the Cubist papiers collés, with cutout shapes of musical instruments from wood-patterned wallpaper and colored papers and a real cigar glued across them.

The first exhibition of American abstractionists took place at the Whitney Museum in New York in 1935, and George L. K. Morris, in his chronological survey of the movement, mentions another approximately contemporary show at the Museum of Living Art which included, grouped under the name Concretionists, the artists Alexander Calder, John Ferren, Charles Biedermann, Charles G. Shaw, and himself. Morris and Shaw thereupon organized the American Abstract Artists association (A. A. A.), which held its first exhibition in 1937 in an unoccupied floor of the Squibb Building in New York.

CHARLES G. SHAW (b. 1892) was among those who passed long sojourns in Paris, and it was there, about 1932 or 1933, that he first tried his hand at collage. In two examples from 1934, the strips of words pasted in present some recollections of Dada, though they also stress formal functions within the composition. The first of these, *Sensation*, shows lines and dots uniting scare headlines into a strange constellation that may well reflect the influence of Miró. The other, *Today* (plate 283), has, in addition to its absurd headlines, a wide-open eye looking out on a parking lot and a stadium with upward spiraling bleachers, both in aerial view. Here the photographic elements serve to give visual form to space and movement among the lines and flat surfaces. Shaw's contribution to the 1938 *American Abstract Artists Exhibition* was a nonrepresentational, Neo-Plasticist relief composition of colored rectangles raised above the picture ground by wooden moldings. In a collage of 1942, *Mother and Child*, the lines of a cut-up engineering drawing

are completed to make a group of stylized figures, a throwback to Picasso's approach in his earliest papiers collés. The Cubists' typical accessories—playing cards, cigar-box labels—occur again in a collage of 1948, where, arranged in simple geometric order on wrapping paper stamped with seals, they provide their own restrained poetic note.

The Gallatin Collection includes a collage by CHARLES BIEDERMANN (b. 1906), a *Composition* of 1935 involving a charcoal drawing into which were pasted colored papers to make what the catalogue describes as an "intelligent study of synthetic Cubism." In Paris in 1936 and 1947, Biedermann became converted to Neo-Plasticism and attempted to translate its principles of painting into relief forms.

SUZY FRELINGHUYSEN, the wife of George L. K. Morris, was another of the artists familiar with the Cubist prototypes. In a composition of 1936, between flat areas dotted or patterned with the brush and stratified and enclosed within an oval in regulation Analytical Cubist manner, she pasted printed matter and music to create a lyrical feeling. On the other hand, her *Toreador Drinking* of 1942 (plate 285), with its pasted labels of *apéritif* and cognac bottles, is more painstakingly constructed and may have been inspired by Juan Gris's plaster sculpture of 1917, *Toreador*, in the Gallatin Collection. Reminiscences of Gris can be made out also in a still life of 1949 (Collection A. Shipman, Hartford, Conn.), which has corrugated cardboard and papers with a hard lattice pattern pasted in and painted over in black, white, orange, violet, and brown.

Gris's *Toreador* was shown in 1936 in the great international exhibition *Cubism and Abstract Art* at the Museum of Modern Art, New York, one of the milestones in the development of abstract art in the United States.

Unlike these artists who were oriented exclusively toward Paris, another of the charter members of the American Abstract Artists, ILYA BOLOTOWSKY (b. 1907), had a more comprehensive acquaintance with developments in Europe, having traveled in Italy and Germany before going to New York in 1923 and supplemented this experience in 1932 with visits to London and Paris. It was toward the close of 1933 that he first tried collage, using plain papers, packing material, and the like, and restricting himself, as a matter of principle, to the primary colors, blue, yellow, and red, to which he added occasional cuttings from magazines if their textures and colors matched his basic conceptions. Because the colors of such cheap materials faded and bleached out with time, he later prepared his own papers with oil and tempera paints.

Collages such as *Balance* of 1934 (plate 286) and *Earth Colors* of 1937 (Collection the artist) are based on organic forms in the manner of Miró, large shapes cut out of paper in shades of gray, brown, green, and red and finished with line drawing. Later, however, under the influence of Mondrian's arrival in New York in 1940, Bolotowsky too changed to purely geometric compositions and thenceforth clung faithfully to the Neo-Plasticist approach. Thus, in a collage of 1953, *Rectangular* (Collection the artist), rectangles of different breadths and lengths are coordinated into a system in which gradated tones of color give the illusion of spatial stratification. By this means Bolotowsky attempted to enrich the uncompromisingly two-dimensional compositions of the Mondrian style.

Pictures by Miró were shown at the 1936 exhibition.

The illustrated catalogue put out by the American Abstract Artists in 1938 reproduced a collage by their first president, BALCOMB GREENE (b. 1904), a composition of abstract shapes arranged at sharp angles as if on a stage. Other collages of the same year have their elements more loosely distributed in

Bertha Schaefer Gallery, New York

space and set apart by harsh or gentle hatched shading. In one (plate 284) there is a large, light-colored shape that contrasts with the dark background like an illuminated wall in which the artist set small windows that open and shut.

Despite these examples, it appears from the catalogue that American artists were more interested at that time in material constructions than in collage, and that their preferred material, for both two-dimensional and three-dimensional works, was painted wood. BECKFORD YOUNG, for example, assembled boards of different colors and grains into a rigidly vertical composition interrupted only by the curves of the flight of an arrow. Rather more interesting is a *Construction* by BYRON BROWNE (b. 1907) based on a system of planes at slightly different levels, onto which projecting round forms cast their shadows.

The Greek-born JEAN XCERON (b. 1890), who joined the A. A. A. in 1940, concerned himself rather more than the others with collage, utilizing it at various periods in studies for his paintings. From 1927 to 1937 he lived in Paris and about 1930 was in contact with Seuphor and his Cercle et Carré group. Only toward the end of his stay in Paris was he able to shake off Cubist influences and turn to fully nonrepresentational painting. In the style he arrived at then, collage elements play a part, as in a composition of 1939 (plate 292), with large shapes of plain and patterned, coarsely woven cloths, some of them painted over with gouache. A collage of two years later is more obviously Neo-Plasticist in style, with a single scrap of checked cloth standing out amid pieces of paper, its threads drawn out to reach the surrounding areas and creating a certain unrest within an otherwise sober atmosphere. As time went on, his compositions became progressively more relaxed, so that in a collage of 1943 one finds a seemingly completely irregular accumulation of overlapping quadrangles, both right-angled and oblique, though with colors still limited, as in earlier works, to red, yellow, blue, and black, in accord with the principles of De Stijl, from which Xceron has only very gradually been able to liberate himself.

Acquainted with De Stijl as far back as 1934 through contacts with Vantongerloo and Van Doesburg, BURGOYNE DILLER (1906–1965) wholeheartedly embraced that movement, once Mondrian arrived in New York, and in the early 1940s he began to produce collages in Neo-Plasticist style. However, two examples from 1944, the only ones by him that we know, prove that he could introduce imaginative variations into otherwise purely horizontal–vertical compositions.

When the German émigré ADOLF R. FLEISCHMANN (1892–1968) settled in New York after several years in France, he became friendly with Diller and Fritz Glarner, who had had close ties with Mondrian until his death. Years before, in Paris, Fleischmann had experimented with collage, cutting newspaper into geometric shapes which he surrounded with animated lines, but not until 1948 did he produce the first of many compositions based exclusively on pure rectangles. Mat tones of black, gray, yellow, and brown papers made up his basic color harmony, intensified here and there by isolated accents of dark blue and red but elsewhere modified by transparent papers. With time, Fleischmann enriched the textures by using roughened papers, let his shapes interpenetrate and overlap, at times interpolated strong-colored vertical strips that articulate the surface rhythmically. He continued with these collages, along with his paintings, first in New York and then, after

He also became acquainted with Mondrian, who later, in 1940, turned to him for help in obtaining an entry visa for the United States.

It was shown at the Museum of Non-Objective Painting in New York in 1942.

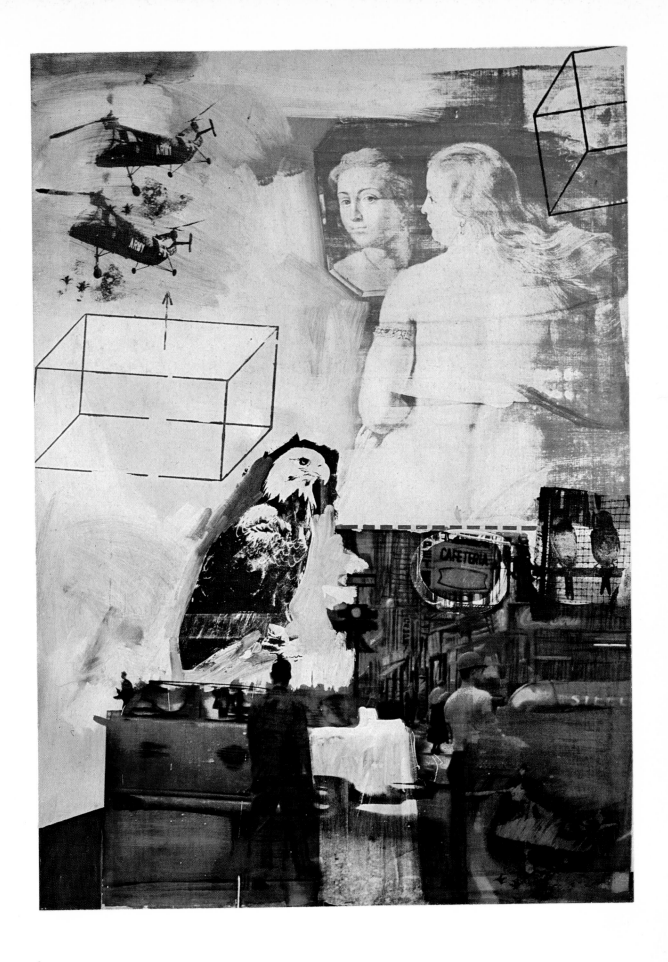

Colorplate 40. Robert Rauschenberg. *Tracer.* 1964

1957, in Stuttgart. As a parallel to his oil paintings, which are composed exclusively of parallel lines with veiled areas of color, he used paper on which he painted colored stripes that set up a kind of vibration within the textures (plate 289).

Although in general the American approaches to abstract collage at first followed European prototypes and led to no new and typically American solutions, AD REINHARDT (1913–1967) was one who pioneered his own paths. His collages, beginning in 1939, the year he joined the A.A.A., were combined from a number of similar elements that covered the pictorial field with dense structures only comprehensible when viewed as a whole. Thus, in a typical abstract collage (colorplate 36) sculptural shapes lead into space on advancing and retreating planes and coalesce in the center into fantastic architectural forms. This multiplicity of levels became even more dizzying when Reinhardt began to add to his colored papers cut-up photographs, especially of cloths in a variety of weaves and patterns. On the other hand, a collage titled *Newsprint* (plate 288) consists entirely of newspaper illustrations, views of cities and industrial installations, facades with and without signs, walls, and bridges, pasted every which way, broken up by light and shadow, making a truly phantasmagoric panorama. The imaginary metropolises that Paul Citroen composed from picture postcards and magazine illustrations are transformed here, by the more abstract use of photographic materials, into a pictorial statement as infinitely varied as a motion picture. Later, Reinhardt also made use of negative prints to construct chaotic conglomerates peopled by dark silhouettes.

On the basis of these works one could scarcely anticipate the change that came over Reinhardt's style in 1940–41, when he turned to abstract collages of simple, plain-colored strips and rectangles in the manner of Neo-Plasticism, though he did not give up the interplay of surface and depth. However, as time revealed, these were only a transition to the absolutely simplified painting he was to do subsequently.

HANS RICHTER, who had settled in New York in 1940 after having emigrated to France in 1933, began there a series of paintings and collages in which he aimed to depict movement and time—problems of considerable moment to him as a filmmaker—in dynamic developments of forms. This represented something of a return to the abstract cycles of pictures he had begun back in his Dada days. In 1943 he started a large "scroll picture," which he later titled *Stalingrad, Victory in the East* (plate 291) because its large, abstract shapes surround newspaper cuttings with news from the front and sketches of the theaters of operations. Between the abstract fields painted flatly in mat red, yellow, blue, and black, the newspaper fragments emerge as graphic structures, and the composition exploits the alternation of rigorously geometric and completely free forms, the former fulfilling the need for order, the latter the product of spontaneous inspiration; and the two aspects reflect the contrast in a war fought both by siege and by mobile attack and counterattack.

Richter executed another of these scrolls in 1944–45, *Invasion*, but using paint only. However, for the *Liberation of Paris*, 1945, a vertical scroll over eight feet high, he returned to collage. Between the abstract shapes painted in glowing blue and red, in the upper part he inserted newspaper clippings with texts only, in the lower part cuttings with news photos. His attempt to

utilize contemporary documentary material to infuse abstract painting with a feeling of reality, of topical significance, and at the same time not to relinquish the fundamentals of the style, was to find a great many followers among the painters of the present generation.

With the wave of Parisian painters who waited out World War II in New York—Léger, Chagall, Masson, Max Ernst, Tanguy, Seligmann, and many others—new ideas, those of Surrealism above all, made their way into American painting. In 1942 Peggy Guggenheim opened her gallery, Art of This Century, which thereupon became a center for European art as well as for young native talent. Robert Motherwell was the first to come into contact with her, and he soon brought in William Baziotes and Jackson Pollock, fellow members of a pioneering group seeking to create a new stimulus for American art. They were given one-man shows by Peggy Guggenheim, and in 1943 she saw to it that they took part in her international exhibition of collage.

ROBERT MOTHERWELL (b. 1915) acquired his first direct experience of painting during his university years, when, as a student of art history, he set about copying reproductions of the old masters in order to clarify for himself their compositional principles. Although he went to France in 1938 for a year's research on his Harvard thesis on Delacroix and there became interested in the Cubists, Picasso in particular, it was not until 1941, during a stay in Mexico in company of the Chilean painter Matta that he decided to give up teaching and to devote himself seriously to painting. His first pictures were influenced by Picasso's way of deforming the figure and by the Synthetic Cubists' system of laying out their planes; but Surrealist tendencies soon made themselves felt, largely through Matta, who was especially attracted to Miró and Masson and their spontaneous, automatic linear calligraphy. At the same time, the intellectual bases of Surrealism were explained to Motherwell by Wolfgang Paalen, whom he met in Mexico. Upon returning to New York in 1941, he worked in Kurt Seligmann's graphics atelier and through him became acquainted with other refugees from Paris, Max Ernst, Tanguy, Masson, and Breton, though he always maintained a certain distance from them and preferred instead to find his own essentially American approach.

When Motherwell met him in New York, JACKSON POLLOCK (1912–1956) was still under the dual influence of Picasso and Masson. The latter, however, won out in Pollock's pictures from 1942, such as *Stenographic Figure* (estate of the artist), the first works in which he surrendered himself to unpremeditated, automatic linear "handwriting" with paint squeezed directly from the tube onto the canvas, an approach in which he went far beyond anything the Surrealists had ventured. For his part, WILLIAM BAZIOTES (1912–1963), in his expressive painting of about 1940, adopted quite thoroughly abstract formulations, within which, nevertheless, certain Surrealistic allusions crop up here and there.

When Peggy Guggenheim proposed to the three painters that they contribute to her collage exhibition, none of them had as yet assayed the medium. Motherwell set to work immediately with Pollock in the latter's studio, and he recalled later how Pollock became more and more tense and vehement as he tore up papers, pasted them down, even burned their edges,

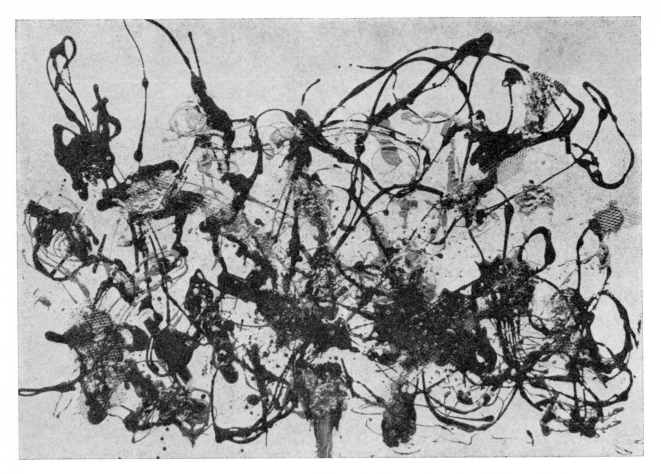

Figure 53. Jackson Pollock. *Number 29, 1950*. Wire, twine, pebbles, and painting on glass, 48 x 72″. Private collection

splashed paint over everything, quite literally in something like a state of trance.

Yet this first experience had no immediate consequences. Five years later, though, in 1948, Pollock mounted the flat head of a rocking horse into a painting titled *The Wooden Horse* (Collection Paul Facchetti, Paris), where it looms out of the thick impasto of paint as an alien relief element. Often, too, he threw all sorts of chance materials into his mass of color—for example, in 1947, the caps of his paint tubes, along with nails, buttons, keys, coins, and other oddments, in *Full Fathom Five* (Museum of Modern Art, New York); in 1952 (later inscribed 1953), a broken Coca-Cola bottle in *Blue Poles* (Collection Mr. and Mrs. Ben Heller, New York). Finally, in 1950–51, he produced two rather more authentic collages. In *Number 29, 1950* (figure 53), wire mesh, twine, and pebbles lend a transparent, multiple-layered effect to the maze of lines that covers the glass ground. The paint in *Number 2, 1951* was covered with moistened shreds of thin paper to tone down the resonance of the colors.

For Peggy Guggenheim's collage exhibition Baziotes concocted *The Drugged Balloonist* (plate 287), which includes paper, cloth, leaves, butterfly wings, and so on; but for him too collage remained an exceptional and anything but natural medium.

The two attempts that Motherwell made in Pollock's studio produced at least one collage of astounding sureness of touch (Collection Mme. Pierre Chareau, New York). It is composed of a number of layers on a sheet of paper over which gray paint has been poured and which makes an inner

rectangle on the pasteboard ground. Two salient geometric shapes may, or may not, represent a head in profile and a hat or cap, and these are cut out of papers in glowing colors that Motherwell had brought back from Mexico. The forms are loosely linked by thick white lines laid on in Pollock's manner, directly from the tube, while alongside them a small glass button—contributed by Pollock—makes a somewhat timorously added material element.

Motherwell soon adopted the collage technique consistently as a way of facilitating his work, since he found that it was easier and faster to vary the compositions he created in successive stages by using torn or cut paper rather than oil paints, which must be allowed to dry slowly and thoroughly between coats. During 1943 and 1944 he worked on a number of large collages to explore various principles of composition in an effort to find his own style. In *The Joy of Living* (colorplate 37) the painted and plain-colored papers are set like picture screens into the projection in depth, which leads obliquely into the spatial background, where it is blocked by a black-framed military map. The approach is quite different in *Pancho Villa, Dead and Alive* (Museum of Modern Art, New York), also of 1943; there the picture surface is divided into vertical fields in which the schematized figure of the champion of Mexican liberty appears twice, side by side, in purely frontal view. While the figure of the dead Pancho Villa is marked with pink stains like seeping blood, the living Pancho is gay in a German Christmas paper sprinkled with black and red dots, something Motherwell was to use many times again. In a later and entirely nonrepresentational composition, *In Green and White* (now destroyed), with a white and a green oval on a black ground enclosed by two gray vertical stripes, Motherwell carefully calculated the precise relationships and tensions between forms and colors. The oval as a form is found again on two other collages, *Collage in Beige and Black* of 1944 (Collection Ivan von Auw, Jr., New York) and *Mallarmé's Swan* of 1944–47 (Cleveland Museum of Art), where it is juxtaposed as a constant, objective element to the changeable, subjective forms that spring from the artist's spontaneous inspiration.

From 1945 on, Motherwell continued to exploit other symbolic figures like his *Pancho Villa*, often in collage. In the portrait of *Maria* of 1945 the body is cut out of paper, while the head is given three-dimensionality by heaped-up sand. The completely abstract figure of the *Poet* of 1947 (formerly Collection Mr. and Mrs. Mark Rothko, New York) is drawn on a ground covered with papers and bathed in colorful shades of orange, pink, and cobalt blue. During the 1950s Motherwell created unrealistic coastal landscapes out of torn and sometimes patterned papers with pen-drawn contours. He also occasionally introduces labels, on which he writes casual and irrelevant words or his own name in large letters, or package wrappings addressed to him, thereby bringing in a personal note. Then again he may insert neutral numerals, printed matter, and advertisements. At times he returns to rigorous pictorial constructions, as in *The Easel*, of about 1951 (plate 290), where the interrelation between surface and depth is repeated in the pasted printed matter. More often, however, he uses collage elements chiefly to evoke effects of contrast. Thus, the colorful commercial labels that he has pasted into his pictures of the last decade act as curious halting points in the midst of explosive lines and colors, as if he wished to demonstrate that, in the general chaos of our environment, only the small everyday

H.H. Arnason, "On Robert Motherwell and His Early Work," *Art International*, vol. X, 1966, no. 1, with seven reproductions of early collages. See also Frank O'Hara, *Robert Motherwell*, catalogue of the Museum of Modern Art, New York, 1965, p. 14.

Reproduced in *Fourteen Americans*, New York, Museum of Modern Art, 1946

things are still deserving of our faith. Constantly developing his own special combination of painting and pasting, Motherwell has devised new forms for collage, and his works occupy an important place in the Abstract Expressionist style that gave such a great impetus to American art in the immediate postwar years.

Whereas the verve of paint application gives the collages of that school their special expansive, expressive force, those by CHARMION VON WIEGAND (b. 1900) are quite the opposite, concerned as she is with the intensity that arises out of a calmer and more thoughtful way of working. She arrived at a nonrepresentational style in 1941 under the influence of Mondrian, with whom she had a close friendship, and for a few years she submitted to his guiding principles and created austerely geometric compositions. Nevertheless, about 1946 she began to produce collages in which the systematic organization becomes relaxed, and a playful pleasure in materials and colors gains the upper hand. Between the fantastic signs of the zodiac in *Map of the Heavens* of 1947 she pasted strips of paper lace and papers painted with animals. In *Tarot* she spread out "playing cards" decorated with brightly colored signs, and she broke up the mosaic with plain-colored strips, triangles, and rectangles. Her first exhibitions, held in 1947 at the museums in Massillon and Akron, Ohio, stimulated a new wave of interest in collage in the United States, heightened by the show of Schwitters that she organized in 1948 at the Rose Fried Gallery in New York, in collaboration with Katherine Dreier and Gabo.

At the beginning of the 1950s she worked exclusively in prefabricated painted papers, which she cut up and distributed densely and colorfully across the picture surface. In *Buddha's Fingers* of 1953 (Zoë Dusanne Gallery, Seattle) small sheets textured with brush and paint create a kind of showcard of tiny "Informal" paintings, the individual boldness of which is modified by their systematic arrangement in rows. During recent years Charmion von Wiegand has steeped herself in Oriental thought and philosophy as the source of that inner harmony she strives to express through art. Even as a girl in San Francisco, the Chinese quarter fascinated her, and her interest in Far Eastern art and culture was further strengthened later through her contact with Mark Tobey, who, like herself, was seeking to transmit to his fellow Americans something of the Oriental spirit. As a step in that direction, she began to introduce into her collages Chinese characters, either cut from texts or copied and varied by her; and this form of ornamentation, both dynamic and formally restricted, lends a mysterious animation to her compositions (plate 293). Besides these, she uses series of numbers, gleaming and glistening papers, and papers printed with delicate patterns, which she shades and surrounds with watercolor or oil in rose-red and sky-blue tones. Her collages are limited to small formats, which guarantee them a special intimacy in which material and form chime subtly together.

She contributed an article, "The Oriental Tradition and Abstract Art," to *The World of Abstract Art*, 1957.

Developments in 1930s Paris

In the somewhat confused picture of art in Paris in the thirties, when both Constructivism and Surrealism kept a firm grip on their adherents, even collage no longer held a special place. Yet, over and beyond the works

prepared specifically for the big Surrealist occasions, there was much that passed unnoticed at first and only later disclosed all its significance.

HENRI MATISSE (1869–1954) had nothing to do with collage until 1931, when the American collector Albert C. Barnes invited him to decorate a room in his private museum in Merion, Pennsylvania. There, Matisse promptly ran into difficulties, for his compositions had to be fitted into the curved areas created by the ribbing of the ceiling vault. As his theme he chose the *Dance*, a long-time preoccupation of his, but work on the sketches dragged on and on, and several times they had to be changed because of errors in calculating the dimensions of the compartments to be painted. At first Matisse drew his dancing figures on large sheets of cardboard, but he found himself faced with new problems when it came to covering with paint the vast areas around them. To facilitate the work, he cut black, light blue, and pink papers into shapes that could be moved around and interchanged at will. The result, in 1931–32, was various series of collages with different arrangements of the figures and color areas, and from them developed the definitive compositions that Matisse completed in 1933.

Again, for one of the sketches for the *Pink Nude* of 1935 (Baltimore Museum of Art), Matisse made use of cutout colored papers, though there he only thumbtacked them down and did not paste them. However, he produced a genuine collage in the *Dancer*, dated May 1, 1938, and dedicated to Léonide Massine, one of the sketches for the ballet *Rouge et Noir*, choreographed by Massine to the first symphony of Shostakovich. The sets, curtain, and costumes were commissioned from Matisse by René Blum.

It was performed by the Ballets Russes, under the title *L'Étrange Farandole*, first in May of 1939 in Monte Carlo and then in June in Paris.

In addition to these, Matisse also designed various collages as title pages for the review *Verve*, and in 1943, when he offered a new sketch depicting *Icarus*, the editor of the review, E. Tériade, proposed that he illustrate a book in this manner. Matisse seized upon the idea, and two collages of that year, *Clown* and *Toboggan*, marked the beginning of the album titled *Jazz*, which Tériade brought out in 1947.

The collage was used for the title page of *Verve*, no. 13, 1945.

Matisse cut his forms directly out of colored papers without any preparatory drawing, a procedure that he called "drawing with scissors" and equated to the work of the sculptor in stone. As he explained, what came from his scissors crystallized into reminiscences of the circus, folk tales, or his travels. Many of these collages are limited to a very few pictorial elements, which are subjected to highly abstract transpositions; others are embellished with ornamental accessories and reflect an almost childlike gaiety. Between the illustrations in the album Matisse inserted a handwritten text explaining his artistic ideas and his way of working.

From 1948 on, scarcely able any longer to manipulate a drawing pencil or brush, he worked extensively with scissors. Between 1949 and 1951 he relied on collage for his designs for stained-glass windows, wall tiles, and liturgical vestments for the chapel of Notre-Dame du Rosaire in Vence, which was constructed on his plans.

Decorative leaf and plant motifs glow in ultramarine blue, bottle green, and lemon yellow on the windows of his chapel. Many-leafed plants, multi-fingered leaf forms, algae, and the like are found also on innumerable separate sheets, as cutout shapes in black and white pasted over with small pieces of colored paper and affixed on differently colored grounds. Colorful four-petaled blossoms crowd around the *Masks* and loosely surround the large

Exhibition catalogues, *Henri Matisse, papiers découpés*, Paris, Galerie Berggruen & Cie., 1953; and *Henri Matisse, les grandes gouaches découpées*, Paris, Musée des Arts Décoratifs, 1961

figure of *The Negress* (figure 54). A number of silhouettes of human figures are caught in spontaneous gestures or movements (figure 55). Some of these were cut out of blue paper and mounted into a frieze over fifty-two feet long titled *The Swimming Pool* (private collection, Paris). In these "*découpages*" form and color constitute a unity, a single substance, and the blank intervals between the separate elements function as intimations of space and lend the strictly two-dimensional shapes a feeling of volume.

Besides these there are also large, complete pictorial compositions such as the fairytale-like *Tristesse du Roi* (Musée National d'Art Moderne, Paris), in which Matisse conceived the sorrow of King David; the *Souvenir d'Océanie* (private collection), with memories of Tahiti transmuted into light and color; and the most abstract of all, *L'Escargot* (Tate Gallery, London), a snail envisioned only in two-dimensional forms in subtle tints of color. Matisse himself esteemed these works as the high point of his creative production.

Exhibition catalogue, *Julio González*, New York, Chalette Gallery, 1961, colorplate p. 55

It was shown in the exhibition *Hans Hartung, Oeuvres de 1920 à 1939*, Paris, Galerie de France, 1961.

About 1937 the sculptor JULIO GONZÁLEZ (1876–1942) turned to collage for a certain number of sketches for his sculptures. He used tinted papers, usually torn, to distinguish spatially his various formal constituents, and he alternated light and dark papers to transform the flat surfaces into volumes.

HANS HARTUNG (b. 1904) worked for an entire year, 1938–39, in González's atelier, and in 1938, in addition to an iron sculpture translating his innate nervous, linear idiom into metal rods, he produced a collage or, strictly speaking, a material picture, the only one he ever did (Collection the artist). On a dark-green painted ground he pasted triangles of newspaper, a perforated board, and a piece of rusted wire sieve, all in geometric forms; and around these things he laid a rope in broad loops set into relief by yellowish shadows. These secondhand materials bring a certain note of oddness, of alienation, to a formally meticulous composition, and their utilization quite certainly derives from Surrealist influences, noticeable also in the hints of figuration one finds in his painting of the same period.

Hartung showed this piece at an exhibition of collages and photomontages in 1938 at Peggy Guggenheim's new London gallery. On that occasion she enticed other artists to experiment with unconventional materials. ALBERTO MAGNELLI (b. 1888) contributed a relief based on elements taken from nature (plate 294). He mounted vine leaves and gnarled branches over grooved planks, and between them he casually distributed bits and pieces of colored ceramics. Only the ground itself, on which the vertical furrows of a strip of corrugated cardboard at the upper margin match the broad horizontal grooves of the plank, displays the tight structure typical of Magnelli's feeling for form.

The paper collages that Magnelli began to create at the same time do, however, parallel the development of his abstract style, which was initiated in Florence about 1915, with a first series of nonrepresentational paintings, and was given fresh impetus when he settled in Paris in 1931. In his first efforts (plate 295), black and marbled papers in simple geometric shapes form background compositions on which he painted freer abstract shapes in gouache. He also executed a series of collages on small slate tablets with wooden frames that close the composition as if they were part of it. Often he combines materials selected with great discrimination, for example pasting a scrap of pink tissue paper on an olive-green leather wallpaper, or a

Figure 54. Henri Matisse. *The Negress.* 1952. Cut paper, 14′ 8¹/₂″ x 20′ 2¹/₂″

Figure 55. Henri Matisse. *Girl Skipping Rope.* 1952. Cut paper, 57¹/₈ x 38⁵/₈″

sheet of ruled paper between shapes cut from smooth, plain papers. For the *Collage on a Black Ground* of 1938 he used a wallpaper with a Renaissance-style pattern to make a "figure" with broken-up coloring, which he super-imposed on a darker, unpatterned sheet. In another case (plate 296), over a ground of shapes cut out of canvas, marbled paper, and leather paper he mounted three Japanese bamboo rakes, which, opened fanwise to different degrees, become highly effective formal elements.

During the war years, which Magnelli spent in Grasse with Arp, Sophie Taeuber-Arp, and Sonia Delaunay, he produced many more collages, because paint and canvas were hard to come by. For a series in small format (plate 297) he used music paper as a ground and cut large heads of notes from colored reproductions of Sophie Taeuber's knitted materials. These knitting patterns, with their ribbings, checks, dots, and stylized flowers, were a source of diversified textures that he sometimes contrasted with corrugated-cardboard shapes. In 1942, however, alongside such collages of rather inti-mate character he devised a number of more dynamic compositions with plain and patterned colored papers in round and angular forms distributed across the surface in an impulsive manner and shaded with vehement strokes. To one such work he added a twisting and coiling length of cord; to another, a thin piece of wire.

With the end of the war his pictorial conceptions became simpler and more reposeful. He arranged his elements on a neutral ground and carefully calculated the relationships of form, color, and material. Thus, a collage of 1949 (plate 298) achieves a harmonious union of such diverse textures as coarse canvas, ribbed packing paper, and printed pages from a book. Elsewhere the smooth and rough surfaces are enlivened by lined or marbled papers. For color he confines himself chiefly to a scale of blue, black, and brown such as Henri Laurens too favored in his collages. Certainly Magnelli has instilled fresh value into the everyday materials which, since Schwitters's time, had again fallen into neglect and been little appreciated by exponents of one Constructivist trend or another. Yet, the poetry inherent in such scraps is felt only fleetingly in Magnelli's hands, because his pronounced

feeling for form demands clear and distinct solutions, though his materials confer on many of his collages an astonishing monumental forcefulness (colorplate 38).

From Informal Art to Pop and Op

Collage enjoyed a new heyday after World War II, when artists everywhere embraced abstraction in painting. The effect was to bring about yet another transformation in collage itself. The first generations of abstractionists had turned to it as a means of establishing clear relationships between lines, forms, and colors in order to guarantee objective validity for their pictorial conceptions, but the postwar generation cared more about using the abstract idiom to reflect their individual subjective moods, impressions, and experiences, without worrying too much about definitive formulations. In place of precise, delimited forms, the concern now was all for indeterminate textures and the manner of applying paint, and these uncommitted means, behind which the artist could preserve his anonymity, were susceptible of being enriched in manifold ways with the aid of collage. Pasted papers and other substances gave the "message" a material solidity that made its voice more forceful.

In the development of lyrical–abstract painting that took shape toward mid-century, once again Paris took the lead, and it was there that collage found its most passionate supporters. In 1950 the Galerie Allendy showed a series of new works by JEANNE COPPEL, the Romanian artist discussed earlier, who had eventually settled in Paris. These were compositions of cut and torn papers, with their own dramatic note arising from the contrast of light and dark tones. Subsequently she went on to group dull and shiny or smooth and crumpled papers in loose, geometric arrangements that give the sensitively harmonized materials a singular new resonance. The American JOHN F. KOENIG (b. 1924), resident in Paris since 1948, assembles pictures of a festive good humor from narrow strips of varicolored, glistening, and transparent papers or composes melancholy pictorial poems out of torn elements which he surrounds with delicate lines. An artist of rather austere tendencies, such as the native Frenchman JEAN DEYROLLE (b. 1911), may organize his abstractions with pieces of painted canvas whose raw edges lend some animation to the surfaces; whereas another American, JOE DOWNING (b. 1925), compiles fantastic visual narratives with the aid of office supplies from the notarial bureau where he works in Paris: cut-up letters and envelopes, second sheets, carbon paper, and staples that make glistening lines across the shapes. Downing has also fastened small sheets of Manila paper together with paper clips so that they stand slightly away from the ground in rolls and make airy structures of fragile equilibrium.

Like Schwitters, KARSKAYA (b. 1905) finds treasures in any rubbish heap and brings new life to old odds and ends of wool, leather, dirty paper, cloth, and wood, either by arranging them carefully in sequences or by heaping them up helter-skelter. Her inexhaustible stock takes in also stones, bark, fungi, and withered leaves and grasses, which infuse their own connotations into essentially abstract contexts.

The Italian ALBERTO BURRI (b. 1915), who had begun to paint while he was a prisoner-of-war medical officer in a camp in Texas, discarded smooth

Works by a great many artists are reproduced in the double number of *Art d'Aujourd'hui*, March–April, 1954, devoted to collage.

oil paints about 1950 in favor of cruder substances. He began by letting thick masses of paint break up and crumble on his canvas, then added scraps and rags on which he had wiped his brushes. Soon he resorted to sewing to his canvas, with large, crude stitches, large or small pieces of old sacking of fine or coarse weave and then filling the interstices with red paint gushing out like blood from open wounds. Sometimes, though, he underlaid all this patchwork with black and gold colors, which gave it an unexpectedly ceremonial character. In 1957 he began to burn and char paper for such works and to assemble strongly organized compositions of burned planks. Still later he used metal that he had maltreated with a soldering iron so that blisters and nodules rose up at points of juncture. The image of our time, for Burri, seems to demand expression only in an inexorably tragic key.

Cesare Brandi, *Burri*, Rome, 1963, is copiously illustrated.

While a number of Americans followed Motherwell's lead in incorporating collage elements into their Abstract Expressionist painting, others restricted themselves to working only with nonconventional materials. ANNE RYAN (1889–1954), for one, made subtle pattern cards from delicate, thin cloth or even tissue paper. Another woman artist, RONNIE ELLIOT (b. 1916), has utilized in her compositions old Chinese cloth and rags that her husband, a foreign correspondent, salvaged for her during the war: printed calico, flowered silks, washed-out handkerchiefs, torn stockings, and other fragments still replete with traces of human existence. The Spanish-born New York artist ESTEBAN VICENTE (b. 1906) piles torn papers in mat tones and approximately geometric shapes into layers one above the other, using the brush here and there to insert among them a touch of one or two brighter colors.

One would have thought collage wholly committed to abstraction by this time, but after a few years realistic aspects once again forced their way through. Suggestions of landscape, previously reflected only in the choice of colors, now began to take on clearer contours. Although the collages that NICOLAS DE STAËL (1914–1955) produced in 1953 in southern France might appear to be abstract, they were in fact based on highly condensed schematic forms of houses, trees, boats, mountains, or stars. However, the colors he arbitrarily assigned to them preclude all hint of naturalism.

During that same year of 1953, JEAN DUBUFFET (b. 1901) fabricated a first series of pictures using butterfly wings, inspired by the montages of butterflies made by Pierre Bettencourt, with whom he was spending some time in the mountains. These became the point of departure for his "assemblages," in which at first he used waste paper from his lithographs but later ordinary white paper marked with tusche and upon occasion added or substituted pieces of newspaper cut out and smeared. From such elements grew, as if by chance, grotesque human figures and heads (figure 56). Later he made "*assemblages d'empreintes*," collages of self-imprints of household objects—sieves, soap holders, dust rags, salad baskets, and so forth—which provide specific textures.

When he moved to Vence in 1955 and became familiar with the scanty vegetation along its dry and dusty roads and with its gardens overgrown with weeds, he also made assemblages of cut-up canvas, which he painted in advance with leaf, stone, and plant motifs, always of the same sort, to make a stock of collage material which he then spontaneously massed on

Figure 56. Jean Dubuffet. *Personage.* 1954. Newspaper

His association with Dubuffet in Vence led Philippe Dereux to make collages out of the dried peels and husks of all sorts of fruits and vegetables.

paper or canvas without any set plan. Some of his color schemes imitate the shimmering iridescent tonalities of butterfly wings, and he was inspired by the great diversity of butterflies in southern France to use this raw material once again in collage. In 1959 he collected leaves from all sorts of plants and trees as "botanical elements" from which he created human figures, gardens, and patches of earth. His use of rocky, earthy, sandy, and muddy colors and textures is well known.

The rehabilitation of the real world manifested itself in the collages made from torn posters—"*affiches lacérées*"—which multiplied in the 1950s in France, the United States, and Italy, and in which the sort of material already unearthed by the Dadaists and Surrealists was now exploited systematically. In Paris RAYMOND HAINS (b. 1926) experimented with torn posters as early as 1947, but his work and that of JACQUES DE LA VILLEGLÉ (b. 1926) was not exhibited publicly until 1957, when the Galerie Allendy organized a show called *Loi du 29 juillet 1881*, the words one sees stenciled everywhere in France proclaiming a particular stretch of wall as prohibited for posting bills. Whatever topical or realistic interest may be intended in these works is dissipated by the fragmentation of the words and phrases, which are regrouped according to formal principles; and the whole point becomes even more dubious in the "*décollages*" of FRANÇOIS DUFRÈNE (b. 1930), who prefers to use the undersides of posters, so that the printed matter is perceived only as imprecise textures.

The Italian MIMMO ROTELLA (b. 1918), whose first poster collages date from 1954, maintains that by tearing up and regrouping his elements he aims to startle the public out of its complacency. In later efforts he has added cinema posters to his other advertising material and utilizes brilliant colors as a way of giving his pictures an alarming note (colorplate 39).

Rotella exhibited with French artists using the same approach in the *Nouvelles Réalités* salon, organized by the Paris critic Pierre Restany in 1960 as a forum for artists of varying convictions attempting to come to grips with reality in new ways. The change of attitude is evidenced particularly in the kinds of materials adopted. JEAN TINGUELY (b. 1925) assembles old iron junk, wire, wheels, strips of metal, and the like into fantastic machines that somehow or other he manages to set into motion. In his "self-destroying" work, *Homage to New York*, 1960, he went so far as to include a bathtub and a piano. The technological age could scarcely be attacked with more biting sarcasm.

Among similar efforts, in 1949 a Danish artist resident in Paris, ROBERT JACOBSEN (b. 1912), began to make "dolls" from household refuse to "portray" his friends. Shortly after 1950 the Japanese-American SHINKICHI TAJIRI (b. 1923) began to comb the Paris rubbish dumps in search of scrap iron to be welded into fantastic figures. ZOLTAN KEMENY (1907–1965) made his first reliefs of rags, sand, and glue, but after 1954 he turned to factory-fresh products of the metal and electrical industries—iron or brass nails, rivets, screws, and so on—which he combined in compositions of animated structures and textures. At the Salon de Mai of 1960 CÉSAR (Baldaccini) (b. 1921) exhibited wrecked autos pressed into blocks by a scrap-metal plant, claiming that such compression intensified the expressive potential. FERNANDEZ ARMAN (b. 1929) is another who "portrays" his friends, but he does so by emptying the contents of their wastebaskets into glass showcases. Even-

tually he began to fill his cases with similar objects—old pistols, false teeth, dolls' hands, forks and spoons, shoetrees, electric bulbs, alarm clocks, and what have you—which, displayed in such great numbers, become virtually abstract elements.

The demand that artistic conception should be replaced by mere "information," and thereby reflect total, unselected reality, is best fulfilled by DANIEL SPOERRI (b. 1930), who simply glues or nails to a surface whatever he happens to find on his table: plates with leftover food, painting utensils, loaded ashtrays, matchboxes, and any kind of rubbish whatever. This activity, in which collage becomes primarily a technical problem, signified for him, he says, a way of perpetuating situations that chance alone brought about.

It is noteworthy that both the European "New Realists" and the American experimentalists characteristically employ only old and used materials; in fact, the two movements run entirely parallel.

Well before Tinguely, RICHARD STANKIEWICZ (b. 1922) was using sheet metal, wire, buckets, wheels, and pipe for sculpture, and JOHN CHAMBERLAIN (b. 1927), like César, joins parts of smashed automobiles, though Chamberlain paints his wreckage in bright colors.

However, in the narrower field of collage the really new paths were opened up by ROBERT RAUSCHENBERG (b. 1925), with his "combine paintings" dating from 1953 on. Into paintings with the techniques of American Action Painting he inserts wildly disparate objects which he integrates by dashing paint over them. Whatever he can lay hands on is serviceable: pieces of cloth, underclothing, frames and wooden panels of earlier days, objects useful and useless. Empty fields of color are filled with letters and words. News photos of current events are slapped down side by side with irrelevant drawings. Rauschenberg opens a real umbrella, paints it in all the colors of the rainbow, then pastes pictures from a book of art history all over the wall next to it. As he says, his aim in all this is not to create art works but to bridge the gap between life and art.

A new style fathered by Rauschenberg and Jasper Johns, and fully deserving of the name "Neo-Dada," takes shape in such works of Rauschenberg as his *Bed*, of 1955 (Collection Mr. and Mrs. Leo Castelli, New York), in which the subject is propped up on end against a wall, with floods of paint poured down the neat, geometric pattern of its pillow and patchwork quilt. Rauschenberg's *Monogram* of 1955–59 (Moderna Museet, Stockholm) is a flat panel on which a stuffed angora ram stands inside a rubber tire. His *Pilgrim* of 1960 has a chair screwed to an abstract painting.

JASPER JOHNS (b. 1930) began by putting into his pictures only painted or printed numerals, more symbolic than realistic in significance, but he excited greater attention with his "target constructions" of 1955, on which he mounted boxes, open or closed, containing the "prizes" for the winner: modeled faces, ears, mouths, hands. Such mysterious and anxiety-arousing allusiveness was abandoned in 1960, when Johns began to make bronze casts of everyday objects such as tin cans and paint brushes in an open pot, which he painted naturalistically and inscribed.

Here Neo-Dada is well on the way to becoming Pop Art, the aim of which is to present the furnishings of daily life just as it is, plain and unadorned. This is what JIM DINE (b. 1935) tries for when he paints patterned neckties on monotone painted grounds or slightly textured canvas or hangs

Andrew Forge, *Robert Rauschenberg,* New York, n.d., illustrates these works.

bathrobes, household utensils, garden tools, and the like on his pictures. His *Wash Basin* bordered in black paint was trumped by TOM WESSELMANN (b. 1931), with his bathroom installation complete with curtains, towels, laundry basket, and all the other appurtenances.

The characteristic feature of Pop Art is its focus on everything that is thought to interest the masses: television, advertisements, electric signs, comic strips, every kind of consumer goods. Indifferent to worn-out things with their patina of time, Pop Art shows everything spanking new and fresh, just as it comes from the ten-cent store and, by preference, made of garishly colored plastics. Pop "ready-mades," unlike those of Marcel Duchamp, are not displayed as individual pieces in themselves, but are set out in show windows or installed within whole rooms directly open to the viewer.

However, that sort of display is alien to the spirit behind Rauschenberg's work, since for him all that counts is the act of artistic creation by which reality is subjected to an ever-changing process of transformation. In connection with his "combines" he developed new possibilities of representation from the basic principle of collage. In the illustrations for Dante's *Inferno* he merely enriched the drawings by *frottage*, but elsewhere he transfers black-and-white or colored photos into his oil paintings by means of silk-screen printing, with the result that those works contain an astonishing jumble of political images and sporting events, machines and buildings, geometric forms, mathematical tables, and what not. Alongside photographs of Eisenhower and Kennedy appear masterworks by Titian and Michelangelo, and an American eagle, king of the air, perches like an evil omen among army helicopters, hard-hat workers, and a voluptuous, blue-printed nude (colorplate 40). Geometric diagrams endow the picture surface with a multidimensional aspect, and through transparent layer upon layer the images emerge as if in a dream vision.

Sam Hunter, *Larry Rivers*, New York, n.d., has extensive pictorial documentation.

New forms of collage were introduced also by LARRY RIVERS (b. 1923). Like Rauschenberg, he finds that everything glimpsed by his eye is worthy of being perpetuated, and he is especially fascinated by the products of industrial mass production. Art works live for him in their practical utility: Rembrandt's group portrait of *The Syndics of the Drapers' Hall* in a cigar advertisement, a portrait of Napoleon on French bank notes. Rivers's colored drawings, with their many collage elements, take on the character of sketchbook pages in which leaves from a calendar or menus are as important as pictorial representations. Alongside his nudes he draws the separate parts of the body, and he provides "program notes" for his pictures, as if he considered the interpretation of equal significance with the representation itself.

J. Reichardt, "Pop Art and After," *Art International*, vol. VII, 1963

In Europe, not only France but England especially followed the new course, and it appears that, even before New York and Paris, London previewed the Pop Art program in 1956 in an exhibition at the Whitechapel Art Gallery titled *This Is Tomorrow*, for which twelve teams of architects, painters, and sculptors created new "environments" in mass taste. RICHARD HAMILTON (b. 1922), who along with John McHale belonged to the team of the architect John Voelcker, provided the catalogue with a double-page collage (original, Collection Edwin Janss, Jr., Thousand Oaks, Calif.), which was also projected to cover the wall of the entrance hall. Under the title *Just What It Is That Makes Today's Homes So Superior*, this early example of

the new genre showed an interior decorated with everything guaranteed to delight the heart of the man-in-the-street: a family portrait hangs on the wall along with a music-hall program and a sentimental comic strip; and the vacuum cleaner, television set, and tape recorder are joined by two other utilities, the naked figures of a seductive girl and an athlete. Later on, Hamilton depicted human individuals in relation to a mechanized environment in oil paintings with details rendered by pasted-in portrait photos, technological illustrations, or solid materials.

Exhibition catalogue, *Richard Hamilton*, London, Tate Gallery, 1970

Among the younger English practitioners of Pop Art, PETER BLAKE (b. 1932) has become known for collages full of pictures of pin-up girls such as one might find in the dormitories of boarding schools or army barracks. He also fits into his romantic collages English valentines, dolls, and sentimental keepsakes.

Pop Art has also been a stimulus to material collages. These sometimes reveal distinctly folkloristic influences, as in the work of the Argentine ANTONIO BERNI (b. 1905), who in the 1930s painted in the Metaphysical style but about 1960–62 portrayed the life and adventures of his compatriot Juanito Laguna in a large cycle of collages. Juanito and the members of his family are dressed in draped cloth and laces; houses and factories are sheathed in pieces of iron, metal plaques, and grates; and Juanito's path is blocked by a gigantic junkheap of scrap metal, chains, sieves, bands, and the like. These real materials, incorporated into Expressionistic painting, cast a false glow and glitter over a wretched reality and create a direct and dramatic impact. On the other hand, the reliefs of the Mexican ALBERTO GIRONELLA (b. 1929) are quite Baroque in effect, with their copies of pictures by Velázquez and Goya surrounded by absurdities such as wax hands, animal heads, hides, and pieces of furniture, often individually framed and placed one next to the other as if hanging on the walls of an antique shop.

Perhaps the most out-of-the-way ideas in collage during the last decades are those of the Italian ENRICO BAJ (b. 1924). In 1951, in Milan, he launched the Nuclear Movement, whose name was intended to proclaim that its supporters wished to open new horizons in art and to create works that keep pace with the events of the time. His protest against an abstract art that had petrified with time led Baj to a spontaneous style of painting with naive figuration not unrelated to that of Dubuffet; this he has tended more and more to combine with the most heterogeneous materials. In 1959 he studded heads and busts with bits of broken mirror and bright-colored glass, which he linked together by oil paint. The next year he launched his series of *Generals and Their Ladies*, portraits backed by flowered or striped wallpapers. The officers are decorated with real orders and medals, while their wives rejoice in embroideries, pearl necklaces, and purses. Later he trimmed other female portraits with the cloth, lace, braid, tassels, and furbelows in which he obviously takes great pleasure. However, his most noteworthy series is the *Furniture* of 1961, with wooden pieces and inlays glued flat on wallpapered walls or patterned cloth and equipped with metal locks and wooden knobs. It is precisely the realistic decorative elements that give these works their entirely unrealistic aspect, and for all their good-humored irony, the doors and drawers that cannot be opened and the mirrors that reflect no images are as disturbing in their effect as Daniel Spoerri's "accidental" tables.

Tristan Sauvage, *Art Nucléaire*, Paris, 1963

They were shown at the Venice Biennale of 1966.

There are interesting surveys in the following exhibition catalogues: *The Art of Assemblage*, New York, Museum of Modern Art, 1961; *Cinquante ans de collages*, Saint-Étienne, Musée d'Art et d'Industrie, and Paris, Musée des Arts Décoratifs, 1964; *Collages*, Frankfort on the Main, Kunstverein, and Zurich, Kunstgewerbemuseum, 1968; *Die Fotomontage: Geschichte und Wesen einer Kunstform*, Ingolstadt, Stadttheater, 1969.

One can see as counterparts to these imaginary pieces of furniture the large cupboards that the American artist LOUISE NEVELSON (b. 1900) fills with fragments of old-fashioned furniture, chair legs, backrests, seats, straight and curved boards, and so on. Painted over in a uniform black, white, or gold, they lose all their immediate character, all trace of when they were made, and the boxes piled one above the other are metamorphosed into mysterious treasure chests.

There may be an element of protest against the arbitrarily combined Pop assemblages in the fact that not a few artists now set their compositions into cases and boxes and thereby impose on themselves a modicum of formal discipline. Nevertheless, in the leather-cased *Cabinets* of the German HORST-EGON KALINOWSKI (b. 1924) the weighty wood and metal components often burst through the framework and tower above and outside it, though one's eye is still drawn to the depths where one senses some sort of awful chasm.

Many such "showcases" nowadays are often crammed with sentimental items. The American ILSE GETZ (b. 1917) fills hers with exotic little dolls and Japanese parasols, as well as with such meaningless odds and ends as candles, clothespins, and matches which, painted white, exude a certain odd poetry. The Italian LUCIO DEL PEZZO (b. 1933), however, in his series of *Panels of Memory* imbeds in a thick impasto of color things that speak of his lost childhood. In Paris one finds YOLANDE FIÈVRE (b. 1915) packing little boxes with pebbles, slivers of wood, little bones, and tiny twigs, which somehow take on the appearance of ghostly figures and heads. By comparison with these macabre reliquary cases, the cabinets made by the Stuttgarter HEINZ E. HIRSCHER (b. 1927) seem all the more cheerful, with their brightly colored glistening baubles, lace, metal foil, tulle, golden hair, brooches, beads, and beetles. He takes his inspiration from works of Baroque folk art, a source whose influence can be traced in other artists too. The reawakened passion for everything romantic can be seen too in the fact that Parisian artists haunt the flea market on the lookout for bizarre finds to be incorporated into their material collages. Perhaps this is a sign that people have grown a little bored with the glorification of the banal, of the everyday and drab, that has been a part of art for some years now.

If collage remains a favorite procedure for artists concerned chiefly with imaginative invention, it is also utilized by the scientifically objective exponents of Op Art. VICTOR VASARELY (b. 1908) resorted to it first in 1949–50 as an aid in laying out his compositions and in experimenting with the trompe-l'oeil effect he aimed at in his first "zebra pictures," with their alternating black and white stripes. The advantage of working with pre-fabricated elements as a timesaver is obvious in the large so-called "kinetic" collages of the last few years, whose uniform squares and circles can be provided only by mechanical means.

At no time in the past have collage and material montage been represented with such diversity in all orientations and tendencies as in recent years, and a more exhaustive analysis of the interconnections could well constitute an essential contribution to clarifying the present-day situation in the arts. First, though, it has been necessary to survey, however briefly, the history of the medium and to single out the key examples that opened the path behind and illuminate the way ahead.

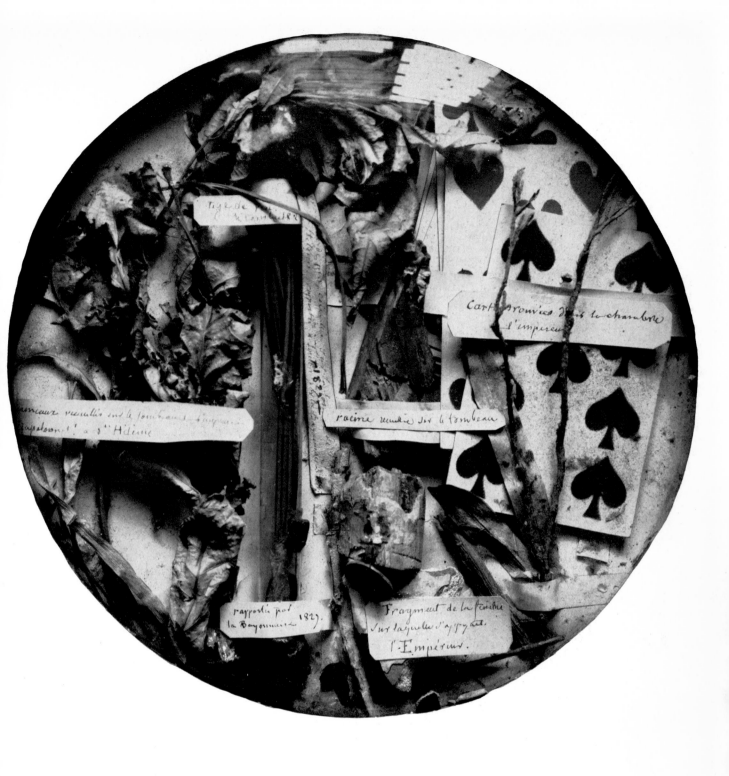

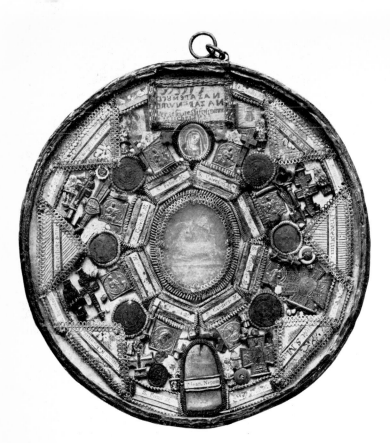

2 German folk weather charm. Eighteenth century

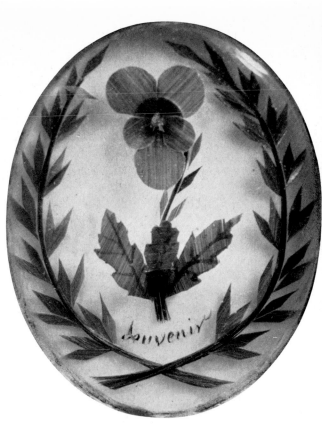

3 *Souvenir*. French hair picture. 1869

4 Greeting card for Saint Catherine's Day. *c.* 1920

5 *Barometer of Love*, Valentine. *c.* 1845

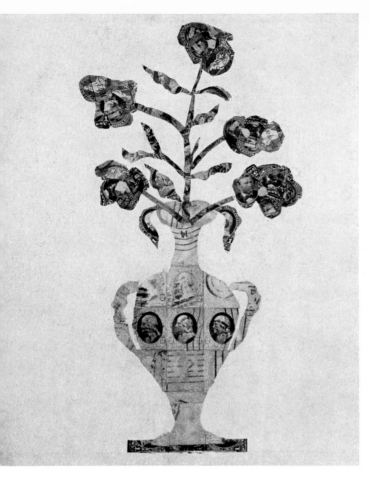

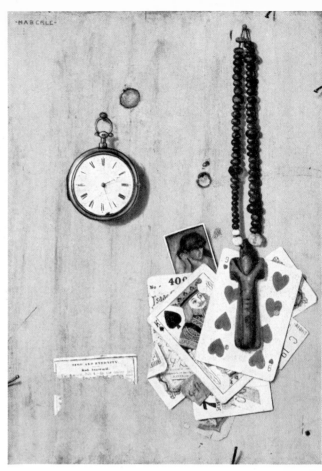

Vase with Flowers. Postage-stamp collage. Nineteenth century

7 John Haberle. *Time and Eternity*. Late nineteenth century

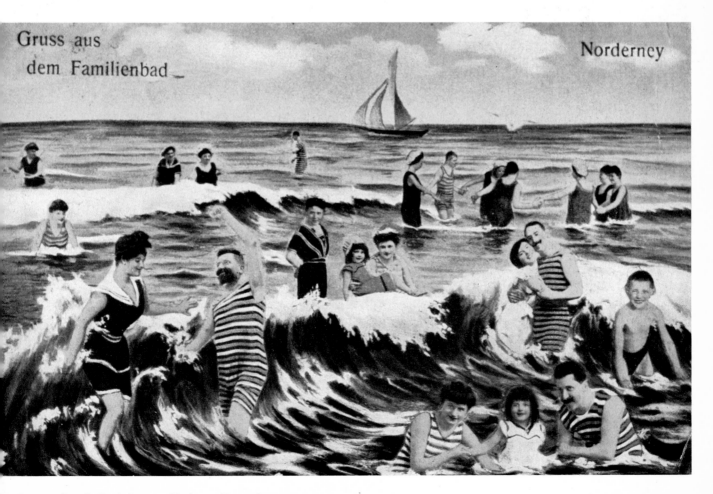

Greetings from the Beach Resort at Norderney. Postcard. *c.* 1910

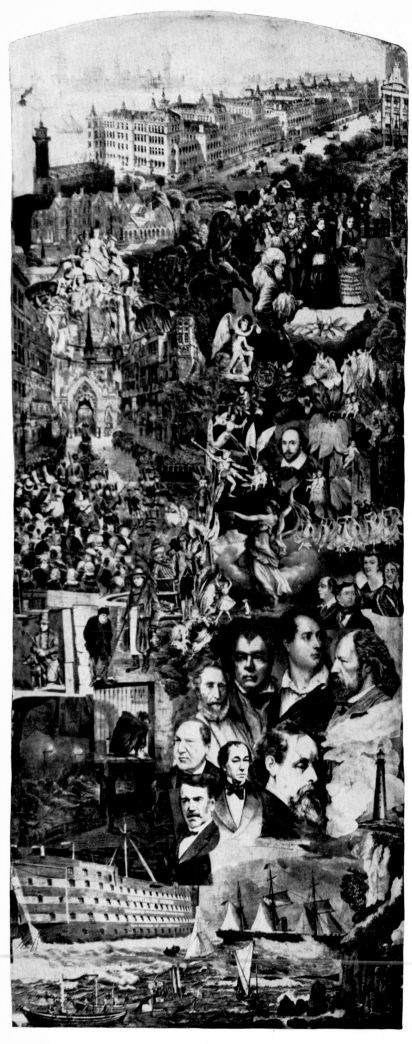

9 Hans Christian Andersen. Leaf of folding screen. 1873–74

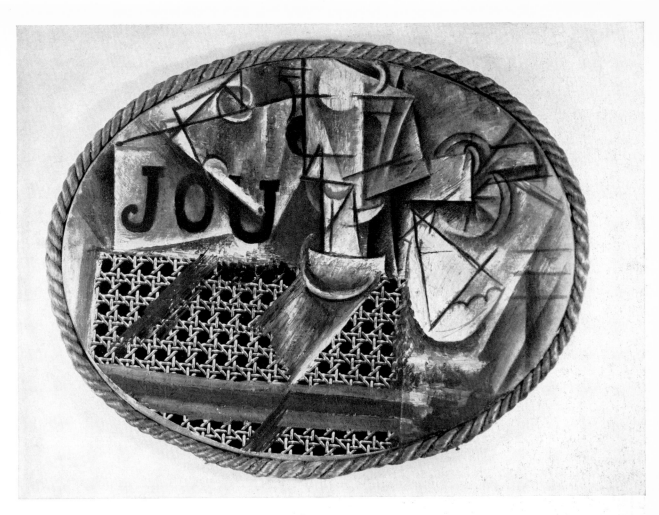

10 Pablo Picasso. *Still Life with Chair Caning.* 1912

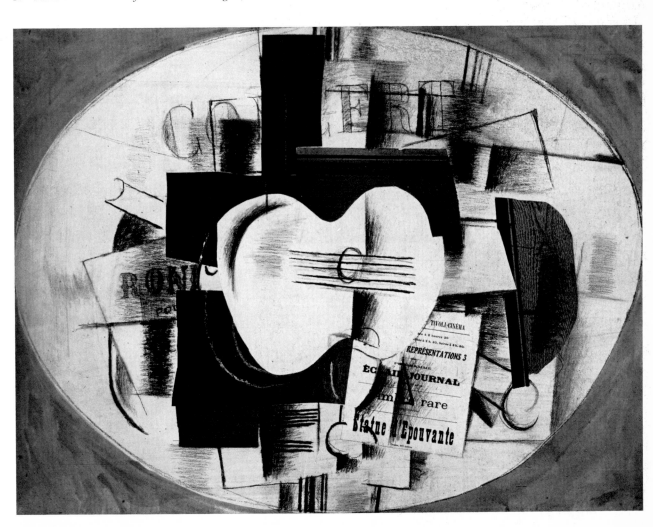

11 Georges Braque. *Guitar and Cinema Program.* 1913

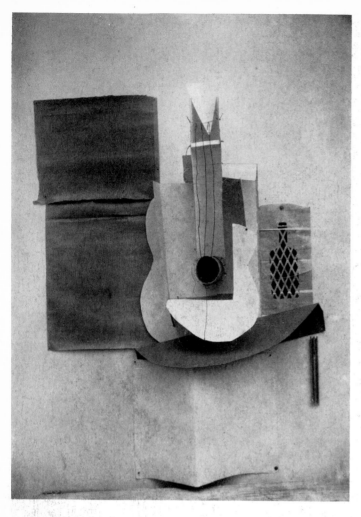

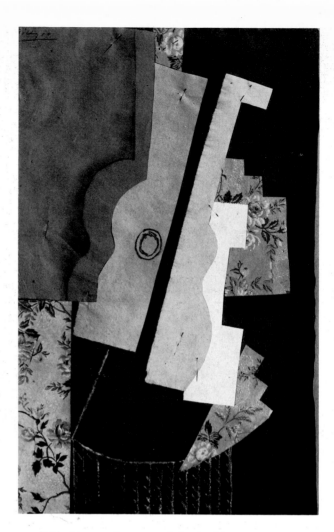

12 Pablo Picasso. *Guitar*. 1912

13 Pablo Picasso. *Guitar on a Pedestal Table*. 1912–13

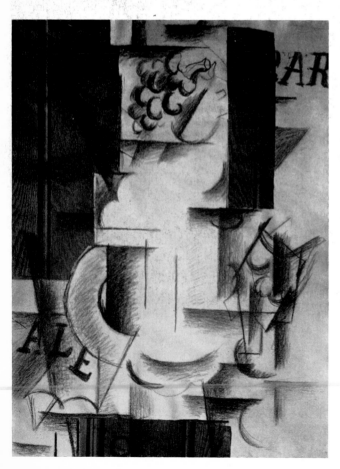

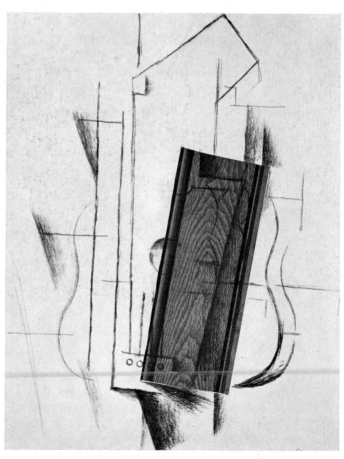

14 Georges Braque. *Still Life with Fruit Bowl and Glass*. 1912

15 Georges Braque. *Musical Instrument*. 1912–13

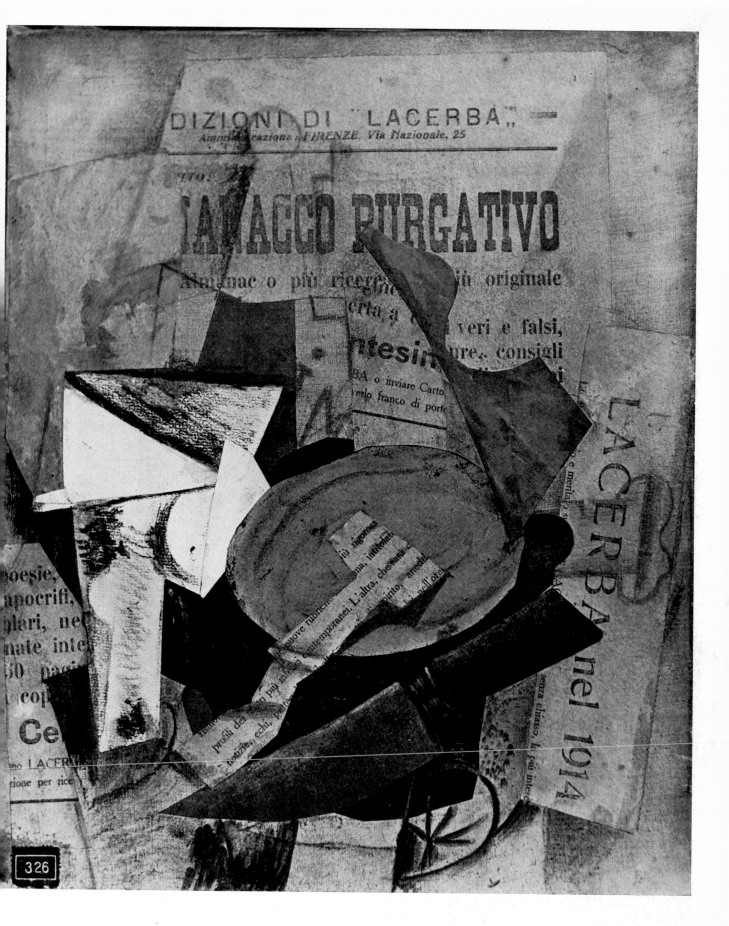

6 Pablo Picasso. *"Purgativo,"* or *Still Life with Lacerba.* 1914

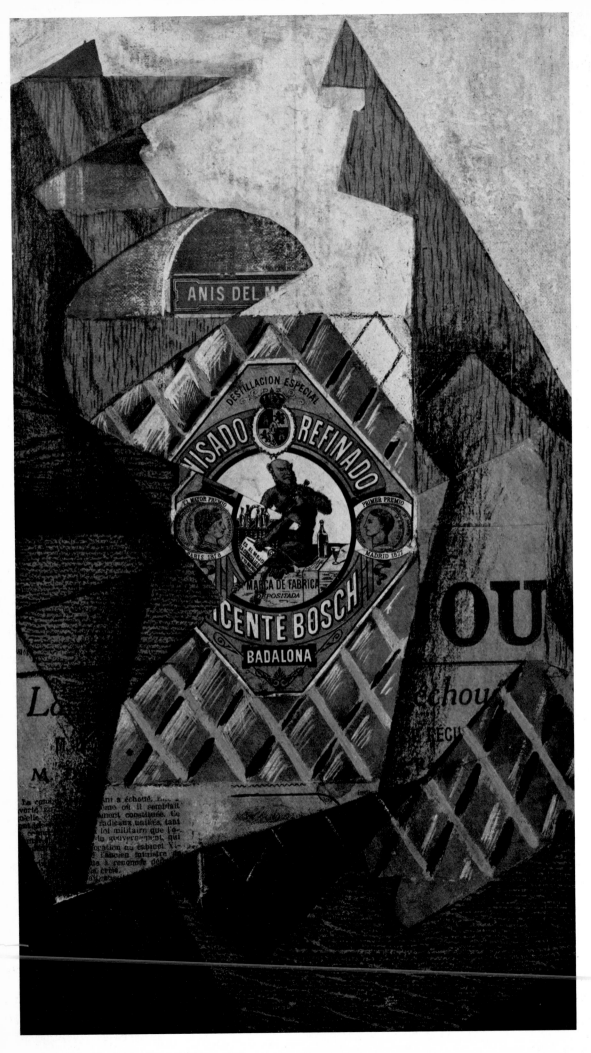

17 Juan Gris. *The Bottle of Anis del Mono*. 1914

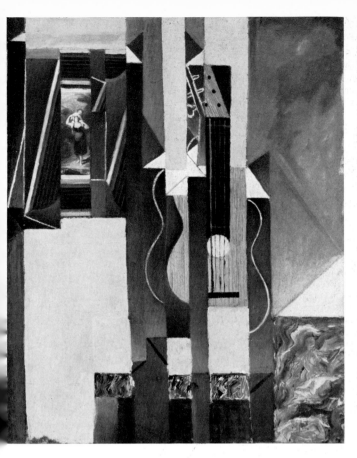

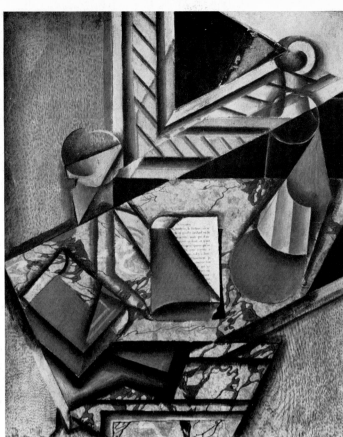

18 Juan Gris. *The Guitar*. 1913

19 Juan Gris. *The Marble Pier Table*. 1914

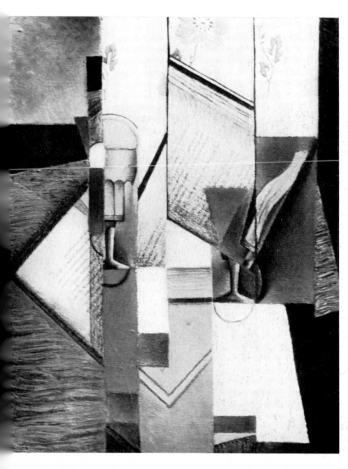

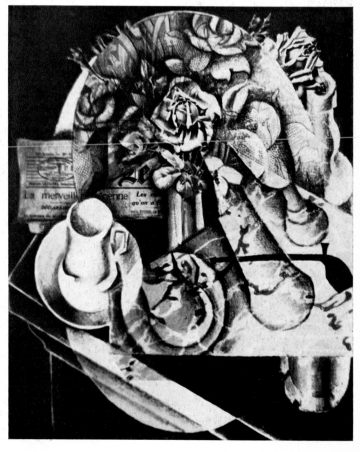

20 Juan Gris. *Still Life with Book*. 1913

21 Juan Gris. *Bouquet of Roses*. 1914

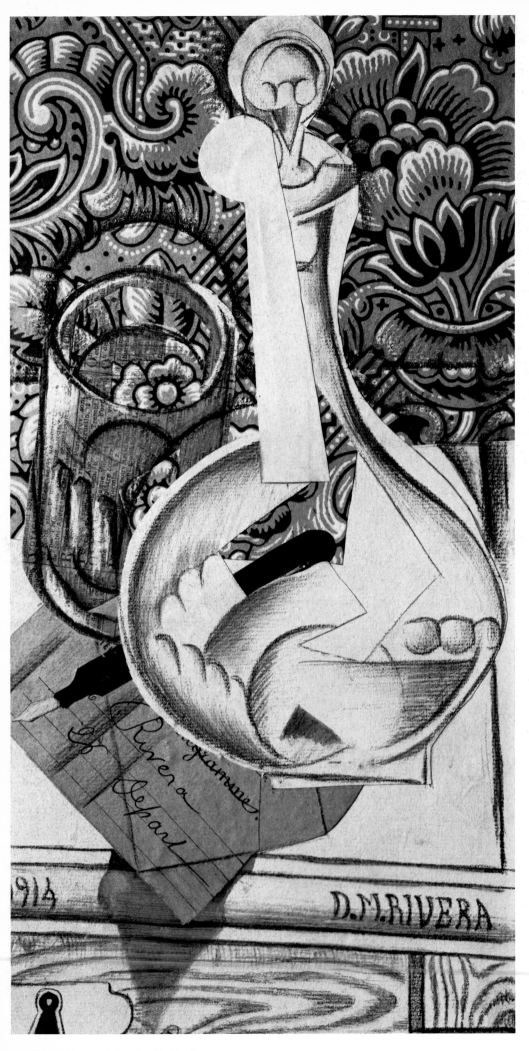

22 Diego Rivera. *Still Life with Carafe.* 1914

323 Alexander Archipenko. *Woman in an Armchair.* 1913

24 Henri Laurens. *Guitar with Sheet of Music.* 1917

25 Sonia Delaunay-Terk. Bookbindings in collage. 1913

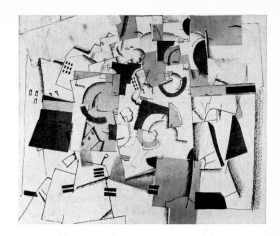

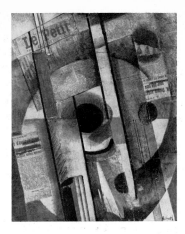

26 Léon Tutundjian. Collage.
1925/26

27 Alfred Reth. *Le Petit Parisien*.
1916

28 Georges Valmier. *Landscape*. 1920

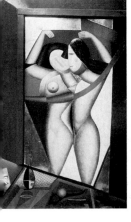

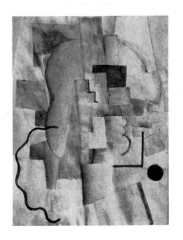

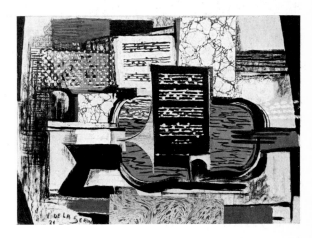

29 Alexander Archipenko.
In Front of the Mirror.
1915

30 Roger de La Fresnaye.
Sketch. 1913

31 Ismael de la Serna. *Still Life with Violin*. 1920

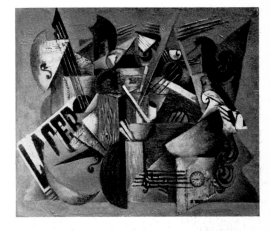

32 Léopold Survage. Untitled.
1916

33 Louis Marcoussis.
*Still Life with Scaferlati
Tobacco*. 1914

34 Serge Férat. *Still Life with Lacerba*. 1914

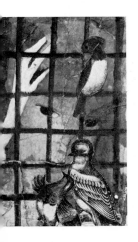

35 Marie Laurencin.
The Captive. 1917

36 Fernand Léger. *Horses in
Village Quarters*. 1915

37 David Kakabadze. Untitled. 1925

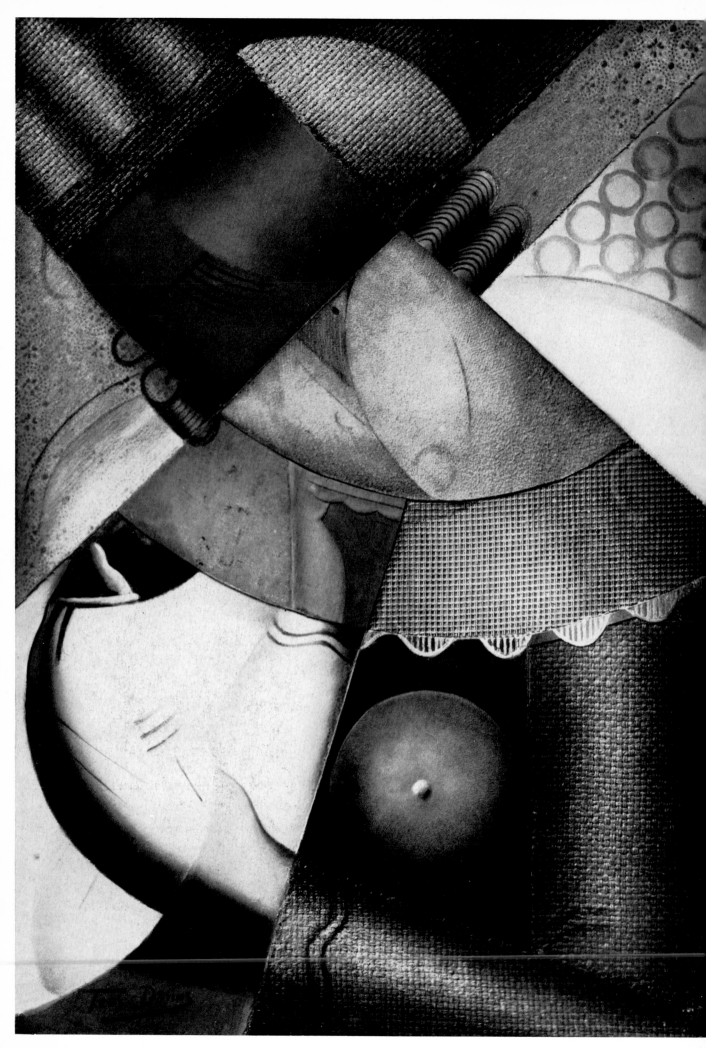

38 Marthe Donas. *Woman Looking at a Vase.* 1917

9 Otto Gutfreund. *Still Life*. 1914

40 GAN (Gösta Adrian-Nilsson). *Registered Letter.* 1921

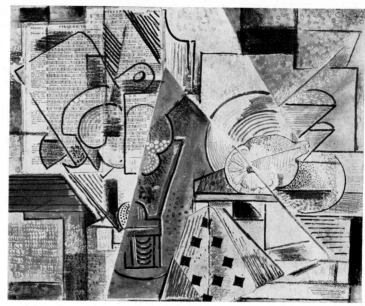

42 Emil Filla. *Amsterdam Still Life.* 1915

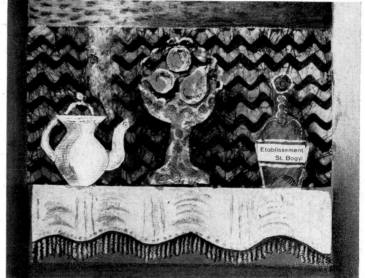

1 Vilhelm Lundstrøm. *Lattice Picture.* 1917

43 Antonín Procházka. *Still Life with Fruit in a Glass Bowl.* 1923/24

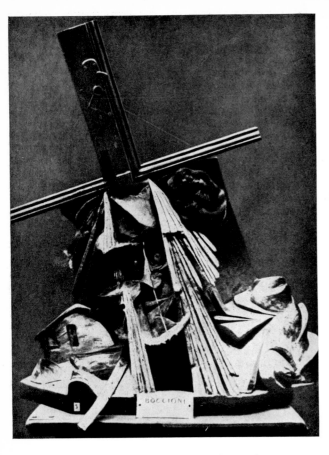

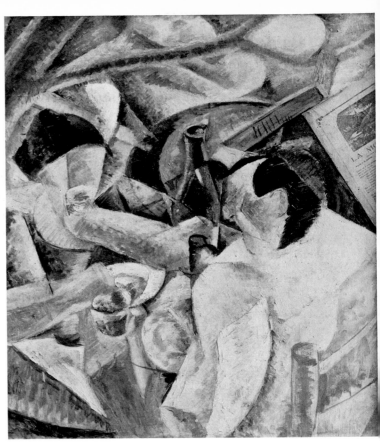

44 Umberto Boccioni. *Fusion of a Head and a Window*. 1912

45 Umberto Boccioni. *Under the Pergola at Naples*. 1914

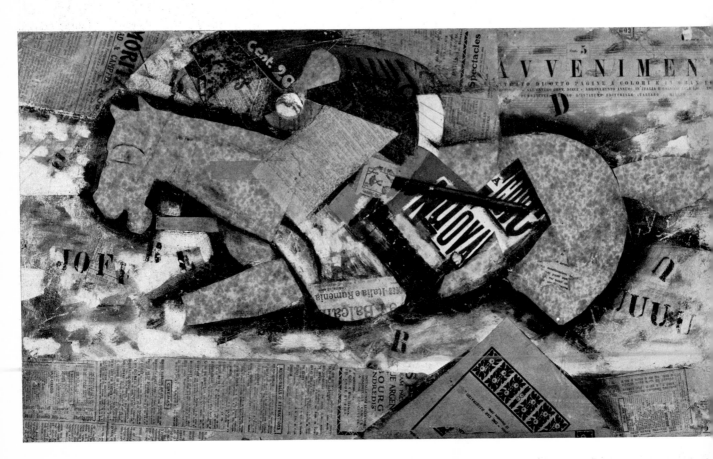

46 Carlo Carrà. *Pursuit*. 1914

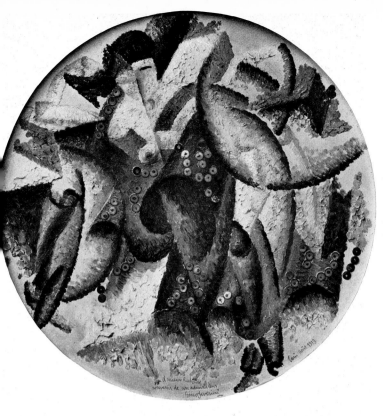

47 Gino Severini. *Dancer.* 1913

48 Gino Severini. *Portrait of Marinetti.* 1913

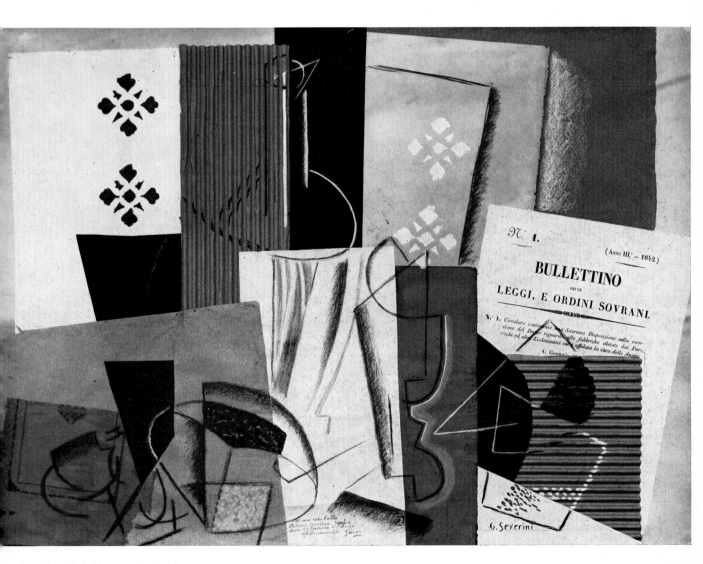

49 Gino Severini. *Homage to My Father.* 1913

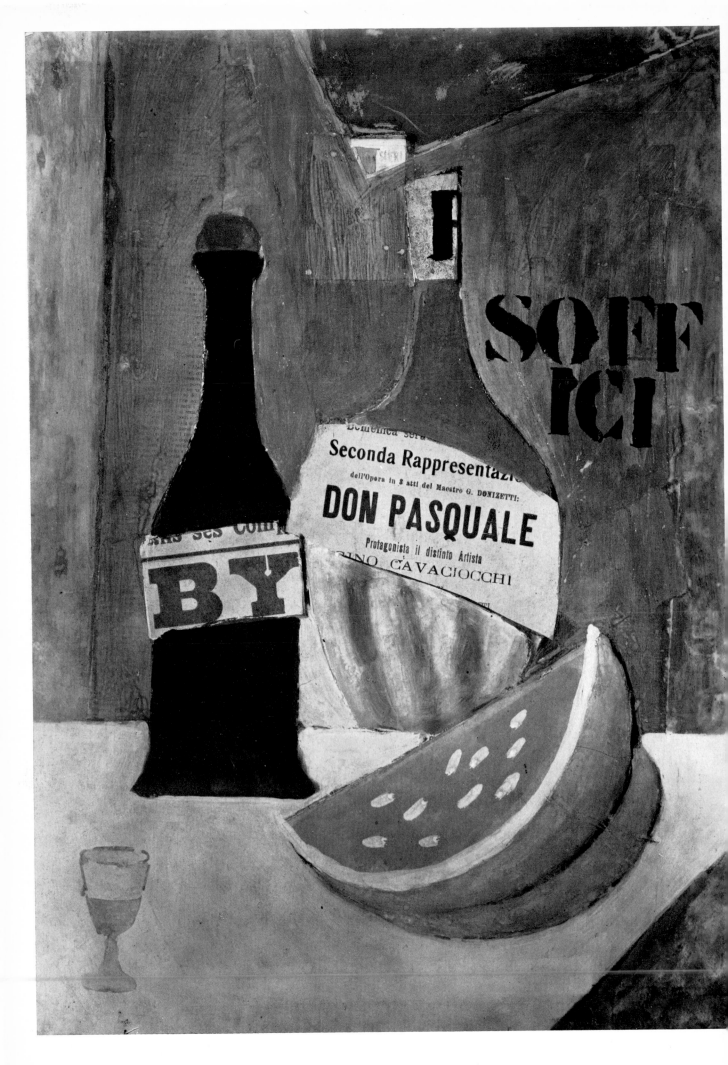

50 Ardengo Soffici. *Still Life with Watermelon*. 1915

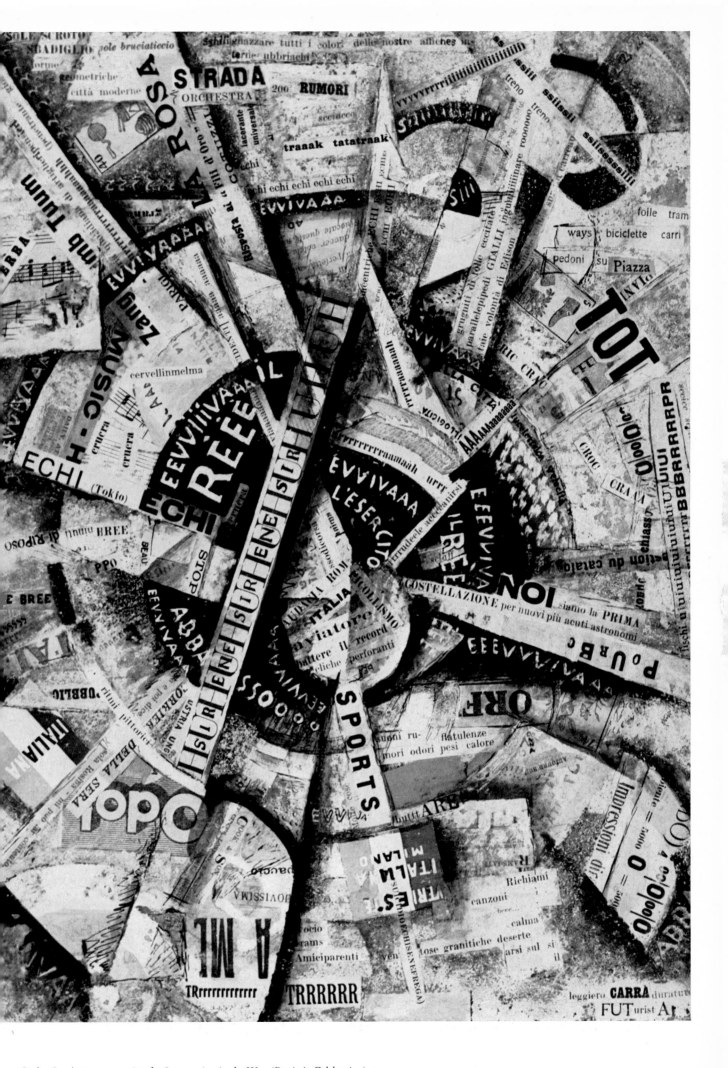

1 Carlo Carrà. *Demonstration for Intervention in the War (Patriotic Celebration).* 1914

52 Giacomo Balla. *Collage for Marinetti.* 1915 53 Enrico Prampolini. *Spatial Rhythms.* 1913

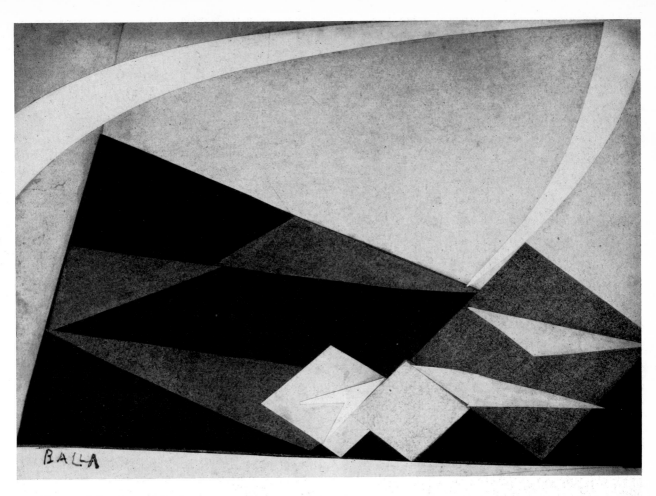

54 Giacomo Balla. *Geometric Landscape.* 1915

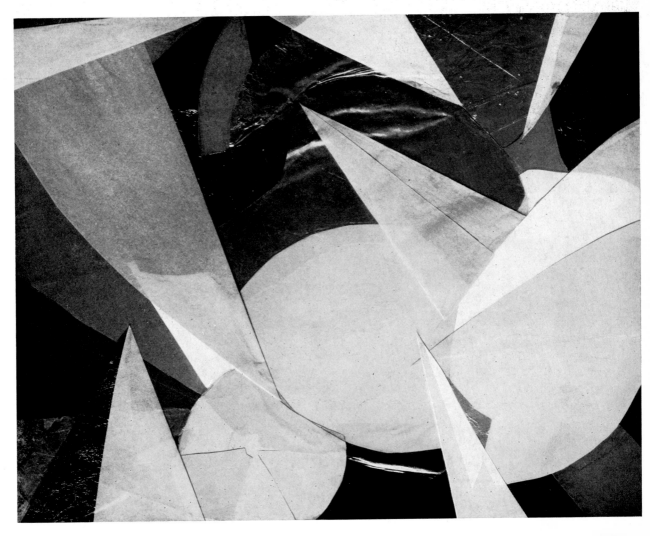

55 Rougena Zadkova. Untitled. *c.* 1913

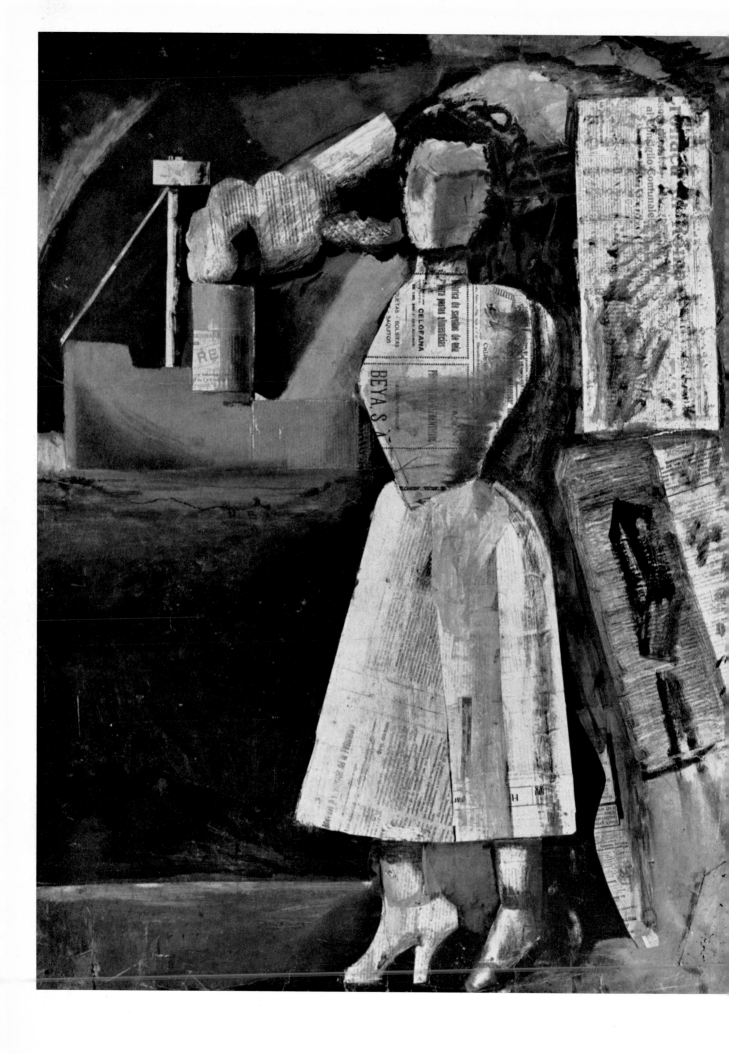

56 Mario Sironi. *Fisherman's Wife.* 1916

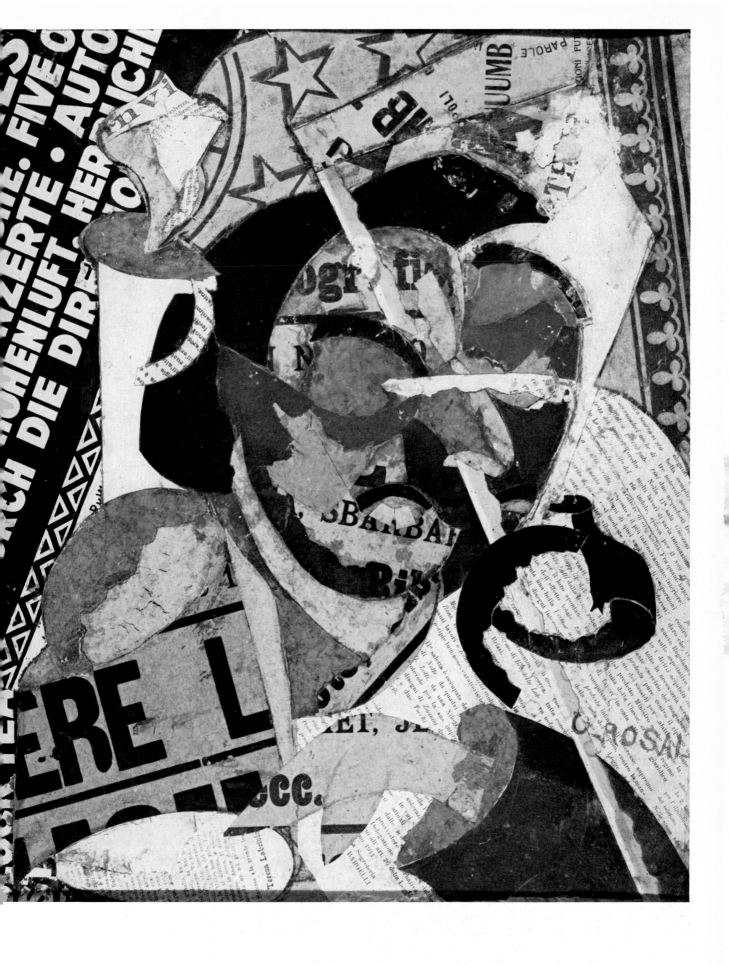

Ottone Rosai. *Dynamism of Bar San Marco.* 1913/14

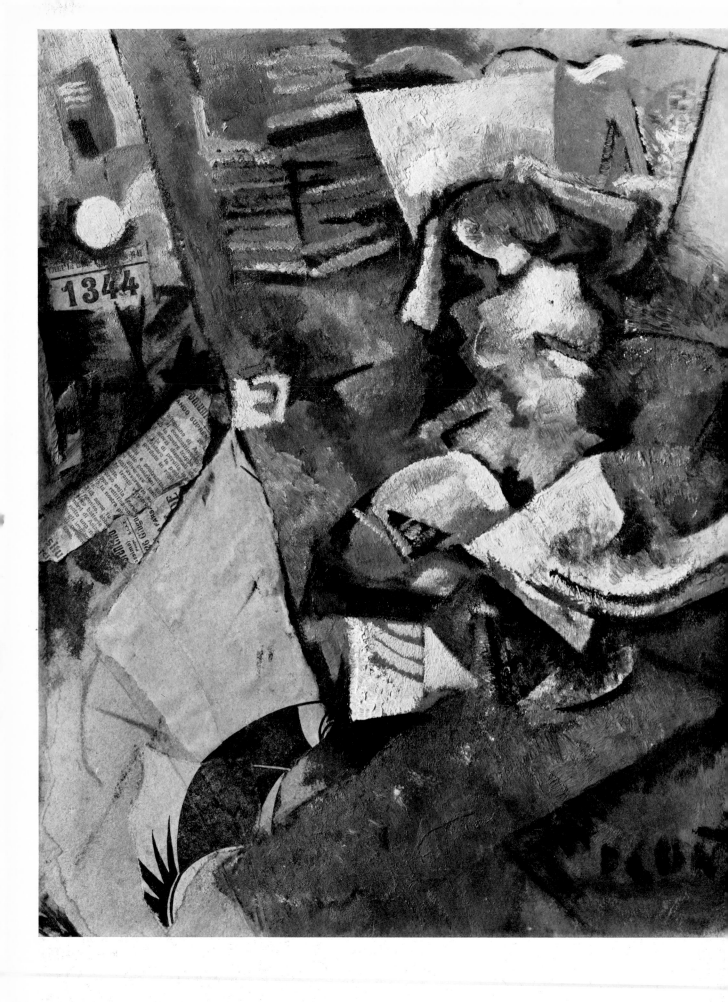

58 Primo Conti. *Simultaneity of Environment.* 1917

60 Mario Nannini. *Two and Stroll*. 1916

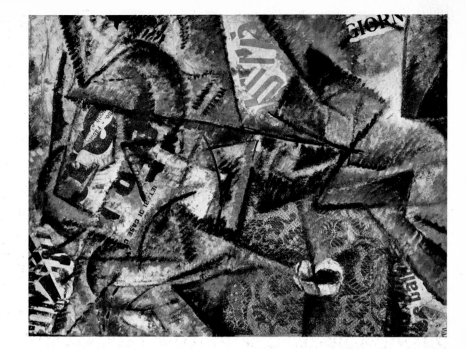

61 P. M. Bardi. *Panel of Horrors*. 1931

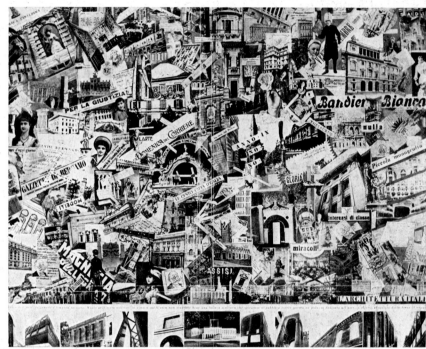

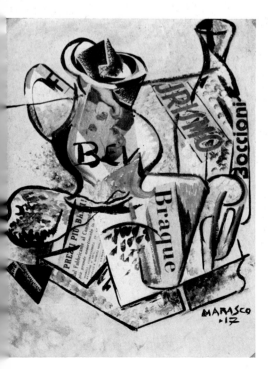

9 Antonio Marasco. *Still Life with Carafe*. 1917 62 Giuseppe Terragni. Mural for the *Exposition of the Fascist Revolution*. 1932

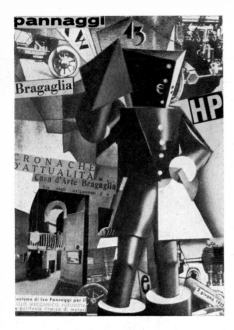

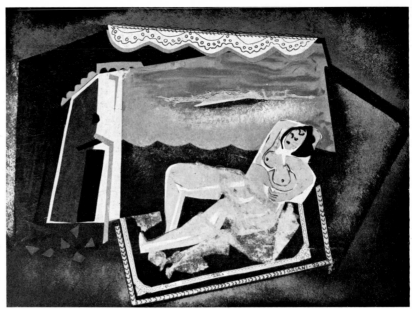

63 Ivo Pannaggi. Poster for the *Ballo*
 Meccanico-Futurista. 1922

64 Pippo Oriani. *Woman Bathing.* 1929

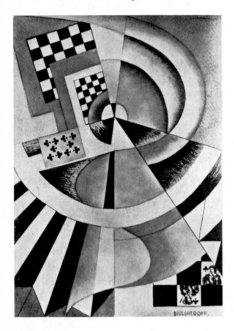

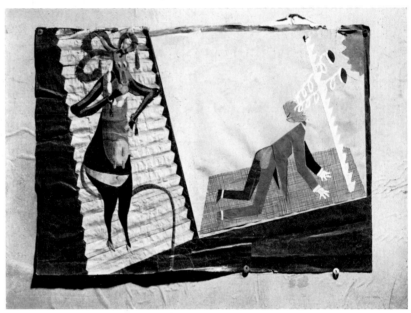

65 Nicolay Diulgheroff. *Space-Force-*
 Composition. c. 1927/28

66 Farfa. *Soubrette.* 1927

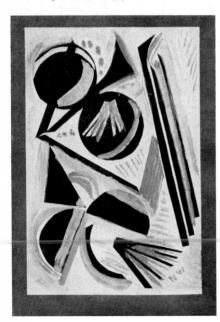

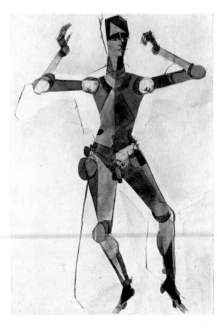

67 Nell Walden. *Abstract Composition.* 1924

68 Gabriele Münter. *Votive Image, c.* 1910

68 a Paul Busch. *The Dancer.* 1921

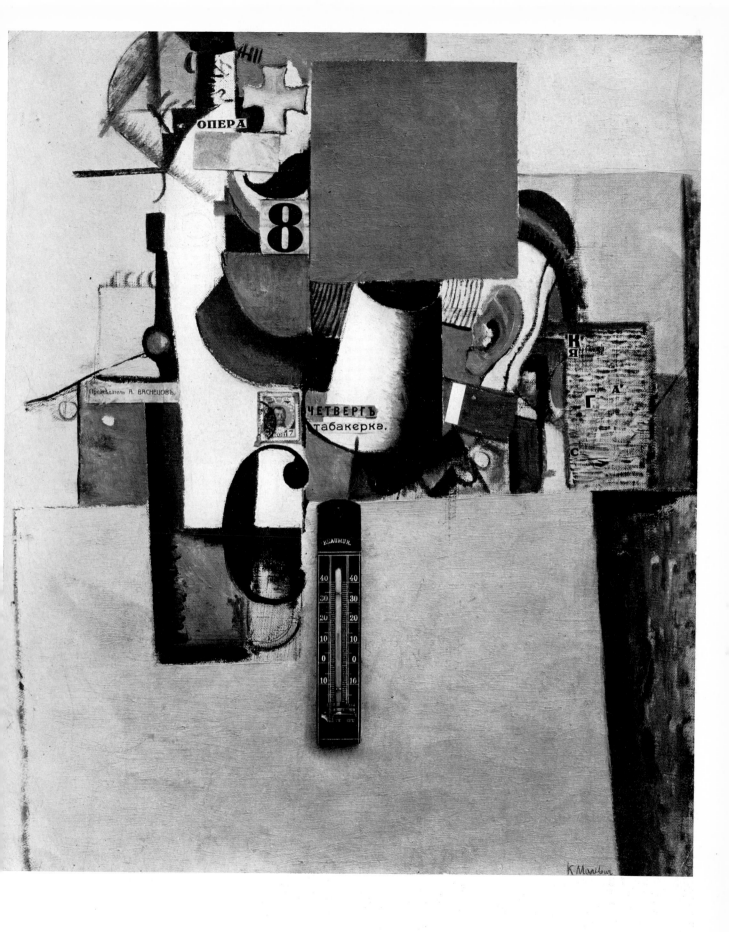

9 Kasimir Malevich. *Soldier of the First Division*. 1914

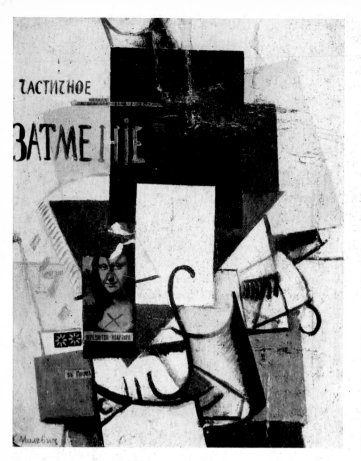

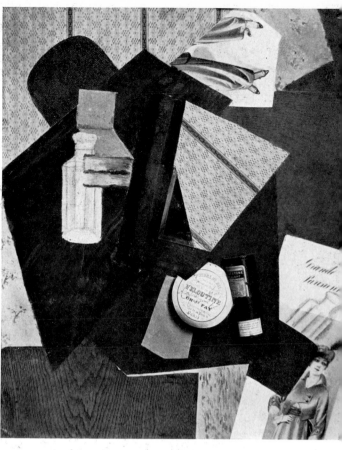

70 Kasimir Malevich. *Still Life with Mona Lisa.* 1913

71 Xenia Bogoslavskaya. *Dressing Table.* 1915

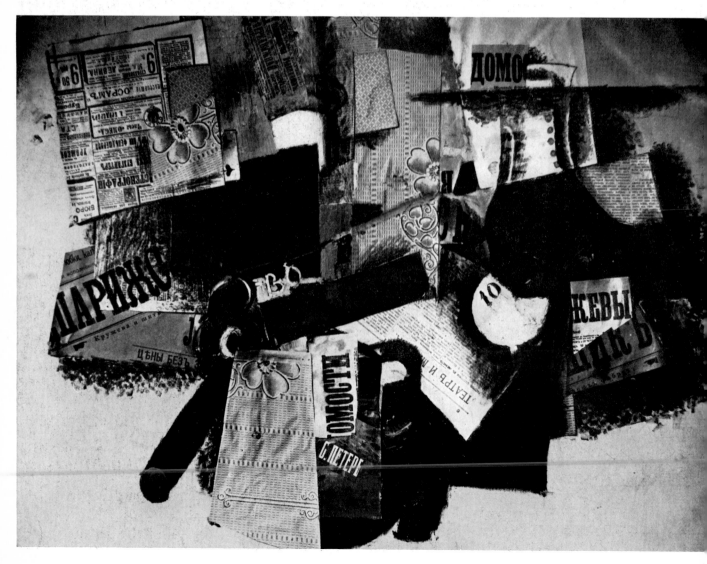

72 Ivan Puni. *Chair and Shoe.* 1914

73 N. Granovsky. Cover for *Ledentu le Phare*, by Iliazd. 1922

74 Yuri Annenkov. *Portrait of Alexander Tikhonov*. 1922

75 Alexandra Exter. *Still Life*. 1913

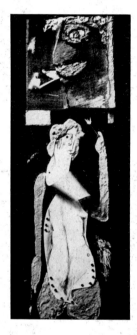

76 Georgy Yakulov. Decorations in Café Pittoresque, Moscow. 1916/17

77 Mikhail Larionov. *The Smoker*. 1912

78 Mikhail Larionov. Untitled. 1915

79 El Lissitzky. Collage drawing. *c.* 1922–23

80 Lyuba Kosintseva. Collage with portrait photo. Date unknown

81 Varvara Stepanova. Jacket for *Zaumchata*. 1919

82 Alexandr Sakharov. Costume design for *Turandot*. 1917

83 Natalia Gontcharova. Costume design for *Liturgie*. 1915

84 Michel Andreenko. Sketch for a stage curtain. 1925

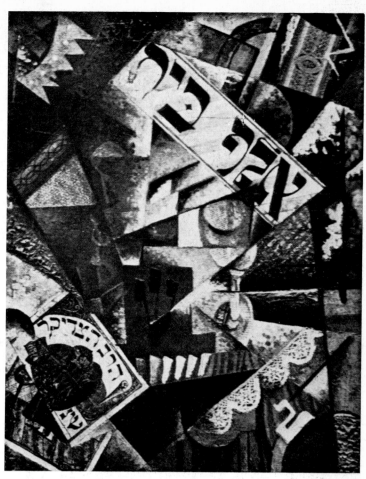

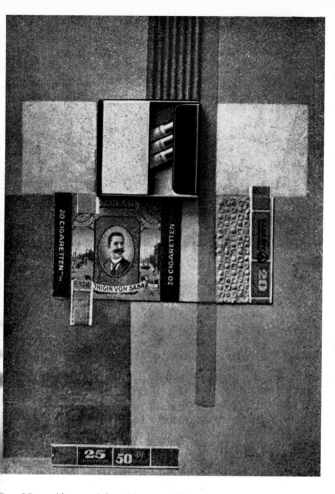

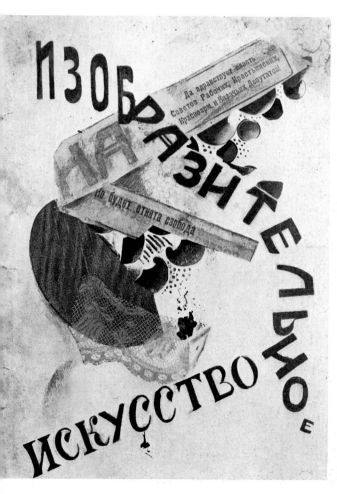

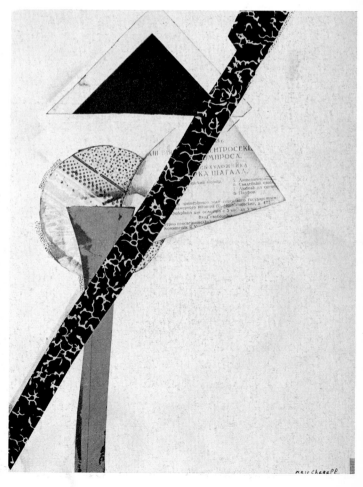

85　Natan Altman. Advertising poster. 1923

86　Issachar Rybak. *Still Life with Alphabet.* 1923

87　David Shterenberg. Cover for the magazine *Izo*, no. 1, Petrograd, 1919

88　Marc Chagall. Collage. 1921

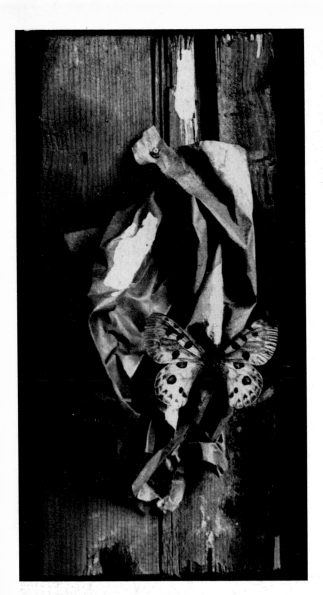

89 Pavel Mansurov. Material assemblage with butterfly. 1922 90 Pavel Mansurov. Material assemblage with butterfly. 1922

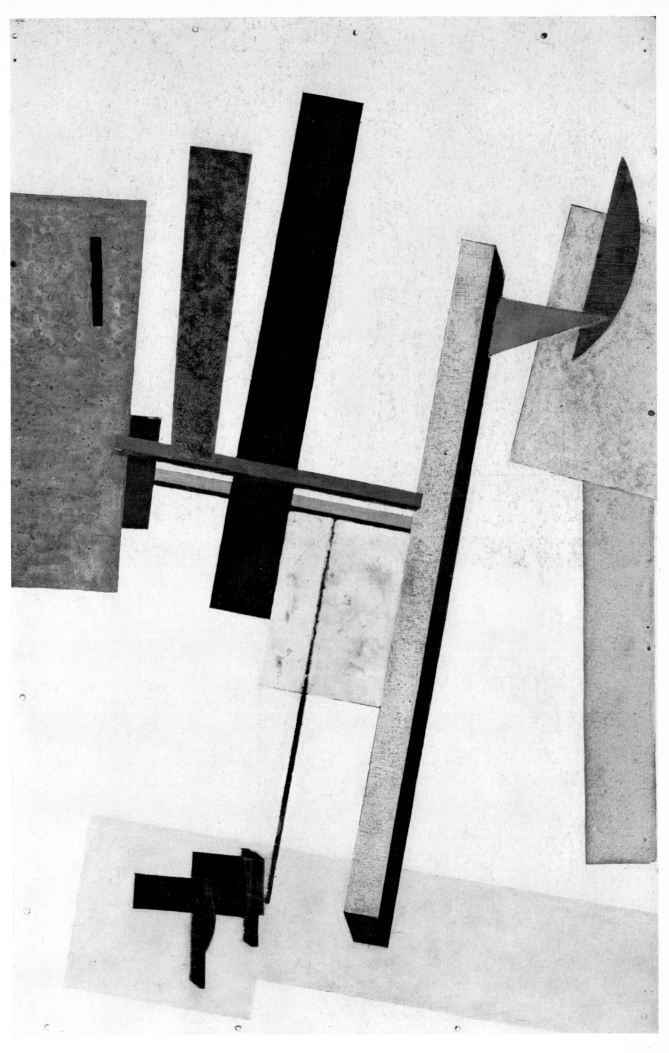

91 El Lissitzky. *Construction—Proun 2.* 1920

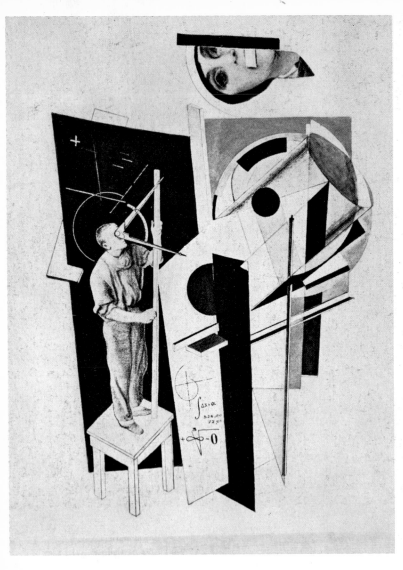

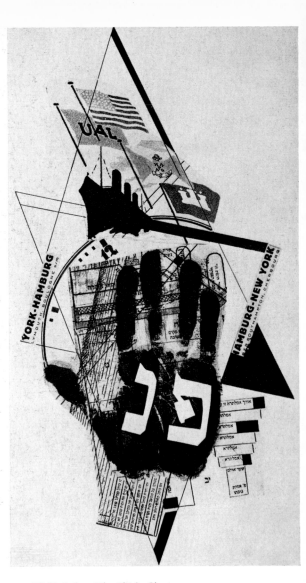

92 El Lissitzky. *Tatlin at Work. c.* 1924

93 El Lissitzky. *The Ship's Chart.* 1922

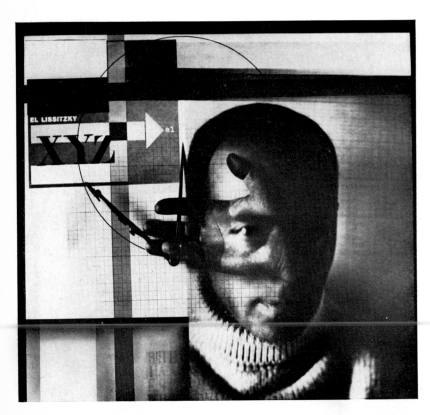

94 El Lissitzky. *Self-Portrait.* 1924

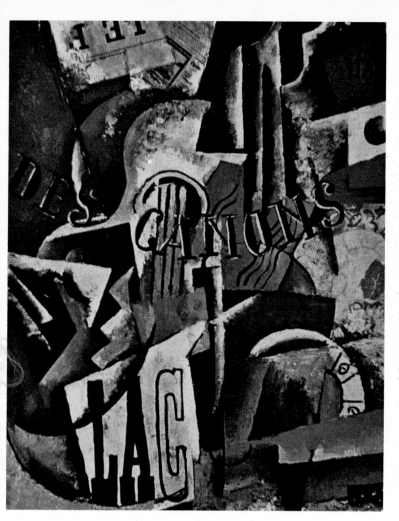

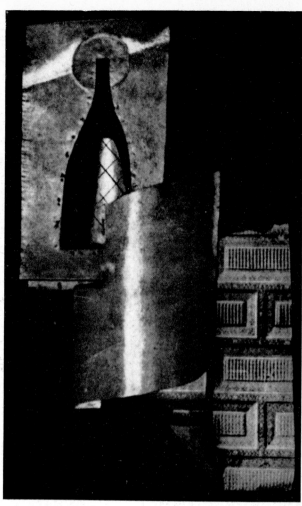

95 Liubov Popova. *Italian Still Life*. 1914 96 Vladimir E. Tatlin. *The Bottle. c.* 1913

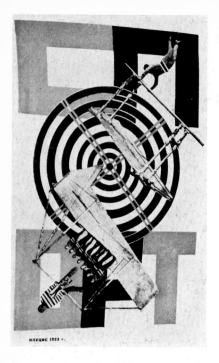

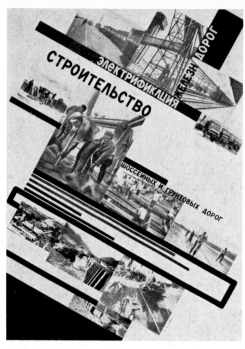

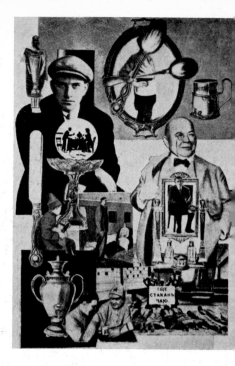

97 Gustave Klutsis. *Sport.* 1923

98 S. Syenkin. Road-building poster. 1931

99 Alexandr Rodchenko. *Another Cup of Tea*
1923

100 Alexandr Rodchenko. *I Hold the Balance of Power.* 1923

101 S. Friedland. *The Mercenary Press.* c. 1927

102 A. Shitomirsky. *Here's the Corporal Who Generaled Germany into Catastrophe.* 1941

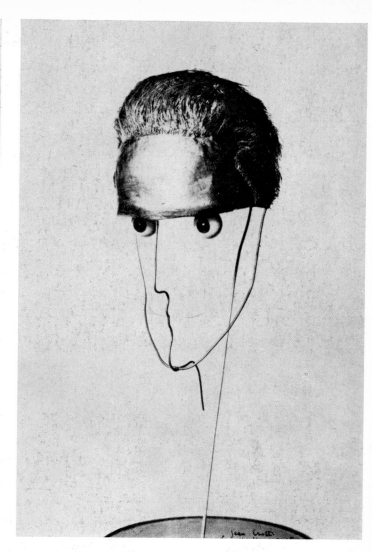

103 Marcel Duchamp. *Bearer Bond for the Roulette at Monte Carlo.* 1924 104 Jean Crotti. *Portrait to Measure of Marcel Duchamp.* 1915

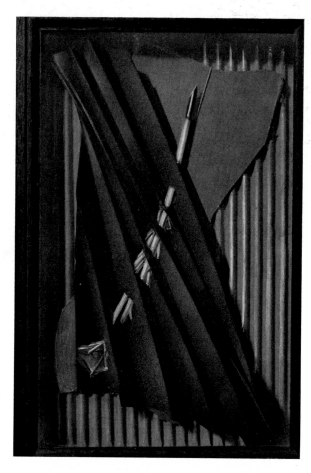

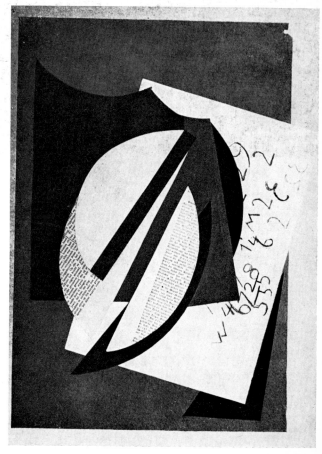

105 Man Ray. *The Wherewithal to Write a Poem.* 1923 106 Otto van Rees. *Adya.* 1915

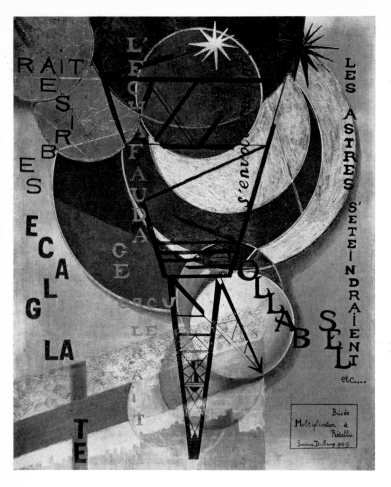

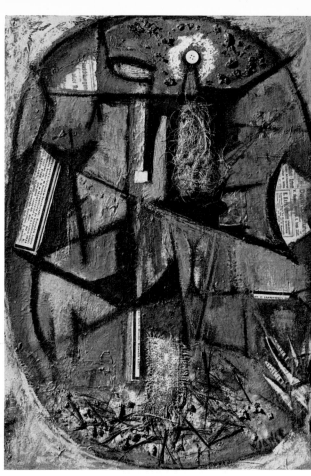

107 Suzanne Duchamp. *Multiplication Broken and Re-established*. 1918–19

108 Marcel Janco. *The Front-Line Soldier*. 1924

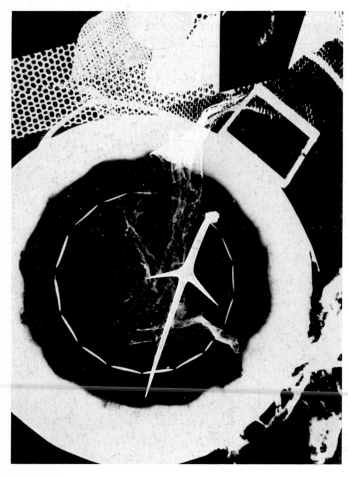

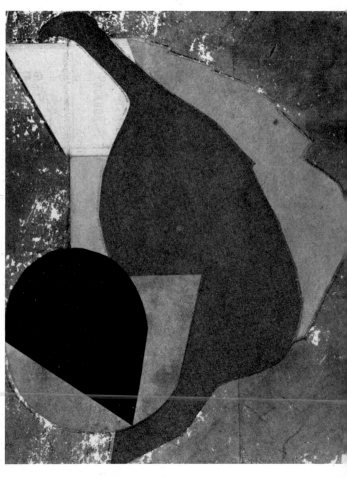

109 Christian Schad. *Schadograph 29 a (Variant)*. 1960

110 Hans (Jean) Arp. *Before My Birth*. 1914

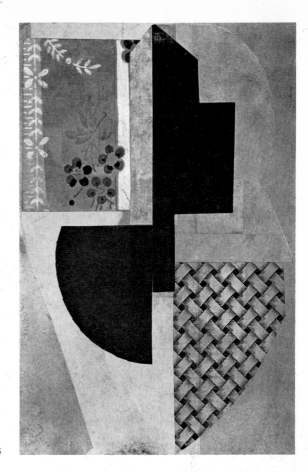

111 Hans (Jean) Arp. *Construction with Planes and Curves.* 1915

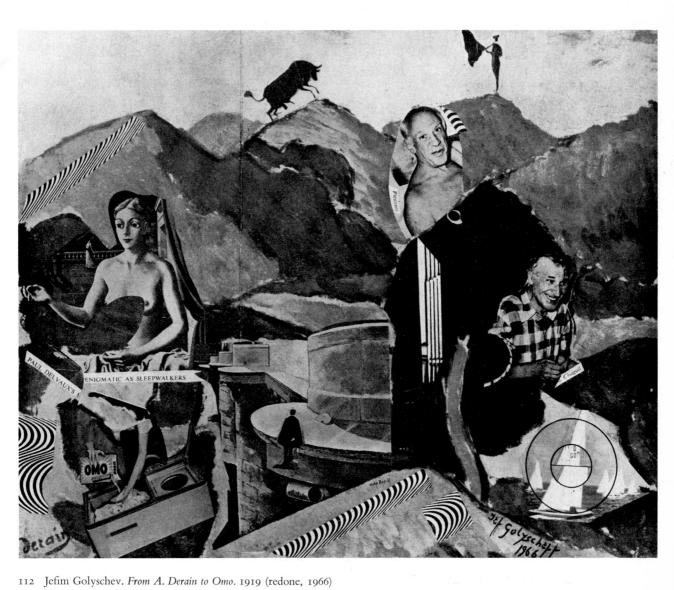

112 Jefim Golyschev. *From A. Derain to Omo.* 1919 (redone, 1966)

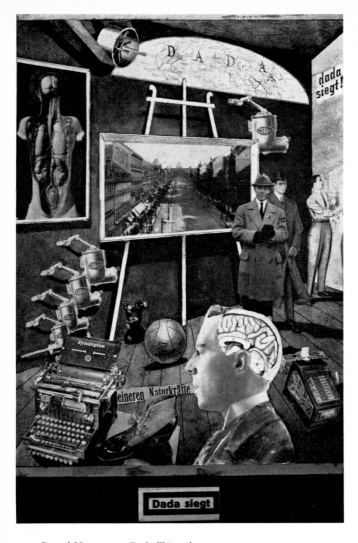

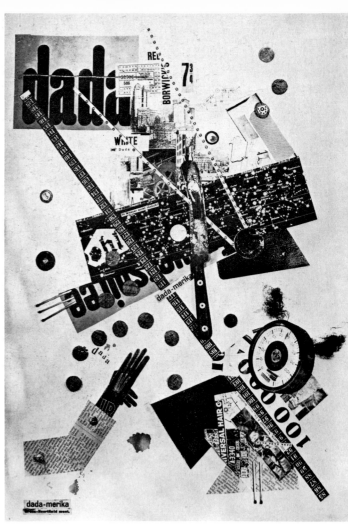

113 Raoul Hausmann. *Dada Triumphs.* 1920

114 George Grosz and John Heartfield. *Dada-merika.* 1919

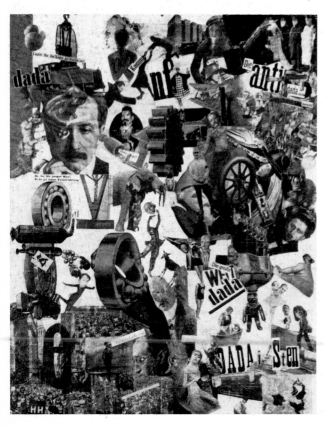

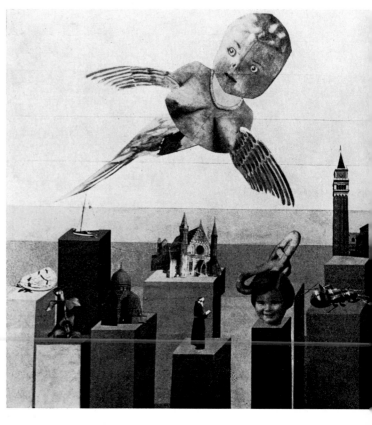

115 Hannah Höch. *Cut with Kitchen Knife....* 1919

116 Hannah Höch. Collage. 1925

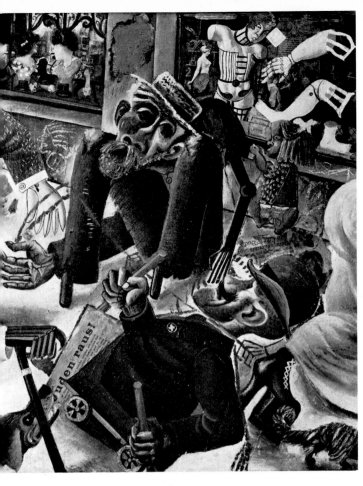

17 Otto Dix. *Prague Street*. 1920

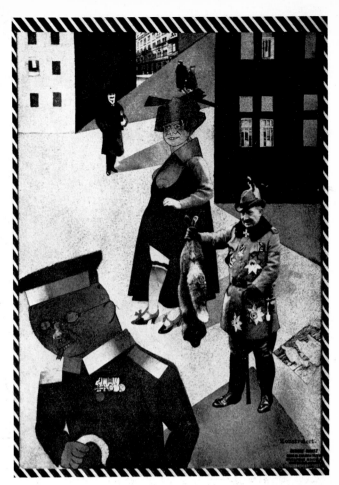

118 George Grosz. From the portfolio *Mit Pinsel und Schere*, Berlin, 1922

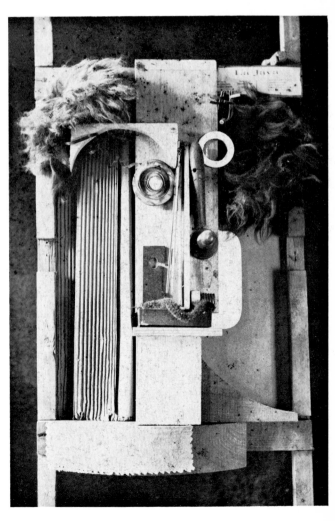

119 Paul Joostens. *The Javanese*. c. 1924

120 Paul Citroen. *Metropolis.* 1923

121 Kurt Schwitters. *Merzbild 14, 6 Schwimmt.* 1921

122 Kurt Schwitters. *Young Plan.* 1929

123 Kurt Schwitters. *Mz 26, 48 Berlin.* 1926

124 Kurt Schwitters. *Gallows of Desire. c.* 1919

125 Max Ernst. *Winter Landscape: Gassing Up....* 1921

126 Max Ernst. *The Slaughter of the Innocents.* 1920/21

127 Francis Picabia. *Flirt. c.* 1922

128 Louis Aragon. *Portrait of Jacques Vaché.* 1921

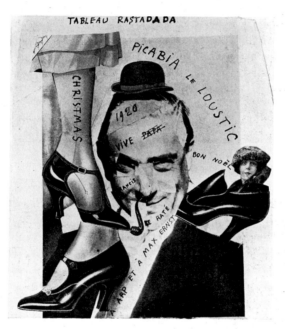

129 Francis Picabia. *Tableau Rastadada.* 1920

130 Sergei Fotinsky. *The Dove That Announces the End of the Flood. c.* 1924–26

131 Alica Halicka. *Bougival.* 1923

132 Alica Halicka. *Roland in Roncevaux.* 1924

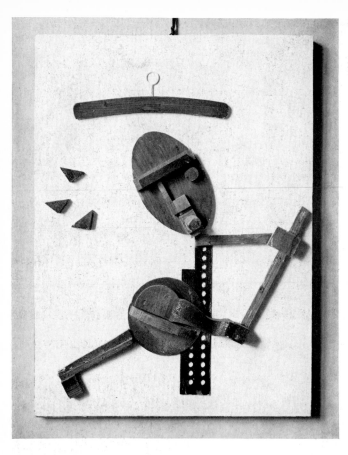

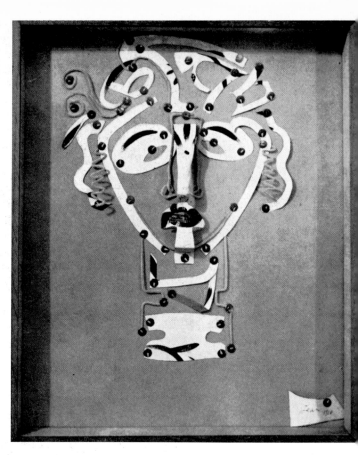

133 Kurt Seligmann. Untitled. *c.* 1929

134 Jean Cocteau. *Thumbtacked Head.* 1920

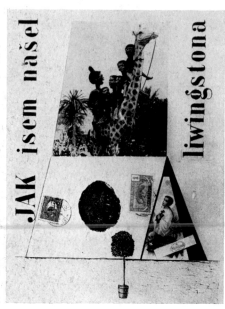

135 Morton L. Schamberg. *God. c.* 1918

136 Jindřich Štyrský and Toyen. *How I Found Livingstone.* 1924

137 George Voskovec. *Siphons of the Colonial Siesta.* 1925

138 Kurt Seligmann. *Annual Fair*. 1928

139 Aldo Fiozzi. *Abstract Values of an Individual Y.*
1920

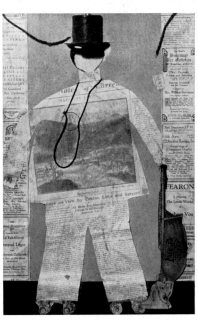

140 Johannes Baargeld. *anthrophiliac tapeworm*. 1919

141 Arthur G. Dove. *The Critic*. 1925

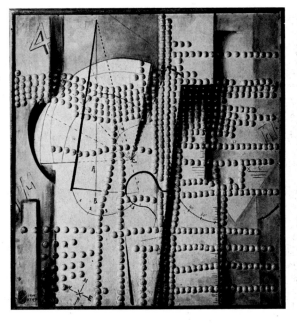

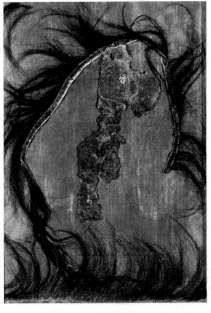

142 John R. Covert. *Time*. 1919

143 Arthur G. Dove. *Monkey Fur*. 1926

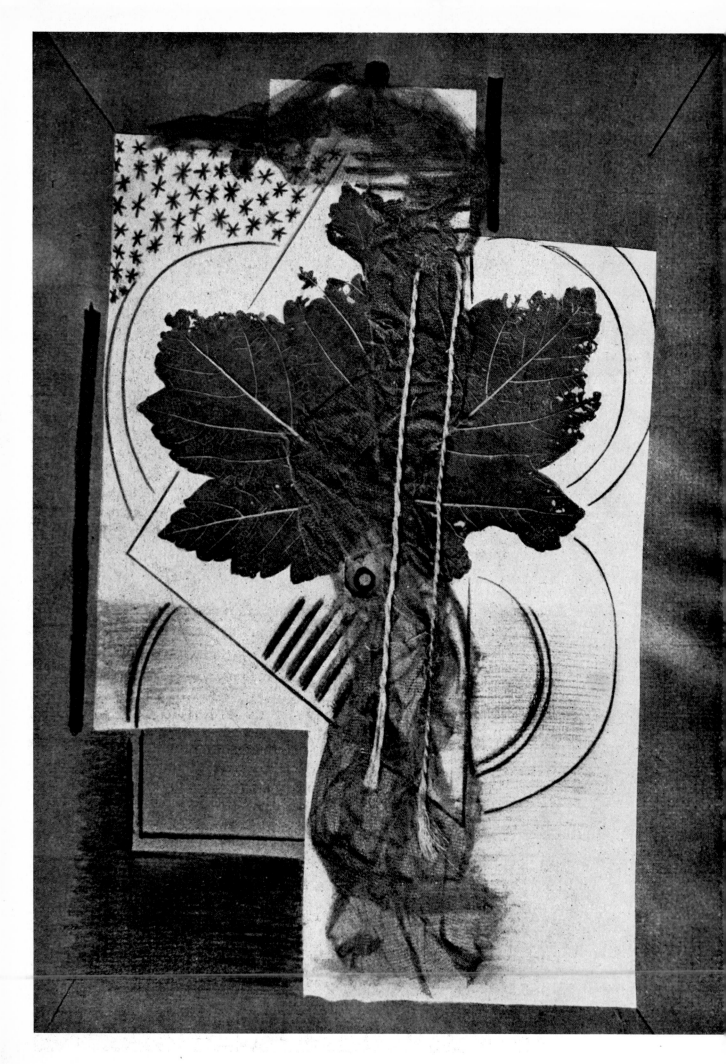

144 Pablo Picasso. *Guitar.* 1926

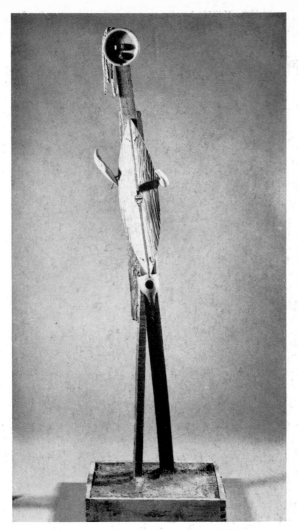

145 Pablo Picasso. *Figure.* 1935 146 André Masson. *Ludion: Bottle Imp.* 1937

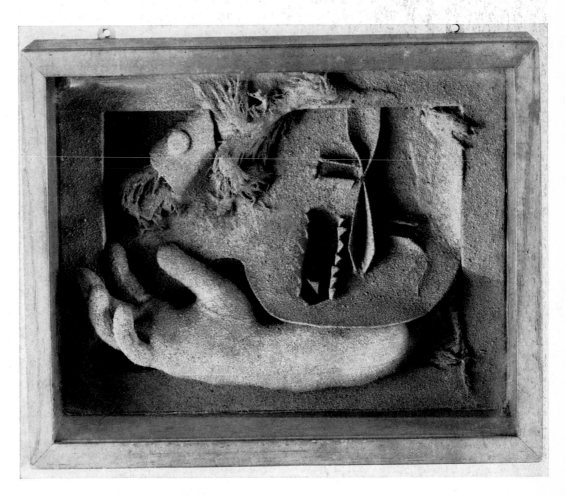

147 Pablo Picasso. *Construction with Glove.* 1930

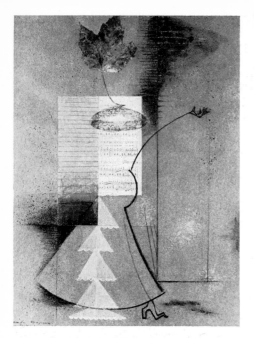

148 André Masson. *The Street Singer*. 1941

149 Joan Miró. *The Firmament*. 1929

150 André Masson. *The Wild Beast and the Bird*.
1927

151 Joan Miró. Untitled. 1930

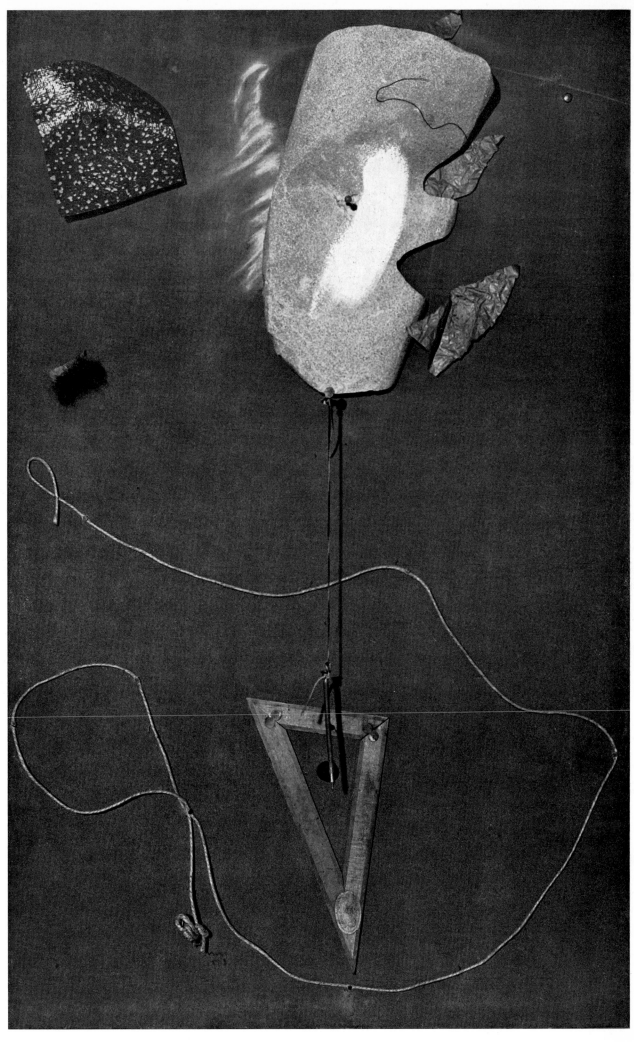

152 Joan Miró. *Spanish Dancer.* 1928

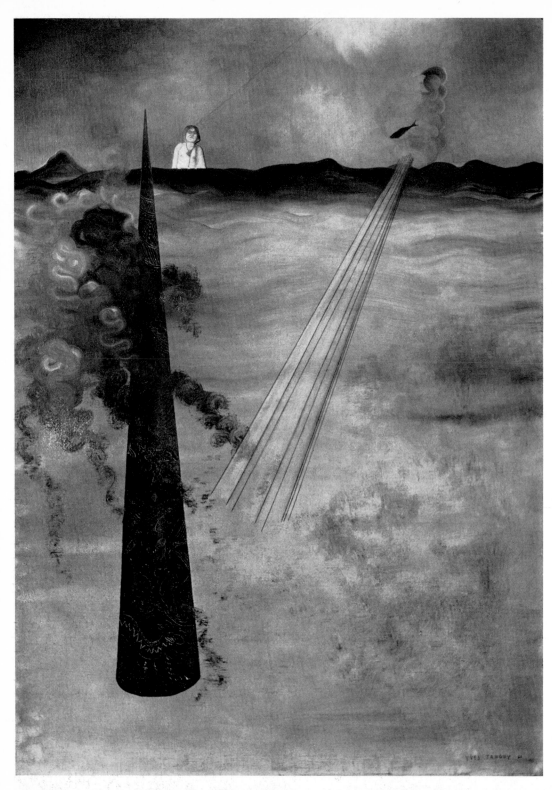

153 Yves Tanguy. *I Came as
 Had Promised, Farewel*
 1926

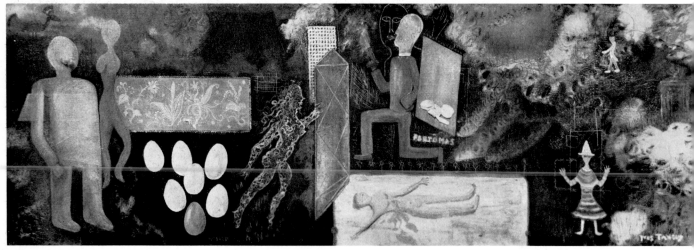

154 Yves Tanguy. *Fantomas. c. 1925*

155 André Breton, Max Morise, Jeannette and Paul Naville, Benjamin Péret, Jacques Prévert, and Yves Tanguy. *Cadavre exquis: Figure.* 1928

156 Camille Bryen. *Montage social du montage du coup.* 1938

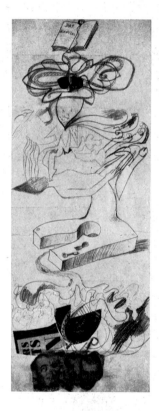

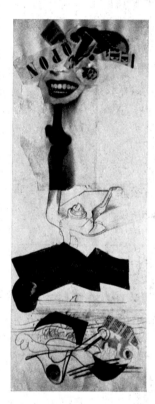

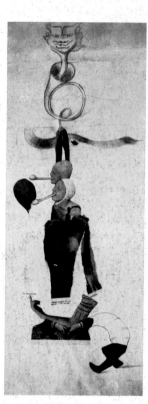

157 Hans (Jean) Arp, Raoul Hausmann, Oscar Dominguez, Marcel Jean, and Sophie Taeuber-Arp. *Cadavre exquis.* 1928

158 Maurice Henry. *The Ambuscade.* 1935

159 Maurice Henry. *On the Horizon Line.* 1935

160 Victor Brauner. *Edible Portrait*. 1938

161 Valentine Hugo. *Portrait of Arthur Rimbaud*. 1933

162 Salvador Dali. *The Remorse of Conscience*. 1930

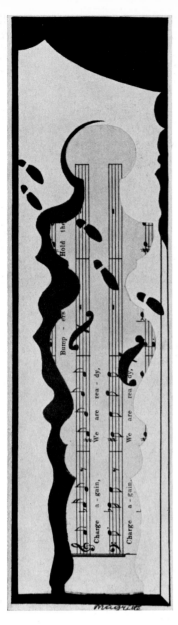

163 René Magritte. *Musical Notes.*
 c. 1963

164 Salvador Dali. *Still Life.* 1923

165 René Magritte. *Delicious Roots.* 1926

166 Max Ernst. *Facility.* 1931

167 Max Ernst. Sketch for stage set for *Ubu enchaîné.* 1937

169 Max Ernst. *Homage to a Little Girl Named Violette.* 1933

168 Max Ernst. *A Sad Specimen.* 1967

170 Hans Bellmer. *Odds and Ends from the Coat Pocket of Gasahl Gaboya.* 1938

171 Joan Miró. *Personage*. 1931

172 Gala Éluard. *Surrealist Object of Symbolic Function*. 1931

173 André Masson. *Mannequin*. 1938

174 Salvador Dali. *Rainy Taxi*, detail. 1938

75 E. L. T. Mesens. *I Think Only of You.* 1926

176 Paul Éluard. *The Venetian Night.* 1934

77 Henri Goetz. *Portrait.* 1940

178 Georges Hugnet. Page from *La septième face du dé*, Paris, 1936

179 Kurt Seligmann. *The Surrealist Animals.* 1938

180 Serge Brignoni. *Blossoms of Star Coral.* 1938

181 Hans (Jean) Arp. *Drawing Torn and Colored.*
1946

182 Raoul Ubac. *Penthesilea in Combat.* 1937

83 Jindřich Štyrský. *Untitled*. 1934 184 Title page of *Svetozor*, Prague, April, 1935 185 Jindřich Heisler. *The Casemates of Sleep*. 1941

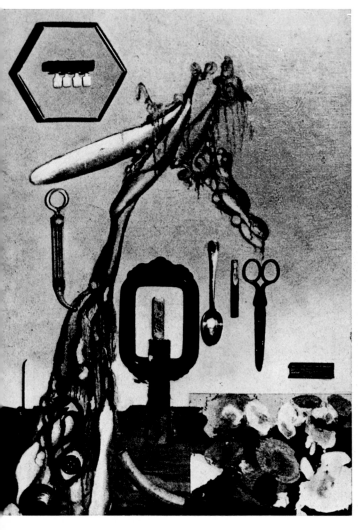

86 František Gross. *It Is a Man, a Stone....* 1937 187 Zdeněk Rykr. *Glass*. 1936

188 Karel Teige. Untitled. 1939

189 Karel Teige. *Joséfine*. 1939

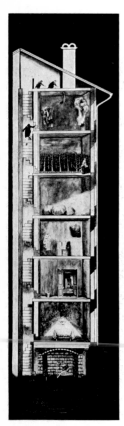

190 Toyen. *Natural
Law*. 1946

191 Adolf Hoffmeister. *Caucasus*. 1959

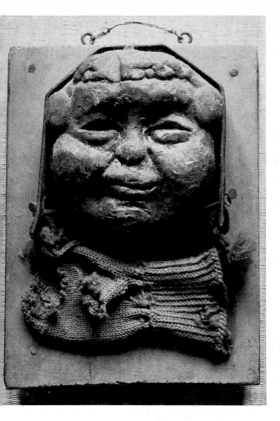

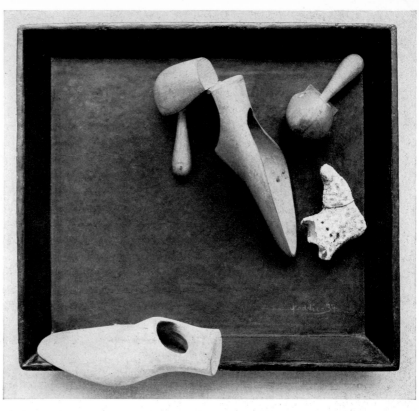

192 Henry Heerup. *Child with Glove. c.* 1930 193 William Freddie. *The Pink Shoes of Mrs. Simpson.* 1937

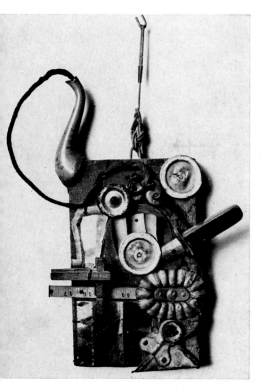

194 Henry Heerup. *Rubbish Model. c.* 1937 195 William Freddie. *Nocturne.* 1933

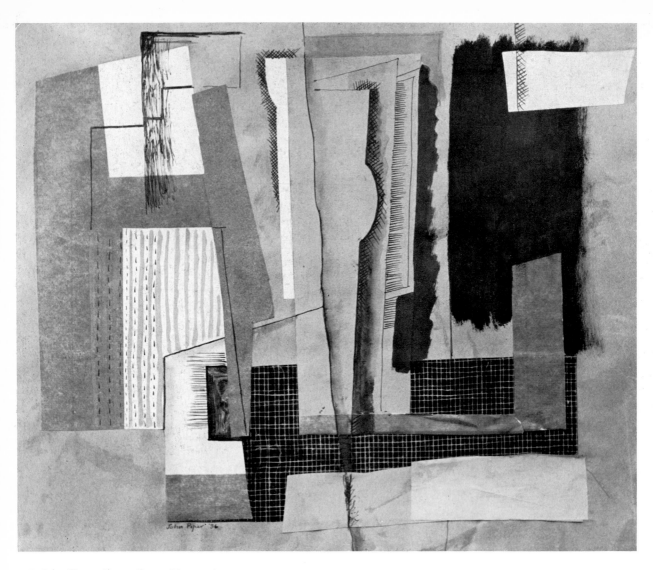

196 John Piper. *Abstract Composition.* 1936

197 Eileen Agar. *Foot in Hand.* 1939

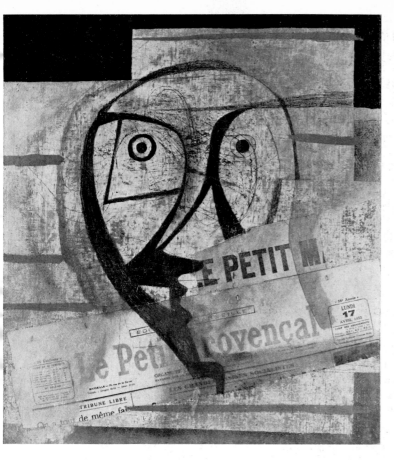

198 Ben Nicholson. *Le Petit Provençal*. 1933

199 Roland Penrose. *Miss Sacré-Cœur*. 1938

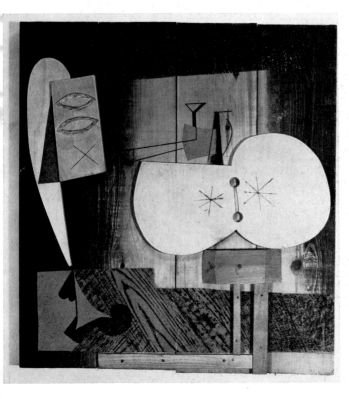

200 Ceri Richards. *The Sculptor in His Studio*. 1937

201 Ceri Richards. *The Variable Costerwoman*. 1938

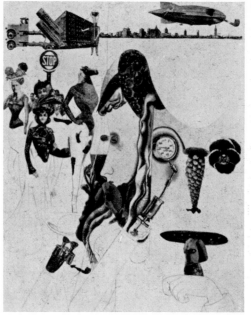

202 Paul Nash. *Portrait of Lunar Hornet.* 1937 203 Edward Burra. Untitled. 1928/29 204 J. B. Brunius. *Ad nauseam.* 1944

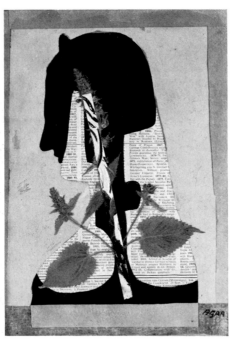
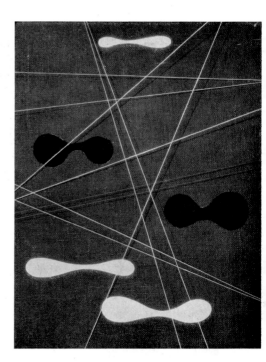

205 Robert Baxter. *Bird's-eye View.* 1937 206 Eileen Agar. *Woman Reading.* 1936 207 Paule Vézelay. *Lines in Space no. 4.* 1936

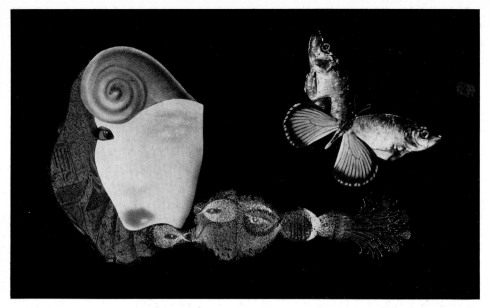

208 J. B. Brunius. *La Mélusine sans-culotte*. 1936

209 Merlyn Evans. *Fleurs du mal*. 1937?

210 Conroy Maddox. *Uncertainty of the Day*. 1940

211 Ben Nicholson. *396*. 1944

212 Roland Penrose. *Broad Daylight (Le grand jour)*. 1938

213 Paule Vézelay. *Noir et blanc*. 1946

214 Laurence Vail. Portion of scrap screen. 1940–41

215 Joseph Cornell. *Moon Surface.* 1955

216 Joseph Cornell. *Pavilion: Soap-Bubble Set.* 1953

217 Laurence Vail. Bottles. *c.* 1947

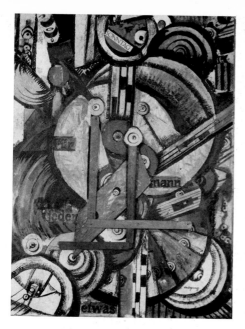

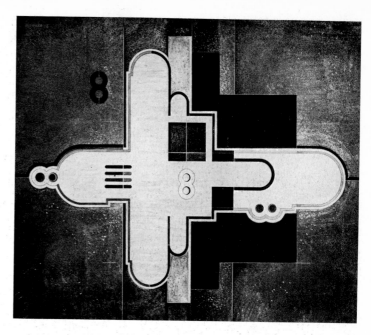

218 Ella Bergmann-Michel. *Sunday for Everyman.* 1917/18

219 Robert Michel. *Alu-Paradise II.* 1930

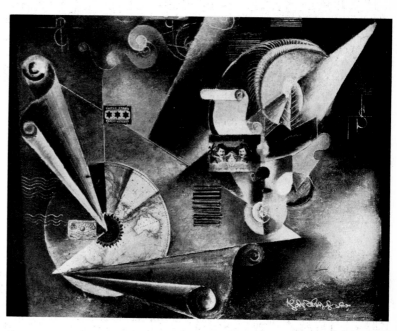

220 Ella Bergmann-Michel. *Fishes.* 1919

221 Johannes Molzahn. *New Lands.* 1920

222 Robert Michel. *Man-It-Man Picture.* 1918/19

223 Johannes Molzahn. *Columbus—a New Voyage.* 1920

224 Edmund Kesting. Relief collage with silver ball. 1924

225 Lázló Moholy-Nagy. *PN.* 1920

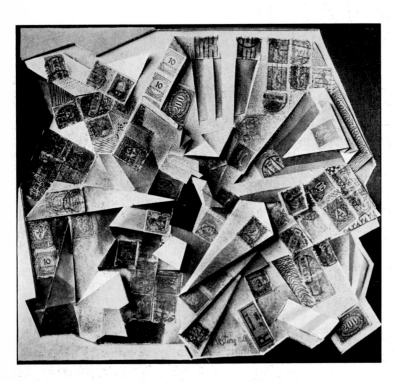

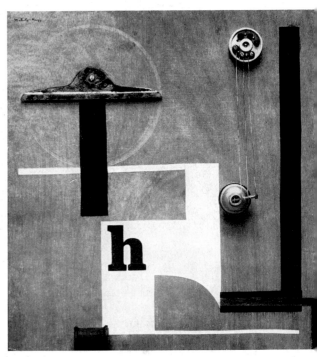

226 Edmund Kesting. *Postage Stamps in Inflation Times.* 1929

227 Lázló Moholy-Nagy. *Relief h.* 1922

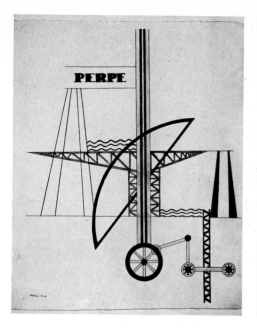

228 Lázló Moholy-Nagy. *Perpe*. 1920

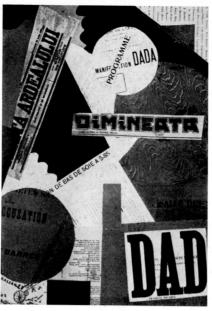

229 Lajos Kassák. Untitled. 1921

230 Lajos Kassák. *Balloon Vendor. c.* 1955

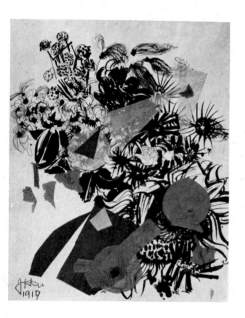

231 Johannes Itten. Untitled. 1917

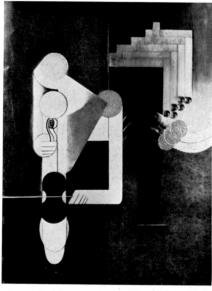

232 Friedl Dicker. *The Cellist*. n.d.

233 Lily Hildebrandt. *Munich, 1916*

234 Otto Nebel. *Collage K 76*. 1964

235 Adolf Hölzel. *Prayer of the Children.*
1916

236 Adolf Hölzel. *Annunciation*. 1916

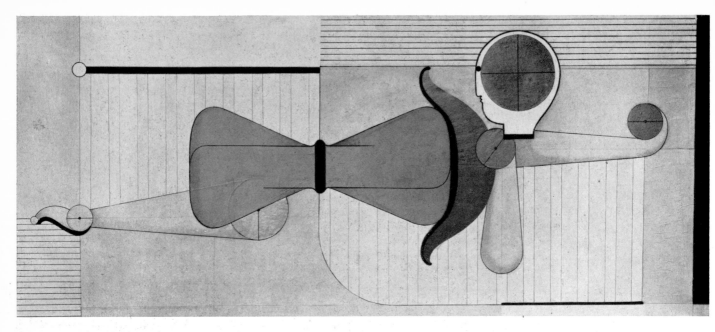

237 Oskar Schlemmer. *Mythical Figure*. 1923

238 Oskar Schlemmer. Figure from
 Triadic Ballet. *c*. 1922

239 Paul Klee. *Destroyed Land*. 1934

240 Alexander (Xanti) Schawinsky and Antonio Boggeri.
 New Year's greetings. 1934

241 Lou Scheper. Letter of congratulation. 1925

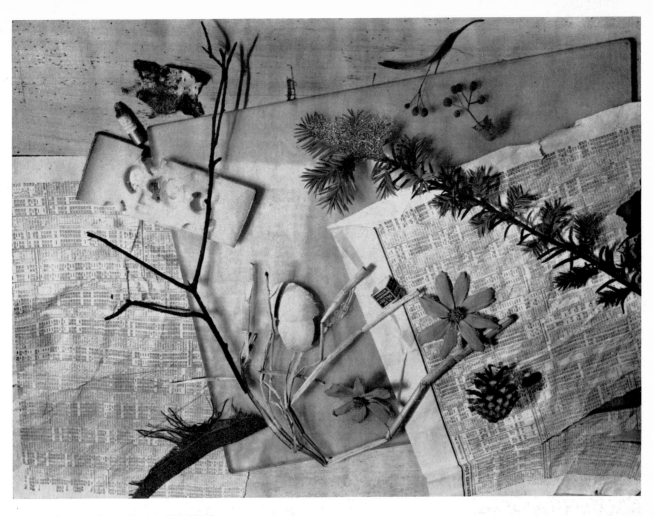

242 Walter Peterhans. *Grünewald Still Life.* 1932

243 Hanns Hoffmann. *Material Composition.* 1921

244 Henri Nouveau. Untitled. 1929

245 Herbert Bayer. *The Five*. 1922

246 Herbert Bayer. *Lonely Metropolitan*. 1932

247 Herbert Bayer. *Self-Portrait*. 1932

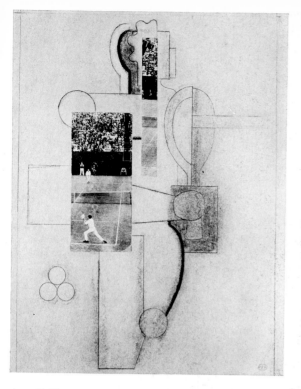

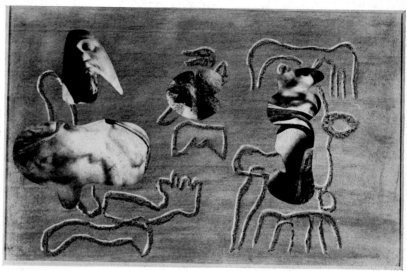

248 Willi Baumeister. *Tennis Player.* 1927

249 Willi Baumeister. Untitled. *c.* 1942

250 Willi Baumeister. Untitled (Head). *c.* 1927

251 Willi Baumeister. Untitled. *c.* 1942

252 Friedrich Vordemberge-Gildewart. *Collage on Hans Arp.* 253 Friedrich Vordemberge-Gildewart. *Composition no. 19.* 1926
 1927

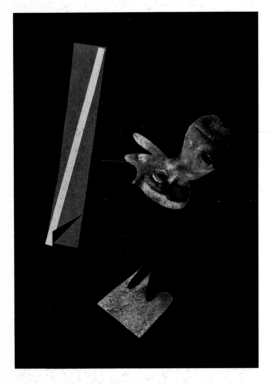

254 Friedrich Vordemberge-Gildewart. Untitled. 255 César Domela (Nieuwenhuis). *Composition.* 1938
 1928

256 Victor Servranckx. *Opus V—1919*

257 Erika Schneider. Collage in a guest book. 1925

258 Carl Buchheister. *White Diagonal.* 1931

259 Joaquín Torres-García. *Wood Construction with Bottle.* 1931

260 Hendrik Nicolaas Werkman. *Composition with Letters X.* 1927/28

261 Hanns Robert Welti. Untitled. 1929

262 Lázló Moholy-Nagy. *My Name Is Hare.* 1927

263 Theo van Doesburg. *Portrait of the Artist's Wife. c.* 1922

264 Max Burchartz. *Top Hat.* 1928

265 Jan Tschichold. Cinema poster. 1928

266 UMBO (Otto Umbehr). *Portrait of Egon Erwin Kisch.* 1926

267 Teresa Zarnower. *Worker-Peasant Unity.* 1928

268 Hans and Grete Leistikow. Title page. 1929

269 César Domela (Nieuwenhuis). *Berlin Museums*. 1931

270 Hans Finsler. *Sachte Neulichkeit*. c. 1927/28

271 F. A. Flachslander. Poster for Křenek's opera *Jonny spielt auf*. 1927

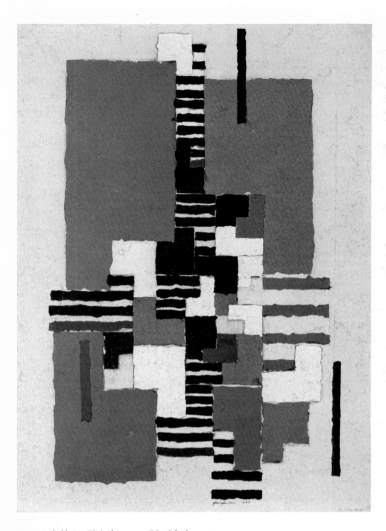

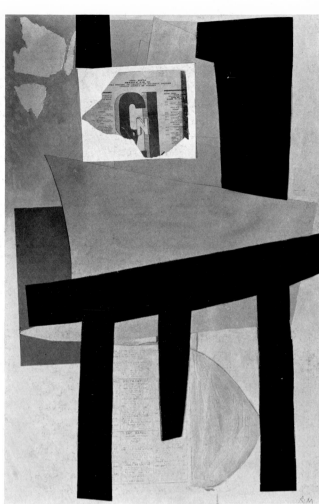

289 Adolf R. Fleischmann. Untitled. 1957

290 Robert Motherwell. *The Easel. c.* 1951

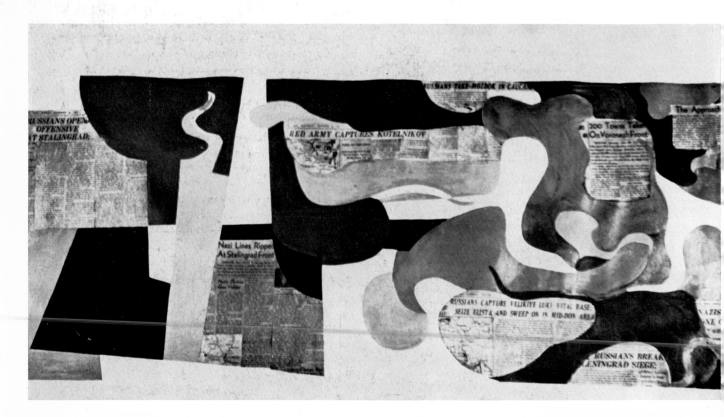

291 Hans Richter. *Stalingrad, Victory in the East*, detail. 1943–44

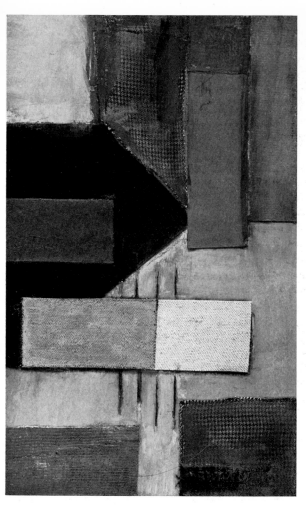 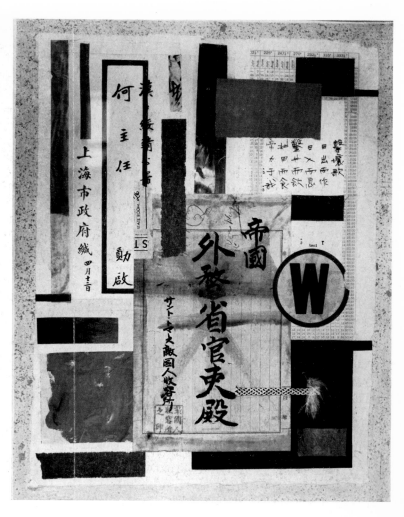

292 Jean Xceron. Untitled. 1939 293 Charmion von Wiegand. *Journey into Fear*. 1958

294 Alberto Magnelli. Untitled. 1937

295 Alberto Magnelli. Untitled. 1937

296 Alberto Magnelli. *Collage with Japanese Rakes.* 1938

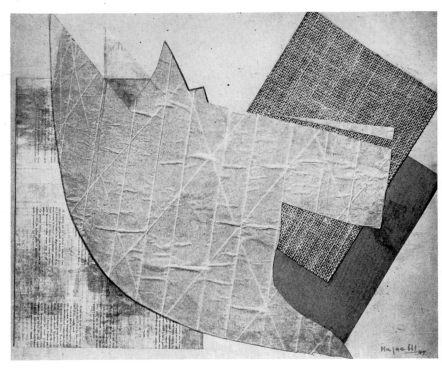

297 Alberto Magnelli. Untitled. 1941

298 Alberto Magnelli. Untitled. 1949

List of Plates

Colorplates

221 32 Joseph Cornell. *Hôtel de l'Europe—Olga Carini Aguzzi*. 1954. Assemblage, c. 17 × 10¹/₂″. Collection Mrs. Eleanor Ward, New York

231 33 Ella Bergmann-Michel. *Of the Moon's Light (des Mondes Licht)*. 1922. Collage and India ink on pasteboard, 25 × 22″. Collection the artist

241 34 László Moholy-Nagy. *Black-Red Equilibrium (Schwarz-rotes Gleichgewicht)*. c. 1922. Collage on paper, 22¹/₂ × 18⁷/₈″. Collection Erna and Curt Burgauer, Küssnacht, Switzerland

245 35 Friedrich (Fritz) Vordemberge-Gildewart. *Construction with Wall Street*. 1924. Oil and collage, 16¹/₈ × 13³/₈″. Private collection

253 36 Ad Reinhardt. *Collage*. 1939. Collage of pasted papers, 9⁷/₈ × 11″. Collection Mrs. Ad Reinhardt, New York

263 37 Robert Motherwell. *The Joy of Living*. 1943. Oil and collage, 43¹/₂ × 35¹/₄″. Baltimore Museum of Art. Saidie A. May Collection

273 38 Alberto Magnelli. Untitled. 1938. Collage on metal, c. 13³/₄ × 17³/₄″. Collection the artist

285 39 Mimmo Rotella. *Announcement (Avviso)*. 1960. *Décollage* of torn posters, 21⁵/₈ × 18¹/₈″. Galleria Schwarz, Milan

297 40 Robert Rauschenberg. *Tracer*. 1964. Silkscreen print on linen, 83⁷/₈ × 59⁷/₈″. Collection Mr. and Mrs. Frank M. Titelman, Altoona, Pa.

Black-and-White Plates

Number

1 *Souvenirs de Sainte-Hélène (Souvenirs of Saint Helena)*. France, 1896. Collage of Napoleonic mementos, diameter 7¹/₈″. Musée Carnavalet, Paris. Gift of Baron Larrey (Photo: Yves Hervochon, Paris)

2 Weather charm, religious folk art from the Reichenhall region, southern Germany. Eighteenth century. Diameter 7¹/₂″. Bayerisches Nationalmuseum, Munich. R. Kriss Collection (Photo: Bayerisches Nationalmuseum, Munich)

3 *Souvenir*. France, 1869. Hair collage (Photo: Yves Hervochon, Paris)

4 Greeting Card for Saint Catherine's Day. France, c. 1920. Collage

5 *Barometer of Love*. English valentine, c. 1845. Paper lace with cutouts. Victoria and Albert Museum, London (Photo: Alan Vines, London)

6 *Vase with Flowers*. United States, nineteenth century. Postage-stamp collage, 10 × 7⁷/₈″. Collection Mr. and Mrs. Jean de Menil, Houston

7 John Haberle. *Time and Eternity*. Late nineteenth century. Trompe-l'oeil painting, oil, 14 × 10″. The New Britain Museum of American Art, New Britain, Conn.

8 *Greetings from the Beach Resort at Norderney*. c. 1910. Photomontage postcard

9 Hans Christian Andersen. Leaf of folding scrap screen. 1873–74. Collage. H.C. Andersens Hus, Odense, Denmark

10 Pablo Picasso. *Still Life with Chair Caning (Nature morte à la chaise cannée)*. 1912. Oil and pasted oilcloth on canvas, maximum dimensions, 10⁵/₈ × 13³/₄″. Collection the artist (Photo: Hélène Adant, Paris)

11 Georges Braque. *Guitar and Cinema Program (Guitare et programme de cinéma)*. 1913. Collage and charcoal on paper, 28³/₄ × 39³/₈″. Collection Pablo Picasso, Vauvenargues, Bouches-du-Rhône (Photo: Galerie Louise Leiris, Paris)

12 Pablo Picasso. *Guitar*. 1912. Construction of mixed materials. Lost (Photo: Galerie Louise Leiris, Paris)

13 Pablo Picasso. *Guitar on a Pedestal Table (Guitare sur un guéridon)*. 1912–13. Collage, 24¹/₂ × 15⁵/₈″. Collection Mr. and Mrs. Joseph Pulitzer, Jr., Saint Louis, Mo. (Photo: Marc Vaux, Paris)

14 Georges Braque. *Still Life with Fruit Bowl and Glass (Nature morte, compotier et verre)*. 1912. Collage and charcoal on paper, 24³/₈ × 17¹/₂″. Private collection, France (Photo: Galerie Louise Leiris, Paris)

15 Georges Braque. *Musical Instrument*. 1912–13. Drawing and wood-grained paper, 24 × 18⁷/₈″. Private collection

16 Pablo Picasso. *"Purgativo,"* or *Still Life with Lacerba (Nature morte au Lacerba)*. 1914. Collage with gouache and charcoal, 13³/₄ × 11³/₈″. Galerie Jeanne Bucher, Paris

17 Juan Gris. *The Bottle of Anis del Mono (La Bouteille d'Anis del Mono)*. 1914. Collage, gouache, and oil on canvas, 16¹/₂ × 9¹/₂″. Collection Herbert and Nannette Rothschild, New York

18 Juan Gris. *The Guitar (La Guitare)*. 1913. Collage and oil, 24 × 19⁵/₈″. Private collection, Paris

19 Juan Gris. *The Marble Pier Table (La Console de marbre)*. 1914. Collage and oil with mirror on canvas, 23⁵/₈ × 19⁵/₈″. Collection Mr. and Mrs. Arnold H. Maremont, Winnetka, Ill. (Photo: Rogi-André, Paris)

20 Juan Gris. *Still Life with Book (Nature morte au livre)*. 1913. Collage and oil, 16¹/₈ × 13³/₈″. Collection Mlle. G. Henry, Paris (Photo: Galerie Louise Leiris, Paris)

21 Juan Gris. *Bouquet of Roses (Bouquet de roses)*. 1914. Collage, 21⁵/₈ × 18¹/₈″. Formerly Collection Alice B. Toklas, now private collection, Paris (Photo: Galerie Louise Leiris, Paris)

22 Diego Rivera. *Still Life with Carafe (Nature morte à la carafe)*. 1914. Collage and gouache, 14⁵/₈ × 7⁷/₈″. Collection Jacques Dubourg, Paris

23 Alexander Archipenko. *Woman in an Armchair (La Femme dans le fauteuil)*. 1913. Collage. Private collection, Germany

24 Henri Laurens. *Guitar with Sheet of Music (Musique)*. 1917. Collage, 16 × 23⁵/₈″. Formerly Collection A. Lefèvre, Paris

25 Sonia Delaunay-Terk. Bookbindings in collage. 1913. Collection the artist (Photo: Marc Vaux, Paris)

26 Léon Tutundjian. Collage with illustration of the French Revolution. 1925/26. Collage and pencil, 17⁷/₈ × 12³/₄″. Estate of Herta Wescher, Paris

27 Alfred Reth. *Le Petit Parisien*. 1916. Collage with painting, 20⁷/₈ × 17³/₈″. Galerie Michel Boutin, Paris

28 Georges Valmier. *Landscape*. 1920. Collage and India ink, 12 × 13³/₄″. Collection Mlle. G. Henry, Paris (Photo: Luc Joubert, Paris)

29 Alexander Archipenko. *In Front of the Mirror (Devant le miroir)*. 1915. Painted wood, metal, collage, 18¹/₈ × 12″. Brinton Collection, Philadelphia

30 Roger de La Fresnaye. *Sketch*. 1913. Collage and gouache, 9¹/₂ × 7¹/₈″. Collection Dr. J. Dalsace, Paris (Photo: Yves Hervochon, Paris)

31 Ismael de la Serna. *Still Life with Violin*. 1921. Oil and collage, 13 × 17³/₄″. Collection Dr. Guy Dulon, Beauchamp, Seine-et-Oise

32 Léopold Surage. Untitled. 1916. Watercolor and collage. Rose Fried Gallery, New York (Photo: John D. Schiff, New York)

33 Louis Marcoussis. *Still Life with Scaferlati Tobacco (Nature morte au tabac Scaferlati).* 1914. Oil and collage, $21^5/_8 \times 18^1/_8''$. Formerly Collection A. Lefèvre, Paris

34 Serge Férat. *Still Life with Lacerba (Nature morte au Lacerba).* 1914. Oil and collage, $21^1/_4 \times 25^5/_8''$. Collection R. Roussot, Paris

35 Marie Laurencin. *The Captive.* 1917. Collage, $5^1/_8 \times 3^1/_8''$. Formerly Collection André Breton (Photo: Luc Joubert, Paris)

36 Fernand Léger. *Horses in Village Quarters (Chevaux dans un village).* 1915. Charcoal and collage, $19^1/_4 \times 13^3/_4''$. Galerie Louis Carré, Paris

37 David Kakabadze. Untitled. 1925. Found objects

38 Marthe Donas. *Woman Looking at a Vase (Femme regardant un vase).* 1917. Collage with fabrics, lace, and metal bell. Lost

39 Otto Gutfreund. *Still Life.* 1914. Collage and pencil, $11^1/_4 \times 8^7/_8''$. Private collection, Prague (Photo: F. Jéžersky, Prague)

40 GAN (Gösta Adrian-Nilsson). *Registered Letter (Lettre recommandée).* 1921. Collage and watercolor. Collection the artist (Photo: Bertel Höder, Stockholm)

41 Vilhelm Lundstrøm. *Lattice Picture.* 1917. Mixed mediums with metal, wood, and cardboard, $50 \times 24''$. Louisiana Museum, Humblebaek, Denmark (Photo: Jørn Freddie, Copenhagen)

42 Emil Filla. *Amsterdam Still Life.* 1915. Collage and gouache, $14^1/_8 \times 18^7/_8''$. Collection Paul Citroen, Wassenaar, The Netherlands (Photo: J. Colomb-Gérard, Paris)

43 Antonín Procházka. *Still Life with Fruit in Glass Bowl.* 1923/24. Oil and collage, $22 \times 27^1/_8''$. Private collection, Brno

44 Umberto Boccioni. *Fusion of a Head and a Window (Fusione di una testa e di una finestra).* 1912. Wood, glass, plaster of Paris, and wreath of hair. Destroyed

45 Umberto Boccioni. *Under the Pergola at Naples (Sotto il pergolato a Napoli).* 1914. Oil and collage, $32^5/_8 \times 32^5/_8''$. Galleria d'Arte Moderna, Milan

46 Carlo Carrà. *Pursuit (Inseguimento).* 1914. Collage and gouache, $15^1/_4 \times 26^3/_4''$. Collection Gianni Mattioli, Milan (Photo: Gian Sinigaglia, Milan)

47 Gino Severini. *Dancer (La Ballerina).* 1913. Oil and sequins, diameter $13^3/_4''$. Private collection (Photo: Marc Vaux, Paris)

48 Gino Severini. *Portrait of Marinetti.* 1913. Collage with mustache and velvet. Lost

49 Gino Severini. *Homage to My Father (Omaggio a mio padre).* 1913. Collage, $19^5/_8 \times 27^5/_8''$. Galleria Blu, Milan (Photo: Yves Hervochon, Paris)

50 Ardengo Soffici. *Still Life with Watermelon (Natura morta con cocomero).* 1915. Collage with painting. Lost

51 Carlo Carrà. *Demonstration for Intervention in the War (Manifestazione Interventista;* original title *Festa patriottica, Patriotic Celebration).* 1914. Tempera and collage on cardboard, $15 \times 11^3/_4''$. Collection Gianni Mattioli, Milan (Photo: Clari, Milan)

52 Giacomo Balla. *Collage for Marinetti.* 1915. Collage and India ink on canvas, $62^5/_8 \times 27^5/_8''$. Collection Mr. and Mrs. Harry Lewis Winston, Birmingham, Mich. (Photo: Lewis Gilcrest, Birmingham, Mich.)

53 Enrico Prampolini. *Spatial Rhythms (Ritmi spaziali).* 1913. Collage and gouache on cardboard, $18^7/_8 \times 12^1/_4''$. Private collection, Rome (Photo: Oscar Savio, Rome)

54 Giacomo Balla. *Geometric Landscape (Paesaggio geometrico).* 1915. Collage of colored papers, $7^1/_2 \times 10^1/_2''$. Estate of the artist (Photo: De Antonis, Rome)

55 Rougena Zatkova. Untitled. c. 1913. Collage of colored papers, metal foil, and plastic film, $9 \times 11^3/_8''$. Collection R. Stanislawski, Warsaw (Photo: Stefan Baptuszewski, Warsaw)

56 Mario Sironi. *The Fisherman's Wife (Moglie del pescatore).* 1916. Collage and tempera, $38^1/_8 \times 28^3/_4''$. Private collection, Milan (Photo: Galleria del Milione, Milan)

57 Ottone Rosai. *Dynamism of Bar San Marco (Dinamismo di Bar San Marco).* 1913/14. Oil and collage on canvas, $24^3/_8 \times 19^5/_8''$. Private collection, Florence

58 Primo Conti. *Simultaneity of Environment (Simultaneità di ambiente).* 1917. Oil and collage, $19^5/_8 \times 15^3/_4''$. Collection the artist, Fiesole, Italy

59 Antonio Marasco. *Still Life with Carafe (Nature morta con caraffa).* 1917. Collage and tempera on cardboard, $13^3/_4 \times 10^5/_8''$. Collection Mrs. Mary Neury, Geneva

60 Mario Nannini. *Two and Stroll (Due e passeggio).* 1916. Collage, printed matter, and cloth, $14^5/_8 \times 19^5/_8''$. Collection Vittorio Frascione, Florence

61 P. M. Bardi. *Panel of Horrors (Tavola degli orrori).* 1931. Montage for an exhibition of the Architettura Razionale group in Rome

62 Giuseppe Terragni. Mural for the *Exposition of the Fascist Revolution* on the tenth anniversary of the march on Rome, Palazzo Venezia, Rome, 1932. Photomontage. Destroyed

63 Ivo Pannaggi. Poster with costume for the *Ballo Meccanico-Futurista (Mechanical-Futurist Baller),* by Pannaggi and Vinicio Paladini. 1922. Montage

64 Pippo Oriani. *Woman Bathing (Bagnante).* 1929. Collage and paint, $9^7/_8 \times 13^3/_4''$. Collection the artist (Photo: Hans C. Belgio)

65 Nicolay Diulgheroff. *Space-Force-Composition (Composizione-spazio-forza).* c. 1927/28. Collage and tempera, $11^3/_4 \times 8^1/_2''$. Formerly Collection Pino Falco, Turin

66 Farfa. *Soubrette.* 1927. Collage of mixed materials, $17^3/_4 \times 24''$. Galleria Schwarz, Milan (Photo: Galleria Schwarz, Milan)

67 Nell Walden. *Abstract Composition,* sketch for a mosaic in the Ermler Museum, Berlin. 1924. Tempera and collage, $7^7/_8 \times 6^1/_4''$. Collection the artist

68 Gabriele Münter. *Votive Image (Votivbild).* c. 1910. Collage with colored papers, $5^5/_8 \times 4''$. Städtische Galerie, Lenbach-Haus, Munich

68a Paul Busch. *The Dancer (Der Tänzer).* 1921. Collage drawing with watercolor, $15^3/_4 \times 11''$. Private collection, Berlin

69 Kasimir Malevich. *Soldier of the First Division.* 1914. Oil and collage with thermometer, $20^1/_8 \times 17^3/_4''$. The Museum of Modern Art, New York (Photo: Soichi Sunami, New York)

70 Kasimir Malevich. *Still Life with Mona Lisa.* 1913. Oil and collage, $24^3/_8 \times 19^1/_4''$. Private collection, Leningrad (Photo: Karel Kuklik, Prague)

71 Xenia Bogoslavskaya. *Dressing Table.* 1915. Collage of cloth, wallpaper, and found objects. Lost

72 Ivan Puni. *Chair and Shoe.* 1914. Collage with brush drawing. Destroyed

73 N. Granovsky. Book cover for *Ledentu le Phare* by Iliazd, Paris, 1922. Collage with gold and silver paper on brown ground

74 Yury Annenkov. *Portrait of Alexander Tikhonov.* 1922. Oil painting with collage and material montage, 26³/₄ × 22″. Private collection, Paris

75 Alexandra Exter. *Still Life.* 1913. Collage

76 Georgy Yakulov. Decorations in the Café Pittoresque, Moscow. 1916/17

77 Mikhail Larionov. *The Smoker.* 1912. Montage of mixed materials, 28³/₄ × 9″. Museum des 20. Jahrhunderts, Vienna

78 Mikhail Larionov. Untitled. 1915. Assembled materials: cartons, sheet metal, cloth, nails, twine. Lost

79 El Lissitzky. Collage drawing. c. 1922–24. Photo-sculpture from the unpublished illustrations for Ilya Ehrenburg's *Sechs Erzählungen mit leichtem Schluss*, Berlin, 1922 (Photo: Eidenbenz, Basel)

80 Lyuba Kosintseva. Collage with portrait photo. n.d. Reproduced from the Czech magazine *Host*, 1925

81 Varvara Stepanova. Jacket for *Zaumchata*, a collection of Zaum poems written by hand on newspaper. 1919. Collage. Formerly Collection Lajos Kassák, Budapest

82 Alexandr Sakharov. Costume design for Busoni's opera *Turandot.* 1917. Collage of patterned paper and foil. Estate of the artist

83 Natalia (Nathalie) Gontcharova. Costume design for the choreographic mystery *Liturgie.* 1915. Collage. Collection John Carr Doughty, London

84 Michel Andreenko. Sketch for a stage curtain. 1925. Collage and tempera on cardboard, 9⁷/₈ × 13³/₄″. Collection Eckhard Neumann, Frankfort (Photo: Werner A. Kilian, Wiesbaden)

85 Natan Altman. Advertising poster. 1923. Collage. Reproduced from the Czech magazine *Pásmo*, 1924

86 Issachar Rybak. *Still Life with Alphabet.* Painting and collage. Reproduced from the Yiddish magazine *Albatros*, Berlin, 1923

87 David Shterenberg. Cover for the magazine *Izo* no. 1, Petrograd, 1919. Collage

88 Marc Chagall. Collage. 1921. Papers and gouache on paper, 13³/₈ × 11″. Collection Ida Meyer-Chagall, Basel

89 Pavel Mansurov. Untitled. 1922. Material assemblage with butterfly, 11 × 6¹/₄″. Lost

90 Pavel Mansurov. Untitled. 1922. Material assemblage with butterfly, 18¹/₈ × 6³/₄″. Lost

91 El Lissitzky. *Construction—Proun 2.* 1920. Collage of mixed mediums in relief, 23³/₈ × 15³/₄″. Philadelphia Museum of Art. A. E. Gallatin Collection (Photo: A.J. Wyatt, Philadelphia)

92 El Lissitzky. *Tatlin at Work.* c. 1924. Drawing, watercolor, and photomontage, 11¹/₂ × 9″. Collection Eric Estorick, London

93 El Lissitzky. *The Ship's Chart.* 1922. Collage and drawing with watercolor. Presumably one of the unpublished illustrations for Ilya Ehrenburg, *Sechs Erzählungen mit leichtem Schluss*, Berlin, 1922. Reproduced from B. Aranson, *Zeitgenössische jüdische Graphik in Russland*, Berlin, 1924 (Photo: Archiv Eckhard Neumann, Frankfort)

94 El Lissitzky. *Self-Portrait.* 1924. Photographomontage with drawing

95 Liubov Popova. *Italian Still Life.* 1914. Oil and collage, 21¹/₄ × 19¹/₄″. Tretyakov Gallery, Moscow

96 Vladimir E. Tatlin. *The Bottle.* c. 1913. Painted relief. Lost, presumably destroyed

97 Gustave Klutsis. *Sport.* 1923. Photomontage poster

98 S. Syenkin. Road-building poster displayed at the *Fotomontage* exhibition in the former Kunstgewerbemuseum, Berlin, April 25 to May 31, 1931. Photomontage

99 Alexandr Rodchenko. *Another Cup of Tea?* 1923. Illustration for Mayakovsky's book of poems *Pro Eto.* Photomontage

100 Alexandr Rodchenko. *I Hold the Balance of Power.* 1923. Illustration for Mayakovsky's book of poems *Pro Eto.* Photomontage

101 S. Friedland. *The Mercenary Press.* c. 1927. Collage and superimposed photographic printing. Reproduced from Roh and Tschichold, *Foto-Auge*, Stuttgart, 1929

102 A. Shitomirsky. *Here's the Corporal Who Generaled Germany into Catastrophe*, from the *Front Illustrated Paper.* 1941. Photomontage

103 Marcel Duchamp. *Bearer Bond for the Roulette at Monte Carlo (Obligation pour la roulette de Monte Carlo).* 1924. Collage, 12³/₈ × 7⁵/₈″. The Museum of Modern Art, New York (Photo: Soichi Sunami, New York)

104 Jean Crotti. *Portrait to Measure of Marcel Duchamp.* 1915. Dada materials: wire, porcelain eyes, etc., c. 15³/₄ × 9⁷/₈″. Formerly Collection Walter Arensberg, destroyed in 1921

105 Man Ray. *The Wherewithal to Write a Poem (De quoi écrire un poème).* 1923. Assemblage, 15³/₄ × 11³/₄″. Collection the artist

106 Otto van Rees. *Adya.* 1915. Collage of paper and cloth

107 Suzanne Duchamp. *Multiplication Broken and Re-established (Multiplication brisée et rétablie).* 1918–19. Collage with gold and silver paper, stars, and printed matter. Estate of the artist

108 Marcel Janco. *The Front-Line Soldier (Le Poilu).* 1924. Oil and collage, 27¹/₈ × 19¹/₄″. Galleria Schwarz, Milan (Photo: Bacci, Milan)

109 Christian Schad. *Schadograph 29a (Variant).* 1960. Photogram with collage, 6⁷/₈ × 4⁷/₈″. Collection the artist

110 Hans (Jean) Arp. *Before My Birth (Avant ma naissance).* 1914. Collage, 4³/₈ × 3¹/₂″. Estate of Herta Wescher, Paris (Photo: Yves Hervochon, Paris)

111 Hans (Jean) Arp. *Construction with Planes and Curves (Construction à plans et courbes).* 1915. Collage on pasteboard, 8¹/₂ × 5⁵/₈″. Collection Marguerite Arp-Hagenbach, Basel (Photo: Dietrich Widmer, Basel)

112 Jefim Golyschev. *From A. Derain to Omo.* 1919, reconstructed and amplified in 1966. Collage, 10³/₈ × 13¹/₄″. Collection the artist

113 Raoul Hausmann. *Dada Triumphs (Dada siegt).* 1920. Collage. Lost (Photo: Schuch, Berlin)

114 George Grosz and John Heartfield. *Dada-merika.* 1919. Photomontage, 10¹/₄ × 7¹/₂″. Collection Paul Citroen, Wassenaar, The Netherlands (Photo: J. Colomb-Gérard, Paris)

115 Hannah Höch. *Cut with the Kitchen Knife through the Last Weimar Beerbelly Cultural Epoch (Schnitt mit dem Küchenmesser . . .).* 1919. Collage, 44⁷/₈ × 35³/₈″. Nationalgalerie, Staatliche Museen, Berlin

116 Hannah Höch. Untitled. 1925. Collage, 10 × 9⁵/₈″. Galerie Nierendorf, Berlin

117 Otto Dix. *Prague Street.* 1920. Oil and collage, 39³/₄ × 31⁷/₈″. Private collection, Düsseldorf (Photo: Gnilka, Berlin)

118 George Grosz. Composition from the portfolio *Mit Pinsel und Schere (With Brush and Scissors)*, Berlin, Malik-Verlag, 1922. Collage and watercolor

119 Paul Joostens. *The Javanese (La Java)*. c. 1924. Mixed materials, $13^3/_4 \times 9^7/_8$″. Collection Jean Petithory, Paris

120 Paul Citroen. *Metropolis*. 1923. Collage, $31^1/_2 \times 19^5/_8$″. Lost (Photo: Luc Joubert, Paris)

121 Kurt Schwitters. *Merzbild 14,6 Schwimmt*. 1921. Collage with found objects, $6^1/_8 \times 4^1/_2$″. Collection Herbert and Nannette Rothschild, New York (Photo: Oliver Baker, New York)

122 Kurt Schwitters. *Young Plan*. 1929. Collage. Collection Herbert and Nannette Rothschild, New York (Photo: John D. Schiff, New York)

123 Kurt Schwitters. *Mz 26,48 Berlin*. 1926. Collage, $4^1/_2 \times 3^3/_8$″. Galerie Berggruen, Paris

124 Kurt Schwitters. *Gallows of Desire (Der Lustgalgen)*. c. 1919. Assemblage, height $19^5/_8$″. Lost

125 Max Ernst. *Winter Landscape: Grassing Up . . . (winterlandschaft: vergasung . . .)*. 1921. Collage with tempera and pencil on paper, $6^1/_8 \times 8^1/_8$″. Collection Marguerite Arp-Hagenbach, Basel

126 Max Ernst. *The Slaughter of the Innocents (Massacre des innocents)*. 1920/21. Photomontage with gouache and India ink, $8^1/_4 \times 11^1/_2$″. Collection Mme. Simone Collinet, Paris

127 Francis Picabia. *Flirt*. c. 1922. Oil and collage, $36^1/_4 \times 28^3/_4$″. Collection Mme. Simone Collinet, Paris (Photo: Ivan Bettex, Pully, Switzerland)

128 Louis Aragon. *Portrait of Jacques Vaché*. 1921. Collage, $9^7/_8 \times 7^1/_2$″

129 Francis Picabia. *Tableau Rastadada* (Christmas greetings to Hans Arp and Max Ernst). 1920. Photomontage. Formerly Collection Tristan Tzara (Photo: J.C. Simonot, Brévannes)

130 Sergei Fotinsky. *The Dove That Announces the End of the Flood*. c. 1924–26. Collage with gouache, $14^1/_8 \times 9^7/_8$″. Collection the artist (Photo: Yves Hervochon, Paris)

131 Alica Halicka. *Bougival*. 1923. Collage with fabrics, braid, celluloid ducks, etc., $24 \times 19^5/_8$″. Private collection, Paris (Photo: Marc Vaux, Paris)

132 Alica Halicka. *Roland in Roncevaux*. 1924. Collage with marbled paper, braid, beads, etc., $24 \times 19^5/_8$″. Collection the artist (Photo: Maurice Poplin, Paris)

133 Kurt Seligmann. Untitled. c. 1929. Assemblage. Lost (Photo: Marc Vaux, Paris)

134 Jean Cocteau. *Thumbtacked Head (Tête aux punaises)*. 1920. Cardboard, string, and thumbtacks

135 Morton L. Schamberg. *God*. c. 1918. Iron pipe, height $10^5/_8$″. Philadelphia Museum of Art. Louise and Walter Arensberg Collection

136 Jindřich Štyrský and Toyen. *How I Found Livingstone*. 1924. Collage, $20^7/_8 \times 19^5/_8$″. Private collection, Czechoslovakia

137 George Voskovec. *Siphons of the Colonial Siesta*. 1925. Collage, c. $17^3/_4 \times 15^3/_4$″. Lost

138 Kurt Seligmann. *Annual Fair*. 1928. Collage with found objects. Estate of the artist (Photo: Marc Vaux, Paris)

139 Aldo Fiozzi. *Abstract Values of an Individual Y (Valori astratti di un individuo Y)*. 1920. Mixed mediums in relief. Reproduced from the review *Bleu*, August–September, 1920

140 Johannes Theodor Baargeld. *anthrophiliac tapeworm (antropofiler bandwurm)*. Assemblage. Reproduced from the review *Die Schammade*, 1920

141 Arthur G. Dove. *The Critic*. 1925. Newspaper and magazine clippings, velvet, etc., on cardboard, $19 \times 12^5/_8$″. The Downtown Gallery, New York (Photo: Oliver Baker, New York)

142 John R. Covert. *Time*. 1919. Drawing with upholstery tacks, $25^5/_8 \times 23^5/_8$″. Yale University Art Gallery, New Haven. Collection Société Anonyme (Photo: Yale University Art Gallery)

143 Arthur G. Dove. *Monkey Fur*. 1926. Monkey fur, ribbon, metal, etc., $16^7/_8 \times 12$″. The Art Institute of Chicago. Collection Alfred Stieglitz (Photo: The Art Institute of Chicago)

144 Pablo Picasso. *Guitar (La Guitare)*. 1926. Found objects and pencil drawing, $16^1/_2 \times 11^3/_8$″. Collection the artist (Photo: Mardyks, Puteaux)

145 Pablo Picasso. *Figure*. 1935. Freestanding assemblage, height $24^3/_4$″. Collection the artist (Photo: Mardyks, Puteaux)

146 André Masson. *Ludion: Bottle-Imp*. 1937. Sand, shells, rope, bones, etc., $13^3/_8 \times 6^1/_2$″. Private collection (Photo: Galerie Louise Leiris, Paris)

147 Pablo Picasso. *Construction with Glove (Construction au gant)*. 1930. Assemblage textured with sand, $10^5/_8 \times 14$″. Collection the artist (Photo: Mardyks, Puteaux)

148 André Masson. *The Street Singer (La Chanteuse des rues)*. 1941. Collage and pastel drawing, $23^3/_8 \times 17^1/_2$″. The Museum of Modern Art, New York (Photo: Adolph Studly, New York)

149 Joan Miró. *The Firmament (Le Firmament)*. 1929. Collage, $26 \times 39^3/_8$″. Kootz Gallery, New York

150 André Masson. *The Wild Beast and the Bird (Le Fauve et l'oiseau)*. 1927. Collage and pencil drawing, $25^1/_4 \times 19^5/_8$″. Galerie Louise Leiris, Paris (Photo: Galerie Louise Leiris)

151 Joan Miró. Untitled. 1930. Collage with drawing and sheet music. Formerly Collection A. Lefèvre, Paris (Photo: Marc Vaux, Paris)

152 Joan Miró. *Spanish Dancer (Danseuse espagnole)*. 1928. Material relief with sandpaper, triangle, string, and nails, $42 \times 26^3/_4$″. Collection Mr. and Mrs. Morton G. Neumann, Chicago

153 Yves Tanguy. *I Came as I Had Promised, Farewell (Je suis venu comme j'avais promis, Adieu)*. 1926. Collage, $39^3/_8 \times 28^3/_4$″. Collection Raymond Queneau, Paris (Photo: Marc Vaux, Paris)

154 Yves Tanguy. *Fantomas*. c. 1925. Oil and collage, $19^5/_8 \times 59$″. Pierre Matisse Gallery, New York (Photo: N. Mandel, Paris)

155 André Breton, Max Morise, Jeanette and Paul Naville, Benjamin Péret, Jacques Prévert, and Yves Tanguy. *Cadavre exquis: Figure*. 1928. Collage, $11^3/_8 \times 9$″. The Museum of Modern Art, New York (Photo: Soichi Sunami, New York)

156 Camille Bryen. *Social Montage of the Hatching of the Plot (Montage social du montage du coup)*. 1938. Collage, $12 \times 9^1/_2$″. Collection the artist

157 Hans (Jean) Arp, Raoul Hausmann, Oscar Dominguez, Marcel Jean, Sophie Taeuber-Arp. *Cadavres exquis*. 1928. Collages. Galerie d'Art Moderne, Basel

158 Maurice Henry. *The Ambuscade (Le Guet-apens)*. 1935. Poem collage, $10^5/_8 \times 7^7/_8$″. Collection the artist (Photo: Yves Hervochon, Paris)

159 Maurice Henry. *On the Horizon Line (Sur la ligne de l'horizon)*. 1935. Collage and drawing, $10^5/_8 \times 7^7/_8$″. Collection the artist (Photo: Yves Hervochon, Paris)

160 Victor Brauner. *Edible Portrait (Portrait comestible)*. 1938. Collage with lentils, 28³/₈ × 23⁵/₈″. Galerie Le Point Cardinal, Paris (Photo: Jacqueline Hyde, Paris)

161 Valentine Hugo. *Portrait of Arthur Rimbaud*. 1933. Oil and collage, 39³/₈ × 29¹/₂″. Collection Mme. Renée Laporte, Paris

162 Salvador Dali. *The Remorse of Conscience (Les Remords de conscience)*. 1930. Oil and collage, 16¹/₈ × 26″. The Salvador Dali Museum Collection, The Reynolds Morse Foundation, Cleveland

163 René Magritte. *Musical Notes*. c. 1926. Collage and India ink, 10⁵/₈ × 3¹/₈″. Brook Street Gallery, London

164 Salvador Dali. *Still Life*. 1923. Collage drawing, 8⁵/₈ × 7¹/₂″. Collection Eric Estorick, London

165 René Magritte. *Delicious Roots (Racines délicieuses)*. 1926. Collage and gouache, 15³/₈ × 21⁵/₈″. Collection Mrs. Henry Epstein, New York (Photo: Paul Bijtebier, Brussels)

166 Max Ernst. *Facility*. 1931. Collage, 25⁵/₈ × 20¹/₈″. Collection Goldfinger, London (Photo: Brompton Studios, London)

167 Max Ernst. Sketch for décor of *Ubu enchaîné* by Alfred Jarry. 1937. Collage and colored chalks, 9¹/₂ × 13″. Galerie Berggruen, Paris (Photo: Cauvin, Paris)

168 Max Ernst. *A Sad Specimen (Un triste sire)*. 1967. Assemblage, 21⁵/₈ × 16⁷/₈″. Private collection, Paris

169 Max Ernst. *Homage to a Little Girl Named Violette*. 1933. Oil and collage, 35 × 45¹/₄″. Collection E.L.T. Mesens, London

170 Hans Bellmer. *Odds and Ends from the Coat Pocket of Gasahl Gaboya (Reste aus der Manteltasche des Gasahl Gaboya)*. 1938. Collage drawing, 8¹/₈ × 5³/₄″. Collection Jean Brun, Dijon (Photo: Yves Hervochon, Paris)

171 Joan Miró. *Personage*. 1931. Freestanding assemblage of wood, foliage, and umbrella, height c. 72″. Destroyed. Reproduced from *Le Surréalisme au Service de la Révolution*, 1931

172 Gala Éluard. *Surrealist Object of Symbolic Function*. 1931. Assemblage of found objects. Reproduced from *Le Surréalisme au Service de la Révolution*, 1931

173 André Masson. Mannequin. 1938. Assemblage

174 Salvador Dali. *Rainy Taxi (Taxi pluvieux)*, detail. 1938. Assemblage

175 E.L.T. Mesens. *I Think Only of You (Je ne pense qu'à vous)*. 1926. Collage and Rayogram, 11³/₄ × 9¹/₂″. Collection the artist, London

176 Paul Éluard. *The Venetian Night (La Nuit vénitienne)*. 1934. Photomontage. Formerly Collection Valentine Hugo

177 Henri Goetz. *Portrait*. 1940. Photomontage and collage, 8¹/₈ × 5¹/₂″. Collection the artist, Paris

178 Georges Hugnet. Page with collage poem from his *La septième face du dé*, Paris, Éditions Jeanne Bucher, 1936

179 Kurt Seligmann. *The Surrealist Animals (Les Animaux surréalistes)*. 1938. Photomontage. Reproduced from *Dictionnaire abrégé du Surréalisme*, Paris, 1938 (Photo: Bibliothèque Nationale, Paris)

180 Serge Brignoni. *Blossoms of Star Coral (Éclosions madréporiques)*. 1938. Collage on photograph, 7¹/₈ × 7⁷/₈″. Estate of Herta Wescher, Paris (Photo: Yves Hervochon, Paris)

181 Hans (Jean) Arp. *Drawing Torn and Colored (Dessin déchiré et coloré)*. 1946. Collage, India ink, and colored paste, 15³/₄ × 11³/₄″. Collection Marguerite Arp-Hagenbach, Basel

182 Raoul Ubac. *Penthesilea in Combat (Le Combat de Penthésilée)*. 1937. Photo collage. Collection the artist

183 Jindřich Štyrský. Untitled. 1934. Collage, 19⁵/₈ × 11³/₄″. Private collection, Paris

184 Title page of the magazine *Světozor*, no. 13, Prague, April, 1935

185 Jindřich Heisler. *The Casemates of Sleep*. 1941. Collage poem

186 František Gross. *It Is a Man, a Stone, or a Tree That Will Begin*. 1937. Assemblage, 31¹/₂ × 20⁷/₈″. Destroyed

187 Zdeněk Rykr. *Glass*. 1936. Assemblage of materials between two sheets of glass, 16³/₈ × 11¹/₂″. Museum for History and Geography, Chotěboř, Czechoslovakia (Photo: Karel Kuklik, Prague)

188 Karel Teige. Untitled. 1939. Photomontage, 12¹/₄ × 9″. Private collection, Lugano, Switzerland (Photo: Illek and Alexander Paul, Prague)

189 Karel Teige. *Joséfine*. 1939. Photomontage, 11³/₄ × 10¹/₄″. Private collection, Lugano, Switzerland (Photo: Illek and Alexander Paul, Prague)

190 Toyen. *Natural Law (Loi naturelle)*. 1946. Collage, 76³/₄ × 22″. Collection Robert Altmann, Paris

191 Adolf Hoffmeister. *Caucasus*, from the series *Typographical Landscapes*. 1959. Collage and India ink, 16¹/₈ × 25″

192 Henry Heerup. *Child with Glove*. c. 1930. Assemblage, height 9⁷/₈″. Private collection, Denmark (Photo: Roald Pay, Bagsvaerd, Denmark)

193 William (Wilhelm) Freddie (Frederick Wilhelm Carlsen). *The Pink Shoes of Mrs. Simpson*. 1937. Assemblage, 15 × 17³/₈″. Collection Kai Bjerregard-Jensen, Copenhagen

194 Henry Heerup. *Rubbish Model*. c. 1937. Relief assemblage, 18¹/₂ × 12¹/₄″. Collection R. Winther, Copenhagen

195 William (Wilhelm) Freddie (Frederick Wilhelm Carlsen). *Nocturne*. 1933. Collage, 18⁷/₈ × 23¹/₄″. Collection the artist

196 John Piper. *Abstract Composition*. 1936. Pen and India ink, watercolor, and collage, 14 × 17³/₈″. Marlborough Gallery, London (Photo: Marlborough Fine Art Ltd., London)

197 Eileen Agar. *Foot in Hand*. 1939. Lace, tulle, colored and printed papers, butterflies, etc., 12⁵/₈ × 17¹/₂″. Collection Andrée Quitak-Melly, London (Photo: Cross Brothers, London)

198 Ben Nicholson. *Le Petit Provençal*. 1933. Oil and newspaper collage, 19¹/₈ × 16⁷/₈″. Collection J. and G. Guggenheim, Zurich

199 Roland Penrose. *Miss Sacré-Coeur*. 1938. Collage with cut-up postcards, 31¹/₂ × 17³/₄″. Collection the artist

200 Ceri Richards. *The Sculptor in His Studio*. 1937. Wood, wood-grained paper, and painting, 18¹/₈ × 16⁷/₈″. The Tate Gallery, London (Photo: The Tate Gallery)

201 Ceri Richards. *The Variable Costerwoman*. 1938. Found objects, 29⁷/₈ × 29¹/₈″. Collection Mrs. Frances Richards, London

202 Paul Nash. *Portrait of Lunar Hornet*. Collage. Lost. Reproduced from *Axis*, no. 8, 1937

203 Edward Burra. Untitled. 1928/29. Lost. Reproduced from *The London Magazine*, Vol. 3, no. 12, March, 1964

204 Jacques B. Brunius. *Ad nauseam*. 1944. Drawing based on collage. Lost. Reproduced from *Free Unions*, London, 1946

205 Robert Baxter. *Bird's-eye View*. 1937. Collage. Collection the artist

206 Eileen Agar. *Woman Reading*. 1936. Collage, 12⁵/₈ × 9″. Brook Street Gallery, London

207 Paule Vézelay. *Lines in Space no. 4.* 1936. Collage with cotton thread on canvas, $11^3/_4 \times 10 \times 2^3/_8''$. Collection the artist

208 Jacques B. Brunius. *La Mélusine sans-culotte.* 1936. Collage, $9^7/_8 \times 15^3/_4''$. Collection A. Henisz, Paris (Photo: Yves Hervochon, Paris)

209 Merlyn Evans. *Fleurs du mal.* c. 1937. Collage of colored papers on white pasteboard, $19^7/_8 \times 15''$. Destroyed

210 Conroy Maddox. *Uncertainty of the Day.* 1940. Photomontage, $5^7/_8 \times 7^7/_8''$. Collection the artist

211 Ben Nicholson. *396.* 1944. Cardboard, embroidery canvas, and paper. Collection Nigel Henderson, London (Photo: Studio St. Ives)

212 Roland Penrose. *Broad Daylight (Le grand jour).* 1938. Oil over collage sketch, $29^7/_8 \times 39^3/_4''$. The Tate Gallery, London

213 Paule Vézelay. *Black and White (Noir et blanc).* 1946. Collage of plain and patterned papers, $9^1/_2 \times 11^3/_4''$. Collection the artist (Photo: Studios Ltd., London)

214 Lawrence Vail. Portion of the back of a three-paneled scrap screen. 1940–41. Collage, over-all dimensions of screen $64^1/_2 \times 61^1/_2''$. Collection Peggy Guggenheim, Venice

215 Joseph Cornell. *Moon Surface.* 1955. Assemblage, $16^7/_8 \times 15^1/_2''$. Collection Adele Maremont, Winnetka, Ill.

216 Joseph Cornell. *Pavilion: Soap Bubble Set.* 1953. Assemblage, $18^7/_8 \times 11^3/_4 \times 6^3/_4''$. Collection Herbert Ferber, New York

217 Lawrence Vail. Bottles decorated in collage. c. 1947. Collection Peggy Guggenheim, Venice

218 Ella Bergmann-Michel. *Sunday for Everyman (Sonntag für jedermann).* 1917/18. Assemblage of found objects, $25^5/_8 \times 18^7/_8''$. Collection the artist

219 Robert Michel. *Alu-Paradise II.* 1930. Collage on aluminum ground, $19^5/_8 \times 22^1/_2''$. Collection the artist

220 Ella Bergmann-Michel. *Fishes (Fische).* 1919. Collage with pen drawing, $16^7/_8 \times 13^3/_8''$. Collection the artist

221 Johannes Molzahn. *New Lands (Neue Länder).* 1920. Oil and collage. Private collection

222 Robert Michel. *Man-It-Man Picture (Mann-es-Mannbild).* 1918/19. Collage, $26^1/_8 \times 21^5/_8''$. Collection the artist

223 Johannes Molzahn. *Columbus—A New Voyage (Kolumbus— Eine neue Fahrt).* 1920. Oil and collage. Private collection

224 Edmund Kesting. Relief collage with silver ball. 1924. "Cut graphics" and collage, $13^3/_4 \times 13^3/_8''$. Formerly Collection Herwarth Walden. Lost

225 László Moholy-Nagy. *PN.* 1920. Collage with wheels and tin foil

226 Edmund Kesting. *Postage Stamps in Inflation Times (Briefmarken der Inflation).* 1924. "Cut graphics" and collage, $13^3/_8 \times 15''$. Formerly Collection Herwarth Walden. Lost

227 László Moholy-Nagy. *Relief h.* 1922. Collage with spool, bell, wire, etc., c. $17^3/_4 \times 15^3/_4''$. Lost

228 László Moholy-Nagy. *Perpe.* 1920. Collage and watercolor

229 Lajos Kassák. Untitled. 1921. Collage, $15^3/_8 \times 12^1/_4''$. Collection Galerie Denise René, Paris

230 Lajos Kassák. *Balloon Vendor (Ballonverkäufer).* c. 1955. Collage, $11^3/_8 \times 15^3/_8''$. Kunstkabinett Klihm, Munich (Photo: Georg Schödl, Munich)

231 Johannes Itten. Untitled. 1917. Collage of tin foil, crepe and tissue paper with ink drawing, $10 \times 8^1/_8''$. Estate of the artist

232 Friedl Dicker. *The Cellist (Der Cellist).* n. d. Oil with wood, metal, and glass. Lost (Photo: Anna Landmann, Karlsruhe)

233 Lily Hildebrandt. *Munich 1916 (München 1916).* Collage. Collection the artist (Photo: Anna Landmann, Karlsruhe)

234 Otto Nebel. *Collage K 76.* 1964. Lace, fabric, and patterned papers, $7^7/_8 \times 7^1/_8''$. Galerie Simone Heller, Paris (Photo: N. Mandel, Paris)

235 Adolf Hölzel. *Prayer of the Children (Gebet der Kinder).* 1916. Collage over oil painting, $19^5/_8 \times 15^3/_4''$. Collection the Pelikan Works, Hanover

236 Adolf Hölzel. *Annunciation (Verkündigung).* 1916. Collage over oil painting, $33^1/_8 \times 26^3/_8''$. Collection the Pelikan Works, Hanover

237 Oskar Schlemmer. *Mythical Figure (Mythische Figur).* 1923. Collage, $31^1/_2 \times 66^7/_8''$. Collection Frau Tut Schlemmer, Stuttgart

238 Oskar Schlemmer. Dancer in his *Triadic Ballet.* c. 1922. Photomontage

239 Paul Klee. *Destroyed Land (Zerstörtes Land).* 1934. Oil and collage, $15^5/_8 \times 12''$. Landesgalerie von Nordrhein-Westfalen, Düsseldorf

240 Alexander (Xanti) Schawinsky and Antonio Boggeri. New Year's greetings to Frau Tut Schlemmer. 1934. Photomontage

241 Lou Scheper. Letter of congratulation on the engagement of Alma Buscher and Werner Siedhof. 1925. Collage

242 Walter Peterhans. *Grünewald Still Life (Grunewald-Stilleben).* 1932. Photographed collage of found objects over and under glass

243 Hanns Hoffmann. *Material Composition (Materialkomposition).* 1921. Drawing of found objects for Itten's course at the Bauhaus, c. $8^5/_8 \times 11^3/_4''$. Lost

244 Henri Nouveau. Untitled. 1929. Collage, c. $7^1/_2 \times 5^1/_8''$. Private collection, Paris (Photo: J. Colomb-Gérard, Paris)

245 Herbert Bayer. *The Five (Die Fünf).* 1922. Gouache and collage, c. $21^5/_8 \times 17^3/_4''$. Collection the artist

246 Herbert Bayer. *Lonely Metropolitan (Einsamer Grossstädter).* 1932. Photomontage, c. $15^3/_4 \times 13^3/_4''$

247 Herbert Bayer. *Self-Portrait (Selbstporträt).* 1932. Photomontage, $15^3/_4 \times 13^3/_4''$

248 Willi Baumeister. *Tennis Player (Tennisspieler).* 1927. Drawing with photos, $15^3/_8 \times 11^1/_8''$. Private collection (Photo: Schubert, Stuttgart)

249 Willi Baumeister. Untitled. c. 1942. Charcoal and chalk drawing with collage, $11^3/_8 \times 18^1/_2''$. Collection Eric Estorick, London

250 Willi Baumeister. Untitled (Head). c. 1927. Collage and pen drawing, $13^3/_4 \times 9^7/_8''$. Collection Margaret Baumeister, Stuttgart

251 Willi Baumeister. Untitled. c. 1942. Drawing with photos, c. $9^7/_8 \times 13^3/_4''$. Kunstkabinett Klihm, Munich (in 1949) (Photo: Klaus Peter Duhnkrack, Munich)

252 Friedrich Vordemberge-Gildewart. *Collage on Hans Arp.* 1927. Ink drawing with photo and pasted cutouts, $20^7/_8 \times 15^3/_4''$. Estate of the artist, Stuttgart (Photo: Dieter Geissler, Stuttgart)

253 Friedrich Vordemberge-Gildewart. *Composition no. 19.* 1926. Oil and wood on canvas, $31^1/_2 \times 31^1/_2''$. Niedersächsische Landesgalerie, Hanover (Photo: Hein de Bouter, Amsterdam)

254 Friedrich Vordemberge-Gildewart. Untitled, no. 7 of a series. 1928. Collage and photomontage, $15^7/_8 \times 11^3/_8''$. Estate of the artist, Stuttgart

255 César Domela (Nieuwenhuis). *Composition.* 1938. Collage with metal bands, $15^3/_4 \times 21^5/_8''$. Private collection, New York

256 Victor Servranckx. *Opus V—1919*. Collage, 24³/₄ × 19¹/₄″. Private collection, Brussels

257 Erika Schneider. Collage contributed to the guest book of Vordemberge-Gildewart. 1925 (Photo: Dieter Geissler, Stuttgart)

258 Carl Buchheister. *White Diagonal (Weisse Diagonale)*. 1931. Relief of painted aluminum and tissue paper on white ground, 35³/₈ × 19⁵/₈″. Estate of the artist

259 Joaquín Torres-García. *Wood Construction with Bottle*. 1931. Relief of sawed and nailed boards, partly painted, 19¹/₄ × 16¹/₈″. Private collection, Montevideo, Uruguay (Photo: Alfredo Testoni)

260 Hendrik Nicolaas Werkman. *Composition with Letters X*. 1927/28. Composite hand print from elements in the type case, 18 × 11⁵/₈″. Stedelijk Museum, Amsterdam (Photo: Gemeentemusea, Amsterdam)

261 Hanns Robert Welti. Untitled. 1929. Collage on panel, heavily painted, 21¹/₄ × 17³/₈″. Galerie Suzanne Bollag, Zurich (Photo: Ernst Scheidegger, Zurich-Paris)

262 László Moholy-Nagy. *My Name Is Hare (Mein Name ist Hase)*. 1927. Photomontage. Collection Sybil Moholy-Nagy

263 Theo van Doesburg. *Portrait of the Artist's Wife*. c. 1922. Photo collage, 19³/₄ × 15³/₄″. Print Room, University of Leiden, The Netherlands (Photo: Prentenkabinet, Rijksuniversiteit, Leiden)

264 Max Burchartz. *Top Hat*, promotion piece for the jubilee celebration of the gentlemen's club Zylinder, Essen. 1928. Photomontage

265 Jan Tschichold. Poster for the film *Die Frau ohne Namen*. 1928. Photomontage and drawing

266 UMBO (Otto Umbehr). *Portrait of Egon Erwin Kisch, The High-Speed Reporter*. 1926. Photomontage. Collection Paul Citroen, Wassenaar, The Netherlands (Photo: J. Colomb-Gérard, Paris)

267 Teresa Zarnower. *Worker-Peasant Unity*, election poster. 1928. Photomontage

268 Hans and Grete Leistikow. Title page for the magazine *Das Neue Frankfurt*, November, 1929. Collage and photomontage

269 César Domela (Nieuwenhuis). *Berlin Museums*. Mural for the *Fotomontage* exhibition in the former Kunstgewerbe Museum, Berlin, 1931. Photomontage

270 Hans Finsler. *Easy-Going Innovation (Sachte Neulichkeit)*. c. 1927/28. Photomontage with the heads of Gropius and Moholy-Nagy replacing those of Goethe and Schiller on the monument at Weimar

271 F. A. Flachslander. Poster for Ernst Křenek's opera *Jonny spielt auf*. 1927. Collage (Photographic collection, Österreichische Nationalbibliothek, Vienna)

272 John Heartfield. *Under the Sign of Rationalization (Im Zeichen der Rationalisierung)*. 1927. Photomontage poster

273 John Heartfield. Title page for the book by Kurt Tucholsky and John Heartfield, *Deutschland, Deutschland über alles*, Berlin, 1929. Montage

274 John Heartfield. *A New Chair in German Universities: Advanced Racial Science (Neuer Lehrstuhl in den deutschen Universitäten: Völkische Tiefenschau)*. 1933. Photomontage (Photo: Deutsche Akademie der Künste, Berlin)

275 John Heartfield. *German Acorns (Deutsche Eicheln)*. 1933. Photomontage (Photo: Deutsche Akademie der Künste, Berlin)

276 Mieczyslaw Szczuka. *Kemal's Constructive Program*. 1924. Photomontage

277 Wladyslaw Daszewski. *Unemployed*. 1932. Photomontage (Photo: Wydziat Historii Partii K.C.P.P.R., Pracownia)

278 Ladislav Sutnar. Title page for the magazine *Žijeme*. 1931. Photomontage

279 Mieczyslaw Berman. *The Dimensions of the Head*. 1944. Collage and photomontage

280 Mieczyslaw Berman. *Prosperity*. 1930. Photomontage

281 Mieczyslaw Szczuka. Title page for the book by Anatol Stern and Bruno Jasieński, *Ziemia na Lewo (The World to the Left)*. 1924. Photomontage

282 Piet Zwart. Prospectus for an advertising agency. c. 1931. Photomontage

283 Charles G. Shaw. *Today*. 1934. Collage, 20¹/₈ × 15″. Collection the artist

284 Balcomb Greene. Untitled. 1938. Collage, 7⁵/₈ × 13³/₄″. Bertha Schaefer Gallery, New York (Photo: Walter Rosenblum, New York)

285 Suzy Frelinghuysen. *Toreador Drinking*. 1942. Oil and collage on wood, 44⁷/₈ × 33¹/₈″. Philadelphia Museum of Art (Photo: Armistudios, Philadelphia)

286 Ilya Bolotowsky. *Balance*. 1934. Collage with drawing, 8⁵/₈ × 11³/₄″. Collection the artist

287 William Baziotes. *The Drugged Balloonist*. 1943. Collage, 18¹/₈ × 24″. Baltimore Museum of Art

288 Ad Reinhardt. *Newsprint*. 1939. Collage, 9 × 11″. Estate of the artist

289 Adolf R. Fleischmann. Untitled. 1957. Collage of torn papers, 25 × 18⁷/₈″. Staatsgalerie, Stuttgart (Photo: Dieter Geissler, Stuttgart)

290 Robert Motherwell. *The Easel*. c. 1951. Collage, 29⁷/₈ × 20¹/₈″. Private collection (Photo: Peter A. Juley, New York)

291 Hans Richter. *Stalingrad, Victory in the East* (detail). 1943–44. Oil and collage, total dimensions 2′7¹/₂ × 1′8¹/₂″. Collection the artist

292 Jean Xceron. Untitled. 1939. Collage with fabrics and gouache, 9¹/₂ × 5⁷/₈″. Private collection

293 Charmion von Wiegand. *Journey into Fear*. 1958. Collage

294 Alberto Magnelli. Untitled. 1937. Framed relief with found objects. Destroyed (Photo: Marc Vaux, Paris)

295 Alberto Magnelli. Untitled. 1937. Gouache and collage, 25⁵/₈ × 20¹/₈″. Collection the artist (Photo: Marc Vaux, Paris)

296 Alberto Magnelli. *Collage with Japanese Rakes*. 1938. Assemblage of bamboo rakes, canvas, marbled paper, leather paper, 48⁷/₈ × 40¹/₂″. Collection the artist (Photo: Marc Vaux, Paris)

297 Alberto Magnelli. Untitled. 1941. Collage on music paper, 13³/₄ × 10⁵/₈″. Collection the artist (Photo: Yves Hervochon, Paris)

298 Alberto Magnelli. Untitled. 1949. Collage of canvas, packing paper, book pages, 19⁵/₈ × 24³/₄″. Collection Mr. and Mrs. Harry Lewis Winston, Birmingham, Mich. (Photo: John D. Schiff, New York)

Index

quelques

paires de ciseaux.

Celle-ci
est
femelle,
cravattée
à la
Lavallière
cependant.

Celle-là
est
mâle,
sèche,
dure,
et
aussi
face-à-main.

La troisième a la
dent fine:
c'est un poisson
carnivore.